THE ENGLISH NATIONAL CHARACTER

The English National Character

The History of an Idea from Edmund Burke to Tony Blair

PETER MANDLER

YALE UNIVERSITY PRESS
NEW HAVEN AND LONDON

For information about this and other Yale University Press publications, please contact:
U.S. Office: sales.press@yale.edu www.yalebooks.com
Europe Office: sales@yaleup.co.uk www.yaleup.co.uk

Set in Baskerville by J&L Composition, Filey, North Yorkshire
Printed in the United States of America

Library of Congress Cataloging-in-Publication Data

Mandler, Peter.
 The English national character: the history of an idea from Edmund Burke to Tony Blair/
Peter Mandler.
 p. cm.
 Includes bibliographical references.
 ISBN 13: 978-0-300-12052-3 (alk. paper)
 1. National characteristics, English–History. 2. Group identity–England–History.
 3. National characteristics, British–History. 4. Group identity–Great Britain–History.
 5. Great Britain–Social life and customs. 6. Great Britain–Civilization. I. Title.
 DA118.M33 2006
 305.82'1–dc22
 2006010259

10 9 8 7 6 5 4 3 2

For Ben and Hannah

Contents

CONTENTS

Illustrations

CHAPTER 1

Introduction

What is it about the English people that makes them so English? Is it their long, continuous tradition of liberty, which makes them so opinionated, so ready to express their opinions so bluntly? Or is it rather their reticence, their stiff upper lip, inculcated by stern, unsentimental child-rearing practices, such as their unusual propensity to send their children off to boarding schools at a tender age? Is it their empire-building, world-beating habits of industry, their readiness to engage in steady physical labour however distant the hope of return? Or is it instead their whimsical eccentricity, their susceptibility to flights of fancy, so productive of lyric poetry, children's literature and bizarre cultural practices like flagellation or cricket? Are they busy or phlegmatic, industrious or lazy, or do they alternate activity and sloth? Are they indeed so eccentric, so individual, that they have no common characteristics at all, except that very individuality, which marks them off from the lemming peoples of Europe, the obedient Germans or slavish Slavs?

All of these traits have, to a greater or lesser degree of unanimity, been attributed by the English to themselves at one time or another over the last two hundred years. That is one theme of this book: the changing menu of characteristics assigned to themselves by the English can tell us much about their changing perceptions of their place in the world and their relationship to other peoples, about their degree of self-satisfaction or discontent, and above all about their relationship to each other. We can use changes in the language of national character to follow changes in fundamental attitudes to nation and society in this way because the language of national character is significant – it tells us what the people who use it think about themselves and about others – but also because the language of national character is slippery and flexible. It is capable of being constantly contested and reinterpreted by a wide range of social actors and from a wide variety of ideological positions – liberal and even radical as much as conservative.[1]

It has to be slippery and flexible to do the job it purports to do. Nations are complex organisms, full of people and things we do not know personally but that we recognize as kin, and national character is one of the strongest ways we have to imagine them as a unit. What could be more compelling than to see in your compatriots those most intimate traits you find in yourself? But this feat of imagination requires numerous sleights of hand. Like the horoscope in a national newspaper, the idea of national character has to use a language that is simultaneously loose enough to appeal to an audience actually very diverse in geography, class, lifestyle and culture, and yet specific enough to strike a chord of recognition in the individual reader. Beyond this, however, the idea of national character seeks to yoke real national differences based on a wide variety of experiences to a few key psychological traits to which those national characteristics may have no connection. Nations do have distinctive qualities – customs, manners, institutions, all kinds of quirks. But these distinctions do not necessarily cohere into a pattern, still less one rooted in psychology. There is no necessary connection between the nature of Parliament, the boarding school, football hooliganism, fish and chips, snooker, the royal family, Monty Python and Admiral Nelson – except that they are all thought to be 'characteristically' English. Yet the idea of national character seeks to connect all such things to a single personality type, an effort that naturally demands a highly creative use of language and an equally creative treatment of cause and effect. So national character can be used quite subtly to reflect its exponents' current beliefs, anxieties, self-understandings and prejudices, while seeming to stand for timelessness and genuine cohesion.

That aspiration to timelessness and cohesion, however, means that the language of national character cannot be too flexible if it is to retain its authority. 'National character' is meant to refer to deep-seated structures in the minds of the people; only after generally acknowledged periods of crisis or great social changes is a substantial reassessment normally permissible. It tends to speak in terms of stability, even when palpably shifting ground. At some points and in some hands it can be treated as a national treasure, attempts to mishandle which will be fiercely resisted. Certain traits are so deeply embedded in the concept that they are almost impossible to dislodge, although they can still be spun with high degrees of variability, so that English 'individualism' or 'love of liberty' can be successively reinterpreted as 'self-reliance' in a period of laissez-faire, 'self-respect' in a period of growing state intervention, and even in a period of high collectivism as 'eccentricity' or just 'freedom of expression'. But it can also be dropped. National characteristics are allowed to go underground for generations, even centuries, and when it is convenient their reappearance after such a long interval can be hailed as proof that they were there, deep down, all along. As is often the case in the

imagining of nations, selective amnesia is a crucial requirement for thinking about national character, enabling the construction in the mind of homogeneities and long-term continuities that simply do not exist in diverse and ever-changing modern societies.

Alternatively, the idea of national character can give way to non-psychological understandings of the nation, or to understandings of the self that have nothing to do with the nation at all. In some periods, the English seem not to have needed to specify clearly who counts as English, how one can tell, and whether it even matters. That is another theme of this book: the identification of an English national character has throughout modern history had to compete with other identities and loyalties that cut across divisions between the English and the rest. During this period England has lain at the heart of a multi-national federation – Britain or the United Kingdom – and a multi-ethnic empire. This position has given the English power but it has often also weakened their restrictive sense of self. For much of the modern period, the power that an elite of Englishmen wielded bonded them together more tightly but separated them from the bulk of their countrymen and women, thus sapping their sense of national commonality. The responsibilities of power threw up a host of competing loyalties and identities, vaguer and wider, that could substitute for the idea of an English national character: the idea of the gentleman, for example, or Christian mission, or 'civilization', or 'liberalism'.

This book begins around the time of Edmund Burke because Burke is often thought of as the great progenitor of modern thinking about Englishness and because his era – the era of the French Revolution – did produce directly a strong idea of 'national character' in France and Germany. But the English reaction to the French Revolution, coupled with the multi-national and multi-ethnic nature of the United Kingdom and the British Empire, meant that in Burke's own time these wider loyalties were strengthened and the idea of national character remained undeveloped, Burke's own Irish origins posing a typical complication. It would take another generation, when a kind of democratic thinking began to blend with thinking about the 'nation' around 1830, before the idea of national character in England began to flower. Conversely, when democrats after 1830 began to think in terms of an English national character, anti-democrats and imperialists continued to resist the idea as incompatible with the hierarchical and multi-ethnic political entity with which they identified.

The legacy of these wider loyalties thus persisted even after the advent of democracy did cultivate among many a sense of national specificity. The sense of national specificity itself did not always take the form of a stable 'English character' either. In an open, liberal, changing society as is modern

Britain, definitions of 'national character' have always been fought over, fractured by varying class, political and cultural interpretations. British identities sometimes draw on, but sometimes deny, 'Englishness'. And there are other kinds of English national consciousness apart from identification with a psychological type – identification with institutions, or the land, or history, or particular customs, or people – that may blur or overlay the idea of 'national character'. In this situation 'national identity', which includes those other kinds of national consciousness, is too loose a term: we need a more complicated language – one that recognizes different forms of national consciousness as well as other identities (including supra-national ones) that bedevil national consciousness.

As a result of this complex – and unique – process of political and social development, it is more difficult to pin down 'Englishness', make it stable or consensual, than Germanness or Frenchness, or indeed Irishness and Scottishness. And that difficulty poses a particular problem for some people in England today. Faced with a wave of apparently relentless globalizing, Americanizing or Europeanizing forces that are everywhere undermining peoples' sense of their own national distinctiveness, some of the English would like to unsheathe the sword of national character to ward off these alien invaders. They point to the recent apparent upsurge of Welsh and Scottish national consciousness as a model for the English to follow. But, as a result of their modern history, the English as a whole do not think of themselves in that way. Today, at a time when some of the peoples of the United Kingdom are feeling less British, the English still feel the most British: only a third will say that they are more English than British.[2] They are also more likely to say that their sense of self has nothing to do with England at all, but comes from individual values or other kinds of community.

To overcome this little difficulty, seekers after an English national character have to rummage around in history, either diving deep into the past to capture a semi-mystical core of Englishness that eludes specificity ('a certain continuity of spirit . . . rooted deep in the psyche')[3] or fixing on a particular, recent period when the idea of the English national character was at a peak (especially during the Second World War, England's 'finest hour') or taking one dominant group's idea of Englishness and applying it to the rest.[4] But any honest estimate of the English national character has to admit at least the possibility that in some periods it may not have existed, even in the minds of its people, or it may have been diminished in significance next to other sources of attachment and self-consciousness. Or, when it has burnt brightly, that it has never meant precisely the same thing for long or for everyone, and that its past meanings may not have any great relevance today.

This book traces systematically for the first time the presence and content
of the idea of an English national character over the last two hundred years.
I focus on the most detailed and coherent expressions of that idea, explaining
why they arise when they do, what alternative expressions of collective iden-
tity they have to compete against, what traits they assign to the English
national character and how those traits change. The central body of sources
are the works in which the English tell themselves in public who they are: their
histories, treatises on English 'culture' and 'society' both learned and popular,
politicians' speeches, clerics' sermons, leaders in major newspapers, trave-
logues, auto-ethnographies, polls and surveys, national inquests at moments of
crisis. Poetry, novels, films and television programmes offer further material,
especially when they ask the question directly, 'Who are the English?' Works
by foreigners are considered only when they form part of the indigenous
discussion, when they are translated and seem to be accorded some cultural
authority. Thus Ralph Waldo Emerson's *English Traits* (1857), which had a
great impact on thinking about the English in England, is given more weight
than Hippolyte Taine's *Notes on England* (1872), which did not.[5] And both are
dwarfed by the outpouring of anatomies of the English by Continental
liberals that so obsessed the English themselves in the 1920s and 1930s.

Looking at self-portraits is not the only way to approach the subject of the
English national character, but there are both practical and principled reasons
for doing it this way. One principled reason is simply that it has not been done.
A great deal has been written, especially recently, on English and/or British
'national identity', much of it historical. These studies tend to be either very
specialized and thus fragmentary, taking some icon of 'national identity' like
roast beef or King Arthur or one writer on the subject like John Stuart Mill
or Ernest Barker,[6] or very monolithic and thus impressionistic, telling one big
story about the development of the national identity, very often (since Linda
Colley's *Britons*) based on allegedly seminal moments in the late eighteenth
century. My own study of national character treads a middle ground by
looking at one strand of thinking about the English nation fairly comprehen-
sively over a long period of time, taking advantage of this mountain of other
work to point out where national character converges or diverges with,
confirms or contests, other forms and symbols of national consciousness.

A practical reason for this study is provided by the sheer volume of mate-
rial. Some of the standard works on English or British 'national identity' say
that there is no tradition of writing about it: the English have always taken for
granted who they are. A quick glance at the bibliography will suggest how far
from the truth this is. People can get away with saying this because imagining
a nation always requires a degree of wilful amnesia; if it is convenient to do

so, a writer will easily skip over the thousand or so writings on the English national character upon which I have drawn (not to mention other ways of reflecting upon Englishness). Fighting that amnesia is another good principled reason for undertaking this work.

Practicality, however, has dictated confining my sources to those writings that aim to anatomize the English directly and wholly rather than implicitly or in metonymic or synecdochic terms, looking at specific traits or symbols or practices and 'taking the part for the whole'. In periods when national character is a central idiom of the culture – in the middle of the nineteenth century or the middle of the twentieth century – practically any writing in or about the English will have something to say about the national character, thus the books about roast beef or King Arthur. But it is difficult to interpret those bits and pieces if we lack a larger framework. The rush to talk about 'national identity' without being clear first what 'national identity' is – what multiple forms of national consciousness there are, how they interact, ebb and flow – means that we know much less about 'national identity' than it appears from the size of this literature. We are constantly being told that this icon or that person or this event 'constituted' the national identity, but not how far, or how much, or among whom, or for how long, or what the thing being constituted is. Accordingly we have many stories – not just different layers or angles, but often overtly incompatible stories. The framework provided here is not an attempt to hammer them violently together into an illusory, coherent whole, but at least to show what relationship they might all bear to each other.[7]

Once again, amnesia is as much an enemy as confusion or multiplicity. Each generation warps or ignores what their parents (not to mention great-grandparents) have said, and we ought at least to be aware that that is what they have done. For example, the idea that 'the English' are or were defined by the ideal of 'the gentleman' is still constantly asserted today, if only as the prevailing myth; yet this idea is a relatively new one, and it only gained wide currency in the 1950s when Angry Young Men made the gentleman iconic so that they could be iconoclasts.

The study of national character by reference to more detailed and coherent expressions of the idea undoubtedly imparts biases. It makes this book more a history of 'ideas' than of dreams, visions and symbols or of unarticulated or half-articulated imaginings. One could probe deeper, or differently, into the psyche using more imaginative (for example, literary) material than I have done, although I have tried to relate my material to what others have said about literature or cinema or art. On the other hand, this history of ideas is not only about 'important' ideas launched by 'great' men. Writing about the national character has often been aimed at, and sometimes written from, the point of view of, the 'man on the street' (less often, as we will see, the woman).

As its purpose has generally been to assimilate elites and masses into one psychological type it has had to be accessible to both. The sources range from cartoons in tabloid newspapers to weighty treatises on social theory cannibalized for mass circulation, from popular histories that sold in the hundreds of thousands for decades to ephemeral journalism in daily newspapers and weekly magazines. Their bias is by definition towards belief in the primacy of national loyalty (rather than, say, class or gender), in favour of social cohesion (rather than diversity or fragmentation). But this is not to say they are in a simple-minded way 'conservative' sources: on the contrary, they are fundamentally about the advent of democracy, about making all the citizens of a nation feel fundamentally alike, though not necessary equal. To write about them is to write a crucial part of the history of the whole of English culture.

ENGLAND BEFORE CHARACTER

It is important to make clear at the outset that the idea of a national character is only one form of national consciousness – perhaps the most specific and tightly focused but still only one among many – and that this book fastens only on the most obtrusive manifestations of that idea.[8] Consciousness of the nation can vary in focus from something quite vague, barely even capable of articulation, to something very tightly defined. On the vague end of this axis lies what the social psychologist Michael Billig has called 'banal nationalism' (the title of his 1995 book) – the barely conscious awareness that people have of living in a nation, triggered by the most casual sights and sounds: the glimpse of a flag on the street, the name of a country on a newspaper masthead, the colloquial use of national labels in everyday speech ('full English breakfast', 'Nationwide Building Society'). Also on the vague end, though not always as vague as 'banal nationalism', is patriotism: a feeling of loyalty to country that does not require a very focused sense of what that nation is or represents.

Intensity of focus says nothing automatically about the strength of feeling. It is possible to have very strong feelings about very ill-focused subjects, and patriotism can be expressed in just this way. Patriotic feelings are often invoked on the eve of battle, for example, to bond soldiers together and make them fearless in the face of danger, yet the rhetoric employed for this purpose need not summon up precise images of the nation in order to achieve heights of emotion. Rhetoric and precision can strain in opposite directions. The famous speech that Shakespeare puts in the mouth of John of Gaunt, used so often to elicit patriotic feelings among the English, says little about England (except that it is an island) that could not be said in the same words about other countries: 'this royal throne of kings', 'this sceptr'd isle', 'this earth of

majesty', 'this seat of Mars', 'this other Eden, demi-paradise', 'this happy breed of men', 'this little world', 'this precious stone set in the silver sea', 'this blessed plot, this earth, this realm, this England'.[9] Yet it is widely esteemed as the most moving and effective evocation of patriotism in the English language.

At the other end of the spectrum lie forms of national consciousness that strive to be very specific about what qualities are most characteristic of, or unique to, the nation in question. The idea of 'national character' – that a people forming a given nation have some psychological or cultural charac-teristics in common that bind them together and separate them from other peoples – is one of the most intensely focused forms of national conscious-ness because it implies specificity both about the people in question (and all of them, not only some) and about other peoples. As a horizontal bond, connecting people together and not only vertically to a common leader or geographical expression, 'national character' is one of those forms of national consciousness that historians have tended to argue are confined to the modern period – the last two hundred years or so. Before the eighteenth century, it was possible for people to feel strong patriotic attachments to a land or a leader, though difficult for them to be aware of these commonali-ties because of barriers posed by distance, dialect, illiteracy and immobility. Some would argue that, lacking any real dimension of common awareness, these patriotic attachments can hardly be called 'national'.[10] Others would say that war and especially popular religious feeling could overleap these barriers to create a common patriotic feeling well before the modern period.[11]

But, in either case, 'national character' is a particularly developed form of horizontal bond that surely requires modern conditions in which to flourish. It assumes not only communication among a people but a detailed awareness of common characteristics. Even positing the idea of a national character requires assumptions about an irreducible level of equality – yoking together a people from dukes to dustmen – that was inconceivable in pre-modern societies. The more elaborated the idea of national character – the more characteristics attributable to the whole of a nation – the more equality is implied. Thus the idea of national character is likely to arise only in modern conditions, to peak in the conditions of fantasized perfect equality that total-itarian states foster and to wane in periods (like the present) of heightened consciousness of individuality.[12]

In addition to its ambiguous place at the centre of a federation and an empire, then, it is England's historic attachment to liberalism – to individual diversity and uncollective identities – and its doubts about equality or even democracy that have troubled its efforts to divine its national character. Yet

England has hardly been unmarked by the less focused forms of national consciousness. Indeed there is a school of thought that argues that England was a pioneer of the weaker forms of national consciousness – especially patriotism – and that this early development of patriotism saved it from, or deprived it of, the stronger forms such as nationalism or national character.[13] Before considering how and why ideas of national character did emerge among the English, therefore, we should look more closely at these earlier forms of national consciousness to demonstrate exactly how and why they were different and the extent to which their presence did indeed inoculate the English against the stronger stuff.

England was undoubtedly the subject of a national consciousness earlier and stronger than that attaching to many other European countries but whether that early consciousness of England translated into an early consciousness of the English, or even laid a foundation for later developments, is more doubtful. Early national consciousness invariably centred upon and was fostered by the figure of the ruler. The personification of the nation in the ruler was possible only in those countries that had become politically unified – a distinction that England achieved partially under the Anglo-Saxon kings and then more fully and permanently after the Norman Conquest.[14] This crystallization of England as a single political unit under the Normans was, however, undercut somewhat by the obviously non-English character of the Norman rulers themselves – an effect reinforced by the extension of their Continental domains under their successors, the Angevins. In the later Middle Ages, the people who felt the presence of 'the English' most strongly were not the English but the Welsh and the Scots, who were threatened by the English rather than the French part of the Angevin Empire.[15]

By the time in the fifteenth century that these issues had been resolved, by the Anglicization of the ruling dynasty and the more or less simultaneous loss of their Continental possessions, England was no longer unique in its status as a single political unit. That distinction was now shared with Spain and France, which had both benefited also from the consciousness-raising entailed in the struggle to throw out 'alien' occupiers. At this point, in the fifteenth century, Spain might also seem to have had a geographical advantage over England in solidifying its national consciousness: its 'peninsularity' provided a real focus in the Reconquista against the Moors for which England – no more an island than Spain given that it shared a landmass with Scotland and Wales and an archipelago with Ireland, and for four hundred years was ruled by a Channel-hopping elite – had no equivalent. The notion of a 'sceptred isle' would have been an outlandish novelty in John of Gaunt's own time, though it had about a hundred years of credibility by the time that Shakespeare put it onto his lips.

Just as the fifteenth century marked the beginning of a turning point in the identification of England, it marked also a beginning in the identification of the English. Without a clear sense of England, a clear sense of the English would have been unlikely to have surfaced at earlier junctures considered later (especially by the Victorians) to be distinctively national: the granting of Magna Carta, for instance, or the assembly of the Commons in Parliament, or the emergence in practice of an unusual system of common law, relatively untouched by written codes and other features of Roman law.[16] Consciousness of these things as belonging to the whole of the people, and as distinctively English as well, surfaced only later: to some extent in John Wyclif's *De Officio Regis* of 1379, more lucidly and memorably in Sir John Fortescue's *De Laudibus Legum Angliae* of 1470 – literally a tract 'in praise of the laws of the English'.

But the fact that such praises were not yet phrased in a language many people could understand reminds us how necessarily limited a sense of the English must have been before the spread of the vernacular language in print. Benedict Anderson has shown forcefully and influentially all the things that print has done to stimulate a consciousness of nationality: it has connected across long distances people who would never have encountered each other face to face; it has given the common tongue a dignity and a permanence previously reserved to sacred, trans-national languages like Latin or the Arabic of the Koran; and, provided with adequate transport facilities, it has made the national community feel more vibrantly alive by giving it a simultaneity of consciousness, in the awareness, for example, that all the members of the community are reading from the same text on a Sunday morning or, in modern times, every morning from a daily newspaper.[17] For these reasons even people who would argue for a dawning consciousness of Englishness in the later Middle Ages have plumped for the spread of the vernacular scriptures in the sixteenth century as the point at which the English people truly became conscious of themselves.[18]

This would have been true in any political unit that adopted vernacular scripture – essentially Protestantism – during and after the Reformation. It was particularly true of the English because the circumstances under which they adopted Protestantism were unusually fraught and contested and, capped by the accession of a female monarch, created an unusual political vacuum giving full vent to expressions of popular will and identity. Certain texts beyond the vernacular scripture were widely read and recognized as particularly English in a way that the New Testament, in whatever language, could not be: first and foremost, John Foxe's *Book of Martyrs*, with its charged providential tales of Englishmen's allegedly unique struggles for religious truth; and then, with remarkable speed, Shakespeare's plays, especially the

histories, from which so many of the most treasured evocations of England originate. This burgeoning sense of national peculiarity, spanning the whole of the people, was then taken up by the late Elizabethan state and used – probably uniquely for the early modern period – as an instrument of rule. It served to consolidate a specially English kind of Protestantism (non-Catholic but also disconnected from attempts to construct trans-national Protestant brotherhoods on the Continent) and to mobilize the people against foreign enemies – at this stage principally the Spanish, although the same cries would be raised later against the Dutch and the French.[19]

As soon as a state latches on to the usefulness of national consciousness, however – and it is worth repeating that this happened earlier in England than elsewhere – the form that that national consciousness takes is less likely to be expressed in terms of the character of the people and more likely to be expressed in the form of patriotism. Before the American Revolution, no state conceived itself centrally as an expression of the people's will or character. The Elizabethan state was no exception. As Richard Helgerson has argued, consciousness of nationality at the end of the sixteenth century had widened inexorably and spread in its object beyond the mere common attachment to the person of the monarch. But in taking advantage of this development the monarchy was still able and determined to limit its attachments. Attachment to the land of England was permissible, even desirable – an attachment expressed not only metaphorically in texts like John of Gaunt's speech but also more descriptively in the great national chronicles of William Camden (1586), Richard Hakluyt (1589) and John Norden (1598), and in durable images such as Christopher Saxton's maps of the counties of England and Wales (1583).[20] Glorification of the language was trickier, representing a clearer shift from the centrality of the monarch than did the land (which the monarch could still be held to personify).

Helgerson suggests that the literary lights of Elizabethan England who sang the praises of the language themselves intended to make such a shift towards the character of the people, tugging against elite preferences for classical literature and at the same time against the 'rationalizing tendencies of the modern state'. Was Edmund Spenser not connecting the language to the people, separate from their monarch, when he asked Gabriel Harvey in 1580, 'Why in God's name may not we, as else the Greeks, have the kingdom of our own language?'[21] But Spenser knew how far to take this, and his enduring legacy to the English language was a rhapsody on *The Faerie Queene*, not the free people. The same limits, Helgerson suggests, inclined Shakespeare – who relied on a popular audience and whose plays frequently side with the people against their rulers in domestic and social settings – to exclude the character of the people from explicit invocations of England. Thus the stately,

abstracted cadences of John of Gaunt's speech: 'Shakespeare's history plays present', Helgerson says, more than any other Elizabethan texts on nationality, 'a pre-eminently royal image of England'.[22]

Of course, Elizabethan control was followed in the early Stuart decades by repeated counter-assertions of a national will separate from or antagonistic to that of the monarch, by lawyers, Parliamentarians, scribblers and, at some points, wider sections of the people. As during the mid-Tudor years, the power struggles of the middle third of the seventeenth century opened a space in which national consciousness could be expressed in more popular and not merely politically deferential, patriotic terms. The most conspicuous and lasting effect of this interlude was the foregrounding of the law rather than the crown as the basis for English distinctiveness.

The groundwork was laid in the early seventeenth century by the voluminous technical works of Sir Edward Coke, who saw it as his task rather to assert the principles of the English common law than to dwell upon its Englishness. Betraying his own classical roots, he traced the common law's origins back to the Greeks and Trojans, not any genetic ancestors of the modern English people. Coke set crucial precedents, however. Merely asserting the centrality of the law to English identity was, if not separating it from the person of the ruler, certainly broadening it to include (potentially) the whole of the people. English law – a common law, unwritten and court-made – could be interpreted as an expression of popular habits and preferences in a way that codified law (especially Roman-based law) could not.[23] After Coke the law would function, at least until the early twentieth century, as a principal support of the very idea of an English national character, as well as supplying some of its chief ingredients. In Coke's own time, however, it was just as likely to function in the opposite way, not as an expression of the national character but as a check on it; from the point of view of pre-democratic lawmakers, the law was more often seen as a necessary discipline for an unruly, fractious people than as a product of their natural propensity for order, justice and collective decision-making.

However, there were coming into circulation as Coke was writing new theories of the historical and ancestral origins of the English suited to giving the common law a more sharply national quality. These theories emphasized the 'Gothic' origins of the English in the invasions that destroyed the Roman Empire. They cast doubt, in a more fundamental way than most Elizabethan authors had been willing to, on the fit between the classical culture of the English elite and the character of the nation.[24] So the liberties secured by Coke's common law derived from a peculiarly 'Gothic', as opposed to Roman, cast of mind. Being anti-Roman did not, as Colin Kidd has reminded us, make the 'Gothic' particularly English, though it did make it

more Protestant. Goths, after all, were dominant across northern Europe. Nor did upholders of the Gothic view have a particularly ethnic conception of the national stock, which they perceived as a confused amalgam of Britons, Romans, Saxons, Danes and Normans.[25]

But there was a more radical variant of the Gothic view that did have some ethnic specificity. This was Teutonism, or Saxonism, which traced the common law more precisely back to the Angles and Saxons who had transported their customs over to the British Isles in the sixth century. Teutonism was more radical because it insisted on a sharper distinction between the 'ancient constitution' of the Saxons and the newfangled innovations brought over with the Normans at the Conquest, equating the former with the purity and simplicity of the common people's liberty and the latter with an arrogant elite of foreigners who had imposed the 'Norman yoke' of arbitrary rule on a formerly free people.

This theory of the 'ancient constitution', and the ethnic qualities of the Saxons deemed to underpin it, thrived particularly in the revolutionary atmosphere of the English Civil War and the Commonwealth. (A landmark in diffusing this view was Nathaniel Bacon's *Historicall Discourse of the Uniformity of the Government of England* of 1647.) It had a long afterlife among lawyers and scholars as well as among popular radicals. In the hands of lawyers and scholars, 'ancient constitutionalism' tended to remain a rather dry, institutional thesis about the common law and deliberative bodies relating to it like the jury and the Parliament. But it laid a basis for a culturally richer portrait of the English people by giving them a specific pedigree traced back to the Germanic tribes. Curiously, the chief source for speculation about the distinctive characteristics of these Germanic peoples was a Roman one, Tacitus' *Germania*, which in the course of the seventeenth and especially the eighteenth centuries became an increasingly cited text on the qualities of the English. Tacitus' authority made Teutonism more respectable, therefore, even among the classically educated.[26]

The very fact that Gothicism, Teutonism and the theory of the 'ancient constitution' were tied up with the revolutionary events of the 1640s and 1650s, however, cast these ideas in the shade after the restoration of the monarchy in 1660. In many ways the later Stuarts were keen to suppress notions of the distinctiveness of the English and their institutions and to reconnect their history and political culture to Continental patterns. Royalist scholars used 'ancient constitutionism' to show that the Norman Conquest had, in fact, transformed the framework of English rule, bringing England into line with Continental ideas of monarchical and religious authority – a view that would be underscored in the next century when Enlightenment thinkers uncovered the common European context of feudalism.[27]

Their efforts did not extinguish Gothicism and Teutonism altogether, though for a time such ideas were rendered politically disreputable. They did highlight, however, the prevailing confusion about who the English were and how different they might be from other peoples. Foreigners – especially royalist foreigners – were highly sensitive to the fact that the English now held a range of competing views about their own defining qualities. Confusion was further heightened by another outburst of civil disorder and the violent displacement of the Stuarts in 1688. The system of relative liberty and toler-ance of diverse political and religious views that was institutionalized after this 'Glorious Revolution' left the identity of the English completely up in the air. In some respects they were again detached from the rest of Europe, despite the fact that their rulers were, after 1688, of Dutch and German origin. Their diversity of views could be seen positively as a defining feature of the English, a product of their unique system of liberty. It could as easily be seen as a sign of quarrelsomeness, rebelliousness, even barbarism.[28]

The prevailing state of confusion is evident in this era's most famous self-depiction of the English, Daniel Defoe's poem, 'The True-Born Englishman' (1700). Defoe starts by identifying each of the world's peoples with a single trait in a way that had been traditional for sailors, pilgrims and other early modern travellers for centuries: the Spaniards were proud, the Italians lustful, the Germans drunken, the Irish zealous, the Persians effeminate, and so on.[29] The English, however, as a crossroads people, were an amalgam of all these traits:

from a mixture of all kinds began,
That het'rogeneous thing, an Englishman . . . a mongrel half-breed race
. . . a contradiction,
In speech an irony, in fact a fiction.

That said, he tries to distinguish each of the qualities the English have inherited from their miscellaneous forebears – fierceness from the Britons, bravery from the Romans, sourness from the Picts, moroseness from the Danes, falseness from both Scots and Normans, honesty from the Saxons. As if this mix were not rich enough, the climate makes them 'terrible and bold', religious liberty makes them 'rigid and zealous, positive and grave', and polit-ical liberty makes them disobedient and grumblesome, the rich humble but the poor peevish.[30]

The post-1688 state was not concerned by this confusion about the quali-ties of the English. Like the Elizabethan state – like most pre-modern states – it was keener to consolidate patriotic feeling than consensus about the 'national character'. The 1688 settlement seemed to offer an ideal opportu-

nity to consolidate patriotism, building upon established themes by that date already 150 years old. If anything, the need to erase memories of the more egalitarian national consciousness that had surfaced during the Interregnum of 1649–60 meant that there was a return to Elizabethan themes, emphasizing common institutions of rule and the 'providential' nature of their origins and survival, downplaying the popular dimension implied by a common ethnic, linguistic and cultural background. The chief difference was that the institution highlighted – the 'constitution' – was now the king in Parliament rather than the emblematic monarch alone.

The eighteenth century turned out to be the patriotic century *par excellence*. A series of wars against France, mounting steadily in scale and expense, dramatically expanded the 'fiscal-military' state – the taxing and fighting state – and with it the need to mobilize ever larger portions of the populace in defence of their country. Thus the state grew and both its need and ability to

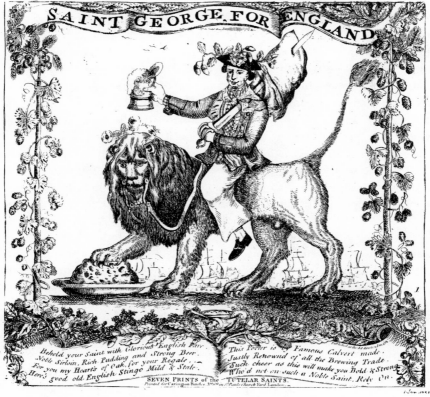

1 A print of 1781, showing almost the full panoply of patriotic imagery

promote patriotism grew with it. The fact that wars were being mounted chiefly against despotic Catholic France conveniently magnified the significance of both the institutional and the religious elements of well-established patriotism. The qualities of the people shrank into the background. As Linda Colley has shown so amply in her trailblazing book *Britons*, eighteenth-century patriotism was immensely fertile with resonant symbols of state and majesty – 'Rule Britannia', 'God Save the King', the heroizing of military leadership, the cult of 'Farmer George', even a nascent cult of Parliament – and decidedly light on symbols of the people.[31] 'John Bull' was only a partial exception: in loyalist propaganda he was often a symbol of the king; in oppositionist usage, a symbol of a people oppressed by 'patriotic' taxes and a professional soldiery.[32]

Even had the eighteenth-century state been keen to develop the self-image of its people, that task would have been difficult as the people in question were becoming markedly more diverse in two key ways. First and most significantly, the union of England and Scotland in 1707 had brought together two peoples in a single state. Although it was just about possible to conceive of a British state – and much of the patriotic effort of the eighteenth century was devoted to retooling old English state concepts as British (thus 'Rule Britannia', written by a Scotsman) – a 'British People' was a leap too far. At least some of the old 'common' institutions remained common in the new state – crown, Parliament, navy – but not all. 'Britain' had to make do with two state churches – one Episcopal and one Presbyterian, though at least both were Protestant – and two legal systems, though both were based on common law. Common ethnicity was out of the question (the very word 'British' would have triggered alarm bells for a more ethnically conscious people, evoking ancient Britons who in England at least were supposed to have been erased by invading Goths). Common topography or language were dubious, and common history and culture were absent; Britishness could be celebrated only in strictly institutional ways.

Secondly, the expansion of Britain's empire raised consciousness of national diversity in more ambiguous ways. Closest to home, the firmer integration of Ireland and Wales, formerly dependencies of England, into the British Union underscored more clearly the ethnically various character of the new nation. Ireland's Catholic population might even have cast into doubt the Protestant character of the union if concepts of the 'people' had had much to do with it. Further afield, the movement of Britons abroad and the expansion of their rule over diverse non-European peoples created a new set of imperial loyalties that had a double-edged impact on national consciousness at home. On the one hand, rule over non-European peoples enhanced consciousness of difference, especially of race. This tended to compress

Britons into a tighter unity when abroad, so that if a 'British people' existed anywhere, it was in Jamaica and India and (for a while) in the American colonies rather than in Edinburgh or London – a trend further reinforced by the large numbers of Irish and especially Scots engaged in imperial adminis- tration. On the other hand, this strong sense of racial difference and of British identity was an imperial and not necessarily a domestic characteristic. The difference between these experiences at home and abroad was a sore point, one of the sources of the American Revolution and other 'creole' nation- alisms, and even a basis of conflict at home between the English and 'impe- rial' returnees, such as the much-reviled 'nabobs' from India and the West Indian 'plantocracy'.[33]

A strong sense of 'national character' was thus undoubtedly in tension with constitutional rule in Britain and with the smooth conduct of the union and the empire. To the extent that it did develop, it bore a subversive cast and a foreign one – there was a feeling, evident already in Defoe, that the English system of ordered liberty permitted individuality to flower and that national uniformity was an alien, despotic concept. It is only against this backdrop that we can understand the peculiar failure of Enlightenment thinking in Britain to embrace the 'nation' as a fundamental category of analysis in the way that it did in France or the German states. This failure is crucial for the subsequent divergence of thinking about 'national character' in England and on the Continent.

The Enlightenment was responsible across Europe for unleashing most of the conceptual vocabulary by which modern Europeans have understood themselves. The very idea of 'society' as something capable of self- consciousness and independent action, separate from the state, was an Enlightenment invention. Improved transport and communications meant that Enlightenment thinkers had much opportunity to observe human soci- eties in different settings and to compare them. What qualities did humans everywhere share? In what qualities did they differ? How did these differences arise and how could they best be classified or typologized? The intense ration- alism and optimism of the Enlightenment at first led to the assumption that humans were by nature everywhere the same, but had been differentiated by their experiences and environments into different stages of development. Enlightenment thinkers built upon this assumption to construct what we can call a 'ladder' classification of human societies, arraying them along different steps of a ladder of development, up and down which all peoples moved according to the various influences upon them. Innate human urges to self- improvement would tend to move societies up the ladder rather than down, though there were well-known examples (the Indians and the Chinese were often cited) of societies that had either degenerated or remained static for

long periods. Ladder classification assumed a high degree of fundamental commonality among all humans and was neatly compatible with biblical theories of monogenesis – descent from a single common ancestor. It also assumed a set of universal qualities to which all humans could aspire, and which societies at the top of the ladder embodied more fully than those below: 'virtue', 'politeness', 'refinement', in short, the ideals of 'civilization'. The most optimistic felt that they were witnessing this consummation in their own time and place. 'Today', wrote Voltaire in his *Essai sur les moeurs et l'esprit des Nations* (1756), 'there are no longer Frenchmen, Germans, Spaniards, even Englishmen: whatever people say, there are only Europeans. All have the same tastes, the same feelings, the same customs, because none has experienced any particular national formation.'[34]

But observation of human societies did not lead all Enlightenment thinkers to view the human race as fundamentally uniform, temporarily differentiated and ultimately convergent. Especially later in the eighteenth century, as awareness spread of greater diversity on the global scale, and as optimism about universal improvement waned after the disappointments of the French Revolution, other classifications of human difference emerged. What we can call 'tree' classification imagined the human race differentiated by branching. Consistent with either monogenesis or polygenesis (multiple origins), tree classifications suggested that human groups became more and more different over time, exhibiting different characteristics that rendered them increasingly incompatible, even to the extent of dividing humans into different species, incapable of cross-breeding or coexistence.

What place did nations have in these schemes? Most Enlightenment thinkers placed a high value on political institutions in determining the character and stage of development of society. As the possession of common political institutions was in this period virtually the sole definition of the nation, it seemed obvious to the Enlightenment to divide peoples along national lines in placing them within a ladder classification. But as different nations passed across the same rungs, and as the general tendency to improvement was gradually grouping all peoples at a similar level high up the ladder, nationhood was viewed as only a fairly shallow and temporary status en route to general human perfection. The rungs themselves were the primary categories: 'feudalism' or 'commercial society' in schemes determined by economic development; 'barbarism' or 'civilization' in schemes determined by the advance of culture and learning.

The idea of the nation was far more important in tree classifications as providing – with race – one of the key horizontal divisions of humanity. Indeed, tree classifications were possible only as people developed a firmer conception of the distinctiveness of nations over the course of the eighteenth

century. Perhaps differences in political institutions were reflections of deeper differences, rooted in nature or history, ineradicable by a superficial change of laws or rulers. The question was then what were these profound factors responsible for differentiating nations and in what ways did the nations differ. Here lie the origins of the systematic investigation of 'national character'.

The most original and influential Enlightenment pronouncements on national character were those of the French *philosophe* the Baron de Montesquieu, especially those appearing in his *Spirit of the Laws* of 1748. While granting in common with mainstream Enlightenment thinking on ladder lines that 'general education' – laws, religion, customs, manners – had a great influence on the character of society, Montesquieu also placed a novel emphasis on climate and landscape in determining the characters of peoples. These geographical factors worked directly on people's bodies and minds and also indirectly in constraining the nature of 'general education'. For example, temperate climates (such as Europe's), where people were very much alike, encouraged peaceful coexistence and thus constitutional systems, whereas climates of extremes (such as Asia's), where peoples were more various and impressionable, courted conflict, oppression and slavery. As this example suggests, when discussing non-political factors such as climate, Montesquieu was not terribly precise about what defined a 'nation': he speaks of units as various as Europe, China, Sparta, the Turks and the Jews. But at least he had begun to tease out the criteria by which a 'scientific' differentiation of nations could be achieved, and also incidentally gave currency – and enhanced legitimacy – to a fresh set of national characters: the English were impatient and obstinate, the Japanese stubborn and perverse, the Indians 'mild, tender, and compassionate'.[35] For Montesquieu, however, 'national character' was still only a perturbing factor of which the state had to take account in framing its laws; it was not a defining factor, simply because Montesquieu assumed that the state defined its people rather than vice versa.[36]

Others then took up Montesquieu's starting points and developed them, particularly at the end of the eighteenth century in the conflicts spawned by the French Revolution. Most of these prophets of profound national differentiation were French or German. France and the German lands were the two principal centres in Europe of popular mobilization – that is, the identification of the whole of the people with the nation – though this mobilization took two quite distinct forms.

In France the presence of a strong state was crucial. The revolutionary and Napoleonic regimes were the first in European history to seek to mobilize the whole of their people into a strong, active national consciousness, first to overthrow the *ancien régime*, then to pursue total war and transcontinental conquest. For more than twenty years the French state devoted itself to cultivating a

powerful idea of uniform Frenchness by means of political education, civic education (including the teaching for the first time of a common language), mass conscription and the creation of a host of national cultural institutions – museums, academies, learned societies, monuments. Not only French political thought, developing Jean-Jacques Rousseau's ideas of government embodying a 'general will', but also French social, historical and even biological thought, developing Montesquieu's ideas of national differentiation, were saturated in this consciousness of national distinctiveness.

Emblematic was the figure of Jean-Baptiste de Lamarck, whose theories of the inheritance of acquired characteristics gave a biological fixity to national differentiation. The early differences based on climate and physical environment posited by Montesquieu could, in the Lamarckian view, be passed biologically through the generations and quite quickly separate the human species into very different stocks. Even French liberals such as Madame de Staël and Benjamin Constant took the view that the path to progress could be different for different peoples, dependent on their peculiar qualities of 'mind' and 'soul', although this fate was for them a source of mournful reflection upon the difficulties that the French were having in stabilizing their political affairs.[37] French historians of the Napoleonic and immediately post-Napoleonic period, such as Augustin Thierry, saw their task as conferring a long, particularistic pedigree on the French people, often explicitly racial.[38]

This kind of thinking developed even further among the Germans, since the idea of the German people preceded the realization of the German state. The lack of a unified state or indeed any common political institutions – felt most strongly during the Napoleonic occupation – caused German thinkers to focus on the qualities of the people, their common customs, dispositions, traditions, language and literature. Starting at least with Immanuel Kant, though in his thought it did not take a strictly nationalistic form, the idea developed that beneath the veneer of 'civilization' – common to all developed peoples – lay a bedrock of *Kultur*, an essential morality that inhered in the people.[39]

The man who developed this insight into what became thought of as a science was Johann Gottfried Herder, whose *Outlines of a Philosophy of the History of Man* (1784) went well beyond Montesquieu both in systematizing the influences differentiating peoples and in insisting on the depth and significance of that differentiation. Climate, Herder argued, was only one of a quasi-mystical complex of physical influences that shaped a people: topography, the character of the soil, the nature of the food and raiment that derived from the soil, the attitudes and morality that grew out of those peculiarities of nourishment and self-protection, and so on. Language – and the highest expression of language, literature – in turn grew out of those physical

differences and laid the basis for a people's *Kultur*, not fixed but inherited and thus only slowly, reluctantly malleable. Herder, it will be seen, moved boldly from physical to moral characteristics, as in his characterization of the Germans: 'Their large, strong, and well-proportioned bodies, with their stern blue eyes, were animated by a spirit of fidelity and temperance, which rendered them obedient to their superiors, bold in attack, unappalled by peril, and to other nations . . . pleasing as friends, terrible as foes.'[40]

Yet even Herder was, ultimately, still a universalist, who looked in the long term to the reunion of humanity – which, as a monogeneticist, he regarded as having a common origin – into wholeness, as their spiritual natures gradually triumphed over the physical. It was only under the political pressures of the Napoleonic period that national differentiation became, for Herder's successors, a proud, permanent and defensible feature of the German people rather than a temporary condition – and not only a defensible feature, but also one that could and should be elevated to the highest level through the creation of a German national state. Under these influences it was German thinkers who brought to their full fruition the supposed sciences of national differentiation: ethnology (the study of the physical differences between humans), philology (the study of the differentiation of human languages, often held to be analogous to physical differentiation), and ultimately *Völkerkunde* – a comparative ethnology that in the nineteenth century sought to put national difference at the very heart of German social science, blending the study of physique, language, history and culture.[41] This was 'tree' thinking with a vengeance.

The British Enlightenment was subject to some of the same influences, but they did not develop so radically as those of the Germans or even the French, and 'ladder' thinking remained predominant into the nineteenth century to an extent unparalleled in the rest of Europe. The reasons for this divergence lie principally in the crucible of the Napoleonic wars, when the British state was able to mobilize its people with appeals to patriotism that did not require a levelling sense of solidarity, but its roots go back into the eighteenth century and the peculiar qualities of the British Enlightenment itself.

The fact that so much of the British Enlightenment was in fact Scottish played its part. The Scottish Enlightenment, far from being proud of its national past, was highly censorious about it. Compared to the English, the Scottish constitution looked like an institutional failure and the ethnic history of the Scots was mixed, even their language highly ambiguous, and their historical and cultural traditions appeared to educated men in Edinburgh and Glasgow to be barbarically clannish and fortunately nearing extinction. The Act of Union offered Scottish intellectuals the chance to ditch what Colin

Kidd has called 'Scotland's unusable past' and throw in their lot with the English.[42]

In asking themselves what had made English liberty so much more successful than that of the Scottish, however, men like David Hume, Adam Smith and John Millar did not – probably could not, from their Scottish position – simply embrace the English tradition as their own. Rather they developed a sophisticated historical and sociological explanation as to why the English had emerged from the common European background of feudalism with so much more individual liberty, so many more consensual institutions, and so much more progressive and commercial a society. They cast a sceptical, comparative eye upon the English pride in their 'ancient constitution' and argued for a much more recent, conjunctural set of explanations, ridiculing the allegedly Saxon origins of Parliament and other key institutions and placing far more weight on the struggles of the seventeenth century, turning points as recent as 1688 or 1707 (for it was in their interest to assert that Scottish culture was salvageable by means of the union). They did not dwell upon factors that kept nationalities distinct, but placed their emphasis instead on universal human qualities – sociability, capacity for selfishness or altruism, acquisitiveness and so on – which in different historical and institutional situations led to different results.[43] This perspective allowed them to pose as counsellors to present-day legislators, offering advice on the manipulation of laws and institutions to achieve optimal results, which a fatalistic attitude to national character would forbid.

Hume, unusually, took up Montesquieu's writing on national character and agreed that peoples had observable differences, but he deplored any attempt to fix these characters in physical differences, insisting that human nature was social and subject to social influences. A people's character, he concluded, was set by the laws and manners laid down by their rulers, and as the English were the freest of all peoples, each individual allowed 'to display the manners peculiar to him', therefore 'the English, of any people in the universe, have the least of a national character; unless this very singularity may pass for such'. This national character – or lack of it – was also available to any people that chose or developed that English system of liberty.[44]

Writers like Hume and Smith may have operated only at the rarefied heights of intellectual discourse, though their influence echoes down the generations and will be felt repeatedly as we pass through the nineteenth century. But their 'ladder' perspective of human development chimed neatly, and not accidentally, with the British political elite's preferences. A hierarchy of nations, based on different stages of development towards 'civilization', was an ideal vision for an expanding British Empire. Within the nation, a hierarchy of classes, based also on different stages of development, was an

ideal vision for a progressive but inegalitarian and anti-democratic ruling elite. It was still possible to idealize English liberty but convenient to see it as a fragile product of recent history, sustained by imperfect but wisely maintained institutions, and to pump up patriotic pride in those institutions without cultivating too far the people's pride in themselves.

This is not to deny the presence of voices that, as in late eighteenth-century France and Germany, insisted on the living traditions and rights of an ancient people. Anti-aristocratic and pro-reform sentiments were in late eighteenth-century England, especially in London, often articulated in the language of the ancient constitution, of a buried 'Gothic' simplicity or 'Saxon' liberties, that had been invented by seventeenth-century radicals. Gerald Newman has gone so far as to argue that 'English nationalism' originated in precisely this anti-aristocratic milieu, protesting against a Frenchified aristocracy and asserting the virtues of old English folkways, poetry, customs and the 'Genius of the People' in a quite Herderian sense.[45]

Less viscerally, we can make out the lineaments of an 'English Enlightenment' that sought more scientifically to trace the long history and development of English political and legal institutions and that was more ready than its Scottish equivalents to hymn English uniqueness. But even at its height in the 1770s and 1780s, this prototype 'English nationalism' remained far more within a universalist framework than its French and especially its German equivalents, embracing, in Colin Kidd's words, 'both the national characters and institutions of the Continent as variants of their own culture. Englishness they celebrated more as an isomer of a common Gothic heritage than as a unique insular identity. Discerning Englishmen knew that it was not character but fortune which separated the English political experience from the normal run of things in the modern European despotisms.'[46]

'Vulgar' egalitarians of course still insisted on the idea of an English national character in order to forward the democratization of English institutions. But in the revolutionary era, just at the point when French and German nationalist thinking blossomed, the British state came down on such English nationalists with a vengeance. In one hand it bore the stick of repressive measures to censor and suppress dangerously nationalist sentiments; but in the other it offered the carrot of a British patriotism that might satisfy nationalist appetites without appealing to popular solidarity. In this atmosphere, the Scottish Enlightenment's vision of a ladder of nations, distinguished not by 'nature' but by their relative achievements in the universal quest for civilization, could flourish. Thus Frodsham Hodson, writing on the idea of 'national character' in the revolutionary year of 1792, echoed Hume's deprecation of excessive attention to 'physical causes' in the tracing of national differences. It was education and good government that permitted peoples to advance,

and it was '[f]rom this alliance of Education and Government, influenced by religion' that 'we deduce the proud pre-eminence of Britain over every nation of the habitable globe'.[47]

Even John Millar, the most radical of the Scottish Enlightenment theorists, whose historical writings on the development of 'English' government are sometimes cited as illustrative of the brewing of English nationalism in this period, fell back on the same 'civilizational' perspective to explain English pre-eminence.

> To the subjects of Britain [he wrote in 1803], who consider the nature of their present constitution, and compare it with that of most of the nations upon the neighbouring continent, it seems natural to indulge a prepossession, that circumstances peculiarly fortunate must have concurred in laying the foundation of so excellent a fabric. It seems natural to imagine, that the government of the Anglo-Saxons must have contained a proportion of liberty, as much greater than that of the neighbouring nations, as our constitution is at present more free than the other European governments ... it is natural to suppose, that the whole has originated in much contrivance and foresight; and is the result of deep laid schemes of policy. In both of these conclusions, however, we should undoubtedly be mistaken.

It was, rather, the 'distribution of property' as it had developed historically – and relatively recently – in Britain that had determined the form of its government. The national characteristics of the British in the present day – their courage, fortitude, sobriety, temperance, justice and generosity – were natural effects of the opulence and civilization that flowed from the right distribution of property, and were available to any people so wisely governed as to ensure that distribution.[48] Millar's formula bears out George Stocking's dictum that if philology was the chief German contribution to anthropology in this period, and comparative anatomy the chief French contribution, political economy was what the British had to contribute – an essentially universalist rather than particularist understanding of humanity, though also a highly ethnocentric one that laid down British achievements as the end points towards which other peoples were struggling.[49]

The limit to the British understanding of national difference is, finally, best illustrated in the work of an Irishman who in the nineteenth century was widely seen by foreigners as the most authentic voice of English nationality: Edmund Burke, born in Dublin in 1729. For a man who represents the extreme mystical and particularist end of thinking on English national identity, who was seen by Victorian successors as laying a blueprint (not followed up) for depictions of Englishness, Burke had remarkably little to say about

what distinguished the English from others. He used a magnetic language of possession when speaking about the national tradition in his immensely influential *Reflections on the Revolution in France* (1790) – a language of 'inheritance', of 'entail', of ways of living passed down as a sacred trust through countless generations.[50] He himself bequeathed to subsequent generations an even more providential understanding of Englishness than had already been generated by Foxe's *Martyrs*. But he was deliberately opaque about who possessed this inheritance and what it contained: part of its appeal was its indecipherability.[51] Like his political masters, he had no interest in exciting the mass of the people – quite the contrary – or in writing them explicitly into the English tradition. As with other elite invocations of patriotism in the eighteenth century, his emphasis lay on the institutions that were responsible for maintaining order and improvement rather than on the people or folk culture or even on the history that these institutions only 'virtually' represented. His usage of 'national character', like many such late eighteenth-century references, referred to the character of the nation – which manifested itself through institutions – rather than to the character of a people. This applied almost equally to his writings on the national character of the English as to his writings on the Irish, the Americans and the Indians.[52]

Shaped both by the Scottish Enlightenment and by the common law tradition in which he was educated, for all his rhetoric Burke had actually a rather historically shallow understanding of English continuities. In the only history he wrote, the youthful 'Essay towards an Abridgment of the English History', which was unpublished in his lifetime, he sneered at the Anglo-Saxons as 'a rude people'. While he acknowledged, following Tacitus and Montesquieu, that 'the faint and incorrect outlines of our Constitution' could be traced back to the Teutons 'in the woods', 'whilst it remained in the woods, and for a long time after', he regretted, 'it was far from being a fine one . . . an imperfect attempt at government, a system for a rude and barbarous people, calculated to maintain them in their barbarity'.[53] For Burke, as for much of the Enlightenment, the point of stressing continuity was not to identify pristine, essential roots of national habits, but rather to illustrate the slow, gradual, halting, fallible process of improvement.

In addition to being historically shallow, Burke's vision of Englishness was also substantively narrow. On the whole, it is the institutions themselves – the law above all – that is the tradition to be cherished rather than anything meatier in the way of morals, culture, folkways or the arts.[54] Burke did speak of 'manners' as well as 'order' as an English possession, but his manners are very much in the Enlightenment tradition – an abstract sense of 'honour', 'the spirit of the gentleman', rather than anything particular to the English, except in the sense that only the English had managed to approximate them.[55]

When writers of Burke's age wrote about the 'national character', generally they meant the character of the nation – of England, defined by its institutions and its governing classes, or more abstractly by its 'soul' or 'genius' – rather than of the people, the English as a whole.[56] Burke did not depart far from this idiom, except in the expression of his (late-blooming) pessimism. He still believed in 'civilization' but was gloomier about other people's ability to attain it.

If Burke intended to be the English Herder, opening the way towards a highly coloured and particularistic understanding of the English national character, he left the Victorians precious little to work with. The patriotic century the eighteenth might be but it was hardly the century of national character. That honour belongs to the nineteenth century and a new generation of post-Napoleonic, more democratic English thinkers who were the first to think of the 'nation' as a psychologically homogeneous unit. And even they continued to work within the civilizational framework and the emphasis upon institutions bequeathed them by the Scottish Enlightenment and also by Edmund Burke.

CHAPTER 2

The English People

Throughout western Europe, the Enlightenment developed a tradition of thinking about the forces that shaped the 'character' both of individuals and of groups. For most Enlightenment thinkers – optimistic, progressive and humane – the aim was to identify those desirable traits embedded by nature in all humankind and to consider what forces were conducive to their establishment and development. Cosmopolitan and committed to change, they did not emphasize fixity or rootedness. Even where climate, geography, language and folk traditions had demonstrably made for local differences, they counselled the wise legislator to select out only those particularities that were compatible with civilization – the Teutonic innovations in self-reliance and self-government, for instance – and to transcend all others.

But these Enlightenment teachings were inevitably inflected by the social and political changes of the late eighteenth century, and in different ways in different parts of western Europe according to different paths of social and political development. In Germany, particularly, somewhat later and less so in France, later still in Italy, the rise of nationalist feeling both among the populace and among intellectuals played up those elements of Enlightenment thought that were compatible with the primacy of national identification. Already in the 1820s, thanks to the philological and ethnological research of German scholars such as Johann Friedrich Blumenbach, to the biological arguments of French Lamarckians and to the immensely popular racialized histories of Augustin Thierry, German and French writing about human nature dwelt upon the significance and enduring qualities of national difference. Only Anglophiles like Francois Guizot continued to place universals such as 'civilization' at the centre of their explanatory structure, though Guizot saw his own people, the French, as the ideal avatars of 'civilization' in a way reminiscent of later English writers on civilization such as Henry Thomas Buckle, for whom the English played a remarkably similar pivotal role.[1]

English thinking about human nature remained much more firmly fixed within a civilizational context, and this was nearly as true of popular and democratic thought as of the elite. In this context the idea of the English national character emerged only slowly and hesitantly. The French Revolution had the opposite effect on the English as on the French or Germans: it did not extend dramatically the purchase of democratic and nationalist thought. Where popular mobilization took place, it was led by the elite around patriotic emblems that stressed loyalty to institutions rather than group identification around a common culture.[2]

The British attachment to the civilizational model was in certain respects fortified by the aftermath of the French Revolution. Anti-democratic thinking drew ever more heavily on evangelical Protestantism – already, as we have seen, a central theme in English patriotism – to justify a moral hierarchy that cut across racial, ethnic and national lines, distributing wealth and political power to those who had earned it by their moral deserts. Making a quick recovery from the loss of its American colonies in the 1780s, Britain also began to erect a new empire in the post-Napoleonic world, extending its holdings in the Caribbean and Africa and especially in South Asia, acquisitions which – now more closely in tandem with missionary Christianity – strengthened Britain's self-perception of its place at the centre of a world civilization. Closer to the metropole, the extension of English political institutions beyond Scotland and Wales to Ireland in the Act of Union of 1800 further diluted the identification of those institutions with a specifically English or even a Teutonic people. 'Civilization' provided a language and an identity that was attractive to the rulers of a multi-national kingdom and a global empire and, from their point of view, safer for their subjects than the revolutionary or democratic language of the 'nation'.

But Britain could not remain forever immune to the appeal of democratic and nationalist ways of looking at the world, especially in peacetime when its disenfranchised people began to question more actively the 'natural' hierarchy of civilization. The 1820s was a decade not only of increasingly democratic turbulence but also of a sharpening awareness of social change as physical and social mobility intensified – to a unique degree in Britain – the concentration of masses in great towns. When around 1830 this popular pressure triggered a national debate about who were 'the people' and what were their rights in the polity, a crucial breach in the monopoly of civilizational thought was made. Through this breach rushed a welter of democratic movements, culminating in the well-known Chartist campaign for universal manhood suffrage.

Not all of this heightened social and democratic consciousness necessarily potentiated thought about the 'nation'; if anything, 'class' – an awareness of

social division within the nation – benefited more. Both Chartists and campaigners for a more moderate political reform were fully capable of speaking of 'the people' in terms that included only one class of people – whether a majority ('working class') or a minority ('middle class').[3] But often a transcendental vision of national unity did lurk behind even sectional campaigning, and there is no doubt that the 1830s and 1840s saw a rapid development of thinking about the national characteristics of the 'English people', especially among democratic sympathizers in the literary classes. They found common cause with those early 'social scientists' who, stimulated by urbanization and new statistical technologies, sought to place on a more systematic footing the study of the behaviour of masses. It is here, on the democratic fringes of respectable society in the turbulent early Victorian decades, that we can locate the origins of the idea of the 'English national character'.

'CIVILIZATION' AND ITS DISCONTENTS

In the heat of the Napoleonic wars, Edmund Burke had given English conservatives the germ of a theory of nationality around which they might have built up in the nineteenth century a solidaristic yet hierarchical idea of national character, such as was developed by German conservatives. Yet English conservatives did not take up the opportunity.[4] While intensely patriotic, proud of England and its achievements, they neither wanted nor needed an idea of an English people of similar traits or qualities. 'Civilization' remained the framework within which they evaluated their own people – a framework within which some English people were palpably different from (and superior to) others, even if most English people were also superior to most foreigners. Liberals and radicals, more friendly to the idea of civil equality within the nation, did seek to build on Burke's ideological legacy, but they too continued to think about their fellow Englishmen within a context of civilizational thinking in a way that was far less particularistic than most of their Continental contemporaries. Why was this?

To begin with, conservatives in Britain did not have to deal with the consequences of popular mobilization on a French or German scale; they were able and willing almost instantly to set about demobilizing the nation at arms. No European power shrank its Napoleonic-era military state more rapidly than Britain, demobilizing its troops, dismantling its emergency institutions and legislation, retreating from the rhetorical excesses of wartime patriotism, and in general seeking to restore the *status quo ante bellum*.[5] Post-war celebrations of wartime triumphs were confined wherever possible to the apotheosis of heroes like Admiral Nelson and the Duke of Wellington, glamorized for their individual qualities or – to the extent that wider symbolism was evoked – for

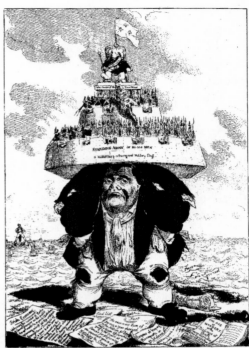

2 John Bull groaning under the
weight of the fiscal-military state,
even in peacetime (here from a
print of 1816)

THE BRITISH ATLAS, or John Bull supporting the Peace Establishment.

their gentlemanly valour and honour, a class act rather than a national one.
Unlike many Continental governments, the British resisted calls for war
memorials that commemorated the *levée en masse*, preferring monuments to
individual heroes. The only general war monument in Britain – London's
Marble Arch, erected in 1828 – was sternly allegorical, unpersonified, lacking
even the *Victory* planned to surmount it or the friezes depicting British triumphs
designed for it by Richard Westmacott. The friezes – Nelson and Wellington
again – were transferred instead to Buckingham Palace, where they flanked
more allegorical figures of Commerce and Navigation and 'Britannia
Acclaimed by Neptune'.[6] After a brief period during the war's height when
'John Bull' was endowed with civil as well as martial virtues, mobilized for war
in defence of his rights, his principal post-war use was as a symbol of the long-
suffering wartime taxpayer, overborne by the fiscal-military state, seeking not
self-assertion or even recognition but relief.[7]

Chilled by the democratic effects of wartime mobilization on the Continent,
post-war British conservatives sought consciously to play down the signifi-
cance of even those national legal and political institutions that had been so
vigorously hymned in wartime. They found themselves drifting towards a

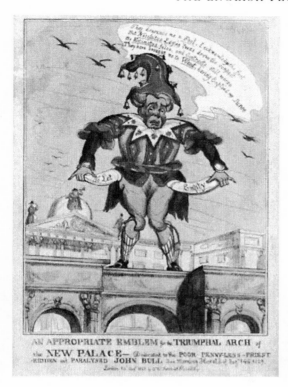

AN APPROPRIATE EMBLEM for a TRIUMPHAL ARCH of the NEW PALACE— Dedicated to the POOR PENNYLESS—PRIEST RIDDEN and PARALYSED JOHN BULL

3 The *Morning Herald*
(14 August 1829) proposes
poor, foolish John Bull as the
most appropriate emblem to
top the Marble Arch

philosophy of individualism that counselled self-help and held out some slender prospect of self-improvement. 'How small, of all that human hearts endure,/That part which laws or kings can cause or cure', the Tory prime minister Lord Liverpool liked to quote from Samuel Johnson. Increasingly Tories like Liverpool turned to the laws of political economy rather than the laws of the land both to explain and protect the social order. They were able to do this because increasingly these laws of political economy, which had been enunciated by the Scottish Enlightenment in generally secular and materialist terms, were being restated and reformed on evangelical Christian principles. A hybrid 'Christian political economy' had emerged in the wake of the French Revolution that combined the egalitarian individualism of polit- ical economy with the spiritual hierarchy and pessimism of evangelical Christianity. Legal and political institutions were of no avail for most purposes and for most people. Individual striving was all.

Unlike the optimistic Enlightenment vision, however, Christian political economy did not expect massive social change and mobility to result from individual striving. The ubiquity of sin put paid to that. God's 'natural order', revealed when human institutions were peeled away, was a terrible one but it

was unavoidable. As the economist Thomas Robert Malthus pointed out, attempts to palliate the natural order artificially – for example, by relieving the poor with cash payments – would only encourage vice. All the spiritually successful could do to relieve the condition of the spiritually failing was to preach virtue, which was the principal function of exclusive political, legal and ecclesiastical institutions. If the sinful atoned for their sins, then material as well as spiritual success would result. The prevalence of this vision among conservatives has caused many historians to adopt Boyd Hilton's coinage to characterize the post-1815 period as 'the age of atonement', rather than that of an earlier historian, Asa Briggs' more optimistic characterization, based on the liberals' vision, of 'the age of improvement'.[8]

By shrinking the effective sphere of 'laws or kings' and seeking to throw individuals back onto their own resources, conservatives were, of course, also detaching themselves from the patriotic vision that Burke had been driven to develop in the very different environment of the 1790s.[9] Instead they elaborated a vision of a universal 'Christian civilization', at the heart of which sat Britain but which ought to be the goal, even the fate, of the whole of humanity. Blending the conjectural history of the Scottish Enlightenment with the 'records of the creation' – that is, with the scriptures and with modern scientific discoveries – they told a history of the world that allotted a remarkably small role to nations and peoples. Humanity is governed by the laws of nature, as are all creatures, and by moral laws fit for humans alone. Moral law, as embodied in the scriptures, gives human society the possibility (though far from the certainty) of progress. Different peoples make more or less progress not according to their nature but according to how far they adhere to a proper understanding of moral law.

'Man is, in fact, the creature of education and discipline', wrote Bishop Sumner in 1816 in the most influential conjectural history of the 'age of atonement'.[10] Differentiation between peoples, therefore, depends on the effects of education and discipline, both within societies (the explanation for inequality) and between societies (the explanation for national difference). Social inequality (the 'division of ranks') was, for this Christian conservative, of far greater interest than national difference.[11] But both were surmountable by the spread of Christian civilization. 'Europe is now the centre', wrote Sumner, 'from which the rays of civilization are diverging in every direction.' The most likely long-term result, he thought, was a perfect equality of civilization around the globe, not excluding Africa.[12]

Coincident and consistent with this Christian history went a Christian ethnology that explained racial difference in fairly superficial terms as a reversible physiognomical sign of moral status. J.C. Prichard, the dominant British ethnologist of the first half of the nineteenth century, definitively

restated the monogenist understanding of common human origins and down-played racial difference, which he saw as a literally superficial marker of short-term environmental adaptation. 'Colour' was not even skin deep, since only the outermost layer of skin was pigmented, while in essential physical and psychical characters all humans were basically alike. Of course, Prichard saw both whiteness and an 'elliptical' cranial formation as signs of a more advanced state of civilization than blackness and 'pyramidal' or 'prognathous' skulls, but the Christian view held firmly that these traits were naturally acquired under the influence of civilization because beneath them lay an essentially unitary humanity. If this was true – as Prichard said it was – of Africans or Polynesians, how much more applicable was it to national differ-ences within Europe. Taking up German philological discoveries, Prichard informed the British of the common Indo-European roots of their supposedly diverse Celtic and Germanic languages and reinforced the view that whatever differences divided Europeans were attributable to short-term detours in their common progress towards civilization.[13]

Setting England in a civilizational framework thus had domestic advan-tages to the ruling elite, providing a rationale for social hierarchy against the levelling effects of nationalism and taking democratic pressure off the state. But it had also international advantages that were particularly vital in the early nineteenth century. In 1801 the multi-ethnic character of Great Britain was further complicated by the union with Ireland, diluting the Anglo-Saxon, Protestant majority with a substantial Celtic, Catholic population. The creation of the United Kingdom had both immediate and long-term impli-cations for the specification of a national character. It cast doubt immediately on the more narrowly Protestant readings of the national character that had flourished during the Anglo-French conflicts of the eighteenth century, lending support instead to the looser view stressing pluralism, tolerance, indi-viduality – in fact no character at all.[14] For the first three decades of the new century Britons of all stripes had to grapple with the practical political ques-tion raised by the union: how far to admit Catholics and nonconforming Protestants into full citizenship. The result was that in 1828 and 1829 most of the remaining political disabilities of non-Anglican Christians were removed. Less familiar to historians is the parallel ideological debate over the conse-quences of the union for national consciousness, which only riveted individual liberty and diversity more centrally into the self-definition of the English in order to make their traits a more plausible core for a plural multi-national Britishness.[15]

'Unionism' as an ideology is still poorly understood, especially as it devel-oped over the course of the nineteenth century. One of its principal features was an acceptance of ethnic and cultural diversity within a unitary political

framework where the 'Imperial' Parliament took on a renewed significance, not as a symbol of ethnic identity but as a bargaining table capable of resolving conflicts at a central level but also of devolving solutions back to local and 'national' level. The enhanced power of the 'Imperial' Parliament was therefore instrumental as much as symbolic – another blow to Burke's reverence for the organic significance of national institutions. The repeal of the religious tests disqualifying non-Anglicans from citizenship in 1828–29 dealt a similar blow to the organic claims of the national church. None of this prevented radical nationalists within each of the 'four kingdoms', including the English, from arguing for national distinctiveness, but it did undermine the plausibility of the Burkean arguments among British conservatives, deepening their suspicion of cultural nationalist language and accustoming them to acting and thinking as unionists instead.[16]

This effect was intensified by the growing significance of empire in British elite consciousness of the early nineteenth century. The idea of Christian civilization was, needless to say, not only well suited to embracing Ireland but also to justifying imperial expansion into 'pagan' realms – an ideological project that one might call 'ethnocentric liberalism'. The immediate target was India, whose fate became ever more tightly bonded to Britain's between 1815 and 1858, when direct rule over the entire subcontinent was finally asserted. In this period at least, when the ideal of universal civilization was at its height and the vigour of missionary activity ever increasing, the ruling assumption was that on 'the basis of this shared humanity' the Indian might be turned into an Englishman or, rather, into a civilized human.[17] The same benefit of the doubt was extended to the African, albeit on a basis of more limited contact and greater ignorance.[18]

In both the Indian and the African cases, the hopefulness or greed of the imperial ambition forced a retreat even from Enlightenment positions on national difference. Hugh Murray's anthropological *Enquiries Historical and Moral Respecting the Character of Nations and the Progress of Society* (1808) deplored the Baron de Montesquieu's overemphasis on climatic differentiation, arguing that 'climate (physically considered) has no influence whatever upon human character' and that it worked its civilizing effects only indirectly in encouraging or discouraging labour. But, reversing Montesquieu's association between tropical climes and a dull lassitude discouraging the development of civilization, Murray thought that the fertility of Asia had precisely been the motive force behind the origins of civilization there and that civilization's spread to the less hospitable reaches of northern Europe only showed how flexible the human mind was.[19] Those East and West Indian medical men and missionaries who shared Montesquieu's more conventional assumption about the dampening effect of tropical environments still found for them-

selves a field of action based upon this same flexibility of mind. Although hard physical labour was difficult in tropical climates, they believed that it was possible for hard workers from temperate zones to export their habits to the tropics and plant civilization there, too – an argument that would be built on at mid-century by Buckle in his civilizational history of the English.[20]

The usefulness and prevalence of these civilizational ideas helps to account for the otherwise surprising failure of Burkean ideas to spread among British conservatives, and thus to account for the thwarting of a conservative vision of the English national character. As the historian of the British 'Right' in this period, James Sack, has pointed out, a populist church-and-king conservatism was viewed by most Establishment Tories as rather cranky, 'an albatross about their necks . . . more of a combustible pressure group outside of the governing coalition, rarely invited inside, and mistrusted by those in the charmed circle'. Equally importantly, even right-wing Tories found Burke's legacy on the national question most uncomfortable: if the prospect of playing up an English national character was tempting, it was rather doused by Burke's insistence on the corollary recognition of an Irish and an Indian national character as well. Burke's thought was accordingly more influential among French, German and even American conservatives than among the British.[21]

The political impracticality of Burkean ideas in Britain is nowhere more evident than in the political failure of Burke's only real British heir, the poet and political philosopher Samuel Taylor Coleridge. In political and philosophical texts written in the first three decades of the century, Coleridge made much more explicit the Herderian tendencies only suggested by Burke, asserting the real continuity of a national spirit invested in national institutions, especially, in Coleridge, ecclesiastical institutions.[22] Coleridge's view of the nation was, potentially, most attractive to conservatives for his insistence that the national 'culture' was actually constructed (and not simply constituted) by church and state, since this gave a creative leadership (and not 'representative') role to educational elites (the 'clerisy'). Coleridge's emphasis on the functions of the national church meant that he was able to dispense almost entirely with specifications of the character of the people.[23] But even in this elite-centred formulation Coleridgean thought proved uninteresting to most conservatives mired in the civilizational framework. To the extent that Coleridge had any lasting influence in Britain it passed through liberals: religious liberals such as the 'Liberal Anglicans' around Thomas Arnold who developed a purposeful theory of English nationality in the 1830s, and Christian socialists like F.D. Maurice; or secular liberals, most famously John Stuart Mill, who has some claim to be the first systematic exponent of the idea of the English national character.[24]

These liberal developments of Coleridgean thought on nationality flowered in the 1830s, as a popular liberalism in its larger aspects flowered in the aftermath of the Reform Act of 1832; they are the subject of the next section. But stresses within the civilizational framework were evident before 1830, most obviously in the growing interest in English history and in the emergence of what in the twentieth century came to be called 'the whig interpretation of history'. The whig interpretation stretched the civilizational framework without breaking it, and yet introduced a flavour of Burke in dwelling upon the special qualities the English could bring to civilization. Once again it is telling that the pressure to emphasize the Englishness of English history came mostly from political Whigs, not Tories.

Although the most influential eighteenth-century histories of England, such as David Hume's, were fixed firmly within a civilizational framework, there was already a small but influential body of antiquarians burrowing into the quiddities of English history by the 1760s. From this decade date classics such as Thomas Percy's *Reliques of Ancient English Poetry* (1765), an inspiration for Johann Gottfried Herder in collecting together early evidences of the nation's oral traditions, and Gilbert Stuart's *Historical Dissertation Concerning the Antiquity of the English Constitution* (1768), an unusually early and serious attempt to document the continuity of English political institutions from Teutonic origins.[25] This early, however, such investigations still smacked either of radical illusions – the old Gothic or Teutonist critique of existing institutions as subversions of an 'ancient constitution' of popular rights – or of a dangerous, almost licentious, self-indulgence. Antiquarians themselves acknowledged the doubtful public utility of luxuriating in the barbarities of the past. 'In general', granted Horace Walpole, one of the leading 'Gothic' revivalists of the day, 'I have seldom wasted time on the origin of the nations; unless for an opportunity of smiling at the gravity of the author, or at the absurdity of the manners of those ages; for absurdity and knavery compose almost all the anecdotes we have of them.'[26]

But from the 1790s Burke's authority gave new impetus to the search for distinctive national origins of modern manners and institutions: what had formerly been a radical critique of the constitution could, by emphasizing essential continuities, be flipped over into a romantic defence. Most conservatives did not feel there was much to be gained from rooting the constitution in ancient history. Thus Walter Scott – whose collections of Scottish oral tradition and novels of both Scottish and English historical imagination could be read ambiguously as fond remembrances or as modernist moralizing – was more influential among French and German historians than among the English. Whigs, however, were groping towards an evolutionary understanding of the English constitution as a way of justifying moderate change within a context of essential stability.

The post-war years saw a marked development in the writing of whig history with a newly aroused interest in the early history of national institutions and manners. Henry Hallam's *View of the State of Europe During the Middle Ages* (1818), while in general cleaving to the Enlightenment suspicion of the Middle Ages and fastidiously abjuring the picturesque devices of contemporary French and German history, nevertheless drew attention to 'the free soccage tenants or English yeomanry [of the Saxon period], whose independence has stamped with peculiar features both our constitution and our national character' – language that had previously been heard mainly from radical Goths.[27] Yet Hallam was careful to distance himself from the racialized essentialism of a Herder or a Thierry: 'the character of the bravest and most virtuous among nations has not depended on the accidents of race or climate, but has been gradually wrought by the plastic influence of civil rights, transmitted as a prescriptive inheritance through a long course of generations.'[28] Emphasis was still placed firmly on the formative qualities of the institutions themselves – improvable but only delicately – and not on the essential character of the people, though Hallam's focus on legal institutions and the ways in which they cultivated habits of liberty and order did bring the institutions somewhat closer to the people. Later historians with a clearer interest in national character would feel that he had not brought them close enough: Hallam, wrote William Stubbs around 1870, 'deals with men and nations very much as if they were wooden figures pulled about by agencies and influences with which they themselves have very little to do'.[29]

Hallam's views – widely accepted as authoritative at least through the middle of the century[30] – received technical support in the scholarly researches of Francis Palgrave. Palgrave grew more conservative as he aged, but his historical understanding of the English always evinced that whiggish concern to demonstrate a unique, evolving continuity without conceding anything to radical populism. Given the common Gothic origins of the English and many Continental peoples, Palgrave asked why the English alone had been able to maintain a system of liberty. 'Amongst the cognate races on the continent of Europe', he wrote in his *magnum opus, The Rise and Progress of the English Commonwealth*, in that pregnant year 1832, 'political freedom was effaced by the improvement of society; England alone has witnessed the concurrent development of liberty and of civilization.'[31] Like Hallam, Palgrave stood fastidiously aside from the vulgarities of race and 'ancient constitutionalism' to explain this, preferring instead to emphasize the habits of the people, which were themselves shaped by evolving legal (and, later, political) institutions. While in his younger days Palgrave was willing to speak of these habits as evincing a spirit of liberty, his mature position was that '[t]he English constitution is not based upon liberty, but upon law . . . our laws

know nothing of the liberty of the people – yet the subject values his liberty only to obtain the protection of the law.'[32]

Once again, it was the institutions that mattered. These emanated from an eclectic combination of Roman legacies, Teutonic forms, Norman adaptations and Christian doctrine. They cultivated a spirit of orderliness and also of inequality or 'aristocracy', 'in which the lowest classes of society participate as fully as their superiors', inaugurating a novel line of inegalitarian thinking about the national character that would reach its culmination in the next generation in the thought of Charles Kingsley. In the early Middle Ages, these institutions enjoined obedience to the king. In more modern times, they made way for a better balance of authority between king and people.[33] Thus the desirable whig combination of enduring (indeed, unique) continuity and progressive adaptation was achieved. And in Palgrave this interpretation was supported by a scholarly apparatus and a rhetoric sufficiently professional to satisfy later nineteenth-century historians like E.A. Freeman, even though Freeman's generation was more eager to stress Teutonic origins.[34]

The whig interpretation forged by Hallam and Palgrave would prove surprisingly resilient and surprisingly popular. Its peak of influence came in the later nineteenth century, especially through the gripping, colourful narrative of Thomas Babington Macaulay's *History of England* (1848–61). It retained the civilizational perspective's ability to girdle a multi-national and multi-ethnic – even global – empire, while still satisfying post-Napoleonic impulses to recognize the special, national qualities of the English. Political moderates, of course, liked it for its institutional, hierarchical, non-popular emphases, for portraying an English way of doing business rather than an English nation or people. But radicals, too, took it to their hearts. While abandoning the myths of 'ancient constitutionalism', of some long-lost English nation practising self-government and universal suffrage, radicals could still see self-government and universal suffrage as the end point of a continuous national evolution from Teutonic glimmerings to ripened modern polity.[35] Nevertheless, in some quarters, the development that Hallam and Palgrave had begun – founding constitutional development at least in some degree in the habits of the people by highlighting the role of law – could and would be deepened into a full-fledged anatomy of the national character. The trigger for this further development came with the explosion of democratic thought after the French Revolution of 1830 and, crucially, the Reform Act of 1832, when 'the English people' first became a leading character on the national stage, not only in backstreet debating rooms but in Parliament, the universities, the bookshops and the sober quarterlies.

THE IMPACT OF 1832

After a period in which the liberal Tory strategy of diverting political energies into economic development seemed to be bearing fruit, suddenly around 1830 the people's relation to the constitution again became the cynosure of public life. Economic difficulties and agrarian unrest disturbed confidence in the 'naturalness' of the natural order. The state was turned to as a source of succour and hope. The success of Irish agitation in gaining political emancipation for Catholics in 1829 seemed to set a precedent for other excluded groups. A new French Revolution raised a fresh set of banners. In these circumstances, Tory quietism seemed not only temporarily inappropriate, but no longer plausible as a world view.[36] Even Whig politicians who had no real democratic inclinations and who meant to encompass only a restricted set of responsible citizens used inclusive language about 'the people' and their 'rights' that raised temperatures and expectations.[37]

This political invocation of 'the people' after 1830 might alone account for the quest for an 'English national character' that followed. But it also coincided with a new appreciation that England had become a kind of mass society. The old trope about English diversity began to give way to a new perception of homogeneity brought about by accelerating urbanization, evident in influential works such as William Mackinnon's *On the Rise, Progress, and Present State of Public Opinion* (1828), George Porter's *The Progress of the Nation* (1838–43), and especially Robert Vaughan's *The Age of Great Cities* (1843). New technologies were on hand to measure the mass – the census (1801), birth and death registration (1836), a host of statistical inquiries sponsored by Parliament – and a new discipline was born from them, 'social science', on the Continent as well as in Britain.[38]

'Nation' was only one way of envisioning this mass, and not necessarily the most obvious or helpful one. For those ready to accept the realities of mass society but still determined to maintain traditional hierarchies, the idea of 'class' enabled key distinctions to be preserved.[39] Political economy and 'civilization' were older, hierarchical ways of anatomizing the mass that were not superseded. 'Machine' and 'body' were metaphors – or something more literal – adopted by those who saw themselves as engineers or doctors of the masses, such as the technocratic Benthamites.[40] When the Belgian social scientist Adolphe Quetelet launched the search for the *homme moyen* – the 'average man' – he took the nation as his unit of investigation because it was nations that produced social statistics, but he assumed that all nations followed in the long term similar paths of social development. As civilization advanced, the variations between individuals would diminish, so that the *homme moyen* of the most civilized nation would represent the *homme moyen* of the species – a

moral and physical ideal. Naturally, his English followers, like Buckle, thought this meant the Englishman.[41]

Among a more democratic audience, hostile to social hierarchy, 'nation' was still not the sole or even the principal alternative. The highly spiritualized and hierarchical concept of 'civilization' found a natural foil in a brutally materialist egalitarianism that flourished in a subculture of popular science in the 1830s and 1840s. This popular materialist understanding of the mass had little truck with such an elevated state as 'nation': it focused instead on the plastic physical state of ordinary people's minds and bodies. Fuelled by Lamarckian theory – forbidden to respectable opinion because it was French and revolutionary – popular materialism adhered to a vision of physical progress that was a kind of mirror image of the progress of civilization. Evolution, in this popular premonition of Darwinism, was a matter of physical change among the mass of the people rather than spiritual elevation emanating from an elite. A belief that moral and intellectual improvement could be transmitted physically, in body and brain structure, ensured that progress was seen as less fragile and provisional – and less dependent upon direction from above.[42]

Although physical differentiation of this kind was sometimes expressed in the language of nation, race was the more salient category. 'The differences of national *character*', wrote the phrenologist George Combe in one of the bibles of popular materialism, *The Constitution of Man* (1828), 'are as conspicuous as those of national *brains*.' But the differences he proceeded to chart were not between Englishmen and Germans and Frenchmen, but between Europeans, 'Caribs', 'Hindoos' and the Chinese.[43] The extreme form of this popular racialism was propagated by Robert Knox, a disgraced anatomist who made a precarious living in the 1840s lecturing on anatomy to popular audiences in the north of England. Knox moved beyond Lamarckianism to argue for the fixity of racial distinctions. His *magnum opus*, *The Races of Man* (1850), would play some role in the rise of Teutonism after 1848.[44] Knox was unusually pessimistic about progress, however, in contrast to most popular materialists, who took the civilizational view that all humans were capable of improvement, although they looked not to churches but instead to a host of physico-mental therapies – such as phrenology and mesmerism – or to self-education.[45]

So it is worth emphasizing once more that, even in the 1830s, 'national character' was not an analytical category of self-evident value and that, even among democrats for whom the levelling qualities of 'nation' ought to have been attractive, popular versions of the civilizational view of progress were still more compelling. Yet it is striking how many key texts, anatomizing and

explaining the emergence of an 'English national character' and claiming novelty for the very idea, were produced in the 1830s: Thomas Arnold's 'On the Social Progress of States' (1830), Richard Chenevix's *Essay upon National Character* (1832), Palgrave's *English Commonwealth* (1832), Edward Lytton Bulwer's *England and the English* (1833), John Stuart Mill's essay 'The English National Character' (1834), Benjamin Disraeli's *Vindication of the English Constitution* (1835). No comparable node of such work would recur until around 1870, uncoincidentally close to the date of the next great Reform Act.

It seems reasonable to conclude that it was, chiefly, the political mobilization of 'the people' that triggered the systematic consideration of the national character, at least among those for whom the shape of the constitution mattered (if not among social engineers or popular materialists, who cared less). This was true even for some who considered the idea of 'the people' only in order to reject it. The anonymous author of a February 1832 article, 'The People of England – Who Are They?' in *Fraser's Magazine*, then a mainly Tory journal, accepted that the English had reached a sufficiently high stage of civilization to constitute 'a people' en masse. Indeed, he regretted that historians had not yet felt able to tell their story as such. But he also concluded that 'the people' still had no meaning in politics, which could be safely entrusted only to an elite atop a natural hierarchy based on individual merit.[46]

More positive, and therefore remarkable, was the emergence – for the first time in such an explicit form – of an overtly Tory recognition of 'the people' as a deliberate riposte to Whig pretensions to speak for it. This came, admittedly, in the eccentric form of Benjamin Disraeli's youthful writings on national character. Disraeli had been disgusted by the pallid apoliticism of the liberal Toryism predominant when he entered politics, and he saw in the reform agitation a great chance at last for Tories to seize the mantle of Burke that was rightfully theirs, to put at the head of the people a government expressive of the true national character, a compound of 'religious belief, ancient institutions, peculiar manners, venerable customs, and intelligible interests', as he wrote in 1832.[47] His conviction that the Whigs would prove to be just as bloodlessly unmoved by 'the people' as his own nominal party leaders only strengthened over the course of the 1830s. He guyed the Whigs' narrow single-class policy in a series of slashing essays, culminating in his *Vindication of the English Constitution*, with its ringing declaration that 'Nations have characters, as well as individuals, and national character is precisely the quality which the new sect of statesmen, in their schemes and speculations, either deny or overlook.' Not that Disraeli had himself anything more specific to say about the English national character; like Burke he tended to fall back on vague 'principles of ancestral conduct'.[48] Alas for Disraeli, not many Tories yet thought that the Burkean moment had arrived. His party remained

firmly locked into the civilizational perspective, both on imperial and on domestic grounds. Far from wishing to conjure the genie of 'the people', the Tories under Robert Peel wished to bottle it back up.[49] In order to work his way into the central councils of his party, Disraeli had to spend most of the next two decades gently back-pedalling from his youthful effusions.[50]

Disraeli aside, most of the running in the development of ideas of 'national character' was made by liberals, for whom 'the people' was either a positive or at least an unavoidable factor in the political equation. We can divide these into two kinds: those thinkers known later as 'Liberal Anglicans' who pursued a religious interpretation of 'national character'; and a diverse group who sought to develop the idea of 'social science' while retaining a conviction of the value and significance of the 'nation', providing a more secular, democratic interpretation. Both leant heavily on Coleridge and on the Germans.

The Liberal Anglicans were a group of liberal clerics clustered around the moral and intellectual leadership of Thomas Arnold, who wished to believe in the reality – and perhaps the inevitability – of progress for the mass of the people, but whose churchmanship and lively sense of the ironies of history set them against the materialism of their age. 'O trust not in the efficacy of Civilization!' warned one of their most alarmist voices, that of Julius Hare, 'When Civilization is severed from moral principle and religious doctrine, there is no power in it to make the heart gentle.'[51] Christianity was, of course, the fount of moral principle and religious doctrine, but in searching for the best engine for its diffusion the Liberal Anglicans turned as Coleridge had done to the national church. Unlike Coleridge, they were, as liberals, capable of engaging with the nation as a reality and not just as an ideal. The youthful Arnold, for example, believed that the propertied classes were standing in the way of the progress of the masses towards the realization of individual liberty.[52]

The Liberal Anglicans, therefore, were willing to take seriously Herder's proposition that a people expressed their true nature in the form of the nation – a compound of race, language, religious and political institutions – though, true to their Christian and English heritage, they tended to emphasize the latter two rather than the former two terms in the formula. '[I]t is better not to admit national identity', thought Arnold, 'till the two elements of institutions and religion, or at any rate one of them, be added to those of blood and language', incidentally coining a phrase – 'national identity' – that would not come into vogue until more than a century later.[53] It was the combination of race and morals that made modern history so eventful and the English so great. 'We derive scarcely one drop of our blood from Roman fathers; we are

in our race strangers to Greece, and strangers to Israel. But morally how much do we derive from all three.'[54] And this central moral dimension meant, too, that the Liberal Anglicans also fitted themselves into a civilizational framework, for they shared not only Herder's belief in the salience of the nation but also his universalistic belief that the nation was but a transitional stage – a proving ground in the struggle for moral perfection – that would end in the holy reunion of humanity. While admiring the diversity of human societies and governments, Arnold's disciple H.H. Milman had to conclude that at root 'Man is the same, to a great extent, in every part of the world, and in every period. Society is part of his nature, and social forms, being circumscribed in their variations, will take the same character, enact the same provisions, establish the same ranks and gradations, aim at the same objects, and attain the same ends.'[55]

The long-term significance of the Liberal Anglican discourse on the 'nation' was that it brought this concept firmly into the precincts of Establishment thought. Arnold's lectures as the first professor of modern history at Oxford, which when published in 1842 became the most elaborate and influential statement of his thinking on 'race' and 'nation', would resonate throughout the middle decades of the century as ever larger portions of the English intellectual class were drawn towards democratic politics. Among his auditors at Oxford, for example, was the young E.A. Freeman, the greatest nationalist historian of the nineteenth century, who later credited Arnold with teaching him 'the truth of the unity of history'.[56] Not many of the older generation were prepared to go so far, which may be one reason why, like Burke and Coleridge, Arnold and the Liberal Anglicans continued to cloak their invocations of an English people in vague, unspecified and quasi-mystical rhetoric. Arnold spoke earnestly of the need for historians to write the biography of 'a common life' shared by a people, and to probe the 'inward life' of the state, 'which determines the character of the actions and of the man'.[57] But he did little to fulfil his own exhortations. That would be left to a post-1848 generation and also, in parallel, to the less respectable secular democrats who did the most before 1848 to explore the 'common life' of the English.

As already noted, those ambitious to develop a truly systematic 'social science' did not always turn to the idea of 'nation' through which to view societies. Many, however, did, particularly democratic liberals and radicals – those most committed to the notion that political institutions had value for and impact upon the mass of the people. The first full-length exposition of the idea of national character was not particularly political, but it was inspired by political events. Richard Chenevix embarked upon his *Essay upon National Character* after witnessing the French Revolution, in which '[a]n immense

population, conceiving all at once that they had yielded up too large a share of their natural liberties . . . undertook to reform their political condition', with subsequent effects that also shaped the whole of the nation's character. On investigating, Chenevix found that in the vast flood of Enlightenment-inspired writings on human social arrangements 'little attention has been paid to the laws which govern the characters of nations', and sought to fill this lacuna.[58]

Disregarding biological differences as irrelevant to nations – fixed natures could not account for national differentiation and Lamarckian evolution did not even occur to him – he considered Montesquieu's views on the determining effects of climate and geography but also Hume's scepticism about both. Anticipating the more developed analysis of Buckle, Chenevix concluded that climate and geography had a potentiating effect, which meant that civilization began to develop only once humanity settled in the ideal environment, the northern shores of the Mediterranean, but also that humanity was so adaptable that civilization could subsequently spread elsewhere by social and cultural means. Thus Europe was the sole generator of civilization but also bore the responsibility of extending it, 'to be the inventress and the diffuser of moral culture . . . and duly to balance the faculties of the species'.[59] In a coda he expressed some uncertainty as to how far civilization could be diffused; there were signs of improvement in Asia but not in Africa. 'All that can with certainty be said is, that the whole world will be simultaneously carried forwards toward the finite limits of human capabilities, but that each nation will preserve its rank and relative situation among empires, according to the number and value of those capabilities which natural circumstances shall have developed.'[60]

Chenevix was still operating at a very high level of generality. His characteristics were really Platonic universals – 'domestic and foreign prosperity, pride, virtue, wisdom, liberty' – and were 'national' only in the sense that the English displayed them all to the highest degree, or, where that seemed doubtful, in a more 'balanced' way than other nations.[61] This special pleading – even more transparent than elsewhere – must have limited Chenevix's influence; he did not become an explicit touchstone for later social-scientific writing on national character, as Montesquieu and Hume had done. Yet he defined a field more clearly than they had, and it was a field that many others would strive to occupy in his wake.[62] Thereafter the language of 'national character' was used more frequently even by those who had in mind only a lampoon on contemporary manners, such as Bulwer's widely noticed (but probably little read) *England and the English*, published in Paris in 1833. And in the works of three men in particular – an historian, a travel writer and a polit-

ical philosopher – the study of national character was taken to new heights, consonant with the high ambitions of social science.

The historian was John Mitchell Kemble, scion of a famous acting family who in his youth fell simultaneously into Teutonophilia, philological studies and radical politics.[63] Unusually early in England, Kemble saw the radical political potential of Herder's understanding of nation: civilizational arguments against the unfitness of ordinary people to rule could be refuted if it could be shown that the whole of the people had been given a collective character by the climate, the land and the environment, and that this national character was largely responsible for the development of free political institutions. After 1832, in short, the people were simply coming into their own.[64]

Like a good Englishman, Kemble believed that political institutions formed national character as well as vice versa, but he was one of the first to emphasize the latter rather than the former, making national character into a primary rather than a secondary force. Following a path charted by his mentors, the Grimm brothers of Göttingen, Kemble began by tracing the origins of the English national character through the study of philology – the origins of language – but quickly moved on to a more expansive vision invoking the history of the nation. History attracted him for two reasons. First, inspired by the great German and French historians of his day, he saw the possibility of a science of history making a crucial contribution to a wider science of society: the respective roles that national character, political institutions and other circumstantial factors played in society could be determined only by a systematic historical study from the origins of the nation to its modern flowering.[65] This social-scientific orientation was what distinguished Kemble's argument from the imaginary realms of lost rights hypothesized by the 'ancient constitutionalism' of seventeenth- and eighteenth-century Goths.[66] But second, in a Coleridgean twist, Kemble saw the promotion of national history as having a profoundly educative function. The people needed to be reminded of their national heritage of liberty and order to ensure that their assumption of power ran smoothly. Otherwise they were in danger, he wrote in 1838, 'of entirely forgetting the past in the present, and in our admiration of the flower and the leaf, neglecting the deep-seated root from which they sprung and have their sustenance . . . the past lives on, and breathes in every ordinance of the present, furnishing that broad basis upon which alone change becomes safe, and progress sure. But the lines grow dim in the long lapse of centuries; and were they not, from time to time, sharpened and renewed by the hand of some self-denying enthusiast, we might at last cease to recognise and to revere them.'[67]

Besides, the Coleridgean twist gave a scholar something to do that engaged more directly with the collective drama of history in the present. '[T]he

spreading among my countrymen, a wise and enlightened knowledge of, and love for these old records', he wrote to Jakob Grimm in 1833, might have a tonic effect: 'without wishing them to turn back the stream of the world's great flow, without calling upon them to become once more Anglo-Saxons, a patriot may wish them to look backward a little upon the great and good of olden time, and to emulate the virtues of their forefathers, without losing the wisdom of our own times.'[68]

Kemble edited a quarterly journal, the *British & Foreign Review*, and loaded it with reports of Continental nationalist movements and writings as well as his own exhortations. In it he gave a mouthpiece to, among others, the romantic Italian nationalist Giuseppe Mazzini, exiled from his own people by Austrian oppressors. In 1838 Kemble helped to found an English Historical Society, a more populist and less academic precursor of the Royal Historical Society (not founded under establishment auspices until 1868), and under its imprint edited a string of early English historical chronicles. Then in the early 1840s he began work on his *magnum opus*, 'a historical review of the political, economical, commercial and moral state of England, in reference to the Anglo-Saxon law', conceived as an English version of what the Grimms had already done for the Germans and Jules Michelet for the French. He was disappointed at how much had been erased by the Norman Conquest – not only in the records, but also in the actual practice of liberty by the common people. But he was determined not to romanticize beyond what the evidence could bear – 'I shall not run mad like Michelet' – and admitted how little evidence there was of manners and customs among the Saxons. As, therefore, 'the *history* of England begins with the history of the king and the Church, and not that of the free man', there was some sense to the Whigs' harping on the history of royal and ecclesiastical institutions. Nevertheless, one could do a lot with the evidence of the common law and records of economic organization.[69]

The Saxons in England was published by Longmans in 1849. Kemble had high hopes for it. 'We have a share in the past, and the past yet works in us,' he insisted in the preface, 'nor can a patriotic citizen better serve his country than by devoting his energies and his time to record that which is great and glorious in her history.'[70] His hopes were not realized. Kemble himself blamed the virtually simultaneous publication of Macaulay's *History of England*, which he admired for its picturesque qualities but not for its whiggish restraint about race and nation.[71] But he knew that his own scholarly scruples were partly to blame. By sticking to the letter of the law *The Saxons in England* could only say so much about the national character of the English – about their native freedom, coupled with their early adoption of law and political authority, about domestic life and the relations between men and women, about the independence and commercial self-sufficiency of English town life,

and about the independence of the English national church. His reliance on institutional records and on deductions from political economy meant that the work was neither as inspiring nor as much of a clear-cut departure from the whig interpretation or the civilizational perspective as Kemble might have liked.

A promised work on social, economic and domestic relations never materialized. Kemble spent most of the rest of his life in bitter obscurity in Germany, where he fed privately a deepening racialism.[72] And, as critics pointed out, even his legal and political assertions about the Saxons were not carried forward adequately through medieval and modern history to show how 'the past yet works in us'. Yet Kemble's influence did work itself out in the long run, especially among experts who knew how to read his clues buried in the minutiae of Saxon legal and political history. After 1848 a rising generation of historians would build upon his aspiration to divine the English national character through the scientific study of the national past. While adopting his critical approach to the sources, they would be bolder in their generalizations about Englishness, more accessible in their style, and more direct in demonstrating how the past lived in the present.[73]

If Kemble's influence lay in the future, the travel writer Samuel Laing found a wide readership in his own generation. Laing, like Kemble, grew up with twin interests in Germany and radical politics, though not philology. He gained fame in middle age for five volumes of European travel writing published between 1836 and 1852, beginning with books on Norway and Sweden – a natural point of departure for a resident of Orkney – but inevitably ending up with a focus on Germany.[74] The most substantial and influential was *Notes of a Traveller* (1842), which propounded a mature theory of national character as well as *obiter dicta* on most of the nationalities of western Europe, particularly the Prussians. Laing's early experiences as a traveller (in Spain as well as Germany) persuaded him of the significance of moral and cultural differences between peoples and, as a radical, he felt these differences were crucial determinants of the successes and qualities of their nations. Like Kemble and other contemporary aspirants to a social science, therefore, he sought to discern the forces that were sufficiently broad to affect the character of the whole of a people.[75] Unlike Kemble, he was not willing to grant even a small share to race: it was 'not in the human animal, but in the circumstances in which he was placed' that the most important qualities resided.

Laing's background as agricultural capitalist and fisheries entrepreneur, as well as, probably, his Scottish origins, caused him to single out economic as much as the traditional political foundations of national character. 'Human

character . . . in the large', he wrote in *Notes of a Traveller*, 'is formed by human employment'.[76] To some extent, he agreed with Chenevix, geography and climate played their role. Dutch stolidity was no doubt partially a reflection of the prosaic landscape, although the Swiss were 'the same cold, unimaginative, money-seeking, yet vigorous, determined, energetic people' with quite spectacular surroundings. Climate and geography could have a more direct impact by affecting the propensity to labour (the fine climate of Italy was thus its curse) or the nature of labour ('a seafaring people' was blessed with libertarian and entrepreneurial qualities denied an inland people).[77] Most decisive, however, were 'the social institutions which educate a people, which form their moral, intellectual, and national character'. This 'social economy' was a compound of economic practices (especially the degree to which property ownership was diffused), 'old established customs, manners, traditions, modes of living and thinking', and, of course, 'laws, rights, or institutions of ancient times' (especially those permitting the exercise of individual liberty).[78]

Laing's Scottishness did not inhibit him from pronouncing upon the superiority of the English national character. He did this alternately by subsuming the Scottish within the English character – a common practice among Scottish writers on national character keen to obscure the more barbaric aspects of pre-union Scottish society – and, occasionally, by differentiating the Scottish character where it had some credible claim to superiority – for instance, in the diffusion of education.[79] His Scottishness was therefore no impediment to his status as an authority on national character. Neither was his fervent opposition to Teutonism. Not only was Laing ideologically indisposed to racial explanations for national difference, his experience with the Germans led him to conclude, on grounds of social economy, that they did not even constitute a nation: their social, economic and political practices were simply too disparate. They could not be made into a nation by the diktat of their rulers; a national character, like individual character, had to develop organically in the souls and psyches of the people.[80]

Laing was one of several radical commentators on the English national character in this period to distance themselves from the Germans essentially on political grounds. William Howitt's *Rural and Domestic Life of Germany* (1842), for example, was as horrified by German authoritarianism as it was positive about German peasant proprietorship.[81] Other radicals echoed the whig emphasis on the unique, possibly freakish preservation of originally Teutonic liberty among the English thanks to their unusual political institutions. For the educated and respectable radical like Kemble or Laing, but also for many of their earnestly self-educated artisan fellow travellers, this kind of thinking was vastly preferable to the material vulgarities of popular science with which explicitly racial arguments remained associated. The socio-

economic and political arguments for the divergence of the English and German national characters would remain vital after mid-century, for the revolutions of 1848, while in certain ways fuelling Teutonism and racialism more generally, in other ways only reinforced assertions about the primacy of divergent political paths in moulding national character. 'Social economy' more than race was the guiding principle behind the radical definition of national character in the 1830s and 1840s and later.

However Laing's observations on 'social economy' were thin and too scattered among his empirical traveller's tales to shape general conclusions about national character. It would take a political philosopher to inaugurate the quest for a true 'science of national character'. That was the achievement of John Stuart Mill. As is well known, Mill was reared in a classic eighteenth-century utilitarian tradition, with all of its assumptions about a uniform, pleasure-seeking human nature, but during his early writing career indulged in a little rebellion against his upbringing that caused him to recognize better the diversity of human motives and actions. What is not always recognized is that this rebellion took place in a context of post-1832 intellectual radicalism that encouraged him to think about human diversity in national as well as emotional and aesthetic terms.[82] Unusually, the national influences on Mill's thinking were not German but French and, indirectly, Irish. Attracted to stereotypical French characteristics for their anti-materialist qualities – the youthful Mill liked to rail against English philistinism and praise French aesthetic impressionability – he was also attracted both to romantic French historians, especially Michelet, and to French social scientists such as Auguste Comte.

In his anti-utilitarian determination to vary as much as possible the repertoire of influences upon the human character, he wished to include rational consideration of race, too, and in this spirit defended Michelet's 'subjective' attachment to the significance of race. 'This subject, on British soil, has usually fallen into hands little competent to treat it soberly, or on true principles of induction', he commented accurately, continuing more controversially, 'but of the great influence of Race in the production of national character, no reasonable inquirer can now doubt.' Having offered that challenge, however, he then retreated from it, pointing out junctures at which Michelet had 'carried the influence of Race too far'.[83] Within a few years, in a famous passage of the *Principles of Political Economy* written in 1848, he would correct himself further: 'Of all vulgar modes of escaping from the consideration of the effect of social and moral influences on the human mind', he wrote, 'the most vulgar is that of attributing the diversities of conduct and character to inherent natural differences.'[84]

A dozen years later, having completed his retreat from his own participation in what he called 'the revolt of the nineteenth century against the eighteenth', he went so far as to compare 'the tendency . . . to attribute variations in the character of peoples and of individuals to indelible differences of nature, without asking if the influences of education and social and political circumstances do not give a sufficient explanation' to the primitive habit of attributing all inexplicable circumstances to the direct influence of the gods.[85] In other words, the purpose of considering the influence of race was to give it its due weight among a variety of forces shaping national character, rather than blindly assuming its primacy. To make that proper estimate required a science of national character.[86]

Apart from his rather childish desire to prick English pride with praise for French characteristics,[87] what drove the young Mill to develop his science of national character was the political context of the 1830s, and in particular a democratic defence of the self-governing capacities of the English people. As Stefan Collini has pointed out, Mill's interest in 'character' as an individual quality was itself part of a democratic impulse to consider the psychological structures that might fit the mass of humans for self-government – less exclusive than the quality of 'virtue' formerly held to be the principal credential for political rights.[88] The further observation that 'character' varied on national lines had even stronger democratic implications because it critiqued the 'civilizational' assumption that a people's fate was determined by the political influences handed down to them by their rulers.

But Mill's concern for Ireland gave this democratic interest in national character an extra urgency. Struggling both with the racialist view that the Irish character was debased by nature, and with the superficial argument that the Irish could be improved by a change in political arrangements, Mill concluded that '[y]ou will never change the people but by changing the external motives which act on them, and shape their way of life from the cradle to the grave . . . What shapes the character is not what is purposely taught, so much as the unintentional teaching of institutions and social relations.' The roots of national character were so deep and so various that a truly revolutionary programme would be necessary to affect them, involving 'sedulous moral culture', a complete change in the legal framework that governed Ireland, and a complete change, too, in the distribution of property. And to permit those changes to work, 'We allow them an entire generation – a term which, under similar circumstances to those we propose, has been sufficient to work a complete revolution in the French peasantry, Celts like themselves, once the most wretched people in Europe, now beyond all comparison the happiest.'[89]

Under these impulses, Mill proposed to social scientists in his *System of Logic* (1843) that they move beyond the impressionistic collections of anecdotes

about national characteristics that had hitherto sufficed and begin to explore 'the Science of Character . . . including the formation of national or collective character as well as individual'. This science of character he dubbed 'ethology'. 'Of all the subordinate branches of social science, this is the most completely in its infancy,' he pointed out, 'Yet . . . it must appear that the laws of national character are by far the most important class of sociological laws.'[90] Mill retained utilitarian convictions of the psychic as well as biological unity of the human race, and much of the time he also held to the conventional view that all human societies would or could progress towards the same advanced state of civilization. But the science of national character, by explaining the historical differentiation of human societies along lines of ethnicity, culture, custom and political development, would not only contribute a crucial missing element to the descriptive science of society but could also be used to guide the civilizing process among 'backward' peoples such as the Irish and, *a fortiori*, the Indians and Africans.[91]

Having set out this stall in the early 1840s, Mill did not choose to carry out its mission himself. He left the science of national character to his acolytes, as his own interests drifted away from sociology towards politics. One consequence of this shift was that in later life he tended, even more than before, to view national character less as a subject in its own right and more as a disturbing factor in the progress of improvement. In his most substantial mature consideration of nationality (chapter 16 of *Considerations on Representative Government*, 1861), he repeated his conventional list of factors contributing to national feeling: 'identity of race and descent', '[c]ommunity of language', 'community of religion', 'geographical limits', and, strongest of all, 'identity of political antecedents; the possession of a national history, and consequent community of recollections; collective pride and humiliation, pleasure and regret, connected with the same incidents in the past'. Where a strong national community existed (not everywhere), political institutions ought to be coterminous with it, not so much because of the primacy of nationality as because collective harmony established the best circumstances in which free political institutions could achieve their prime function of civilizing 'improvement'. Best of all, however, would be the absorption of nationality into universal civilization. 'Whatever really tends to the admixture of nationalities, and the blending of their attributes and peculiarities in a common union, is a benefit to the human race.'[92]

Though Mill's own civilizational impulses were thus so strong as to cause him ultimately to doubt the overpowering significance of national character, his call for a science of national character undoubtedly struck a chord among liberals and radicals in the 1840s, especially among those more eager than he to celebrate what they saw as specifically English traits. Immediately upon the

appearance of Mill's *System of Logic*, Kemble's journal hailed the proposed science of ethology as 'one of the most comprehensive and deeply interesting studies within the range of human knowledge', combining as it did the picturesqueness of romantic history with 'the fundamental laws of human nature'.[93]

Under this influence a young admirer of Mill's, Henry Buckle, began to prepare the most ambitious and widely read nineteenth-century study of the English national character, the *History of Civilization in England* (1857). The impact of the revolutions of 1848, in exciting English curiosity about Continental nationalism, would have a further effect in developing this part of Mill's legacy (just at the time when – partly in revulsion from 1848 – Mill himself was retreating from it). A whole generation of 'University Liberals' at Oxford and Cambridge would take up the *Logic* and the *Political Economy* and, undoubtedly to Mill's surprise, draw inspiration from them to pursue further the idea of national character.[94] This process would be assisted by the trickling of democratic ideals, formerly the province of less respectable or more alienated figures like Laing and Kemble (and Mill himself), into Establishment precincts. National character was, gradually, becoming truly national.[95]

ENGLISH TRAITS

Given these democratic, liberal or radical origins of the idea of the English national character, it stands to reason that the particular qualities assigned to the English national character would be those that best suited the people to govern themselves. This very specific origin of the idea of national character in early nineteenth-century England therefore forces us to consider briefly first what it is that determines the content as well as the form of 'national characteristics'. Where do notions about the character traits of the English people come from?

As Paul Langford has shown, pre-modern ideas about the character of the English people, as seen by travellers from abroad, reflected England's marginal status in European politics and its international reputation as backward, isolated, and politically and religiously divided. These foreign stereotypes changed in the eighteenth century as England's significance changed, and as increasing numbers of foreign visitors took a more favourable view of the elite society in which they mixed. But while these foreign stereotypes hardened in the era of the French Revolution into a new notion of the 'English national character', taking account of stronger views on human character and national difference, most Britons, in contrast, continued to think of nations, including their own, more in terms of institutions, symbols and leaders.[96]

The development of 'autostereotypes' – views of one's own (rather than other peoples') national character – tends to proceed rather differently from foreign stereotypes, though it can of course draw on some of the same stocks peddled by travellers. Historians have not yet given much consideration to how the autostereotypes of the English national character arose. To the extent that they have, they have relied on the assumption that autostereotypes are generated by a process of exclusion: an enemy, 'the Other', is identified and the national character is defined as its opposite. A rough consensus has emerged in recent writing on Englishness that this 'Other' was, in the eighteenth century, the French, and in the nineteenth century, various imperial peoples, particularly non-whites.[97]

Since in these formulations it is never clear how the character of the 'Other' is itself determined, they do not get us very far in explaining the determination of the 'self'. But beyond this, they rely on an overly simplified understanding of how collective identities – or indeed any concepts – are constructed. Conceptual meaning comes from a variety of stimuli and cognitive processes, related to the nature of the concept. Concepts of 'national character' can, for example, be based on positive assessments of 'Others'; the characterizations originating from foreigners described by Langford in the later eighteenth century were on the whole admiring and implicitly emulative. In any case, we always have multiple 'Others' who generate different comparisons in different contexts. Autostereotypes can also be generated without reference to 'Others' at all, where some purposes internal to the in-group are served by the assertion of 'sameness'. Most of these processes are in evidence most of the time, in unpredictable mixtures. Nevertheless, if domestic ideas about the English national character were made possible by and largely generated out of democratic thinking about the self-governing capacities of the English people, then we should not be surprised to find that the early nineteenth-century literature on the English national character revolved very largely around those qualities deemed to be conducive to self-government.[98]

First and foremost this meant a capacity for individual liberty. The capacity for liberty in turn rested on two foundations: individuality – a sense of self and self-worth; and association – the ability of self-governing individuals to cooperate for common ends, which distinguished the individuality of civilization from the anarchic individuality of the state of nature. The individuality of the state of nature had in the past been a problem for the idea of 'national character', for it implied so much diversity as to make such a collectivity as 'nation' nonsensical; thus Daniel Defoe's puzzlement over 'that het'rogeneous thing, an Englishman'. Foreign observers in the eighteenth century, commenting mostly on elite culture and institutions, had flattered the English by calling this kind of individuality 'humour' or a later, less positive term,

'eccentricity'.[99] For nineteenth-century radical writers, however, individuality was cited as precisely that feature that made it possible for the English to have a national character where others did not. It was their common possession of independence that united them across the class barriers that might divide the French or Germans.

Kemble traced this spirit of independence back to Teutonic patterns of settlement, thinly spread through those misty forests, each man 'Kaiser and Pope in his own house', and to the early Teutonic law based on those patterns that the Anglo-Saxons brought with them to England. This was the point at which Tacitus, in the seventeenth and eighteenth centuries principally read in England as an annalist of Rome, took on new interest as an annalist of England in the pages of his *Germania*.[100] 'It is well enough known', Kemble quoted Tacitus, 'that none of the German populations dwell in cities; nay that they will not even suffer continuous building, and house joined to house. They live apart, each by himself.'[101]

Laing came to individuality by a different route, stressing the seafaring origins of the Anglo-Saxons that were then widely diffused throughout the English people by their institutions:

> The seafaring man is bred individually in a school of energy, perseverance, self-reliance and independence of mind and action. This character, formed by physical circumstances common to a large proportion of a population, spreads over a whole nation, and gives its tone and spirit to all their institutions, in every stage of their civilisation.[102]

Whatever its roots, however, it was this capacity for self-rule that lay at the heart of early radical writings on national character. As the Quaker radical William Howitt put it in 1847:

> This free constitution of the British empire, this spirit of general independence; this habit of the peasant and the artizan venerating themselves as men, has led to an universal awakening of mind in the people . . . in Great Britain, there is not a man who does not feel that he is a member of the great thinking, acting, and governing whole.[103]

In order to demonstrate that this universal awakening was compatible with an advanced state of civilization, radical writers on national character had to show that individuality was not anarchy. This was actually easier for them than for those foreign observers who had stressed the eccentric diversity of elite behaviour, and had had to look to the peculiar rule-bound institutions of polite society – gentlemen's clubs, public schools – to explain its contain-

ment.[104] For those radicals who believed genuinely in a national character, it was enough to assert that cooperative, associational features had always coexisted with individuality in the English character. This was particularly easy for radical nonconformists like Howitt who believed in the natural goodness of humankind, but tenable also for those who asserted the early significance of the common law. Kemble displayed both tendencies. Having traced the gut individuality of the Teutons back to their scattered pattern of settlement, he asserted also their early natural tendency to associate together in free unions, due to the 'instinctive yearning, to form a part of a civilised society . . . for man is evidently formed by God to live in a regulated community, by which mode of life alone he can develop the highest qualities of the nature which God has implanted in him'.[105]

Mill, disinclined to trace all English characteristics back to the misty forests of Germany, nevertheless shared the belief that acceptance of the law was deeply imprinted on the English character. In this he differed from less democratic commentators, who saw English reverence for the law as something enforced by institutions, perhaps still only a thin crust over brute anarchy. 'The Englishman's liberty is more in his institutions than in himself or in his conscience,' wrote the Russian exile Alexander Herzen, 'His freedom is in the "common law", in *habeas corpus*, not in his morals or in his way of thinking.'[106] For Mill, in contrast, England's long history of equity in the law had actually shaped the conscience of the people, offering a more secure basis for democracy than in France or Germany. 'How many years, rather how many ages, of legal protection seem necessary to engender that habitual reverence for law which is so deeply rooted in the minds of all classes of Englishmen, from the prince to the pauper!', he reflected in 1837.[107]

Another means of reconciling self-ruling individuality and rule-bound sociability lay via the domestic hearth. Those like Kemble, who believed that the English national character had derived from the misty forests of Germany, followed Tacitus in arguing that the Teutons had learnt to combine individuality and sociability first within their scattered homesteads. The proper balance of liberty and authority displayed in modern English society could have been achieved only by first acknowledging 'the honour and dignity of woman' and then 'the training of children to obedience and love', in both cases combining subordination and respect. Having learnt these lessons from a superordinate position, Anglo-Saxon men were then well placed to accept their own subordination, first within corporate guilds, then within the state, confident that their human dignity would be protected and respected.[108] This line of analysis of the national character had the advantage that it permitted a seamless blending with a rising tide of evangelical morality, which somewhat pre-dated it, asserting the full human qualities of women (albeit in a more

strictly demarcated 'separate sphere' from men) and placing a special emphasis on the sanctity of the marital bond. It had the further advantage of permitting a comparison with the French character, thought to be immodest and degrading to women – a comparison flattering to Englishmen generally but to Kemble particularly, nursing as he did wretched memories of an unfaithful French wife. At the same time, it further reinforced affinities with other northern peoples since, thought Chenevix, the status of women rose in the northern latitudes.[109]

Beyond independence, orderliness and domesticity, one further characteristic was generally agreed among these early nineteenth-century democrats, and that was industry. The climatic theories of Hume and Montesquieu had already laid the foundation for thinking of northern peoples as driven by necessity to hard, steady labour. When societies were viewed hierarchically, however, this axiom could be used to discount the potential of the ordinary northerner – a stolid, unreflective peasant, sunk in eternal torpor. Through the more democratic lens of the post-revolutionary period, however, industry became industriousness: perseverance towards a long-term goal, ingenuity and enterprise, and, once again, the capacity to act for oneself and one's family regardless of social standing.[110]

For Mill, 'their capacity of present exertion for a distant object' and 'the thoroughness of their application to work on ordinary occasions' was the quality that distinguished the English, and their American cousins, most from other peoples. All people, he thought, were able to work hard 'under strong immediate incentives', but the English were uniquely capable of the kind of industry with no or only very long-term incentives that was required for building an advanced modern economy.[111] With his youthful anti-materialism and anxiety to vindicate the French and Irish from common prejudices, Mill insisted also on the traditional corollary to this kind of industriousness: dullness and stolidity, in contrast to the lively and artistic French or the passionate and generous Irish. In a passage drafted for but never published in his *Principles of Political Economy*, he went so far as to hold that 'life in England is more governed by habit, and less by personal inclination and will, than in any other country, except perhaps China or Japan' – the view shared by foreigners like Herzen who benefited from English liberty but also sneered at its superficiality.[112]

However, most of Mill's democratic contemporaries thought that the English combined industry and independence, which combination was responsible not only for the unique accumulation of material goods in Britain but also for their achievements in innovation and enterprise. As Billie Melman has pointed out, there was a growing tendency, especially in the 1840s, to play up the virtues of English application in sharper contrast to Irish whimsicality, and

also to associate it with the English heartlands (East Anglia and Mercia) as an antidote to the air of romance attaching to Celtic qualities.[113] Howitt thought that 'bustle' was an English phenomenon, 'that scene of stir and hurry . . . that shouting to one another and running, where the need of dispatch rouses all the life and energy of the English character', though he and Mill agreed that English labourers would be better equipped to display these characteristics if they had the access to land of the German peasant, 'patient, untirable, and persevering'.[114] Laing, happier with the industrial system of his day, was more forthright about this 'general habit of quick, energetic, persevering activity':

> It is no exaggeration to say, that one million of our working men do more work in a twelvemonth, act more, think more, get through more, produce more, live more as active beings in this world, than any three millions in Europe, in the same space of time; and in this sense I hold it to be no vulgar exaggeration that the Englishman is equal to three or four of the men of any other country.

The English social system had implanted both hard work and creativity in the national character. It was up to the Continentals to emulate this system, and their own character would soon improve to match.[115]

As these differences over the relationship between industriousness and activity indicate, it was all too easy to extrapolate a variety of secondary characteristics from the basic ones and accordingly difficult to agree on what they might be. Mill thought the Englishman a creature of habit; others thought him restless and changeable. Some argued that he was cold and unemotional (in contrast to the hot-headed Celt); others, worried that these traits might be thought incompatible with domesticity, excepted his relations with spouse and children. He could be proud and unsociable, or generous and hospitable. He could be hypocritical or a slave to duty and morality. He could be melancholy or just phlegmatic. Other characteristics cited in this period were survivals from an earlier discourse meant to apply only to the educated classes: the Englishman's celebrated eccentricity, his taste for poetry, his 'wit' and 'humour', not obviously relevant to the ordinary labourer or easily rendered compatible with the national homogeneity that Mill and others like him perceived.[116]

These differences reflect the clumsiness of the very category of 'national character', based as it so often was on casual or partial observations and on an extremely crude and contradictory typology of human traits. Attempts to weave all of these diverse characterizations into a consistent portrait invariably required dazzling feats of sophistry and wordplay. But such trickery should not be allowed to obscure the mounting seriousness, even obsessiveness, with which the idea of national character was being treated in the 1830s

and 1840s. Among liberals and radicals, at least, there was an emerging consensus that nations had a real human meaning, moral and intellectual. They had begun as political constructs but – at least in the case of England with its long, continuous history – political institutions, working in combination with climate and geography if not race, had gradually forged a people with common qualities: independence, orderliness, domesticity, industry and activity.

By the 1840s, when mass political mobilizations such as Chartism and the Anti-Corn Law League were at their height, these generalizations about the national character had become commonplaces in liberal and radical circles. When the great American liberal Ralph Waldo Emerson embarked on an English speaking tour in 1847–48, he was so conscious of national character, not only through his own observations but also through contemporary discussion, that he added a lecture on American characteristics in mid-tour and upon his return wrote up his conclusions into a book-length treatment of *English Traits*.[117] When published some years later it became probably the most influential of foreign commentaries on the English among the English themselves. By then the idea of national character had achieved even broader currency in an intellectual atmosphere where Mill's disciples, the 'University Liberals', were moving into the national mainstream, and nationalist and populist themes were swelling in parliamentary politics. The decades after 1848 – the year of national revolution on the Continent – would witness the full flowering of English thinking on the national character without eclipsing entirely established traditions of Christian and Enlightenment universalism.

Anglo-Saxons

In the mid-Victorian decades, from the 1850s to the 1870s, the idea of the English national character developed for the first time into a serious and respectable category of self-analysis for the writing and reading classes. The revolutions of 1848 had a very great effect on thinking about nationality – as great an effect, in many ways, in Britain as on the Continent. The sight of peoples apparently rising spontaneously on national lines against multi-national empires like Austria's and against particularist rulers like Germany's and Italy's destabilized the traditional view that states made peoples rather than vice versa. That conclusion was drawn in Britain as well as in Germany or Italy. But in Britain another, more pessimistic conclusion was drawn from the anarchy and repression that followed the failures of 1848, which was that the supposedly universal model of liberty and order held out by Britain might not be so readily applicable to the rest of Europe (still less to the rest of the world). Perhaps liberty and order were peculiarities of the English, and centralization and discontent peculiarities of the French, and so on?

As these contrasts appeared to deepen through the 1850s and 1860s, English self-satisfaction increased further, and developed a sense of national peculiarity in another way: the confidence of the governing elite in their countrymen began to grow, and figures hitherto suspicious of democracy came slowly to perceive fundamental similarities between themselves and their social inferiors, the lack of which had previously inhibited the development of thinking about national character except among a minority of out-and-out democrats. The political culmination of this process came with the Second and Third Reform Acts of 1867 and 1884, which were widely understood to have brought democracy to Britain. Democratization extended dramatically the currency of ideas of national character, manifesting itself particularly in what Matthew Arnold sardonically called 'Teutomania' – a celebration of common 'Teutonic' or Anglo-Saxon origins and corresponding character traits that reached a climax around the fateful year of 1867.

But Teutomania neither swept all before it, nor did it erase – rather it over-laid – the pre-existing Christian and Enlightenment traditions that had asserted a common humanity, linked by the rungs of a ladder rather than separated by the branches of a tree. Not even Teutomaniacs necessarily believed in an ineradicable racial basis for Teutonic virtue: their 'race' was one you could join, as well as be born into. The year 1848 and its sequels may have revealed how difficult progress towards liberty and order was, but they did not warrant an abandonment of liberal ideals for the benighted parts of humanity. On the contrary, these decades saw a heightened sense of global responsibility on the part of liberal Englishmen who lent their support to nationalities on the Continent struggling towards the common goals of liberty and order. This sense of responsibility was challenged, but not yet shattered, by difficulties encountered in its application to the non-European world, too. The idea of national character was, in fact, to prove compatible with liber-alism. Indeed, it was so closely identified with liberalism that conservatives, certainly up to the 1880s, continued to stand aloof from it. But while the universalist creed came under stress, was inflected, even bent, it did not break.

THE IMPACTS OF 1848 AND 1867

In British eyes, the revolutions of 1848 marked a turning point in European history, possibly in world history. The universal applicability of the British model of constitutional development – and thus in certain key respects the British model of humanity – was cast dramatically in doubt, first by scenes of horrifying bloodshed and class struggle on the streets of European capitals, and then by an extended period of political instability or retrogression that threatened to extirpate liberalism everywhere but in the British Isles. Already in the spring of 1848 the news from Paris had seemed to suggest an outbreak of irrationality, even madness, on a scale that made it difficult to blame on the traditional nemeses of liberalism – kings and priests. Barricades in the streets, demands for fixed prices and wages or employment by the state, blood-curdling language aimed at an indiscriminate range of enemies of the revo-lutionary *patrie* – these should all have been familiar enough from the 1790s. But the first French Revolution could be explained away as a natural over-reaction against the awful tyranny and misgovernment of the Bourbons, whereas for the last half-century the French had seemed to have rather better leaders, including liberal gentlemen like François Guizot who were almost English in their measures and methods. What could explain a second lapse into barbarism? Perhaps only a fundamental national flaw? The French, sighed the historian Thomas Babington Macaulay to his Whig colleague Lord Morpeth in March 1848, 'are refuting the doctrines of political economy in

the way that a man would refute the doctrine of gravitation by jumping from the Monument'.[1] W.R. Greg, writing anonymously in the *Economist* a few weeks later, put it more fatalistically and fundamentally: 'It is the unchanged national character of the French which most inclines us to despair.'[2]

Then the contagion spread. Revolutionary *journées* broke out in nearly every capital of western and central Europe. In the case of the Germans and Italians, who had not had the French benefits of constitutional government in recent years, it was still possible to see revolution in 1848 as a step forward, and indeed to see their nationalism as the natural vehicle for liberalism. Greg's article had been subtitled 'Why we have no hopes for France; why we have much hope for Italy and Germany'. But those hopes, too, dwindled quickly. Stout repression doused these liberal revolutions, in some cases triggering more atavistic counter-attacks reminiscent of the French experience but in no case leading to a constitutional regime of which English liberals and radicals could approve.

The short-term effect was to put a blight on the image of nationality as a transitional phase diffusing liberty and sociability among peoples advancing towards the civilized state. The lost causes of Continental nationalism – particularly those most thoroughly trounced, the Hungarians and the Poles – became sentimental favourites of English reformers for the next decade, but they were cherished (perhaps misguidedly) as movements for liberty and popular sovereignty rather than nationality as an end in itself. 'It speaks ill for the principle of "nationality"', wrote the liberal *Daily News* in autumn 1848, 'that all the revolutions, or attempts at insurrection made in its name, have lamentably and ludicrously failed, whilst those on behalf of liberty, unblended with nationality, have succeeded, have imposed upon the strongest governments.'[3]

English conservatives, for their part, who had had fewer illusions about nationality and no interest at all in popular sovereignty, found their old prejudices confirmed, and their old predispositions to multi-national empires like the Austrian and the Ottoman reinforced. The Tory *Quarterly Review* made a robust defence of such empires (with an eye on their own) in December 1848. The benevolent political institutions of empires, it pointed out, could survive only if they respected the differences between peoples under their rule.

> It is evident that so many and such highly diversified elements can be combined in one political system, on no other condition than that the supreme government shall scrupulously respect the historical peculiarities of the different races. This is and always will be the secret of an imperial sway; and the observance of this fundamental condition has contributed in a great degree to maintain the ascendency [sic] of British rule in the East.

But conversely those peoples had also to respect the authority of the empire:

> Any other kind of sovereignty, that for instance of the people, as it is termed, would immediately find other sovereignties of the same kind arrayed against it, and a struggle which would necessarily terminate in the subjection of one or other of the antagonistic sovereignties, in which case a fusion of the several parts into one whole would result, and the original type of the sovereignty, which constituted its special value, would disappear.[4]

Even Benjamin Disraeli, torn between his youthful romantic nationalism and his new responsibilities as a rising leader of the Tory Party, distanced himself prudently from the idea of nationality in the shadow of 1848. It may have been a good principle for the long-settled, well-behaved English, but 'this modern new-fangled sentimental principle of nationality' was no good for the diplomatic and political stability of Europe.[5]

Dissatisfaction with the seeming mess other European peoples had made of their political arrangements was twinned with satisfaction at the contrasting state of Britain. Although there was great alarm, particularly in London in spring 1848, that a planned Chartist mass meeting might be the spark to light an English revolution, there were in fact more people signed up as special constables than there were Chartists in attendance. The very fact that a national guard was assembled in 1848 to defend the constitution – whereas in France in 1848 or for that matter in England in 1832 national guards were mounted to attack it – suggested that the English people had reached permanently the advanced state of civilization from which the French were backsliding and which others had not yet attained.

Events elsewhere in the British Isles confirmed this impression. Decimated by famine and drained by emigration, the Irish did not mount in 1848 the constitutional challenge that had been widely feared. The usefulness of ethnic stereotyping in order to justify otherwise 'immoral' exclusion and oppression of the Irish was probably therefore at a peak in the 1840s. After 1848 it was easier for the English outside Ireland either to ignore the Irish or to imagine complacently that the moral order of the civilizing process had resumed among them. The closer identification of the English as a 'Teutonic' people that developed in the mid-Victorian decades was fully capable of accommodating the Irish or, more commonly, of marginalizing them by neglect rather than by stigma.[6] Not until the 1880s would the Irish again pose a challenge to the British constitution. Scotland – across Europe widely admired as a model 'small nation' with its own history, culture and tradition – showed hardly the

slightest inclination to assert its independent nationality at least so far as
political institutions were concerned.[7]

It will be apparent already that this growing sense of the distinctness and
separateness of English or British politics from Continental experiences had
a rather mixed impact on the discussion of national characters. Conservatives
were again horrified by the practical consequences of popular mobilization
and in 1848 were able to blame those consequences more directly than in the
1790s on spurious claims for the sovereignty of 'nations'. With the stability of
their own multi-national kingdom and empire in view, they had a further
reason to cast doubt on such claims. At the same time they had more reason
to hymn the virtues of British institutions – precisely the formula that Disraeli
adopted in the 1850s and 1860s. Liberals and radicals were also still able to

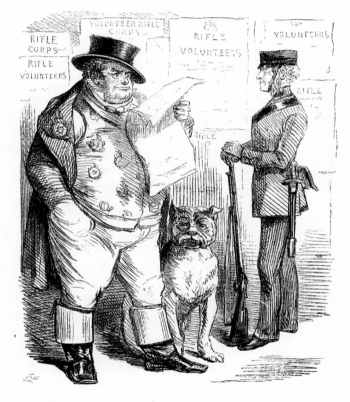

Mr. Bull. "INVASION, INDEED! THAT'S A GAME TWO CAN PLAY AT!—WHY, TO HEAR THESE POODLES
TALK, ONE WOULD THINK MY BULL-DOG WAS DEAD!"

4 John Bull's swelling feelings of superiority to Continental peoples (and he doesn't need
conscription to fight them off): as seen by *Punch*, 12 Nov. 1859

explain the divergence of Continental peoples from an English model by reference to their long history of misgovernment (and not necessarily their essential difference), which caused their erratic behaviour – an explanation that John Stuart Mill had already used in defence of the Irish.

In fact, a good deal of mid-Victorian writing about Continental difference did dwell sadly on the deleterious effects of bad government more than on any deep-dyed flaws in other people's national characters. 'Why, it is all Bureau and Barrack!' wrote the novelist Charles Lever in *A Day's Ride* (1863), summing up the Englishman's experience of Continental travel. Between them, 'bureau' (that is, centralization, associated particularly with the French) and 'barrack' (that is, militarism, associated particularly with the Germans) accounted for a lot of bad behaviour on the Continent.[8] The French case was the most puzzling, because – unlike the Germans, Italians and Slavs, or even the Irish, depending on how beneficent was your view of the effects of union since 1801 – their institutions had seemed to be improving, so they had fewer grounds for mitigation. Perhaps, as some concluded, progress, while still built into the human animal, was not as automatic or as unidirectional a process as it had proved in Britain.

Here we have the germs of the 'degenerationist' anxieties that would prolif-erate later in the century and lead some former liberals in more conservative directions, although still not necessarily in more nationalist directions. As Walter Bagehot and Sir Henry Maine, two early prophets of degeneration, both argued, the English had the seeds of stagnation or decay in their progressive being perhaps as much as the French did, and why one people advanced and another did not became a pressing – but not easily answered – question. '[T]he difference between the stationary and progressive societies is . . . one of the great secrets which enquiry has yet to penetrate,' wrote Maine sadly.[9] That was the view of a fairly conservative man, but not one with an overwhelmingly dogmatic sense of the uniqueness of the English.

However, there can be no doubt that for many people, including some conservatives, the impact of 1848 and of subsequent political divergences between Britain and the Continent was to consolidate the idea of a distinctive national character, responsible for those divergences. Even the intensification of harping upon 'bureau and barrack' revealed a heightened sense of which characteristics marked out the people of Britain: self-government, a man's ability to stand on his own feet, a devotion to hard work and the enjoyment of prosperity rather than listless submission to authority. This linkage between the wonders of the English constitution and the character of the English people was sufficiently prevalent by the 1860s for Charles Dickens to single it out for parody in the person of Mr Podsnap in *Our Mutual Friend* (1864–65). 'We Englishmen are Very Proud of our Constitution, Sir,' says Mr Podsnap to

a foreign gentleman. 'It Was Bestowed Upon Us By Providence. No Other Country is so Favoured as This Country.'

'And if we were all Englishmen present, I would say,' added Mr Podsnap, looking round upon his compatriots, and sounding solemnly with his theme, 'that there is in the Englishman a combination of qualities, a modesty, an independence, a responsibility, a repose, combined with an absence of everything calculated to call a blush into the cheek of a young person, which one would seek in vain among the Nations of the Earth.'[10]

For a number of reasons, belief that those characteristics could mark out the whole of the people of Britain and not only an elite – thus a belief in a truly national character – was also spreading in these climactic Victorian decades, although not to everyone. One factor was a national self-confidence at such a peak that it could even generously (albeit temporarily) be held to glorify the whole of the nation. Britain's place in Europe and the world was not unlike that of the United States after the fall of communism: that of the single great power. France was troubled, Germany still divided, Russia absorbed with its own internal consolidation and with an eastwards expansion that did not yet trouble Britain. Britain's relationship with its own empire was not as yet defined as that of first among equals, with the English people asserting commonalities with other culturally and even racially distinct peoples. Rather the empire was still seen principally as an offshoot of the mother country, so that national diversity was not quite the conundrum it would become later. (Even so, the nature and capacities of the Indian people were already posing difficulties for people like Bagehot and Maine, growing doubtful about the unity of mankind but uncertain how to explain English progressiveness and Indian stagnation.)

Commercially, Britain thought of itself quite literally as the centre of the world: the headquarters from which decisions were made for the whole world about international trade and communications; the 'workshop of the world' in which all the most advanced industrial products were manufactured; and the place from where most new ideas and inventions emanated. Although this centrality could still be (and was) interpreted in a 'civilizational' perspective as the engine of Britain pulling the train of civilization forwards it could also (and did) engender a hubris in which Britain was seen to be so far ahead as to be leaving the rest of the train behind it. At the same time, while religious faith remained undimmed, the sense of human power unleashed by this great wave of new prosperity and technology, by the self-consciousness of the conquest of nature, naturally caused more people to attribute the brave new world to their own qualities rather than to the hidden workings of a divine plan.

More obviously and relevantly, the British were coming to see themselves as more homogeneous and uniform, less fissured by differences of region, religion, morals and class if not gender. The results of the 1851 census revealed that a majority of the population was now 'urban', crystallizing a growing self-perception of Britain as a densely packed 'urban nation'.[11] In a country that had always experienced a relatively high level of physical mobility, the early and rapid extension of the railway network dramatically extended people's horizons on a national though not yet on an international scale. Between them, the railway, telegraphy and steam printing further integrated the nation as a cultural unit, making possible a national market in daily and weekly newspapers, prints and pictures, magazines and novels.[12]

These material changes lay behind great conceptual leaps in thinking in terms of masses. Social statistics, collected and studied from the 1830s onwards, became in the 1850s of much wider interest and the basis for social policies and grand theories of collective behaviour. This was evident in the founding of the Social Science Association in 1857 and the almost simultaneous publication of H.T. Buckle's *History of Civilization in England*, which purported to be the first scientific history based on the study of statistical aggregates.[13] At the same time, social psychology took its first baby steps forward. A growing appreciation of the foundations of human psychology, which could explain similar behaviours among large numbers of people exposed to similar stimuli, helped liberals previously allergic to thinking in terms of masses to accept regularities or homologies in human behaviour without abandoning entirely their individualist moralities and presuppositions (although a continuing attachment to 'free will' complicated matters).[14] For example, the idea of 'consensus' in its modern meaning of the 'coordinated thinking of large groups of individuals' appears at this time – as it happens, in Mill's *System of Logic* (1843) – and gained in purchase and appeal in the 1850s.[15]

These ideas of social statistics, mass psychology and consensus show that the 'English national character' was not the sole beneficiary of thinking in terms of masses. It was, however, the principal beneficiary, for more specific reasons, which caused the British to think of themselves as 'the English' with the distinct national character of the English. The subsidence of Irish nationalism, albeit only temporarily, and the comparative absence of Scottish nationalism, slightly surprising even to contemporaries, meant that confidence in the union was probably at an all-time peak, especially in England. To the age-old stereotype that the English were a 'mongrel' nation was now added a newer stereotype that the British people as a whole were mongrels, too – a stereotype that acknowledged that within this mix the English formed the preponderant or even the dominant element. It was now possible unself-

consciously to talk about 'England' and mean 'Britain'. Of 112 Victorian textbooks on the history of Britain, for example, 108 called themselves histories of England.[16] The long-term decline of Irish and Scots Gaelic and Welsh was widely predicted, encouraged, even celebrated by some (not all of whom were English), and so for the first time 'English' was becoming the lingua franca of the British Isles as well as the imperial label for its culture, although both kinds of 'English' had altered as a result of a richer Celtic blend.

Forms of social divisions persisted, of which the two most significant were religion and class. The Church of England, which had never had supreme authority in the other parts of the British Isles anyway, lost much of its authority in England in this period to a more militant nonconformity. But at the same time a new religious consensus emerged – more pluralist, more tolerant of ecclesiological differences, and at the same time more homogeneous in a shared commitment to religious earnestness, individual responsibility and the possibility of human progress.[17] Class remained the great divider, and in certain respects class differentiation grew in the second half of the nineteenth century.[18] But the religious consensus offered a way in which class differences could be imagined as shrinking or converging, and a way that was particularly potent for the idea of national character.

This was the idea of 'character' not as a synonym for 'characteristics' but as an ideal psychological profile ('good character') – what Stefan Collini has considered as a shift from a descriptive to an evaluative usage.[19] There was a solid consensus in mid-Victorian Britain as to what constituted 'character' and, equally importantly, a good deal more optimism than previously as to whether the mass of the people either did or could possess it. 'Character' represented the deep inner qualities of the developed human being (it was nothing so superficial as 'manners' or the narrowly political 'virtue' beloved of early modern theorists). It encompassed both reason and emotion. It was the basis of human morality as revealed by the scriptures and by inquiry into the details of human physiology. It was widely held to be an innate potential of all human beings, though not necessarily developed by them all – that required either a propitious environment or an act of will or both.[20]

What is most striking about mid-Victorian writings about 'character', however, is the spreading assumption that most Englishmen had it. Samuel Smiles, the author of *Self-Help* (1859) and *Character* (1871) among many similar titles, held that it was a universal potential – 'Character is human nature in its best form' – and also that it had always featured most prominently in the English make-up.[21] A radical Unitarian, Smiles was just the kind of person who in the preceding generation had been pioneering the idea of the English national character on the radical fringe of social science, like John Mitchell Kemble, William Howitt and John Stuart Mill. But he had a much wider

audience than they had had – a national audience, in fact. *Self-Help* was prob-ably one of the two or three best-selling works of non-fiction in the second half of the nineteenth century, far outstripping the levels attained earlier in the century by George Combe's *Constitution of Man* (1828), to which in some way it forms a natural successor. Smiles recognized this broad audience by explicitly assimilating the 'character' of the common man to the ideal of the gentleman, the 'True Gentleman' who, properly defined, was not the property of any single rank or station.[22]

Believers in the 'character' of the ordinary Englishman could also now be found in much larger numbers rather closer to the governing elite. Impressed by the example set by the English working man in 1848, a group of Liberal Anglicans, misleadingly calling themselves 'Christian Socialists', began to beat the drum for a specifically English national interpretation of Christian fraternity. '[F]or as surely as there is an English view of everything,' as Charles Kingsley put in 1848, 'so surely God intends us to take that view; and He who gave us our English character intends us to develop its peculiarities . . . so each nation by learning to understand itself, may learn to understand, and therefore to profit, by its neighbour.'[23] At Oxford and Cambridge a whole generation of young liberal intellectuals grew up after 1848 reading John Stuart Mill and taking him seriously, not as a radical gadfly but as the wisest diagnostician of economy, society and politics. These 'University Liberals' gave equal weight to both the 'national', Coleridgean elements in Mill and the more cosmopolitan, Benthamite elements, believing that in the 'nation' (by which they really did mean the whole of the people, undivided by classes) lay the best hope for rationality and universality in politics.[24]

These were still radical ideas, though more widely diffused. As the 1850s wore on, and especially after the Crimean War of 1853–56 and the India 'Mutiny' of 1857, when the ordinary soldier was thought by many to have outperformed his officer, commentators who were far from radical found themselves coming around to similar conclusions on their own terms. Among them were several influential followers of Thomas Carlyle. Carlyle had himself gained a reputation in the 1830s and 1840s as a blistering polemicist on social and political questions, taxing the governing elite for its failure to provide moral leadership for the nation. He combined a then unusual concern for the moral, religious and spiritual condition of the people with a conviction that that condition could be uplifted by the moral force of exhor-tation and example. '[I]t is', he wrote famously in an early essay, 'the noble People that makes the noble Government; rather than conversely.' But still he looked to the hero, the prophet, a 'nobility' (of being rather than birth) to make the people noble.[25] Thus the Italian nationalist Giuseppe Mazzini had complained that Carlyle reduced the history of great nations to the biography

of their great men: 'The shadow thrown by these gigantic men appears to eclipse to his view every trace of the national thought of which these men were only the interpreters or prophets, and of the people, who alone are its depositary.'[26]

After 1848 Carlyle's already fairly gnomic pronouncements turned twisted and alienated, but he had by then acquired a number of acolytes, who in the more liberal atmosphere of the 1850s adapted his early polemics into praise of the common man and continuing calls for connection with them by the nation's traditional leaders. The historian J.A. Froude, for example, wrote 'England's Forgotten Worthies' in this vein – a paean to the common people of the sixteenth century and implicitly of the nineteenth as well, which triggered a fashion for historical epics in praise of the ordinary Englishman by the likes of Kingsley and Alfred Tennyson.[27] As Kingsley and the Christian Socialists lost some of their youthful idealism, Froude's liberal Carlyleanism offered them a way to continue praising the moral qualities of ordinary folk, especially those of the past, without having to approve of contemporary materialism or the inevitability of progress or democracy. In an 1856 review of Froude's *History of England*, Kingsley praised his unfashionable respect for the moral heroism of his forefathers, which could at least be glimpsed in the present in theatres such as the Crimea. '[England's] people', he wrote, 'have physical strength, animal courage, that self-dependence of freemen which enabled at Inkerman the privates to fight on literally without officers, every man for his own hand . . . therefore she stands and grows and thrives, a virgin land for now eight hundred years.'[28]

James Fitzjames Stephen, another cooling liberal, took the same morally approving tone when considering the ordinary Englishman, past and present. Again linking the Elizabethan yeoman to the Crimean trooper, Stephen wrote in a review of Buckle's *History*,

Alter the spelling and the grammar, and Shakespeare's common soldiers might write home letters from India or the Crimea. Bates, Williams, and the other good yeomen whose limbs were made in England are much like their countrymen of the nineteenth century, as if they had crossed the Channel in the *Golden Fleece*, and been carried to Agincourt by the Northern Railway . . . They love and hate, they think and speak, and fight, in precisely the same way, and on just the same principles. Even between different classes living in the same age, the moral identity is more important than the intellectual disparity.[29]

With Stephen, as with Froude, asserting the compatibility of 'moral identity' with 'intellectual disparity' was a way of acknowledging and exalting the

English national character without having to accept democracy – a novel departure that might open the way for more conservatives to embrace the idea of national character. But it was an unstable compound.[30] Both Froude and Stephen worried that contemporary materialism, and indeed the advance of democracy, were undermining the moral unity of the nation. Stephen did not believe that the moral integrity of the people was safe in their own hands and increasingly held that only the rule of law and religion and firm government could preserve it – an 'authoritarian liberalism' that, as Tom Metcalf has said, held more appeal in the empire than in Britain, where it was deemed too authoritarian by the democrats and too liberal by the conservatives.[31]

There were still plenty of conservatives who would continue to believe in the rule of law and religion and in firm government and who did not need to believe at the same time in the moral integrity of the common man, still less in the moral unity of the nation. In a later essay, Stephen himself asserted that the moral as well as intellectual characteristics of a nation were more properly the characteristics of their ruling class.[32] As Britain edged closer to democracy, indeed, some former liberals such as Bagehot and Maine began to question their earlier belief in the healthiness of the national character and worry about degeneration.

That said, the tide was not yet running in a conservative direction, and both politics and intellectual discourse were by the 1860s dominated by liberalism in a populist key, which was entirely favourable to the idea of the English national character. By the early 1860s such was the confidence in the stable and enduring qualities of the English people that momentum began to build behind another parliamentary reform, one that would go far enough to make the nation a democracy. A politician as hitherto indifferent to parliamentary reform as William Ewart Gladstone, moving about the country, meeting a more diverse constituency than had been customary and receiving delegations of working men representing trade unions and friendly societies, noted the 'good sense and practical turn' of the English people and was moved to advocate in public their wider enfranchisement.[33] Mill's followers, the University Liberals, made an explicit link between the high quality of the English national character and argument for a more democratic enfranchisement in an important volume, *Essays on Reform* (1867).[34] The most enthusiastic supporters of reform used the highly dramatic, almost Utopian language of what Patrick Joyce has called 'the democratic romance'. 'Let us try the nation,' pleaded the parliamentarian John Bright before a huge audience in Glasgow in October 1866. What was wanted, said another radical voice, was a reform 'which will enable the common sense and the common honesty of the nation to express itself'.[35]

The enactment of the Second Reform Act in 1867 crowned this rhetorical turn. While far from democratic in the modern sense of the term – after 1867 just under half of adult males in Britain had the vote, and many fewer than that in Ireland – the Second Reform Act was widely interpreted by contemporaries as the advent of democracy, at least in Great Britain if not in the United Kingdom. The gulf between the English people and the English constitution had been closed. Conservatives who continued to doubt or mistrust the English national character kept their peace. Moderates who were recent converts argued that the national character had now formed sufficiently to make democracy work. Some were cheered by Mill's view that the advent of democracy would build the national character, laws and institutions being the most powerful instruments by which a people could be brought to perceive accurately their common interests. This ought to make not only the nation but also the world more stable. 'The spirit of patriotism', wrote W.E.H. Lecky, the political philosopher, then, in 1865, rather under Mill's and Buckle's influence, 'has . . . assumed a position scarcely less prominent than in antiquity, while at the same time . . . it has lost its exclusiveness without altogether losing its identity, and has assimilated with a spirit of universal fraternity. The sympathy between great bodies of men was never so strong, the stream of enthusiasm never flowed in so broad a current as at present; and in the democratic union of nations we find the last and highest expression of the Christian ideal of the brotherhood of mankind.'[36]

Those more radical voices who had always believed in the national character, whatever the constitution said, smiled at the realization of the inevitable. 'In the order of nature', as Smiles had said, 'the collective character of a nation will as surely find its befitting results in law and government, as water finds its own level. The noble people will be nobly ruled' – an echo there of Carlyle. 'All experience serves to prove that the worth and strength of a state depend far less upon the form of its institutions than upon the character of its men.'[37]

Now the search was on in earnest to explain why the English national character was the way it was, and why it was so superior to the national characters of those who had failed to make democracy (as in France or Germany, still plagued by 'bureau and barrack') or failed to make democracy work (as in America, then just recovering from a nearly fatal civil war). The standard whig accounts, which laid so much emphasis on institutions, proved unsatisfactory to full-blooded democrats who wished to give the people themselves more credit and to give English liberty a longer pedigree. 'We ought not only to chronicle the acts of sovereigns and statesmen', wrote the author of *The Popular History of England*, 'but we should "read their history in a nation's eyes".'[38] A rash of theoretical, historical and polemical tracts on the subject

appeared during and after the Second Reform Act debates just as they had during and after the First Reform Act debates. Now the idea of an English people had been accepted, with a distinctive character running like a silver thread through all classes, faiths and regions, how could it be explained?

WHAT MAKES A NATION? RACE AND CIVILIZATION

Thinking about race – about the biological differentiation of the human species – had a significant impact on thinking about nations in this period. Charles Darwin's *Origin of Species* appeared in 1859, accompanied by a rich current of biological and anthropological data, gleaned from medical science and global exploration. This and the thinking, speculating and writing that flowed along with it, greatly stimulated a tendency to view humanity as a natural phenomenon, subject to the same biological laws and forces that governed the plant and animal worlds. The complex racial hierarchies that accompanied and rationalized global exploration and conquest – imperialism – could as a result be seen as more 'scientific', firm and fixed.

Historians of our own time, peculiarly fascinated by the operation of the forces of race and empire in the past, have tended to pin nearly the whole of mid-Victorian thinking about national character on these forces. But it would be as bad a mistake to overestimate their significance as to deny it entirely. The existing civilizational perspectives, deeply rooted in English Protestant and Enlightenment modes of thought, were perfectly serviceable for most imperial and national purposes. They, too, supported a hierarchical distribution for the world's peoples, giving the English a superior position and also a more active role, for civilizational perspectives offered a wider sphere for the work of missions, schools, civil services and constitutions than would a strictly racial perspective. The events of 1848 raised doubts about the inevitability of progress and the universal applicability of the English model in the European theatre. And there were clear imperial analogues, notably the Sepoy Mutiny of 1857 in India and the Morant Bay rebellion of 1865 in Jamaica, which stirred up English anger against the 'ingratitude' of fractious colonial subjects and English doubts about their capacity for civilization.[39] But as in the European theatre, these imperial conflicts stirred up debates rather than simply striking a new consensus. The civilizational perspective had to be defended, deepened, adapted in the new contexts.[40] It would have been curious if this most Protestant of nations had suddenly just given up on the conversion of the heathen. Was race really the insuperable divider of nations? If not, what did explain the apparent widening rather than the expected shrinking of the gulf between the English and everyone else?

The orthodox position on race in the early nineteenth century was, as we have seen, the Christian 'monogenist' view, typified by the work of the ethnologist J.C. Prichard, that humanity formed one species and that racial distinctions were comparatively superficial. There had always been a 'polygenist' minority that saw the different races as distinct species, and after the French Revolution a Lamarckian third way that accepted the common origins of all humans but posited a biological divergence based on the inheritance of acquired characteristics. Under this Lamarckian interpretation, a people's common environmental experiences became over historical time their biological endowments. In Britain the Lamarckian position was very largely the province of democratic materialists, who wished to emphasize both the common biological make-up of the whole of the people and the possibility of progressive improvement through environmental (and thus eventually physical) change.

The Darwinian revolution in theory put an end to these differences. By extending greatly the time-frame available for human development, Darwin was able to reconcile monogenism with the widely perceived fact of great human diversity and, through the mechanism of natural selection, to explain evolution as a long, slow process, not much susceptible to short-term environmental changes. The pure Darwinian position could, therefore, just about be used to justify radical biological differences between races that were thought to have separated many millennia in the past, but it was not helpful at all in explaining national differences between, for example, the peoples of Europe. The mainstream Darwinians who populated the Ethnological Society, founded in 1843, were hostile to biological explanations of national difference and tended to be agnostic, leaning towards the negative, regarding biological explanations of racial difference.[41]

However, the Darwinian revolution was not a 'revolution' in the sense that the modern interpretation of Darwin swept all before it. Before the discovery of genetics, especially, the chief impact of Darwinism was to popularize the idea of human evolution but not to discredit Lamarckian explanations for how and why evolution happened.[42] The mid-Victorian decades therefore witnessed not a Darwinian triumph but a mêlée of competing and contradictory – and, often, self-confessedly confused – accounts of the evolution of the human animal. Nearly everyone who borrowed from the authority of evolutionary biology to make statements about human differentiation hedged their bets with doubts and reservations. They used a language of race that was frustratingly, sometimes deliberately ambiguous: a 'race' could be a physical stock, it could be something like a 'tribe' or a 'clan', or it could be both at once. It is not an easy task to characterize the competing accounts, still harder to determine which were dominant or even influential.

The version that has most fascinated historians recently was not, however, either dominant or widely influential.[43] This was the extreme biological version propounded by Robert Knox in *The Races of Men*, first published in 1850 and reissued unamended (but with supplementary chapters) in 1862. Knox had an unusually strong belief in the fixity of races and their moral as well as physical character, such that he was able to distinguish clearly not only between Caucasian and Negroid but also, denying the biological unity even of Caucasians, between Saxon and Celt. He was therefore equally dismissive of civilization and of Christianity as bases of character. Guizot, he felt, had been 'most outrageously mistaken' in writing about 'European civilization . . . an abstraction which does not exist'.[44] Racial difference would make forever impossible Christianity's dream of universal brotherhood, and Protestantism was nothing more than the 'physical and moral nature' of the Saxon.[45] This creed was attractive to upwardly mobile plebeian materialists because it made all (English)men equal, and certainly spelled out a recipe for a specifically English national character; but it was fairly repellent to anyone else – the vast majority of all classes – who clung to civilization and Christianity as the chief animating principles of the human race.[46]

Knox himself complained in 1850 that Englishmen would not admit the application of racial theory to 'Ireland or our *colonies*' because they still had a sentimental belief in the civilizing effects of institutions. ' "Persons", say they, "situated as the Irish, so favoured by Divine Providence as to be permitted to live under our glorious institutions in church and state, should dismiss from their minds all questions of race; such questions may and do apply to the continental people, but we happy islanders have nothing to do with them." ' 'The illustrious Prichard', he complained, 'has succeeded in misdirecting the English mind.' Knox had hopes that the revolutions of 1848, as their true import sunk in, would change all that, causing the English to abandon their sentimental humanitarianism.[47] But in a review of his own influence at the end of his life, written for the second edition of *Races of Men* in 1862, he was not so sanguine. He even took the view that it was a racial flaw in the Saxons that they felt themselves to be the pioneers of humanity, rather than a distinct species.[48] His line of thinking was, in fact, most popular firstly in America, where it harmonized with a native strain of anthropology that underpinned the defence of slavery, and secondly in France, where democratic materialism was better established among an intellectual as well as a plebeian audience.[49]

A slightly milder – though still pretty virulent – strain of biological racism was espoused by the Anthropological Society of London, founded in 1863 as a protest against the monogenist orthodoxy prevalent in the Ethnological Society. Reflecting the impact of Darwinism, the Anthropologicals were less interested in human origins than Knox had been and more evolutionary in

their thinking, but they were sufficiently Lamarckian to believe in wide moral and intellectual disparities between the races. What really exercised them was the difference between Negroes and Caucasians: in the racial conflicts of the 1860s, they sided with the South in the American Civil War and with the forces of repression in Jamaica after the Morant Bay rising, gaining their greatest notoriety in championing Governor Eyre of Jamaica for his summary arrest and execution of the rising's black leaders. Mostly they did not, however, share Knox's view of the racial homogeneity or fixity of the English people.[50] And even among the Anthropologicals there were concerns about radical racial distinctions as too French and republican for their tastes. Their merger with the Ethnologicals in 1871 to form the Anthropological Institute marked the triumph of a Darwinian consensus that eventually excluded the idea of environmental influences on racial divergence and put racial differentiation far back in time, long before the historical development of nations. This consensus thus accommodated a racial hierarchy but not a biological basis for national difference.

The more biologically inclined psychologists drew the same conclusion. Compared to their Enlightenment forebears, mid-Victorian psychologists were more anxious to acknowledge that the mind formed part of a body that was itself subject to evolutionary forces. But there remained a substantial body of liberal opinion that insisted, in the tradition of John Stuart Mill, that national or racial differences were social rather than biological constructs. 'No physiological explanation of mental phenomena', argued G.H. Lewes, 'can dispense with a constant reference to spiritual conditions . . . In the case of human beings, the experiences are complicated by the operation of social influences: it is through these that the highest powers are evolved. The conspicuous mental differences between a Goethe and a Carib cannot be assigned to differences in their organisms and functions, but solely to their developed faculties.'[51] Most psychologists, however, had come to agree that human psychology was a compound of the physical and the mental. Even Mill's principal disciple, Alexander Bain, was ready to concede some biological basis for emotional differences: 'The Celtic races in general – Irish, Welsh, Scotch Highlanders, French – are emotional in comparison with the Teutonic races, while even among these some are more so than others; the lowland Scotch and English have least of the peculiarity. The ancient Greeks resembled the modern Celts in this respect.'[52]

The leading physiological psychologist of the day, Henry Maudsley, was most categorical. 'The intellectual differences which exist between the Bosjeman, or the Negro, and the European are attended with differences in the extent and complication of the nervous substance of the brain.' These differences were accumulated by a Lamarckian process as well as by

Darwinian natural selection. The fundamental unity of mankind, 'the same general type of cerebral conformation', was therefore splintered by evolutionary developments. But Maudsley held back from asserting that these developments took place in historical time, separating not only races but also nations. And he endorsed the civilizational perspective insofar as he held that Christianity's development of the moral sense was tending to unite previously separated tribes and nations into a 'universal brotherhood of man'.[53] Herbert Spencer was relatively unusual in discussing characterological differences between nations, as well as races, as a product of Lamarckian development. In his schema, civilization was advanced not so much by international morality as by international competition and/or mixing, the dominant breed being that which was successful in combining the virtues of the various races while excising their vices.[54] Spencer's diagnosis of the hybridized racial basis of the English was more generally congenial than Knox's purism, accommodating as it did older visions of a mongrel race and warranting more rather than less imperial expansion.[55]

Anthropologists and physiologists were professionally steeled to this new kind of biological realism, and many of them – certainly the likes of Maudsley and Spencer – rather enjoyed the shock that their theories gave to respectable ideas of religion and civilization. Yet those respectable ideas still carried authority. Maudsley paid at least lip service to Christianity. His coadjutor, W.B. Carpenter, emphasized the centrality of 'that *conscious volitional* agency, which is the essential attribute of personality; for without this there can be no Moral Government, and man's worthiest aspirations after the Divine Ideal would have no real object'.[56] Even a great believer in the racial basis of English liberty like Charles Kingsley, who was after all an Anglican priest, felt that a racialist like Carlyle had carried too far the reaction against 'civilization'. 'He undervalues, even despises, the influence of laws and constitutions: with him private virtue, from which springs public virtue, is the first and sole cause of national prosperity.' Yet 'the family, and the society, the nation, exists only by casting away selfishness and by obeying law.'[57]

As many historians have observed, the British retained a stubborn attachment to the view that there was one human nature and thus one ideal human morality towards which all peoples were tending, only the British more rapidly than everyone else.[58] 'Common sense', Carpenter argued, was not a uniquely British trait but a basic capacity of civilized humanity that less civilized people had simply not yet acquired.[59] The question was how to adapt this traditional civilizational perspective to the new awareness of national differentiation. Knox had drowned the baby of civilization in the bathwater of race. How to explain the nation in terms that defended civilization without denying race?

If there was a dominant way of explaining nationality in this way in the mid-Victorian period, it was what historians have called the idea of 'social evolution', using what contemporaries called 'the Comparative Method'. The Comparative Method took the new body of evidence, gleaned from physiology, philology, archaeology, anthropology and historical scholarship, and used it to reconstruct the ladder of civilization. Now the rungs on the ladder were much further apart. 'Primitive' peoples – both those in 'civilized' peoples' distant pasts and those still living in a primitive state (for example, Maudsley's 'Bosjeman' or 'Hottentot') – were perceived to be very distant indeed from 'civilized' peoples in Europe. At the same time, it could be shown that 'civilized' people had themselves begun in the same state that typified primitive people in the present. Both philological and racial theories of the 'Aryan' descent of the European people from central or south Asian ('Indian') origins bore this out. In between the state of nature and the state of civilization could also be found many intermediate states, both in the history of the European peoples and in the condition of semi-civilized peoples in the present.

The 'Comparative Method' demonstrated these truths by comparing peoples in the past and in the present to show that they were in similar states of development. The same comparison was used to vindicate the fundamental principle of the civilizational perspective that there was basically only one path: from 'status' to 'contract', as the most famous exponent of the Comparative Method, Sir Henry Maine, put it, or, considering other aspects of civilization, from superstition to common sense, from despotism to liberty, from anarchy to law and order.[60]

What distinguished this 'social evolutionary' ladder from its Enlightenment forebears was its greater length; its ability to comprehend all the peoples of the earth, past and present; its greater specificity and latitude about what constituted civilization; and, most significantly for our purposes, its tendency to view whole peoples – races or nations – rather than individuals or legislators as the travellers along the rungs. A social evolutionary perspective, it was felt, could explain why a given people stood on a given rung at a given time in terms of that people's inner state rather than their institutions.[61] It was, in short, a machine for delineating and explaining national character, or, to put it another way, for producing John Stuart Mill's much-desired 'ethology' – the science of nations.[62] Two of the more detailed applications of the Comparative Method to the science of nations – Bagehot's and Buckle's – may reveal its workings and some of its variety.

Walter Bagehot was one of those radically inclined liberals who found his universalism severely tested by the events of 1848. A Unitarian journalist and banker who had been educated as a boy by J.C. Prichard and William Carpenter, his interest in the distinctiveness of national character seems first

to have been aroused by the dismal spectacle of French politics between 1848 and 1851.[63] Among his first publications was a series of letters on this subject to the Unitarian journal the *Inquirer*, which addressed 'the Aptitude of the French Character for National Freedom'. At this stage Bagehot was already pessimistic about that character (leading him to an unusual admiration for Napoleon III as benevolent dictator), yet puzzled as to why he should be.

> Why nations have the character we see them to have is, speaking generally, as little explicable to our shallow perspicacity, as why individuals, our friends or our enemies, for good or for evil, have the character which they have . . .
>
> What stealthy, secret, unknown, excellent, forces may, in the wisdom of Providence, be even now modifying this most curious intellectual fabric, neither you nor I can know or tell.

'Let us hope they may be many', he concluded. But he was not in fact hopeful: 'All nations have a character, and that character, when once taken, is, I do not say unchangeable – religion modifies it, catastrophe annihilates it – but the least changeable thing in this ever-varying and changeful world.'[64]

Once the crisis had passed, however, and the French national character was safe for the moment in the firm grip of Napoleon III, Bagehot set about trying to find out what those 'stealthy, secret, unknown, excellent forces' shaping national character might be. He read widely in the physiological and social sciences and absorbed the Comparative Method, most obviously from Sir Henry Maine.[65] The results of his researches appeared finally in 1872, in a much-quoted but widely misunderstood volume misleadingly entitled *Physics and Politics*.[66]

On the surface of it, and certainly in its title, *Physics and Politics* was an attempt to apply the latest discoveries in 'physical science' to the study of politics, and particularly to the force of national character in politics. '[T]he existence of national character is the greatest commonplace in the world,' but, Bagehot complained, it had never been properly explained: 'When a philosopher cannot account for anything in any other matter, he boldly ascribes it to an occult quality in some race.' Modern physiology, implicitly Lamarckianism, might be able to clear the air by identifying the 'transmitting nerve element' that formed '"the connective tissue" of civilization'. Furthermore, and here Bagehot gestured not so much at Lamarck as at Knox, with his vision of fixed racial characters, physiology might be able to explain 'the constant' – what made, for example, the 'English character' 'much the same in many great respects in Chaucer's time as it was in Elizabeth's time or

Anne's time, or as it is now'. Taking physiology into account might therefore compensate for the civilizational perspective's bias towards the variable and the progressive.[67]

However, having dutifully recorded these hopes in his opening passages, Bagehot spends the rest of the volume reverting to type, frankly acknowledging a traditional whiggish Englishman's difficulties with a biological understanding of national character, his preference for progress, individuality and diversity. For one thing, 'the constant' – the fixed racial component of national character – is hardly referred to again. Instead, Bagehot turns his attention to explaining 'the variable'. How does the character of a whole nation change? To answer this question, he turns immediately to a solution that would have been familiar and congenial to the liberal Carlyleans: great men emerge, through their greatness provide moral as well as physical leadership, and the people around them are insensibly moulded in their image. 'I think there will be a disinclination', he admitted, 'to attribute so marked, fixed, almost physical a thing as national character to causes so evanescent as the imitation of appreciated habit and the persecution of detested habit. But, after all, national character is but a name for a collection of habits.' By Lamarckian means these habits might become ingrained over long periods of time; but they need not. A 'national character' could be changed by the emergence of a small elite of a distinct character, which was then only imitated by the mass, permitting very rapid changes in short periods (something which, Bagehot felt, would be hard to explain by reliance on physical means alone).[68]

A few years earlier, Bagehot had already shown how 'imitation' had worked in detail in the English case, in a famous exposition of *The English Constitution* (1867), which controversially played up the colourfully irrational, 'dignified' parts of the constitution that captured the masses' allegiance, rather than the practical and rational 'efficient' parts. Here, in practice, Bagehot showed very little interest in an ingrained, generally distributed 'national character'; when he spoke of it, he referred principally to the middle classes, and he had little if any truck with ideas of an innate capacity for self-government in the mass of the English people, 'infinitely too ignorant to make much of governing themselves'. It was 'imitation' or 'deference', acting on the imagination rather than through reason, that caused the English constitution to work.[69] If the most civilized nation, the English, were susceptible to such irrational processes, everyone must be. In *Physics and Politics* Bagehot made explicit his view that the phenomenon of 'imitation' was, indeed, a human universal, an 'innate tendency of the human mind', and 'I believe this unconscious imitation to be the principal force in the making of national characters.'[70]

Borrowing the popular misreading of Darwin that held that the process of natural selection had a direction ('progress'), Bagehot tried to show how

natural selection worked on the level of nations, allowing the best to progress and relegating others to stagnation, absorption or conquest. A 'strong nation' was one that was able to acquire 'legal fibre' – not only the leadership of great men but a sufficiently ordered and flexible form of leadership (in other words, the whig's old friend, liberal political institutions) to allow the masses to imitate its good qualities without losing their ability entirely to forge their own lives and develop new moral qualities: 'Progress is only possible in those happy cases where the force of legality has gone far enough to bind the nation together, but not far enough to kill out all varieties and destroy nature's perpetual tendency to change.'

What enables a nation to develop this magical formula? Not, as it turns out, race: the 'race-making force' undoubtedly functioned at the dawn of man, but it 'has now wholly, or almost, given over action'. There are many more nations than there are races, so some further process of differentiation must be identified, a 'nation-making force, properly so called, which is acting now as much as it ever acted'. Race may have some residual effect in the nation-making stage, principally by encouraging maximum variation, so that the mixed-race nations – the French and (of course) the English, for example – have an advantage, although mixes between very disparate races, as in America or India, seemed not to work so well.[71]

But apart from this marginal element, what else allows a nation to progress? Bagehot rejected climate and other environmental factors, since the Baron de Montesquieu a popular resort of speculators upon national character. He rejected the material and technological factors, too, that were favoured by Buckle.[72] While expressing a good deal of frustration and puzzlement, ultimately he returns to his process of imitation. Somehow, a few peculiar individuals emerge – perhaps as randomly as the variation Darwin spotted in finches and turtles: 'They labour and prosper, and their prosperity invites imitation.'[73] In an earlier, emptier world, distinct nations grew up around these distinct individuals. The strongest were those who discovered first the trick of combining leadership and diversity, order and liberty, and preserved this fragile combination from the raging passions that dwelt within all humans. 'Some races of men at our earliest knowledge of them have already acquired the basis of a free constitution.' These seemed to have been the Teutonic (German) and classical (Greek and Roman) nations. It was curious, and possibly significant, that ethnologists traced them back to a common Aryan racial origin:

Upon the first view of the facts a speculation might even be set up that they were peculiar to a particular race. By far the most important free institutions, and the only ones which have left living representatives in the world,

are the offspring either of the first constitutions of the classical nations or of the first constitutions of the Germanic nations. All living freedom runs back to them, and those truths which at first sight would seem the whole of historical freedom, can be traced to them.

But a second view of the facts spoilt the simplicity of the explanation. 'The eastern Aryans', in India, 'are amongst the most slavish divisions of mankind', while some non-Aryans have been free. 'There then must be something else besides Aryan descent which is necessary to fit men for discussion and train them for liberty,' but, alas, sighed Bagehot, 'I am not prepared with any simple counter theory . . . what that something is I do not know that any one can in the least explain.'[74]

He could not explain how it happened, but he was in no doubt that the English had it. England had to an almost unique degree that 'general intellectual freedom' that permitted originality, diversity and progress. Even more rarely, it also had that sense of order and decorum – the characterological *beau idéal* that Bagehot labelled 'animated moderation' – that channelled originality and diversity into the fruitful paths of civilization, without the concomitant outbursts of animal passion that had so frustratingly set back Irish and French progress.[75] This combination was now seen to be rarer than had previously been thought, yet it still ought to be within the reach of all white people, at least. The purpose of *Physics and Politics* was, after all, to reveal a true science of 'verifiable progress' that might help all people possessed of the innate human propensity to labour and self-improvement to discover that tricky formula of liberty and order.[76]

Bagehot's was perhaps the most intellectually respectable attempt to combine the new science of race with the old faith in universal progress and civilization into a modern explanation of 'national character'. It was hobbled by uncertainties about the compatibility of race and civilization and, in the end, Bagehot found his moderate political views better served by an elite theory of national character, working through 'imitation', than by the vulgar materialism of race. Those with more radical political views could choose between racial purism or a more democratic understanding of civilization. Although there were a few who followed Robert Knox along the former path, the latter was still by far the most common and its mid-Victorian apostle was Henry Thomas Buckle, who has some claim to be the most widely read nineteenth-century authority on national character.[77]

Buckle was the son of a West India merchant. He inherited his father's fortune in 1840, aged nineteen, and devoted the rest of his life to international travel and study.[78] He died of his travels, succumbing to disease in the Middle East in 1862, his last words allegedly, 'Oh my book, my book! I shall never

finish my book!'[79] The world had to make do with the first two volumes of the *History of Civilization in England*, published in 1857 and 1861. Buckle's *History* was a history of civilization, not at all confined to England, but dedicated to explaining why civilization had been achieved first and best in England, why others had been left behind, and how they might catch up. In those ways, it was a classic mid-Victorian application of the Comparative Method to explain why the nations were distributed as they were along the rungs of the ladder, and, as with Bagehot, to show them the way up. What distinguished Buckle was his uncompromising refusal to dabble in the new politics of race. He was a follower *pur sang* of John Stuart Mill and saw his book as the realization of Mill's projected 'ethology' – the science of nations.[80] It was, therefore, intellectually very much a continuation of the project of the early Victorian radicals to write the democratic history of civilization – that is, a history in terms of peoples rather than elites or institutions – but with the Comparative Method's conception of 'universal man' developing differently in different environments and a greater mid-Victorian sensitivity to the uniqueness of the English path.[81]

'The fundamental ideas of my book', wrote Buckle in his journal around the time of the publication of the first volume, were:

1st. That the history of every country is marked by peculiarities which distinguish it from other countries, and which, being unaffected, or slightly affected, by individual men, admit of being generalised.

2nd. That an essential preliminary to such generalisation is an enquiry into the relation between the condition of society and the condition of the material world surrounding such society.

3rd. That the history of a single country (such as England) can only be understood by a previous investigation of history generally.[82]

In the early history of mankind, Buckle argued, the material conditions shaping nations were principally natural ones: not biology, but climate and soil, and through them food, and, most innovatively, what he called 'the aspect of nature' – environmental factors such as local flora and fauna and the frequency of storms and earthquakes. It was the instability of these latter factors and the lack of incentives to labour in hot climates, not racial difference, that held back civilization in the equatorial regions. They explained not only the barriers to improvement traditionally held to impair the Egyptian or Indian psyche – sloth, dependence, impracticality – but also other features such as 'an exaggerated respect for past ages' and a preference for supernatural rather than rational explanations.[83] Cooler and more stable environ-

ments had had the opposite effect in parts of Europe, but not all. Scandinavia and Iberia suffered from some of the same geographical and climatic discouragements, and the freakish backwardness of Ireland could be explained by the unusual presence there of 'a very cheap national food', as in China.[84] Elsewhere in Europe, however, their natural endowments and stability gave other peoples incentives to labour and to reason. As a result, both 'wealth' and 'thought' were well distributed among the masses from an early stage.[85]

This account of the early stages of civilization gave Buckle a reputation as a climatic determinist, the culmination of a line of thought that began with Montesquieu. But Buckle was clear that after this early stage 'the progress of European civilization has been marked by the diminished influence of the external world . . . a diminishing influence of physical laws, and an increasing influence of mental laws'.[86] Most of his history is devoted to the operation of these mental laws. Like Bagehot, Buckle pinned the possibility of real progress on 'free discussion'. Unlike Bagehot, he was a democrat, who thought free discussion was a genuinely popular characteristic and looked less to leaders and institutions (even as sources of 'imitation'); in fact, for Buckle, scepticism about leaders and institutions was itself almost as important a factor in the promotion of progress as free discussion itself. These qualities of free and critical discussion had developed in England from the sixteenth century, and continuously since the seventeenth century.[87]

Because Buckle did not finish his *History*, he did not actually write the history of civilization in England at all – the bulk of the first two volumes are devoted to the history of civilization in Spain, France and Scotland – and we have to infer his views on that subject from *obiter dicta*. The civilized spirit of free enquiry did not flower in Spain, Buckle concluded, mostly owing to the less propitious natural environment, although in modern times the resulting undue deference to church and state ought to have been corroded by the general march of mind.[88] France had more promising beginnings, which made it more difficult to explain its comparative failure. For this explanation Buckle had to forage somewhat further back in time, to the Middle Ages when, he concluded, the greater strength of the rule of law in England in comparison to France cultivated a 'tone of independence' and 'lofty bearing' among the people that in turn fostered superior institutions. 'The consequence of all this has been that the French, though a great and splendid people . . . have always been found unfit to exercise political power', and it would take some generations of gradual weaning from the 'protective spirit' that kept them down until their national character could be found capable of self-government.[89] Scotland, however, had advanced halfway: it had thrown off its princes but not its priests – thus the paradox of a nation that was liberal

in politics but illiberal in religion, a people that was shrewd and bold in practical matters but deficient in speculation and credulous in spirit.[90]

Buckle's theory of national character was therefore a dogmatic variation on the 'bureau and barrack' theme. He stoutly defended the private morals of the Spanish and even the French against the stereotypical slurs: their defects were not moral but political, although these political defects bit deeply into their national character and could only be made up (as Mill had said of the Irish) by generations of self-improvement.[91] This moral generosity and the simplicity and universalism of his vision did not, however, sap his patriotic pride in English achievements – a combination that was irresistible to so many self-improving English working men of the Podsnap decades. A contemporary rhyme spoofed his appeal:

> This is the creed, let no man chuckle,
> Of the great thinker, Henry Buckle;
> I believe in fire and water
> And in fate, dame Nature's daughter;
> I believe in steam and rice,
> Not in virtue or in vice.
> I believe that all the gases
> Have the power to raise the masses.[92]

Respectable gentlemen were unhappy on much the same grounds. They were irritated by Buckle's refusal to moralize, by his sweeping confidence that he could capture the whole of human history in a few simple scientific principles, and by an unchristian determinism that seemed to deny the significance of free will and great men – what was the point of individualism if it was only a kind of national fatality? 'I do not believe in the Philosophy of History, and so do not believe in Buckle,' grumbled the historian Bishop Stubbs.[93] Some also jibbed at his point-blank refusal to admit any role for race.[94] But this did not make Buckle a dinosaur: his was still a vital, even central understanding of human nature and national differentiation in the latter half of the nineteenth century.[95] Given the problems that non-democrats like Bagehot had in integrating racial homogeneity into their world view, Buckle's rationalist progressivism could and did influence later Victorian writers who wished to cling to progress without giving in to the vulgarities of democracy and mass society.

Bagehot himself was obviously very much influenced by Buckle, though he didn't like to admit it.[96] So were later advocates of grand-sweep history like W.E.H. Lecky and J.R. Seeley. Lecky's *History of European Morals* (1869) was practically a sequel to Buckle, adding a tale of moral progress to stand alongside the intellectual, with some of the same appeal to self-improving working

men, although Lecky was no friend of proletarian democracy. In Lecky, civilization required 'a double action': the broad popular movement towards rationality charted by Buckle, plus Carlyle's 'men of genius or heroism' to supply the masses 'with nobler motives or more comprehensive principles, and modifying, though not altogether directing, the general current'. Racial difference may have cast doubt upon the speed with which civilization could spread around the globe, but Lecky was in no more doubt than Buckle that English civilization was a model at least for the whole of Europe, and one that was breaking down national distinctions left over from more primitive times.[97]

Grand theories of nationality in this period thus ran the gamut from Knox's dogmatic racialism to Buckle's dogmatic anti-racialism. Civilization kept the upper hand, however. Knox's influence was limited. To most British readers his doctrine denied the fundamental principles of progress, Christianity and history that they held most dear. The improved understanding of the varieties of humanity allegedly conveyed by ethnology did not fracture the perceived unity of the species, nor did it necessarily cast much light on national differentiation. Probably the most widely read ethnologist of this period was Robert Latham,[98] who in Prichardian vein asserted the unity of the species (such that he refused to speak of 'race', only of 'varieties') and consistently deprecated attempts to link ethnological information to 'such differences as those which exist between the superstitions, moral feelings, natural affections, or industrial habits of great families'.[99]

To attribute national aptitudes and inaptitudes or national predilections and antipathies to the unknown influences of blood, as long as the patent facts of history and external circumstances remain unexhausted, is to cut the Gordian Knot rather than to untie it. That there is something in pedigree is probable; but, in the mind of the analytical ethnologist, this something is much nearer to nothing than to everything.[100]

People did talk more in a language of 'race' in this period; it was a natural development arising from the intersection of ethnology and the democratic impulse to speak of peoples and nations rather than of great men and institutions. Often, as Latham pointed out, they held contradictory views about the unity of the species and the different capacities of the races.[101] Those who thought more systematically about the question used 'race' to distinguish between people of colour and white Europeans, but not between Europeans. In this view, 'race' was a factor in the early history of humanity but of diminishing significance in the period of recorded history, at least of Western civilization. This interpretation left open the question of how likely the rest of the world was to follow the Western path. Within Western civilization, the

differentiation between nations had more to do with their peculiar trajectories from the primitive state in historical time, which were set by an inscrutable mix of factors: climate and geography, language, religion, the development of political institutions, and the great acts of great men. As a result, it was difficult, if not impossible, to connect ethnological data to national characters and behaviours in the present.

To some extent these views were held by European liberals of all nationalities, reflecting a characteristic mixture of feelings of superiority and confidence in the general applicability of the European model.[102] But the British attitude remained more liberal, and more Christian, than most. With its multi-national kingdom and its global ambitions, Britain was always likely to resist the stronger theories of national differentiation. It lacked both the radical materialism and the romantic conservatism that were undermining Christian liberalism in France and Germany at the same time.[103] It continued to see itself instead as the leading edge of the human race. This distinctive self-perception of specialness within a universal framework remains palpable as we move from general theories of national differentiation to the specific characterization of the English nation that was most in vogue at mid-century: that is, Teutonism – the idea that the English were, fundamentally, nothing more than Germans.

TEUTOMANIA

'[T]he Battle of Hastings occurred – let me see, take 1066 from 1842 – exactly seven hundred and seventy-six years ago; yet I can't help feeling angry to think that those beggarly, murderous Frenchmen should have beaten our honest English as they did. (*Cries of "Never mind, we've given it 'em since".*)'[104] In this 1842 lampoon on popular history, 'Miss Tickletoby's Lectures on English History', W.M. Thackeray neatly caught the beginnings of a spectacular growth of interest in English history and the nationalist impulses that directed that interest back before the Norman Conquest, to the supposed founding of the English polity in the Saxon period. The mid-Victorian generation was so caught up by the Anglo-Saxon fantasy that Matthew Arnold (always more partial to the French than the norm) scorned them as 'Teutomaniacs'. The impacts of 1848 and 1867 made them easy prey for such a fad. The great desire to explain and characterize the distinctiveness of the English in a way that recognized the achievements of the whole of the people made whig history seem somehow inadequate. The agonized lucubrations of the ethnologists and social scientists had only limited appeal; they offered few clear answers and little entertainment. An English history that connected the English to the Germans was particularly welcome. Between the advent of

Napoleon III in 1851 and his defeat by the Germans in 1870, hostility to the French and admiration for the Germans was at a peak. A history that would put the Norman Conquest in its place was, as Thackeray gleefully pointed out, almost begging to be told.

Celebration of the German origins of the English began before Napoleon's *coup d'état*. There had, of course, been a long-standing English radical tradition, dating back at least to the seventeenth century, of championing the 'Ancient (that is, Saxon) Constitution', so long fettered by the 'Norman Yoke'.[105] Until the early nineteenth century, that tradition had remained pretty much confined to a cultish clique of political radicals, and its focus had been much more institutional than ethnological – it was the constitution that was Teutonic, or, more often, 'Gothic', not the people. It was the preservation of these institutions that made England unique, which was why other 'Gothic' peoples, who settled in France and Spain, had lost their liberty. Around 1800 a romantic attorney, Sharon Turner, produced the first serious history of the Anglo-Saxons that portrayed them as the founding fathers of the English people. But Turner's ponderousness and his very neglect of the political narrative told against him, though his scholarship was praised by Walter Scott and Henry Hallam.[106] Kemble was better able to weave together the ethnological and the political stories, and it was largely through his efforts that the idea began to circulate that the capacity for liberty, not just the institutions, was something that the Saxons had introduced into England. It began to matter more exactly how many Saxons had come to England since the sixth century, exactly where they had been, and what happened to the Britons whom they conquered.[107]

The year 1848 again marked a milestone. Teutonism could perhaps explain why the English were so signally fortunate in that year of disasters. Kemble tried to capitalize on this feeling when his *magnum opus* on *The Saxons in England* finally appeared in the following year. In his introduction he wrote:

On every side of us thrones totter and the deep foundations of society are convulsed. Shot and shell sweep the streets of capitals which have long been pointed out as the chosen abodes of order: cavalry and bayonets cannot control populations whose loyalty has become a proverb here, whose peace has been made a reproach to our own miscalled disquiet. Yet the exalted Lady who wields the sceptre of these realms, sits safe upon her throne, and fearless in the holy circle of her domestic happiness, secure in the affections of a people whose institutions have given to them all the blessings of an equal law.[108]

Kemble, it is clear, was still as interested in the institutions that forged a people as in the people who made those institutions work. A purer advocate of democratic Teutonism was that celebrated popular moralist, Martin Tupper, author of the wildly successful *Proverbial Philosophy*, which first appeared in 1838, who organized the Alfred the Great centenary celebrations at Wantage in 1849 and in the same year produced a short-lived journal, *The Anglo-Saxon*, aimed at cultivating unity between English working men the world over.[109]

All this activity threatened to be a flash in the pan. Tupper's Saxonism was much more popular in America than in England. The English history that really caught the national imagination in 1849 was a version still very much in the whig tradition. The first volume of Thomas Babington Macaulay's *History of England* appeared in that year and caused a sensation. To Kemble's disgruntlement it put his own precious volume completely in the shade.[110] It sold and sold and went on outselling every other English history possibly until G.M. Trevelyan's in the 1940s. Macaulay was not unaffected by the nationalizing spirit blowing through liberalism, and he was capable of vying with the Podsnaps when writing of the Englishness of English liberty. 'Our liberty is . . . essentially English. It has a character of its own . . . which accords with the peculiarities of our manners and of our insular situation,' he once wrote. 'It has a language, too, of its own . . . full of meaning to ourselves, scarcely intelligible to strangers.'[111] But the story he told of its development did not go back to the Saxons, or even to the Reformation: rather it was fixed in the constitutional struggles of the seventeenth century, when the England he prized really came into being. That England was a land of law and Parliament and of social and economic progress but, except in the sense that the people benefited from the latter, it was not an England conspicuously inhabited by ordinary Englishmen, certainly not by horny-handed Teutons. Its popularity demonstrates mainly the craft of Macaulay's prose, its sense of narrative drive and carefully constructed drama, but it is not far-fetched to attribute some of it to the enduring appeal of whig history – a simple story of progress towards liberty, with admirable patricians in the starring roles.[112]

Macaulay's focus on the seventeenth century had another advantage that Teutonism could not match: it chimed with an evangelical and nonconformist insistence that true moral progress was possible only once the English had landed on the correct interpretation of the scriptures. Strongly Protestant chroniclers of the English national character liked to harp on the special virtues of those toilers after truth of the Tudor and early Stuart periods. This was true of Anglicans like Froude but especially of nonconformists.[113] 'I do not believe that a Dissenter could write a history of England,' complained Bishop Stubbs to Edward Freeman of one such nonconformist history in 1859:

The determination of the Dissenters to see nothing good before the Reformation is so obvious in all that they do, that I have begun to wonder that they allow that our Saviour lived before it – as certainly they believe the Bible as written about that time. One must not expect that one's fore-fathers were anything but rascals in such people's opinions. I suppose they had none of their own.[114]

Freeman and Stubbs, as it happens, were two of the three men – the other was J.R. Green – who did finally push beyond the limits of the patrician whig story and brought the Teutonic version of English history firmly to the fore in the 1860s, when Teutomania was at its height.

Freeman was the most fervently Teutomaniac of the three, so much so that he has been branded a 'liberal racialist' or worse.[115] That obscures again the fact that real biological racism was generally looked down upon by mid-Victorian liberals as too narrow and exclusive (and unchristian, importantly for Freeman who was, like Gladstone, both a strong Liberal and a High Church Anglican). Freeman prided himself on being one of the more advanced practitioners of the Comparative Method, which explained why the English were on the top rung of the ladder and suggested how others might join them. But in doing so he drew with more gusto and more method than anyone else on the Teutonic heritage to explain English pre-eminence. He had been inspired as an undergraduate by Thomas Arnold's lectures on modern history, where he may have caught a whiff of racial explanation, though he himself recalled mainly Arnold's teaching of 'moral right' and 'the unity of history'.[116] By the later 1840s he had already entered into the budding spirit of Teutonism, and in an early prize essay he championed Saxon morals, language, architecture and law and argued for their consider-able survival after the Norman Conquest. Throwing himself into historical research with the scientific spirit of a good Teuton – that is, in the tradition recently imported from German universities – he praised Kemble's scholar-ship but felt that he had not done enough to trace the relevance of Saxon values and institutions through modern history to the present day.[117] In his great five-volume history of *The Norman Conquest*, and in more widely influen-tial lectures and essays, he adumbrated both a heroic nationalist history of the Saxons, based on the latest scholarship, and a fairly coherent analysis of just how far that Saxon history should matter to the present day, based on the latest social science.

For Freeman the early development of modern institutions began among peoples speaking languages with a common 'Aryan' root; that is, the Greeks, the Romans and the Teutons. Among these, only the Teutons' institutions proved to have staying power. Thus it was important that the English people

sprang from Teutonic stock in northern Germany, that when their forebears came to England in the invasions of the sixth century they were able to eliminate by conquest or assimilation all of the existing Roman or Celtic influences, and that the insular position of England thereafter excluded other foreign influences.[118] Certain crucial English qualities – especially representative institutions, but also the self-governing instinct that those institutions inculcated, other qualities emanating from the character of the English language, and, after the Saxons converted to Christianity, the peculiar nature of their religion – were thus well established by 1066.[119]

But as a Christian and as a progressive, he could hardly argue – as Knox did – that everything essential about the English had been pre-programmed by 1066. 'We confess that we are not up to the last lights of the age; we have not graduated in the school of Mr Buckle,' he wrote sardonically in 1860.

> We still retain our faith in the existence and the free-will both of God and of man. National character, geographical position, earlier historical events, have had much to do with the difference; but we believe that the personal character of individual men, and the happy thought, or happy accident, of some particular enactment has often had quite as much to do with it as any of them.

In fact, it was not until the thirteenth century that 'the still living England in which we have our own being' was completely formed, and, of course, since then many improvements had been wrought and the full realization of earlier potentials – such as the extension of the suffrage – had been achieved.[120]

There was something almost providential about the preservation of these fragile qualities through the vicissitudes of history. But Freeman's bullishness about their superiority was matched by optimism about their diffusion under the right circumstances. He did not believe they were restricted to people with the right biological inheritance, and in later life he fumed against ethnologists who sought to upset his work by demonstrating either the racial fixity or the mixed-race character of the English. 'By Greeks, Franks, Saxons . . . I mean that company of people to which that name historically belongs; never mind by what means they came together. I never said or thought that any of them were of pure blood of any kind,' he wrote tetchily to a Tory ethnologist in 1887.[121] In his most extensive treatment of race, in 1877 – which to the end of his life he offered as his definitive statement on the subject – he insisted that it was 'an artificial doctrine, a learned doctrine' (an imagined community?), belief in which had spread so widely that it had to be taken seriously but which had little to do with real characteristics.[122] He admitted that 'this comes pretty nearly to saying that there is no such thing as race at all . . . We must

content ourselves with saying that certain groups of mankind have a common history, that they have languages, creeds, and institutions in common, but that we have no evidence whatever to show how they came to have languages, creeds, and institutions in common.'[123]

The natural corollary of this was that other people could come to adopt the same languages, creeds and institutions by a 'process of adoption, naturalization, assimilation', and thereby 'in speech, in feeling, in thought and in habit, [become] genuine members of the community which has artificially made them its own'.[124] This was precisely what had happened in England.

> There is now no practical distinction between the Englishman whose fore-fathers landed with William, or even between the Englishman whose forefathers sought shelter from Alva or from Lewis the Fourteenth, and the Englishman whose forefathers landed with Hengest. It is for the physiologist to say whether any difference can be traced in their several skulls; for all practical purposes, historical or political, all distinction between these several classes has passed away.[125]

Whatever their ethnological origin, the various waves of immigrants into England had been swept into the 'dominant element . . . which sets its standard and determines its character . . . which draws to itself and assimilates to itself all other elements'; that is, they had become Teutonized.[126] The proof of this was there for all to see in America, where 'Men of various nationalities are on American ground easily changed into good Americans,' which made them, for all intents and purposes, good Englishmen.[127]

Freeman's idea that national character could be transmitted to immigrants was a common one in this period, consonant with a relatively free (and low-level) flow of people across national borders in an age before immigration control, and with the prevailing self-image of Britain as the global mainstay of free trade.[128] It was implicit in a scheme such as Bagehot's, where national characters grew by a process of imitation. It was also compatible with more biological versions of national character, where a core stock like the Teutonic was seen to be 'dominant' or 'stronger' and was thus able to absorb grafts.[129] Difficulties arose where two populations of roughly equal number or 'strength' came into contact: whose character was to prevail? This was more than an academic question in an age of imperialism and was raised pointedly in the British case by the ongoing struggle since 1801 to integrate Britain and Ireland. Conservatives who still did not really believe in 'national character' had a simple answer for the Irish and similar questions: the British influence was a civilizing influence and ought to be maintained at all costs. But liberals who did believe in 'national character' had to face up to its implications. If

Teutonic peoples had become imbued over centuries with a self-governing character and thus suited to freedom and possibly democracy, then other peoples had been imbued with other characters, and it would take more than pious intentions, and more than a few years, to alter them.

Some mid-Victorian liberals adopted what we might now call a 'Social Darwinist' solution: the stronger race had to prevail, though this might mean 'extermination' of the weaker (whether through attrition or more violent means).[130] But that was a minority position. More common was the view that different nations ought to keep their distance from each other. There was still sufficient belief in the beneficent effects of 'civilization' to allow the view that even the most benighted nations might be expected to benefit from it eventually. In the meantime, it was neither healthy for the more civilized nor efficacious for the less civilized to blend. This was, in fact, Freeman's stance towards Ireland, and eventually it made him a committed Home Ruler.[131]

In part because he was too honest to make biological claims he knew could not be supported, even Freeman, that most enthusiastic of Teutomaniacs, was aware to some degree of the artificiality of this construction. He was certain that the English first became English when the Saxons arrived and conquered – and, as he argued, exterminated – the Celts who inhabited the south and east of the British mainland. He believed that the qualities that then emerged – and their embodiments, the great Saxon heroes – ought to be better recognized and celebrated by the modern-day Englishman. He hoped that his writings would make the likes of 'the Staller Esegar', 'Aelfric of Gelling' and 'Godric the Sheriff' into 'names to be cherished wherever the tongue of England is spoken' and, in a personal contribution to the cause, named his sons Harold and Edgar after revered Saxon kings.[132] On the other hand, he acknowledged that such campaigning was itself a sign that national consciousness did not come naturally, that it had to be induced. He felt, like Mill, that a degree of national consciousness was necessary to make democracy work, and he also felt that in an increasingly unstable Europe Britain would lose out if it lacked the national cohesion other peoples had found.[133] But he was realistic about the power of the other forces binding together the British – their institutions, their Christianity, their economic power – and he was not oversanguine about the appeal of his own Teutonic myth-making. 'To the mass of Englishmen,' he granted, 'Arthur and his fantastic company seem more their own than Hengest and Cerdic . . . it has been a hard task to make them feel as they ought to the heroes of their own blood.'[134]

Freeman's partners in developing a Teutonic history were less Teutomaniac than he was. As one would expect of a Tory bishop, William Stubbs, the most scholarly of mid-Victorian historians, argued in his classic *Constitutional History of England* (3 vols, 1874–78) that it was not simply primitive Saxon virtues but

rather 'the commixture of race and institutions' that made the English what they were. Stubbs, in fact, rather shared Carlyle's low opinion of the Anglo-Saxons, that 'gluttonous race . . . lumbering about in pot-bellied equanimity; not dreaming of heroic toil, and silence, and endurance, such as leads to the high places of this universe'. The Saxons had needed the civilization that only Christianity, law and leadership could provide; it was the interaction between 'national character' and Christianity that explained English history.[135]

So Stubbs shared Freeman's view that the Saxon element provided the substratum on which the peculiarly successful English version of Christianity was built, and in this he distanced himself firmly from the earlier whig historians who had been unable to recognize 'distinctions of national origin and temperament'. 'The freedom of modern Europe', he wrote, 'is based not on the freedom of Greece or Rome, but on the ancient freedom of the Teutonic nations, civilised, organised, and reduced to system by agencies of which Christianity and the system of the church are far the greatest.'[136] Also like Freeman, he was not much interested in the anthropological interpretation of Teutonism: it was 'laws, language, religion, customs, and institutions' that mattered and that explained, for example, the divergence of England and Ireland – not the shape of the skull or the purity of the blood.[137]

J.R. Green was more populist than either Freeman or Stubbs, and one might expect him therefore to be more Teutonized even than Freeman. He was not – partly because he concluded, with Kemble, that the materials for the earliest English history provided too few clues to the lives and characters of ordinary Englishmen. As a result, Green regretted that his friend Freeman's history would inevitably speak 'too much of wars and witenage-mots, and too little of the life, the tendencies, the sentiments of the people'.[138] Though a clergyman, Green was a radical in politics and aimed, far more than Freeman or Stubbs, at a popular rather than a scholarly audience. His history would have to be for and therefore about the people, and thus practically would have to dwell more on later periods for which more abundant evidence on popular habits and customs existed. Green, in other words, was a pioneer of what he himself called social history – a history that went well beyond political institutions and behaviour and so also a history that saw in the English national character a richer set of qualities than simply self-reliance and orderliness.[139]

Green's masterwork was the *Short History of the English People*, published in 1874 – one of the best-selling works of English history from that date until at least the 1920s, vying with Macaulay for popular influence.[140] The *Short History* cleverly blended Freeman's Teutonism with Green's own more layered and more progressive understanding of English history. It maintained that English history began with 'the landing of Hengest and his war-band at

Ebbsfleet', which marked the advent in these isles of 'the one purely German nation that rose upon the wreck of Rome'. By the time of the Norman Conquest certain lasting traits were embedded: Christianity (but here Rome reinfiltrated the English consciousness), 'a national literature', 'an imperfect civilization', and 'a rough political order' based on self-government, free speech and common deliberation.[141] But Green was not ready to say that 'Englishmen' had come fully into existence by then, and he taxed Freeman and Stubbs with their own vagueness on this account:

> The old rule was to state that in 800 Ecgberht made Angle and Saxon into Anglo-Saxon; and that in 1066 William made Anglo-Saxon + Norman into Englishmen. Then came the Lappenberg aera which took them as Anglo-Saxon from the beginning till 1066, and then made Anglo-Saxon + Norman into Englishmen. Then came the early-Freeman-and-Guest time in which the Anglo-Saxon was wholly abolished, and Englishmen were held to have been in the beginning, are now, and ever shall be. Now we have reached the late-Freeman-and-Stubbs-and-High-Dutchmen-time in which Englishmen are held not to have been in the beginning, but to have come into being – when?[142]

In his own history, Green kept his options open and found Englishmen remade constantly as every era endowed them with new qualities. As Stubbs had argued, the Normans brought a new stock, greater unity, their own brand of Christianity, and links to the Continent that broke up the Saxons' 'mental stagnation'. 'Teutonic liberty' survived, especially in the towns, but was modified and forged into a kind of 'patriotism'.[143] Under Continental influence the life of the mind flowered and the modern English language emerged, sufficiently Frenchified to relieve its Saxon stolidity and 'ponderous morality'.[144]

Nor did the story stop there. A 'lower', more liberal churchman than Freeman or Stubbs, Green was keener to stress the transforming effects of the Reformation on the English character: '[T]he great religious, social and political change which had passed over England . . . had broken the continuity of its life,' he contended. New powers of mind were unleashed by the Reformation, daily life was transformed by 'the increase of wealth, of refinement and leisure', and a new national consciousness was awakened by the successful struggles against Rome and Spain. Over the next century, these tendencies percolated much deeper into the national psyche than even those brought by the Saxons: 'No greater moral change ever passed over a nation than passed over England during the years which parted the middle of the reign of Elizabeth from the meeting of the Long Parliament . . . The whole

temper of the nation was changed. A new conception of life and of man superseded the old. A new moral and religious impulse spread through every class.' The English were now animated by 'moral grandeur', 'a manly purity', and a 'new conception of social equality'.[145] This Puritan bequest survived the storms of the mid-to-late seventeenth century, and Green – like many Low Churchmen and nonconformists – saw it still living in the England they knew.[146] If this was Teutonism, it was Teutonism overlaid, often obscured, with many other things.[147]

The popular success of Green's *History* may indeed suggest that by then Teutonism was already past its peak. Its heyday, certainly of intellectual respectability, was in the late 1860s and early 1870s, when national confidence was high, a popular Liberal government in power, few rivals for global dominion yet on the scene, the implications of Darwin still excitingly ambiguous. These were years also when a united Germany had not yet materialized as a threat, and Germanic lands for the first and only time could act as a counterweight in the English imagination to the classical and religious attractions of the Mediterranean. The prospect of holidays in cold-weather climes would test the proposition that cold weather had formed the English character: '[I]n Alpine valleys and snowy heights all the faithful recognize [their] shrine,' one keen lecturer insisted in 1863.[148] Edward Freeman's discovery in the remote Alpine cantons of Switzerland of what he portrayed as authentic fragments of ancient Teutonic democracy did attract some English tourists whose appetites had already been whetted by Ruskinian and other evocations of the Alps.[149] Less successfully, Samuel Smiles recommended the North Friesian Islands, where he took an extended holiday in 1871 'to find out something about the beginning of the English people'.[150]

At the same time, artists like William Holman Hunt and the very popular W.P. Frith modelled their characters, especially their middle-class characters, upon recognizably 'Teutonic' lines.[151] The leading novelists essayed ethnological romances. Charles Kingsley, having embedded Teutonist themes in the modern settings of his earlier novels, now took the Saxons head on in seeking to heroize *Hereward the Wake* (1866) in a way that must have met with Freeman's approval. Kingsley's own democratic enthusiasms having dimmed, he tried to explain in a more philosophical tract, *The Roman and the Teuton* (1864), that the Saxons provided only the crude basis for the English national character (evident in modern times in the common English sailor or navvy – affectionate, sentimental, superstitious, quarrelsome, 'with a spirit of wild independence'), which required Christian leadership to civilize it.[152] On balance, he still held that the unique combination of Teuton and Roman influences in the English and Scottish peoples was healthy enough to warrant the enfranchisement of all but those untamed sailors and navvies.[153]

A very different kind of novelist, George Eliot, weighed in almost simulta-
neously with equally idiosyncratic views that nevertheless captured a whiff of
the Teutonist Zeitgeist. She had always been more interested in racialized
understandings of human differentiation than most of her fellow radicals,
including her partner G.H. Lewes.[154] As early as 1856 she had praised in the
Westminster Review the German peasantry's racial consciousness and strong
sense of continuity in culture and character, in sad contrast to England, where
'Protestantism and commerce have modernized the face of the land and the
aspects of society in a far greater degree than in any Continental country'.[155]
The Teutonist afflatus of the late 1860s gave her more hope. In her 'Address
to Working Men, by Felix Holt' (1868), she saluted the new spirit of national
consciousness in England, and in *The Spanish Gypsy* (1868) and *Daniel Deronda*
(1874–76) she attempted her own ethnological romances, though these rather
missed their mark by perversely focusing on peoples – Gypsies and Jews – with
whose ethnic consciousness Teutonists were least likely to identify. Of course,
Eliot was trying to suggest that ethnic consciousness was not inconsistent with
the religion of humanity that her radical friends espoused, but that was
probably too subtle a point to make by means of fiction.[156]

Eventually Eliot got around to the English themselves, in her oddest book,
Impressions of Theophrastus Such (1879), which praised the Teutonist historians
for reviving the national memory of 'our forefathers ... These seafaring,
invading, self-asserting men were the English of old time, and were our
fathers who did rough work by which we are profiting. They had virtues which
incorporated themselves in wholesome usages to which we trace our own
political blessings.' But still her message was blurred by wavering between
exclusiveness and racial fusion, and even more by the very oddity of the book
– a series of reflections neither avowedly fictional nor written in Eliot's own
voice.[157] Her Teutonism was certainly of its time, yet too personal to flow into
the mainstream.

A whole book could be written on mid-Victorian Teutonism alone. For the
present we ought to conclude with some reminders of the limits on how far it
could spread. One limit placed was the continuing prestige of ideas of
universal civilization along the lines of Mill or Buckle, as suggested in the
previous section. Another was the concern among spokesmen for Christianity
that a racial or even a deeply seated cultural understanding of 'national char-
acter' was conceding too much to popular materialism, undermining the
value of the biblical message and of the individual's free will to heed or spurn
it. Kingsley demonstrates that it was possible to hold both views together.

But other, more responsible churchmen were concerned to keep 'national
character' within bounds. In three lectures at his cathedral in February 1873,
much cited in later years, the Dean of St Paul's tried to present 'national char-

acter' as a neat analogue to individual character – the raw material with which God presented man but which could then be worked and moulded by the church.[158] So, in the idiom of the day, he was sufficiently triumphalist about the Teutonic peoples – 'the fathers of a nobler and grander world than any that history had yet known . . . a race which was to assert its chief and lordly place in Europe . . . to be the craftsmen, the traders, the colonists, the explorers of the world'. And yet to the civilizing effects of Christianity he attributed many of their modern qualities, which produced not only 'conquerors, heroes, statesmen, "men of blood and iron"', as one might have expected of the ancient Teutons, but also 'Shakespeare and Bacon, Erasmus and Albert Durer, Leibnitz and Goethe . . . an English court of justice, English and German workshops of thought and art, English and German homes, English and German religious feeling, and religious earnestness'.[159] The very fact that Christianity worked on the individual's free will and moral nature enabled it to develop all the different sides of human nature, in contrast to 'Mahometanism, which seems to produce a singularly uniform monotony of character' (a stab at a faith then in bad odour among Gladstonian Liberals because of the Turks' persecution of the Balkan Christians).[160]

That was as far as most liberal churchmen were willing to go towards acknowledging the moral salience of nationality. Conservatives were still just as likely to insist on the primacy of civilization, seeing little merit in Teutonist fantasies – imagine, 'English beer and beef, German sauerkraut and the vintage of the Rhine, exalted to the dignity of political coefficients', when 'the deeds of kings, the worth of an aristocracy, the beneficial effects of order and religion' were clearly the only reliable motors of progress.[161]

Finally, what of the limits imposed on Teutonism by possible feelings of exclusion among the Scots and the Welsh and, even more so, among the Irish? In theory, there need not have been any limits of this kind at all. The Teutonist historians believed on the whole that the Germanic invaders had largely wiped out the Celts in England; but they also believed that practically anyone could, in time, be Teutonized. Apart from the followers of Robert Knox, most ethnological opinion agreed with them. There was still a powerful feeling that the English were ethnologically not Teutonic at all but a mixed race.[162] A 'native of Tipperary is just as much or as little an Anglo-Saxon as a native of Devonshire', insisted Darwin's bulldog, Thomas Huxley, in an 1870 lecture. But even if they had been ethnologically distinct, he denied that there was 'sufficient proof of the existence of any difference whatever, except that of language, between Celt and Teuton'. There was, consequently, no 'political difference' that would prevent the Celt from learning the Teuton's ways.[163]

That was the prevalent theory. Willingness to accept it varied considerably in different parts of the British Isles. It was understandably most widespread among the English. But it was nearly as widespread among the Scots. Some lowland Scots defined themselves as Teutons, ethnologically and culturally. Others took pride in a mixed ethnic background (just as the English often did), but had no difficulty aligning it with values that the English called Teutonic. For most Scottish intellectuals, the leading student of Scottish ethnology has concluded, ambivalence about the relevance of Teutonism probably put them off ethnological explanations for national identity altogether. Their allegiance was to British liberalism.[164]

Pride in Celticism was more pronounced in Wales, but this, too, could be expressed in a way that harmonized rather than conflicted with Teutonism.[165] From 1864 the Council of the Welsh National Eisteddfod offered annually a prize of 100 guineas for an essay on the origin of the English nation. Although the prize was not awarded until 1868 it did elicit entries that went into general circulation, notably Luke Owen Pike's *The English and their Origin* (1866) and a half-plagiarism of Pike, Thomas Nicholas's *The Pedigree of the English People* (1868).[166] Both Pike and Nicholas argued that the English were a mixed race, Celtic and Teutonic, and that much of what was praised as 'Teutonic' in the English character derived from the beneficent Celtic influence.[167] Positioning himself midway between Knox and Buckle, Pike was cautious about attributing this mixed character to the mixture of actual blood lines, but both he and Nicholas tended to use the languages of blood and culture interchangeably.[168] For both, stressing the cross-fertilization of Celtic and Teutonic influences in the making of the English was a way of embracing English nationality without giving up entirely their Welsh pride. 'The Welsh, like the Scotch, should aspire to be in intelligence, enterprise, culture, all that the English are,' wrote Nicholas – but this was a man who dedicated his life to advancing the claims of the Welsh, and founded the first Welsh university at Aberystwyth.[169]

These speculations found their echo in England. Most famously, the literary critic Matthew Arnold expounded his own thesis on the Celtic contribution to the English character in a set of Oxford lectures that became *On the Study of Celtic Literature* (1867). Arnold had, from an early age, leant towards Celticism, influenced by his father Thomas Arnold's mystical quasi-racialism, by his mother's allegedly Celtic qualities (she was Cornish), and especially by his own mature critique of English materialism. 'I have long felt that we owed far more, spiritually and artistically, to the Celtic races than the somewhat coarse German intelligence readily perceived,' he wrote to his sister in 1859, 'and been increasingly satisfied at our own semi-Celtic origin, which, as I fancy,

gives us the power, if we will use it, of comprehending the nature of both races.'[170]

The Oxford lectures, the immediate stimulus for which was a visit to the 1864 Eisteddfod, adopted a similar position to Pike's and Nicholas's, but Arnold's was more prescriptive than descriptive. While the ethnological evidence was still little explored, he felt instinctively that 'there is a Celtic element in the English nature, as well as a Germanic element, and that this element manifests itself in our spirit and literature'.[171] But he was more concerned to argue for further intermixing in the future, to the benefit of the Welsh and Irish and also, consistent with his long-running critique of Saxon materialism, to the benefit of the English.[172] Arnold's thinking was racial in a fairly hard-edged way; probably he enjoyed the pricking of English compla-cency here as so often elsewhere.[173] But his fellow Francophile Mill made the same arguments from an explicitly non-racial position – mutual benefits flowed from the intermixing of Teutonic and Celtic cultures – and Stubbs and Green also had a largely non-ethnological reading of the English character that attributed many of its virtues to post-conquest infusions of Gallic sweetness and light.[174]

The Scots, then, were content to see themselves as Teutons or to do without ethnology altogether. The Welsh and some of their English sympathizers fell back on a mixing of Celt and Teuton in which the Celt remained the junior partner, much as Stubbs and Green saw the post-conquest Englishman as a modification of the basic Teutonic stock.[175] The Irish had no easy way out, however.[176] To some extent they could benefit, too, from the perception of the English as a mixed-breed race, and it was occasionally pointed out that such quintessential John Bulls as Lord Palmerston or the Duke of Wellington hailed from Anglo-Irish backgrounds.[177] But the Irish were most often seen, rather like the Jews, as so homogeneous and, furthermore, so numerous that they could not mix happily with the English.[178]

Historians have differed in their assessments of the consequences, however. Some see mid-Victorian Teutonism as an instrument of aggressive imperial rule over Ireland, used to denigrate and thus to subjugate resident Celts in Ireland and immigrant Celts in Britain.[179] Others have argued that the perception of difference was just as often appreciative, taking the Irish in Arnoldian fashion as a complement or an antidote to the English.[180] What we can say is that this more benign view was undoubtedly easier in the compar-atively peaceful years between the Irish Famine of the late 1840s and the Home Rule crisis of the 1880s. In these years it was possible for English observers to imagine that the Irish were mixing and coming to benefit from Teutonic institutions. Only when the Irish showed more open and widespread

hostility to Teutonic institutions in the 1880s would the English finally begin to examine more closely their ethnocentric assumptions about the universal value of their Teutonic qualities. Then the Irish would pose one of several simultaneous challenges to the stability of this characteristic mid-Victorian compound of race and civilization.

TEUTONIC VIRTUES

Identifying with precision the psychological characteristics of the English was important to the Victorians, both because they felt that it was now possible to make the study of character into a science and because they had strong feelings about what kind of character made the best human being. Some who saw a direct connection between race or physiognomy and psychology thought it was even possible to show how very particular aspects of the English character could be scientifically derived from their specific racial mixture. Borrowing from the German racial theorists Gustav Kombst and Heinrich Berghaus, Thomas Nicholas, the plagiarizer of Pike, was able on this basis to draw up a table that demonstrated conclusively (as he thought) that the English were a racial and thus a psychological compound of Celt and Teuton.[181]

Celtic	English	German or Saxon
	Deliberativeness	Slowness
	Accuracy, thoroughness	Accuracy
	Directness	Steady purpose
Quickness, clearness of perception	Clearness of perception	
Powers of combination	Powers of combination	
Imagination	Imagination	
Wit, humour	Wit, humour	
	Providence	Providence
Individuality	Independence	
Loyalty to princes	Aristocratic tendencies	Aristocratic tendencies
	Adventure	Adventure
Love of society	Sociability	
Patriarchal or family government	Sentiment of home	
Reverence	Reverence	
	Patient labour	Patient labour
	Silence and reserve	Silence and reserve
Generosity	Generosity	

5 English traits as a compound of the Celtic and Teutonic, as seen by Thomas Nicholas in *The Pedigree of the English People* (1868)

Nicholas's scheme was certainly ingenious: by positioning the English as a mercurial blend of Celt and Teuton, he got over some traditional contradictions in analyses of the English character, which was supposed to be both solitary and sociable, sober and witty, independent and deferential, sluggish and energetic. However, his was not a widely accepted scheme. Even in this period, few people were willing to be so dogmatic about the racial basis of character. And especially in this period, fewer still were willing to accept Nicholas's theory of the English as a compound of Celt and Teuton (which was, after all, prepared for a Welsh audience).

Instead, most mid-Victorian writers on national character continued to focus on a few leading characteristics that could be identified as Teutonic, viewing the contradictions as the modifying effects of historical processes such as Christianization and civilization.[182] In this they very largely carried on, while diffusing more widely, the work of the democratic radicals of the previous generation who had pioneered serious thought on the idea of national character. More emphasis was now placed on the Teutonic origins of English traits and also on their psychological depth – the way in which they characterized the 'whole man' and not only his political aspect. However, because the idea of national character was being taken up by more socially elite and politically moderate writers, there were also early attempts to make more safe and respectable the wild and anarchic Teutonic elements that only radicals had been able to celebrate comfortably.

All these forces are evident in the handling of that central feature of the English national character, the capacity for self-government. 'Self-reliance' was the mid-century byword. Popularized by Ralph Waldo Emerson and Samuel Smiles (along with its sibling 'self-help'), 'self-reliance' was gradually replacing an older, more narrowly political word: 'independence'.[183] Much more was implied by the term than a simple ability to do without over-lordship. It suggested a well-balanced person, responsible, dignified, 'self-possessed', 'self-respecting', and, where necessary, 'self-denying': capable, therefore, of recognizing his own true self-interest in obedience to the law and cooperation with others.[184] These were Teutonic qualities that were also seen as ideal human qualities.[185] Such descriptions flattered the ordinary English working man without frightening elite opinion. Even so, for the more conservative they put too much faith in innate qualities. The most radical versions could still raise hackles. Joshua Toulmin Smith, for example, a rabble-rouser in the City of London, made a specialty in this period of formulations that provocatively disclaimed any superior role for guiding institutions. 'The English Constitution', he wrote in 1852, 'has been the result of the maintenance, through ages, by men free when roaming the forests of Germany, and no less free when landing on the shores of England, of the active sympathies

and aspirations of free men.' The law itself was authorized only by 'the will of the folk and people', expressed at the most local level possible (that is, the parish). National feeling itself was therefore alien to the English.[186]

This went too far for Toulmin Smith's social superiors. Even Kemble and Freeman could find little evidence of individual responsibility in the early history of the English. Stubbs thought what evidence there was only beto-kened the savage state of the ancient Teutons, who required 'a great leader' to give them unity or, better still, Christianity. His verdict on the Christianized Anglo-Saxons betrays a continuing ambivalence:

> The individual Englishman must have been formed under circumstances that called forth much self-reliance and little hearty patriotism. His sympa-thies must have run into very narrow and provincial channels. His own home and parish were much more to him than the house of Cerdic or the safety of the nation. As a Christian, too, he had more real, more appre-ciable social duties than as an Englishman . . . There was a strong sense of social freedom without much care about political power. It was inherent in the blood.

Subsequent progress was almost wholly owing to Christianity and 'the rod of discipline' wielded by the Normans, while the Germans in Germany fell further behind, fissiparous and tribal.[187]

An intermediate position between innate self-reliance and learnt discipline was taken up by those emphasizing the law-abiding or even deferential elements in the Teutonic character.[188] The Liberal Anglican dean R.W. Church argued that the Teutons' 'instinct, wild and untamed as they were, for the advantages of law' explained why they so readily took to Christianity. Their 'obedience' was 'free and loyal'.[189] They recognized quality and will-ingly submitted to it, thus the 'aristocratic tendencies' marked in Nicholas's table (and speciously distinguished from the Celtic 'loyalty to princes').[190] Kingsley, in later life more anxious than most liberals about popular indisci-pline, even made a novel racial analysis of these tendencies. Inverting the traditional racial schema that made the rulers Norman and the English people Saxon, Kingsley proposed that the Anglo-Saxon chiefs were the only pure Saxons, their people mostly Germanized 'Sclavonians': 'Only by some such actual superiority of the upper classes to the lower can I explain the deep respect for rank and blood, which distinguishes . . . the Teutonic peoples. Had there been anything like a primaeval equality among our race, a hereditary aristocracy could never have arisen.'[191]

As the idea of 'self-reliance' detached the national character gently from political relations, a new emphasis was naturally placed on extra-political

qualities, significantly widening the range of traits identified. The width of this portfolio, however, makes it more difficult to see any kind of consensus behind particular traits – a problem exacerbated by the imprecision of psychological language, which often hampers discussions of national character. So we find more evidence of the divergent views already evident among the political writers of the 1830s and 1840s. The Teutonic spirit was nurtured in bleak, isolated homesteads, so the English love the countryside; but their 'constructive power' causes them to build great factories and cities. Their sportiness is due to the toughening effects of urban life or to the rigours of nature.[192] They are modern and traditional.[193] They are cautious, reserved, antisocial, but still somehow hospitable.[194] They are fierce and warlike, but also peace-loving (this a particularly fraught argument at a time when liberalism and pacifism were closely linked).[195] They are sober and witty. They are 'a practical people', but then again, considering the state of the railways, perhaps not.[196] They have no great capacity for speculation or imagination, except when it comes to poetry, yet how to reconcile this with the well-known Teutonic capacity for 'Wonder'?[197]

None of these traits appears prominently or consensually in the mid-Victorian literature; but two other traits do. One is domesticity, which we have already seen playing a political role in the previous generation as giving stability to Teutonic individualism, following a hint dropped by Tacitus. Now it comes more fully into its own, consonant with mid-Victorian notions of the importance of 'feminine' as well as 'masculine' virtues. 'Manliness', used almost synonymously with 'character' or 'self-reliance' to refer to the qualities requisite for self-government, was seen to rest firmly on men's proper relations to women, which in turn could be traced to Teutonic origins. Tacitus and the fifth-century Christian writer Salvian both observed that the women of the ancient Teutons were noted for their chastity, and this was seen to generate an atmosphere of truthfulness, lawfulness and self-restraint in the domestic sphere that men then took into public.[198] There were classical warrants, too, for thinking that Teutonic women were not only chaste but unusually autonomous, granted respect and equality by their men, and also an unparalleled degree of control over household labour.[199] The kind of liberal who was defending the political capacities of working men in this period was often also defending the political capacities of women: though no women were given the parliamentary suffrage in 1867, some did win the vote in local elections in 1869.[200]

Most important of all to English 'manliness' or 'self-reliance' was work. Especially for the radicals, it was essential to elevate the dignity of labour so that it appeared to be a noble alternative to (as well as a qualification for) the exercise of political powers. In the mid-nineteenth century, when hard work

and enterprise had seemed to elevate Britain to a position of dizzying pre-eminence in the global economy, this ought to have been an easy task.[201] The difficulty was that Tacitus and other authorities commented not on the dynamism of the Teutons but on their sluggishness.[202]

There were a number of ways around this problem. One was to have it both ways – to assert that the English were alternately lethargic and energetic.[203] Another was to take advantage of the slipperiness of psychological language to claim that there was no contradiction in seeing the English as at the same time phlegmatic and hard-working; their specialty was 'continuous steady labour', which betokened perseverance and endurance but not liveliness.[204] Another solution, common before the nineteenth century when Anglo-Saxon origins were not so highly prized but still very much present, was to play on the ethnic mixture of the English, which combined Teutonic 'steadiness' or 'stubbornness' with Celtic 'quickness' and 'imagination': that explained English 'enterprise'.[205] An alternative reading dwelt upon the Viking element in the mixture. As George Eliot mocked gently:

> one of our living historians finds just sympathy in his vigorous insistance [sic] on our true ancestry, on our being the strongly marked heritors in language and genius of those old English seamen who, beholding a rich country with a most convenient seabord, came, doubtless with a sense of divine warrant, and settled themselves on this or the other side of fertilising streams, gradually conquering more and more of the pleasant land from the natives who knew nothing of Odin . . . These seafaring, invading, self-asserting men were the English of old time.[206]

Others simply ignored the classical authorities, describing the Teutonic nature as 'vigorous, enduring, enterprising in the highest degree', 'energetic', 'the best workmen in the world'.[207]

But many commentators seized on the paradox to show that the English national character just was not Teutonic after all. Perhaps it was only the working class – the 'navvies' – who had the dull perseverance that made them 'unrivalled as human machines', while the upper classes provided the wit and imagination that made for true entrepreneurship.[208] Or it was only their transposition to an island setting that made the Teutons into a nation of rovers rather than homebodies; even Freeman believed that.[209] Or the modern English character was proof of the workings of civilization, maturing the inadequacies of the Teuton: as the University Liberal Goldwin Smith put it, 'a loftier type of character and a higher civilization . . . gave spirit and purpose to a somewhat dull and aimless race'. That was something upon which a Tory like Stubbs and a radical like Buckle could agree.[210] Even at this

height of Teutonic sentimentality, when the core of the English identity in self-reliance and enterprise was at stake, it was still easier for many Englishmen to think of themselves as the products of civilization – however chancy and reversible that might be – than as the ideal types of racial myth.

Great Britons

It was natural that the liberal idea of the English national character, which had emerged from debates and struggles over the political enfranchisement of (the male portion of) 'the English people', would recede from the limelight after that enfranchisement was largely achieved in the Reform Acts of 1867 and 1884. And to some extent that was what happened: the liberal idea of the English national character became part of the conventional wisdom, hardly requiring detailed explication except by or to foreigners.[1]

At the same time, however, this idea came under intense pressure both in its particulars and as a concept. Many educated liberals found their elevated expectations of 'the people' very quickly disappointed. Democracy was no Utopia, nor even a source of national unity. It faced and apparently failed to meet escalating threats to the national character – urbanization, secularization, the alleged break-up of the family unit – and seemed to be directly responsible for new threats – class-based politics, a scurrilous popular press, a culture of 'sentimentalism' and diminishing self-reliance. And the national character was seen to be thus failing just at a time when national efficiency and solidarity were at a premium, as Germany, the United States, Russia and Japan posed threats to British economic and imperial superiority, and the byword of the day in international competition seemed to be 'survival of the fittest'.

It was, of course, possible to maintain that the traditional virtues of the English national character were the fittest, that they remained strong and suited to new conditions. At the height of this so-called crisis of liberalism, in 1896, a mainstream liberal churchman, Mandell Creighton, could still produce an evocation of *The English National Character* celebrating 'the modern Englishman' in terms identical to those that had flourished in the 1850s. But even those bullish on Britain were inclined to feel in these times of fierce international competition that reliance on the virtues of ordinary people was an inadequate or unsafe bulwark of the nation's integrity. This period saw a revival of more conservative ideas of patriotism, based on leadership, emula-

tion and institutions rather than on individual psychology, and presenting – as
had been the case in the eighteenth century – a Great Briton rather than a
self-helping Englishman. In short, comparative silence on the subject of the
English national character could betoken either tradition or novelty, compla-
cency or a sense of crisis – or, in a culture marked by increasing diversity and
participation, all of the above.

CHARACTER UNDER SIEGE

Some Gladstonian Liberals were already predicting their own disillusionment
with the English working man on the eve of the 1867 Reform Act, and
certainly by 1874, when the 'democratic' electorate chose flashy, flabby and
foreign Disraeli over the sober, upright and thoroughly English Gladstone.
The glad, confident morning of Liberalism was fading fast.[2] The new direc-
tions in which Gladstone chose to take his party after 1874 – first in defence
of the Bulgarian Christians and then, divisively, in support of Home Rule for
the Irish – seemed to many 'old' Liberals either irrelevant to or destructive of
the ideals of English Christianity and civilization for which they had once
stood. With such a choice of leaders it was no wonder that the doughty
English workman whom they had celebrated in the 1860s had begun to dete-
riorate. By the 1880s there were mounting concerns about the moral and
physical health of the great towns, where more and more of the populace was
concentrated. Such extraordinary heaps of humanity were surely unnatural;
they would crush individuality, breed a 'mass society' rather than a nation of
liberty and diversity, and separate the masses from their natural leaders.[3]

Urban degeneration and class separation seemed all the more threatening
because at just the same time the British position in Europe, and possibly the
world, was challenged by renewed international competition with France and
Germany. Although France had been laid low by defeat at German hands in
1870 and by its own social divisions exposed by the Paris Commune of
1870–71, it was soon attempting to recoup its position by challenging British
colonial positions in Africa. The result was the 'scramble' to divide up a whole
continent between European powers in the 1880s and 1890s. By then France
appeared to have rediscovered its unity in a republican form of democracy
that rather belied the sneers of mid-Victorian Englishmen about the inca-
pacity of the French national character. In preparing a 1904 edition of H.T.
Buckle's *History of Civilization in England*, the Liberal J.M. Robertson, normally
admiring, had to chastise him for his misplaced disparagements of French
'unfit[ness] to exercise political power'. By then, the French had been living
under constitutional government for a generation, and, Robertson pointed
out, with a suffrage 'wider than the English'.[4]

More worrying was the example of Germany. Liberals of all tempera-
ments had been supporters of the Germans in the Franco-Prussian War, on
Teutonist, Protestant and democratic grounds. But the course charted by
Otto von Bismarck thereafter was not reassuring. His idea of democracy was
not the British liberal one. It seemed to lean upon rather than to discourage
the tendencies towards 'mass society'. A strong state providing universal
welfare benefits inevitably sapped self-sufficiency. Its militarism and imperi-
alism whipped up aggressive, exclusive, almost neo-feudal sentiments among
the vulnerable masses – more Disraelian than Gladstonian. And it seemed to
work! The German economy outpaced the British, class division was
suppressed, and a formerly divided, virtually landlocked people acquired a
navy and colonial possessions to begin to rival the British. For liberals who
had viewed the nation as a transitional form in the march from primitive
clannishness to a universal civilization of individual expression, the German
example was not just disturbing but practically revolutionary: it suggested
that progress was not assured, or, worse, that the truly natural course of
progress went in a different direction than they had suspected. What made
this all so hard to take was that the German spirit was still in many ways so
admirable: hard-working, efficient, responsible and very modern. But it was
not very liberal, or very English.

One by one, the classic traits associated with the English national character
were being cast into doubt. Either the English were not exemplifying their
supposed characteristics, or those characteristics looked like dubious assets in
the modern world. Self-reliance itself, the very core and pith of the national
character, was questioned. Moderate liberals like Henry Maine and Walter
Bagehot had always said that self-reliance was properly a characteristic only of
elites, to whom the English masses were blessedly but maybe only temporarily
in thrall.

Late in life, in 1885, Maine issued a gloomier gloss on *Popular Government*,
which expressed in no uncertain terms his view that '[a]ll that has made
England famous, and all that has made England wealthy, has been the work
of minorities, sometimes very small ones'. He stuck to the Comparative
Method, comparing the savage with the civilized, but was now more keenly
aware 'how much of the savage there still is' in the civilized man. In the wake
of 1848, it had seemed evident to most English commentators that the
English people, at least, were demonstrating the sobriety and deliberativeness
that was necessary to make representative government work, in contrast to the
French, the Irish and most other European peoples. Now Maine viewed the
ordinary Englishman with distaste: excitable, belligerent, clannish, 'with a
newspaper for a totem, instead of a mark on his forehead or arm'.[5] As the
penny press, demagoguery and the commercial excitements of urban life sunk

in their claws, observers claimed to be witnessing a 'change in the national temperament': 'The end of the 'eighties left us a stolid phlegmatic people; the close of the century found us emotional, if not hysterical,' remembered one old peer.[6]

But it was not only disappointed liberals like Maine whose diagnosis of 'the popular mind' was darkening. Conservative electoral hegemony after 1886 made many left-leaning liberals question the sanity of democracy. And after one particularly bad night, 18 May 1900, at the height of the Boer War, many liberals moved into open condemnation. The behaviour of patriotic crowds celebrating the relief of the Siege of Mafeking on that night created a new characterization of English behaviour, 'mafficking', which was nearly the polar opposite of civilized self-reliance: a reversion to the state of nature, marked by credulity, brutality, vainglory and short-sightedness.[7] As the liberal sociologist L.T. Hobhouse noted, 'the man in the street' now more embodied 'the character and tone which the proud and slow-going John Bull of old days was wont to attribute to his volatile and emotional neighbours who made revolutions and cut off the heads of kings'.[8] Those conservatives who had never believed in the strength of the national character, but only in elites and institutions, gloated at the evident disappointment of liberal ideals: 'It is a mistake to credit the masses of any country with self-control,' Sidney Whitman wrote loftily in a liberal quarterly in 1907, 'least of all in England' – this was twisting the knife – 'which history shows to have been in times of crisis moved by sentiment and emotion alternating with irascible, passionate temper. Self-restraint . . . has always been an exclusively aristocratic characteristic.'[9]

Conservatives and souring liberals could unite in complaining of the modern tendency towards reliance on the state, or 'sentimentalism', which to those who believed in it provided further evidence of a slackening of self-reliance. '[S]ympathy with suffering, especially the suffering of the weak, has grown so strong, that it disturbs the judgment,' worried the *Spectator* in April 1887. At that point, the rot had not yet gone too far, and the *Spectator* concluded:

> [N]ational character . . . is always, under all circumstances, in its essence the same . . . The nation has become merciful to weakness not through a change of nature, but through an acquired sense of sensitiveness to others' pain; and the moment the new sense produces visible evil instead of good, it is laid aside or repressed, and the genuine character . . . reappears in all its strength.[10]

The ageing University Liberal Goldwin Smith was less sanguine. 'Factory hands are bad material', he wrote in 1890 to an American professor, 'such sentiments as they have, beyond the desire for higher wages, are

pseudo-humanitarian and Socialist.' He concluded that Anglo-Saxon quali-
ties were safe only in North America.[11] The Tory Flinders Petrie thought 'the
general want of self-reliance' was 'shown by all the grandmotherly legislation
which is sought and granted'.[12] Persistent liberals tried to put a good face on
it: philanthropy had always been a part of the English national character, one
compatible with self-reliance.[13]

An alternative recourse was to recast self-reliance for modern conditions,
construing it as mutual aid or mutual tolerance rather than strict individualism
– something mid-Victorian radicals like Samuel Smiles had already tried to
argue. The English had a 'town frame of mind', wrote the novelist Ford Madox
Hueffer, 'by which men may live together in large masses' – an ideal trait for the
modern world that could show others 'how great and teeming populations may
inhabit a small island with a minimum of discomfort, a minimum of friction,
preserving a decent measure of individual independence of thought and char-
acter, and enjoying a comparatively level standard of material comfort and
sanitary precaution'. For the Left, and for Liberals moving leftwards, this alter-
native offered the hope that ideas of national character might still be salvaged,
if tweaked.[14] For the Right, and for Liberals moving rightwards (probably more
numerous), it only confirmed their worst forebodings about degeneration; it
had always been a bad idea, they thought, to pin too much on the character of
the common man.[15]

Self-reliance was under threat; so was the spirit of enterprise and adventure
that had spread the Anglo-Saxon seed so far and wide. In 1893, Charles
Pearson, another ageing University Liberal, who had spent the decades since
the 1867 Reform Act in Australia, published a controversial broadside
exploding his formerly high hopes for the ordinary Englishman. *National Life
and Character* predicted a dim, dull future for Anglo-Saxon civilization. The
English had grown 'bulbous, heavy-witted, material', not (as in Thomas
Carlyle's version) because they were so by nature, but because the will and
ability to colonize were slackening. The temperate zones had filled up, the
Tropics were unsuitable (and in any case being eyed by the Chinese); in the
future lay only stagnation in hive-like factory towns.[16]

Pearson's book was the sensation of the season. Such an apocalyptic vision,
conveyed in measured, credible, quasi-scientific tones – the concept of
entropy was much bandied about – from the ranks of the most optimistic
progressives of the previous generation – all this came as quite a shock, and
although the influence of the book was more lasting in America and
Australia, it did establish in Britain an explanation for imperial decline in
terms of the bottling up of the spirit of enterprise.[17] Again, it was perfectly
possible to argue that the qualities of enterprise and adventure that were once
appropriately channelled into imperial expansion were now being diverted to

new modern ends, and one can find plenty of liberals and radicals turning this element of the national character to anti-imperial purposes. 'There are some people who seem to think that an unlimited supply of what we call the Anglo-Saxon race is the best remedy for all the evils of the world,' granted the progressive philosopher David Ritchie in 1889, but he doubted whether 'the filibuster, the mercantile adventurer, and the missionary' were really England's noblest contribution to civilization; could not the same energies be put at the disposal of domestic social reform?[18]

Pearson had also levelled his sights on other treasured dimensions of the English national character, in some ways even more sensitive than liberty and enterprise: religion and domesticity. He had warned that in the stationary future the state would take over many of the socializing functions previously exercised by the church and the family, with possibly deadening effects.[19] These were the most controversial and, to many readers, the most incredible parts of his thesis. When the *Spectator* again, a magazine that liked to puncture conventional pieties, questioned the connection between Christianity and 'national success' in the modern world, it unleashed a storm of protest from Protestants and Catholics alike, each in their own way insisting on the traditional view that religion was the cement of human character, on both a national and a global scale.[20]

As the *Spectator* exchanges suggest, all of these attacks on sanctified understandings of the English national character met with counter-attacks, and the net effect was in many ways a reaffirmation or a restatement of older views. But the calling into question was itself the most important point. The very fact that English traits needed to be defended or reinterpreted caused people to wonder what national character was; whether, as the *Spectator* had asked, it was permanent; whether it was plastic (and if so, what made it so); whether it could be said to exist at all. These questions, raised by changing conditions and changing self-analyses, were further pressed by developments in history and anthropology, those disciplines that had contributed so much in the middle of the nineteenth century to establishing in the first place the idea that national character was real and strong.

If the tone of the social sciences at mid-century had been optimistic and ambitious, the tone at late century was more sceptical and cautious. The great, overarching explanatory schemes like Buckle's were at something of a discount: progress seemed no longer so universal or inevitable, human nature looked rather more heterogeneous and unpredictable, even shorter-term prediction felt hazardous and hubristic. 'We are learning daily that our modern civilization is not the simple thing which the theologians and political speculators of the last century fancied it to be,' sighed a reviewer in the *Athenaeum* in 1882, 'it is, indeed, a far more complex organism than thinkers

such as Buckle or Guizot imagined.'[21] Leslie Stephen, perhaps the greatest and most influential of all the University Liberals, agreed. While he had succeeded in identifying the great question of the day – what makes progress possible? – Buckle had underestimated 'the enormous magnitude of the task'.[22] The interplay between race, environment, nature, circumstance, morality and intellect was so incredibly complicated – all the more so in a diverse modern nation such as Britain. '[S]uccinct descriptions and short, terse formulae', such as Mandell Creighton was still offering in his depiction of the English national character, 'are altogether inadequate when applied to a highly heterogeneous community, full of life and therefore capable of great changes', concluded *The Times* in a leader in June 1896.[23]

One common response amongst *fin-de-siècle* intellectuals was further specialization, making it harder for them to compass a concept like 'national character'. Historians were less likely to believe that they were also political scientists – that, as Edward Freeman had said, 'history is but past politics, and . . . politics is but present history'.[24] As the Comparative Method came into question, anthropologists were more likely to make distinctions between the primitive and the civilized, the past and the present. Old disciplines fragmented: medieval and modern historians drew apart from one another; physical and social anthropologies gained definition from their mutual contrast. New disciplines emerged as the older holistic social science broke up: 'social psychology', studying the behaviours of modern societies from which ethnologists were retreating; 'sociology', retaining some of Buckle's ambition to find patterns in social development, but with a less cavalier approach to historical evidence; 'eugenics', an attempt to define a science of social engineering based on strictly Darwinist principles. This fragmentation was increasingly institutionalized in universities, where these distinct disciplines had their separate departments, chairs and journals. A modern society, it was felt, needed all these different tools to understand itself. No one person could use them all at the same time, as Buckle or Bagehot had thought to do. The direct consequence was a less confident handling of the concept of 'national character', which in the preceding century had brought together history, politics, ethnology, psychology and sociology in a way that was now almost unthinkable.

History was particularly badly hit by this tendency. The mid-Victorian historians thought that their nationalist version of the whig interpretation of history represented the key to understanding the whole of human progress: if you could work out what the Teutons had, what they got from and gave to the Celts and the Normans, and what had been the contribution of Christianity, then you could determine how (and to what extent) other peoples could travel the same road. Now both the links making a unity of English history and the links uniting the English to human history were being broken. On the publi-

cation of his last history in 1882, J.R. Green was already being mocked as 'cloying' and 'tribal', and the Saxon founders Hengest and Horsa scorned as mythical.[25] How could anyone have believed that the English were ethnically pure Teutons? In the 1880s, when Irish arguments for Home Rule were often based on ethnic dissimilarity, it was political dynamite to distinguish between Celt and Teuton, and anthropologists were cautiously distancing themselves from any such distinction.[26] Green went to an early grave but Freeman lived on to defend their honour, and he protested vigorously that they had never relied upon any such ethnological claim; indeed, our modern view of the Victorian Teutonists as prophets of racialism derives largely from this later generation's distorting mockery.[27]

But it was worse than Freeman knew. The rising generation of historians was uninterested in Teutonism either as an ethnological or as a political argument. The waning of Liberalism revived some of William Stubbs's and Carlyle's Tory doubts about Anglo-Saxon liberty, 'synonymous with complete anarchy', as the medievalist J.H. Round characterized it in 1895. 'An almost anarchical excess of liberty, the want of a strong centralized system, the absorption in party strife, the belief that politics are statesmanship, and that oratory will save a people – these are the dangers of which it warns us . . . When our fathers were playing at democracy . . . the terrible Duke of the Normans was girding himself for war.'[28]

Clearly influenced by the darkening international scene in contemporary Europe, Round's approach did not criticize the Teutonists for their uses of history, only for using the wrong history. He saw the 'making of England' as coming after, not before the Norman Conquest. Others agreed – indeed, the continuing popularity of Green's *Short History* owed much to the fact that, unlike Freeman, he was very vague about when England was actually made. There were now many equally respectable candidates. Several bore the marks of a Tory admiration for firm political and military leadership, as in Round. The so-called 'historical economists' praised Henry VIII and the Tudor state for staking out a national mission and pursuing it aggressively, writing in terms that were meant to cast doubt on liberal individualism and internationalism. Nevertheless, there were limits to how far this historical idolization of the state could go. As the leading historical economist William Cunningham put it in 1885, 'The State is the embodiment of what is common to the different persons in the nation,' so that 'we cannot represent the State as an abstract entity that is antagonistic to the individual citizens'; that might sound rather too German.[29]

The most widely read version of this new history, with its emphasis on the state and the economic projection of England, was in fact a more moderate version that straddled the Liberal and Tory visions. This was J.R. Seeley's *The*

Expansion of England, published in 1883 – an immediate best-seller that kept on selling. Said in 1895 to have been the work of history that had made the greatest contribution to 'the general political thinking of a nation', it was still influential through the 1920s and continuously in print until 1956.[30] Seeley, who had succeeded Charles Kingsley as Regius Professor of History at Cambridge, had roots in Liberal Anglicanism, Christian Socialism and University Liberalism – all of those mid-Victorian schools that had sought to express English ideals in national terms without giving up on the universal aspirations of Christian liberalism and civilization. Like many of that generation, Seeley found his liberalism moderating after 1870, as he grew impressed by competition from Germany and by the necessary role of the state in expressing and defending those national ideals.[31] In *The Expansion of England* he made a critique of the older liberal understanding of the English national character and offered a modified version:

> England is now pre-eminently a maritime, colonising and industrial country. It seems to be the prevalent opinion that England always was so, and from the nature of her people can never be otherwise . . . This unhistorical way of thinking, this disposition to ascribe necessity to whatever we are accustomed to, betrays itself in much that is said about the genius of the Anglo-Saxon race . . . It seems to us clear that we are the great wandering, working, colonising race, descended from sea-rovers and Vikings . . . And yet in fact it was only in the Elizabethan age that England began to discover her vocation to trade and to the dominion of the sea.[32]

In fact, Seeley really saw 'the making of England' as coming later still – after the civil wars and the development of settlement in the New World, after 1714 and the assertion of British naval predominance, in other economic respects after the Industrial Revolution (a new idea, the term itself only coined a few years later by the historical economist Arnold Toynbee).[33]

In Seeley's scheme, therefore, the expansion of England made the English as much as the other way around. The state represented the crucial mediating force, driving expansion and maintaining the unity of the peoples of the expanding empire. The state was hardly infallible – it lost the American colonies when it failed to keep in touch with the needs and interests of the colonists – but it was the only effective guarantor and the most reliable expression of nationality.[34] For this emphasis on the state Seeley was criticized by Liberals who felt he had underplayed the importance of the moral and intellectual qualities of the people, and thus been lured into a Tory quest for empty imperial greatness.[35]

But Seeley had not gone wholly over to the side of the state, of *force majeure* and top-down cohesion. The lesson he drew from the American Revolution was that states and peoples had to have mutual respect to endure. He was uncertain about the future of the Indian Empire, which functioned, he felt, only because the Indian peoples had (as yet) no national feeling of their own. And he claimed to prefer a lesser Britain that was morally and intellectually in the first rank than a greater Britain that sacrificed those human qualities: 'Bigness is not necessarily greatness.'[36] Yet a few years later, he was opposing Home Rule and defending British suzerainty over Ireland on the grounds that, like the Indians, the Irish had no true national existence – a harder case to argue in the 1880s than it had been in the 1850s and 1860s.[37] Seeley had been walking a tightrope, balancing imperial institutions and national character. Forced to choose over Home Rule, he fell onto the Tory side of preferring civilizing institutions to the expression of a national character. Bigness may not have been greatness; yet it had its attractions.

It was not only Tories or crypto-Tories who were undermining liberal historical beliefs in the enduring national character. Liberals themselves re-examined the English past and queried whether their old belief in a long tradition of English liberty was really tenable. Nonconformist liberals, like S.R. Gardiner, reinterpreted the national character in terms of the Puritan virtues of spiritual and moral striving in preference to an Anglo-Saxon liberty that now looked dated and inadequate.[38] A young school of 'New Liberals' was trying out redefinitions of liberty, in which the liberty enjoyed by Anglo-Saxons or even the Puritans was too distant to have modern relevance. This school saw the economic transformations of the eighteenth and nineteenth centuries as having essentially remade the nation, splitting the English into classes and requiring remedial action from the state in order to restore true freedoms.

Arnold Toynbee's 1884 invocation of the 'Industrial Revolution' was only the first of this kind of 'catastrophist' argument. The most influential was that associated with the historians J.L. and Barbara Hammond, and especially with their trilogy of books on the English labourer. The Hammonds' understanding of the grievous breach in the social fabric caused by the Industrial Revolution led them to advocate limited state action as a means of bridging the gulf between elites and masses and re-forming a healthy national character.[39] There was an odd Catholic version of catastrophism, associated with the writers Hilaire Belloc and G.K. Chesterton, that romanticized the preindustrial English peasant and advocated non-statist redistributions of land in order to restore him to his prelapsarian status.[40] And there were more left-wing versions prevalent from the 1880s, conceiving of socialism as a 'new life' after the Industrial Revolution, although some of these still appealed back to

ancient Anglo-Saxon liberties and other qualities that had survived from 'before the fall' and could yet be salvaged in a socialist reformation.[41]

Not all of these reinterpretations undermined the very idea of a national character. Some simply sought to relocate the cradle of the national character forwards, from ancient Anglo-Saxon liberty to a time more credibly connected with modern characteristics. Though Seeley was rather sceptical of such an interpretation, many people read his *Expansion* as doing just that: relocating the modern English spirit of enterprise and colonization to the sixteenth and seventeenth centuries.[42] Teutonism had always been problematic for the more pious Christians, and late Victorian clergymen just as much as their mid-Victorian predecessors felt more comfortable starting with the Reformation.[43]

Yet the fragmentation of the narrative, the multiplicity of starting points, and the shock of the catastrophist argument undoubtedly had their effect. Even the more optimistic Gladstonian Liberals were less inclined to invoke the authority of history. Their own sudden reversal on the question of Irish Home Rule, switching with Gladstone from the view that the Irish had no nationality to the view that they had, almost dictated a depreciation of the past. 'The worth of history for the purposes of practical politics is . . . gravely overrated,' wrote James Bryce in a Home Rule tract in 1888, blithely dropping the line he had pursued as a University Liberal arguing for democratic reform a generation earlier.[44] Scholarly historians seeking to professionalize their discipline were happy to agree. F.W. Maitland, studying in the 1890s the same 'primitive' legal institutions that Sir Henry Maine had examined in the 1860s, deprecated such crude attempts to find there the seeds of modern civilization. 'Perhaps', he said in celebrated Oxford lectures of 1897, 'it is too late for us to be early English.' Modern scholarship would not be 'so graceful, so lucid, as Maine's Ancient Law', but it would be truer to fact; and the only lesson it would teach, he wrote to A.V. Dicey, is that 'each generation has . . . free hands'.[45]

As history became more professional, therefore, it distanced itself gently from the great explanatory schemes that accounted for and exalted national character. Something of the same process affected the usefulness of anthropology for the study of national character. The Darwinian consensus of the 1870s had already cast doubt on the cruder associations between physical anthropology and national (if not racial) psychology that had been offered by Robert Knox and later polygenists. On the other hand, the continuing influence of Lamarckian ideas had made it possible to retain a link between physical and social evolution in the schemes of people like Henry Maudsley, W.B. Carpenter and Herbert Spencer. In the early 1890s, however, the rediscovery of Gregor Mendel's work on mechanisms of inheritance and the new

findings of August Weismann delivered severe blows to the credibility of Lamarckianism. Modern genetics was in birth, and its principles emphatically denied that acquired characteristics could be inherited. Genetics made much more severe the puzzlement that Bagehot had already registered, in the heyday of Lamarckianism, as to how the character of the whole of a nation could emerge in historic time (and how it could change dramatically over still shorter periods of time). A number of different and not always well-defined positions emerged, some of which reinstated concepts of national character in non-Lamarckian terms, others casting doubt on the biological basis of national character, still others wondering if national character could mean anything at all in such a changeable world.[46]

The one anthropological position that did support the idea of national character was a reversion to the quasi-polygenist view that the primordial races or stocks had different psyches, which were still evident in modern man, although mixed together. In the British context, this view manifested itself principally in a concerted late-century 'anthropometric' effort to prove that different blends of Teutonic, Celtic and prehistoric 'Iberian' stocks – or, in an alternative formulation, 'Nordic', 'Alpine' and 'Mediterranean' – were concentrated in different parts of the United Kingdom with, possibly, perceptible psychological effects.[47] Given the very fine physical distinctions between the supposed stocks, and the very high degrees of mixture, this anthropometric enterprise proved arduous and frustrating. The British Association for the Advancement of Science set up an Anthropometric Committee in 1875, and on the basis of its eight years of study as well as his own observations John Beddoe, winner of the 1868 Eisteddfod prize on the origins of the English, published the first systematic anthropometric study of *The Races of Britain* in 1885. The physical picture he drew was highly complex, and although Beddoe was not averse to making psychological inferences from anthropometric evidence he was far too preoccupied with drawing out the implications of the latter to say much about the former.[48]

At this stage it was more common to argue that the racial element had been overplayed by mid-Victorian anthropology than it was to desire to reinstate it via anthropometry. *The Times* reported in 1887:

For a generation or more the advocates of the view that the English are almost unmixed Teutons pressed their ideas upon the scientific and literary world with a persistence and a learning which went far to produce conviction. But this has been followed by a reaction, due to a widespread recognition of the truth that almost every phenomenon of human life is more complex than it appears on the surface, and to the increased study of the actual people of our own day by improved methods. It has been found that

language is but an uncertain guide in determining questions of race, that physical characters are more permanent than mental, and that very probably few races have been so completely exterminated in the historic period as not to have left decipherable remnants or traces.[49]

Just as Freeman had protested angrily that there had never been a consensus around a racial analysis of English history, so T.H. Huxley had to defend the earlier generation of anthropologists against a similarly exaggerated charge: the 'baseless notion' of Teutonism had never 'produced the slightest effect upon scientific anthropologists'.[50] In 1892 a new Ethnographic Survey was launched by a confederation of anthropological and antiquarian societies. This, too, foundered on the mismatch between incredibly precise anthropometric and incredibly vague psychological data, and it was wound up in 1899 without reporting.[51] By then most reputable anthropologists had given up the whole enterprise, and the centre of gravity of the discipline began to shift to the study of 'culture', progressively loosened from racial moorings.[52]

The failure of anthropometry did not stop anthropologists who wanted to believe in a racial basis for national character from continuing to believe in it, especially as the decline of Lamarckianism revived the possibility of fixed racial stocks. The most prominent of these new racialists was A.H. Keane, whose *Man Past and Present* (1899) evinced a boldness about differentiating not only the physical but also the mental characters of the 'races' unusual even in the days of Knox:

> The Kelt is still a Kelt, mercurial, passionate, vehement, impulsive, more courteous than sincere, voluble or eloquent, if not imaginative, quick-witted and brilliant rather than profound, elated with success but easily depressed, hence lacking steadfastness . . . The Saxon also still remains a Saxon, stolid and solid, outwardly abrupt but warm-hearted and true, haughty and even overbearing through an innate sense of superiority, yet at heart sympathetic and always just, hence a ruler of men.

Similarly dogmatic judgements were pronounced upon the French and the Spanish, portrayed as distinctive blends of various primitive strains (Gascon, Basque, Castilians, and so on), and predictably harsher but equally doctrinaire verdicts laid down upon various African tribes. It is notable that when more moderate colleagues revised and reissued *Man Past and Present* in 1920, they carefully excised the Celt and Saxon comparisons and softened the characterizations of Africans, but left the French and Spanish passages intact.[53]

Keane's position was open to criticism for all the reasons that Knox's had been: by exaggerating the fixed (though in Keane's version also mixed) racial characters, he was closing down the scope for the civilizing mission at home and abroad, although he remained useful to Americans arguing for racial separation in their own land.[54] Like Charles Pearson, he could be accused of excessive pessimism about the Anglo-Saxon's ability to thrive off his own turf, though Keane was more optimistic about the Anglo-Saxon's adaptation to his native climes. And this defence of fixed stocks was rendered even more difficult than in Knox's day by the failure of anthropometry to come up with the scientific evidence for distinctive stocks persisting into historic time.

The discrediting of Lamarckian adaptation did not, therefore, lead to a great resurgence in belief in a fixed racial basis for national character in Britain. Indeed, it was more respectable to argue that the ending of the Lamarckian option meant that evolutionary processes could have only little or no relevance to the formation of nations. In this view, the end of Lamarckianism spelt an end to the idea of significant developments in historic time – a conclusion compatible with Darwinian ideas of evolution. In the 1880s there had been a moment when secularizing liberals had clung to an evolutionary explanation for the ethical principles they had inherited from Christianity, but this soon gave way to the simpler position that evolution and ethics were just separate – consecutive stages in human development, the one biological, the other philosophical or sociological.[55] The principles or personalities of individuals or nations were not in their genes, but in their experiences, transmitted culturally.

This was the position 'Darwin's bulldog' Thomas Henry Huxley thought he was advancing in his important Romanes Lecture of 1893, 'Evolution and Ethics', although historians have since noted that he left open the door for an evolutionary struggle between nations continuing into modern times.[56] Perhaps less ambiguously, it was the position of David Ritchie's equally influential 1889 book *Darwinism and Politics*, which restated in a more up-to-date idiom the old sociological truth propounded by Buckle and G.H. Lewes that 'the "inheritance" in any advanced civilisation is far more in the intellectual and moral environment – in the spiritual air we breathe, rather than in the blood that runs in our veins'.[57]

The Darwinian respectability of this position enabled a Buckle mini-revival around the turn of the century, spearheaded by the Liberal MP and sociologist J.M. Robertson.[58] Buckle may not have been sufficiently Darwinian, Robertson conceded, but Darwinians now agreed that sociology could be studied separately from evolutionary processes. 'National character', if it existed, could be formed only by historical experiences. And it could be unformed in the same way. Struck by the liberating effects of denying the

influence of 'blood', Robertson began to distance himself from his heroes
Mill and Buckle, suggesting that if individuals and nations varied as much and
as quickly as recent historical evidence suggested, then 'there is no collective
"national character"' at all, not even one formed by climate, geography,
history and institutions.[59]

Robertson's sociological position that there was no national character was
still at the turn of the century an extreme one, though it did draw on a civi-
lizational perspective that continued to exert a powerful attraction upon
people of all political stripes, and it would grow in attractiveness, especially
after the First World War.[60] A more popular variant before the First World
War was what has since come to be called 'Social Darwinism'. Social
Darwinists argued that, while the process of strictly biological selection may
have ended or slowed, a process of moral and/or intellectual selection had
picked up where it left off. While obeying roughly the same laws, Social
Darwinism, because it did not rely on the mysterious biological processes of
variation, competition and adaptation that took generations to differentiate
species, could explain national differentiation over relatively short periods of
historic time. Even better, it could explain both a people's triumph in its
ecological niche and its spread outwards over time – a Darwinism for a
national and an imperial people.

The most popular vehicle of Social Darwinism in Britain was Benjamin
Kidd's *Social Evolution*, an overnight sensation in 1898 that translated the
expansionist Teutonism of Charles Wentworth Dilke's *Greater Britain* into
Darwinian language. The spread of the Anglo-Saxon people represented the
'survival of the fittest' in the temperate zones where they originated and also
in the more challenging northern zones where they proved their mettle. What
had begun as a biological process now continued as an ethical and intellectual
development: 'The winning races . . . have been those which have possessed
the best ethical systems' – that is, the Teutonic system of combining free play
for individual development with a religious or ethical commitment to the
interests of the group. Even if Pearson was right, and the Anglo-Saxons were
now physically unsuited to the tropical regions, Kidd argued, their ethical and
intellectual superiority would still tell.[61]

Other Social Darwinists were less optimistic, especially after the setbacks of
the Boer War of 1899–1902. There was no guarantee that the evolutionary
successes registered by the Teutonic peoples in earlier eras would be sustained
in the flux of modernity. Pearson argued that the Anglo-Saxons had reached
both their biological and their ethical or intellectual limits. Others saw the
possibility of non-biological adaptation by means of education, social reform
or other instruments for the re-formation of character: the current crisis
would be the test of whether the British remained 'the fittest'.[62]

One current, the eugenics movement, pressed the possibility of biological adaptation by conscious policy. Natural selection worked too slowly to do much to the character of nations, but knowledge of its processes could be used to accelerate the weeding out of negative ('dysgenic') characteristics and the concentration of positive ('eugenic') ones. Dysgenic lines could be cut off by sterilization, immigration control, birth control; eugenic lines could be fostered by giving the best and the brightest financial incentives to multiply. This policy had been championed in the previous generation by Francis Galton, Darwin's cousin, but had not then flourished: mid-Victorian liberalism was shocked by its dirigisme, and belief in the inheritance of acquired characteristics rendered it unnecessary. In a period of anxiety about the national character and doubts about the efficacy of environmental change, eugenics had at least a chance to put its case. Its highest profile exponent, Karl Pearson (no relation to Charles), hoped at the time of the Boer War the nation would at last awake to the truth that 'the psychical characters, which are, in the modern struggle of nations, the backbone of a state, are not manufactured by home and school and college; they are bred in the bone'. Then it might accept the case for selective breeding, or at least for discouraging the breeding of the unfit.[63]

The eugenists were unusual in asserting that the evolutions of the physical and the psychical characteristics were exactly the same processes; most Social Darwinists relied only on analogy. The competition between species was reproduced within the single human species by the competition between nations. The 'fittest' nation was the one that, among physically similar humans, had developed the best and strongest character. But these analogies kept breaking down. It was possible to define species with some precision: they were groups that could not interbreed. Nations lacked such clarity. Who was to say that Social-Darwinist competition necessarily pitted nation against nation rather than individual against individual or class against class? In the eugenic view, for example, while the health of the nation was the goal, the real competition took place between eugenic and dysgenic breeds within the nation, which looked suspiciously like different social classes. And then what defined 'fitness' in a nation? Its ability to thrive in its own space or its ability to spread? Its achievement of higher ethical states or economic growth or political stability or just corporate consciousness?

In the end, the Darwinian revolution had the same impact on the idea of the national character that symptoms of degeneration were held contemporaneously to be having upon the content of that character: both drove home the lesson that the nation was an artificial and potentially changeable beast. Mid-Victorians liberals had been pretty certain that the nation was a natural (if perhaps temporary) form of human organization, and that their national

character was naturally the best – the human archetype. Their children were sure of neither. Nations were made, it appeared, not born. The question of the epoch was: did the English have what it took to thrive, even to survive?

PATRIOTIC ALTERNATIVES

Anxieties about the degeneration of national character under the pressures of mass society were widespread across western Europe at this period. If anything, they were less prevalent in Britain than in France or Germany.[64] Certainly, the British state took fewer actions to check this degeneration: it enacted fewer (indeed, hardly any) eugenic laws, made no effort to halt or reverse the flow of population into towns, and before 1906 made comparatively little effort to improve social conditions in towns either. This may have betokened a policy paralysis, stemming from a constitutional aversion to state action, rather than a continuing confidence in the moral and physical health of the people: that is, it may have reflected a liberal view of the state but not of the people.[65] Such a liberal view of the state did preclude the kind of serious nation-building policies that are said over the same period to have helped turn 'peasants into Frenchmen'. Still, it remains possible that there was a real crisis of confidence in the state of the British people, even if little was done about it. It is, furthermore, particularly difficult to say in this period what were the dominant or mainstream views: the British press and publishing worlds were among the freest in the world, spewing out a bewildering range of orthodoxies, protests, platitudes and novelties; the growth of class consciousness split the political and cultural spectrum into increasingly incompatible and irreconcilable positions. In short, the very noise and bustle of modern life about which contemporaries complained, with rival factions jostling for attention in a crowded commercial marketplace of ideas, makes it hard to distinguish the ephemeral from the foundational or the serious from the trivial.

Most seriously, in singling out interpretations of national character, we are in danger of undervaluing the revival of other, older understandings of Britain's place in the world. In the preceding discussion of attacks on character, we found both liberals and conservatives deploring the deterioration of the character of the people. But a key difference between them was that, while liberals had increasingly vested their political hopes in that national character, conservatives had other resources to draw upon. Traditionally, British conservatives had held a civilizational view of the world in which they looked to the commandments of law and religion and to the 'laws' of political economy – often seen as working together – to maintain order and promote social progress. They did not share in the growing liberal faith that

order and improvement were vested in the character of the people, and looked dimly on the liberal promotion of democracy and religious pluralism, which threatened to undermine those institutions (Parliament, the church, the crown) that had been the traditional guarantors of order.

With the advent of democracy, effectively in 1867, they had nevertheless grasped the nettle and sought to make the best of a bad lot. Disraeli's genius, as an opposition leader and then in government after 1874, had been to revive older Burkean themes of deference and patriotism in such a way as to appeal to the democracy and cement its loyalty to national institutions. Taking a cue from moderates like Bagehot and Maine, the emphasis was not on the character of the people but rather on the ability of institutions to lead and hold them. Even shaping the character of the people by means of institutions was secondary to celebrating the institutions themselves.

Disraeli hammered away at this theme in celebrated speeches in the aftermath of the Second Reform Act that were thought to have paved the way to his victory in 1874. 'The programme of the Conservative party is to maintain the institutions of the country,' he pronounced at Manchester in March 1872; 'not from any sentiment of political superstition', he continued in the same vein a few months later at the Crystal Palace, 'but because we believe that they embody the principles upon which a community like England can alone safely rest. The principles of liberty, or order, of law, and of religion ought not to be entrusted to individual opinion or to the caprice and passion of multitudes, but should be embodied in a form of permanence and power.' The greatness of the people, he held, lay not – or at least not only – in their own greatness, individually or collectively, but in 'the greatness of the kingdom and the empire'. They felt it themselves: 'They are proud of being subjects of our Sovereign and members of such an Empire.'[66] Patriotism, in Disraeli's vision, was not a substitute for character, which was undoubtedly being developed by the progress of civilization; but it was a crucial supplement. From a Tory point of view, it was safer, because it guaranteed a continued role in a democracy for elite institutions. It went further, however, and offered a form of belonging greater than the individual and, in the global ambitions of the empire, greater than the national belonging offered by other European countries.[67]

This patriotic faith in institutions would prove a very serviceable alternative to liberal ideas of national character in the generation after Disraeli. It could provide a degree of greater national cohesion that seemed necessary in a world of international competition without intruding too deeply into the private inner world of the citizen in a way that violated Britain's libertarian norms, or relied too much on individual potential. It was, in fact, to a great degree agnostic about the character of the people – a neutrality that could be

convenient in periods of panic about degeneration.[68] The patriotic organizations of turn-of-the-century Britain – the Primrose League, the Navy League, the National Service League, and so on[69] – may have looked thin and pallid to French or German observers, but in British conditions they gained something by not insisting on homogeneity and regimentation, and no one could say they had 'failed' if they recruited only certain strata of the nation.

By rolling back the liberal nationalist interpretation of British history and reverting to Edmund Burke's simpler whig narrative of institutional continuity, patriotism could also tell a story to people about their history that would not be belied by events or fears for the future. The mere fact of continuity was reassuring: it did not rely on a liberal or socialist teleology in which nationalism yielded to internationalism or the people inherited the earth. 'It is the institutions of a country that chiefly maintain the sense of its organic unity, its essential connection with the past,' as W.E.H. Lecky, a sometime Liberal now turning Unionist if not Conservative, said to a popular audience in October 1892. 'By their continuous existence they bind together as by a living chain the past with the present, the living with the dead . . . This is one of the chief lessons you will learn from Burke – the greatest and truest of all our political leaders.'[70]

Even if Disraeli had not staked out this patriotic claim in the 1870s, the events of the 1880s would have pushed the Conservatives in that direction, for the revival of Irish nationalism in that decade and Gladstone's sudden decision in 1886 to commit the Liberal Party to Irish Home Rule underscored the hazards of national character and the virtues of civilization and patriotism for the integrity of the United Kingdom. Before the 1880s Gladstonian Liberals had squared their belief in national character with the subjection of the Irish to British political institutions by claiming either that the Irish and the English were successfully merging into a united nation, or that the Irish had not yet reached that stage of political maturity where they wanted or needed their own national institutions.[71] Neither of these positions seemed tenable to Gladstone any longer in 1886. The resurgence of Irish nationalism under Charles Stewart Parnell indicated both that the Irish felt separate from the English and that they would benefit from their own institutions. Gladstone's burgeoning sympathies for Balkan Christian nationalities that had emerged during the 'Bulgarian agitations' against Turkey in the late 1870s had convinced him that he could no longer deny the Irish the same recognition.[72]

Gladstone's conversion to Home Rule and his dogged pursuit of it for the remainder of his career was so divisive because it fingered precisely the tension within liberalism between the pure civilizational perspective, which warranted English 'trusteeship' for the Irish, and the radical view that nationality was a perfectly acceptable – even preferable – vehicle for fostering

civilized values. Because race had, even in the previous generation, played a back-seat role in thinking about nationality, the Home Rule–Unionist split among English Liberals was a disagreement not so much about race (there were racialists and, more commonly, non-racialists on both sides) as about the ability of nationality to express or promote a set of common values. It left on the Home Rule side a minority who followed Mill in seeing national self-government as one of the principal modes of practising liberty and, increasingly, national sentiment as one of the principal means of expressing equality and fraternity.[73]

Equally importantly, and in a way much less well understood, the split over Home Rule reinforced the Unionist position that nationality was not an ideal vehicle for the diffusion of civilization.[74] It did bring over to the Unionist side some Liberals who believed in nationality but who frankly preferred the English to the Irish national character, and these Liberals may have been expressing the private prejudices of a wider body of English opinion. The ageing Carlylean J.A. Froude was notorious for voicing these prejudices with unusual frankness, and others chimed in more mildly, championing the 'mental assimilation' of the Celt by the Saxon.[75] Sometimes this was put in racial terms: Goldwin Smith, who in 1861 had written that 'the peculiarities of race, however strong, are not indelible', now in 1887 tellingly shifted his emphasis: 'The character of races, though perhaps not indelible, is lasting.'[76] Often Irish inferiority was asserted in an explicitly non-racial way, but, as T.H. Huxley's biographer has put it, '[b]y removing "race", he undercut Nationalist demands for a homeland while leaving English prejudices intact'.[77]

However, the impact of the Home Rule crisis upon the public discourse was greatly to amplify the broadcasting of an older Unionist language – the language of a world civilization that was not well served by national sentiment. Of course, this language of civilization, too, played to popular feelings of superiority, but it did so by blending liberal rhetoric about Teutonic virtue with the old Tory values of religious virtue, deference to authority and faith in a patrician elite operating through historic institutions. Thus, famously, Lecky, who had made his reputation as a liberal historian documenting Irish grievances and English oppression – inspiring Irish nationalists and Gladstonian Home Rulers – now came out loudly in favour of the civilizing influence of the union. Some felt that the Irish had not yet reached the stage where they could be a nation.[78] But many others argued that the nation was an atavism that the Irish – and the rest of the peoples of the United Kingdom – needed to outgrow. 'Ireland has been a nation – a most unhappy one,' wrote Matthew Arnold to *The Times* in May 1886. But 'Wales too, and Scotland, have been nations. But politically they are now nations no longer, any one of them . . . This country could not have risen to its present greatness if they had

been.'[79] They had merged into a greater cause.[80] It was not an English or an Irish cause, a Teutonic or a Celtic one, but rather the cause of civilization – of education, economic improvement, liberty and order.[81] The most novel element of this argument was the characteristically Unionist point that neither England nor Ireland was sufficiently 'great' in modern conditions of international competition to wage this fight alone: the union was the best guarantee of survival, and the empire the best guarantee of expansion.[82]

This case was most consistently put by the Conservative politician with the greatest experience of Ireland, Arthur Balfour, who from 1886 through to the Home Rule crisis of 1910–14 fixed on the political institutions of the union themselves as the ultimate argument against Home Rule: 'The reason is not that the Englishman was superior to the Irishman; the reason is that the English polity was superior to the Irish polity', as his own Scottish ancestors had appreciated. 'Under the clan system or the tribal system it was perfectly impossible either economically or in any other way to rise to a higher grade of civilization.'[83] This harping on the virtues of civilizing institutions had, by 1914, begun to seem inadequate to the more populist kind of Tory who was then emerging. 'The only thing I regret', Leo Amery confided to his diary after endless Home Rule debates in Parliament in 1913, 'is that not a soul throughout these debates ever says anything to suggest that he feels that the United Kingdom really is a nation and that Irish nationalism in any shape or form means the end of United Kingdom nationalism.' Amery's frustration testifies to the difficulty up to that point of selling a full-blooded idea of national character to a Conservative Party that had hitherto preferred civilizational and patriotic alternatives to the more integrated, egalitarian understandings of nationality – even though Unionism, with its Liberal recruits, was striving to become a halfway house.[84]

Unionism after 1886 therefore blended Burkean themes of patriotism and the wider resources of civilization with liberal ideas of national character, and the way in which the former helped to shore up doubts about the latter can be seen in reactions to both the pessimism of Charles Pearson's *National Life and Character* (1893) and the optimism of Mandell Creighton's *The English National Character* (1896). Nearly every respectable organ of opinion that appraised Pearson's jeremiad felt he had underestimated the adaptability of civilization and, in particular, the continuing civilizing function of the church.[85] In most cases, articles that began with confidence about the resources of civilization were able to proceed to more specific commendations of the qualities of the national character than the more conservative among them might have otherwise allowed themselves: Seeley felt Pearson had overdone the 'decay of character'; the *Quarterly* defended the 'preservative' effect of Christianity; the *Edinburgh* saw no evidence of physical or intellectual deterioration; and nearly

everyone contested his view that the state had extinguished self-reliance.[86] Liberal Unionists were in the forefront of defences of the national character at this time, notably John St Loe Strachey, who took over the *Spectator* in 1895 and pursued its line that the national character was what it had always been. Such Liberal Unionists were probably further reassured by the 'good behaviour' of the electorate that returned a substantial Unionist majority in 1895 – a sign, as the prime minister Lord Salisbury said, that the democracy had determined not 'to upset the institutions they found here'.[87]

It was in this atmosphere that another Liberal Unionist, Bishop Creighton, published his Romanes Lecture on *The English National Character*. While indulging in additional Burkean touches, dwelling upon constitutional 'continuity' and 'historical associations', and in certain other respects making the Englishman more conservative than he had been a generation earlier,[88] Creighton mostly simply restated the liberal clichés of the mid-Victorian generation on 'the characteristics of the modern Englishman':

> An adventurous spirit, practical sagacity, a resolve to succeed, a willingness to seek his fortune in any way, courage to face dangers, cheerfulness under disaster, perseverance in the sphere which he has chosen . . . personally acceptable in the land where he goes, valued for his capacity and probity, treated with kindness and consideration, exciting no animosity, and intermarrying with the folk amongst whom he lives, yet all the while he remains every inch an Englishman, does not change his ideas or modify his opinions, cannot hold his tongue when he is challenged, but is ready to put everybody right.[89]

Unlike Pearson's tract, Creighton's attracted little press comment – either because it was uninteresting or, more probably, because it was uncontroversial. It was certainly quoted approvingly in later years as an authoritative statement.[90] One of the few contemporary reactions, a *Times* leader, praised Creighton for unearthing the time-honoured platitudes, but wondered whether their applicability was not reduced by the complexity and diversity of modern society. Above all, it fretted, might his line not engender complacency, 'if it were understood to encourage a fatalistic belief that what has been in England must always be'?[91] Perhaps Creighton's conservative twists on the liberal platitudes had overemphasized the continuities and 'historical associations' that, in times of perilous change, might be weaknesses rather than strengths?

That set of concerns – not that the English national character was deteriorating, but that it was not sufficiently strong or unified to thrive in modern conditions – came to a climax a few years later, around the time of the Boer War. In the run-up to that war, concern was already mounting that British

national cohesion was inadequate to the challenges of international compe-
tition, whether it relied on the Liberals' individual self-reliance or on the
Tories' deference and patriotism. In the fleetingly fashionable Social-
Darwinist interpretation, the 'successful' nations of the world were all more
homogeneous and more tightly integrated than Britain could ever be.
Awareness of the artificiality of nations sparked programmes for nation
building. The ideas of the French philosopher Ernest Renan, that nations
were constructed by a 'daily plebiscite' of remembering and forgetting, were
much on people's minds.[92] In the words of Spenser Wilkinson's popular book
of the day, *The Nation's Awakening* (1896), a democratic Britain could not prop-
erly appreciate or deliver upon its global mission without 'an incessant effort
of national self-education'.[93] *The Times*'s worry about Bishop Creighton's
complacency was that it might short-circuit that national effort. This line of
thinking was given further impetus by the advent and outcome of the Boer
War itself, in which the British performance, while ultimately successful, had
seemed pitifully inadequate against the tiny but tightly knit Boer republics.

By the time of the Boer War such concerns were not confined to the right
wing. *Fin-de-siècle* anxiety about national cohesion was one of the sources of
strength of the 'New Liberalism', more willing than the old to think of British
society as organic and national, and feeling greater urgency after the dispir-
iting displays of 'mafficking' and the terrible results of the 'Khaki' Election of
1900, so-called because it seemed to be determined solely by war cries. New
Liberals preferred models based on egalitarianism and democratic homo-
geneity – the Germans or the Boers, for example – rather than on mindless
obedience to flags and leaders, exemplified by the Japanese, or the Germans
in a different guise. But they saw nevertheless that they had something in
common with the new thinking on the Right. Cross-party discussion groups
sprang up – the Rainbow Circle, the Coefficients, the Round Table – to
explore the possibility of a political realignment in which imperialism and
social reform could be harnessed together to improve national cohesion.[94] A
decade later H.G. Wells both publicized and guyed such manoeuvrings in a
widely read novel, *The New Machiavelli* (1911), in which the 'Pentagram Circle',
loosely based on his own memories of the Coefficients between 1902 and 1908,
plotted to remake the British in the image of the 'better organised, more
vigorous, and now far more highly civilised peoples of Central Europe'.[95]

However, even at their peak in the early years of the twentieth century,
these impulses to build national cohesion by artificial means came to little. As
the historian of Edwardian patriotism J.H. Grainger has put it, the 'witch's
brew turned out to be quite mild after all'.[96] The most invasive programme,
that of the eugenists, made headway in the United States and Germany,
where racial purity was widely seen as both possible and desirable.[97] In

Britain, eugenics was foiled quite explicitly by individualism in its several aspects. There was an aversion to the degree of state intervention necessary to make a eugenics programme effective. There was a deeply rooted belief that a strong nation was best achieved by fostering diversity and individual choice, rather than by any artificial means (particularly artificial means in the hands of anonymous London professors). Even a moderate eugenist like William Bateson actually preferred, at least in public, 'that we should be of many sorts, saints, nondescripts, and sinners', as befits 'a polymorphic and mongrel population . . . made of fragments of divers races, all in their degree contributing their special aptitudes, their special deficiencies, their particular virtues and vices, and their multifarious notions of right and wrong'.[98] And the movement's very leader, Karl Pearson, admitted that 'our present economic and social conditions are hardly yet ripe . . . the all-important question of parentage is still felt to be solely a matter of family, and not of national importance'.[99]

Above all, there remained the powerful belief that the individual character that the English system had produced was the best, in fact the human ideal. It was for this reason that, while no measures were taken to foster the 'eugenic' or ideal types, there was one piece of legislation to discourage the 'dysgenic': the Mental Deficiency Act of 1913 – 'the only legislative success of the British eugenists throughout their history'.[100] A related impulse produced the Aliens Act of 1905 – the first restriction on immigration into the United Kingdom, aimed at pauperized Jews who, it was feared, would sap the strength of the nation.[101]

If it was not possible in present conditions to meddle directly with the content of the English national character, it might still be permissible to improve national cohesion indirectly by intensifying national consciousness through education and propaganda. This position was compatible both with a traditional Conservative outlook, seeking to drum up loyalty to institutions, and with a more aggressively Unionist outlook, seeking to associate the English character with the state. One obstacle was the difficulty of deciding which institutions and which state should be the objects of identification. The Unionist argument that a 'great' nation and indeed a world empire was the best hope for civilization suggested that imperial institutions ought to be emphasized. This position was taken up by a group of young men, mostly Liberal Unionists, followers of Alfred Milner, who formed the 'Round Table' group in 1902. As many Liberals pointed out, however, while it might be possible to stir up patriotic feelings for the empire, it was more difficult to engender a deeper, more profound sense of kinship in peoples, however similar, that were so far-flung.[102] Unionists were inclined to agree. They were unsure about how far equal citizenship could be taken in the empire, even

among white populations. And if the goal was a more intense sense of nationality, then the ideals of civilization represented by the institutions of the empire were surely too diffuse for the purpose.

The old liberal ambivalence between nation and civilization showed; the imperial federalism espoused by the Round Table looked more like internationalism than nationalism. 'It would be difficult to point to qualities inherent in the English which distinguished them above their neighbours on the Continent,' granted Lionel Curtis, one of the chief Round Table ideologues. To his colleague Alfred Zimmern, what distinguished 'the British ideal of civilisation' was 'the enforcement of the rule of law and the spreading of free political institutions', unlike the narrower and more organic *Kultur* of the Germans.[103] This was not, Unionists sensed, a very promising foundation for a strong and united nation.[104]

More, perhaps, could be achieved on a United Kingdom basis. Here it was easier to identify not only institutions but also a common history, culture and national character that might be cultivated and disseminated. Even Rudyard Kipling, the poet of empire, found himself drawn to the home country in his writing after about 1900, feeling for themes in which nationhood could properly be extolled.[105] The Conservative government took back control of education from the local school boards in 1902 and sought to impose a stronger national curriculum in which history, citizenship and patriotism did play a greater role. This marked a change. Education had long been neglected at the national level, and what education most children got was dominated by religion and the '3 Rs'. History had not been compulsory in schools before 1900 and for a time it was now more central. History books of all kinds formed a larger proportion of English titles published than ever before or since.[106]

However, the nationalizing campaign in the schools faced formidable obstacles. The long period of neglect could not easily be overcome. Many teachers still felt that their principal task was to teach 'character' and 'individual initiative', and that a sense of nationality would follow naturally. Flags and maps – the stuff of the 'banal nationalism'[107] that is the starting point for most modern citizens' sense of nationality – were sorely lacking until the First World War. Bibles were more common and early twentieth-century schoolchildren often considered that 'their country' was the holy land. Compulsory history amounted to a dozen lessons a year. Before the First World War, critics often complained, history, citizenship and patriotism remained the stepchildren of the curriculum.[108]

As Stephen Heathorn has recently shown, the basic school readers by which literacy was taught in this period did take as part of their mission the inculcation of ideas about citizenship, history and national character. If anything, the thrust of these readers was moving in a direction opposite to

that of the general drift of ideas, reverting to earlier Victorian ideas of Teutonic origins, ethnic homogeneity and the naturalness of nations, with a few more modern touches extolling loyalty to crown and empire.[109] In part, this may have been due to the fact that many of the schoolbooks' authors were from modest backgrounds and educated at teacher training colleges, far from the cutting edge.[110] Mostly, however, such old-fashioned bromides must have seemed perfectly suited for the indoctrination of the lower orders: of a childlike simplicity, colourful, easy to digest, salutary doses of character for the characterless. Some of the schoolbook authors were leading Liberal Unionists, fully aware of the flaws in the old Liberal orthodoxy but also full of anxieties about degeneration, class division and national fragmentation, and eager to grasp at any opportunity to lend state authority to simplistic ideas of national and imperial solidarity.[111] These were, however, but the clumsiest of tools. It is unclear how much impact they had among their intended audience, and in cultivated circles they may well have engendered some embarrassment.[112]

In the aftermath of the Boer War, in fact, there was a good deal of revulsion from the cruder attempts at the artificial construction of national character. On the international level, the backlash against the jingoism of the Boer War, which led to the landslide victory for the Liberal government in 1906, was seen to vindicate the internationalist turn taken by many Liberals. Social Darwinism had put national cohesion above all other ethical considerations and led Britain down a blind alley.[113] As international tension heightened again in the run-up to the First World War, a conscious effort was made to distinguish between Britain's national spirit of internationalism and German exclusivism. British 'patriotism' was said to be more tolerant than German 'nationalism'.[114] Internally, too, there was a reaction against state attempts to manipulate character. An Inter-Departmental Committee on Physical Deterioration, which reported in 1904, rejected the eugenic diagnosis altogether and laid the emphasis back upon environmental factors.[115] 'The wave of emotion which for a time roused the nation to self-consciousness has passed', regretted Karl Pearson, 'scouring out very little of our stagnant backwaters in the process. It is possibly with a nation as with an individual – both feel only intensely and are only capable of vigorous self-reform in moments of unwonted stress, or of novel spiritual experience.'[116]

With the return of a Liberal government in 1905, government policy focused on optimizing the social and economic conditions into which the young were born, thus pleasing both social reformers of the Left and traditional Liberals with their concern for individual (or family) responsibility for the development of character. A few of the New Liberals, notably J.A. Hobson, talked about the government's responsibility to build 'social

character', but for most the older concerns for diversity and individual self-expression and development won out.[117] Character building was left to free-lance efforts such as the churches, the Salvation Army, or the so-called 'Character Factory' – the Boy Scouts, founded by Robert Baden-Powell, the hero of Mafeking.[118] What remained of the turn-of-the-century anxieties about national cohesion, at least within the Liberal Party, was a more modest concern for the qualities that made a good citizen; what Roberto Romani has called 'civism' – qualities not necessarily thought of as peculiarly English at all.[119]

Conservatives were uncertain how to respond, unsure how far they were ready to jump onto the bandwagon of national character, either to believe in it or to take seriously the job of rebuilding it. The party leadership's instinct was to return to the *status quo ante* – the more institutional and deferential, less organic and integral form of Unionism that had been enunciated by Balfour in the 1890s. Now the party leader, Balfour issued a kind of philosophical manifesto in the form of an influential lecture published in 1908, *Decadence*. Despite its title, which has misled some historians, *Decadence* was not a jeremiad but rather a call for steadiness and confidence in civilization and its leaders. Balfour waved aside the parallels with the fate of the Roman Empire that had been rife a few years earlier. Science, technology and economic development meant that modern civilization had internal resources that gave it more endurance than the ancients had, as the last millennium of progress had already demonstrated.

Nor did he believe that progress depended on the character or physique of the people, as Social Darwinists would have it, so much as in their leaders: 'Democracy is an excellent thing; but, though quite consistent with progress, it is not progressive per se . . . Movement may be controlled or checked by the many; it is initiated and made effective by the few.' So long as 'the exceptional stir and fervour of national life' created conditions favourable to the emergence of 'a due succession of men above the average', an environment where 'great things . . . are being done and thought', then social progress was assured. Leadership in science as in religion and politics would diffuse itself throughout the entire community, as scientific knowledge exerted 'an influence which resembles religion or patriotism in its appeals to the higher side of ordinary characters'.[120]

However, Balfour's was too elitist and too complacent a view for some. The *Spectator* doubted his reliance on modern science, insisting that 'character . . . is the mainspring of national life'.[121] The *Spectator*'s Liberal Unionist perspective reflected the migration of older liberal ideas of national character into the mainstream of Conservatism as it came to terms with democracy. As we have seen, a more organicist right wing had emerged, including imperialists

from the Round Table group like Leo Amery, agitating for a 'United Kingdom nationalism'. These elements were roused by the crises of 1910–14, when Liberal threats to the House of Lords and the union with Ireland were met by defences of those institutions but also by a more militant 'Constructive Conservatism', which called upon 'the gentlemen of England' to summon up 'the spirit of a great people' and 'engrain it in our national character'.[122] 'Constructive Conservatism' marked a re-engagement by Conservatives with questions of national character that had been evident among their Liberal Unionist friends at the time of the Boer War. Across the bridge it threw up between patriotism and nationalism would walk the bulk of the Tory Party during and after the First World War, putting it in a position to take over the rhetoric of national character from a Liberal Party that was in the process of breaking up, and that was in any case increasingly enamoured of the language of internationalism.[123]

BRITISHNESS AND ENGLISHNESS

How were ideas about the content of the national character affected by this conservative tendency in turn-of-the-century Britain? The Unionist idea of the national character was necessarily coloured by the effects of the Home Rule crisis and of rampant imperialism, by the greater emphasis laid upon the state and the binding institutions of the nation, and by the new understanding of the artificiality of nations. At the same time, as Mandell Creighton's tract demonstrated, it was possible to reproduce virtually intact the older clichés about the English national character even at a time of heightened self-doubt. Towards the end of this period, some of these older clichés enjoyed a revival in new circumstances, reflecting doubts about the more bombastic side of the Britishness purveyed by Unionism at its peak.

What was in question now was more clearly the character of the British people, more than at any time in the nineteenth century and more than would again be the case until the 1950s. A measured response to Irish nationalism required downplaying the ethnic distinctions within the British Isles and asserting a common mixed ethnicity.[124] It was still habitual to characterize this common mixed ethnicity as 'English' or 'Anglo-Saxon', but now neologisms were being devised to avoid such an exclusive label: for example, 'the British race' or even 'the Celto-Teutonic people' – a hybrid facilitated by the anthropologists' new typology, which lumped many Celts with the Teutons as 'Nordics'. Lord Rosebery, the Scottish Liberal leader, was predictably fond of such neologisms and was occasionally chided for indulging in them. It was, for example, technically incorrect to call Oliver Cromwell a 'great Briton'.[125] Yet such references served a purpose, straining to transcend the old language of

Celt and Saxon and to assimilate English into British history. The Liberal Unionist Joseph Chamberlain, an Englishman speaking as rector of Glasgow University, called in 1897 for Scottish and Irish nationalist leaders like William Wallace or Robert Bruce to be recognized as British heroes too.[126]

Imperial federalists went further, seeking to assimilate the English, the British and their 'kith and kin' in the British diaspora. 'British', for their purposes, was too narrow (except within the formula 'British Empire' or 'Greater Britain'). Sometimes they fell back on 'Anglo-Saxon', but this was often a more diffuse and less Teutonized Anglo-Saxon than its mid-Victorian counterpart. It was used, for example, to indicate kinship between Americans and the British at a time when consciousness was high of the Irish element in both.[127] Particularly around the turn of the century, when imperial federalism was coming to the boil but Anglo-American relations were also touchy, the unity of the 'Anglo-Saxon race' was much pressed on racial grounds or on political grounds or both. Thus Rosebery appealed, at a crisis point in 1897 when Britain and the United States were squabbling over the boundaries of Venezuela, to 'the two mighty nations of the Anglo-Saxon race' to bury their differences 'in the best interests of Christianity and civilization'.[128] Kipling addressed his famous poem on 'The White Man's Burden' to Teddy Roosevelt and the Americans, embarking on their own first imperial war in the Philippines in 1898.[129] The specifically racial import of 'Anglo-Saxon' was more important to the Americans, who could use it to differentiate white from black in their own country as well as to reach out to the British, which explains why the Social Darwinist use of Teutonic language to explain Anglo-Saxon predominance (for example, in the work of Kidd and Pearson) remained influential among them.[130]

The language of 'Britishness', even when referring to a British race, inevitably mixed the character of the people with the nature of their institutions in a way that satisfied Unionists but irritated Liberal diehards like Freeman. 'There is an English folk, and there is a British Crown', he insisted in 1890. 'The English folk have homes; the British Crown has dominions. But the homes of the English folk and the dominions of the British Crown do not always mean the same thing . . . These are but plain facts . . . so plain that mankind, above all orators and statesmen, will not understand them.'[131] Orators and statesmen, at least Unionist ones, were blurring the two deliberately. They wanted to evoke a sense of 'Britishness' that was not solely dependent upon the national character.[132]

This motive was at work in the evocation of 'British heroes' like Cromwell and William Wallace. The heroism of exceptional military and political leaders, especially but not exclusively those from elite backgrounds, could be used to exemplify the virtues of the national character and to intensify tradi-

tional patriotic deference simultaneously. This device had been a common resort in periods of war before, and in the work of Carlyle and his epigones.[133] Now it became an everyday phenomenon, drawing on imperial, exploratory and even missionary exploits, from General Gordon in the Sudan and David Livingstone in the Congo to Captain Scott at the South Pole and, later, T.E. Lawrence in the Arabian desert.[134] In elite culture, heroism on behalf of the nation was sedulously cultivated, especially through the promotion of 'chivalric' values of gentility, selflessness, sacrifice and devotion to country in public schools and universities.[135] If these values did not percolate deeply into popular culture, at least in this period it became unusual to attack hero-worship – common enough in the previous generation – although it was still a complaint among advocates of hero-worship that English individualism and self-reliance remained an obstacle to the national cohesion enjoyed by the French or the Germans.[136]

Patriotism and hero-worship undoubtedly inflected the traditional radical understandings of the national character. For obvious reasons the 'self-reliance' of the English figured more rarely, except as a defect inhibiting national cohesion, or in those rarer cases where a Teutonist version was still being peddled.[137] Rather than sturdy individualism, the real English contri-bution was to show 'how liberty might be adapted to the conditions of a nation-state', as Seeley put it.[138] Debate about the fate of 'self-reliance' in a mass urban society revolved around the question of 'sentimentalism'. Opinion was divided as to whether the English character manifested it and, if it did, whether it was a good or a bad thing. But the sturdy independence so much a feature of mid-Victorian radical discourse had assuredly taken a drubbing. Bizarrely, even Mandell Creighton found on one occasion that whereas '[t]he Frenchman conceives himself as an individual, the Englishman conceives himself as part of a community'.[139] In the same way, perseverance and the dull, plodding capacity for hard work also yielded, except in Teutonist accounts, to a more martial virtue, grit or courage; a new adjective, 'resolute', pops up.[140]

While in their relations with each other the English had thus become less independent, more clannish and deferential, in their relations with the wider world their capacity for leadership was enhanced. In the imperial sphere they still had that 'love of action, the insatiable desire for strenuous energetic labour' that made for expansion, as well as a peculiar genius for colonizing foreign lands and governing backward peoples. 'Colonizing' was an old theme, now beefed up by the likes of Seeley, who made it less racial but more central to the modern English character. 'Governing' was a relatively new and controversial characteristic.[141] As Mark Girouard has pointed out, even J.A. Froude, always keen to stress the martial elements of the English national

character, did not specify 'governing' as a national talent until as late as 1888, when he accepted for the English the 'duty' of ruling weaker nations to teach them freedom, in the discharge of which 'the highest features in the English character have displayed themselves'.[142]

This uneasy combination of domestic submissiveness and imperial leadership could be justified by reference to the very different environmental conditions prevailing in metropolis and periphery, as appeared in the debate over Pearson's *National Life and Character*. But it also caught nicely the halfway house represented by Unionism, desiring deference at home and self-reliance abroad, a mixture previously impossible for Conservatives, to whom hierarchy was everything. Even now it was an uncomfortable position for true patriots. In 'The White Man's Burden', Kipling had squared the circle in the line, 'Send forth the best ye breed': the English stock was still fertile, but England was not its theatre of first choice. Almost immediately Kipling began to have second thoughts about this, and turned his concerns back to England itself. The New Liberal Graham Wallas thought that this idea of a national character purpose-built for imperialism had held sway between the publication of Seeley's *Expansion of England* in 1883 and the conclusion of the Boer War in 1902, but that at the time of writing, 1908, it was confined to the stubborn imperial idealists around Alfred Milner.[143]

Unionism and imperialism had therefore not only bent conventional ideas of the English national character into aggressive bulldog shapes; the new versions of old stereotypes also embodied, as they sought to combat, the anxieties of the age about international competition and mass society. Was, for example, the spirit of enterprise exemplified by imperialism the same as, or as wholesome as, the spirit of enterprise shown by the Victorians when England was the 'workshop of the world'? Sometimes the imperial economy seemed like nothing but the shuffling of paper and the practice of smart salesmanship – a sad decline from the days when England made things out of sweat, steam and iron.

This contrast was evoked by mixed feelings about 'the nation of shopkeepers' – a phrase coined by Adam Smith in *The Wealth of Nations* (1776) but widely identified as a sneer hurled by Napoleon against the English, denigrating their narrow individualism and materialism in comparison to the higher French ideals of national honour and glory.[144] The Victorians had gladly embraced the sobriquet. Shopkeeping to them summed up the national virtues: a genius for making useful things and the ability to buy them. 'Mazzini sneers at the selfishness of shopkeepers – I am for the shopkeepers against him,' wrote Bagehot proudly in 1852. 'The selling of figs, the cobbling of shoes, the manufacturing of nails – these are the essence of life.'[145] At the end of the century, there was doubt about whether England deserved the

epithet, or indeed whether shopkeeping was such a good model if it meant trading things rather than making them.[146]

This tension was raised acutely by the Boer War. Not only 'Pro-Boer' Liberal intellectuals back home identified with the doughty Boer farmers, so reminiscent of the persevering Teutonic working man of the mid-nineteenth century. The imperialist generals on the front line also admired their adversaries – 'a virile race' – and wondered how the British had ended up fighting against them, and in defence of the gold mines of the Jewish financiers alleged to be the pretext for war. 'I cannot tell you how strongly I feel', wrote General Ian Hamilton to Winston Churchill at the end of the war, 'that if we incorporate these Boers into the Empire, we should be doing a vast deal more for the future of our race and language, than by assimilating a million Johannesburg Jews.'[147] Milner, on the other hand, felt that the Johannesburger Jews were better imperial citizens than the Boers could ever be – 'a pack of sheep', 'mere animals to be driven'.[148]

So here were two models for the great Briton: self-reliant freemen out on their farms like ancient Teutons, or modern, efficient, flexible traders capable of keeping ahead of rapidly changing world markets.[149] Part of the appeal of Joseph Chamberlain's campaign for imperial tariffs was its ability to reconcile these two models: yoking together the freemen of Australia, South Africa, Canada, Ireland and England would make them competitive in the global economy.[150]

The same uncertain re-evaluation was applied to what had formerly been seen as English aloofness or reserve. This trait had been linked to self-reliance and self-sufficiency and approved as a source of dynamism, softened by domestic affections and hospitality in the home, though it was understood that foreigners did not like it, seeing it as haughtiness, arrogance, an overweening sense of superiority. In the new competitive world, where English superiority could no longer be automatically assumed, the same trait could now appear as a dangerous complacency, shunting the Englishman off to a lonely backwater where he would enjoy his splendid isolation but might miss the refreshing mainstream of change. This was the danger courted by playing on Burkean themes of continuity. 'We do not find it necessary to adopt the most modern methods,' granted Mandell Creighton in *The English National Character*, 'to follow the newest fashion of advertising, or to explain our procedure to everybody'. But still he called this same trait 'the hardness which goes with a long period of steady success', evoking foreigners' envious irritation.[151] Others dispensed with the positive gloss. In falling back on an unthinking materialism and patriotism, thought the liberal Bernard Bosanquet, the English had been 'too comfortable, too self-satisfied'.[152] 'I believe there are more Englishmen who shrink from that which is new,' wrote a Liberal MP in

1912, sketching the typical Englishman, 'who suspect novelty in any form, and who hold firmly that all those who differ from them in any respect are scoundrels.'[153]

A further step beyond the complacent Englishman was the amateur Englishman. As a result of Boer War bungling, in the autumn of 1900 the 'nation of shopkeepers' was being described as a 'nation of amateurs'. This was also the point at which the English way of business began to be described as 'muddling through' – a more critical characterization (it first arose after British reverses in South Africa in late 1899 during 'Black Week')[154] than it would become after a better performance in 1914–18.[155] Whereas bungling by leaders in the Crimean War had led to defences of the character of the average soldier, now bungling by leaders was projected upon the nation – an indication both of greater pessimism and, importantly, of the blurring now possible between leaders and people.

To take the social elite as the whole of the people had been common in the eighteenth century – it lay behind the character of John Bull, originally a squire – but difficult in the nineteenth century. Now it began to return, haltingly. G.C. Brodrick, the Liberal Unionist who had raised the charge of amateurism, granted that it had historically been a feature of leisure-class not working-class life in England. Nevertheless, he thought that this spirit had, with the advent of general prosperity, percolated down to all classes, and he made the claim – which would have astounded Buckle or Smiles – that 'the spirit of independence and self-reliance' of the English had derived from 'all this amateur energy' of the upper classes. Conversely, 'if amateur tendencies could be checked in our landed and commercial aristocracy, it would have a beneficial effect on the whole population'.[156] Rosebery deflected this analysis in the following month, in his rectorial address at Glasgow. A strategy to combat amateurism had to be aimed at the whole of the people, for in 'the Anglo-Saxon nations . . . [t]he people wield their own destinies; they walk their own paths'.[157]

Yet this tendency to characterize the whole people through their social elite would not go away. It had always been more common among foreign visitors, who tarried comfortably for a time in high society and then went home to translate 'England' for their compatriots.[158] Now, as figures from the social elite set themselves up more readily and intimately as role models for the nation, the practice extended to domestic commentators. Sidney Whitman's *Conventional Cant*, a popular excoriation of cant of 1887 in which upper-class mores were both the problem and the solution, was a pioneer of the type. It became increasingly common later, particularly as the social and political Establishment came to grips with democracy after 1918.[159]

Anxieties about Britishness also expressed themselves, with growing force-fulness between the Boer War and the First World War, in a reassertion of Englishness. As Kipling's example suggests, this reaction was hardly confined to the anti-imperial (or 'Pro-Boer') left. Historians have amply – perhaps over-amply – documented a right-wing nostalgia for a 'Merrie England' of lords and peasants, cakes and ale, folk song and pageantry.[160] This loving cultivation of 'Englishness' was in every respect a riposte to blustery, imperial 'Britishness'. It, too, focused on patriotism, loyalty to institutions and deference to superiors, but by editing out the imperial dimension it resolved the tension between domestic submissiveness and imperial dynamism. More diffusely, and less explicitly conservative, there was, as Stefan Collini has argued, 'a greatly increased preoccupation with the ways in which the national character had expressed itself in what was coming to be seen as a uniquely rich cultural and intellectual tradition' – again as a means of avoiding some of the unpleasant choices and harsh realities faced in the political realm. 'Englishness' in this way was seen to be vested as much in an elite literary tradition as in the historic rural social structure – a tradition that was shored up in this period through a variety of projects: the *Oxford English Dictionary*, proposals for a National Theatre, English literature courses in schools and universities, and publishers' series of 'English classics' such as the 'Everyman' series, which began in 1906.[161] Whatever doubts there may be about how widely this understanding of Englishness was diffused,[162] there can be no doubt that it was an alternative to, or at least a complement of, the idea of Britishness.

Conservative Englishness naturally fixed on elite-dominated institutions and cultural forms. Radical versions also proliferated, especially after the Boer War, aimed at defending the character of the English people from the degen-erate effects of militarism and imperialism, which threatened to recast them as deferential and jingoistic. The anti-imperial variety of Liberal admired the Boers not because they were good material for imperial citizenship but because, as an 'emerging' nation like the Irish, they were doing what liberals since Mill had thought nations were best at: advancing the cause of civiliza-tion by building civic virtues. The nation was a staging post on the road to world civilization or, as J.H. Grainger has so perceptively put it, 'big achieved nationalisms were bad, little emerging nationalisms were good'.[163]

The problem was that England – or, rather, Britain – was now more the former than the latter. One plausible response to this dilemma was a franker internationalism, common on the socialist Left but also a growing taste among radical Liberals.[164] Another response was to call for the revival of the primitive virtues of what came to be called 'Little England'.[165] This could take the form of defending older characterizations of the English as sturdy, self-reliant, self-governing, enterprising and so on against the new.[166] Or it could

take the form adopted by Belloc and Chesterton of resurrecting an England long gone, sometimes seriously, sometimes as a kind of fashion statement, ridiculed as 'the cult of the peasant' by one Liberal paper in 1913.[167] Or it could take an even more Utopian form. As early as the 1860s William Morris was already associated with an idea of Englishness, including the Englishman, developed as a protest against the grosser elements in the mid-Victorian stereotype. Drawing on themes sketched out by Samuel Taylor Coleridge and John Ruskin, and indeed by Mill in his more Coleridgean moments, Morris and his coterie idealized 'the poetry of that very insular characteristic "littleness of English nature"'.[168] In place of the harder, more materialistic, venturing and seafaring Teuton, they imagined a softer, more domestic, homely, almost feminized, insularized Teuton – which, as always, they counterposed to the Frenchman, in this version gross and vulgar with delusions of grandeur. '[E]verything English, except stockjobbing London or cotton Manchester, is essentially small, and of a homely farmhouse kind of poetry,' wrote Warington Taylor, the future manager of Morris & Co., in a private letter in 1862. 'Above all things nationality is the greatest social trait, English Gothic is small as our landscape is small, it is sweet picturesque homely, farmyardish, Japanese, social, domestic – French is aspiring, grand straining after the extraordinary all very well in France but is wrong here.'[169]

If the Morris clique reacted thus in the 1860s, how much stronger was their feeling by 1900, when the British had become firmly modelled in that supposedly French image, 'aspiring, grand, straining after the extraordinary'. By then Morris's essentially aesthetic protest had swelled into a political movement – a significant strain of alienated 'oppositional Englishness' within the broader Left. That very alienation put limits on its growth, however. Whereas the English national character of earlier radicals had praised the people to warrant democracy, the Utopian Englishness of Ruskin and Morris was a vision of a people that might be, and at least implicitly a reproach to people as they were. And because it reached right down to the very soul of the people, it was a critique with illiberal, potentially revolutionary implications – only a complete overthrow of existing institutions, conditions and modes of thought would do, as Morris came to realize. This had a chiliastic appeal to the most alienated culturally, and possibly to the most deprived socially; but to the extent that it went beyond the superficial trendiness of the 'cult of the peasant', it became harder and harder for most present-day English people to swallow. The fact that it used an idiom of Englishness to indict the English was significant, but not necessarily persuasive.

A moderate alternative was promoted by some New Liberals who found themselves in government from 1905. They had been caught up in the fashion for 'nationalizing' uses of government around the turn of the century, and

now found opportunities to cultivate the 'social character' of the people that they felt had been damaged by the jingoistic and imperial propaganda of the Unionists. Much of this activity involved both social reforms that aimed to stabilize working-class households, partly in order to enable the exercise of full citizenship, and more direct supports for citizenship such as political education and (for some) the advocacy of women's suffrage. Such activity was not necessarily couched in national terms: the anti-nationalist or positively internationalist sympathies of many Liberals often caused them to draw a distinction between citizenship and nationality, putting less emphasis on nationality than did even the older contrast between patriotism and nationalism. Some policies were, however, devised to cultivate national loyalties to bridge and displace sectional (including class and gender) loyalties, using self-consciously English instruments – folk song, English history – to shore up a popular sense of English nationhood.

This latter strain of policy was identified especially with the New Liberal Charles Masterman, who as education minister sought to fill what he saw as a void of 'inarticulateness and apathy' in the working-class character with good solid English materials. Masterman's position was a tricky one: it was driven by a catastrophic interpretation of English history that saw the English character as having been almost wiped clear by urbanization and the Industrial Revolution, yet as a democratic politician he was unable to attack too openly the present character of the people; and while tempted by the tools available to the minister with a growing state apparatus, he was, as a Liberal politician, hindered by persistent individualism, which trusted best the character that was self-made, and by universalism or internationalism, which mistrusted the narrowly national character.[170]

On the eve of the First World War, attitudes to the English national character remained deeply muddled. Unionists and imperialists were still mostly clinging to a 'Greater Britain' to which the character of the people was subordinate. As Amery complained, even in their most fervent defences of the union in the last Home Rule crisis they were unable to enunciate a 'United Kingdom nationalism'. Anti-imperialists, mostly Liberals, were more concerned for the character of the people, but were torn between their anxieties about the tendencies of the modern world and their libertarian principles. The much-vaunted party realignment, bringing together imperialism and social reform in a party of 'national efficiency', had collapsed.

The First World War would effect a realignment of a different sort. In many respects it restored the mid-Victorian consensus: confidence in the character of the people was rebuilt by the experience of war and even more by the experience of peace, as Britain's sense of distinctiveness vis-à-vis the rest of Europe returned. Politically, this process was overseen not by the

Liberals, who receded into the background, but by the Tories, now posing more credibly as a 'national' party, personified by their leader Stanley Baldwin – Kipling's cousin and the son of a Liberal Unionist MP. Baldwin's vigorous advocacy of the once liberal idea of national character rendered it even more conservative than 'Britishness' had done in the Edwardian period, and brought it back into the cultural mainstream. Caught between Liberal disillusionment and Tory inegalitarianism before 1914, the idea of national character would make a triumphant comeback between the wars.

Little England

The years between the world wars were the heyday of the idea of the English national character, embraced now as enthusiastically by Conservatives as by Liberals. Many of the doubts about the character of the people raised in the preceding decades were swept away – swept away by the scarifying experience of war, by a much greater sense of unity and stability among the survivors, and by a returning sense of separateness from the rest of Europe. At the same time, these experiences of war and post-war democracy swept away many of the older understandings of what the character of the people was, triggering the greatest change in national stereotypes since the days of Edmund Burke. Then a rough and uncivil mob had begun its transformation into the model for all humanity – solemn, upright, self-reliant, venturesome. Now that John Bull was cut down to size. He pulled in his horns, became gentle and domesticated, kindly and humorous. He was England's man, not the world's – certainly not Ireland's, possibly not the empire's, sadly not even Europe's. This would raise new questions and fears about England's fate in a darkening world – questions and fears that would be answered not necessarily with plans to reform the national character but perhaps with a new determination to do without it on the part of a large number of men and women for whom the idea of the 'Englishman' no longer satisfied their self-images either as citizens or as human beings.

THE IMPACT OF WAR AND DEMOCRACY

When war broke out in August 1914, the focus of national consciousness had for some time been drifting away from the more ambitious or grandiose forms of Britishness. One might have expected this drift to have been halted suddenly and reversed by the mobilization for war. The war was, after all, fought by and in the name of the United Kingdom, under the Union Jack, in loyalty to the institutions of the union – the monarchy, Parliament, the armed

forces – and in intimate alliance with its empire. The ideals summoned up by wartime propaganda were those now familiar ideals of 'civilization' with which not specifically England but more generally Britain, the British Empire and ideally the whole of humanity were associated. We might have expected the war to have rescued the civilizational perspective from the doubts that had beset it in the pre-war period of international competition and class tension. And in some ways it did. But the values of civilization, insofar as they survived the carnage of the Great War, travelled under different names and were transmuted into different forms – so much so that many people claimed to find them unrecognizable. The most glaring of these transmutations was the decline of Britishness and the reciprocal rise of Englishness; what followed in its wake was the invention of a different kind of Englishman.

'Civilization' itself suffered badly from the harsher experiences of the war. It was one of those 'Big Words' that returning servicemen found hard to utter after 1918 without irony or bitterness. While the war was supposed to have been fought to prevent one people (the Germans) trying to impose a universal *Kultur* on others, its conduct and outcome cast a pall on the claims of other apparently more innocent universals. The extent and savagery of the war was widely blamed on pre-war doctrines of Social Darwinism that had seen conflict between national ideals as a natural and inevitable social process.[1] English opinion continued to defend its own ideals of 'civilization', but it was now considerably less enthusiastic or optimistic about extending them to others. For many English observers between the wars, even the internationalism of the League of Nations was a recipe more for the peaceful coexistence of ideals than for the propagation of a universal one.[2]

It was the idea of national conflict that got knocked on the head, therefore, not the idea of nation. The experience of war profoundly deepened the consciousness of national difference, particularly of the differences between peoples. Partly this was a matter of the unusually high levels of cross-cultural contact that all classes experienced in the course of the fighting, and then again in a peculiarly intense way at the peace negotiations in Versailles. Britain, of course, had not fought a war with its neighbours for a century, and even then had not considered it a war of 'the peoples', in contrast to the Germans (their Völkerschlachtdenkmal – monument to the 'war of the peoples' against Napoleon – had only just been completed in 1913). The Great War, involving unprecedented mobilization and allegedly the informed consent of democratic electorates, was truly Britain's first 'war of the peoples'.[3] Interest in the 'national characteristics' of allies and enemies alike was unusually high in 1915 and 1916 especially, before familiarity and war-weariness set in.[4] While there were few intimate contacts between enemy peoples, in an age before mass tourism even the opportunities for intercourse

with supposed 'kin' – Canadians, Australians, South Africans – triggered ruminations on the 'differentness' of peoples, undermining casual suppositions about racial bonds.[5] After the war, at Versailles, the dominant language of the peace negotiations was precisely the vocabulary of human diversity. National difference was just as fundamental as it had been before the war, perhaps more so, but now it was to be protected and celebrated as a source of human strength and (largely metaphysical) unity rather than feared and at the same time coveted as the motor of international competition.[6]

These international contacts need not, of course, have led to a heightened appreciation of difference. They might, as idealists for either the empire or the League hoped, have helped to develop a transnational consciousness, and people did continue to think of both empire and League in civilizational terms at the same time as they reverted to a more differentiated view of their own nationality. The language of Versailles had as much to do with the immediate political needs of the great powers as with an inexorable tide of national consciousness sweeping across Europe. There were, however, more local factors that militated against international, imperial or even British forms of identification and that reinforced a highly introspective and narrowing understanding of English character.

During the war itself, there was already a growing sense on both sides that the English – officers and 'other ranks' alike – were less interested in international fraternizing than, for example, their allies the French and the Belgians. The Englishman's feeling for national difference seemed to be restricted to his own difference from everyone else. 'Insularity', 'aloofness', 'self-sufficiency' or 'reserve' had been long-standing tropes applied to the English gentleman at least, and in modern times had come to be applied to the character of the nation as a whole. What was more novel was the assertion of the complete unfathomability or 'mysteriousness' of the English character. This assertion was, if anything, made most vehemently by those who were trading on fathoming it.[7]

The most famous Continental depiction of the mysterious Englishman was a direct product of wartime contact: *Les Silences du Colonel Bramble*, conceived by the French biographer André Maurois while he was attached to the 9th (Scottish) Division on the Western Front, and published in French before the Armistice. A kind of Great War premonition of Colonel Blimp, Colonel Bramble is (as the title suggests) an almost totally silent bundle of contradictions, surrounded by more loquacious Scots and Irish, who explain to Maurois' narrator exactly how mysterious and contradictory he is. Immensely popular among the French, Bramble got only mixed reviews in English translation. The Brambles, Maurois consoled himself, only ever read *The Times*, the army list and thrillers. But the truth was, probably, that the English audience

had been put off by his own Frenchness. Subsequent, frankly Anglophile accounts of the mysterious English would be more influential, especially George Santayana's *Soliloquies on England* (1922), a hotbed of lyrical clichés, Karel Čapek's *Letters from England* (1925), or *Englishmen, Frenchmen, Spaniards* (1928) – a superficially more scientific study by a League of Nations functionary, Salvador de Madariaga. As for an English equivalent to Bramble, anatomizing the French, there was little chance of that.[8]

The long pre-war spell of assumed English superiority had supplied ruling-class Englishmen with few resources to grapple with, much less appreciate, foreign cultures apart from a vague expectation that they would gradually and eventually become more civilized; that is, more English. After the war, declining faith in civilization as a universal ideal left them only with a pronounced feeling of unbridgeable difference. Political events on the Continent subsequently reinforced these feelings immensely. Well before the Nazis' rise to power in 1933, though most acutely felt then, Establishment impressions of the Continent were dominated by visions of failed democracies and abortive revolutions, the streets owned by extremist leagues and paramilitaries, society and economy fatally corrupted by worthless paper money, scheming politicians and foaming demagogues. 'Our methods are not of the stiletto, the bomb, and the cup of bad coffee,' was one wonderful stereotype purveyed by a retired military man.[9]

It was the summer of 1848 all over again, but prolonged over years and decades, and the same incapacity for self-government, law and order, moderation and compromise was again attributed to the French, but now extended to most of the peoples of Europe, east and west, and with less optimism about their ultimate educability.[10] The novelist E.M. Forster looked back with nostalgia from the grim vantage point of 1934 to the days when the Englishman had been able to believe that he was 'the human norm':

> More enthusiastic and more ignorant than he is today, he believed that our freak of an island is an example for continents, and that the lamp of democracy, flickering in the Westminster marsh-lands, not only descended from heaven but is the parent of a universal fire . . . every dwelling-place from China to Peru was to turn into a home and every home into a castle, and though the Englishman would remain freer than anyone else because of his natural superiority, he would easily start all the other inhabitants of the world following him.

Now, with liberty ebbing away nearly everywhere, England looked more freakish, though also more lovable.[11] '[I]n these times of dictatorship abroad',

the historian J.E. Neale put it more bluntly in the following year, 'we may thank God that we are not as other men are'.[12]

To some extent, this newly defensive sense of uniqueness – quite different from the expansive, assertive sense of the Victorians – suggested a retreat not only from 'world civilization' but also from the civilization of the empire. The Round Table group of imperial intellectuals tried to refashion empire as a projection not of British power but of British culture, a community rather than an empire – a new formulation summed up in the idea of the 'Commonwealth'. Others, like the New Liberal J.A. Hobson, were made uneasy after 1918 by any notions of 'a world Kultur'. 'The word "Kultur" is misleading,' complained the Round Table's Alfred Zimmern, 'it confuses what is national with what is civic and universal'. His ideal for the Commonwealth, he protested, was 'simply the old liberal doctrine of the Victorian era'.[13]

Yet faith in that old liberal doctrine was flagging even within the empire. If English or British culture was emphasized, the white settler colonies might be happy, but huge swathes of Africa and India in particular would be affronted. As Indian nationalist organization mounted steadily in these years, such concerns could no longer be brushed aside. If 'the old liberal doctrine' was emphasized, then the Commonwealth appeared to be a rival to the League of Nations. All of these tensions came out in 1925 when the Round Table's father figure, Alfred Milner, died, leaving a posthumous 'Credo' declaring his ultimate loyalty to 'the English race' and to the empire as an expression of it. The various factions immediately fell upon this 'Credo': Asians deplored the emphasis on English blood; the white dominions doubted that the empire had any meaning beyond blood; and even some English imperialists wondered if the whole business was worth the candle.[14]

No one would say that imperial consciousness vanished or even diminished in this period; the actual geographic extent of the empire in fact grew and peaked if League of Nations mandates are taken into account. Many contemporaries blamed British disengagement from Europe on its lingering sentimentality about the empire.[15] But there was no longer a clear and simple correspondence between English values and institutions on the one hand, and the imperial mission on the other, and in this gap an independent English consciousness found plenty of room to flourish.[16]

Imperial consciousness was thus one historic constraint on English national consciousness that loosened in the inter-war years. Another, the multi-national status of the United Kingdom, did fall away dramatically. The cause was the partition and partial independence of Ireland, traumatically achieved in 1922 after two civil wars. These two civil wars taught English opinion several important lessons: first, that 'English values' could not simply be imposed, even on a near neighbour; second, that problems could be solved by retracting

British power – the beginnings of what Paul Kennedy has seen as 'a tradition of appeasement'; third, that imperial outposts like Ulster, claiming to be 'British', might not be 'British' at all.[17]

Not all of these lessons were learnt well, nor indeed were they all necessarily wholesome. India in the 1930s and the Falklands in the 1980s led to different outcomes. The gulf that opened up between Ulster's essentially prewar, unionist idea of the superiority of British values and the more inward-looking ideas about Englishness that flourished on the mainland after 1918 would bedevil both Anglo-Irish and Anglo-Ulster relations for the rest of the century.[18] Nevertheless, casting off the bulk of Ireland did make it much easier for the English to think of their country as England, rather than as a multi-national kingdom.[19] The 'England'/'Britain' semantic confusion was never greater than at this time. Naturally this annoyed – to put it mildly – the Scots and the Welsh, particularly the former. Only faint stirrings of nationalism resulted at first: small Scottish and Welsh nationalist parties were formed. But beyond overt nationalism a new asperity appears in Scottish commentary of this time on the foibles of the English, as in A.G. Macdonell's celebrated comic novel, *England, Their England* (1933), which portrays the English as a vapid, deracinated set of upper-class twits.[20]

A resurgence of English national consciousness need not have manifested itself as an interest in the English national character: other forms of Englishness were already in circulation, less psychological and less populist. Historians have dwelt much, for example, on a surge of sentimental and nostalgic patriotism for the land and traditions of 'old England' during and after the war – a smugger and more conservative version of the 'Little England' feeling already noted among thinkers of the William Morris or G.K. Chesterton or 'Pro-Boer' varieties. There was undoubtedly more of this about, whipped up by the war (during which English patriotism seems to have eclipsed the British variety) and generated afterwards by some of the defensive, centripetal forces we have been surveying.

Romantic celebrations of the old English countryside and its traditional social structures in poetry, prose and topographical albums became stock items in certain circles, especially aesthetic public-school circles and others particularly alienated from the main currents of modern urban living. Some of this genuinely purported to represent the nation. The poet (later Poet Laureate) John Masefield published just after the war a long poem, *Reynard the Fox*, which depicted an English panoply of squires, farmers and ordinary huntsmen meant to provide a composite picture of 'English character and mind'.[21] The novelist John Galsworthy, to whom *Reynard* was dedicated, was in the process of painting a similar, though more urban, composite in his novel cycle *The Forsyte Saga*, which, as it approached its end in the 1920s,

became much more elegiac and traditionalist than his probing pre-war criticisms of high society had been.[22] But those who were truly elegiac were likely to be correspondingly doubtful about the ability of the present generation to live up to their ideals. They were torn between describing the England that was, or should be, and the England that is – a tension that their audience recognized. For the mass audience it was easier to swallow depictions of the old English countryside that offered it as a fantasy or a complement to modern life rather than as a critique.[23]

If the English wanted to see themselves, patriotic images provided only a very partial view: the landscape (and, in nostalgic versions, a decreasingly familiar wedge of the landscape), history and traditions, institutions. After the Great War, there was a pressing demand for a more direct and faithful image. This demand came as much from the educated and literary classes (who provided the bulk of the images) as from a mass audience. It reflected, above all, the widespread recognition of the advent of democracy, and with it the recognition of social diversity so that 'England' could no longer be so easily represented 'virtually' or synecdochically. Of course, far-sighted commentators had seen democracy coming for a long time. Yet the late Victorian and Edwardian solution had often been, as Walter Bagehot recommended, to mount a patriotic puppet show for public consumption while pursuing a 'national' policy set by and suited to an elite. Only a few New Liberals before the war had urged that the public's personality or temperament, however 'irrational', be taken seriously by its governors.[24]

Up to this point the personality or temperament of 'average' people was in any case pretty much a mystery to their social superiors. What they did know about they were not inclined to respect. The war then delivered a great shock. Far more significant than the cross-cultural contacts afforded by meetings with Frenchmen and Canadians were the cross-class contacts between officers and men. These contacts were startling and, on both sides, thought-provoking. They revealed elements in the 'national character' that educated people had not hitherto imagined – notably a coarse sense of humour and at the same time a streak of kindness, gentleness and laziness – as well as in other respects confirming long-standing beliefs about English traits.[25] These wartime encounters might have triggered mutual loathing rather than sympathy (and often did at the time), just as the encounters between urban evacuees and country people in 1939 have been shown to have elicited both feelings. But the way in which democracy was negotiated after 1918 laid down a modus vivendi. This was not established without conflict, but it was established, and bore fruit in a new and widely diffused idea of the English national character.

First, British Conservatives gave themselves a crash course in the theory and practice of democracy. Still in coalition with Lloyd George Liberals at the

time of the Armistice, they promptly embraced the enfranchisement in 1918 of all adult men and most adult women that they had furiously resisted up to 1914. Their conversion was neither easy nor unanimous. Some Conservatives (mostly the unelected kind) still expressed openly their doubts about the character of the people and reasserted their paternal task of leadership. 'The fate of the country is largely in the hands of men and women who have lost the shrewd and natural instincts of ignorance without gaining the difficult and compensating wisdom of culture,' wrote William Begbie, pseudonymously, in 1924. 'We are an urbanised nation of half-educated people . . . sceptical, apathetic, unimaginative and capricious. The awakening of such a nation as this to the true nature of the many great moral and economic changes confronting civilisation is one of the most urgent duties of our time' – a duty he assigned to the Tory Party.[26] The 'Gloomy Dean' of St Paul's, W.R. Inge, Tory successor to the Victorian liberal dean R.W. Church, concurred: industrial civilization was 'confronted with a new and dangerous type, whose character is still imperfectly known', and '[h]ow far this part of the population can be leavened by what is most wholesome in the national tradition, is a problem of the future'.[27]

But others, and crucially the party leadership, which wisely put Stanley Baldwin at its and the nation's head in 1923 after breaking with David Lloyd George, began to see for the first time that a more benign representation of the national character was both a pragmatic and an ideological necessity. In conditions of universal suffrage, one Tory agent wrote to his colleagues, 'we no longer have to bother with the psychology of the individual but of the masses', and the same Conservative Party agent's journal recommended various pre-war texts of liberal sociology to provide clues.[28]

And systematically, in speeches and journalism and regular collections of essays, Stanley Baldwin set about painting a picture of the English national character that might be reassuring to Tories, familiar to Liberals, and perhaps even placatory to socialists. This project began in earnest around the time of the General Strike in 1926, when the nation seemed so badly riven by class and ideology as to revive older conservative doubts about the very idea of a 'people', as well as Bagehot's warnings about the fragility of civilization. Citing the Liberal Ramsay Muir's definition of the nation – 'a great body of people who feel that they belong together because they are linked by a multitude of ties, which create a real homogeneity' – Inge observed mordantly, 'Where this loyalty and patriotism are absent, democratic Liberalism, which is government by public opinion, becomes impotent, and the impotence of government leads to anarchy.'[29] Baldwin, in his public pronouncements, chose deliberately to strike these very liberal chords, albeit in muted, conservative tones. Industrialism, he argued, had not ruined the national character, it had

only tested it, and the people had passed the test. Trade unions themselves, if they followed the evolutionary and voluntarist traditions of the English character, could be seen to form part of it. Common sense, good temper, ordered freedom, progress – these were all qualities and traditions held in common by the English people.[30]

Once the crisis had been weathered, of course, the diagnosis appeared even more credible, and could be embraced by the less optimistic.[31] For those who wanted to believe in the national character, the General Strike lingered in the memory not as Inge's proof of unbridgeable heterogeneity but as a set piece of national unity.[32] The story was frequently told that a French journalist rushed across the Channel to report on the English Revolution, only to find the port where he landed absorbed by a football match taking place between police and strikers. 'You English are not a serious people!' he spat, and flounced back to France.[33] Another story, with a bit more edge, depicted a strike-breaker's encounter with a 'sordid-looking woman, probably a Communist', who called him a 'buggering bastard'. '"Good morning, mother", answered the volunteer, "we haven't met for a long time". Such is the spirit which flays revolution alive.'[34] These stories were meant, of course, to convey a particular idea of the English national character, as well as its strange, unfathomable difference from everyone else's.

Something similar happened during the political and economic crisis of 1929–31, when alternative ideas about nationality once again came into conflict, and when Stanley Baldwin's idea again triumphed, allowing him to displace a Labour government and install a 'National Government' in its place. While in certain ways the crisis itself was attributed to flaws in the national character,[35] its outcome was seen after the fact as a ringing endorsement of the very existence of a national character, as well as of Baldwin's specific depiction of it. The contrast between what was widely seen as an 'organic' English national response to crisis and the more 'artificial' German response, highlighted by the Nazi seizure of power in 1933, led to a veritable orgy of anatomizing, congratulating and self-congratulating upon the English national character throughout the early 1930s. Natives and foreigners alike agreed that, however mysterious it might be, the English had something in their psyches that other people did not.

Following the initial success of Santayana's *Soliloquies*, and similarly admiring books by Čapek and Madariaga, an avalanche of imitations descended on English audiences in the early 1930s and, probably for the first and last time, English readers turned to foreign authorities to find out about themselves. 'The number of learned books in which, of recent years, foreign authors have expressed their opinions on English life and problems is becoming so large that the idea of writing such books has lost all originality,'

one Belgian author of such a book was admitting already in 1930.[36] This stopped neither him nor various German, French and American pundits from issuing a further wave of particularly influential texts on the subject in the next two years.[37] Nor did it stop them from continuing to insist that the subject of the English character was still fresh, inquiries still exploratory, the object of study still mysterious.[38]

In the aftermath of the 1931 crisis, British authors joined the discussion. The most unlikely aesthetes and dissenters discovered a previously muted (or absent) belief in the national solidarity of the classes and the natural goodness of the national character, as in Noel Coward's stage pageant of Englishness, *Cavalcade* (1931). 'Come to Paddington!' wrote Robert Byron to his exiled aesthete friend Harold Acton in Italy, 'here are public houses, funfairs, buses, tubes, and vulgar posters' – everything that refined cosmopolitan Bloomsbury was not.[39] The BBC devoted the whole of its season of talks in autumn and winter 1933–34 to 'the national character', compèred by the Tory historian Arthur Bryant, with an accompanying study guide by the left-wing intellectual H.W. Nevinson (who agreed with Bryant on most substantive points) for balance.[40] There followed another welter of impressionistic tracts on the same subject, from hands both foreign and domestic, right up to the outbreak of the Second World War.[41]

The deliberateness with which Baldwin set about portraying his Tory Party as in tune with the national character, and the surge of interest in the subject after Labour defeats in 1926 and 1931, suggests correctly that the vogue for the subject was concentrated among Conservatives and was a device for converting others to Conservatism. But it would be wrong to conclude that it was in any simple way just a piece of Tory salesmanship.[42] As Inge had unhappily pointed out in celebrating the national character the Tories were taking on a traditional Liberal position. In this they were exploiting broader Liberal weaknesses, which had little or nothing to do with the Liberals' 'patriotism', but they were also benefiting from the established Liberal ambivalence about whether the higher virtues were best expressed through nationality or cosmopolitanism. That ambivalence was heightened in this period by some Liberals' enthusiasm for the League of Nations or the Commonwealth, which caused them to mute their assertion of nationality, and left room for the likes of Baldwin to occupy their traditional redoubts.[43]

Yet there were still plenty of Liberals holding this ground, and probably the most influential of all inter-war statements on the English national character, Ernest Barker's *National Character and the Factors in its Formation* (1927), was a classic restatement of Liberal doctrine on the subject in the manner of John Stuart Mill and H.T. Buckle. Nor should we be surprised by the employment of a language of national character in the inter-war period by figures politi-

cally well to the left of either Baldwin or Barker, such as J.B. Priestley, George Orwell and Hugh Dalton, for whom it was one way of expressing a faith in democracy.[44] It was Dalton, the future Labour chancellor of the exchequer, who had told the story about the strikers and the policemen playing football, not to induce quietism but actually to show that at the time of writing, in 1935, English soil was more fertile for democratic socialism than Germany or Russia, then in the grip of militarism and authoritarianism.[45]

Of course, the idea of national character had a long pedigree as an established way of speaking about nations as democracies – agglomerations of people, similar and equal, whose similarity and equality made self-government possible. The English – one of the last peoples in Europe to attain universal manhood suffrage (in 1918) and long hobbled by consciousness of their multinational and imperial responsibilities – were only just coming around to a way of thinking about nations that had been more common elsewhere in Europe. Instead of conceiving of nations metonymically or synecdochically through their historic institutions or monocled diplomats or patrician rulers, people of democratic sensibilities naturally preferred to think of nations in terms of their people's common characteristics.

The Great War had made this easier, not harder. By discrediting biological arguments and analogies, it had turned nations from exclusive, inevitably warring monoliths into groups that differed more vaguely and equably, with their own internal quiddities and diversities. In their experience of international relations between the wars, the English began to get used to thinking of the players in this game as peoples, with their own distinct interests and distinctive modes of behaviour. 'We are apt in this country to be a little shy of attempts to depict national "souls",' granted A.D. Lindsay in introducing Wilhelm Dibelius' *England* to an English audience in 1930:

> We feel . . . that 'there is a certain amount of tosh' about national psychology. So there is . . . [But] for all our prejudice against such generalizations we are beginning to recognize that there is something in these broad national characters. As we sit in international conference, we can notice that the Frenchmen and the Germans and the Italians are behaving each in their characteristically national way . . . [and] that we are probably doing the same.[46]

The mounting consensus against any racial interpretation of national character – already strong in Britain before 1914 and strengthened further by the inter-Teutonic war of 1914–18 – helped remove some remaining British scruples about the idea of national character. Whereas before the war J.M. Robertson's anti-racialism had set him against any belief in national

homogeneity, his more relaxed followers after the war argued that the discrediting of race cleared the way for a more objective assessment of what made a nation.[47] The removal of biological factors also helped to make the idea of national character more fluid, allowing it to incorporate the reality of social change that had been difficult for biological interpretations since the decline of Lamarckianism. In some European countries, early twentieth-century social changes were hardly conducive to the better appreciation of national character because they produced greater inequality, class conflict, even civil war, not national solidarity. In Britain social change was almost equally palpable, but susceptible to a number of national interpretations.

In certain respects the behaviours and experiences of different social groups did converge in inter-war Britain: working-class alcohol consumption and crime rates were markedly down, health and dress standards moved closer to middle-class norms, and these were all key features in the Victorian idea of character by which individual behaviour was traditionally judged. The greatest disparities were regionally concentrated in the north, Scotland and South Wales, which made it easier still for the educated middle classes to imagine that the working class truly had been integrated into the nation. Inter-war statements of the national character were often very frank about how recent and even sudden these social changes had been. Such adjustments to the more romantic and racial ideas of national character prevalent in the nineteenth century may have made the new idea fuzzier and less stirring. However, the same adjustments made this new idea more compatible with observable social reality and more attractive even to radicals, who naturally disliked an idea of national character erected as a barrier to further social change.[48]

We can see both the new respectability and the new conceptual blurriness of the idea of national character in the treatment it received from social science. One might imagine that the idea of national character would, by the 1930s, with the rise of the modern disciplines of psychology and sociology, have been thoroughly discredited, yet the reverse was the case. It is true that the biological arguments that had been the basis for the most radical scientific theories of national difference were decisively marginalized. In Britain, these arguments had always been weaker than in France, Germany or America, and there had been neither an extensive anthropometric audit of the British peoples nor much eugenic legislation for their 'improvement'. British physical anthropologists were correspondingly cautious about drawing psychological conclusions from physiological data.

While the American W.Z. Ripley's *Races of Man* (1900), with its beguiling tripartite division between Teutons (or Nordics), Alpines and Mediterraneans, had lent itself to such uses, the inter-Teutonic war of 1914–18 made them

highly controversial. It cast doubt – to say the least – on assertions of Nordic homogeneity; further, it rendered tragic and absurd the eugenic view that racial conflict and evolution could be the motors of progress. When the physiologist Sir Arthur Keith came out as a hardline eugenist and racist during the war, at which time he was president of the Royal Anthropological Institute, the response of most of his peers in the scientific community was respectful puzzlement at best, angry resistance at worst.[49] A similar treatment was accorded to another physiologist, William Bateson, when he argued for the racial basis of the nation during and immediately after the war.[50] When he came to revise A.H. Keane's overtly racist *Man Past and Present* for a new edition in 1920, A.C. Haddon weeded out most of the strongest such claims.[51]

Significantly, the separation of Ireland and Britain did not lead to a reassertion of racial identification based upon the Celt-Saxon divide.[52] Those who continued to argue for a racial basis to British civilization did so almost exclusively now on the basis of racial diversity, pointing to the benefits either of a Celt-Saxon cross or, more loosely, of diversity in general.[53] When they did so, they often expressed discomfort with using a language of race at all – 'dangerous even to approach', as W. Macneile Dixon warned – aware, as Dean Inge said in 1926, 'that the Nordic theory has been an excuse for patriotic arrogance and unbridled aggression'.[54]

These voices were not, on the whole, scientific ones. There was, however, one prominent physical anthropologist of the younger generation, a follower of Ripley, H.J. Fleure, based initially in Aberystwyth, who did pursue research into possible racial bases of the national psychology. Like Matthew Arnold, Luke Owen Pike and A.H. Keane before him, Fleure was proud of his Celtic heritage: he believed that physical and psychological characteristics were 'bundled' together and were inherited in these bundles even in periods of racial mixture. Thus he was one of the last anthropologists to believe that one could isolate the aboriginal British elements both in the national physique and in the national character.[55] Yet Fleure urged that 'Race-type is an abstraction, to be used with much reserve,' especially when extrapolating social values and psychical qualities, and upon the rise of the Nazis he was as vocal as anyone in rebutting myths of racial purity and superiority.[56] When he joined Arthur Bryant's BBC series on national character in autumn 1933, though selected because he was the one anthropologist with known scientific views on 'national character', he acted entirely as a brake: no, there was no racially pure nation; yes, physical and mental characters may go together, but none of the traits proposed by Bryant could be shown to have a racial basis; no, immigration made little difference to the national character; in the end, all one could say was 'that perpetual intermixture of race which . . . has gone to

build up our national character, is – in the immortal words of *1066 and All That* – "a Good Thing"'.[57]

If the biological basis of national character was looking very doubtful, neither was there much enthusiasm after 1918 for an idea that had surfaced just before and during the war that could be seen as a halfway house: the idea of the 'group mind' or 'group instinct'. The aristocratic version of this idea, advanced in Gustave Le Bon's *The Crowd* (1896), positing a tension between a rational elite and an increasingly irrational mass mind, had never caught on in Britain. The alternative idea that nations had an enduring soul, not exactly biological but transmitted in some metaphysical manner, which appeared in another book of Le Bon's, *The Psychology of Peoples* (1899), was also dismissed as Continental 'tosh' by the British.[58]

In the post-Boer War crisis, however, there had been a growth of interest in the idea of 'instinct' – still more powerful in France and Germany than in Britain, where rationalism ruled the roost, but evident in Britain, too, in the emergent discipline of social psychology. Psychologists like A.F. Shand, Wilfred Trotter and especially William McDougall hypothesized that groups (such as nations) formed a collective mind that was more than the sum of its parts, capable of influencing the behaviour of its components and transmitting itself across generations. While McDougall thought there was probably a racial basis underlying the character of a group, and although he toyed with Lamarckianism, he did not really believe that the group's evolution was achieved biologically. Harking back to the puzzlements of Henry Maine and Walter Bagehot, he was desperate to discover what did make progress possible for some groups and not for others.

What is interesting about these group theorists is that their thinking, while wild and confused and sometimes highly metaphysical, was grasped at by serious intellectuals around the time of the Great War, including many liberals, because it took the nation seriously without reducing it to race, offered an explanation for national differentiation, and suggested ways in which nations might progress and also coexist. These were the most pressing of questions in the post-war world. If biology had doomed nations to conflict, perhaps psychology could find a road to peace and fulfilment.[59]

In the end, group psychology did not catch on either, except, popularly, in Carl Jung's ideas of race memory, which were seen to have therapeutic purposes for the individual. It proved impossible to test in this form, either for the presence of a group mind or for its transmission across time. However, the short-lived vogue for group psychology during and after the war attests to the powerful need among social scientists to come up with a plausible theory of national character. Among sociologists, for instance, the formation and behaviour of national groups became a subject of pressing interest. Whereas J.M.

Robertson had been content to pursue the destruction of racial theories, post-war sociologists wished to put something in their place. The nation could not be wished away. 'All the laws of life conspire to give a common and distinctive character to every area of community,' wrote sociologist R.M. MacIver in 1917, 'especially to those areas bounded by the frontiers of states. The great currents of culture that sweep over continents and even over the world along the increasing channels of communication will never obliterate but rather will enrich that character of national individuality.'[60]

What was needed, urged John Oakesmith in *Race and Nationality* (1919), was to move on now to the proper, scientific study of 'the popular view of what is described as the "English National Character" . . . generally thought to be something specific and well defined, something that is unmistakably manifest in all the work performed by the English People, so that when you use the words "the English National Character" you employ an expression with an almost scientifically precise connotation . . . serving to mark off the "English National Character" from the national character of any other people under the sun.'[61] Though it had been two generations since Mill and Buckle had exposed the racial myth, and 'no distinguished British author' had defended it, nevertheless the 'non-racial view of nationality' had not been systematically expounded, leaving popular ignorance intact, and scare stories about the inevitable conflict of nations undispelled.[62]

More or less the same view was still being expounded a decade or more later by the Viennese sociologist Friedrich Hertz in *Race and Civilization*, the 1928 English translation of an earlier work in German.[63] Hertz did make some progress in raising the question as to what exactly was the 'character' that was being differentiated nationally: was it a society's most abstract ideas, or the characteristic emotions of its people, or their 'instincts', or their 'temperament' – itself 'a highly controversial and indistinct notion'? But no breakthrough was going to be made so long as the focus remained, as it did in Hertz, on refuting pernicious German and American racial doctrines, rather than on developing a new theory of national character.[64] In the early 1930s sociologists had only Ernest Barker's *National Character and the Factors in its Formation* to recommend, though methodologically it was hardly more than a *réchauffé* of Buckle and Christian liberalism.[65]

The traditional way in which British sociologists and anthropologists had understood national character – the comparative approach based on social-evolutionary assumptions – retained much appeal. The most widely read British anthropologist of the 1920s was still probably J.G. Frazer, whose *Golden Bough* (1890–1915) embraced all the old assumptions about the psychic unity of the human race and its differentiation on the basis of 'stages of cultural development'.[66] But this kind of thinking was badly shaken by the war. Unitary

ideas of 'civilization' were thereafter in bad odour. It was no longer seen as necessary or even desirable to assert that humans were 'everywhere the same' (only in different stages of development) in order to combat polygenism or strong racial determinism. Could not people in fact be 'everywhere different', while still all human? Stripped of racial implications, Johann Gottfried Herder and Giuseppe Mazzini's ideas of humanity as a great tree branching ever outwards began to seem more generous – and also more scientific – than the rigid imperial hierarchy of the single ethnocentric ladder.

Here the key figure was an American anthropologist, Franz Boas, and the key concept was 'culture', or rather 'cultures' in the plural. Boas taught anthropologists to see that each people had its own culture, with its own peculiar traits, norms, values and 'personality', which it had evolved for reasons of its own, to suit its own environment and historical trajectory, and not as part of some divine master plan for the whole of the human race. This Boasian relativism, by seeming to offer a philosophy of 'live and let live', rather than of preordained conflict or hierarchy, had much to recommend itself to shell-shocked survivors of the Great War. It allowed westerners, disgusted with the savageries of their own 'civilization', to see that other 'cultures', including those they had previously looked down upon as 'primitive', had an integrity of their own and possibly something to teach 'civilization'.[67] By casting into doubt the determinisms of race, science and religion, it turned history into more of an adventure, the formation and reformation of nations and cultures into something more chancy and plastic, as well as more lifelike, than the rather one-dimensional view afforded by linear development.[68] On the individual level, too, it chimed with new American ideas about the wonderful diversity of human existence: instead of a single fixed standard of 'character' to which everyone ought to aspire, the individual was held to be endowed with a unique 'personality', to be developed by their own lights.[69]

Not all of this immediately recommended itself to British opinion, public or scientific. The imperial mission did not pack up shop overnight; neither did the social-evolutionism that underpinned it. The language of 'civilization' remained current in social-scientific circles, though shorn of some of its more universalistic or teleological implications: it was a pious hope, not a divinely ordained outcome.[70] The American idea of personality was widely seen as too gushy and solipsistic, and Rudyard Kipling spoke for many in defending the old-fashioned view that only 'character, and again character – such mere ingrained common-sense hand-hammered loyal strength of character as one may humbly dare to hope 15 hundred years of equality of experience have given to us' would preserve the English place in the world.[71]

On the other hand, British social science was not so backward as it has been portrayed,[72] and public opinion was frankly entranced by the new visions of

global diversity that social scientists were increasingly able to put before them. Sociology may have made little headway, but Britain became a world centre for the new discipline of 'social anthropology', inspired by Boasian relativism.[73] British psychologists, unlike their American counterparts, remained interested in the psychological differences between cultures and societies, not only individuals.[74] And, often ignored, archaeology became an immensely popular discipline in the inter-war years.

The old archaeology had followed a social-evolutionary doctrine that assumed most people would independently develop all of the great achievements of human civilization as they reached the appropriate level of development. The new archaeology was, instead, 'diffusionist': it explained similar developments in different places by reference to migration and the 'diffusion' of cultural practices from one people to another.[75] That could cultivate a more insidious kind of racialism, hinting at a 'master race' – the ancient Egyptians were a favourite – who had spread civilization around the world from one starting place, or an explanation for progress like Bagehot's, crediting some superior individuals with unpredictable breakthroughs.[76] However, by emphasizing mixing and migration, it also gave a more confusing and more accurate idea of the ethnographic picture of the world, including Europe. No longer did pure aboriginal 'Saxons' overwhelm pure aboriginal 'Celts'. Instead, peoples, distinguished not by hair colour or head size or even language but only by their pottery or their burial customs ('Beaker Folk', 'La Tène cultures'), moved restlessly around whole continents, spreading art and technology and ritual.

More attractively to the wider public, diffusionism – as opposed to social evolution – also admitted the possibility of fundamentally dissimilar cultures in far-flung corners of the world.[77] Much of the appeal, for example, of the Tutankhamen craze of the early 1920s was that the objects of fascination did not obviously represent 'the origins of the modern world': they were, rather, incredibly exotic, more like the South Seas – another contemporary object of fascination – than the London of Stanley Baldwin. Whether the same public could be persuaded to think of themselves as exotic if viewed from the South Seas was moot; but at least it was now a question.[78]

The physical anthropologists were not, on the whole, happy with this development. Some of the leading figures in British anthropology, notably A.C. Haddon and W.H.R. Rivers, had converted to diffusionism during and after the war, and altered their research programme accordingly, but those who had devoted their lives to collecting and measuring skulls would not give up the enterprise easily. When the Institute of Sociology approached the Royal Anthropological Institute after the Nazi seizure of power and proposed a joint statement against racism, the resulting committee found it difficult to agree on

anything but the blandest minimum, drawing the distinction between 'race' (principally a physical characteristic) and 'culture' (the means by which 'man in his group or social life adapts himself to his environment'). While one group, led by the diffusionist Grafton Elliot Smith, wished to go further and rule out any connection between race and culture, another, led by Fleure, refused. Fleure and his party clung to the idea that physical and psychological characteristics might be 'bundled' together (though he would rarely specify instances), which Elliot Smith and others strictly denied: 'Examination of national culture demonstrates very emphatically the arbitrariness of the process of the acquisition of culture,' and there was 'no evidence to justify' the belief in an 'innate tendency for certain races to develop distinctive types of culture and character'.[79] After this failure to agree a clear anti-racist line, two anthropologists not on the joint committee, the eminent Haddon and the young Julian Huxley, produced as a private enterprise a best-selling book, *We Europeans* (1935), which made an unambiguous attack on racial myth.[80]

Huxley and Haddon granted that 'national feeling . . . is at the basis of modern corporate existence', but they deplored demagogic attempts to shore this feeling up with pseudo-science. They reprinted an illustration of sixteen European 'types', used the previous year in the *Listener* by an anthropologist making the same argument, and invited readers to attempt to match them with their national origin, to show how subjective and impressionistic national prejudices based upon race were.[81] On the subject of national characteristics based on other factors, they left an ambiguous impression. 'All the evidence we possess goes to show that the expression of such mental characters is dependent on the social environment to a very high degree,' which meant that 'national character' was subject to regular, sometimes rapid social changes. But the glib uses to which this phrase 'national character' was put meant that they felt it 'all but meaningless'.[82] By popularizing the phrase 'ethnic group', to replace 'race', they did, however, provide the beginnings of a new basis for the study of collective behaviour.[83]

Other social scientists were not so tentative. Precisely because confusions of race and culture were now seen as less likely, they could explore cultural differences more boldly. Friedrich Hertz, expelled by the Nazis from his chair at Halle, published his first positive contribution to a science of national character in a British sociological journal in 1934. He posited an idea of 'national spirit' that was flexible enough to accommodate diversity and change, combining conscious elements (which could be used in a feedback loop to cement national spirit further) and unconscious elements (real national homogeneities that may not be apparent to the nation itself, without scientific assistance). He called for a major programme of psychological and sociological research, freed from the romantic and racial assumptions of German and American

Can You Guess their Nationality?

These sixteen photographs represent two Germans, and one each of the following: American, Australian, Austrian, Belgian, British, Danish, Dutch, Finnish, French, Italian, Norwegian, Polish, Russian and Spanish. (When you have made your guess, turn to page 583 where you will find a key)

6 The anthropologist Lord Raglan challenges popular stereotypes about the physiognomy of nations: 'Can You Guess their Nationality?' from the *Listener*, 3 Oct. 1934 (and used for similar purposes in Huxley and Haddon's *We Europeans*, 1935)

science.[84] This call got a mutedly positive response from Morris Ginsberg, who had succeeded his teacher L.T. Hobhouse as professor of sociology at the London School of Economics, and who had been exploring social psychology since the war. 'Despite the large number of books that have been written on the psychology of peoples', he regretted, 'the distance between the raw generalizations which they utilize and scientific psychology is as great now as when Mill first planned his science of ethology.' Given this gulf, he thought it was likely to be easier to explore the conscious kind of national character – that is, nationalism – than the unconscious kind.[85]

The social anthropologists were more comfortable with making such gener-alizations. While they were mostly still studying 'primitive' societies, the fact that they no longer considered them as fundamentally different from 'civi-lized' societies pointed inevitably towards more anthropological scrutiny of the latter, and not only by anthropologists. Geoffrey Gorer, a young man with literary leanings but inspired also by Sigmund Freud and the anthropologist Rivers, broached the idea of an anthropology of the English after completing quasi-ethnographical studies of West African and South-East Asian peoples: 'Unfortunately the hardest of all cultures to investigate is our own. We are so much part of our own culture that it is impossible to be objective about it . . . This is extremely unfortunate, for almost the most pressing necessity today is to understand our own culture in order, if possible, to transform it.'[86] After reading this trial balloon in the spring of 1936 his friend George Orwell wrote, 'What you say about trying to study our own customs from an anthro-pological point of view opens up a lot of fields of thought.'[87] Both men would subsequently publish ethnographies of the English.

Shortly thereafter the idea of an 'anthropology at home' was broached at a meeting of social scientists, and this idea was then taken up by Charles Madge and Tom Harrisson, who launched 'Mass-Observation' in 1937.[88] 'M-O' was controversial among social scientists, for it relied on amateur 'observers' for data collection, and its very political agenda took for granted some social distinctions and some popular attitudes that perhaps ought to have been investigated rather than assumed. Yet it won the endorsement of a few prominent anthropologists such as Julian Huxley and Bronislaw Malinowski, and its ambition to perform an 'anthropology of ourselves' certainly caught something in the Zeitgeist.[89]

The idea of anthropologizing civilized societies would become more pressing during the Second World War, when it seemed to offer insights into the psychology of allies and enemy alike, just as during the Great War. The differ-ence was that in the Second World War it became an integral part of the war effort, with Mass-Observation commissioned officially to take the national temperature, Geoffrey Gorer employed by the Foreign Office to anatomize the 'Japanese national character', and his co-worker, Margaret Mead, scripting propaganda films on 'Anglo-American Similarities and Differences'.

Racial understandings of national character may have been in retreat, but the idea of national character was, if anything, strengthened thereby. Flexible enough to accommodate the social changes of which everyone was so aware, yet scientific enough to satisfy the most scrupulous of academics, it seemed to be the 'X' factor that could explain all sorts of social, political and cultural phenomena, from the odd behaviour of British diplomats in peace to the fighting habits of Japanese soldiers in war. If sober scientists felt this way, we

should not be surprised at the enthusiasm expressed for the idea of the English national character by the 'man in the street' (who was, after all, its subject) between the wars.

FROM JOHN BULL TO 'LITTLE MAN'

The ubiquity of the idea of 'national character' between the wars meant that it was put to many purposes. It therefore took many forms, and embraced a surprisingly varied menu of contents. The looseness of the vocabulary in which it was expressed – a problem for the analyst of national character in any age – makes it in this period almost maddeningly flexible. As national character had been gradually unmoored from 'deep' racial or historical foot-ings and from the imperial Briton's responsibility to serve as prototype for 'universal man', the range of attributable traits inevitably widened to include both very specific cultural peculiarities and very modern ones. As all classes and political camps were now tussling over the national character, the range of social milieux from which these characteristics could be selected widened at the same time: it is fair to say that the national character became simulta-neously more 'gentlemanly', more bourgeois and suburban, and even more proletarian. Retrospectively amusing but frustratingly slippery games had to be played to reconcile these various milieux.

The intrusion of more foreign voices into the domestic discourse imparted a further bias. Mostly they were writing in the first instance for their home audi-ences, for whom it was necessary to give a vivid and detailed picture of contem-porary mores, as well as of the essential national character. Every aspect of contemporary life was therefore fodder for generalization; as with the foreign reporters of the late eighteenth and early nineteenth century surveyed by Paul Langford, the line between 'national character' and 'manners' in their writing was constantly being blurred. Partly as a necessary simplification, therefore, and partly because (in the manner of journalists everywhere) they reported from a narrowly upper-middle-class and metropolitan standpoint, they shared another characteristic with their earlier counterparts: a tendency to model the 'English national character' upon the people they met in West End hotels, clubs and restaurants.[90] A full account of the English national character in inter-war writing would have to delve into virtually every nook and cranny of inter-war society – into the dance halls, the attic boxrooms, even the bath-rooms of all classes.[91] Still, by focusing on a few key traits, it is possible to give some sense of a composite without losing all sense of the diversities (and contrived reconciliations). In particular it is possible to convey the real shift in the balance of qualities attributed to the Englishman as compared to the prevailing norms of his Victorian heyday.

Of course, it was one of the staples of writing on national character to assert its timelessness, even in conditions of heightened consciousness of modernity and social change. Conservatives, especially, who had not previously thought much about the national character were now rather more inclined to assert its essential permanence, poised sometimes almost consciously between hopefulness and despair. The romantic Tory Arthur Bryant, an adept of the catastrophic interpretation of English history that saw the English people as having been almost irretrievably cut off from their original state of grace by a century of modern materialism and environmental blight, talked endlessly of an eternal national character still out there somewhere waiting to be revived.[92] His real hopes, however, were vested in the appearance of a small knot of men of action – possibly even Nazis – whose example would practically re-create the national character from scratch.[93] Bryant's was a timeless, idealized national character that had little to do with the real people of England. For those more in sympathy with their own times, however, a positive appreciation of the national character generally entailed a recognition of the great social changes of the last few generations – and often of a change in the national character as a result.

A common way of acknowledging the scope and character of these changes was to observe how unsuited the image of John Bull was to the modern Englishman.[94] The Englishman did not look like John Bull,[95] and he did not think like him either.[96] Or, sometimes in premonition of dissatisfaction with the whole notion of national stereotypes, perhaps he represented only one element in the national make-up.[97] John Bull was not a worker – that is, the average Englishman – but, significantly, he was not a gentleman either.[98] 'It is time that the national figure of John Bull was redrawn,' wrote one old Tory in 1926.[99] But it was easier to junk John Bull than to summon up a single alternative. That old Tory had in mind something like the Conservative's ideal-type 'Tommy', chirpily springing 'over the top' with a song on his lips and plucky dutifulness in his heart. Others proposed Samuel Pickwick, Stanley Baldwin, the 'Little Man' of Sidney Strube's cartoons in the *Daily Express*, even Austen Chamberlain or Philip Snowden.[100] John Bull was an eighteenth-century invention that had not fully captured the Victorian idea of the national character, either. But it was only now that this disjunction became a source of complaint, as the image and the perceived reality had drifted too far apart under the remorseless workings of social change.

What all of these anti-Bullites in their different ways were attempting to sum up was the transformation of the Englishman from a stolid, self-reliant, rather aggressive and rugged individualist into something decidedly kindlier, gentler, more relaxed, more cooperative, more domesticated, if anything a rather shy and timid sort. Pickwick represented an intermediate type: John

Bull in stature and social origins, yet more cheerful and sympathetic. It is no coincidence that Charles Dickens enjoyed a renewed vogue in the inter-war years, and that Priestley and Orwell were among his leading champions as the man who had kept alive a humane alternative to the Victorian self-image of 'sturdy islanders' and 'stubborn hearts of oak' that had flourished in an age of imperial hubris.[101] Strube's 'Little Man', however, was the fully fledged exemplar of the new type: an imaginative compound of the City gent and the 'man in the street', dressed in bow tie and bowler hat and armed with tightly furled umbrella, but, as Harold Nicolson said in proposing him as the national symbol, 'small, kindly, bewildered, modest, obstinate and very lovable'.[102]

This new type, symbolized by the 'Little Man', combined a number of features relatively novel to depictions of the English national character, reflecting post-Victorian conditions and drawn conveniently from a range of social locations. Obviously the new type reflected in part a new awareness of a distinctive working-class personality that needed to be incorporated into the national character, as seen in the image of the chirpy Cockney, and even more so the bourgeois suburbanite – an insurance clerk as may be, ensconced in his garden or sitting room with his pipe and dog and his nuclear family arrayed about him.[103] What is less obvious, but if anything more important, is the way in which the new national figure incorporated also the idea of the gentleman, which although an older type had not previously been thought to signify so clearly the national character, and whose incorporation was now also seen as a bell-wether of social change.

7 Enter Sidney Strube's 'Little Man', a fixture in the *Daily Express* between 1920 and 1947 (here in the *Sunday Express*, 24 Dec. 1933)

The idea of the gentleman was obviously an ancient one, and the idea of a specifically English type of gentleman nearly as old, though it too subtly metamorphosed over time.[104] When foreign visitors extrapolated the national character from their gentlemanly acquaintances in the loose way that they did, especially in the eighteenth century, they might speak of the gentleman's character as the national character, but they were hardly interested in anyone other than gentlemen anyway.[105] In the nineteenth century, some traits – especially reticence and reserve and the spirit of fair play – were assumed to be both uniquely their own by people of the gentlemanly class, and also national characteristics, derived from other sources (climate, race, political traditions), by democrats unwilling to single out the gentleman.

There arose at the same time, however, a sharper image of the gentleman, propagated by the likes of Cardinal Newman and Thomas Arnold and conceived very much as an antidote, even a reproach, to the national character rather than as its representative. This was the idea of the gentleman as gentle-man – sweet, chivalric, cultivated, somewhat detached from the hurly-burly of the world, a counterpoint to the rough, tough, self-reliant and persevering English character in the Teutonic mould. This idea of the gentleman performed similar critical functions to the idea of 'culture' as propounded by Matthew Arnold, moderating or civilizing English philistinism and materialism.[106] So that when the gentleman came to be incorporated into the English national character in the early twentieth century, his traits could be portrayed as elements of continuity but also of change – an improvement on both the power-mad proconsular type of the governing class and the dull, toiling commoner.[107]

This was the notion purveyed by George Santayana's *Soliloquies*, the most influential text on the gentlemanly character of the English. 'We should none of us admire England today', he wrote in his opening pages, 'if we had to admire it only for its conquering commerce, its pompous noblemen, or its parliamentary government' – just the things many Victorians had thought most admirable about their country. 'There is, or was, a beautifully healthy England hidden from most foreigners; the England of the countryside and of the poets, domestic, sporting, gallant, boyish, of a sure and delicate heart.' This Englishman was 'no missionary, no conqueror', but rather a homebody – modest, domestic, that 'frigid exterior' only 'a cuticle to protect his natural tenderness'.[108] In Arthur Bryant's more squirearchical moments he struck similar pro-gentleman, anti-Victorian notes: 'I sometimes think that our business in the years to come is not so much to govern, as in the past, as to give the world a lead in the business of living wisely and peacefully and nobly, as it seems to me we did in the little England of 250 years ago.'[109] These were Tory voices, eager to vest the national spirit in the pre-modern gentleman,

hoping that the grasping materialism of the last century was an aberration – an accident, as Dean Inge thought, of England's abnormally rich coalfields. 'Our brutal commercialism has been a temporary aberration; the quintessential Englishman is not the hero of Smiles' "Self-help"; he is Raleigh, Drake, Shakespeare, Milton, Johnson, or Wordsworth, with a pleasant spice of Dickens. He is, in a word, an idealist.'[110]

Others assimilated the gentleman and the nation in a more thoughtful and sophisticated way. 'It is a thing unquestioned that the ideal of character, which holds good in England, is the ideal of the Gentleman', thought the German liberal Hermann Kantorowicz. But, he said, it had only become a truly national ideal since the democratization of England after 1867.[111] The standard view of this process was that the gentlemanly spirit was diffused through the public schools to the ruling class and then, through deference to the ruling class, to the rest of the nation.[112] Some adopted an early version of a 'gentrification' thesis later popular among historians, whereby the previously dominant middle classes had been gradually assimilated into a gentlemanly elite and brought the masses along in their train – a view particularly popular around the crisis of 1929–31.[113] Others simply ignored the nineteenth century, drawing a straight line of popular subservience to a gentlemanly elite from the French Revolution to the General Strike, blending an earlier story of the civilizing of an ungovernable people during the Industrial Revolution with the recent story of the civilizing of a philistine people since the Victorian zenith.[114]

For those who pinned much on deference, it was not even necessary to argue for a genuine 'national character', only acceptance of the gentleman as the symbolic or leading type.[115] But many observers genuinely believed that the English people as a whole had come to emulate the gentleman.[116] The Belgian journalist G.J. Renier, whose sarcastic report on the English (asking, memorably, 'are they human?') was to the 1930s what Santayana's *Soliloquies* were to the 1920s, agreed that the gentlemanly virtues had gradually conquered England, but he thought they were sustainable over long periods and for masses of people only through a severe act of repression and self-denial. Reservoirs of ungentlemanly humanity survived in the masses and might yet be retrieved to make the perfect combination: the Englishman of aplomb and good form and moderation, but with a taste for beauty and self-expression as well.[117]

There were others, however – natives, not conservative – who described the same virtues without reference to the gentleman at all: for the novelist Rose Macaulay and, later and influentially, Geoffrey Gorer, they were just part of the civilizing process affecting all classes; for the journalist Philip Gibbs, they were, on the contrary, evidence of the 'soul of England' surviving underneath

the repressions of civilization and mass society; for businessman Sir Herbert Austin, they were a natural adaptation to the conditions of modern life, of prosperity, education, urbanization; for E.M. Forster, they were the quintessential middle-class virtues (the public school being a middle-class rather than a gentlemanly creation); for J.B. Priestley, they stemmed from 'the natural kindness and courtesy of the ordinary English people', not the toffs at all, who were the 'Big-Englanders' he most disliked, 'red-faced, staring, loud-voiced fellows, wanting to go and boss everybody about all over the world, and being surprised and pained and saying, "Bad show!" if some blighters refused to fag for them'.[118] From the far Right, Wyndham Lewis complained of foreign 'attempts to saddle the Englishman with all the attributes of his middle-class masters', and denied that the public schoolboy was anything like the ordinary 'straightforward, tolerant, peaceable, humane, unassuming, patient man'.[119]

So in different versions, the new type of Englishman could be the gentleman taming the proles, or the gentleman taming the ruling class, or the proles taming the ruling class, or the middle class taming both upper and lower, or indeed the civilizing process taming the whole of society. That flexibility was what allowed the idea of the English national character to function in a still very diverse and divided society. The single thread running between all of these versions was the theme of social harmony, all the classes converging on a national character.

If we look at the depiction of specific traits, we can see exactly how the different versions managed to coexist. Take, for example, one of the most common assertions about the English in this period: that they had a good sense of humour. In many ways this marked a real departure. Eighteenth-century references to English 'humour' implied not wit, still less cheerfulness, but just individuality – a quirkiness or unpredictability that differentiated the English from their Dutch and German kin.[120] Thanks to their depressing weather and a dose of Puritanism, the English were thought generally to be melancholy killjoys and, especially in company, sober, frigid, tongue-tied, stifled and possibly without feelings altogether – 'reticent' and 'reserved'.[121] The stock phrase, thought to have originated in the Middle Ages with poet and historian Jean Froissart, though in reality it appears to have been coined by the duc de Sully, a French courtier of the early seventeenth century, was that the English 'took their pleasures sadly' – one of those usefully ambiguous formulations that could accommodate both pleasure and sadness, though the emphasis here was usually on the sadness.[122]

The rumbustiousness of Mafeking Night and similar effusions of mass celebration had already cast this stereotype in doubt.[123] Then came one of the great discoveries of the war: the rollicking humour of the Tommy – 'such a mirth and cheerfulness . . . as caused the ordinary British private soldier to

THE BRITISH CHARACTER.
RESERVE.

THE BRITISH CHARACTER.
A TENDENCY TO BE HEARTY.

8 The 'British Character' series that ran in *Punch* in the 1930s, by 'Pont' (pseudonym of Graham Laidler), may be remembered for capturing 'precisely' that character, but Laidler was just as interested in sending up the contradictions within the stereotype

sing the snatch of a familiar music-hall song as he sprang "over the top".'[124] There were various ways to finesse this. It was not really humour at all but 'defensive', or it was stoical, cheerfulness in misfortune; it was grumbling or just the reverse – 'mustn't grumble'.[125] One could play it down, call it 'good nature' or 'good temper', and melt it into the older stereotype of equanimity, tolerance and self-control.[126] When Arthur Bryant tried to get H.J. Fleure to go along with a traditional view of the English as melancholy for climatic reasons, Fleure would concede only that there was little 'cheerfulness of the bubbling kind'.[127] Or one could simply deny it. E.M. Forster, who identified the national character with the hated Victorian middle class, called it joyless but hoped it was changing.[128] Foreigners, whose contacts were mostly with the upper classes anyway, showed less interest in the English sense of humour or wrote it off as 'the same exuberance, sentimentality, pathetic weakness, love of gossip, sociability, and touching humility which characterise the poor and the lower middle classes all over the world'.[129]

But for English commentators especially, a good sense of humour fitted nicely with their new self-image as relaxed, genial, happy-go-lucky stay-at-homes. It turned out that they were fundamentally content; their 'grumbling' was really something more cheerful – 'grousing'; they even had a genius for laughter.[130] There was a gentlemanly version of this new stereotype – one that stressed the whimsicality and childlike qualities of the public school or cricket or the sillier bits of high culture. *Peter Pan* (1904) could now be enlisted in support, alongside Edward Lear and Lewis Carroll.[131] More often, though, observers were happy to draw on their new acquaintance with (and sense of solidarity with) the 'man in the street' – the Tommy, the porter, the radio comedian, even, as we have seen, the striker.[132] Now the cliché was subtly inflected, so that the English took their pleasures seriously – that is, enthusiastically; pleasure was the only thing they did take seriously.[133]

Along with the good sense of humour came some allied traits. Far from being cold and unfeeling to others outside their family, the English were fundamentally kind and gentle – to animals, as was traditional, but now also to a much wider array of 'underdogs', including each other. Before the war, tendencies of this sort were disdained as 'sentimentality'; now the same tendencies were more likely to be celebrated – a particular speciality of Baldwin's, who thought the English 'the kindest people in the world'.[134] Kind, merciful, soft-hearted, amiable, even romantic and lovable – all these unfamiliar adjectives were regularly applied to the English between the wars.[135] The more gentlemanly version continued to contrast external coolness, aplomb or 'phlegm' with the true warmth of humanity beneath the surface, but in some formulae, notably Santayana's, the warmth was portrayed so gushingly that it did not seem very far beneath the surface at

all: '[W]hat governs the Englishman is his inner atmosphere, the weather in his soul . . . the atmosphere of his inner man,' he swooned. 'Never since the heroic days of Greece has the world had such a sweet, just, boyish master.'[136] Even Colonel Bramble, said to have 'a contempt for sentiment' (though also for melancholy), was '*au fond* . . . terribly sentimental, which explains everything'.[137] Alternatively, a rather traditional contrast could be drawn between the frigid upper classes and the expressive lower classes, as already seen in the assignment of the sense of humour. In the 1930s, when it was chic to speak of sex, this contrast could be given a further twist by those inclined to Freudianism, like G.J. Renier, for whom 'repression' was the key to the national character and liberation the message of the modern masses.[138]

Curiously, the new association of the English with gentleness and sentiment did not make them appear more feminine, despite the enfranchisement of women and the consciousness of women's emancipation in other spheres. The discourse of national character proved almost impervious to feminization.[139] The English on the whole remained men who had attitudes to women. Even Renier thought that women were women the world over, the only difference being that in England women had to deal with Englishmen.[140] Where considered, they were compartmentalized and assessed upon their looks and housewifery.[141] Men writing about the new English gentleness for a male, middlebrow audience preferred to view it as the results of a process of infantilization (England becoming smaller, even childlike) rather than feminization (England becoming more female). Women writing about themselves for themselves tended either not to employ a national idiom or to employ a national idiom that did not require generalizations about the character of the people. In other words, women's exclusion from the English national character came in part from their own choice to employ different idioms of Englishness, as well as from their exclusion from the national character by men.[142] This is why some historians can argue that Englishness became deeply feminized between the wars, others that it became more masculine.[143] So far as the language of national character goes, it remained as explicitly masculine as ever, yet had traits stereotyped as feminine assigned to it.[144]

One final trait associated with humour, kindness and gentleness, and certainly new to the idea of the national character, was laziness. As with sentimentality, ominous warnings about creeping laziness had been aired since the late nineteenth century and, as with sentimentality, laziness became a more permanent feature of the national character after the war. It was not, of course, worn as a badge of pride; yet neither was it always regretted, because it was seen to form part of that package differentiating the modern Englishman from his harder, more selfish, more driven Victorian grandparent.

Again, officer-class experiences with their men during the war seem to have been very influential. Affection for the men and satisfaction with the outcome of the war meant that the accusation of laziness had to be qualified with the admission that the Tommy always stirred himself when his back was to the wall.[145] This chimed with an older stereotype that the English were basically lethargic, but were capable of impressive bursts of energy, or vice versa (another formula that met all eventualities).[146] That stereotype had faded in the nineteenth century with the rise of a more Teutonized, persevering and materialistic type. Now the basic lethargy could be re-emphasized. For those who were so inclined, the General Strike added fuel to the charge.[147] It was repeatedly claimed that the English were 'work-shy', indolent, unreliable, extravagant, improvident – basically, lazy – traits formerly reserved for Celts and Mediterraneans.[148]

Of course, this was the authentic voice of the badly served bourgeois through the ages – workers never showed up for a job on time, waitress service in London was deplorable (no iced water on the table or grapefruit for breakfast, in contrast to America), clerks in shops were polite but 'extremely slow and inefficient'.[149] But now it was built into the national character. It could still be a source of concern.[150] It could be spun into 'indolence' or insouciance – a gentlemanly capacity, both pre-modern and post-modern, that hid an inner core of grit and determination.[151] Mostly, however, it was grudgingly accepted as a natural concomitant of advanced civilization and a certain level of comfort, these things having long since countervailed against the alleged effects of cool, misty weather.[152]

Since indolence could be seen as a consequence of prosperity – 'England . . . is like a rich old woman whose sole ideal is to keep what she has got', an embittered Beverley Nichols wrote in 1938[153] – it did not necessarily imply a diminution in English materialism.[154] Yet that was a conclusion drawn by many commentators, both those who celebrated the retreat from materialism as richer and more civilized, and those who regretted it as a loss of competitive edge. On the Left, R.H. Tawney urged his countrymen to make a historic choice against 'the acquisitive society' with which they had been conventionally associated.[155] On the Right, Arthur Bryant and W.R. Inge alternately hoped and feared that Victorian materialism had been merely a temporary aberration in a naturally rural, simple and slow-moving people.[156] Modernizing conservatives and radicals alike wondered if a mature society like Britain's could or should keep up. However they felt about it, most agreed, however, that England was no longer a 'nation of shopkeepers'.[157]

Did these new ideas of the national character displace the old ones, or were they in some way deemed compatible? It would be odd if the old stereotypes were displaced entirely, as one of the unstated assumptions of the idea of

national character is – even in this period of greater cultural relativism – that it is timeless. The terms in which it is expressed are left comfortably ambiguous in order to make it so. It is true that inter-war observers had generally given up on 'John Bull', Samuel Smiles' *Self-Help* and the heroic imperial proconsul. The Englishman was not as hard-working, persevering or adventurous as he had once been. He had been urbanized, massified and domesticated. On the surface, he appeared obedient, conventional, lemming-like, obsessed with ritual behaviour, lacking individual character.[158] Yet he still retained an irreducible core of individuality that distinguished him from his European neighbours – if anything, more so in the age of the dictators – though that individuality was now expressed in different ways.

'Self-reliance' did not carry the same cachet that it once did.[159] There was a greater premium placed on kindness and sympathy – made concrete in mutual aid and social solidarity – that was not formerly so much emphasized (though Samuel Smiles wished he had done). Social solidarity did not mean, however, that the Englishman had buried his individuality in the mass. On the contrary, if his outward behaviour was more homogenized and socially conscious, it became all the more important that his inward orientation remained sacrosanct. The new byword was 'self-respect'.[160] It was less about standing on your own two feet and more about knowing your own mind. Reticence and reserve, which in foreigners' accounts especially was thought to have been inherited from the gentleman, symbolized this independence of thought and soul that was the birthright of all Englishmen. Because of the class dimension, it remained more about 'self-control' and 'self-mastery' than about the prevalent American idea of personality; after all, British Conservatives were only just discovering that their working-class compatriots had the same moral capacities as themselves, and they used the idea of national character to acknowledge and celebrate that discovery.[161] But it was also about the exercise of free will and free choice, and especially about the achievement of common goals by means of a million autonomous individual resolutions rather than by regimentation or Diktat.

Again, precisely because it was important to distinguish the well-ordered mass society of England from the well-ordered mass societies of Germany or (latterly) Russia, tremendous emphasis was placed on the propensity of the English to engage in free association. In the nineteenth century, it had been almost impossible to have too much individualism, and the idea of a nation of self-reliant individuals (or families) had seemed perfectly plausible. That was harder to imagine in the early twentieth century, with a stronger awareness of human weakness and difference. Individually, the Englishman – like anyone else – might be useless, too odd or too self-sufficient to make a modern society function. But his kindness and his sentimentality, combined

with his self-confidence and possibly also his sense of kinship with other Englishmen, enabled him to reach out to his fellows and to engage in collective work on a daily basis. There was considerable disagreement as to whether this propensity for united action came from the gentleman or from older and broader currents in the English make-up,[162] but a broad consensus that these resources came from inside the Englishman; they were not imposed from outside, by church or state or Führer or Duce.[163]

Salvador de Madariaga popularized this principle in the formula, 'One Englishman, a fool; two Englishmen, a football match; three Englishmen, the British Empire.'[164] Madariaga's apophthegm appealed because it combined the reproachfulness of Kipling's pre-war diatribe against amateurism – 'ye contented your souls/With the flannelled fools at the wicket or the muddied oafs at the goals' – with a post-war satisfaction that voluntary action had proved effectual after all, not only in 1918 but also in 1926 and 1931 – three 'declarations of the national will' linked not by politics but by character.[165] It also appealed because it leant upon the pundits' favourite exemplar of English associationalism – sport. Cricket, the foreigners' preference (as usual, favouring a gentlemanly interpretation),[166] or football, as in Madariaga,[167] or both, as in Kipling,[168] were the perfect expressions of the English propensity for voluntary association. Similarly, 'good form' (in the gentlemanly version), 'fair play', or, more neutrally, 'playing by the rules' were said to be the classic English prescriptions for combining an inward individualism with social solidarity.[169]

Satisfaction with the formula of free association for common purposes was registered clearly in a new interpretation of 'muddling through'. Victorian individualism had seen little need for concerted association, and what need there was could be catered for by the application of practicality and common sense. Leadership and patriotic obedience had been a Tory alternative. After the Boer War doubts surfaced about both. The Edwardians fretted about the demands of the modern world for professionalism and organization and wondered if individualism and/or amateurism would suffice. New Liberals, eugenists and 'national efficiency' enthusiasts held that 'muddling through' might be a characteristically English way of doing business, but it was not for that reason necessarily a Good Thing. The mainstream of public opinion remained uncertain. While mobilization for the Great War ultimately entailed a great deal of professionalism and organization, in its aftermath 'muddling through' nevertheless came to seem at the same time more English and more satisfactory. The war suggested that, when up against it, the English could work together to a triumphant outcome without compulsion or direction. Edwardian doubts had been misplaced. As one writer said in the midst of war, '"the weary Titan" [was] a gross misnomer'; rather, England was 'a great,

sprawling, overgrown schoolboy, half unconscious of his strength'.[170] The
General Strike and the crisis of 1929–31 provoked similar conclusions. The
alternatives of a bureaucratic or corporate or totalitarian state looked worse
and worse. 'Planning', like abstract thought, was not English;[171] 'muddling
through' was, and would do.[172]

Even a New Liberal like J.A. Hobson, still as much as ever an advocate of
state action to develop the 'social character', was more affectionate and
respectful about this English trait than he and his ilk had been earlier.
Writing 'in praise of muddling through' in 1926, he saw the bright side of
opportunism, anti-intellectualism, common sense and short-termism. They
inoculated against Bolshevism; they made for a 'supple and easygoing'
national policy, responsive to a rapidly changing environment; besides, they
were fun. 'In our light-hearted moods all of us are gamesters; and thinking
spoils sport.' Probably these qualities were essential to true democracy – 'a
mainly instinctive process of the general mind, that common sense always
needed to hold in check the forces of intellectualism and expertise', though
clearly a well-educated 'general mind' was preferable to an ignorant one.[173]

HELLO ! EVERYBODY.

9 Strube's Little Man 'muddles through' the General Strike, as seen in the *Daily Express*,
15 May 1926

These were deeply complacent perspectives; but, then, so much of the inter-war discourse of national character was deeply complacent, especially in the 1920s, when reinforced by foreign sycophants like Santayana, Maurois and Madariaga. In the 1930s, it was not so easy to maintain such 'typically English' aplomb. European liberals continued to idolize the English, increasingly a lonely hold-out against the rule of the dictators, but even these friendly voices now took on a note of anxiety. Could such a kindly, temperate, sentimental, muddle-headed and, what was more, fundamentally mysterious people compete with the dictators in the long run? For the first time, the English national character became an international problem – one that concerned Continental liberals and, reciprocally, came to concern the English themselves.

AS OTHERS SEE US

During the 1920s the English public did not seem terribly interested in what the Continental public thought of it. It was enough to receive, occasionally, dewy-eyed tributes like Santayana's or Madariaga's – testimony to one's lovable unfathomability. Criticisms of the English national character – those denunciations of 'Perfidious Albion' that rolled regularly off French and German presses, or even purportedly more objective accounts – were simply not translated.[174] Around 1930, however, a sudden change of mood became apparent. A flood of foreign guidebooks to the English national character appeared on the market and were snapped up, bearing titles like *England: The Unknown Isle* (by the German Paul Cohen-Portheim, 1930), *Discoveries in England* (by the Belgian Emile Cammaerts, 1930), *John Bull at Home* (by the German Karl Silex, 1931), *The English: Are They Human?* (by the Dutch G.J. Renier, 1932), and *England, This Way!* (by 'Felix de Grand'Combe', pseudonym for the French F.F. Boillot, 1932).[175] Some were English translations of books originally for European markets, others written explicitly for an English audience; some were reports from the front line by, for example, foreign correspondents coming to the end of their London posting, others more anecdotal or polemical.

This wave coincided with a fit of self-inspection on the part of the English themselves, as the political and economic crisis of 1929–31 and its resolution triggered both anxiety and bouts of reassurance. What made this outburst different from the reaction to the crisis of 1926 was the welcoming admission of foreigners to the domestic discussion. 'We are very important these days,' Silex noted in a BBC dialogue with Renier entitled 'Ourselves as Others See Us',[176] broadcast in September 1931. 'That's rather a novelty,' said Renier. 'When I arrived here more than seventeen years ago, foreigners counted for

very little.'[177] Inclusion of the views of 'others' quickly became almost compulsory. One angry listener wrote in to the BBC after Arthur Bryant's 'right little, tight little' broadcasts on the English national character in autumn 1933, suggesting that 'a series of talks on "As others see us" by well-known foreigners' would be a necessary antidote, possibly including, for example, 'a Spaniard's view on John Bull's own brand of sadism as exhibited in prize-fighting, hare- and rabbit-coursing, fox- and stag-hunting, etc.'[178] French, Scottish, Welsh, Irish, German, American and Czech viewpoints dutifully followed.[179]

Within a few years the conspectus of foreign views of the English, along-side domestic views, had become a journalistic commonplace.[180] Nor was the appetite for full-length diagnoses of the English character sated. Books and articles from increasingly divers hands continued to appear on the market up to and beyond the outbreak of war.[181] The reason, of course, was that 'England's crisis' of 1929–31 was seen both at home and abroad as part of a world crisis. It had two dimensions, one economic and political and one diplomatic, and in both dimensions the English national character – and not only the behaviour of English policy makers and diplomats – was seen to be implicated.

In the economic and political crisis, England's foreign friends asked whether the hitherto successful English formula of gentlemanly leadership, voluntary social cohesion and 'muddling through' was not breaking down. The sharpest questioning came from André Siegfried, a French Protestant and Anglophile of long standing,[182] whose *La crise britannique au XXe siècle* (published in March 1931) was not only immediately translated into English but also extracted in *The Times*. Owing to a combination of influences – of which the 'ideal of a gentleman' was one, but imperial delusions, democracy, egalitarianism, proletarianism and the simple self-satisfaction of a rich island nation were others – the English had become weak, lazy, slack and second-rate.[183] This was a problem for England, but it was also a problem for Europe – or at least for liberal Europe, which counted upon a strong, competitive England as a pole of attraction countervailing the growing influence of Fascism and Communism.

Siegfried's diagnosis was too scattershot, and his prescription – basically, that England should become more like his own ideal of France, with the indi-vidualism of the peasant, lower living standards, protectionism, an orientation to Europe rather than to the world – too easily written off.[184] He did crystal-lize a keen debate over how well suited the English national character was to 'modern' European conditions in politics and economics. This debate was confused by disagreement on both what was the English national character and what was 'modern'. Some, notably Renier, followed Siegfried in blaming

the ideal of a gentleman – lax, amateurish and complacent – for England's troubles.[185] Renier's version was arguably more influential in England than Siegfried's because he was more optimistic about the outcome, seeing England as a successfully modernizing people who were blending the traditional virtues of the gentleman with the humanity and progressiveness of the 'Little Man'.[186] Others regretted what they saw as the gradual eclipse of the gentleman, either because they thought him too delightfully picturesque, or often because they thought him still to be one of England's great strengths, or both.[187]

This debate ran out of steam after a few years, principally because England seemed successfully to have weathered its political crisis, at least. The outcome – a 'typically English' compromise of a 'National Government' bringing together portions of all parties within the existing parliamentary framework – was widely hailed, including by Siegfried, as a triumph for the English character.[188] It confirmed what had already been much discussed after the General Strike: the unique nature and intensity of English national cohesion. The English seemed unusually capable of finding a common cause, not by state dictation or regimentation, but organically – either out of deference to an elite,[189] or by 'muddling through', or out of a national preference for tolerance and compromise, or just 'instinctively'.[190] Whatever its sources, this degree of national unity boded well for the economic as well as political future, since it suggested England could be 'modern' – that is, coordinated, planned, cohesive, even machine-like – without the trappings of authoritarian government. As Hobson had argued in 1926, 'muddling through' seemed to offer the perfect combination of flexibility and planning, individual initiative and coordination, making England 'the most united and communal nation of convinced individualists!'[191] When foreigners (and not only natives) said that 'English patriotism is not nationalism', this is one of the things they meant: that English patriotism sprang from the hearts of individuals, not from the order of the state.[192]

Another of the things they meant was that English patriotism was inward- rather than outward-looking,[193] and this attribute – less clearly favourable – was the subject of the second great debate about the English character among European liberals in the 1930s. Here the focus of concern was diplomatic rather than political and economic. British isolation from Continental affairs was, of course, a long-standing concern. Over an extended period, but especially since the years of 'splendid isolation' in the late nineteenth century, a psychological stereotype of the English had been built up to explain their international relations: they were cold and aloof, moralizing and self-righteous, but in reality just as self-interested as any other people, thus 'hypocritical'; because they tended to hide their true intentions in high-flying moralities until forced to come out into the open, they were deemed devious

and treacherous, too – thus 'perfidious Albion'. These feelings about the English intensified in many quarters between the wars, when British policy continued to bear out the stereotype: its aloofness from and ingratitude towards its recent ally, France; its intense selfishness in its relations with Germany, failing to register racial kinship, all disguised in a rhetorical fog of Christianity and internationalism; and its high-minded talk about imperial and international responsibilities, for example to the League of Nations, without the slightest sign of willingness to make any sacrifices towards those ends. Putting these charges in the language of national character, too, made them seem more deeply ingrained and ineradicable: the problem lay not in the minds of a few diplomats but in the hearts and souls of the whole people. And since these charges came most often from the radical Right, they were generally taken to be biologically fixed racial traits as well.

As international tension mounted in the 1930s, this racialist or quasi-racialist Anglophobia became more and more strident, and increasingly a cause for concern in Britain. In 1934, almost immediately after the advent of Nazi power, for example, a previously obscure German geographer named Ewald Banse became briefly a cause célèbre, when his 1932 book *Raum und Volk im Weltkriege* was translated into English, revealing a devastating diagnosis of the 'English popular character'. Banse held the English to have all the basic traits of the 'Lower Saxon peasant', but hardened by a harsh climate, insular situation and 'strict Norman discipline'. Thus they were materialistic, tenacious and self-confident, with an 'egotistical lust for power'; they combined 'free manhood with complete incorporation in the state and society, so that government can rely on popular support at any rate in all questions of foreign policy'; and, of course, they were hypocritical and perfidious, concealing 'a distinctly fiery nature' behind 'a cold and self-controlled exterior' and phony rhetoric – as the novelist Theodor Fontane had observed, 'They say Christ and mean cotton.'[194]

This was bad enough, twisting virtues of which the English were proud (self-reliance, independence, social solidarity, morality) into vices. What was really objectionable was that Banse combined this traditional view of the English character with a version of Siegfried's critique of over-civilization, turning the English into softies and cowards, in a military context:

It is very important to judge English popular character in the event of an enemy invasion. The people, to a man, would certainly rush to arms, and would allow themselves to be mown down in heroic tenacity in front of the Ouse line, or the chalk and jurassian heights, before giving ground step by step. But it is a question whether this people would stand the test of hunger. For centuries bodily comforts have sorely spoiled them, and they would

hardly bear real privations (which during the Great War they never knew, despite rationing). A part of the people would stand even this out of patriotism, but another part would give up the game – which it would no longer feel to be a game – sooner. We confess that it is charming to imagine and to portray the downfall of this proud and secure people at some future time, a people which will have to obey foreign lords in a country unconquered since 1066, or will have to renounce its lucrative colonial empire. Every Englishman and Englishwoman would regard these sentences as a monstrosity, indeed a blasphemy, if they ever came to know of them.

And they did come to know of them, as early as October 1933, when the journalist Wickham Steed leaked them to *The Times* after another of Banse's books had already been suppressed by the Nazis as an embarrassing bit of overfrankness. Then a British publisher managed to bring out a translation of the whole book, despite Nazi attempts to suppress this one, too. Ultimately Banse had to be removed from his post as professor of military science.[195]

A similar controversy flared up in France in the autumn of 1935, when the ultra-right-wing journalist Henri Beraud, inflamed by the combination of English moralizing and inaction, levelled the same mix of accusations against English hypocrisy, self-interestedness and weakness of will – a moment, the historian Philip Bell has suggested, 'when the wilder strains of Anglophobia coincided with rational and well-grounded resentment against British policy'.[196]

One of the main purposes of the burst of writing on the English national character by Continental Anglophiles after 1930 was to rebut these charges. From a Continental liberal's standpoint, it was vital to 'explain' the apparent inconsistencies and inadequacies of British policy by reference to a fundamentally innocuous (or virtuous) national character, in order to build up support for Britain on the Continent and also to reassure the English that not all Continentals misunderstood them. In other words, the national character had to be used to bring Britain and Europe back together, not to divorce them further. One particularly serious and influential book, *The Spirit of British Policy and the Myth of the Encirclement of Germany* (1931), by the professor of law at Kiel University, Hermann Kantorowicz, was (despite its title) almost entirely devoted to an analysis of the English national psychology, because 'it is in the character of a people that what we may call the *spirit* of a policy has its source'. So Kantorowicz focused on those aspects of the English character that the Germans seemed most ignorant about, and that put British policy in the best possible light, and the English edition of his book was aimed at showing the English that Europe might be readier for peace than it sometimes appeared, that Continental politics was not all 'ambitions and terrors'.[197]

As the 1930s deepened, however, and the 'ambitions and terrors' proved all too real, it was no longer enough to interpret England to Europe and vice versa. More of these Continental Anglophiles now pressed for a firmer British policy in defence of English ideals, against havering, appeasement, lip service only to the League of Nations. England owed it to the world 'to be enormously and unswervingly English', as the Czech Karel Čapek wrote in 1937. The world crisis was a crisis of English ideals, and only England could defend them.[198]

The gist of the Anglophiles' argument was simple enough. Yes, the English were insular and self-righteous. But they had reason to be – they had virtually invented the principles of liberty, tolerance, national self-determination and peaceful coexistence that were now recognized as international ideals through the League of Nations, and they had actually lived these ideals for generations while all around them chaos and barbarism ruled.[199] Their high-flown rhetoric was not hypocritical at all: they meant it.[200] In fact, they were not mysterious at all: they were people just like the French or Germans (in this regard, the adoringly mystical rhetoric of Santayana and his ilk was now something of an embarrassment).[201] If you understood their character, you could predict and take account of their behaviour in foreign relations. Their reticence made that difficult, but with effort and sympathy the English character could be penetrated. For example, they had no head for planning or logic and therefore did 'muddle through': this indecisiveness made for a poor foreign policy, but it was not perfidy or bad faith.[202] They criticized themselves a lot – 'grumbling' – but that, too, was perfectly genuine, not an attempt to confuse, and it was not incompatible with aplomb and self-confidence.[203]

For some, like Renier, it was important to deconstruct the now outdated image of 'John Bull' or the 'English gentleman', neither of whom represented the true national character any longer. A new image had to be propagated, something closer to the 'Little Man', who was not cold, aloof, imposing and arrogant at all, but kindly, a bit shy, very human, possibly more like his Continental equivalents. 'Anyhow', wrote the American humorist Ogden Nash in 1936, 'I think the English people are sweet,/ And we might as well get used to them because when they slip and fall they always land on their own or somebody else's feet.'[204]

That same message motivated a good deal of the English writing on the English character in this period. 'There still exists in many heads', regretted *The Times*, 'the stage Englishman, monocled, haughty and humourless, and the stage English statesman in whom these qualities are combined with craftiness and ambition.' Baldwin's usefulness lay in his ability to dispel such images.[205] At the height of international tension in May 1935, Harold Nicolson, one of the great advocates of the 'Little Man' as exemplar of

Englishness, urged strenuously against the 'appalling misconceptions' held about the English by foreigners. The Germans, he thought, had in mind 'a tall, spare man, immaculately dressed in top hat and frock coat, wearing spats and an eyeglass, and gripping a short but aggressive pipe in an enormous jaw', ruthless, cunning, hypocritical, egotistical and opportunist, a cad who talks foamily of fair play. The Americans held a similar image, but more comic. The French think of 'an inelegant, stupid, arrogant and inarticulate person with an extremely red face'. They don't understand our shyness, which they read as pride, or our unwillingness to think things through, which they read as hypocrisy, but '[w]e know that we are patient and good-humoured and very modest, and the least jealous race on earth. We know that we are bewildered and muddle-headed and decent, just as Strube's little man.'[206]

Nicolson, the National Labour MP and former diplomat, knew that this message had to be hammered home if Britain's diplomacy was to work. This was one reason why he was so distressed at David Low's cartoons of Colonel Blimp, which began to run in the *Evening Standard* in the spring of 1934, and which portrayed just the kind of ancient stereotype of the English gentleman that Nicolson was trying to dispel: Colonel Bramble *redivivus*, complete with stiff upper lip, blind self-confidence, a slew of social prejudices, xenophobia, quirky ('sentimental') contrariness, and unpredictability masquerading as principle. Blimp was not meant to be a depiction of the national character, only of the ruling class, but Nicolson thought him uncharacteristic even of the ruling class. Once the Second World War had broken out, he begged Low to put Blimp to rest: granting grudgingly that Blimp may have had some use in an attack upon Britain's wayward foreign policy in the late 1930s, now, he argued, the propagation of such stereotypes only undermined the war effort.[207]

The tension between Low and Nicolson reminds us that stereotypes of national character in this period, however much their advocates strained to make them appear consensual, always had their critics. There were sufficient differences about what was the national character to permit considerable dissent from inside the discourse. One could defend the national character by distancing it from the gentleman, either from the Left, advocating a more populist self-image, or from the Right, from where Winston Churchill, for example, stuck up for a bolder 'John Bull' image.[208] Churchill and others worried both that Strube's 'Little Man' represented a depressed national morale and that his elevation as an icon would only depress it further.[209] But in the 1930s, it was also increasingly popular to savage the whole idea of national character as a swindle aimed at blurring social distinctions or under-mining internationalism. That was what Low was aiming at by portraying in his cartoons both a parodic Colonel Blimp and an anonymous 'Little Man', looking on quizzically. Possibly aloofness and scepticism were expressions not

As Others See Us

How the English Appear to the Foreign Mind

By the Hon. HAROLD NICOLSON

10 Harold Nicolson's contrast between the English 'as others see us' and 'as we see him ourselves' (Strube's Little Man), from the *Listener*, 15 May 1935

Correspondents in the press deplore the loss of JOHN BULL from cartoons and the modern representation of the average Englishman as "an undersized, flustered, bewildered and apparently half-witted individual."
(Is STRUBE'S face red?)

By *!!!$!le! this must not go on, sir!

Low's Topical Budget 1 April 1939 *Evening Standard*

11 David Low pokes fun at those who wished to ditch the Little Man and bring back John Bull (here compounded with his own Colonel Blimp, from the *Evening Standard*, 1 Apr. 1939)

of nationality but of anti-nationality. That possibility was admitted with some horror by a populist patriot like George Orwell, who pinned it on the intellectuals and blamed it for sapping the national will to stand up against the dictators. He had a similar (though more ambiguous) dislike of those *New Statesman* readers who 'snigger at Colonel Blimp and proclaim [their] emancipation from all traditional loyalties'.[210] And although the events of the early 1940s dispelled such anxieties, in fact the Second World War did witness a sea change in attitudes to the national character, such that the conventional norms of the inter-war years were progressively undermined.

ENGLAND, WHOSE ENGLAND?

Orwell's wartime sneers, lobbed at Communists with their external loyalties and at cowards like W.H. Auden who had fled overseas, were common enough – and understandable – in 1940. It was easily self-exculpating to blame the disastrous drift of foreign affairs in the 1930s, retrospectively, on a small gang of intellectuals; in addition to Auden and the Communists, the Bloomsbury group were a favourite target.[211] But it was too easy. Orwell's indictment at least extended to the 'Blimp' class, who were just as culpable as the intellectuals but not as unpatriotic, and whose public-school instincts kicked in to rally them to the flag in 1940. Yet a more honest retrospect ought to have extended to consider the complicity of prevailing ideas about the 'English national character' itself. As we have seen, there was no shortage of self-consciousness of the 'English national character'. It was simply not couched in sufficiently political or militant terms to provide an adequate bulwark against the rise of the dictators. In short, responsibility for appeasement and its consequences might be laid not only at the feet of intellectuals and Blimps, but at the feet of the English people themselves, at least in part owing to the way they had constructed their 'national character'.

There had been some worries of this kind raised in discussions of the 'Little Man' and his suitability to direct a great power, but on the whole these had been swept aside either by resort to the leadership qualities of the 'gentleman' or, increasingly commonly, insistence on the almost metaphysical ability of 'Little Men' to act as one when the national or international interest required it.[212] Anglophiles were hardly likely to admit that the 'Little Man' had such a weak side, and Anglophobes were not heard. It was only after disaster was averted in 1940 that candid observers were able to admit that the average Englishman had become dangerously detached from the public sphere. Some of the very traits that had been proudly hailed as 'quintessentially English' – absorption in home life, pottering in the garden, self-possession and aplomb – had nearly proved fatal, to England and to Europe. There had been some

truth in 'the accusation in the uneasy period between 1934 and 1939', granted A.J. Cummings in November 1944, 'that they were prepared to present half the world to Herr Hitler on a silver salver if only he would leave them to their own agreeable and prosperous devices, to their motor cars, their cinemas, their bungalows, their holidays at the seaside, their multiple shops, to all the congenial paraphernalia of a thriving and developing trade'.[213]

Such an admission articulated the possibility that English complacency before 1939 had derived not from a patriotic 'insularity' but rather from more generic distractions and alternative loyalties that were becoming endemic to modern society. English people might have turned away from the blaring trumpets and stamping jackboots of Continental nationalism not out of a preference for a more modest and understated 'Englishness', but simply to 'cultivate their garden'. In many ways that seemed the 'modern' thing to do. It need not feel narrow-minded, xenophobic or 'insular' at all.[214] For one thing, it united the English consumer with the modern American, whose lifestyle was increasingly seen and admired in the films, particularly by women and young people. For another – here the intellectuals undoubtedly did play a role – it chimed with a 'pacifism' and an 'internationalism' that many writers and artists were prescribing as the coming creed for a world sick of war and industrial strife and petty political bickering.[215]

Perhaps 'Englishness' was the backward-looking option? Certainly there was a marked decline, from the First World War onwards, in the number of books on English history published. History in general was something of a drug on the market. There were exceptions – some of them in the traditional whig vein, like the works of G.M. Trevelyan, but more of them a new kind of global history, typified by H.G. Wells' *Outline of History* (1921, the biggest seller of the period), which portrayed English history as having been swept up in a greater, longer-term movement towards a world united by modern communications, growing prosperity, and social and physical mobility.[216] As nearly everyone granted in 1940, this proved a dangerously complacent stance for a people faced by a Hitler or a Mussolini; but it was not a stance that could be blamed solely on the likes of W.H. Auden or Virginia Woolf, or even Neville Chamberlain. And it was a stance to which, once Hitler and Mussolini were dealt with, many people would return.

In addition to those uninterested in the reflection offered them by depictions of the national character, we must also take into account those irritated by that reflection – those who believed in nations but did not feel that the dominant representations looked like them. More people fitted into this category in the increasingly fractious 1930s than ever before. Popular film of that decade that sought to reflect the interest in the national character evident in print (the work of J.B. Priestley, who practised in both media, is an obvious

example) had to resort to increasingly ingenious devices – diverse casts of characters, multiple and interweaving narrative lines, kaleidoscopic effects, montage, symbolism – to capture 'unity in diversity'.[217]

Not everyone was convinced. Women, as we have noted, were often explicitly excluded from characterizations of the 'Englishman', and although the predominant reaction was probably to opt out – to cultivate the garden – there are signs of outright rebellion, which responsible authorities such as the BBC were keen to recognize.[218] People of non-British origin, still a small minority in the resident population, were more frequent visitors and more vocal dissidents, too – particularly South Asians balking at imperial oppression or condescension.[219] Most common of all were protests from a class perspective that the received views on the 'national character', however far they stretched to define homologies featured in all classes, reflected the self-perceptions of only an elite minority. Often these protests concluded not that a more ingenious formula could properly capture social diversity, but that social diversity was so great as to invalidate the idea of national character – though not necessarily the nation: as socialists pointed out, there were other representations of the nation that could capture social diversity, indeed were designed to do so, principally the state.[220]

12 How to visualize 'unity in diversity'? J.B. Priestley's *The Good Companions* adopts the metaphor of the travelling troupe of entertainers, pictured here clustered variously around a table in the film version directed by Victor Saville (1933)

How far this detachment or alienation from the idea of national character went before the Second World War is hard to estimate. The advent of war in 1939 appears to have eliminated or suppressed it. The Second World War in many respects marked the high watermark of the prevalence and cultural authority of the idea of national character in modern British history. It was certainly the only war in which the national character was seen simultaneously as providing the means of war fighting – its principal weapon – and the ends, setting the aims of war – 'the people's war', as it has become widely known.[221] That testifies to the strength of the inter-war discourse. Yet the heightened consciousness of national character during the war stretched its usefulness to breaking point, and the wartime tensions and postwar decline in the idea therefore provide evidence also of the weaknesses that can be traced back before 1939.

The uses of the language of national character during the war have already been much studied. We can detect three generations of interpretation. First, from the very beginning of the war, Orwell and like-minded patriots roughly on the Left rather suddenly decided that English self-consciousness had hitherto been too pallid and needed to be shored up. They blamed the intellectuals and upper-class appeasers and looked to the working classes or people of 'indeterminate social class' between the working and middle classes to inspire a revival.[222] Substantively, this involved the annexation of 'Little Man' stereotypes that had actually been generated by the allegedly unpatriotic older generation, but galvanized and democratized to make them suitable for wartime use and to prepare the ground for a post-war reconstruction of society. Fortunately for this interpretation, the 1945 general election brought a Labour government to power that was able in part to effect such a reconstruction, and so the English people of the 'people's war' lived on into the 'people's peace'.[223]

The breakdown of the post-war consensus in the 1970s and 1980s, however, elicited a new interpretation of the 'people's war'. In this second version, the 'people's war' turned out to have been something of conservative myth – a myth not in the sense that it had falsified the story, but rather in the sense that it had sustained an aura of nostalgia and complacency. The Blitz had not, in fact, created a popular democracy; it had not reconfigured Orwell's 'family with the wrong members in control'. While it had made possible some social changes, it had also cultivated self-satisfaction and thus shored up deference to traditions, including pernicious militarist and hierarchical traditions, and the rule of entrenched elites.[224] Here leftist critics of Thatcherism rediscovered (though they did not put it in these terms) what inter-war writers on Englishness had known well: that the 'Little Man' and the gentleman were fully capable of peaceful coexistence.

Finally, in the last decade or so, as the direct impact of Thatcherism has ebbed, historians have begun to rediscover the subversive elements of the national character unleashed by war – not so much those that laid the foundations of the welfare state as those that triggered subsequent anti-Establishment, feminist and multi-cultural rebellions. These latest re-evaluations doubt that there has been anything like a 'national character' at all in the post-war world, and trace back to the Second World War the origins of our current, fragmented, multi-cultural state, keenly sensitive to the plurality of 'identities' and to the artificiality of collectivities such as 'nation'.[225]

If we look closely at the wartime language of national character, we can see that all three interpretations have their merits. There was, undoubtedly, a current – by midway through the war it was the dominant current – that sought consciously to evoke a national character that was at the same time both familiar and more dynamic and democratic. Evidence can be found in the sharp struggles that took place over the depiction of the national character in official propaganda between 1939 and 1942. The first instinct of Chamberlain's government was to fall back on very traditional conservative images that invoked patriotism – the nation that was fought for rather than the people doing the fighting. Early propaganda from the Ministry of Information and the BBC – Alexander Korda's film of autumn 1939 *The Lion Has Wings*, or contemporary BBC output later scorned as 'the speeches of Queen Elizabeth . . . linked by snatches of Elgar to the sonnets of Rupert Brooke' – revived self-consciously the spirit of the Great War.[226] From the beginning, however, there were doubts about the efficacy of this approach. For one thing, it did not chime with the portrayal of the English people that had been carefully cultivated ever since the Great War – little men, not John Bulls, essentially human-scale, kind and likeable, their patriotism contrasted to nationalist bluster. 'To be opposed to Hitler it is not necessary to be a patriot – it is necessary only to be a normal man,' as one correspondent to the *Listener* put it in June 1940.[227]

Churchill's premiership, with its more aggressive leadership and its more genuinely 'national' complexion, provided an opening for such impulses, although Churchill's personal role was equivocal. Nevertheless, from all sorts of official as well as unofficial sources, a new note was struck. 'To some people there was something almost indecent, as well as platitudinous about that lyrical affirmation, heard so much a few months ago, that "there'll always be an England",' the BBC granted in July 1940. 'The BBC has no intention of . . . setting up standards of self-conscious nobility that are foreign to our nature as a people.'[228] There began to emerge depictions of a new kind of Englishman, similar in many respects to the 'Little Man' of the inter-war years, but more active and decisive (a fit opponent for the dictators), and less fettered by his ambiguous relationship to the 'gentleman'.

The best-known and most influential purveyor of this new depiction was J.B. Priestley, whose 'Postscript' broadcasts after the Sunday evening news in the summer of 1940 and winter of 1941 were highly controversial and immensely popular.[229] As he had done in the 1930s, but now to a much larger and more attuned audience, Priestley described the English to themselves as 'likeable human beings, cracking jokes with their wives and sweethearts', kind, humorous, 'warmly imaginative', cheeky and charming.[230] All that was in the soul. Where they had gone wrong was in letting these traits be muffled or suppressed by snobbery and officialdom. For years, Priestley had worried 'that there was a real danger of these pundits and mandarins creating a rather thick, woolly, dreary atmosphere in which that national character of ours couldn't flourish and express itself properly'.[231] Dunkirk showed that this danger could be – and, for the sake of the war and England's future, must be – averted. 'It was very English in what was sadly wrong with it . . . we must resolve never, never to do it again.' Do away with the Blimps and their 'woolly, pussy-footed officialdom', their 'coldly rational' punctilio, and their muddling through, and the true mettle of the ordinary Englishman would become clear as it had not been clear before.[232] He was not just a quiet, dreamy, inward-looking gardener, but 'so grand and gallant' (as the 'little pleasure-steamers' saving the day at Dunkirk had shown), brave and well organized, not just improvisatory but in fact full of 'heart, and height of imagination': 'Always, when we've spoken or acted, as a people, and not when we've gone to sleep and allowed some Justice Shallow to represent us, that lift of the heart, that touch of the imagination, have been suddenly discovered in our speech and our affairs, giving our history a strange glow, the light that never was on sea or land.'[233]

A similar picture was sketched by George Orwell in what has endured as the most famous wartime statement of the national character, *The Lion and the Unicorn* (1941). Orwell also took over the basic 'Little Man' stereotype, gentle and good-natured, rooted in 'the back garden, the fireside and the "nice cup of tea"', though, as left-wing writers had tended to do before the war, made him more proletarian, adding 'the pub, the football match' to his habitat and bawdiness, irreligion, gambling, xenophobia and hobbyism to his habits. 'We are a nation of flower-lovers, but also a nation of stamp-collectors, pigeon-fanciers, amateur carpenters, coupon-snippers, darts-players, crossword-puzzle fans.'[234] Less encumbered than Priestley by the hortatory demands of broadcast propaganda, Orwell did not have to romance up these traits into bravery, efficiency and imagination. He was too well aware of the sloppiness and hypocrisy that had pervaded the whole pre-war culture. But he shared Priestley's belief that '[t]he heirs of Nelson and Cromwell . . . are in the fields and the streets, in the factories and the armed forces, in the four-ale bar and the suburban back

garden; and at present they are still kept under by a generation of ghosts'.[235] He retained some optimism that if the Blimps and the intelligentsia were shaken off an 'English revolution' could be wrought that could win the war, and the peace. The new England would retain '[t]he gentleness, the hypocrisy, the thoughtlessness, the reverence for law and the hatred of uniforms . . . along with the suet puddings and the misty skies' but would permit social modernization that would foster new attributes necessary to displace totalitarianism: technical expertise, more widely distributed education, more social equality, more economic efficiency.[236]

Orwell's and Priestley's were the most widely diffused versions of this self-portrait, and have lingered in the national memory. But they were not the only versions at the time. Theirs was a recognizably left-wing version, which took on more weight as the country swung to the Left – a process that had begun in the mid-1930s.[237] There were also less clearly left-wing variants. For instance, those who felt that the amateurish spirit of the gentleman had not only overlaid but also infused English culture were not able to fall back on the sturdiness of the working-class character. The task of galvanizing the nation was from this point of view a more difficult one and involved making appeals to the gentlemen as well as to the masses. This was more or less the view of the team responsible for translating David Low's Colonel Blimp to the silver screen in 1942–43 – the film-makers Michael Powell and Emeric Pressburger, and also Powell's first choice to play Blimp, Laurence Olivier. 'Englishmen are by nature conservative, insular, unsuspicious, believers in good sportsmanship and anxious to believe the best of other people,' wrote Powell to the War Office, explaining his ideas for the film in order to get official authorization. 'These attractive virtues, which are, we hope, unchanging, can become absolute vices unless allied to a realistic acceptance of things as they are, in modern Europe and in Total War.'[238] Olivier's view of the initial treatment was that it did not show forcefully enough '*how* the English constitutional complacence has re-set the English nature time and time again simply by various attitudes of good taste . . . It must have been industrial success coupled with the smug knowledge that we had never abandoned our aristocracy (like the French) that made "the Thing" our religion and the old school tie, our gonfalon. I believe our national carelessly flung public school and family clichés have been far more potent in moulding our character, than the most forceful slogans in the totalitarian states . . . Ever since Drake. It has been "we'll muddle through" . . . And when, every quarter of a century or so, some Nelson or other by sheer genius has saved our bacon for us, all it has really done has been to justify our attitude – to us.'[239]

Olivier's diagnosis reproduced that of the more cynical inter-war observers of the gentleman. But it did see in the wartime moment some chance to knock

the English out of their constitutional complacency. Powell and Pressburger
were in fact slightly more sympathetic to Blimp, who was 'made, not born',
and furthermore did embody some signal virtues (loyalty, a sense of honour,
geniality). As befitted a character in a feature film rather than in a cartoon, he
was not a caricature. However, this portrayal was still too critical for the War
Office. It reminded the secretary of state for war too much of the intellectual
carping that during the 1930s had so lowered national morale. The Ministry of
Information, which was more tolerant of the Blimp project, still worried about
the negative tone, especially what they saw as an attack on 'the British outlook
on life as expressed in the terms of sportsmanship and fair play'.[240] It remained
the majority view, at least in government, that traditional English virtues, now
that they had been roused by Churchill and the Blitz spirit, were sufficient to
fight and win the war, without the need of a 'revolution' either in the constitu-
tion or in the character. The virtues to be emphasized were not egalitarianism
or efficiency or initiative or imagination, but rather stoicism, tenacity, 'team
spirit', compromise, pragmatism and, above all, that long-suffering 'sense of
humour'.[241]

"Is it all right now, Henry?"
"Yes, not even scratched"

13 The 'Little Man' in war (from the *Daily Express*, 29 Aug. 1940), still 'muddling
through', but was 'muddling through' enough this time around?

It is this emphasis that concerns the modern-day critics of a 'conservative' or 'mythologizing' wartime discourse. The long-suffering, good-humoured, pragmatic and compromising Englishman was no model for the active citizen that these critics look to in a modern democracy. One of the most resonant characterizations drawn from this lexicon was 'a nation of gardeners' – a self-description offered by Frank Gibbons in Noel Coward's script for the popular wartime film *This Happy Breed* (1944), intended explicitly, as Jeffrey Richards points out, to evoke comforting memories of pre-war suburbia and to prepare for a post-war 'return to normality'. When Gibbons amplifies, 'We've got our own way of settling things, it may be slow and it may be a bit dull, but it suits us all right and it always will,' he is hardly describing the more democratic or more resourceful Englishman foreseen by Priestley and Orwell.[242]

This model of Englishman, too, required leadership from above. This was a tricky subject in wartime. It was a natural and easy instinct to blame the drift to war on the failings of an outmoded ruling class, and this feeling, if anything, grew during the course of the war. Fewer anatomies of the Englishman placed such explicit emphasis on the virtues of the gentleman: 'John Smith' was more to the fore.[243] This explains the general puzzlement that greeted the more sympathetic portrayal of Colonel Blimp in the film adaptation. What were Powell and Pressburger saying? That 'muddling through' was good enough after all? That the only alternative was Prussianism? Or – as was in fact the case – something in between?[244] The men in Whitehall who thought the message was far too sophisticated for wartime propaganda may have had a point. On the other hand, few people thought that Blimp was meant to represent the Englishman.

Scepticism about the gentleman as the very type of the Englishman did not preclude admiration for acts of chivalric heroism as performed by RAF pilots, or indeed national leadership by hero gentlemen, such as Churchill appeared to provide. Churchill probably did view himself in something like those terms. He had a decidedly Great War cast of mind when it came to the military side of things in particular, feeling that traditional 'king and country' patriotic appeals ought to be sufficient to galvanize the armed forces and that criticism of the officer corps of the Colonel Blimp kind ought not to be tolerated.[245] On the other hand, he knew well that his career had been resurrected because Chamberlain and his ilk had been seen to fail in the leadership stakes. Accordingly he did – vividly, memorably – summon up the spirit of the English people in his great wartime speeches, but in such an orotund and sometimes Olympian way as to draw as much attention to his own leadership qualities as to the capacities of the people themselves.[246]

In this way, as historian A.L. Rowse said at the time, he brought together 'the old historic ruling class' and 'the solid representatives of the working

class' without wanting or needing actually to bridge the divide – a very tradi-
tional Tory solution to the problem of national character.[247] Churchill, too,
therefore, might be said to have reinforced the view of the English as a noble
but essentially passive people, needing to be summoned by their leaders to
great things.

So there were multiple national characters in play during the war, some more
bourgeois and some more proletarian, some more passive and some more
active, some looking backwards and some looking forwards. This is only to be
expected from what was, after all, the first war fought by Britain in which the
character of the people was universally acknowledged from all points of the
political spectrum as the key to winning the war, and even to deciding what
the war was for. It was, consequently, the first war in which all of the people –
on home front and war front alike – were constantly bombarded with intimate
descriptions of what they themselves were like.

For this reason, as we are only just beginning to appreciate, it was also the
first war in which character fatigue clearly manifested itself. This fatigue
sprang from a number of different sources. First, there was the tendency,
reaching back to earlier in the century (and further back still to nineteenth-
century liberalism), for the English to think of themselves as a people uniquely
unneeding of, or at least unused to, appeals to their public character. In
1939–40 many were put off by the 'king and country' propaganda initially
aimed at them. It was the overtones not only of the Great War but also of
Nazi propaganda that made them uncomfortable. Although the evidence
suggests that the public was more receptive to the populist alternatives that
were employed to rally them in the Battle of Britain and in the mobilization
for total war that followed, these appeals could still carry unpleasant echoes of
nationalist bluster. Efforts were made, for example, to target not Germans but
Nazis in propaganda aimed against the enemy.[248] The argument that the war
was being fought in defence of English, British or even European values had
to compete with a powerful alternative discourse of 'human' and 'universal'
rights and values. One effective mouthpiece for this discourse was the new
BBC 'World Service', as the Empire Service had been renamed in 1938 when
it widened its remit and began foreign-language broadcasting. The 'civiliza-
tional' perspective was back; it had never completely vanished, nor been so
totally saturated in ethnocentrism as to be unrecognizable.

Furthermore, there was evidence that these less specifically national war
aims resonated with the public. Particularly after the release of the Beveridge
Report in December 1942 there is a keener utilitarian edge to people's imag-
inings. They might be indomitable and tenacious, they were undoubtedly
determined not to be pushed around and they wished to speak up for the
underdog: but they also wanted a reliable income, a steady job, better housing

and health care.[249] And it suited reforming politicians to turn their focus to these things, partly owing to a second factor that made the English national character outmoded, which was that a fully mobilized nation could not recognize itself in such a homogenized stereotype.

Historians have outlined this process as it applied particularly to women (who were very poorly catered for in national stereotypes) and to the Scots, Irish and Welsh (who were equally badly served by a discourse about the 'English').[250] But the principle applied more broadly. The inter-war stereotypes, even the most capaciously ambiguous, worked because their audiences were relatively compact and self-selected. Scots and professional women were not forced to buy copies of *The English: Are They Human?*, and one imagines few did. But war propaganda had to aim at a true lowest common denominator, and it was not easy to find that in the language of the English national character. Instead, war propagandists and politicians naturally preferred to adopt a language of Britishness, and a Britishness that talked not so much about the people (who were various) as about the state (which could offer something to everyone). It was possible simply to adapt the language of Englishness to Britishness, and many did: 'when I say "English" I really mean British', was Priestley's covering apology in his very first 'Postscript'.[251] But such a thin excuse might only aggravate the offence. Better to stick to subjects that could be truly termed British: Parliament, the government, the social services, the promised nationalized industries, the 'citizen'.

Citizenship was an increasingly favoured subject in political circles in the closing years of the war. On the Right it smacked of responsibility, on the Left of entitlement. When the Army Bureau of Current Affairs drew up its educational programme for the troops in 1942 – over Churchillian objections that, again, 'king and country' ought to suffice – its important series of booklets, 'British Way and Purpose', had singularly little to say about the 'national character'; it was nearly all about the generic 'citizen', who could have lived in almost any country.[252] Only one brief section on 'What We Are' raised 'the question of national character', suggesting that contacts with soldiers of other nationalities ought to provide opportunities to test whether it existed. But it also answered its own question: 'human nature is much the same in all beings. The outstanding character which distinguishes man from other animals is that he is far more educable . . . And this capacity does not depend on his nationality or his race.' This answer allowed 'BWP' to deal briskly with race and put itself on the side of 'human rights'. But it had the further advantage that it moved the discussion of 'What We Are' onto social and economic structures and practical questions of population, jobs and living standards.[253]

Contemporaries noticed at the time, and historians have often observed since, that many of the high ideals voiced during the war seemed to dissipate

with horrifying speed after 1945. While this observation has been applied often to social and cultural ideals – the 'New Jerusalem' of socialism, the vision of an active citizenry and of a people thirsting for education and culture – historians have not yet ventured to consider whether it might apply to sentiments of nationality as well.[254] How long did the 'English national character' so frequently evoked during the war survive in the hearts and minds of its nominal subjects after the war was over?

CHAPTER 6

England After Character?

The outcome of the Second World War seemed to vindicate the English national character – both the idea that nations did have a character and that, in the English case, it was made of the right stuff. The people that had seemed to be dwindling to a passive, narcissistic nothingness in the period of appeasement had proved their mettle when their backs were against the wall. In the immediate postwar environment, these characteristics could be seen again – briefly – as something that the rest of the world could use. Yet in a scant few years confidence in national characters of any kind, and of the English kind in particular, was already markedly on the wane. By the late 1950s, comment on the strength and virtues of the English national character – of a kind that had been standard for a generation among both the English and admiring foreigners – was dying out.

When a new crisis of national confidence hit with Suez in 1956 – a crisis similar in many respects to that which gripped Britain after the Boer War – responses and antidotes were no longer framed so clearly in terms of the national character, what had happened to it and how it might be reformed. Democratic society found it hard to blame itself for such disasters; it was easier to turn the heat on elites and institutions. The growing individualism of western societies in general reduced people's willingness to see themselves as psychologically group formed. Did this mean that 'the nation' itself was shot? Not necessarily. Social scientists begin to talk less of 'national character' and more of 'national identity': the consciousness of belonging to a group, though not necessarily sharing with it all one's innermost qualities. This was compatible with other forms of identity, including a sense of individual uniqueness. Still, the post-Suez mood in Britain generated concern that as national character dissolved, national identity dissolved with it. Fifty years on, at the beginning of the twenty-first century, the question remains, can the nation survive its loss of character?

AFTER THE WAR

Over half a century after the end of the Second World War, it is widely felt that 1945 marked the last point at which Britain enjoyed true national unity. In the immediate aftermath of war, however, the feeling was rather that the wartime experience had vindicated longer-term assumptions about the national character, which could thus be safely projected into the future. The post-war literature thus resembled in many key respects, and often explicitly cited, the deeply complacent theses on the national character so lovingly adumbrated in the late 1920s and early 1930s. George Orwell's voice was slowly, sadly fading, muted by tuberculosis and then finally extinguished in 1950, but Ernest Barker, Arthur Bryant and J.B. Priestley were still in fine, full-throated fettle, and George Santayana, Salvador de Madariaga, Karel Čapek and G.J. Renier were still much on people's lips.[1] An unsettled international situation even in certain respects re-created the atmosphere of the 1920s, in which England's virtues might still be wheedlingly solicited by Continental supplicants.

The wider international setting was certainly favourable for continued consideration of national character. As after the First World War, the post-war settlement was founded not so much on internationalism as on the community of nations – the League of Nations, the United Nations. The cultural organ of the United Nations, UNESCO, saw as one of its principal tasks the improvement of understanding between the nations, by which it meant understanding of each other's peculiarities rather than the fostering of homogeneity. The first two executive secretaries of UNESCO were in fact British intellectuals – Alfred Zimmern and Julian Huxley – who had devoted their lives to cultivating the comity of nations. Huxley was one of the motive forces behind UNESCO's best-known post-war project, the 'Statements on Race'.

The first statement, released in July 1950, was written by the British anthropologist Ashley Montagu, very much under the influence of the work of Huxley and A.C. Haddon in the 1930s. It denied the salience of biological race in defining human social groups like nations, proposing instead the category 'ethnic group', which had earlier been favoured by Haddon, Huxley and Montagu. What made this statement controversial was its assertion that 'the range of mental capacities in all ethnic groups is much the same' and that cooperation between ethnic groups was as much a feature of human experience as competition – an article of faith in UNESCO circles but deeply objectionable to some in the United States, where the politics of racial difference was still highly sensitive. A second 'Statement on Race', issued in June 1952, again asserted the uselessness of racial categorization in determining differences between nations, but omitted the emphases on racial equality and cooperation.[2]

Other UNESCO projects returned to the theme of national difference as a source of human strength and diversity rather than conflict and competition. The 'Tensions Project', established in 1947, aimed among other goals to explore national stereotypes, not so much to challenge them as simply to establish them more scientifically (based on opinion polling) and thus to improve international understanding on a rational basis of national difference. The published version of the 'Tensions Project', which appeared in 1953, went so far as to describe national stereotypes as the 'common property of the Western culture'.[3] UNESCO also sponsored the 'International Studies Conference', which published a series of studies of national differences in 'way of life', the British volume of which appeared in 1955, more sociological than psychological, and fairly anodyne at that.[4]

At this international level, much of the impetus for positive studies of differences in 'national character' came from the United States and Britain, and particularly from the United States. This was a natural reflection of Anglo-American leadership in social science after 1945, but more particularly of the strong sense of exceptionalism that the British had had, and that the Americans as a rising superpower were developing. During the war the Allies had sponsored studies of national character designed to ease their own relationship and also to crack the secrets of their German and Japanese adversaries.[5] At the dawn of the Cold War, the same study groups were now gearing up to probe the psychologies of new Russian and Chinese adversaries, and to compare them unfavourably to their own. The continuities were clear and direct. The concern to explain the 'authoritarian personality' in the German and the Japanese context was carried over into a Russian context, in all cases counterposed to the conditions favouring individual liberty in the United States and Britain.[6]

The connection formed during the war between the American anthropologist Margaret Mead and the British cultural critic Geoffrey Gorer, which led to their joint work on Anglo-American relations and on the Japanese character, was institutionalized after the war in the Columbia University project 'Research in Contemporary Cultures', directed by Mead from 1947 and funded by the Office of Naval Research, which employed Gorer while he worked on books on *The Americans* (1948) and *The People of Great Russia* (1949).[7] In the latter book Gorer set out his controversial 'swaddling' hypothesis in which the 'authoritarian personality' was traced back to the Russians' practice of binding their young tightly in infancy. This hypothesis probably did more than any other to discredit the idea of national character in the long run. But in the short run it illustrated nicely the prevalent assumptions of the Mead–Gorer group – the Freudian emphasis on early childhood practices and the conviction that a 'whole personality', and

indeed a 'whole culture', could be extrapolated from these – as well as the Cold War context in which they were embedded. Around 1950 Mead was explicitly angling her research towards an explanation of what might trigger confrontation between Russia and America and how it could be avoided. The high watermark of this work was the 'manual' published by the Columbia University team in 1953, edited by Mead and Rhoda Métraux under the title *The Study of Culture at a Distance*, to which Gorer contributed the chapter on the idea of national character.[8]

In addition to these specifically Cold War contexts, the idea of national character had special purchase on American culture in this period – partly because Americans sought explanations for their exceptional success in the same way that the nineteenth-century practitioners of the 'Comparative Method' had sought to explain the unusual emergence and survival of liberty in Victorian Britain, and partly because Americans were increasingly turning to social sciences of all kinds for practical solutions to social problems. Thus the two most influential books on national character in the early 1950s both took the American character as their subject. David Potter's *People of Plenty: Economic Abundance and the American Character* (1954) aimed to explain America's exceptional economic success; David Riesman's *The Lonely Crowd: A Study of the Changing American Character* (1950) aimed to explain why Americans were so lonely, and also to help them be less so.

These international and especially American contexts certainly raised the intellectual profile and respectability of the idea of national character to an all-time high, including in Britain.[9] But of course the British had their own powerful reasons in the immediate post-war years to anatomize their national character, and to do so in their own ways, reflecting the pre-war tradition. Some of the therapeutic uses of national character were controversial enough in early 1950s America; in Britain, prying into such private corners as child-rearing practices and sexual impulses was even more so.[10] But there were ample public grounds to celebrate the national character, firmly re-established by wartime. The doubts that had surfaced in the 1930s about whether the 'Little Man' was quite up to the demands of dealing with dictators were, generally, dispelled by his performance in the Blitz and in ultimate victory over the Germans and the Japanese. Though perhaps slow to anger, slow to bestir himself, he had proved that – as the cliché had it – when pushed, he could summon up ample energy and fight with the best of them. Fairly conventional celebrations along these lines were therefore a feature of the late 1940s and into the 1950s, notably Orwell's little booklet on *The English People* (written during the war but published in 1947) and a blockbuster collection of essays on *The Character of England* edited by Ernest Barker, which also appeared in 1947.

At the same time, uncertainty about the future of shell-shocked France and Germany before the advent of the European Economic Community and the *Wirtschaftswunder* caused foreign elegists of the English spirit to resume their pre-war calls for the English to come out of their shells and take up the leadership of Europe, bearing worryingly familiar titles like *The English Way* (Pierre Maillaud, 1945), *The Amazing English* (Ranjee Shahani, 1948), *England, The Mysterious Island* (Paulo Treves, 1948), as well as those complacent surveys 'as others see us'.[11] The most popular of all such works, George Mikes's *How To Be An Alien*, appeared in 1946. Virtually a parody of the genre, it quickly eclipsed those earlier books in whose footsteps it trod, so that today no one remembers Renier or Karl Silex – their pretty fair stabs at social analysis leave them too rooted in the 1930s – but Mikes can still raise a laugh with his famous apophthegms: 'Continental people have sex life; the English have hot-water bottles'; 'An Englishman, even if he is alone, forms an orderly queue of one', and so on.[12]

The basic qualities of the 'Little Man' established between the wars remained intact, though his portraitist Sidney Strube was no longer around to re-imagine him daily in the *Express*. As always, these qualities required tweaking to suit the peculiar environment of the post-war years. Most agreed that the Englishman was essentially kind and gentle, tolerant of his own foibles and of others', polite and decent, good-humoured, even happy-go-lucky.[13] As Gorer put it in his first tentative foray into anatomizing the English character in December 1949, 'The contemporary English would appear to have as unaggressive a public life as any recorded people.'[14] Given the austerities of the post-war world, the Englishman was also amazingly optimistic.[15] He had, after all, redeemed himself by his wartime performance in his own eyes and in the world's. The war had seemed to resolve the question as to whether he was lazy or energetic: when his back was to the wall, his true potential showed itself.[16] That impression, admitted the novelist Mary McCarthy when asked by the BBC to share the 'thoughts of an American in England', had been consolidated almost in defiance of the facts of the war itself. Since the war, she wrote, her sympathy for England had grown: 'the evacuation of Dunkirk turned upside down in my mind and became a heroic exploit, though I had previously seen it as a rout and a shambles.'[17]

It was less common now to say that the Englishman was lazy.[18] There was a brand of alienated, aesthetic Toryism that did specialize in condemnations of the 'new man' of socialism and the welfare state for his mediocrity, selfishness, philistinism and sloth, symbolized by the figure of Hooper in Evelyn Waugh's *Brideshead Revisited* (1945), or in Osbert Sitwell's account of the English national character sapped by the decline of empire and the dullness of social security:

He will fight and die willingly in order to defend his home.

14 The Englishman 'as others see him', from Paolo Treves' *England, The Mysterious Island* (1948), reviving the interwar stereotype

> Their former vigour and robustness had succumbed before a cult of timid, pallid suffering, alternating with paltry rewards ... A novel democratic folly possessed the educated, making them praise virtues that did not exist: the very faces of the former rulers had altered, softened, lost force, while a creeping wave of envy about small things seeped into the homes of the people ('She has a quarter of an ounce of marge more than I have; I don't mind how little I have, but no one must have more!')[19]

John Betjeman began to win a cultish public following at this time with poetic evocations of the 'ordinary' Englishman that were just ambiguous enough to cross ideological lines. Betjeman himself, in the introduction to *First and Last Loves* (1952), had tried to show which side he was on, condemning 'the common man' or, rather, 'the average man, which is far worse', as dull, stagnant and mediocre.[20] But to the truly alienated, like Waugh, Betjeman was still a traitor – 'a leader of the fashionable flight from Greatness'.[21] Yet the likes of Waugh,

Sitwell and even Betjeman were clearly protesting against the spirit of their age, which was to hymn the 'average man', not to denounce him.

The prevailing view was that the Englishman may have been gentle, but he was not torpid. Evocations of the 'bulldog spirit' were again more common: the Englishman was hard-working, energetic, tenacious.[22] The UNESCO Tensions Project found in 1948 that 'hard-working' was one of the character-istics most often attached to the British, including by themselves (57 per cent) and the Americans (43 per cent), though not by the Germans. As a self-characterization, 'hard-working' came third after 'peace-loving' (71 per cent) and 'brave' (59 per cent) – further evidence of the positive effect of the war on the British self-image.[23] At worst, the ancient stereotype – that the English alternated between periods of sluggishness and activity – could be dredged up (like all the best stereotypes, one that could never be falsified), and used to spur the English on to new levels of achievement in peacetime.[24] Gorer had a psychoanalytic explanation for this trait: the English had repressed their natural capacity for aggression, and unleashed it only in emergency – 'The picture is then of potentially strong aggression under very strong control.'[25]

If a question mark remained over the capacity of the English to work, it was raised by the vexing problem of the welfare state. The fact was that two of the most enduring stereotypes about the English – firstly, their love of liberty and hatred of centralized power and secondly, their sense of enterprise and adventure harnessed to hard work for the benefit of their own families – seemed to be imperilled by the socialist turn of the immediate post-war period. This tension almost certainly undermined the value of 'national char-acter' for purposes of self-description, but those who wished to continue using the idea could always find ways to finesse such problems.

So far as attitudes to work went, a solution could be found in the notion of balance. Between the wars, the 'Little Man' was praised for combining domestic repose with a hard day's work, for finding the right balance between grinding materialism and selfish hedonism. The same basic idea was now revived in modern language as 'the art of living'. Pierre Maillaud found the English in 1945 less interested in making money than he had expected, but with a healthy combination of great individual striving and a strong sense of social responsibility.[26] Industrialists seeking to galvanize the British economy without stepping too far outside the new social-democratic consensus resorted to similar language. Sir George Schuster's contribution on 'Commerce and Finance' to the Barker volume in 1947 asked timidly: 'can we, the nation of shopkeepers and money-makers, show the world how to put money-making in its right subsidiary place in the scale of values, without ceasing to perform well all the valid – and vital – functions which underlie the process of money-

making?'[27] A year later, the president of the Federation of British Industries made essentially the same point more fretfully: 'I think we have been apt to give the impression abroad that we are becoming soft, that we are relying on manna falling from heaven. We have to take action to show that we realise our present situation, that we are as a people united for the achievement of a common object.'[28]

In striking a balance between hard work and hedonism, the English were also seen to be following a 'middle way' – a formula that was adopted to explain the social and political as well as the economic features of the welfare state. The 'middle way' had the advantage of chiming with long-standing stereotypes about English moderation, and it was deployed in a wide variety of contexts in this period: a middle way between materialism and hedonism, between the arts and the sciences, between tradition and modernity.[29] Most of all, the middle way was a course between political extremes, as it had been in the nineteenth century, although the poles had shifted significantly since then. Formerly, the middle way had been steered between absolutism and revolution; now it was squeezed between capitalism and communism. In the old dichotomy, the middle way had emphasized liberty, avoiding the extremes of authoritarianism and anarchy; in the new dichotomy, the middle way emphasized social cohesion and solidarity at the base, avoiding the extremes of libertarianism and authoritarianism. Thus the Victorian ideal of liberty with order had shifted gradually, almost imperceptibly, to a modern ideal of order with liberty. It was the unity of the English people that now most impressed – 'a degree of moral unity equalled by no other large national state', though as always a unity achieved from the bottom up rather than from the top down: 'society and not the state is the basis of English national life'.[30]

This characterization, another hangover from the inter-war period, was hard to square with the extraordinary growth of the state after 1945. One solution lay in emphasizing the truly democratic character of the state, which was directed by the people rather than vice versa.[31] However, those on the Left who did have a positive view of the state tended not to consider it in terms of the 'national character', but rather as a more psychologically neutral source of or focus for national cohesion.[32] Another, vaguer approach, more congenial to Conservatives, was to place weight upon the means rather than the ends: the English were employing their traditional, practical, empirical methods, 'spontaneous organisation in order to solve immediate and practical problems', slowly adapting, always compromising, tolerant of minorities, interests and individual foibles.[33] Margaret Mead, oddly, provided one of the most lyrical evocations of this 'naturalization' of the post-war state in her contribution to the 1947 BBC series on national character:

Man, as the junior partner of God, is seen as a responsible gardener of a social order which he can tend but which he cannot fully control. The English gardener is not a maker of blueprints and streamlined plans, but one who notes the way in which the sunlight falls on a clump of larkspur in the late afternoon, and next year plants larkspur again in the same place, or perhaps a little to the left.[34]

A less accurate account of how British state planning actually proceeded in the post-war period would be hard to imagine; yet it was an account that would undoubtedly have appealed to those who wished to believe in an English national character still braced for the challenges of the modern world. It was also an account designed to appeal to Americans: Mead's talk was part of a little sub-genre of early Cold War writings on Britain aimed to reassure Americans that the British were not defecting to the other side. As the title of one of these books put it, there was 'no cause for alarm'.[35] In tracking this political 'middle way', as in the realm of economics, the English still had something to teach the Europeans, if not the Americans.[36]

What had happened to liberty? In the old sense of freedom from the authority of the state, it had pretty much vanished. This was a source of deep regret to contemporary political theorists of the Right like Friedrich von Hayek and Michael Oakeshott and even to liberals like Isaiah Berlin, some of whom were beginning to get nostalgic about the vanishing traditions of 'independence' in English life.[37] But it did not feature much in popular depictions of the English national character at the time. 'Individuality' remained intact, but beneath the level of the public. In a development from inter-war trends, the inward-looking quality of English individuality was played up instead. The Englishman kept 'the innermost core of his personality' to himself; with public life increasingly arrogated by the state, he would have to take his future fulfilment from 'new worlds within himself'.[38]

This turning inwards had its own dangers, however. Whereas previously 'independence' and 'self-reliance' had shored up self-esteem, engendering mutual respect and self-respect alike, reliance on the state combined with self-fashioning was seen to engender shyness and – the great social plague of the 1950s – loneliness.[39] Some observers still thought, as had been commonly held earlier, that the English 'reserve' was only a show for strangers, and that among themselves they were actually quite sociable.[40] But a rising body of psychoanalytically inspired opinion argued that the English had become the most lonely people on earth. This was the gravamen of Gorer's work on the English character in the early 1950s, for example.

Loneliness was not a peculiarly English feature. David Riesman's book about the contemporary American character, *The Lonely Crowd*, argued that it

was a pitfall of all modern societies in which individuals had lost their sense of 'inner-direction' – 'conscience', 'character' – and had only social norms to measure themselves by ('other-direction'). The upshot was a sense of inadequacy and failure – loneliness, paradoxically, because the individual felt lost in the crowd.[41] Gorer thought the English had a worse problem, however: they were severely repressed from infancy, and although this restraint had benefits in their extremely unaggressive public life it carried over damagingly into private life as well. The fear of natural impulses restrained sociability, sexuality and self-indulgence, leaving the English immobilized in their own private worlds.[42] 'Liberty' had come to a pretty pass: the freedom to be miserable deep inside.

If all of this logic chopping about the true nature of the English seems rather defensive, even a little desperate, that may be because by the early 1950s the whole idea of the English national character was running out of steam. It is noticeable that more of the writing about the English in the late 1940s was by foreigners than by the English themselves, and by the early 1950s this body of writing by foreigners went into decline as well. As the French, the Germans and others were getting back onto their feet, they were less concerned to seek guidance on 'how to live' from the English, and were in fact beginning to construct a new framework for European cooperation without Britain. As for the writing by the English, it was now more controversial than equivalent work had been in the inter-war period, for a number of reasons.

Most importantly, the kind of psychological homogeneity stipulated by the idea of 'national character' – even a character based on individuality and diversity – did not appeal to the more aggressively individualistic or sectional society of the post-war world. Most of the unspoken assumptions or omissions embedded in the language of national character came under sharp scrutiny. For example, although Scottish nationalism as a political movement had as yet made hardly any headway, it was no longer possible to use 'English' and 'British' interchangeably without causing offence. Ernest Barker's *Character of England* of 1947 evoked a good deal more contention on this ground than his *National Character* of 1927 had done. A front-page review in the *Times Literary Supplement* by an anonymous outsider – mischievously identified as André Maurois, Cyril Connolly or Bernard Shaw, though we now know him to be the ex-politician and journalist Walter Elliot – scornfully demolished Barker's portrayal of the 'Little Man' as the kindly, gentle servant of humankind. 'The English are in fact a violent, savage race; passionately artistic, enormously addicted to pattern, with a faculty beyond all other people of ignoring their neighbours, their surroundings, or in the last resort, themselves.'[43] This was not a denial of national character, but it was certainly a refusal by a Scot to be lumped in silently with the English.

Elliot's blast at the English was so popular that it was reissued as a twopenny pamphlet by *The Times* and triggered a debate that rumbled on into the mid-1950s. Among the contributions was a full-length defence of Elliot's position co-authored by his close friend, the playwright James Bridie, with Moray McLaren, which pitched itself explicitly as a subversion of the clichéd celebration of national character. 'I'm tired', wrote McLaren, 'of reading the sentimental or abusive outpourings of Americans, the flatulent pedantry of Teutons, the finnicking, tittering subtlety of the French, the well-bred evasions of the Spaniards or Italians or, for that matter, the complacent remarks of the English on themselves.'[44]

Among the dirty secrets that McLaren thought should finally be unearthed were the Englishman's volatility, his relationship to art and religion, and the Englishwoman. The silent inclusion (or exclusion) of the English woman within the category Englishman was thus also under question.[45] So, especially, was the problem of class. Barker's *Character of England* came under intense criticism both for burying the whole issue of class under the category of 'national-character' and, worse, continuing to assert the salience of the gentleman. There was a gentlemanly and a pastoral streak in Barker's analysis that spoiled the delicate finesses of the inter-war discourse or at least aroused more overt opposition now. 'Much of it reads', wrote the historian David Thomson, 'as if the writer wrote full-time for the British Council, and thought only of the politer, more elegant and least controversial aspects of English social life.'[46]

Class consciousness was a new subject of absorbing interest, not incompatible with national consciousness, but not easily reconciled with the 'national-character' form of national consciousness. The UNESCO Tensions Project found, to its puzzlement, that the British had among the highest levels of working-class consciousness: 60 per cent identified themselves as working class, large numbers relative to other countries saying they felt a strong commonality with people of their class elsewhere in the world. But at the same time equally large numbers said that they felt a strong commonality with people not of their class in their own country.[47]

Attempts to capture the 'national character' of the English – or, as it was increasingly felt it had to be, the British – struggled to incorporate these diversities of ethnicity, gender and class, as well as not to offend growing feelings of individuality. One way around this, which Orwell had pioneered, was the 'list', evoking Englishness with a carefully indiscriminate mix of psychological traits, institutions, bits and bobs of culture, people, places, things, from all classes and regions. Orwell's original list, from *The Lion and the Unicorn* (1941), was almost plaintively aimed at finding a cultural pattern where none obviously existed.

Are there really such things as nations? Are we not forty-six million individuals, all different? And the diversity of it, the chaos! The clatter of clogs in the Lancashire mill towns, the to-and-fro of the lorries on the Great North Road, the queues outside the Labour Exchanges, the rattle of pin-tables in the Soho pubs, the old maids biking to Holy Communion through the mists of the autumn morning – all these are not only fragments, but *characteristic* fragments, of the English scene. How can one make a pattern out of this muddle?[48]

John Betjeman's wartime list was also aimed at capturing and defending diversity:

I do not believe we are fighting for the privilege of living in a highly developed community of ants. That is what the Nazis want . . . For me, at any rate, England stands for the Church of England, eccentric incumbents, oil-lit churches, Women's Institutes, modest village inns, arguments about cow parsley on the altar, the noise of mowing machines on Saturday afternoons, local newspapers, local auctions, the poetry of Tennyson, Crabbe, Hardy and Matthew Arnold, local talent, local concerts, a visit to the cinema, branch line trains, light railways, leaning on gates and looking across fields; for you it may stand for something else . . . something to do with Wolverhampton or dear old Swindon or wherever you happen to live.[49]

T.S. Eliot then supplied the third of the most famous such lists in 1948, describing English culture as a 'way of life' that encompasses 'all the characteristic activities and interests of a people': 'Derby Day, Henley Regatta, Cowes, the twelfth of August, a cup final, the dog races, the pin table, the dart board, Wensleydale cheese, boiled cabbage cut into sections, beetroot in vinegar, nineteenth-century Gothic churches and the music of Elgar'.[50]

These three lists, all composed in the 1940s, stand out. They were cited over and over again in ensuing decades (most famously, bastardized by John Major), indicating both that the 1940s was the last point at which intellectuals still felt they could reconcile the real diversity of society with the idea of 'national character', and also that subsequent generations who wanted to use the idea of 'national character' were happiest looking back to the 1940s.

Some of the devices employed by Priestley and the film industry before the war to portray the English in all their diversity – multi-character casts, multi-stranded stories, montage, symbolism – were still useful in the late 1940s, although increasingly tricky. The famous cycle of films from Ealing Studios, which represents many people's idea of the 'national character' in the ten years after the war, adopted all of these devices with great ingenuity, and

Ealing was not alone. There were multi-class groups like Priestley's *Good Companions* – notably in Humphrey Jennings' *Family Portrait* (1950) – and 'average' (that is, usually lower-middle-class or upper-working-class) families like the Huggetts (films from 1947 and radio from 1953), the Archers (radio from 1951), and the Groves (television from 1953).[51] The characters of Charters and Caldicott, 'the archetypal screen Englishmen' who had first appeared in Alfred Hitchcock's *The Lady Vanishes* (1938) and during the war in *Millions Like Us*, sustained jokily the gentlemanly model of Englishness in post-war films: eccentricity combined with cool, amateurism yet ability to rise to the occasion, all bathed in incessant chatter about cricket.[52]

'But by the late 1940s', as the film historian Andrew Higson argues, 'it had become increasingly difficult to represent the nation as a tight-knit knowable community.' Ealing resorted to nostalgia for wartime or to highly artificial communities or, tellingly, to communities in the process of break-up.[53] The series and the studio came to an end in 1955. When the building was sold to the BBC a plaque was left with the inscription, 'Here during a quarter of a century were made many films projecting Britain and the British character.' Already the tone is elegiac, retrospective. Tellingly, when the *Daily Express* came to replace Sidney Strube's 'Little Man' with a new cartoon characterization of the English in the 1950s, it commissioned three separate series – Giles' working-class family, Barry Appleby's middle-class Gambols and Osbert Lancaster's upper-class Littlehamptons. As Colin MacInnes has shown, they all embodied some supposedly distinctive English traits (philistinism, materialism, conservatism and patriotism), but still represented three separate social worlds and, even so, omitted entirely 'the newly erupted social groups of the 1950s – born of the "new prosperity" and of the cross-fertilisation of English classes'. Capturing the English now required fractured, overlapping and yet patently incomplete images.[54]

Similar difficulties were encountered when the authorities began to plan for the Festival of Britain of 1951. The festival marked the one hundredth anniversary of the Great Exhibition, but instead of inviting the nations of the world to display their wares, the festival was meant to project an image of Britain (and its wares) to the world. Visitors from the United States and the Commonwealth especially were courted. It was, wrote the Home Secretary, Herbert Morrison, in the official book of the festival, 'an act of national auto-biography'.[55] In certain ways, it did try to present a unitary 'national char-acter', especially in the Lion and Unicorn Pavilion at the main festival site on the South Bank of the Thames, meant to reflect 'two of the main qualities of the national character: on the one hand, realism and strength, on the other fantasy, independence and imagination'.[56] But the organizers understood the limitations of such an exercise. 'One mistake we should *not* make', said the

TAKEN IN THE WRONG SPIRIT **by GILES**

"*Isn't it lovely? Thanks to Gaitskell we'll all be able to come and stay with you for Christmas.*"

THE GAMBOLS . . . *by* **Barry Appleby**

15 Diversity, *not* unity: the 'Little Man' displaced in the *Daily Express* by three classes of cartoon, by Carl Giles, Barry Appleby and Osbert Lancaster

festival's director, Gerald Barry, 'we should not fall into the error of supposing we were going to produce anything conclusive. In this sceptical age, the glorious assurance of the mid-Victorians would find no echo.'[57]

To make the festival a truly national event, it could not be confined to London nor to unitary evocations of the national character: it was planned and executed as a United Kingdom event, with 'national exhibitions' in all four nations, travelling exhibitions, and hundreds of local events. Great sensitivity was shown towards local, regional, national, political and class identities.[58] Jennings' film *Family Portrait*, commissioned for the festival, also dwelt upon 'the diversity of the people', although it still caught criticism from the younger generation for its traditionalism.[59]

The BBC put out an extremely disparate programme of broadcasts to mark the festival. It had considered a series on the national character, but at least two ideas in a traditional vein were rejected: Graham Hutton's proposal for a series 'as others see us' (on which he had been writing himself for twenty years), and Roger Cary's for a series on English traits (for example, heresy, simplicity, underhandedness, clumsiness, laziness, conceit). Even Cary, citing Orwell, admitted that it was difficult to convey the necessary sense of diversity through such an approach. Others at the BBC chipped in that it was nearly impossible to illustrate 'British characteristics'; easier to tackle 'things which are in fact "British exports"' like parliamentary government, law, empire, industry, language, sport and humanitarianism. In the end, all such ideas were ditched. A more sociological plan was adopted instead, with programmes on People, School, Leisure, Work, Abroad, Home, and so on, with some of the exports (Freedom, Inquiring Mind, British Taste, British Humour) tagged on. As it was, 'British Humour' was so much about educated people's humour that it was barred from the Light Programme, aimed at the mass market, as 'not really in their vein'.[60]

By far the most ambitious attempt to anatomize the English national character – of this or indeed any period – was Geoffrey Gorer's *Exploring English Character*, which finally appeared after years of preparation in 1955. It, too, fell prey to some of the doubts and hesitations about the whole idea of a national character that were manifesting themselves with increasing forcefulness. Gorer had held the public position that a native such as himself was incapable of writing about the English national character scientifically, and it had been the anthropological doctrine of his projects with Margaret Mead that such work ought to be done by outside observers, or even 'at a distance' (as was necessarily the case when scrutinizing the Japanese and the Germans during the war).[61] Thus it was Mead who had undertaken the fragmentary English parts of the Columbia study. However, Gorer's fascination with the English national character pre-dated his encounter with the anthropologists – as we

have seen, he shared some of Orwell's ambitions to study English culture before the war – and in private he talked constantly about 'being my own rabbit', 'trying to find out . . . what is the value of ethnology for extrapolating into our own culture'.[62] Combining his own psychoanalytic predispositions with what he had learned from Mead and her associates about the relationship between 'culture' and 'personality', he had already formulated some pretty firm conclusions about the English by 1949.

The real obstacle for a proper research project was lack of funding, as he was not himself an academic and had no institutional base. After the success of his book on the Americans in 1948, however, he attracted the interest of the editor of the *People*, a mass-circulation Sunday paper, who ultimately offered him the facilities of the research department at Odhams Press. From this point Gorer lost his public scruples about objectivity and argued that the only *sine qua non* for a scientific study was lots of data.[63]

This he got from the readers of the *People*. In his initial appeal in the newspaper in December 1950, he put forward the idea of assembling panels of 200 men and women in each of four age groups, 1600 in all. But so enthusiastic was the response that the panels gave way to a mass-circulated questionnaire that produced more than 10,000 completed forms, from which a representative sample of 5000 was selected and which Odhams then coded and machine processed. Gorer began releasing selective results from the study as early as August 1951, when the *People* ran an article luridly headlined, 'The Gorer Report: A Great Scientist Has Found out the Truth about the English'.[64] After the *People* got its money's worth, Gorer wrote up the full study as the book *Exploring English Character*, published in Britain and the United States.

For all the scientific apparatus, the study 'confirmed' nearly all Gorer's conclusions about the English as laid out in 1949. He claimed pretty much to have discovered the transition since 1914 'from the Roaring Boys to the Boys' Brigade, from John Bull to John Citizen', which, as we have seen, was a staple of the inter-war discourse, though he put it in a novel psychoanalytic language.[65] The key to understanding English character, he maintained, was 'the problem of aggression'; that is, how had it been suppressed and channelled since the transition, and with what effects on private and public life. The chief results were shyness, puritanical views on sex, companionate but not emotional marital relations, the severe disciplining of children, and a connected orderliness and exaggerated respect for the law and the police. 'What dull lives most of these people appear to lead!' he concluded, but also, 'What good people!'[66]

These findings were neither 'scientific' (Gorer's interpretation of the data calls for careful scrutiny, so closely does it accord with his preconceptions)[67]

nor surprising (in most respects, they chimed with well-established stereo-
types). 'We're so like us that we sound like a caricature of ourselves by
a Frenchman,' complained one reviewer.[68] Cyril Connolly, writing in the
Sunday Times, agreed, more sympathetically: 'We are, in fact, essentially
decent, humane, God-fearing, garden-loving, one-man women or one-
woman men, beloved of foreigners and cartoonists and George Orwell, if a
little bit odd about murders and flogging.'[69] A few reviewers echoed Connolly
in commending the unprecedented scale and scope of the inquiry, and its
scientific method.[70] But the general reaction was less positive than the recep-
tion of Gorer's *Americans* and, though the critical audience was (post-Kinsey)
a bit more inured to the psychological and sexological dimension, it would
probably have felt a stronger conviction about and attraction to the whole
idea of national character if Gorer had been able to publish on the English
five years earlier.

There were many criticisms of Gorer's sampling technique, the represen-
tativeness of the *People*'s readership, and of that portion of the readership that
responded to Gorer's call.[71] Some reviewers noticed that Gorer's questions
had been artfully phrased to elicit conventional answers – 'the familiar heads-
I-win-tails-you-lose argument beloved of psychoanalysis', or the 'Have you
stopped beating your wife?' kind of question.[72] There was not much outright
criticism of the psychoanalytical approach, though some regret that the
romantic business of national stereotyping had been ground down to so grim
a statistical and sociological level.[73] (Mead had urged Gorer to include some
local colour, but he could not because, he admitted sheepishly, 'I don't know
England nearly well enough to give really vivid descriptions of "streets and
houses and shops and chapels"; you know I don't know the Midlands or
Northern districts at all.')[74] The strongest reactions came from intellectuals,
repelled by the picture of 'dullness' and 'goodness' presented. If that was the
English, so much for them – a 'claustrophobic mass struggling against the
imprisoning dullness which is the context of their living'.[75] They were 'all
conscience and no imagination', regretted V.S. Pritchett, and, if true, 'then
John Citizen may be nicer than John Bull but he will not be much of a
creative or important force in the world'.[76]

Gorer's study came a little too late. Its science did not impress the scien-
tists, and its 'authoritative' generalizations about the 'national character'
proved unpalatable both to elites and to almost everybody else. People did not
like to have a mirror held up to them, either because they did not recognize
the image, or because they did not believe in the mirror. It did not help that
Gorer's portrait omitted many of the best qualities of the traditional self-
image – the warmth, kindness, gentleness and humour – which Gorer could
not measure with his questions about restraint and punishment, and which

his psychoanalyst's equation of privacy with repression would not admit.[77] But critics did not hit back with 'better' portraits: they rather poured scorn on the whole project. Nikolaus Pevsner's Reith Lectures in the same year, published as *The Englishness of English Art*, suffered much the same fate, though Pevsner proffered only a very loose and tentative idea of national character.[78] 'National character' was by the mid-1950s already feeling fusty and inadequate, even when couched in a high-flying scientific idiom.

A declining belief in 'national character' does not necessarily imply a declining sense of national consciousness – or, to use the new term, 'national identity'. 'National character', it must be remembered, is only one form of national consciousness, suitable for certain purposes in certain times. Its intensity and specificity were particularly useful in a period of competing nationalisms in Europe from the mid-nineteenth to the mid-twentieth century, and particularly useful to liberals and radicals seeking to vindicate the political capacities of the masses. Conservatives then annexed this idea when they found they had to reconcile themselves to mass democracy, and mass democracy to them. But a fully enfranchised democracy felt that 'national character' was rather patronizing and excessively homogenizing. It did not help that, as so many different parties were now seeking to interpret the national character, its meanings (supposed to be so stable) were so fluid. Democracy could seek other, more plausible ways – and find other reasons – to identify with the nation. So it is a mistake to take declining enthusiasm for 'national character' as a sign of weakening 'national identity'. All the evidence is that English – or, now more likely, British – national consciousness was unusually strong in this period, though perhaps on the brink of a wane by 1955.

We have already glimpsed some of the alternative forms national consciousness took in the decade after the war's end. The wartime experience had a long-lasting effect in cementing a sense of Britishness, not only as a quality of the people (though there was some of that too – brave, peace-loving, hardworking, as the Tensions Project found), but also as a common project in defence of values – minority rights, anti-militarism, equality, social justice.[79] These were universal values, but the effect of the war was to make the British feel again that they had a special role to play in the global theatre in their defence. As Richard Weight has pointed out, the decision to continue conscription of male labour through national service right up to 1960 reflected a determination to institutionalize the spirit of the Blitz and also to fight against the drift to disengagement that had marred the 1930s.[80] This marked a continuation of a traditional kind of patriotism, on which the British continued to congratulate themselves, as distinguished from the 'nationalism' (implying a narrower, more selfish, more aggressive and also more lockstep creed) of others. But it now appeared in up-to-the-minute forms, incorporating

anti-imperialism and socialism.[81] The journalist and academic Peter Laslett wrote thoughtfully in 1950:

> The attitude which we like to adopt when we wish to impress, the attitude we should strike if we were to be called upon to have our national photograph taken, is that of the mentor, the hesitant and somewhat retiring instructor of others, a teacher notwithstanding a lack of intellectual interest and a sense of mission – 'Goodbye, Mr Chips' on a national scale. Now the lesson we have been teaching to recent generations and which we are in the middle of demonstrating now, is the working out of a way to reconcile an equitable economic system with genuine freedom for the individual.[82]

As the 'middle way' emerged in the late 1940s and early 1950s, pride in social democracy as a 'peculiarly British' formula for national success in the post-war world also grew, again not necessarily as a manifestation of national character traits, but simply as a common project. This left-of-centre patriotism was built up by political rhetoric, by the national media (both the BBC and the press), by international attention (even by the nervous attention paid by Americans), and also by a set of institutions that associated the nation closely with the ideals of social democracy: the new social services, especially the National Health Service; the new nationalized industries, bearing proud titles like British European Airways (1946), the British Transport Commission (1947, which later spawned British Rail), the National Coal Board (1947), the British Iron and Steel Corporation (1949, later British Steel); and national cultural institutions such as the Festival of Britain in 1951 and the Arts Council of Great Britain, founded in 1946. Traditional institutions sought to make themselves more populist, to fit better into this new national consensus. Promoters of imperial unity painted pictures of a 'people's empire' or, increasingly, a 'Commonwealth'.[83] The Church of England adopted a more socially conscious and inclusive image that ushered in its last period of growth. The new 'Elizabethan' monarchy portrayed itself as being in a contractual relationship to the people, inaugurated with a triumphantly national coronation ritual in 1953, which, as a famous sociological commentary of the time noted, gave a heightened sensitivity to group consciousness, investing it with a sacredness and a tenderness that not even the National Health Service could quite achieve: 'a great national communion'.[84]

None of these forms of heightened national consciousness was essentially about defining the British against an 'Other': they had positive and internal sources.[85] Ethnic minorities did not yet in the first decade after the war have much of a visible presence in Britain. 'Europe', meaning Continental Europe, was no more of an 'Other' than it had been between the wars, and probably

less. There was still a sense that Britain had something to teach the rest of Europe, but a new sense that this could be achieved through some form of tighter European community. British public opinion was, in the 1950s, just as much in favour of European unity as Continental opinion (although no one knew yet what this really meant in practice): an average of 67 per cent of British respondents to opinion polling favoured European unity, against 56 per cent in France, 69 per cent in Italy and 76 per cent in Germany.[86]

British national consciousness was therefore compatible with class consciousness and with European consciousness, and all were relatively stronger in the early to mid-1950s than before or after. But to imagine the nation as an entity in such a way that these other identities were unimpeached, and just as importantly in such a way that individual identity was unimpeached, a lighter personification of Britain had to be adopted than the language of national character allowed – a formula that was less static, less aggressive, less homogenizing and less nakedly 'English'. There was less talk about the 'English national character' or 'the English people' or even 'the British people', and more about 'Britain', 'British society' or 'culture', its 'values' and, as so often in a patriotic period, its institutions. The nation was more something people were in, less something inside the people. This remained the case when, after 1956, talk about the nation turned from a general optimism to a general pessimism.

AFTER SUEZ

Britain's exceptional atmosphere of unity and relative self-satisfaction had begun to dissipate scarcely a decade after the war's end. It was not so much that the memory of the war had faded as that new benchmarks – notably the international humiliation suffered in the Suez Crisis of 1956 – were laid over it. The late 1950s and early 1960s were years of growing cultural division and national self-criticism. In addition to the keener appreciation of the loss of world power triggered by Suez and by the process of decolonization that accelerated in this period, there was a sharp surge in the awareness of Britain's relative economic decline. These two narratives of decline – international (especially vis-à-vis the United States) and economic (especially vis-à-vis Britain's nearer neighbours France and Germany) – became intertwined and yoked to a left-of-centre political critique, climaxing in the early 1960s and helping to elect a Labour government in 1964 after thirteen years of Tory rule.[87] That political turning point was itself connected to a third area of national self-examination: an awareness not necessarily of decline but of rapid cultural change that we now refer to in shorthand as 'the Sixties'. Generational change, a new experience of affluence, a new wave of American imports (tourists, consumer goods, popular music and television) – all these came to be

associated with a new morality, more focused on the acquisition and posses-
sion of material goods, on individual freedom in sexual and social morality,
on iconoclasm and anti-Establishment postures.

The coincidence of all these crises and critiques directed a great deal of
attention to 'the condition of Britain', particularly between 1956 and 1964.
These were the last great years of the national inquest in Britain, marked by
a series of influential texts by journalists and social scientists, bearing titles like
Anatomy of Britain and *This Island Now*.[88] The atmosphere was in many respects
similar to the immediate aftermath of the Boer War at the beginning of the
century, in which voices from across the political spectrum asked, 'what went
wrong?', and prescribed various tonics to the nation to reverse its course and
lift its spirits. Yet the 'national character' was no longer the object of inquiry
in the way it once was. A mature democratic society found it difficult to blame
itself, its ordinary citizens, still less its most intimate habits. From this point on,
'national character' became more the property of the Right, and indeed a
particularly nostalgic segment of the Right. For most others, the object of
inquiry was now more likely to be the lightly personified 'Britain' or 'British
society' or something more abstract still – 'society' plain and simple.

At this point we are moving out of the history of 'national character' and
into a related but distinct story: the history of social criticism and social
reform. In the heyday of national character since the Boer War, the two
stories had fused, but now they were disentangling once again. A more
acute perception of the diversity and dividedness of society meant that criti-
cism could be aimed not even against 'Britain' as a whole but against some
ailing portion of it – 'the Establishment', 'the affluent worker', the immigrant.
People began to ask, indeed, if Britain was losing its 'national identity' –
a concept they had only just invented to express the lowest-common-
denominator sense of group consciousness, as the tighter, more intimate bond
of 'national character' was coming to seem an anachronism.

Of the three interlinked crises, the first two, the perceptions of interna-
tional and economic decline, which were felt most immediately and acutely,
were also the easiest to express in sectional rather than national terms. During
and after Suez, blame for national decline fell most heavily upon 'the
Establishment', a term used sporadically before but popularized at just this
juncture by the journalist Henry Fairlie.[89] Suez itself could be easily explained
away as a failure of an antiquated ruling elite, nicely symbolized by Anthony
Eden, still operating on the assumptions of empire and/or 'splendid isolation'
and thus incapable of forming working alliances either with the Americans or
the French and Germans. The same ruling elite and its institutions could
then be blamed for the failure to keep up with the French and Germans in
economic growth and 'modernization'.

This assault on a tradition-bound ruling elite reached its apotheosis in Anthony Sampson's *Anatomy of Britain* – an extremely influential book by a South African journalist settled in Britain that was first published in 1962 but has since run through many editions under varying titles. In tune with the temper of his times, Sampson's 'anatomy' was not of the people and their character but of the British machinery, with chapters on the aristocracy, the land, the monarchy, Parliament, clubs, the political parties, the press, the Cabinet, the law, the churches, schools (principally the public schools), universities (principally Oxbridge), committees, the armed forces, the Treasury, the honours system, the diplomatic corps, the prime minister, the City, the Bank of England, bankers, financiers, the insurance business, property developers, corporations, managers, accountants, chairmen, companies, directors, scientists, the nationalized industries, unions and – unusually – 'leisure', which is 'changing everyone's character'.[90] But the character of the people remained, on the whole, unimpeached, indeed virtually untouched. 'The British are still quite capable of surrendering to facts provided they are told them,' was Sampson's populist conclusion. 'But the institutions and the men who work them have, I believe, become dangerously out of touch with the public, insensitive to change, and wrapped up in their private rituals.'[91]

Labour politicians, in particular, were quick to seize on this diagnosis. As Anthony Crosland said in a BBC dialogue on 'What is Wrong with Britain?' in July 1962, 'we still have a cult of the amateur, of the all-rounder, of the dilettante, an emphasis on character and on manners, and a strong basic hostility to professionalism and expertise and technocracy.' But he was clear whose fault this was: 'our rulers, political rulers, top management, civil servants and the rest, have the attitude of amateurism, and this belief that we can muddle through as we used to in the past'.[92]

It was really only at this point, retrospectively, that the 'English national character' was rewritten as the character of the gentleman by people of all political complexions, further tightening the grip of the nostalgic Right on the idea of national character. At a time when the gentleman was the archetype of the ruling class, as before the First World War, he had ruled, but he had not been the nation. At a time when the gentleman and the nation were being assimilated, as between the wars, the gentleman's role was controversial; it had had to be finessed or juxtaposed and overlapped with his fellow citizens. Now, at the point where the gentleman was seen to go into irretrievable decline, he could be closely identified with the national character on both Left and Right – rejected by the Left, celebrated by the Right.[93] There was little room left for a Priestley or an Orwell (or even a John Stuart Mill, an H.T. Buckle or an Ernest Barker), who had constructed the national character as everyman, deliberately marginalizing the gentleman.

After Suez, the gentleman may have been all that was left of the national character.

This period thus saw an almost obsessive sensitivity to the gentleman on all sides, locating all of the nation's problems in his rule, or in his ouster. On the Left, populists who had previously downplayed the national representativeness of the ruling class in order to hymn the virtues of the people were now tempted, in a symptom of cultural despair, to blame it for everything. Tosco Fyvel could write in 1956 what his friend George Orwell would not have written ten years earlier: 'It is ruling classes which set cultural patterns.'[94] After several years' absence in France and America, the literary critic Martin Green came back to Britain in the late 1950s and found that it now looked more gentlemanly than he had ever previously thought it: fussier, more eccentric, more governessy. What he had used to think of as English virtues he now saw as gentleman's vices.[95] J.H. Huizinga, a Dutch Anglophile who had grown up admiring the English pact between the gentleman and the 'Little Man' (very much like his countryman G.J. Renier), felt after Suez that such compromises were no longer tenable, and that the gentleman who had previously been England's saviour had become its nemesis.[96]

On the other side, defenders of 'traditional' English values were now more likely explicitly to associate these with the gentleman – 'the old qualities of stiff upper lip, straight bat, self-effacement and modesty which are still to be met among English gentlemen of all callings, from bishops to taxi-drivers'.[97] Part of the continuing fascination with Mikes's *How To Be An Alien* throughout the 1950s and 1960s was that it gave an almost purely gentlemanly account of the Englishman, reinforced by Nicolas Bentley's comic illustrations of old men with cigars poking out from under walrus moustaches, dressed in plaid waistcoats, bowler hats and overcoats with astrakhan collars (not all at once). Such was the obsession with the role of the gentleman even in tirades from the Left that Simon Raven, a defender of the gentleman, was surely right (if mischievous) to see some underlying ambivalence. 'Even as he tells us how out of date we all are with our Colour Parades and May Week Balls', wrote Raven in a review of Sampson in the *Listener*, 'his pen oozes affection.'

> The point is, of course, that while long-established institutions tend to be illogical and wasteful, the values which they promote, however limited in their scope, are morally and aesthetically far superior to anything which the new world of admass tastes and applied science can show. If I care to spend my day writing Latin verses or watching cricket, as opposed to selling some beastly machine or rubbishy gimmick over a fat expense account luncheon, who is to say I am not the better man for it? Certainly not Mr Sampson

Sabbath morn

16 The gentleman as Englishman: fashionable nostalgia in George Mikes' *How To Be An Alien*, with cartoons by Nicolas Bentley

(Westminster and the House) [that is, a graduate of a top public school and of Christ Church, a top people's Oxford college].[98]

Visiting Americans tendered the same ambivalent tribute to the gentleman: he seemed to them 'essentially' English (in other words, the kind of Englishman least like the American), but also responsible for English failings.[99]

The gentleman's vices (or virtues) were both institutional and characterological. International and economic decline could be attributed largely to 'a failure to modernize', that is, to build new institutions, national and international: the failure to make the United Nations a reality or to join the emerging EEC; or the failure to modernize Parliament, schools and universities, the BBC, the planning machinery or the sense of citizenship and participation; or, as in Sampson, all of the above and more. Underlying unmodernized institutions, however, might be something more psychological and more insidious:

'psychological and cultural attitudes are at the root of the economic evils'.[100] Again, everything the gentleman represented psychologically could be held up as the source of national decline – the cult of the amateur, 'muddling through', a lack of seriousness about science and technology, snobbery sustaining class division, reticence inhibiting communication, nonchalance inhibiting energy.[101]

This psychological analysis gathered pace in the late 1950s, voiced by 'Angry Young Men' of upper-working-class or lower-middle-class back-grounds, railing against the class system that held them back but also against a system of values and morals (riddled with hypocrisy) that the 'top people' deployed to keep the masses in their place. 'I can't go on laughing at the idiocies of the people who rule our lives,' wrote John Osborne, most famous of the Angry Young Men, in *Declaration* in 1957:

> We have been laughing at their gay little madnesses, my dear, at their point-to-points, at the postural slump of the well-off and mentally under-privileged, at their stooping shoulders and strained accents, at their waffling cant, for too long . . . they are stupid, insensitive, unimaginative beyond hope, uncreative and murderous.[102]

Although politicians preferred to stick to the institutional critique – among other reasons, institutions were easier to change than personalities – left-wing attacks on the Conservative government also took on an increasingly moralistic tone in the early 1960s. The Profumo Affair of 1963, when a gentlemanly Tory minister was shown to have been enmeshed in a 'high society' low life of call girls, drug addicts and Soviet spies, allowed the institutional and the psycho-logical analyses to fuse for a moment.[103] Conversely, those who bewailed the decline in morals among the mass of the people also tended to connect it to the loss of the gentleman's institutional grip: crime, violence, rebellious youth, sexual licence – all could be traced back to the loss of authority, to the abandonment of 'standards', maintained for so long by the gentleman.[104]

However, the psychological analysis of decline necessarily placed less emphasis upon the gentleman than did the institutional analysis. The English character had, after all, been given a much deeper historical pedigree and a much broader social complexion by the writing of the previous century. If 'the English' were to blame for their own plight, then the little man as well as the gentleman had to be put in the dock. Furthermore, not everyone was inclined to load all the blame on the gentleman. Foreigners, in particular, could blame the ordinary Englishman too.[105] A more politically even-handed critique blamed the affluent worker as well as the gentleman: 'Every boss class gets the working class it deserves.'[106] Institutionally gentlemen and workers

were part of the same class system, and psychologically they shared many undesirable traits, including selfishness, laziness, a lack of initiative and energy, an excessive love of tradition. They had been dulled by prosperity, blighted by complacency, stalled by lack of ambition.[107] At best, worried the then expatriated critic Alan Pryce-Jones in 1968, England was 'an aquatinted country, full of very nice people, half asleep'.[108] Was it possible to keep their kindness and gentleness while still restoring international competitiveness through an infusion of new energy – 're-winding the clock' as one commentator put it in 1962, bringing back the spirit of the Blitz, or giving them a new, more modern Establishment?[109]

From the mid-1960s, especially after the election of a self-consciously 'modernizing' Labour government in 1964, 'declinism' itself went into temporary decline. Attention shifted instead to the third ground for national self-examination: the cultural revolution of 'the Sixties', by then in full swing. This cultural revolution was not, of course, unconnected to the diagnosis of decline. Critics of the gentleman's rule tended to offer libertarian prescriptions for cultural change as the alternative; correlatively, defenders of the gentleman saw his beneficent rule being undermined by individualism, affluence, 'Americanization' and a loss of respect for authority. But cultural change was often not seen in the context of decline at all, or indeed as a function of gentlemanly rule. Just as psychological and moral critiques of decline could implicate the 'Little Man' as much as the gentleman, so, if 'the English' were changing for the better, then perhaps the hegemony of the gentleman was not as complete as the prophets of cultural despair suggested.

The cultural changes of 'the Sixties' were manifold and complex: they were material (the new experience and enjoyment of 'affluence'), spiritual (new attitudes to life, more secular and hedonistic), moral (changing attitudes to sexual behaviour, to relations between the classes, sexes and generations), social (a shifting balance of responsibility between the individual and the collective). They were also very partial – regionally and class specific, and probably more effective in the imagination than in practice, since research suggests a considerable persistence in 'traditional' values in post-Sixties Britain.[110] One thing is clear, however: they did further undermine the idea of national character, perhaps even delivering the *coup de grâce*.

For one thing, yet another fundamental change in the morals, values and behaviour of the people might still be perceived as a national shift, but the frequency with which such shifts were taking place robbed the idea of national character of the rootedness and stability upon which much of its appeal had rested. The stereotype had lived too long, been employed by too many different hands, been stretched too far in order to accommodate too much diversity to function any longer in a credibly monolithic way. Now the

'generation gap' was requiring some outright reversals that no slipperiness of language could fully disguise. As J.B. Priestley pointed out in his last full-length survey of the English, in 1973, he had seen three great changes in the national character in his own lifetime: from John Bull to the 'Little Man' to the 'inept, shiftless, slovenly, messy' younger generation he so deplored in his old age.[111] 'The Myth of England', wrote the literary critic John Holloway in 1969, was fading out because there was by now too much of it, its history 'too long and varied to fit smoothly into a single Myth', brought down by its 'latent inconsistencies'.[112] This showed a touching faith in the rationality of national consciousness, but it was a faith characteristic of the late 1960s, and by this test 'national character' had failed as a concept.

The new kinds of personality that cultural change was forming were in any case seen less and less as distinctively 'English' or 'British'. They were both more individual than that – a bricolage of traits, habits, preferences that could not even be summed up as a unitary 'personality' – and more global – the fruit of social processes spanning the west and perhaps the world. When the BBC asked the social psychologist G.M. Carstairs to perform his anatomy of 'This Island Now' as the 1962 Reith Lectures, they specified 'an examination of our own society in the United Kingdom with the aid of the latest psychological and sociological research', but by this they meant a study of 'the anxieties and discontents of the individual' under the pressures of global modernization: 'the weakening of traditional norms, the effect upon our social structure of international affairs, of industrial and technological development and of our educational system'.[113] What they got was indeed a picture of the repressed, over-disciplined, pessimistic Englishman (and, especially now, woman) that Carstairs had inherited from Gorer, but giving way to a new model, as international relations, science and technology, growing equality and psychological sophistication bridged the gaps between classes, genders and nations.[114]

Carstairs was moving in the same direction as the social sciences generally and society as a whole: away from an emphasis on group life towards an emphasis on the fulfilment and happiness of the individual. The quest to find the link between 'culture' and 'personality', to discover how child-rearing and socialization practices built up a 'national character', had begun to founder in the late 1950s. Social psychologists abandoned their search for the 'basic personality' – the fundamental personality type tailored to a given culture. They began to look instead for a 'modal personality' – an average personality type in each nation – and then abandoned that search, too, as nations simply seemed too diverse, acculturation too messy and disjointed to produce a meaningful average.[115] By the 1960s, psychologists were not sure they even believed in a 'personality' – people did not form integrated wholes.[116] One

attempt to study 'Patterns of English Culture' found that there were no unifying patterns, and ended up only with 'samples'. The same study found there was no 'single personality type' in England and that, although class was becoming less important in determining personality, social change was so rapid that it was not possible to chart any convergence onto an inter-class mean either.[117]

Faced with such challenges, the social content of psychology diminished sharply and more attention was paid to the basic processes of the human mind. Where society was taken into consideration, it was less as a constituting force and more as a context within which individuals had to fit – or not.[118] As Riesman emphasized in later editions of *The Lonely Crowd*, 'the liberation of men from the realm of characterological necessity' allowed 'individuals to shape their own character by their selection among models and experiences'; perhaps, he concluded hopefully, 'the cast of national characters is finished'.[119]

The new kinds of personality being thrown up by cultural change in Britain were, therefore, not necessarily seen (either at home or abroad) as particularly British. In fact one of their distinguishing features was their indifference to public and collective life, a 'turning away from any image of society to the immediate and personal life that people live', as the sociologist Donald MacRae put it in 1962.[120] Privacy might not be 'the English secret' after all; perhaps it was just privacy.[121] Like young people elsewhere in the developed world, the rising generation was seen as devoted above all to the pursuit of individual happiness, particularly through the acquisition and enjoyment of material goods, although as the Sixties wore on also through the pursuit of sexual and other fleshly as well as spiritual pleasures.

Readers of this book – though not many contemporaries – will note that it should have been easy to fit these new kinds of personality into ideas about the English national character. Not only was individualism one of the most ancient stereotypes about the English, but also, more recently, the individualism of the 'Little Man' had been built up almost entirely around ideas of domestic affluence, private enjoyment and 'inner' freedom. At the height of the Sixties, in an attempt to boost Sixties values and national morale at the same time, there were indeed efforts to portray the national character in these familiar terms, though as a recent phenomenon of liberation.[122]

In addition to the usual application of selective amnesia, this reinvention of the wheel was made more plausible by the recent onslaught against the gentleman. The 'Little Man' had been forgotten; the gentleman was now centre stage, and in fighting free of the gentleman the Sixties generation was free to reinvent the 'Little Man' in its own image. In fact the same explanation was given in the 1960s as in the 1920s for the change in national character: the

Industrial Revolution and empire had produced the tightly wound, stiff-lipped type of Englishman, but now, 'after' industry and empire, a new, more natural type was allowed to emerge, to some extent a reversion to the pre-industrial Englishman. Tony Richardson's 1963 film of *Tom Jones*, scripted by the gentleman's nemesis John Osborne, was thus taken to offer 'a fresh and valid national image of life and behaviour', presenting 'traits of charity and generosity, an ebullience and vigour, that one can identify as essentially English but which seem to have gone partially underground in our national life since the beginning of the Industrial Revolution' – very close to the terms in which the 'Little Man' was hymned decades before.[123]

In accord with Sixties self-images, of course, 'Tom Jones' was rather more rambunctious than the 'Little Man'.[124] Britain, one journalist suggested, had become the 'Corinth of Europe . . . where the serious Athenians would go for a good debauch'.[125] Some squared this in the usual, slippery way of national stereotypes: the Englishman was so contradictory that he could be stylish, vivacious and mirthful in a Sixties way, but also hypocritical, frigid and snobbish like John Bull and quiet, gentle and domestic like the 'Little Man'.[126] Others simply chose to view the 'new' character of the English in quieter, kindlier terms that were easier to reconcile with the 'Little Man' stereotype: private, domestic, tolerant and genial, with a good sense of humour and a relaxed attitude to life.[127] This sunny Sixties presentation of the 'Little Man' was – and probably remains – more congenial to the national self-image than Gorer's Freudian version had been; later studies have shown that foreigners think of the English as much more cold, repressed and humourless than the English think of themselves.[128] But only a few contemporaries recognized that the more genial and relaxed stereotype of the English was an old one, dating back at least to the 1920s, not new to the Sixties at all.[129]

However, most strikingly, and very unlike the instinct of the 1920s, most journalists, politicians and social scientists felt gloomily that the new individualism among the English represented the dissolution of the national character, not its apotheosis. Individualism and national consciousness were now framed as an either/or choice. When a new weekly, *New Society*, polled its readers in 1963, it asked them whether they preferred 'individual happiness' or 'national greatness' – perhaps unsurprisingly, 79 per cent chose individual happiness, though 42 per cent still wanted Britain to be great.[130] Worse still, most commentators held that the new individualism was not only an alternative to but also an actual corrosive of national consciousness – a turning away from society to personal life, in MacRae's words. Some thought this was a by-product of Americanization or globalization – a modern aimlessness and purposelessness brought about by the spiritual vacuum of affluence.[131] It might represent the global triumph of a peculiarly British individualism, 'the

behaviour models of the young people of the world', but at the cost of a loss of national feeling.[132] Others, and not only older people who had grown up before and during the war, worried that the new individualism was aggravated by specially British problems – a product of post-war decline and post-Suez depression. By overemphasizing the place of the gentleman in their own culture, the younger generation had come to feel vaguely ashamed and dishonoured by that culture, at best 'good-humouredly pessimistic' about Britain.[133] A generation earlier, people had praised English patriotism as a low-key alternative to Continental nationalism; now they were more worried by English self-criticism as a weaker alternative to Continental patriotism.[134]

The problem was that in an atmosphere of 'declinism' not only the idea of national character but also a lot of other, alternative forms of national consciousness were under attack, across a spectrum that affected young and old, Left and Right, working and middle class alike. For the younger generation, the memory of the war no longer functioned so effectively to summon up a sense of a common project or experience. For the older generation, some traditional nodes of patriotic feeling were besieged: Suez sapped the civilizational project as well as the spirit of empire; the EEC, which had rebuffed Britain in 1963, threatened either to dissolve or displace Britain's place in the world. 'Great Britain has lost an empire and has not yet found a role,' as the American Dean Acheson famously put it in December 1962.[135]

The post-war national projects of social democracy and the welfare state were also looking rather tarnished by the late 1960s, rendered less credible even as class projects, much less national projects, by the rise of sectional rivalries within the trade union movement. Alternative national projects were floated – business, science, education and, increasingly, sport.[136] '[T]he man who scoffs at his national flag almost surely believes in his heart that Britain ought to be a great nation,' reasoned *The Times*, hopefully, 'we should do admirable things and . . . we should do them better than anyone else'.[137] But with some signal exceptions – the odd British Nobel Prize, pride in British achievements such as the discovery of penicillin, the soccer World Cup in 1966, occasional opportunities for royal pageantry – there were few occasions for a broad national recognition that Britain was doing admirable things, fewer still that it was doing them best.[138] It was much more fashionable to laugh at patriotism than to cultivate it, a fact of which the satire boom of the Sixties took full advantage. As before, the effect was to dredge up some of the most antediluvian gentlemanly stereotypes solely for the purpose of sinking them again. 'England' and 'Englishness' were almost more likely to be represented as parody than as realism.[139]

So it was not only 'national character' that had fallen apart; 'national identity', a term just beginning to come into vogue, was also called into question.

The term 'national identity' itself reflects an enhanced awareness of how arti-
ficial, fragile, even superficial national consciousness could be. Social scientists
had become convinced that, while it might be difficult to find and study a
people's character or personality, it was easier to pin down and examine its
simpler consciousness of national existence, its 'national identity'. Such
studies could be deployed to help nations foster their 'positive' feelings of
national identity – patriotism, for instance – and to avoid 'negative' feelings
like nationalism.[140] The same consciousness of the artificiality of 'national
identity' made some intellectuals of the late 1960s feel they ought to be
shoring up Britain's: there was guilt that liberal intellectuals in the post-Suez
world might have encouraged too much self-seeking individualism, and
concern that Britain's peculiar problems with globalization and national
decline were sapping its morale in international competition with France,
Germany, Russia and the United States. It was not only conservatives who
felt, like the jurist Lord Radcliffe writing in 1966, that '[w]e must . . . get
back quickly to the active realisation of our identity as a nation . . . National
feeling is the strongest bond of union that exists in the world today, and an
old and experienced people, as we may call ourselves, can be trusted not to
abuse it.'[141]

These anxieties deepened palpably in the 1970s, as all of the post-Suez
problems exploded into what was predicted to end as 'the break-up of
Britain'.[142] Profound economic problems, part of a global recession, deep-
ened social divisions and embittered the public sphere. Trade union militancy
was seen by those who did not like it as a further betrayal of patriotism and
public spirit, a grosser version of the selfish sectionalism and individualism of
the Sixties.[143] When French resistance to British entry into the EEC was aban-
doned in 1972, Britain limped in, hoping for economic benefits but without
any real dedication to 'Europe' as a concept, much less an identity.[144] There
was puzzlement at the time at how low-key the 'great debate' over Europe
was, how it had seemed to fail to generate any thinking about 'identity' at all
– British or European – and this, too, could be taken as a sign of failure.[145]
The political rise of Scottish and Welsh nationalism, which registered strongly
in the 1974 general elections (but not in the 1979 devolution referenda), at the
same time undermined the sense of Britishness and posed a contrast between
the apparent national feelings of the Scots and their lack among the English.
Opinion polls showed that the Scots were beginning to describe themselves as
more Scottish than British, while the Welsh and English were not following
suit in realizing their Welshness and Englishness.[146]

By the late 1970s, there was a surprising degree of unanimity among jour-
nalists, politicians and intellectuals at least that the British were losing their
national identity and needed to recapture it, in one form or another. On the

whole, 'national character' was not the preferred form, even on the backward-looking Right.[147] There were, of course, some ancient exceptions – J.B. Priestley wrote his last, rather despairing, plea for the English national character in 1973 – but even Arthur Bryant had given up, mourning that 'there is no unifying faith to bind us together'.[148] Most interestingly, the maverick Tory Enoch Powell, who since the early 1960s had been trying to reclaim an older Englishness that had been temporarily subordinated to global and imperial do-gooding, adumbrated a deeply mystical, abstracted idea of Englishness in which 'people' and 'community' were often evoked but generally without any specific qualities or character. He was making his own half-conscious, half-desperate appeal to 'national identity' – a gut-level sense of solidarity – in default of the old character that now seemed lost forever. This was one powerful reason why racialism now figured more strongly in his formula: the lowest-common-denominator whiteness of the English was a substitute for the middle-order specifics that had made the old language of national character such a force for cohesion. At the same time, it limited his appeal to those parts of Britain where economically disadvantaged white people could plausibly view black people as their 'out-group' or 'Other' – places like London and the West Midlands.[149] Those on the Right unwilling to play the racial card had to make vaguer appeals to national 'values' or the self-evident virtues of national pride.[150]

Away from the ideological Right, it was easier to recognize the positive side of diversity and fragmentation. 'People are infinitely diverse, and behave in a delightful confusion of ways,' wrote the historian M.R.D. Foot in 1973, celebrating the demise of the national character.[151] Writing a few years later, Asa Briggs pointed out how dated was not only Gorer's 1955 depiction but also Carstairs' revision in 1962: national characters were both too diverse and too fluid to pin down.[152] There was a strong feeling on the Left and on the individualist New Right – which we will see resurfacing in the 'heritage' neurosis of the 1980s – that talk about 'national identity' was code for a reactionary nostalgia for past imperial glories or a cosy, ruralist Englishness.[153]

But even on the Left, the bitter social divisions of the mid-to-late 1970s engendered a longing for the lost solidarities of nation. In a bell-wether essay of 1976, 'Who Are the English?', the liberal author A.S. Byatt, repulsed by the new nationalism of Enoch Powell, argued for a multi-cultural vision of Britain in terms that would be more familiar twenty years later: 'I see our nation increasingly as a bright mosaic of little, unrelated patches.' Yet she also worried that the richness of this cultural mixture was not really an adequate substitute for the old solidarities of history, culture and morality.[154] Like others, she yearned for some way to express national unity that did not do violence to diversity, at a time when the most attractive vehicles – the lightly

personified British project of social democracy or social solidarity, celebrations of modern science and technology – were looking old and creaky.[155]

It was not entirely clear that the British people as a whole shared their intellectuals' and politicians' anxiety – and the possible indifference of the people to their 'national identity' could be interpreted by intellectuals and politicians as further signs of the people's lack of backbone. Although for this period of the 1960s and 1970s we have records of opinion research and plenty of non-elite voices in the mass media, it is still very difficult to tell either how 'British' people felt or whether they cared at all about 'national identity'. We do know that in the post-Suez period British attitudes to the EEC grew increasingly negative, though these attitudes were highly volatile and superficial.

Growing anti-European feeling has been taken by some historians to betoken a strengthening of 'traditional' British insularity and sense of self.[156] Yet attitudes to Europe do not correlate at all well with attitudes to 'national identity'. One study after Britain's entry into Europe showed, for example, that the Italians had the most positive feelings not only about their own national qualities but also about other nationalities and about Europe; the Germans had the least positive feelings about their own national qualities and also about other nationalities, but among the most positive feelings about Europe; the British fell somewhere in the middle in their feelings about their own national qualities, but had the least positive feelings about Europe.[157] Another study, a very thorough comparative survey conducted by the European Values Systems Study Group in 1981, found that the British were unusually proud of their nation, but not of their national institutions, certainly not of Parliament and politicians. They had ridiculously high levels of satisfaction with their lives in their non-national dimensions – jobs, housing, health, education, leisure, living standards. They had a high opinion of human nature in general; thus they were unusually willing to fight for their country, but they were also unusually willing to die to save anyone else.[158]

Faced with the public's complacency and indifference to the evident decline of the public sphere, the pundits and politicos were stumped: the British claimed to care for their nation, but were unwilling to do anything to show it. There were some half-hearted attempts to turn complacency and indifference into a British national virtue, permitting a lazy, genial, post-industrial enjoyment of life, not dissimilar to attempts in the 1930s to read appeasement as a national trait.[159] It was possibly too horrifying to consider that, in a period of declining consciousness of national solidarity, the people who appeared in the national media cared more about it than the people who read and watched them.

AFTER THE NATION?

Over the last twenty-five years, journalists, intellectuals and politicians have continued to chart – and decry – the remorseless decay of British 'national identity'. They have also continued, if anything with mounting purposeful-ness, to try to reverse it. It seems sometimes as if the only point on which the 'chattering classes' of all political and ideological stripes agree is that British national identity has diminished, is diminishing and ought to be increased. The alleged sources of decay are multiple and slightly contradictory. In the background are the internationally homogenizing forces of global capitalism (in certain versions, American capitalism), and the heterogenizing forces of mass emigration and immigration.[160] These affect everyone in the west and are, at least, therefore not a peculiarly British affliction. For Europhobes espe-cially, the rise of a sense of Europeanness threatens national identity across the Continent, although there is less evidence of this Europeanness in Britain than elsewhere.[161]

Britain is also thought to suffer from some identity problems peculiar to itself. Although Britain has not in fact broken up as has been widely predicted since the 1970s, the idea of Britain apparently has. The common projects represented in the past by the idea of Britain – empire, Parliament and monarchy, Protestantism, the spirit of the Blitz, the welfare state, social democracy – have all been discredited.[162] The Scots and the Welsh are going their own way, leaving the English on their own and uncertain of 'who they are'. Often it is said that the English have never had a very strong sense of 'who they are' because they have been hiding for so long behind these largely institutional constructs of 'Britishness' – a view reinforced by readings of Linda Colley's book *Britons* (1992), about eighteenth-century ideas of national identity.[163] '[T]o quite a large extent we relied on our global ambitions and duties – very important that – to define our national character. This is obvious and often said,' wrote the journalist Henry Porter in 1993, '[now] there seems so little left. What are the English about today?'[164]

Such a reading encourages amnesia about the periodic bouts of obsessive self-scrutiny among the English since the eighteenth century, which the present book has been documenting.[165] For instance, the idea of the gentleman as the national character has been used sporadically at least since the late 1950s to suggest that British national identity was wedded to an outdated imperial project that left the English rudderless in the modern world; yet the idea of the 'Little Man' has been used sporadically at least since the 1920s precisely to assert a distinctive Englishness already detached from that outdated imperial project. There are plentiful materials out there with which people could construct a modern Englishness if they wanted one.

This is also sometimes said: that the English know not too little about themselves but too much – they are too lumbered with the baggage of the past to think sensibly about where they are today.[166] Lured by the infinitely malleable language of national identity, some pundits say both at the same time: the English know themselves too well, and not at all. 'The English have an acute sense of who they are, where they are from and what their country stands for. They recoil, however, from talking about it except, occasionally, among themselves and then only in a code camouflaged by layers of self-irony.'[167] Thus both the alleged lack of writings on English national identity and the obvious surplus of such writings are taken as requiring . . . more writing.

These overlapping explanations of the decline of national identity nearly always carry the message that it ought to be reversed, that the English must recapture their old identities or, more commonly, build a new one.[168] Why a 'strong' national identity is so important is an interesting and not obvious question. The answers given are normally evasive, slightly panicky, and they may reflect an unconscious awareness that the pundits' interests are not the same as everyone else's. National identity, writes the journalist Jeremy Paxman, 'seems something the English can no longer avoid'.[169] 'At some point they have to decide who they are *in sum*,' writes the historian Robert Colls, otherwise they might find themselves 'exposed'.[170]

There is the long-standing social-scientific view (now not held by many social scientists) that healthy cultures just are coherent; they form patterns that touch every aspect of life, psychological and social, and that are recognized as such by their inhabitants. There is the related view that group consciousness is a natural, nearly a biological human instinct – we identify Others and identify ourselves in contrast to them.[171] National consciousness is sometimes taken as a very special kind of group consciousness that somehow satisfies deeply atavistic yearnings better than most – an 'imagined community', in Benedict Anderson's famous phrase, for which, unlike most imagined communities, people are willing to die.[172] There is the more immediate declinist concern, that Britain's relative economic decline vis-à-vis America, France or Germany must relate to its coincident decline in national identity (though it is not clear how valuable those rivals' sense of national identity has been to their relative economic position). Again in Paxman's words: 'Those countries which do best in the world – the ones that are safe and prosperous – have a coherent sense of their own culture.'[173] Then there are the concerns relating more explicitly to the public sphere: the value of political and civic participation in developing individuals' best qualities and in making a caring and purposeful society;[174] and, equally importantly but more rarely acknowledged, the need for politicians and the media professions to defend the centrality of their

own national institutions (Parliament, the party system, newspapers and broadcasting enterprises).[175]

So politicians and intellectuals have continued to make powerful and often very constructive arguments for national identity in general, and for particular kinds of Britishness or Englishness specifically, but by their own admission national identity continues to decline. A final survey of the varieties of national identity they have offered over the last twenty-five years, and their fates, may clarify why this has been the case and illustrate the difficulty of constructing a British or English national identity after national character.

Margaret Thatcher came to power in 1979 with, apparently, such a mandate to restore to the British people their 'national identity' that she gave them a choice of three. Although there was not a lot of evidence that the electorate had this particular solution in mind – more immediate economic and political problems were pressing in 1979 – nevertheless Thatcher herself had a strong conviction that Britain needed a kind of cultural revolution in which a restored national identity would play a leading role. Of the three different versions with which Thatcher became associated over the next decade the most obvious was a traditional Tory patriotism that she had inherited from, among other influences, Churchill and Powell, and in which she believed much more intuitively than her immediate predecessors in the Conservative leadership. Although in the first years of her premiership it was not at all clear how she might rebuild patriotic attachment to traditional institutions, in 1982 she found, fortuitously or not, the ideal vehicle in the Falklands War. Mobilization for this war and celebration of the victory afterwards at least temporarily fixed the people's loyalties onto some traditional national institutions – the armed forces mostly, but also Parliament, though not the monarchy – and restored for a time a sense of common purpose in pursuit of traditional British values – self-determination, support for the underdog, resistance to bullying, perseverance in adversity.[176]

Enoch Powell, naturally, was delighted: 'The people of this nation have discovered that they have a self, which the older among them supposed had been lost forever, and the younger, who never knew it, have nevertheless recognized for theirs . . . Suez, with all its confusion and its squalor, never laid the nation's belief in itself upon the line as these events have done.'[177] But so were 'wetter', more liberal sections of the Conservative party. Even Julian Critchley, one of Thatcher's more persistent critics within her own party, hailed the peculiarly English patriotism – 'a very old form of loyalty' – that had been rediscovered at the time of the Falklands: 'the very same inherited, untaught devotion to one's homeland which has survived all of the changes and chances of our national life', despite half a century or more of 'official' internationalism and apparently declining national purposefulness.[178]

This emphasis on a national identity that had been submerged, obscured or underrated and was now rediscovered, resurrected or newly appreciated reflected a mildly surprised delight that national identity had not been as completely dissolved as these same voices had feared a few years earlier. The same sentiments were surprisingly evident among left-wing intellectuals who, however horrified by the militarism and jingoism of the Falklands escapade, were nevertheless impressed by the atavistic force they felt these things to represent. They were also impressed by any collective expression from a people in whom they had largely lost faith. The Left felt guilty for having underestimated the power of the nation.[179]

Again these reactions are evidence more of intellectual thirst for the nation than of national thirst. Although Thatcher tried to use the 'Falklands spirit' for domestic purposes after the war was over – notably against the striking miners, the 'enemies within' – it did not wear well. The miners were a less plausibly 'national' enemy than Argentina, and in the case of the miners' strike it was not clear which 'British' values were being defended against the enemy: certainly not sympathy for the underdog. At the point where 'patriotism' appeared to be giving way to a more artificially aggressive nationalism, the more liberal Tories began to shrink back. Many reached that point when Thatcher turned her patriotic rhetoric from Argentines and miners to other Europeans, as she used it increasingly to mount opposition to closer European integration. Around 1990, for example, there was a pretty general revulsion against some aggressively anti-German statements that leaked out of the inner Thatcher circle, revealing a lingering belief in a malevolent 'German national character' that seemed absurdly out of date.[180] Others worried that Thatcherite patriotism was providing respectable cover for the outbursts of mindless violence that seemed increasingly common in late twentieth-century Britain: football hooliganism, racial violence, 'skinhead' nihilism, crime and vandalism.[181]

Nor did Thatcher herself consistently harp upon patriotism. She had another agenda which was, if anything, more prominent and which could be viewed either as an alternative national identity or as an alternative to national identity: her strong streak of individualism, manifesting itself in policy as a hostility to economic collectivism but also to collectives of all sorts. Her most notorious statement of this part of her philosophy came in a September 1987 interview with *Woman's Own* magazine where she lambasted people for looking to 'Government' or, worse, 'society' for solutions to their personal problems: '[W]ho is society?' she demanded. 'There is no such thing! There are individual men and women and there are families and no government can do anything except through people and people look to themselves first.'[182] In Thatcher's own view, this individualism was perfectly compatible

with patriotism and with a specifically English–Tory variety that went back to Edmund Burke. The state provided a fundamental, possibly minimal, moral order within which the 'little platoons' of individuals, families and voluntary organizations got on with the business of living otherwise unmolested and unmobilized.

However, given that Thatcher's Falklands-style patriotism was not enduringly popular, the effect both of her policies and her rhetoric was more destructive of national cohesion than otherwise, smashing icons of British national identity more dramatically than she was able to build up patriotic feeling. The privatization of nationalized industries, the devaluation of 'social justice' and the institutions of social democracy, the hail of criticism against corporate interests of all kinds – this left a stronger mark than the short-lived Falklands effect. The net impact – as most Conservatives as well as others saw – was to accelerate rather than to reverse the perceived decline of national consciousness.[183]

A third, very different kind of national identity associated, perhaps unfairly, with Thatcher was inspired by continuing anxieties about national decline – notwithstanding Thatcher's efforts at national reveille. Here the worry was not so much about the decline in national identity as the danger that the British were coming to accept their decline as their national identity. In what became known later as the 'heritage debate', intellectuals on both the Left and New Right had been deploring since the mid-to-late 1970s the tendency of some, primarily southern and middle-class elements, to revel in the past, especially in the tradition-laden rural and gentlemanly past. In the late 1970s, as we have noted, there were still a few who construed this as a positive choice for a slower, less competitive, more 'civilized' lifestyle. Hardly anyone took this position after 1979. The obsession with identifying and preserving the 'national heritage' was very widely cursed as a British disease. This critique of the 'heritage industry' bore a close relation to the critique of 'gentlemanliness' that had been prevalent since the late 1950s: again the emphasis was not so much on the deficient qualities of the people as on their kowtowing to traditional elites. The problem lay not in the national character, or even necessarily in the culture but, as the historian Martin Wiener wrote in his highly influential book *English Culture and the Decline of the Industrial Spirit* (1981), in the 'cultural conservatism' of the elite.[184]

Of course, Thatcherites themselves criticized the British for forgetting their 'bourgeois' Victorian heritage and its enterprising, freedom-loving, forward-looking values.[185] In contrast to the 1950s and 1960s, most of the warnings in the late 1970s and early 1980s against nostalgia for gentlemanly values came from the Right. Indeed Wiener saw Thatcher as the best hope for a reversal of post-industrial decline, though he thought she had a tough job ahead of

her.[186] Nevertheless, left-wing intellectuals were still inclined to blame Thatcherism for encouraging rural nostalgia. The word 'Conservative' itself was something of a bugbear.[187] The de-industrializing effects of Thatcherite economic policies were taken as the harbinger of a dreary post-industrial future in which Britain became a museum. The Churchillian overtones of the Falklands spirit could also be portrayed as reactionary and the war itself as 'the encapsulating heritage event: a battle for a distinctly "British" and utterly remote piece of moorland ... against a group of fascist foreigners out of a Bulldog Drummond story'.[188] Writers like Patrick Wright and Robert Hewison thought Thatcherism, beneath a superficial 'modernization' rhetoric, hid a profound 'sense of history as decline'.[189]

This rather perverse interpretation of Thatcherism was given some post-Thatcher respectability by the postures adopted by her Conservative successor John Major, who did play up to the 'heritage' image of Britain to some degree, seeking to tone down both Thatcher's nationalism and her individualism. Major's chosen middle ground, which was to try to resurrect some of the 'Little Man' themes of Stanley Baldwin and George Orwell, was no more successful, however – showing how difficult it was to shove any pre-packaged vision of national identity down a sceptical public's throat. 'Fifty years on from now,' Major famously pronounced in a speech on St George's Day 1993, 'Britain will still be the country of long shadows on county [cricket] grounds, warm beer, invincible green suburbs, dog lovers, and – as George Orwell said – old maids bicycling to Holy Communion through the morning mist.'[190] This farrago of half-remembered Englishnesses – including a quote from Orwell's famous 'list' – triggered only a volley of sniggers, not the feelings of warm familiarity Major sought to evoke.[191] It was just not that easy any longer to find a consensual 'national identity', no matter how many people agreed that in theory it might be desirable to have one.

Since 1997, New Labour governments have offered their own national identities, again in multiple varieties. Just as convinced as was Thatcher that Britain 'needed' a stronger national identity, but at the same time seeking to distinguish theirs from hers, New Labour's leaders have punched away hard at 'national identity' from the beginning. Like Thatcher, Tony Blair, Gordon Brown and their think-tanks believed that an upbeat characterization of the nation was practically a good thing in itself: it provided a 'story' linking the people and the public sphere, which might help make people feel good about their politicians by making them feel good about themselves. This would require downplaying some of the more divisive elements in Thatcher's formula – the belligerence, the 'enemies within', the nostalgia – and (more difficult) finding new consensual idioms and symbols. Tony Blair's favourite word in this context was 'modern' – but what did 'modern' mean?

In a much publicized report, *Britain*TM, published in September 1997 by the New Labour think-tank Demos, Mark Leonard proposed six national stories as 'a toolkit for renewing Britain's identity', each interpreting 'modern' in a slightly different way: 'Hub UK – Britain as the world's crossroads'; 'Creative island'; 'United colours of Britain', the nation of diversity; 'Open for business', the nation of shopkeepers; 'Britain as silent revolutionary'; 'The nation of fair play', of solidarity and social democracy. Each of these options took an old idea about Britain or England or the national character and gave it a modern spin: empire and the civilizational perspective became Britain as a centre for the global trade in goods and ideas; traditional views of English individualism were merged with Sixties libertarianism and fun and emerged as 'creativity'; Daniel Defoe's mongrel people could easily become multiculturalism; Napoleon's gibe about shopkeepers, not always worn as a badge of pride, could, with the end of relative decline, betoken a new confidence in British entrepreneurship, especially in 'creative' goods and services; 'the middle way' between conservatism and revolution, or between communism and capitalism, had already been re-embraced by Blair's 'third way' between 'Old Labour' and Thatcherism; social democracy and the welfare state seemed more consensual and less 'Old Labour' if connected to 'fair play'.[192]

New Labour did not favour all of these options equally, though it toyed with each. The strongest push was given to the entrepreneurial element, combined with creativity, as Blair's modernization rhetoric required a bullishness about the economy, much like Thatcher's, without the divisiveness associated with her industrial and labour policies.[193] Fortunately for Blair, Britain had by the late 1990s become more comfortable with its post-industrial status, and it was possible to project a rosy economic future based on 'creative industries' such as fashion, design, advertising, the arts, the media, and also on travel and tourism, without summoning up depressing images of nostalgia and 'museumization'.[194] Gordon Brown for his part gave a higher profile to social solidarity and 'fair play' in his presentations of 'New Britain'.[195]

For a while Blair tried to yoke entrepreneurialism and creativity more closely to specific trends in popular culture, entertaining pop stars, fashion designers and avant-garde artists as part of the ill-fated 'Cool Britannia' campaign. Here he was gifted – or perhaps saddled – with a slogan for an American ice cream company that had been launched, fortuitously, in the summer before New Labour's 1997 victory. A London solicitor, Sarah Moynihan-Williams, had entered 'Cool Britannia' in a contest to pick a name for a new British-themed ice cream. Ben & Jerry, the hippie entrepreneurs who ran the ice cream company, must have liked the Sixties overtones – 'Cool Britannia' had been the title of a 1967 song by the Bonzo Dog Doo Dah Band – and the international media liked it, too, picking it up in 1997 to describe

the cultural tone of Blair's New Britain.[196] Just as one American news magazine, *Time*, had dubbed London 'the Swinging City' in April 1966, now another, *Newsweek*, publicized 'Cool Britannia', from where it was gratefully received by New Labour.[197]

Another fortuitous event seized upon by New Labour to promote a new sense of national identity was the death of Princess Diana in late summer 1997, and most particularly the public reaction to her death. Towards the end of her life the mass media had already been portraying Diana as an alternative national character in waiting, 'the People's Princess' with the common touch, a natural expressiveness and emotionality, to counterpoise the stiffness, formality and traditionalism of her husband and mother-in-law (a rerun, it might be thought, of the Angry Young Man campaign against the 'gentleman', although with a very novel appeal to women).[198] The intense emotional release that was held to characterize the national reaction to her death merged this characterization of the princess with the characterization of the nation. For his part, Tony Blair did his level best to merge this characterization of the nation with his own 'New Britain'.[199]

Tabloids of the Right as well as of the Left were talking already in the first week of September of the 'new British spirit' with 'none of that old British reserve' (*Daily Mirror*), 'a new sense of Britishness' in which the people were 'visibly renegotiating their contract with their rulers' (*Daily Express*).[200] 'In the new "Cool Britannia"', wrote a journalist in the *Sunday Times* a few weeks later, 'the done thing is to wear your heart on your sleeve and a yellow ribbon on your lapel.'[201] 'We have ceased to become a nation known for its stiff upper lip . . . and become a nation intoxicated by pain and compassion,' wrote another in the *Observer* just after Christmas.[202] And the feminist commentator Susie Orbach made the connection between the two New Britains as close as it could be made:

> The death of Diana is pinned to the election. When we put our vote in the ballot box on 1 May, we didn't realise until the next day that our action was part of something enormous, and we, overnight, had become part of something promising, exuberant, exciting and inclusive. There was an absolutely parallel response to Diana's death. People registered their feelings, a simple act . . . which allowed Britain to begin the process of reshaping itself.[203]

That was how it looked to Susie Orbach: how widely shared were her views? Though not as divisive as Thatcherism's, New Labour's various national identities were still very far from consensual. 'Cool Britannia' was the butt of jokes just as John Major's list had been. Efforts to capture 'Britain' in the Millennium Dome three years later suffered from similar ridicule, for the

two-dimensional representations of a diverse and complex nation as well as for alleged incompetence. Princess Diana was not everyone's model, and the alleged national sobfest after her death was far from universal. 'Where is this, Argentina?' fumed the Tory journalist Boris Johnson in the immediate aftermath.[204] A year later, polls suggested that half the public felt the other half had overreacted to the whole episode, and over three-quarters that the media had made too much of it. There was no agreement as to whether the public mourning represented a change in the national character or an expression of the traditional national character or a betrayal of the traditional national character or an event irrelevant to the national character should such a thing exist. The most extensive study of the national reaction concludes that 'the popular memory of Diana's mourning as "mass hysteria" serves as a largely negative narrative of national identity'.[205]

In fact Blair had been better served by vapidity and vacuousness than by association with such specific cultural phenomena as 'Britpop' and Dianamania. It is today very difficult to project any vision of 'national identity' that can satisfy even a simple majority of the country, and virtually impossible to project an idea of 'national character' – a psychological profile – that even a small minority recognizes in itself. The sheer variety of national characters currently on offer testifies both to the growing desperation of politicians seeking to resonate with the electorate and also to the real diversity of that electorate. Aspiring national portraitists have a very large menu of national characteristics accumulated over the last two hundred years from which to choose, all now bearing respectable historical pedigrees: self-reliant John Bull, the nation of shopkeepers, the plucky Tommy, the sweet gentleman of Santayana's fantasies, the nation of amateurs, the nation of gardeners, the 'Little Man', the nation of the Blitz or of the Falklands, the nation of fair play or social democracy, the nation throwing off the gentleman, the repressed people, the swinging people, the nation of individuals. All have been given a recent airing. Thatcher tried at least three variants, Blair six; anyone for nine?

Though people may not recognize themselves in any of these national characters, they may still hope one will come along that they do recognize. Yet the proliferation of images engenders cynicism, or at the very least undermines the timelessness and presumed stability that national characters are supposed to have. People are beginning to suspect that 'history is too complex to provide an unchanging set of values, let alone a solid identity'; ergo 'nothing is forever England'.[206] In assessing their history, the social psychologist Susan Condor has suggested, people are now more likely to adopt 'the perspective of the external voyeur': history is something you have rather than something that has (or defines) you, and it can therefore be used more freely – to measure change, to facilitate change, as a source of entertainment and

education as well as affiliation, as an object of irony and argument as well as affection.[207] Heavy-handed uses of history to impose a monolithic national identity, especially when employed by discredited politicians, simply cannot carry the conviction they once did. At the same time, the keener awareness that 'national identity' is something constantly being constructed rather than inherited, its very artificiality, is prone to render people suspicious of attempts to construct it for them. *Britain*[TM] cheerfully announced its set of national identities as a 'toolkit' for a 're-branding' of Britain but, while people willingly display 'brand loyalty', who today wishes to be 'branded' themselves?[208]

If politicians and media interests lack the ability or credibility to construct a national identity, perhaps people are doing it for themselves. In recent years, there has been intense interest – though again more obviously among academic and media commentators than anyone else – in the possibility that a new 'English' national identity is bubbling up from the grass roots. Because politicians are wedded to their existing national institutions, organized on a United Kingdom basis, they are almost automatically disqualified from playing a role here, which increases the hopefulness that the new English identity might have deep and genuine roots in society. The creation in 1999 of a Scottish Parliament and a Welsh Assembly, but no equivalent English body, gave impetus to the view that England needed a new national identity and that politicians were as yet playing no role.

Despite repeated assertions that grass-roots interest in English national identity is strong and growing, there is as yet little evidence of it.[209] When asked to say whether they felt more English or more British, English respondents have shown some but not an overwhelming tendency to say more English: in 2000, a third said more English, a bit under a third said more British, a bit over a third said both equally. This represents a small shift since 1997, but nothing like the shifts registered in Scotland, where up to 80 per cent prefer Scottish to British.[210] In short, changes in one part of the United Kingdom do not imply parallel changes in other parts. Nor do such statistics tell us how much or in what ways people feel 'English', especially as they are normally compiled on the basis of 'forced choices'. As we will see, there is considerable evidence that people in England feel less and less of a national identity of any kind.

Qualitative evidence is spottier still. Every two years, international football tournaments in which England is represented separately offer opportunities for explicitly English patriotism, and there has undoubtedly been increased visibility of the flag of St George on such occasions (and, less so, on St George's Day, 23 April) at least since 1996, especially in pubs and on cars.[211] Unfortunately, close associations between England and football are far from consensus building; on the contrary, they run the risk of importing into

English identity some of the associations between British patriotism, violence, social division and aggressive masculinity prevalent in the Thatcher years.[212] Beyond football, most people find it difficult to pin down anything particularly emblematic of England today: one poll had 36 per cent volunteering football, 17 per cent soap operas (two of them, one northern, one southern – *Coronation Street* and *EastEnders*), 14 per cent the monarchy, with a scattering of further suggestions ranging from fish and chips to pop music.[213]

In fact, most of the recent writing on Englishness has found it difficult to conceive of a positive English identity that is both deep and broad. Attempts to rediscover the national character – an undoubtedly 'deep' sense of Englishness – founder on the difficulty of applying it broadly to a very diverse and individualistic people. Recent analyses have therefore been largely historical and retrospective – either elegiac (accepting that conceiving of an English national character is hardly possible any longer)[214] or merely hopeful (accepting that characterizing the English was easier in the past but wishing it might be possible again in the future).[215] Jeremy Paxman's best-selling book *The English* (1998), for example, trots out rather indiscriminately a range of historical expressions of the English national character – John Bull, the 'Little Man', the gentleman – while accepting that in the present 'the conventions that defined the English are dead'.[216] For a work by a political journalist, the book says surprisingly little about the English in the present; it is easier to imagine the many readers of this book in Condor's posture of 'external voyeur' than in a process of active identification. Other research of Condor's has shown, indeed, that people who are willing to cite English national characteristics are unwilling to apply them to themselves.[217] Most people prefer not to cite 'trait terms' at all – purposefully they avoid talking about 'the English' in psychological language, portraying that very practice as a thing of the past.[218]

Have we then put the idea of the English national character behind us, and if we have, have we lost something valuable? Psychologists tell us that we need stereotypes; they are one of the principal mechanisms by which we order, and thus make sense out of, the otherwise unmanageable barrage of data that our senses pick up about our environment. But this does not mean that all stereotypes are equally useful. As it happens, our culture is so saturated with means of thinking about 'nation' that we do not have to rely on the clumsy semi-automatic mechanisms of brute psychology. We have other options, and we are in a position to weigh up their costs and benefits.

For example, we can see the dangerous ambiguities involved in labelling certain practices or icons – cricket or fox-hunting or the cup of tea or Big Ben – as 'peculiarly English'. We do not necessarily mean they are only English – Big Ben, yes, but cricket? tea? We do not necessarily mean even that they are

the example of their type most prized by the English – tea rather than coffee, perhaps (just about), but cricket more than football? And what about those footballers or coffee drinkers or hunt saboteurs? Are they less English? In fact, we tend nowadays to be savvier about such designations as 'peculiarly English', using them in the language of that 'external voyeur' to express affection for a familiar friend but without really feeling that they say something essential about ourselves. We often know, too, that they are 'stereotypes', oversimplifications, often out of date and exclusionary, based on the practices and prejudices of specific social groups; they can hurt more than they can help. Often, nowadays, when we recognize a stereotype, our half-instinctual response is to suppress it.[219]

This 'stereotype suppression' applies all the more to the particular type of stereotype that has been the subject of this book – the idea that there are psychological characteristics that define the English, uniting them as a body and dividing them from others. In the present era of psychological individualism, we do not like to be told how to behave, within the law; still less how to think. To talk as some people do about certain traits and behaviours constituting our 'cultural DNA', prescribing almost every last detail of social interaction in contemporary Britain, suggests an understanding of national homogeneity even more rigid and exclusive than the strong forms of the early to mid-twentieth century.[220] Where once democracy was served by asserting a common 'English national character' that was capable of self-discipline and self-government, now that self-government is taken for granted, democracy may be better served by leaving our character to ourselves. To the extent that we need a national consciousness for purposes of social cohesion, we have other means of expressing it: the exercise of citizenship; looser sets of 'national values' that do not require so much individual conformity as 'national characteristics'; and, indeed, half-jokey celebrations of symbolic practices and icons that we know may not be 'peculiarly' English at all.

Weaker conceptions of 'the English' abound. Travelogues such as Bill Bryson's *Notes from a Small Island* (1995), another best-seller, give an anecdotal, highly fragmented picture of a people with few things in common, though bathed in a foreigner's affection.[221] More 'lists' have surfaced – longer than Orwell's and Major's, reflecting diversity and also reflecting the great difficulty in finding 'patterns' in culture.[222] Already in 1998 one shrewd journalist pointed out that ' "Englishness", as a contemporary concept, is now terminally stylised in order to be rehabilitated from any suspicion of either nationalism or anti-multiculturalism.'[223] As yet, no common project binding together the English has surfaced to replace older projects of democratization, social justice and modernization. Looser common values upheld by large sections of the English population such as freedom, tolerance, fairness, diversity

are associated as much with Britain as with England, or indeed with no particular national identity at all.[224] If, as many of the proponents of Englishness on the Left maintain, the new English national consciousness must be internationalist, what is added by calling it English?[225]

It may be, then, that the looser set of common values and practices associated with 'Britain' is the maximum 'national identity' we can expect in the early twenty-first century. Politicians and political scientists, in particular, are inclined to prefer the idea of 'citizenship' to 'national identity' and to argue that Britain remains a perfectly acceptable expression of the kinds of national affiliation that people need or want.[226] Spokespeople for ethnic minorities often prefer 'British' because it seems to keep open the possibilities for diversity and multi-culturalism better than 'English';[227] it is the case that people calling themselves 'English' tend to be more anti-European and anti-immigrant than people calling themselves 'British'.[228] (At the same time, people associate both 'English' and 'British' with an aggressive national exclusiveness from which they are keen to distance themselves, showing that answers to questions about national identity are not stable but context sensitive.)[229]

A British identity for the English would imply not necessarily that the English are still fantasizing about a Britain dominated by the English but simply that the looser British citizenship would suffice for them, without the stronger common culture or common project apparently possessed additionally by the Scots.[230] As the Scots show no sign of seeking separation from Britain, it is evidently possible for some parts of the United Kingdom to feel more (or less) British than others without threatening the union. Across the United Kingdom, opinion research shows that people still feel quite ample national pride – particularly in their democracy, their scientific achievements, their armed forces and their history – and at the same time high levels of acceptance of regional identity. They show now about the same levels of national pride overall as most peoples in Europe.[231]

But equally it may be that people will associate themselves with common values and practices outside any national context at all. There is a good deal of evidence that people in Britain today, while continuing to feel pride in 'Britain', do not 'identify' themselves with it as they might once have done. On those rare occasions when people are asked not how they identify with their country but whether they identify with their country, their answers are not always very positive. A 1996 survey asked people what were 'the most important components of identity': the most common answers were 'my principles and values' (66 per cent), 'my interests' (61 per cent), 'being a parent' (59 per cent), 'emotions and feelings' (57 per cent), 'circle of friends' (55 per cent), and 'my intelligence' (52 per cent), with national identifications just behind. When

asked what was 'most important to your sense of self-identity', only 'being a parent' was mentioned by even half of respondents, and nation came far behind, around 20 per cent, clustering with many other bases of identity.[232] Condor's studies into the meanings of 'England' and 'Britain' have been inhibited by the reluctance of many of her respondents, especially the young, to identify with either. In one sample of students, a fifth said they had no national identity at all and 70 per cent said that it was not very important to them. A majority of a sample of skilled workers from the north-west also said that national identity was of uncertain personal significance to them.[233]

If these quantitative measures have not been matched by qualitative investigations, that may have a lot to do with the investment of social scientists and journalists in the presence rather than the absence of national identity.[234] People continue to display a commitment to certain values – individuality, diversity, tolerance, fair play, the rule of law – that have in the past been coded as 'English' or 'British'. But the same values have in the past also been coded as universal human values, and may now be re-emerging in that form.[235] Whereas once a commitment to universal human values seemed easier and more authentic when conceptualized as 'peculiarly' English, now defining these values as 'English' makes them seem more problematic and less sincere. The whig 'progress narrative', which saw universal values being realized most perfectly in national contexts, has to some extent been displaced by a new 'progress narrative', which sees universal values being realized on a global scale.[236] After national character, after nation – humanity, just as the Enlightenment imagined things before national character? Maybe so. Yet history is full of surprises.

Acknowledgements

It took me a while to work out what this book was going to be about. It emerged initially out of previous work on the 'national heritage' and out of my slightly surly conviction that existing literature had oversimplified British ideas about 'nation', starting with the idea of 'heritage'.

I ought to begin by thanking Martin Wiener, whose *English Culture and the Decline of the Industrial Spirit* was my model for what had gone wrong with that literature. Martin has had to endure much more battering on my account than this stimulating (if wrong-headed) book really deserved. He has been very gracious about that. Martin Daunton and the Neale Lecture committee gave me a first opportunity to air my emerging views on the full range of understandings of 'Englishness' in the 1998 Neale Lecture at University College London. Stefan Collini, Richard Whatmore and Brian Young then gave me a second opportunity by inviting me to join in the intellectual celebration of Donald Winch and John Burrow, which led to the unique double-barrelled *Festschrift* in their honour and a further essay by me on ideas about 'race' and 'nation' in the mid-Victorian period.

By that stage I was happily engaging (if sometimes disagreeing) with Julia Stapleton's important work on the intellectual history of Englishness, and I had decided to specialize on this question of 'national character', which I thought was in danger of getting submerged in much woollier discussions of 'nationalism' and (worse) 'national identity', both in academic and in popular discourse. Probably already at this point I was betraying some very early intellectual influences from my parents, Jean and George Mandler, academic psychologists, which made me curious (and, eventually, sceptical) about those chameleon-like concepts 'character', 'personality' and 'identity'.

The early phases of the research were accomplished in a wonderful sabbatical year in 1998–99 provided by my former employer, the now superseded London Guildhall University, for which I have to thank especially my then head of department, Iwan Morgan. Much of the writing was accomplished

in a second sabbatical year provided by the US National Endowment for the Humanities in 2002–03. In between I quarried out little pockets of time for both research and writing in London and in Cambridge.

I have had lots of help from professional colleagues. Julia Stapleton kept up a steady stream of publications and e-mails to stimulate and provoke. Glenda Sluga was very generous in sharing her then unpublished work. Susan Condor was equally generous with unpublished work, and also bravely endured my pretty ignorant (and yet quite persistent) questioning about social-scientific approaches to 'national character'. Professor Nico Frijda answered e-mails from out of the blue about an episode in his youth that he might reasonably have been expected to have long forgotten. My parents and Mel Spiro were asked to forage back even further. I had helpful invitations from the history departments at Manchester, Leicester, Aberystwyth, York, Nottingham and Queen Mary (London) to give talks based on this research, and in each place I found myself tested forcefully in ways that I think have improved my argument. Rob Colls was particularly generous in inviting me to say things that he clearly thinks are misguided. David Cannadine and, at Profile Books, Andrew Franklin and Peter Carson, asked me to take a break from this book to write another one, but even that proved fruitful in focusing my thoughts on this one.

I have been luckiest of all in my friends. Mark Mazower cheerfully waded into many, many conversations about 'nation' over too many years. (He also did an amazing thing: he gave me a book about Erik Erikson, somehow sensing long before I could that it was going to be useful. Its full value will appear only in the book after this one, or maybe even the book after that.) Deborah Cohen organized a conference with me at the German Historical Institute in Washington, DC, on a tangential subject but one that gave me invaluable opportunities to soak up ideas from colleagues and, best of all, from her. Susan Pedersen, as always, is my closest and most clear-headed critic – if we end up agreeing on a lot, that is partly because I have learnt to listen to her carefully. In Cambridge, I found wonderful intellectual companionship from Emma Winter and Clare Pettitt. All five of those people read the full manuscript of the book and peppered me with comments, criticisms, teases and jokes. Many other colleagues offered hints and steers, and I have tried to acknowledge those I have remembered in the notes, but so generous and bounteous has been the flow that I know I have recorded only a small fraction.

I am delighted to be renewing my connection with Yale University Press and especially with Gillian Malpass, queen of editors, who has waited patiently, first for me to decide what I wanted to write about next, and then while I took that break to write a different book. It is good to be back. Stephen

Kent has done the impossible – worked out how to represent a book (through its jacket design) which otherwise sets itself against such easy metonymic representations. He is also responsible for the interior design. Philippa Baker was an immensely scrupulous copy-editor, embarrassingly good at catching the author at fluffs and inconsistencies, and offering that invaluable final reader's-eye-view to pare down obscurity and over-elaboration. What remains is owing to the author's traditional (no doubt misguided) belief that the last twist is always the most significant.

This book is dedicated to two English characters, who I don't think would ever define themselves that way – but that is, and they are, part of the story. That they are I owe to Ruth Ehrlich, along with a lot else.

Notes

CHAPTER 1: INTRODUCTION

1. Surprisingly little has been written about the language of 'national character' as distinct from other forms of national consciousness, but in the recent historical literature see Romani, *National Character and Public Spirit*; Langford, *Englishness Identified*; Rée, 'Internationality'; Duijker and Frijda, *National Character* – an older social-scientific treatment; and a newer one, Reicher and Hopkins, *Self and Nation*, ch. 5.
2. *British Social Attitudes* (2001), 236.
3. Vansittart, *In Memory of England*, 5, 202.
4. Paxman, *The English*, 2–5. For a more extended criticism of all these strategies, see Mandler, 'England, Which England?', and below, ch. 6.
5. Taine's *Notes* did not appear in full in English until 1957. The only contemporary version was expurgated and serialized in a daily newspaper: Taine, *Notes*, xxx.
6. Rogers, *Beef and Liberty*; Barczewski, *Myth and National Identity*; Varouxakis, *Mill on Nationality*; Stapleton, *Englishness*. Each of these books has its virtues, and the latter two are particularly fine intellectual histories, much discussed in their appropriate places below.
7. For some discussion of these methodological issues, see Mandler, 'Problem with Cultural History', and subsequent debate.
8. See n.1. Most of the existing studies of English national consciousness in the modern period use the unitary concept 'national identity': Colls, *Identity of England*; Kumar, *Making of English National Identity*. An older book, Grainger, *Patriotisms*, is more careful about this, perhaps because it covers a more manageable chronological range. Langford, *Englishness Identified*, runs together 'character' and 'manners'. Smith, *National Identity*, e.g., 72–3, makes some distinctions between different forms of national consciousness but then reverts to a more unitary concept.
9. *Richard II*, ii, 1. Cf. Hastings, *Construction of Nationhood*, 56–7, which sees in this speech signs of an intensely horizontal consciousness of an English people, and Helgerson, *Forms of Nationhood*, 244, which (in my view persuasively) puts it in a wider context where Shakespeare's history plays present 'a pre-eminently royal image of England', strategically emptied of popular content.
10. Anderson, *Imagined Communities*; Hobsbawm, *Nations and Nationalism*; Kumar, *Making of English National Identity*.
11. Greenfeld, *Nationalism*; Hastings, *Construction of Nationhood*; Smith, *Ethnic Origins of Nations*.

12. For an early recognition of the degree of 'egalitarian moral discipline' necessary to sustain the stronger forms of national feeling in England, see Newman, *Rise of English Nationalism*, 52–6.

13. Kohn, 'Genesis and Character of English Nationalism', was the pioneer of this view. See also Grainger, *Patriotisms*. But for a contrary view, see Newman, *Rise of English Nationalism*, 53–4.

14. Campbell, 'United Kingdom of England'; Foot, 'Making of *Angelcynn*'; Wormald, '*Engla Lond*', reflecting a new tendency among Anglo-Saxon historians to emphasize the 'nation-building' activities of rulers; also Davies, 'Peoples of England and Ireland II'.

15. Davies, 'Peoples of England and Ireland I'; Gillingham, 'Beginnings of English Imperialism'; Gillingham, 'Civilizing the English?'.

16. Hastings, *Construction of Nationhood*, relies rather too much on the Victorian understanding of these junctures: see esp. 50–1, 59.

17. Anderson, *Imagined Communities*, ch. 3.

18. Greenfeld, *Nationalism*; Hastings, *Construction of Nationhood*, 55–7.

19. But for some doubts about how well diffused was a sense of national religious distinctiveness, see Fletcher, 'English Protestantism and National Identity'.

20. Helgerson, *Forms of Nationhood*, 107–26.

21. Ibid., 1–16.

22. Ibid., 196–244. Greenfeld's contrary assertions, *Nationalism*, 42–67, need to be considered in the light of such constraints.

23. Helgerson, *Forms of Nationhood*, 70–2, 103–4.

24. Ibid., 36–7, 41, 53–4; note especially the difference between the Gothicism of Spenser, rather more aristocratic and even classical, and the Gothicism that spread so rapidly under the political pressures of the early seventeenth century.

25. Kidd, *British Identities*, 211–17.

26. Hill, 'Norman Yoke'; Kidd, *British Identities*, 86–91; Smith, *Gothic Bequest*, 6–13.

27. Kidd, *British Identities*, 214–16, 231–2; Pocock, *Ancient Constitution*.

28. Langford, *Englishness Identified*, 9–10, 137–40.

29. Defoe, *True-Born Englishman*, 28–30. On these early, traditional characterizations, see Hodgen, *Early Anthropology*, and Samuel, *Island Stories*, 8–11.

30. Defoe, *True-Born Englishman*, passim.

31. Colley, *Britons*, esp. chs. 4–5, and see also her 'Whose Nation?'.

32. Langford, *Englishness Identified*, 11, claims 'John Bull' as a popular figure though few illustrations are adduced and those only from the 1790s. Against this interpretation, see the survey by Miles Taylor, 'John Bull', and Hunt, *Defining John Bull*, 144–8, arguing that until the 1790s 'John Bull' represented the people as passive and put-upon (indeed bestial).

33. Cf. Wilson, *Island Race*, 5–16, giving a more ambivalent account of these processes.

34. Voltaire, quoted in Godechot, 'New Concept of the Nation', 13–14.

35. Montesquieu, *Spirit of the Laws*, 246–56, 278, 281–3, 289; these are excerpts from the first English edition of 1750. See also Montesquieu, 'Essay on Causes Affecting Minds and Characters' (1736–43), but not published in any language until 1892.

36. On these early to mid-eighteenth-century impediments to thinking about 'national character', see the helpful discussion in Romani, *National Character and Public Spirit*, ch. 1.

37. Crossley, *French Historians and Romanticism*, 3–6, 22–4, and 47 on debates about Montesquieu; but cf. Welch, *Liberty and Utility*, 232, n. 104, about the limits to Montesquieu's influence; Romani, *National Character and Public Spirit*, ch. 2; also Berger (ed.), *Madame de Staël*, esp. 41–2, 62–3.

38. Crossley, *French Historians and Romanticism*, 48, 56, 58, 62.

39. This famous distinction, between *Kultur* and 'civilization', is now probably best known from Elias, *Civilizing Process*, 8.
40. Herder, *Outlines*, vol. 2, 340–1.
41. Smith, *Politics and the Sciences of Culture*.
42. Kidd, *Subverting Scotland's Past*, esp. ch. 7.
43. Kidd, *British Identities*, 231–2; Kidd, *Subverting Scotland's Past*, passim; Smith, *Gothic Bequest*, 72–84.
44. Hume, 'Of National Characters', quote from 85–6. See also Romani, *National Character and Public Spirit*, 165–9. This kind of thinking encouraged the writing in England, more and for longer than on the Continent, about 'characters' – social types – rather than a unitary national character. See Smeed, *Theophrastan 'Character'*, 289–90; and cf. Langford, *Englishness Identified*, 10, who argues that foreigners thought 'national character' peculiarly appropriate to the English, which may tell us more about French or German uses of the category than about the English usage.
45. Newman, *Rise of English Nationalism*, esp. 115, 161–6, but cf. 222.
46. Kidd, *British Identities*, 216.
47. Hodson, 'Influence of Education and Government', 292–3.
48. Millar, *Historical View of the English Government*, vol. 1, 39–40, 127, 373–6, vol. 4, 174–265; also Millar, *Distinction of Ranks*, 241, for a sneer at Tacitean Saxonism. See further the discussion in Romani, *National Character and Public Spirit*, 177–84.
49. Stocking, *Victorian Anthropology*, 30.
50. See, esp. Burke, *Reflections*, 117–21.
51. A point well made by Breuilly, *Nationalism and the State*, 336.
52. See Frohnen, 'Empire of Peoples', esp. 131.
53. Burke, 'Essay', 394, 430.
54. For an understanding of the way in which free institutions did foster the national character, see, however, Burke's speech of 7 May 1789, where he appeals to the need to keep judicial institutions pure in order to maintain that character: Burke, *Writings and Speeches*, vol. 7, 60–3. I am grateful to Peter Marshall for pointing out to me this instance.
55. Burke, *Reflections*, 169–75, a key passage on the characteristics of 'civilization' that sees them as the legacy of modern Europe as a whole (distinguishing it from Asia). See also Courtney, *Montesquieu and Burke*, esp. 23, 51–3, 93–6, 103, 133–8, on the weight Burke gives to national character, and Romani, *National Character and Public Spirit*, 184–92.
56. See, for example, the observations by Smith, *National Identity*, 85–6.

CHAPTER 2: THE ENGLISH PEOPLE

1. Guizot, *History of Civilization*, 11. For Buckle, see below pp. 81–5.
2. As argued by Colley, *Britons*; but cf. Romani, *National Character and Public Spirit*, 192, 221; and, for a critique of Colley, Dinwiddy, 'England', 64–9. Supporters of the French Revolution in Britain might have been more inclined to dwell upon the national character of the masses: see, for example, Junius Junior, *National Character*, 1, 3–6, 8.
3. Stedman Jones, *Languages of Class*; Wahrman, *Imagining the Middle Class*.
4. Sack, *From Jacobite to Conservative*, covers those Tories who did attempt to build on the Burkean example, but see below.
5. Harling, *The Waning of 'Old Corruption'*; Harling and Mandler, 'From "Fiscal-Military" State to Laissez-Faire State'.
6. Hoock, *King's Artists*, ch. 9; Penny, '"Amor Publicus Posuit"'. Another general war monument, on Calton Hill in Edinburgh, remained unfinished.

7. Hunt, *Defining John Bull*, 162–9; cf. ibid., 293–303, with Taylor, 'John Bull', on the post-war John Bull, who in both accounts becomes more of a middle-class figure, beset by taxes and regulations.

8. Hilton, *Age of Atonement*; Briggs, *Age of Improvement*. Wilson, *Island Race*, 10–11, rightly emphasizes the 'glacial slowness' of Christian improvement. More consideration needs to be given to the variety of contemporary explanations for this, ranging from race to deeply embedded moral differences to the ubiquity and stubbornness of sin.

9. For an alternative tradition of Tory political economy, more national in its orientation, see Gambles, *Protection and Politics*, though this tradition was on the defensive for most of this period and its national and imperial ambitions were at odds. For an alternative tradition of Tory moral economy, also more national in its orientation, see Connell, *Romanticism, Economics*. But, as Connell notes 237–7, this tradition, too, was on the defensive from the 1820s and under pressure subordinated its national rhetoric to its Christian rhetoric.

10. Sumner, *Records of Creation*, vol. 2, 21–2. The influence of the Scottish Enlightenment, particularly Adam Smith and Dugald Stewart, is palpable throughout.

11. This is the subject of nearly the whole of vol. 2 in Sumner, *Records of Creation*.

12. Ibid., vol. 2, 359–60, explicitly echoing Dugald Stewart.

13. Prichard, *Researches*, esp. 226–33, on the effect of civilization on skin colour. See also Sumner, *Records of Creation*, vol. 1, Appx. II.

14. Colley, 'Britishness and Otherness'; Ditchfield, 'Church, Parliament and National Identity'.

15. See below, pp. 66–7, 97–100, 124–7.

16. For a brave, early stab at unionism, see Robbins, *Nineteenth-Century Britain*, and, more recently, *Great Britain*. See also Brockliss and Eastwood (eds), *Union of Multiple Identities*; Morton, *Unionist-Nationalism*; and the unionist orientation of Hoppen, *Mid-Victorian Generation*. For the practical workings, see Innes, 'Legislating for Three Kingdoms'. Kumar, *Making of English National Identity*, 145–95, argues for Britishness as a powerful alternative to Englishness in this period, distinguishing between a 'missionary nationalism' that binds the union, and a related 'missionary' spirit that was not nationalist, binding the empire (cf. 164–5, 186).

17. Metcalf, *Ideologies of the Raj*, 32–4.

18. Curtin, *Image of Africa*, 235–8.

19. Murray, *Enquiries Historical and Moral*, esp. 12–13, 141–51. Murray granted that there must be something physical in the more extreme human racial differences, but denied that this necessarily extended to mental difference. See similar in Elliott, *Effects of Climate on National Character*.

20. Harrison, *Climates and Constitutions*, 88–108; Curtin, *Image of Africa*, 245–50; Metcalf, *Ideologies of the Raj*, 32–3; Hall, 'Missionary Stories'. It was possible to hold both racialist and civilizational views at the same time: see, for example, Arnold, 'On the Social Progress of States', esp. 110. But Arnold was unusual in being so even-handed; it was more normal to assert the long-term triumph of civilization over national and racial difference, as in the end Arnold did himself.

21. Sack, *From Jacobite to Conservative*, 90–1, 253–4; Mehta, *Liberalism and Empire*.

22. On Coleridge's national thought and the legacy of Burke, see Smith, *Gothic Bequest*, 137, 149, 153–5; Stafford, 'Religion and the Doctrine of Nationalism'.

23. See esp. Coleridge, *On the Constitution of Church and State*. On Coleridge's failure to develop German ideas on language as the foundation of a national character, for example, see Perkins, *Nation and Word*, 76–8, 81.

24. See below, pp. 49–52. On Coleridge's heirs, see Forbes, *Liberal Anglican Idea of History*; Jones, *Victorian Political Thought*, 43–52; Smith, *Gothic Bequest*, 181–2, 190–1.

25. Peardon, *Transition in English Historical Writing*, 1933, is still, astonishingly, the most ambitious survey. See also Blaas, *Continuity and Anachronism*, ch. 2; Newman, *Rise of English Nationalism*, 112–15; and Smith, *Gothic Bequest*, 97–8.

26. Peardon, *Transition in English Historical Writing*, 144.

27. Hallam, quoted in Smith, *Gothic Bequest*, 141.

28. Hallam, quoted in Burrow, *Liberal Descent*, 30; Burrow's account of early nineteenth-century whig historiography is definitive. See also the discussion in Peardon, *Transition in English Historical Writing*, 271–6.

29. Stubbs, 'Comparative Constitutional History', 198. See also Freeman, 'Dr. Vaughan's *Revolutions*', 136–7; Green, *Short History*, 384.

30. Hallam was the leading English historian in the Cambridge Moral Sciences tripos when its history content was briefly fortified in the 1860s: Slee, *Learning and a Liberal Education*, 33–6.

31. Palgrave, *Rise and Progress*, in *Works*, vol. 6, 2–3. See also 'The Gothic Laws of Spain', *Works*, vol. 9, 335–6, cited by Smith as an example of Palgrave's racialism, but rather another explicit reference to the divergence of English political development from other Teutonic peoples.

32. Compare 'Ancient Laws and Institutions' (*Edinburgh Review*, 1819) in Palgrave, *Works*, vol. 9, 331–3, with 'The Conquest and the Conqueror', in *Works*, vol. 9, 470. See also Smith, *Gothic Bequest*, 142–6, which, however, oscillates between emphasizing the racial, populist and 'aristocratic' tendencies in Palgrave's work, and the fuller account in Smith, 'European Nationality'; cf. Blaas, *Continuity and Anachronism*, 78, 82–7. Palgrave's critique of Thierry in 'The Conquest and the Conqueror' accuses him, confusingly, of being too romantic and insufficiently national.

33. Palgrave, *Rise and Progress*, in *Works*, vols 6–7, passim (quote at vol. 6, 26).

34. Freeman, 'Dr. Vaughan's *Revolutions*', 149–50; Stephens, *Life and Letters of Freeman*, vol. 1, 116–17, 336. But Stubbs was more censorious: Hutton (ed.), *Letters of Stubbs*, 105.

35. See, for example, Craik and Macfarlane, *Pictorial History*; and on the changing temper of radical history more generally, Joyce, *Visions of the People*, 173–5; Smith, *Gothic Bequest*, 195–204.

36. Parry, *Rise and Fall of Liberal Government*, ch. 2, gives a good account of this juncture.

37. On the Whigs' understanding of 'the people', see Dinwiddy, 'Fox and the People'; Fontana, *Rethinking the Politics*, ch. 5; Mandler, *Aristocratic Government*; Wasson, 'Great Whigs'.

38. Eastwood, '"Amplifying the Province of the Legislature"'; Goldman, 'Origins of British "Social Science"'.

39. Wahrman, *Imagining the Middle Class*.

40. Berg, *Machinery Question*; Poovey, *Making A Social Body*.

41. Porter, *Rise of Statistical Thinking*, 52–5, 60, 101–4.

42. Desmond, *Politics of Evolution*.

43. Combe, *Constitution of Man*, 193, 194–218.

44. Desmond, *Politics of Evolution*, 73–4, 388–9; Richards, '"Moral Anatomy" of Robert Knox'; Stocking, *Victorian Anthropology*, 64–5. See below, chapter 3, p. 74.

45. Cooter, *Cultural Meaning of Popular Science* (emphasizing the hierarchical character even of phrenology); Winter, *Mesmerized*. See also Stocking, 'From Chronology to Ethnology', lxxxiii–lxxxv, on the changes Prichard made in the 3rd edition of his *Researches* (1836–47) to respond to this new racialism, emphasizing further the powerful effects of civilization on physiognomy. This should not necessarily be viewed as a concession to racialism, though it acknowledges further differentiation.

46. The author is unidentified even in *Wellesley*. Cf. an unusual adoption of the language of 'national character' – even evoking popular materialism – in a Tory journal,

Blackwood's: 'Characters of the English', probably by Alaric Watts, an unusually romantic (in fact, Coleridgean) Tory.

47. [Disraeli], *England and France*, 50–1, and the essays collected in *Whigs and Whiggism*.

48. Disraeli, *Vindication*, 16–17. See Hertz, 'National Spirit and National Peculiarity', 350, for an early recognition of Disraeli's language of national character and its limits.

49. On Peel's attitudes to nationality, see Eastwood, '"Recasting Our Lot"', esp. 38, where the rhetoric is described as 'simultaneously expansive, loose and quintessentially English'. The latter term is accurate only in the sense that it repeats the previous two terms.

50. Cf. Smith, *Disraeli*, 64–5, 190–1.

51. Hare's *Guesses at Truth*, cited by Forbes, *Liberal Anglican Idea of History*, 7.

52. Arnold, 'On the Social Progress of States', 108, and more tentatively in *Introductory Lectures*, 19–20.

53. Arnold, *Introductory Lectures*, 31–2. The phrase was then picked up by H.H. Vaughan in 1849, more or less to refute Arnold's propositions: Vaughan, *Two General Lectures*, 12. It appears also once in Green's, *Short History* of 1874, 440; but otherwise it hardly figures in discussion of nationality until the modern understanding of 'national identity' was developed by social psychologists in the 1960s. See below, pp. 225–6.

54. Arnold, *Introductory Lectures*, 33. See also Forbes, *Liberal Anglican Idea of History*, 51.

55. [Milman], 'Prescott's Conquest of Peru', 323. See also Forbes, *Liberal Anglican Idea of History*, 34–6, 41–2, 46, 56–60, 85–6, 99–101.

56. Stephens, *Life and Letters of Freeman*, vol. 1, 66.

57. Arnold, *Introductory Lectures*, 4–5, 11. After the inaugural lecture, from which these quotes have been taken, Arnold's subsequent lectures paid little attention to distinctive national qualities and in fact displayed some of the same obsession with external relations that he had deplored in earlier histories. Perhaps he would have made more progress had he lived to write the further lectures in English history that he had promised.

58. Chenevix, *Essay upon National Character*, vol. 1, 5–6. Virtually nothing has been written about Chenevix; even his entry in the *Oxford Dictionary of National Biography* discusses only his achievements as a chemist. Alaric Watts in 1829 had also said similarly that 'national character . . . is a subject at once of great curiosity, and of the very highest importance . . . I am not aware that any thing has yet been written about it': [Watts], 'Characters of the English', 818.

59. Chenevix, *Essay upon National Character*, vol. 1, 15–18, 35–41, 66–8, 76–7.

60. Ibid., vol. 2, 531–2, 574–5. Chenevix thus has a somewhat less plastic view of national difference than implied by Langford, *Englishness Identified*, 8, quoting only the earlier passage (although otherwise Langford wants to emphasize the increasingly fixed, biological thinking of early nineteenth-century writing on national character).

61. For example, Chenevix, *Essay upon National Character*, vol. 1, 270, 288, 452. Vol. 2 centres mostly on national differences in the arts of war.

62. The fact that Chenevix's work was published posthumously cannot have helped.

63. Given his significence as a historian, there is also surprisingly little written about Kemble; see the appreciative biography in *Old DNB* and Raymond A. Wiley, 'John Mitchell Kemble's Lifetime Debt to Jakob Grimm', in Wiley (ed.), *Kemble and Grimm*, 5–18.

64. For Kemble's views on the political qualities of the people, see for example, Kemble to Grimm, 26 March 1837, 24 May 1839, in Wiley (ed.), *Kemble and Grimm*, 138–9, 174.

65. See [Lewes], 'State of Historical Science in France', for an important statement reflecting the historical orientation of Kemble's journal, including debts to Giambattista Vico and Herder, a distancing from the Scottish Enlightenment, and an admiration for French and German historiography. While this anonymous article is

credited by *Wellesley* to G.H. Lewes on good evidence, it bears traces of Kemble's fingerprints, notably in a diatribe against women's rights and divorce, a pet peeve of Kemble's deriving from his own tragic marital experience. Lewes was a frequent contributor to the *British & Foreign Review* on French topics during this period, having been introduced to Kemble by J.S. Mill.

66. For Kemble's own awareness of such similarities, see Kemble to Grimm, 21 April 1849, in Wiley (ed.), *Kemble and Grimm*, 269–70. But see also Kemble, *Saxons in England*, esp. vol. 1, 122, 127–31, for a conjectural history rather closer to that of the Scottish Enlightenment.

67. [Kemble], 'English Historical Society', esp. 167–92 (quote at 192).

68. Kemble to Grimm, 28 May 1833, in Wiley (ed.), *Kemble and Grimm*, 35.

69. Kemble to Grimm, [?] January 1842, [?] July 1842, 16 September 1842, 23 August 1844, 22 March 1848, in Wiley (ed.), *Kemble and Grimm*, 225, 230, 241–2, 254, 266. Note also Stubbs's point that Kemble could acknowledge the Norman contribution to the English national character: Stubbs, *Constitutional History*, vol. 1, 216n.

70. Kemble, *Saxons in England*, vol. 1, p. viii.

71. Kemble to Grimm, 21 April, 17 December 1849, in Wiley (ed.), *Kemble and Grimm*, 280–1, 295.

72. As with many people, the events of 1848 had the effect of aggravating Kemble's racialism, both in its Teutonic and its anti-Celt and anti-Slav qualities (not much in evidence in *The Saxons in England* or earlier). See, for example, Kemble to Grimm, 22 March 1848, 9 March, 21 April, 15 September 1849, in Wiley (ed.), *Kemble and Grimm*, 266–8, 276, 278–9, 289–90. But the evidence of a strongly universalistic, normative political economy is still here, too, despite his protestations to the contrary. Kemble lived in Hanover between 1849 and 1855, and died in Dublin in 1857.

73. See the prescient review by Kemble's close friend W.B. Donne, 'The Saxons in England'. For E.A. Freeman's debt to Kemble, see Stephens, *Life and Letters*, vol. 1, 115–16, 336; for Stubbs, Hutton (ed.), *Letters of Stubbs*, 105. For Burrow's view of *Saxons in England* as a turning point, see *Liberal Descent*, 119–20.

74. Laing has received little more attention than Chenevix or Kemble. Aspects of his thought (though not the national aspects) are covered in Porter, '"Monstrous Vandalism"' and 'Virtue and Vice in the North'.

75. When speaking of 'a people', Laing took more care than most to specify that he meant 'the labouring mass of a nation, living principally by agricultural work, and in every country constituting the mass of the population': Laing, *Notes of a Traveller*, 271, also 417–20.

76. Laing, *Notes of a Traveller*, 9–10. See also Laing, *Observations*, 514–15.

77. Laing, *Notes of a Traveller*, 5–6, 318–20, 386–8, 477–8; *Observations*, 515–16.

78. Laing, *Notes of a Traveller*, 76, 89–90, 271. Laing's emphasis on social economy rather than climate or geography allowed him to explain why civilization arose in the allegedly unfavourable climates of India, Mesopotamia, Egypt and Mexico: 414–16.

79. For examples of the former, ibid., 9–10, 61–2, 77–8, 89; of the latter, ibid., 272–3.

80. Laing, *Notes of a Traveller*, 89–92. Buckle was particularly influenced by this line of thinking: see his notes on Laing in 'General Remarks on National Character', in Taylor (ed.), *Miscellaneous Works of Buckle*, vol. 1, 591–2.

81. Howitt, *Rural and Domestic Life*, for example, 41, 202. See also John Stuart Mill's approving comments on this work in the *Morning Chronicle*, 30 November 1846, in Mill, *Collected Works*, vol. 24, 968–71. Morgan, *National Identities*, 77–8, 149–50, misplaces Howitt in a 'Tory' view of Englishness.

82. For relatively recent treatments of Mill's ideas on 'character', which downplay the significance of the national dimension, see Collini, Winch and Burrow, *That Noble Science*, esp. 138–9; Collini, *Public Moralists*, 107–8, 138 and n. 40; Leary, 'Fate and Influence of Ethology'. With mounting interest in issues of nationality, however, this

neglect is beginning to be redressed: see, for example, Varouxakis, 'Public Moralist versus Ethnocentrism' or, rather less sophisticated, Smart, 'Mill and Nationalism', and, more recently, Varouxakis, *Victorian Political Thought on France*, and idem, *Mill on Nationality*.

83. Mill, 'Michelet's History of France', *Edinburgh Review*, January 1844, in Mill, *Collected Works*, vol. 20, 235, 236–7. The opening salvo is often quoted, the moderating remarks that follow – arguing that Michelet's views on race were 'contestable' but at least 'suggestive of thought' – rarely if ever. Horsman, 'Origins of Racial Anglo-Saxonism', 339, and *Race and Manifest Destiny*, ch. 3, even uses the first quotation as key evidence of the prevalence of racial thinking in the 1840s without appreciating that it is Mill's. For a healthy corrective, see Varouxakis, 'John Stuart Mill on Race'.

84. Mill, *Collected Works*, vol. 2, 319 (this is the 1871 text, but the wording is nearly identical in the 1848 first edition). He used virtually the same language in his response to Thomas Carlyle on 'The Negro Question' in 1850. Notice also that Mill deletes a passage touching on racial propensity to labour at the proof stage of the *Principles* and in 1852 changes the word 'races' to 'nations' in the one line from this passage that survives: Mill, *Collected Works*, vol. 2, 104 and n.

85. Mill to Charles Dupont-White, 6 April 1860, in Mill, *Collected Works*, vol. 15, 691 (my translation from Mill's French). There is a similar rebuke to Charles Wentworth Dilke in Mill to C.W. Dilke, 9 February 1869, in Mill, *Collected Works*, vol. 17, 1563.

86. Mill made the same complaint against phrenology – that its value could not be properly assessed until balanced against other factors in a science of character: Mill to Auguste Comte, 30 October 1843, 26 March 1846, in Mill, *Collected Works*, vol. 13, 604–6, 697–8.

87. Mill's first thoughts on national character do seem to stem from this motive: see Mill to Gustave D'Eichtal, 15 May 1829, in Mill, *Collected Works*, vol. 12, 31–3; 'French News', *Examiner*, 18 December 1831, in Mill, *Collected Works*, vol. 23, 375; 'Comparison of the Tendencies of French and English Intellect' (1832), in Mill, *Collected Works*, vol. 23, 442–7; and esp. 'The English National Character' (1834), in Mill, *Collected Works*, vol. 23, 717–27. Varouxakis, *Victorian Political Thought on France*, defends this as a conscious strategy.

88. Here I am singling out only one strand of a subtle argument in Collini, *Public Moralists*, 104–13.

89. Mill, Leaders in the *Morning Chronicle*, 19 November, 2 December, 17 December 1846, in Mill, *Collected Works*, vol. 24, 955–8, 872–5, 1001–4. The phrase 'sedulous moral culture' comes from an earlier piece, 'The Irish Character', *Examiner*, 22 January 1832, in *Collected Works*, vol. 23, 397, showing a stronger interest in racial characteristics but also many of the concerns present in 1846.

90. Mill, *Collected Works*, vols 7–8, 863–70, 905.

91. This is a difficult point, on which Mill himself appeared to waver in different directions at various stages in his career, but on the whole he seems to have cleaved to a unitary ideal of civilization with multiple, possibly unique pathways to it. See the helpful discussions in Collini, Winch and Burrow, *That Noble Science*, 132–48, and Stocking, *Victorian Anthropology*, 39–40. For an important early statement against Comte's view that there was 'only one law of the development of human civilisation', see Mill to D'Eichthal, 8 October 1829, in Mill, *Collected Works*, vol. 12, 37. But this makes him optimistic rather than pessimistic about the hopes for universal civilization, since diversity of paths opens the possibilities for experimentation: 'State of Society in America' (1836), in Mill, *Collected Works*, vol. 18, 93–4. In the *System of Logic*, Mill holds that 'the better the diversities of individual and national character are understood, the smaller, probably, will the number of propositions become, which it will be considered safe to build on as universal principles of human nature' (Mill, *Collected Works*, vols 7–8, 906), which can be interpreted as both an assertion of difference and

also, at root, of unity; in short, of complexity. There is a huge literature now on Mill's application of these principles to India – see, most recently, Mehta, *Liberalism and Empire*, esp. ch. 3 – though less on Ireland, but see Steele, 'Mill and the Irish Question'.

92. Mill, *Collected Works*, vol. 19, 546–9.

93. Kemble, quoted in [Lewes], 'State of Historical Science in France', 85–6.

94. Harvie, *Lights of Liberalism*, esp. 38–40, 153–6, possibly underestimating Mill's influence on national as well as related questions; discussed further below, ch. 3.

95. This is not to gainsay the argument in Leary, 'Fate and Influence of Ethology', that Mill's science of ethology failed to take off in England. Leary is concerned with ethology as a science of individual character, in other words, psychology, which did indeed run into the sand. The two aspects tended to separate. See, for example, Mill's principal psychological follower, Alexander Bain, whose *Study of Character* (1861) hardly considered national difference. Conversely, note the interest in Mill's ethology among ethnologists (for example, Latham, *Man and His Migrations*, 39–40) and political thinkers (discussed below, ch. 3), blending with mid-to-late Victorian interests in evolution and the comparative method.

96. Cf. Langford, *Englishness Identified*, with Colley, *Britons*.

97. For example, to different extents, Colley, 'Britishness and Otherness'; Hall et al., *Defining the Victorian Nation*. For a revealing counter-illustration, see Kidd, *British Identities*, 211–13, which protests against the idea that Englishness was defined against an Other in the eighteenth century but accepts that it might have been in the nineteenth, owing to the more ethnically determinist nature of nineteenth-century thinking. As I have tried to show above, nineteenth-century thinking was not so determinist and was subject to the same 'historical processes' to which Kidd attaches significance in the eighteenth century.

98. For the beginnings of a critique of 'Othering', see Steedman, 'Inside, Outside, Other'. Breuilly makes the point that ideas of nationality may come to fasten on the easy opposition of the 'Other' when they are prepared for popular dissemination by elites: Breuilly, *Nationalism and the State*, 344. For further discussion on the processes of identity construction, see Mandler, 'Problem with Cultural History', and subsequent debate; Mandler, 'What is "National Identity?"'.

99. Langford, *Englishness Identified*, ch. 6.

100. Rendall, 'Tacitus Engendered', discusses some late eighteenth-century uses of Tacitus for English and British purposes, but acknowledges that this perspective had then only a glancing influence.

101. Kemble, *Saxons in England*, 88–9, 123.

102. Laing, *Observations*, 515.

103. Howitt, *Homes and Haunts*, vol. 1, 340. The resonant phrase – 'venerating themselves as men' – is an adaptation of a tag from Oliver Goldsmith's 'Traveller'. Note also Howitt's diplomatic avoidance of debates over the origins of these traits in race, climate and circumstance at pp. 339–40.

104. Langford, *Englishness Identified*, 279–84, a passage notably fixated on elite culture. The only one of the authors of the 1830s who dwelt upon English 'humour' was Chenevix – for example, *Essay upon National Character*, vol. 1, 462 – the least interested in democratic culture.

105. Kemble, *Saxons in England*, 127–30.

106. Herzen, quoted in Buruma, *Voltaire's Coconuts*, 121–2.

107. Mill, *Collected Works*, vol. 23, 485; see also vol. 20, 191.

108. Kemble, *Saxons in England*, 231–2, 237–8; Chenevix, *Essay upon National Character*, vol. 2, 371–3. See Rendall, 'Tacitus Engendered', for the late eighteenth-century origins of this position.

109. Chenevix, *Essay upon National Character*, vol. 2, 371. See also the discussion in Langford, *Englishness Identified*, 109–21, which rather oscillates between assertions of

English uniqueness in these respects and admissions (including by contemporaries) that similar ideas about domesticity were universal or at least shared with the Germans.

110. See the discussion in Langford, *Englishness Identified*, ch. 1, though perhaps unnecessarily seeking to render compatible the different interpretations of English 'energy' (for example, at 36–7). Langford's observation of an early nineteenth-century shift towards emphasizing solidity and drudgery reflects his Continental sources, with a strong anti-industrial bias, though one can see it in Mill, too.

111. Mill, *Collected Works*, vol. 2, 104.

112. Ibid., vol. 2, 104n.

113. Melman, 'Claiming the Nation's Past', esp. 584–5.

114. Howitt, *Rural and Domestic Life*, 41–2; Mill, *Collected Works*, vol. 24, 969–70.

115. Laing, *Notes of a Traveller*, 9–10 See also Kemble to Grimm, 24 May 1839, in Wiley (ed.), *Kemble and Grimm*, 174; Chenevix, *Essay upon National Character*, vol. 2, 63.

116. These characteristics were noted especially in those un- or anti-democratic writers who made implicit or explicit distinctions between the classes: for example, Chenevix, *Essay upon National Character*, vol. 1, 453–78; Bulwer, *England and the English*, passim.

117. See the discussion in Christiansen, *The Visitors*, 101–16, 125–7. Note also Mill's protest against Emerson's early conclusions expressed in a December 1848 lecture: Mill to Taylor, 14 March 1849, in Mill, *Collected Works*, vol. 14, 15–16.

CHAPTER 3: ANGLO-SAXONS

1. Mandler, *Aristocratic Government*, 255.

2. Varouxakis, *Victorian Political Thought*, 68–71. See also pp. 76–7 for the thoughts of the young Walter Bagehot and Matthew Arnold in spring 1848.

3. Cited by Taylor, *Decline of British Radicalism*, 195, n. 24. See also ch. 6 for a full discussion of British radicals' persistently 'whiggish' view of European nationalism in the 1850s.

4. [Twiss], 'Austria and Germany', 186, 188. Twiss repeated these arguments a few months later in 'The Germanic Confederation and the Austrian Empire'. It is certainly not the case, as Catherine Hall suggests, that this period saw 'new discourses of race and nation previously associated with conservative thinking' creeping into liberalism (and Thomas Carlyle, the only example she cites, was a highly eccentric variety of conservative). More or less the opposite process was in train: Hall, '"From Greenland's Icy Mountains . . .', 222.

5. Disraeli, quoted in Smith, *Disraeli*, 190–1.

6. This is a subject of some controversy. The virulence of English racial animus against the Irish, asserted by Curtis, *Anglo-Saxons and Celts* and Lebow, *White Britain and Black Ireland*, has been challenged by Gilley, 'English Attitudes to the Irish'. Gilley suggests that anti-Irish feeling ebbed and flowed with the political threat posed (at something of an ebb between the late 1840s and the late 1860s). See also Foster, 'Paddy and Mr Punch', and Rich, 'Social Darwinism', on the influence of Darwinism from the 1860s. See also below, pp. 91–2, 99–100, on the Irish place in Victorian Teutonism.

7. On Scottish 'unionist-nationalism', which blended political unionism and cultural nationalism, see Kidd, 'Sentiment, Race and Revival', and Morton, *Unionist-Nationalism*. See also below, pp. 97–8, on the Scottish place in Victorian Teutonism.

8. Morgan, *National Identities and Travel*, 162–5; Parry, 'Impact of Napoleon III', 149–50; Porter, '"Bureau and Barrack"', 424–7.

9. Burrow, *Evolution and Society*, 159–62, 166 (quoting Maine); Collini, Winch and Burrow, *That Noble Science*, 164–5, 173–4, 180; cf. Mandler, '"Race" and "Nation"',

234–5; and, on Darwin's cop-out from the same question, see Jones, *Social Darwinism*, 24–5.

10. Dickens, *Our Mutual Friend*, book 1, ch. 11. For earlier comments of a similar tenor, see Dickens, 'Insularities' and 'Why?'

11. Lees, *Cities Perceived*.

12. Robbins, *Nineteenth-Century Britain*, is the authority on these and other subtle processes of integration.

13. Goldman, *Science, Reform, and Politics*, esp. ch. 10; Buckle, *History of Civilization*, for example 128.

14. See below, p. 76.

15. Winter, *Mesmerized*, 308.

16. Calculated from the bibliography in Chancellor, *History for their Masters*. Of the remaining four, one was a history of the British Empire and the other three all dated after 1874.

17. Parry, *Democracy and Religion*.

18. Savage and Miles, *Remaking of the British Working Class*, summarizes the sociological evidence.

19. Collini, 'Idea of "Character"', adapted as *Public Moralists*, ch. 3.

20. Buckle's preference was for the former, and objections to his theses were often based on a preference for the latter. See, for example, [Pollock], 'Civilization in England', 53; [Stephen], 'Buckle's *History of Civilization in England*', esp. 478–81. See also Rylance, *Victorian Psychology*, 131–3, 151–9, 169–70.

21. Smiles, *Self-Help*, 314. See further Mandler, 'Gold out of Straw'.

22. Smiles, *Self-Help*, ch. 13.

23. Kingsley, 'On English Literature', 261.

24. Harvie, *Lights of Liberalism*; Kent, *Brains and Numbers*.

25. Cf. Carlyle, 'Signs of the Times' (1829), 75, with Carlyle, 'Chartism' (1839), both in Carlyle, *Selected Writings*.

26. [Mazzini], 'The Works of Thomas Carlyle', 274–5.

27. Froude, 'England's Forgotten Worthies'. See the useful discussions in Burrow, *Liberal Descent*, 231–67, and Melman, 'Claiming the Nation's Past'.

28. Kingsley, 'Froude's History of England' (1856), in *Miscellanies*, vol. 2, 30–2, 70–2.

29. [Stephen], 'Buckle's *History of Civilization in England*', 496. For a liberal evocation of the Crimea and India for the same purpose, see Smiles, *Self-Help*, 198–202, 331–2, but characteristically Smiles adds instances of self-reliance under duress in less martial circumstances, such as missionary work or a famous shipwreck of 1852.

30. It is striking that critics of my argument that 'national character' was in this period still virtually a liberal monopoly riposte with one name only: Stephen's. See Stapleton, 'Political Thought and National Identity', 248; Varouxakis, *Victorian Political Thought on France*, 113. For a broader critique, see Jones, 'Idea of the National'. For another view expressing confidence in the national character but not in democracy, even more idiosyncratic and less influential than Stephen's, see the work of James Lorimer, *Political Progress Not Necessarily Democratic* and *Constitutionalism of the Future*, which Kingsley admired: Kingsley (ed.), *Charles Kingsley*, vol. 2, 242.

31. Metcalf, *Ideologies of the Raj*, 58–9; Stapleton, 'James Fitzjames Stephen', 252–60.

32. [Stephen], 'National Character', esp. 591, 594–5.

33. Shannon, *Gladstone*, 389. See also Matthew, *Gladstone*, 128–34.

34. Especially G.C. Brodrick, 'The Utilitarian Argument against Reform, as stated by Mr Lowe', 25; James Bryce, 'The Historical Aspect of Democracy', 276–7; and A.O. Rutson, 'Opportunities and Shortcomings of Government in England', 281; but also Lord Houghton, 'On the Admission of the Working Classes as Part of Our Social System', esp. 47–50, 63–4, all in *Essays on Reform*. See also Harvie, *Lights of Liberalism*, 154–8.

35. Joyce, *Democratic Subjects*, 147, 196. Here and in *Visions of the People* Joyce is more concerned to show how the 'social' was articulated – especially the predominance of languages of 'the people' over languages of class – and so the 'national' is rather underplayed. Hall et al., *Defining the Victorian Nation*, purports to take the 'nation' more seriously on its own terms, but here 'nation' is too often conflated with 'race'; see below, pp. 72–86.

36. Lecky, *History of the Rise and Influence*, vol. 2, 248.

37. Smiles, *Self-Help*, 18.

38. Knight, *Popular History*, vol. 1, iii–iv; and see also Buckle, *History of Civilization*, 131. They were drawing on a rhetorical line first popularized by Carlyle. See also Melman, 'Claiming the Nation's Past'.

39. Recently treated by Hall, *Civilising Subjects*.

40. Harrison, *Climates and Constitutions*, 112–13, 116–51, 172, 203, 220, gives a nuanced account of the struggle between racial and civilizational analyses (sometimes coexisting within the same individual) 'on the ground' in India.

41. See, for example, [Carpenter], 'Ethnology, or the Science of Races'; Latham, *Natural History of the Varieties of Man, Man and His Migrations*, and *Nationalities of Europe*; Huxley, *Man's Place in Nature* and 'Forefathers and Forerunners'. The Ethnological Society was, of course, not 'Darwinian' in its origin – its chief intellectual inspiration was Prichard – but the Darwinians gravitated to it in the 1860s. See Stocking, *Victorian Anthropology*, 244–61.

42. Rylance, *Victorian Psychology*, 222–8.

43. Cf. Biddiss, 'Myths of the Blood', 14; Bolt, *Victorian Attitudes to Race*, 18–19; Curtin, *Image of Africa*, 378–82; Curtis, *Anglo-Saxons and Celts*, 69–70; Hall, '"From Greenland's Icy Mountains . . . "', 215; Hall et al., *Defining the Victorian Nation*, 192; Lorimer, *Colour, Class and the Victorians*, 137–41; MacDougall, *Racial Myth in English History*, 90–1; Rich, *Race and Empire*, 13; Richards, '"Moral Anatomy" of Robert Knox', esp. 435; Stepan, *Idea of Race*, 41, 45–6; Stocking, *Victorian Anthropology*, 244–7; Young, *Colonial Desire*, 16, 119–20. Hall, *Civilizing Subjects*, 275–80, now gives a more varied picture.

44. Knox, *Races of Men*, 56–7.

45. Ibid., 3, 43, 49.

46. For criticisms of Knox from a civilizational perspective, see [Adams], 'Human Progress', 1–2 (accepting a biological basis for national difference but not fixity); Emerson, *English Traits*, 50, 54, 56; Latham, *Man and His Migrations*, 41–4; Pike, *English and their Origin*, 5–12 (also accepting biological bases but not fixity); from a Christian perspective, 'The Races of Mankind', 586–604. I can find only one outright endorsement of Knox's views in the mainstream periodical press, 'Types of Mankind', from the *Westminster Review*, which *Wellesley* attributes to Luke Burke, the projector of a short-lived polygenist society in 1848. This lone voice, which is often cited as evidence of Knox's influence, really was highly unusual and its views are directly contradicted in nearly every contiguous number even of the *Westminster* (not to mention the more respectable quarterlies). See, for example, the strongly Lamarckian alternative proposed by Spencer, 'Progress: Its Law and Causes', the next year.

47. Knox, *Races of Men*, 77.

48. Knox, 'The Present Phasis of Ethnology', in *Races of Men*, 563, 565–6, 573–4, 577.

49. Stocking, *Victorian Anthropology*, 67. For British doubts about American and French polygenism, see J. Frederick Collingwood's introduction to Waitz, *Introduction to Anthropology*, xv (n.b. an Anthropological Society publication); Hovelacque, *Science of Language*, viii, 306; Topinard, *Anthropology*, xi.

50. Richards, '"Moral Anatomy' of Robert Knox', 410–28; Stocking, *Victorian Anthropology*, 248–62.

51. Lewes, *Study of Psychology*, 26–7, 71–2, 138–9, 151–3.

52. Bain, *On the Study of Character*, 218. This was, however, the only such racial reference Bain made.
53. Maudsley, *Physiology of Mind*, 102–3, 161, 220, 329–33, 398–403. See also similar views in Carpenter, *Principles of Mental Physiology*, 141–2, 228–9, 335–6, 374–5, 485–6, and *Nature and Man*, 313–15.
54. Spencer, 'Comparative Psychology', esp. 343, 357–60.
55. Acknowledged even by Young, *Colonial Desire*, 18, who otherwise plays up Knox's influence. Cf. Latham, *Ethnology of the British Islands*, 4, 259–60; Pike, *English and their Origin*, 8–12, 246–7; and, in general, Stepan, *Idea of Race*, 93–102.
56. Carpenter, quoted in Jacyna, 'Physiology of Mind', 124–5.
57. Kingsley, *Roman and the Teuton*, 39–40.
58. For example, Burrow, *Evolution and Society*, 98, 132; Jones, *Social Darwinism*, 20–5. Cf. Smith, *Politics and the Sciences of Culture*, 109–10; Whitman, 'From Philology to Anthropology'; Burrow, *Crisis of Reason*, 88–90, for why the Germans differed; though Oergel, 'Redeeming Teuton', argues that they did not.
59. Carpenter, *Principles of Mental Physiology*, 484–6, which claims that Mill – who, of course, shared his views on the unitarity of common sense – had also come around to his views on its hereditary transmission.
60. Maine, *Ancient Law*, 170. See also Bock, 'Moral Philosophy of Maine'; Carpenter, *Principles of Mental Physiology*, 484–5. Buckle, *History of Civilization*, stresses progress towards both reason and liberty.
61. The best accounts are to be found in Burrow, *Evolution and Society*; Collini, Winch and Burrow, *That Noble Science*, 185–246; Stocking, *Victorian Anthropology*. Romani, *National Character and Public Spirit*, 231–51, argues that the shift of focus from the legislator to the people implied a racial explanation: cf. below, pp. 80–6. See also Jones, *Social Darwinism*.
62. For Mill's view of the Comparative Method, see Collini, Winch and Burrow, *That Noble Science*, 129–35, 145–8.
63. Bagehot needs a proper intellectual biography. For a start, see Miles Taylor's introduction to Bagehot, *English Constitution*.
64. Bagehot, *Collected Works*, vol. 4, 49–50, 83. See also Varouxakis, *Victorian Political Thought on the French*, 87–96; Jones, *Social Darwinism*, 80–2.
65. Bagehot, *Physics and Politics*, 23–30, 107.
66. Cf. Romani, *National Character and Public Spirit*, 234–6.
67. Bagehot, *Physics and Politics*, 18, 21, 34.
68. Ibid., 78, 80, 134–5.
69. Bagehot, *English Constitution*, 188–94.
70. Bagehot, *Physics and Politics*, 34–8, 78.
71. Ibid., 56–8, 65.
72. Ibid., 22–3, 65–7; but note the silent adoption of Buckle's ideas about the impact of nature on the early formation of nations at 49–50.
73. Ibid., 80.
74. Ibid., 112, 120–1. Bagehot also held that race mixing was normal in the early nation-building period, so that no conclusions could be drawn about the racial purity of nations. Ibid., 98–9.
75. Ibid., 122–6, 130–3.
76. Ibid., 137–44.
77. For Buckle's impact in Britain, see Goldman, *Science, Reform, and Politics*, 308–10, and Robertson, *Buckle and His Critics*, pt 1; in Europe, Goldman, 'Peculiarity of the English?', 134, and Robertson, *Buckle and His Critics*, pt 2; among women, Flint, *Woman Reader*, 195, 198, 243; among working-class freethinkers, Royle, *Radicals, Secularists and Republicans*, 151–2, 173.
78. St Aubyn, *Victorian Eminence*, is a serviceable biography, but Buckle deserves better.

79. Sayce, *Reminiscences*, 32–3.
80. Mill was slightly uneasy about Buckle, however, because of 'the undue breadth of many of his conclusions' and 'the want of a proper balance in his mind': *Collected Works*, vol. 15, 732, 844–5. One of his objections may have been to Buckle's adherence to a unilinear idea of progress, characteristic of those influenced by Maine and the Comparative Method. See Collini, Winch and Burrow, *That Noble Science*, 143–7.
81. Buckle was also very much influenced by Samuel Laing: Taylor (ed.), *Miscellaneous and Posthumous Works*, vol. 1, 591–2; Buckle, *History of Civilization*, 23–4.
82. Buckle, quoted in Taylor (ed.), *Miscellaneous and Posthumous Works*, vol. 1, xlii–xliii.
83. Buckle, *History of Civilization*, 22–4, 39–53, 68–78.
84. Ibid., 23–4, 28–37, 37–8.
85. Ibid., 87.
86. Ibid., 88–9. For Buckle as climatic determinist, see Freeman, 'Continuity of English History', 50; Jones, *Social Darwinism*, 27; W.E.H. Lecky to Knightly Wilmot-Chetwode, 12 September 1861, in Hyde (ed.), *A Victorian Historian*, 40–1; Stocking, *Victorian Anthropology*, 112–17.
87. Buckle, *History of Civilization*, 133, 189–91.
88. Ibid., 539, 554.
89. Ibid., 357–8, and chs. 8–14 passim.
90. Ibid., 630.
91. Ibid., 125–6, 619–21. The idea of 'national character' as a psychology infusing a whole society, which we find in Mill and Buckle, did give some of the same historical depth and differentiation to their underlying uniformitarianism that critics looked for in Darwin. It was not quite as naive as those seeking to consign Mill and Buckle to the eighteenth century would like to suggest (see below n. 93). Darwin himself spoke favourably of Buckle's understanding of the conditions favouring human progress: see Jones, *Social Darwinism*, 24–5.
92. Sayce, *Reminiscences*, 32–3.
93. Stubbs, quoted in Collini, Winch and Burrow, *That Noble Science*, 192–3. See also Parker, *English Historical Tradition*, ch. 2, on historians' resistance to Buckle's determinism. For criticisms of Buckle along these lines, see [Freeman], 'Dr Vaughan's *Revolutions in English History*', 158 (although the criticism is omitted from the revised version, 'Continuity of English History'); Froude, 'Science of History'; [Pattison], 'History of Civilization in England'; [Pollock], 'Civilization in England'; and also *Quarterly Review* 110 (1861), 139–79. These are all criticisms of Buckle that are not concerned much, if at all, with his views on race, though some remark critically about his dogmatism on the subject.
94. For example, George Eliot to Charles Bray, 23 December 1857, to Sara Sophia Hennell, 6 October 1858, in Haight (ed.), *Eliot Letters*, vol. 2, 415, 485–6. See also Eliot, *Daniel Deronda*, ch. 42; [Stephen], 'Buckle's *History of Civilization*'; [Stephen], 'National Character'. Unusually, Lord Acton had it both ways, in one essay condemning Buckle for denying free will, in another scorning him for ignoring the moral differences between the races: *Historical Essays and Studies*, 305–43. One can also find examples of commentators putting themselves on a spectrum, the extremes of which were Knox and Buckle: Pike, *English and their Origin*, 5–8; Smith, 'Greatness of England', 11.
95. Burrow, *Evolution and Society*, 194n.; Stocking, *Victorian Anthropology*, 138–9; Varouxakis, 'Mill on Race', 31–2.
96. Robertson, *Buckle and His Critics*, pt 1, 456–8; and see above, n. 72, for Bagehot's own view.
97. Lecky was one of those who criticized Buckle for his hostility to race, but Lecky was, like so many others, hesitant about drawing racial distinctions, certainly so far as Europe went. His protest was really against an over-optimistic extension of European

civilization to non-white races: Hyde (ed.), *Victorian Historian*, 40–3; Lecky, *History of European Morals*, vol. 1, 166–8; Lecky, *History of Rationalism*, vol. 2, 245–8, 388–90, 405–6.

98. Latham's work and influence has been almost wholly neglected in historians' over-enthusiasm for Knox and his acolytes. He was probably best known as a systematic philologist – *The English Language* (1841) went through five editions in twenty years, and his books on the principles of English grammar were best-sellers. But he wrote and lectured extensively on ethnology in the 1850s when that subject was most fashionable, and his *Natural History of the Varieties of Man* was available in a number of potted and popularized forms. Latham's ethnological writing was almost entirely post- rather than pre-1848, so he cannot be pigeon-holed with Prichard as emblematic of an earlier, now superseded regime, contrary to Young, *Colonial Desire*, 118.

99. Latham, *Natural History of the Varieties of Man*, 560–6; idem, 'Varieties of the Human Race', 376; idem, *Man and His Migrations*, 26; idem, *Nationalities of Europe*, vol. 1, vii, 351–2.

100. Latham, *Ethnology of Europe*, 255–6.

101. Ibid., 125–6.

102. See, for example, Smith, *Politics and the Sciences of Culture*, esp. 100–7, on the continuing influence of 'neoliberal anthropology' in Germany, asserting the primacy of cultural over biological characteristics.

103. Smith, *Politics and the Sciences of Culture*, 109–10, 129–33. See Whitman, 'From Philology to Anthropology', on the influence of a more materialist anthropology from the 1850s. See also Lees, *Revolution and Reflection*, 126–35, and Romani, *National Character and Public Spirit*, 122–56, on German and French liberals' desire to cultivate nationality as a recipe for backwardness. See also McLeod, *Secularisation in Western Europe*, 49, 110–11, 201, 285–6, 288, on the greater persistence of Protestant influences upon liberalism in Britain than in France or Germany.

104. Thackeray, 'Miss Tickletoby's Lectures', 34. Miss Tickletoby goes on to deprecate the bellicosity of the Middle Ages and to recommend respect for kings regardless of their national origin, consistent with the moralistic (if not exactly whiggish) kind of history writing that Thackeray was in fact spoofing.

105. Hill, 'Norman Yoke'; Smith, *Gothic Bequest*; and above, ch. 1.

106. The best discussion of Turner is still Peardon, *Transition in English Historical Writing*, 218–33. See also Sweet, *Antiquaries*, ch. 6, on the eighteenth-century background to Turner's Saxonism, and the difficulties of attributing virtues to the Saxon destroyers of Romano-British 'civilization' (especially en masse).

107. Melman, 'Claiming the Nation's Past'; White, 'Changing Views of the *Adventus Saxonum*', 585–6.

108. Kemble, *Saxons in England*, vol. 1, v.

109. Hudson, *Martin Tupper*, 69–72, 90–1, 93–6, 107.

110. J.M. Kemble to Jakob Grimm, 21 April 1849, in Wiley (ed.), *Kemble and Grimm*, 280–1.

111. Macaulay, quoted in Burrow, *Liberal Descent*, 59–60 (from an 1828 article, not the *History*).

112. Burrow, *Liberal Descent*, chs. 3–4, gives the definitive ideological analysis. See also Thomas, *Quarrel of Macaulay and Croker*, ch. 7, for a view of the mechanics.

113. Lang, *Victorians and the Stuart Heritage*, ch. 3; Samuel, 'The Discovery of Puritanism, 1820–1914', in *Island Stories*; Gunn, *Public Culture*, 123–4.

114. Hutton (ed.), *Letters of Stubbs*, 75. He was speaking of Robert Vaughan's *Revolutions in English History*, which appeared in three volumes, 1859–63. For Freeman's equally critical view, see [Freeman], 'Dr. Vaughan's *Revolutions in English History*'.

115. Parker, 'Failure of Liberal Racialism', and MacDougall, *Racial Myth in English History*, 100–1, who puts Freeman on 'the extreme limits of racism'; also Bowler, *Invention of*

Progress, 60–8; Varouxakis, *Victorian Political Thought*, 105–6; Young, *Colonial Desire*, 72–3. But cf. Feldman, *Englishmen and Jews*, 91–2; Rich, *Race and Empire*, 16–17; Collini, Winch and Burrow, *That Noble Science*, 223–5, and especially the authoritative account of Freeman's work in Burrow, *Liberal Descent*, pt 3.

116. Stephens, *Life and Letters of Freeman*, vol. 1, 66.
117. As noted below, p. 93, to J.R. Green's mind Freeman did not go much further beyond an interest in institutions than Kemble; but in his own defence Freeman could argue that his greater sensitivity to the character of Saxon Christianity developed a spiritual dimension Kemble had lacked. Stephens, *Life and Letters of Freeman*, vol. 1, 108–9, 115–16, 336.
118. Freeman, *Comparative Politics*, 38–61, 115–16, 122–3. Bagehot borrowed Freeman's conclusions on these points: see *Physics and Politics*, 55, 112, 116–17.
119. Freeman, 'Continuity of English History', 40–1, 50–2; idem, 'National Prosperity and the Reformation', 289–91; idem, 'Alter Orbis', 221, 234.
120. Freeman, 'Continuity of English History', 41, 50.
121. Freeman, quoted in Stephens, *Life and Letters of Freeman*, vol. 2, 369. See also Sayce, *Reminiscences*, 108–9, 138–40.
122. Freeman, 'Race and Language', 211. For references back to this text late in Freeman's life, see Stephens, *Life and Letters of Freeman*, vol. 2, 369; Freeman, 'Latest Theories', 37 (1890); and idem, 'Physical and Political Bases', 34 (1892).
123. Freeman, 'Race and Language', 218–19.
124. Ibid., 223–4.
125. Ibid., 222.
126. Ibid., 224.
127. Stephens, *Life and Letters of Freeman*, vol. 2, 180–1.
128. For example, Acton, 'Nationality', 297; Bagehot, *Physics and Politics*, 37.
129. Bagehot, *Physics and Politics*, 79–80; Dilke, *Greater Britain*, 218, 224.
130. There is a touch of this in Bagehot, *Physics and Politics*, 45.
131. 'I have my notions about Ireland too – to drown it if one can, if not to let it go.' Freeman, quoted in Stephens, *Life and Letters of Freeman*, vol. 2, 175. See further the discussion below, pp. 124–5.
132. Freeman, quoted in Burrow, *Liberal Descent*, 198.
133. Mill differed in thinking that national consciousness could arise rationally only from common experiences, and he disliked the emotional way in which Freeman tried to whip it up. See Collini, Winch and Burrow, *That Noble Science*, 145–7.
134. Freeman, quoted in Burrow, *Liberal Descent*, 213. Kingsley, 'On English Literature', 263, tried to co-opt the Arthur myth for the Saxons on the grounds that he was known only through medieval sources. On the mid-Victorian cult of Arthur, see Barczewski, *Myth and National Identity*; but cf. the wise cautions about the potency of the Arthur myth in Thornton, *Imperial Idea*, 208.
135. Stubbs quotes Carlyle (from *Frederick the Great*) in *Constitutional History*, vol. 1, 216n., alongside Kemble's similar conclusions about the maturing of the English national character after the conquest. As in Green, the fifteenth century also features prominently as a formative period for the national character: Stubbs, *Constitutional History*, vol. 3, 3. See Burrow, *Liberal Descent*, 138–43, 147.
136. Stubbs, 'Comparative Constitutional History', 196–8. See also Stubbs, *Constitutional History*, vol. 1, 1–11, 31–6. This is not to say that Stubbs eschews biological language entirely: he is quite capable of saying that self-reliance was 'inherent in the blood' in the midst of a discussion of the development of national character under the leadership of the Saxon kings before the conquest: Stubbs, *Constitutional History*, vol. 1, 211.
137. Stubbs, 'Elements of Nationality'.
138. From Green's April 1867 review of Freeman's 'History', reprinted in Green, *Historical Studies*, 67.

139. Green to Freeman, 26 February 1876, in Stephen (ed.), *Letters of Green*, 426–7; Briggs, *Saxons, Normans and Victorians*, 19. See also Green, *Short History*, v–vi. As Stubbs appreciated, Green was working on a model pioneered by the radical-democratic histories of Charles Knight, though Stubbs could not see the point of it: Hutton (ed.), *Letters of Stubbs*, 154. See also Kingsley, *Roman and Teuton*, 231–2.

140. Brundage, *People's Historian*, 157–8.

141. Green, *Short History*, 1–2, 7, 11, 59, 60.

142. Green to Freeman, 21 March 1876, in Stephen (ed.), *Letters of Green*, 431–2. Edwin Guest, a fellow of Gonville and Caius College, Cambridge, was a more obscure scholarly historian of the early English, much admired by Freeman.

143. Green, *Short History*, 60, 67, 86–9.

144. Ibid., 131, 163–4, 211–16.

145. Ibid., 398, 412, 447, 449–51.

146. Ibid., 542, 586 (but cf. 587!), 615. Green's account accords closely with Macaulay's after 1660.

147. One boy brought up on Green's *Short History* testified that it was too confusing on that account: Hueffer, *England and the English*, 286–9, and cf. 258–62 on the limited appeal of Teutonism, as well.

148. Byrne, 'Influence of National Character', 25–6.

149. Burrow, *Liberal Descent*, 169–73; Stephens, *Life and Letters of Freeman*, vol. 1, 296–8, 375–6. See also Lorimer, *Political Progress*, 59–60.

150. Smiles, *Autobiography*, 275–6.

151. Cowling, *Artist as Anthropologist*, chs. 5–7. I would not leap as quickly as Cowling does, however, to take these depictions as endorsements of the most extreme anthropologies.

152. Kingsley, *Roman and Teuton*, 6–7. One ought to be cautious about attributing wider significance to this rather wild and unhistorical book, which originated as Oxford lectures. For a variety of reasons, as his own family admitted, *The Roman and the Teuton* was the 'most severely criticised' of all Kingsley's works: Kingsley (ed.), *Charles Kingsley*, vol. 2, 266.

153. Kingsley, 'Ancien Regime', 137–45 (originally lectures of 1867); but cf. his gloomier private views in Kingsley (ed.), *Charles Kingsley*, vol. 2, 242–4, 338.

154. Eliot's thinking about nationality is well covered in Semmel, *Eliot and the Politics of National Inheritance*. She was, for example, one of the few advanced radicals to criticize Buckle specifically for his dismissal of race: ibid., 48–9.

155. Eliot, 'Natural History of German Life', 274, 288.

156. As suggested by more than one contemporary reviewer: Holmstrom and Lerner (eds), *Eliot and Her Readers*, 141–2, 145–6 and, in general, 157–62.

157. Eliot, *Impressions of Theophrastus Such*, 144–5 and cf. 147, 158–60.

158. Church, 'Influences of Christianity', 214–15, 217. See also his opening reservations about the concept at 212, repeated at 313. For later endorsements, see 'The Hopes of Humanity', 361; Pearson, 'An Answer to Some Critics', 164 (the greatest work of Anglican theology since Butler's *Analogy*); *Spectator*, 29 October 1898, 598–9; Inge, *England*, 57–8.

159. Church, 'Influences of Christianity', 305–6, 312; also 325–37.

160. Ibid., 341–4. See also Maurice, *Social Morality*, esp. 14–19, with its ideas of concentric circles of domestic, national and universal morality. Green's idea of moral progress had originally rested heavily on Maurice, until his faith began to wane while he was writing his *Short History*: Stephen (ed.), *Letters of Green*, 118–19, 175–6.

161. [Brewer], 'Green's *History of the English People*', esp. 295–9, 301, 323.

162. This view could be held by the most triumphalist Teutonist: see, for example, 'Who Are the Anglo-Saxons?', 5–6; Smith, *Irish History and Irish Character*, 14, 182–3.

163. Huxley, 'Forefathers and Forerunners', 165–7. See also Latham, *Ethnology of the British Islands*, 4; Allen, 'Are We Englishmen?', 255.

164. Kidd, 'Teutonist Ethnology and Scottish Nationalist Inhibition'; also Kidd, 'Sentiment, Race and Revival', 123, on liberalism as 'a surrogate nationalist ethos'; although, more recently, Kidd, 'Race, Empire and Scottish Nationhood', re-emphasizes Teutonist racialism in Scotland (mostly I think to counter present-day Scottish nationalism). Morton, *Unionist-Nationalism*, makes a similar argument about liberalism as a surrogate nationalism. While referring to a (non-nationalist) 'ethnic' consciousness in Scotland, his emphasis is in fact upon attachments to a set of liberal institutions. See also Devine, *Scottish Nation*, 285–98.

165. Morgan, 'Early Victorian Wales', 95–107.

166. The prize was won in 1868 by John Beddoe. On the Pike–Nicholas debate, see Beddoe's *Memories*, 205–8, and reports in *The Times*, 29 April 1869, 11; 25 May 1869, 10; 25 November 1869, 11. Beddoe's work, *The Races of Britain*, did not appear until 1885 and is considered in the next chapter.

167. Pike, *English and their Origin*, 15–64, 246–7; Nicholas, *Pedigree of the English People*, 498–500, 524–40, 547–8. See also similar views presented by B.W. Richardson at the 1882 Eisteddfod, 'Race and Life on English Soil'.

168. Pike, *English and their Origin*, 179–80, 184–98, 252–7. Among Nicholas's advisers were Latham and Max Müller, who certainly did not believe that Celt and Teuton had biologically derived characters.

169. Nicholas, *Pedigree of the English People*, 552.

170. Arnold, quoted in Murray, *Life of Arnold*, 170. His views were also much developed, of course, by his work as an inspector of schools in Wales.

171. Arnold, *Celtic Literature*, 95–6, and see also 116–69.

172. Ibid., xvi, 12, 14–15, but also 174–5 on the hazards of mixing.

173. Young, *Colonial Desire*, 69–82, 87–9, which rather over-eggs the pudding; Pecora, 'Arnoldian Ethnology'; cf. Varouxakis, *Victorian Political Thought*, 106–11. I think Young is right to attribute significance to Arnold's references to W.F. Edwards, a doctrinaire Lamarckian racialist, and to other bits of fairly controversial contemporary anthropology: see Arnold, *Celtic Literature*, 16–23, 92–5.

174. On the differences between Mill and Arnold, see Varouxakis, *Mill on Nationality*, 38–52. On the virtues of Celt-Teuton hybridity, see also Hall, 'Local and National Peculiarities'; Smith, *Irish History and Irish Character*, 14, 28–9, 182–3; Spencer, 'Comparative Psychology', 359–60; Vaughan, *Revolutions in English History*, vol. 1, 178–1, 368–9, vol. 2, 1.

175. I leave aside here the question, much debated at the time, as to whether the Norman Conquest brought Teutonic, Celtic or Roman influences to Britain, and indeed a related debate as to whether the modern French were themselves more Teutonic, Celtic or Roman.

176. Except for Ulstermen, who were beginning to identify themselves as ethnologically distinct from the rest of the Irish: see Hume, 'Origin and Characteristics', 13 (the later *Origin and Characteristics* was an 1874 popularization of the earlier series, but if anything toned down).

177. Langford, *Englishness Identified*, 20–1. And see also the views of A.H. Keane, an Irish Catholic ethnologist influential in England, discussed below, pp. 118–19.

178. On the Jews, see Feldman, *Englishmen and Jews*, 72–92, and below, p. 129.

179. Curtis, *Anglo-Saxons and Celts*; Hall, 'The Nation Within and Without'; Lebow, *White Britain and Black Ireland*.

180. Foster, 'Paddy and Mr Punch'; Gilley, 'English Attitudes to the Irish'.

181. Nicholas, *Pedigree of the English People*, 536–7. Pike played a similar game, but he was more cautious about pinning specific emotions to particular stocks, and also more honest about his polemical purposes: *English and their Origin*, 198, 234–5.

182. But, still, see reservations of Latham, *Nationalities of Europe*, vol. 2, 305.
183. The *OED* credits Carlyle with the first use of 'self-help' (*Sartor Resartus*, 1831) and Mill with the first use of 'self-reliance' (a private letter of 1833); but it is probably the case that Emerson put both into general circulation. 'Self-help', as Smiles acknowledged, appeared in Emerson's 'Man the Reformer' in 1841, and 'Self-Reliance' was the title of another immensely popular Emerson essay of the same year. In the 1840s it was already being used by Mill, Laing and Kemble: see, for example, Mill, *Collected Works*, vol. 24, 973 (1846); Kemble, *Saxons in England*, 285–6; Laing, *Observations*, 515. See further Burrow, *Whigs and Liberals*, ch. 4, for the equivalent progress from 'independence' to 'individuality' in Victorian political thought, and Collini, 'Idea of "Character"' and *Public Moralists*, ch. 3, for a pioneering statement of the broader cultural current.
184. See, on self-reliance, for example, 'An Easter Offering', 9–10; Buckle, *History of Civilization*, 357–8; Stubbs, *Constitutional History*, vol. 1, 211; Smith, 'Greatness of England', 3; and, for associated virtues, Emerson, *English Traits*, 87, 103–4, 108–9; 'Emerson's English Traits' (1856–7), esp. 395–6; Pike, *English and their Origin*, 203–5; Stubbs, 'Comparative Constitutional History', 202–3; Church, 'Influences of Christianity', 322–4; Green, *Short History*, 2.
185. See, for example, Bain, *On the Study of Character*, 199, 203; Smiles, *Self-Help*, 20, 190, and ch. 13 on 'Character'.
186. Toulmin Smith, *Local Self-Government and Centralization*, 4–5, 8–9, 17–22, 71–2. See also Claus, 'Languages of Citizenship'. I am here, as always, indebted to the work of John Davis and particularly his unwritten paper on 'Toulmin Smith in Catford Parish'.
187. Stubbs, *Constitutional History*, vol. 1, 31–6, 211, 215–16. See also Smith, *Irish History and Irish Character*, 56, on the Norman influence which benefited the English but not the Irish.
188. On some contemporary links between 'self-restraint' and obedience to law, see Wiener, 'Homicide and "Englishness"', dating the turning point for wider acceptance of both as English traits to the 1840s.
189. Church, 'Influences of Christianity', 308–9, 323–4. See also Kingsley, *Roman and the Teuton*, 9–10, 275–95.
190. Similarly, see 'Statistical Outline of the Anglo-Saxon Race', 172.
191. Kingsley, *Roman and the Teuton*, 52–4. Here he was taking up Latham's idea that the ethnological origin of the Saxons was more Slavic than Teuton, although for Latham the lesson to be drawn was that ethnology has little to do with character: see Latham, *Nationalities of Europe*, vol. 2, 305–29, 357–9.
192. 'S.S.', 'Love of Country in Town', 13–14; Pike, *English and their Origin*, 184–91, 209, 266. Note also Matthew Arnold's belief that the northern peoples were naturally urban because energetic: 'In cities should we English lie,/Where cries are rising ever new,/And men's incessant stream goes by./We who pursue/Our business with unslackening stride . . . ' ('A Southern Night', 1861). Arguments in this period about the urban or non-urban nature of the English were still more likely to be about local government than about some fundamental temperament or cultural orientation; see, for example, Stubbs, *Constitutional History*, vol. 1, 32–3, and, of course, Toulmin Smith, *Local Self-Government and Centralization*. For helpful cross-cultural comparisons, see further Lees, *Cities Perceived*.
193. Both in Eliot, 'Natural History of German Life', 288.
194. Mill, *Autobiography*, in *Collected Works*, vol. 1, 60; Lord Robert Cecil, quoted in Smith (ed.), *Lord Salisbury on Politics*, 55.
195. Buckle, *History of Civilization*, 114 (disputed by his own editor).
196. Dickens, 'Why?', 358–9.

197. Pike, *English and their Origin*, 200, 216; Church, 'Influences of Christianity', 306. Cf. Byrne, 'Influence of National Character', linking English poetry to a love of nature but also the progress of civilization.

198. On Teutonic origins, Church, 'Influences of Christianity', 324–5, 336–7; Dilke, *Greater Britain*, 457 (a climatic as well as racial explanation); Kingsley, *Roman and the Teuton*, 41–2, 46–7; Pearson, 'Historical Aspects of Family Life', 166–7; and see above, p. 254, n. 100, for the longer history of the gendered uses of Tacitus. The basis for such inferences can be found in Tacitus, *Agricola and Germany*, 46–8. For less Teutonized versions, see the same passages in Church; Pike, *English and their Origin*, 201–3; J.C. Jeaffreson, quoted in Crosby, *Ends of History*, 73.

199. Church, 'Influences of Christianity', 303; Kingsley, *Roman and the Teuton*, 282–3; Pearson, 'Historical Aspects of Family Life', 167–8. See also 'Gentle-Women', 195–200, and the suggestive comments for a slightly later period in Mackay and Thane, 'Englishwoman', 191–2: they are surely right to say that it is difficult to separate 'national' from 'universal' characteristics, though, as argued above, this is almost as much of a problem for men as for women.

200. Rendall, 'Citizenship of Women'.

201. As Miles Taylor has shown, the usage of 'John Bull' in caricature at this time was very largely to celebrate British prosperity and economic dynamism: Taylor, 'John Bull', 113–14.

202. Tacitus, *Agricola and Germany*, 39.

203. Church, 'Influences of Christianity', 303. See also Lecky's description of the 'industrial spirit' as blending caution and enterprise: Lecky, *History of European Morals*, vol. 1, 146–7.

204. Bain, *On the Study of Character*, 203; Galton, 'Hereditary Talent and Character', 68. See also the discussion of 'continuous labour' in an imperial context: Hall, 'Nation Within and Without', 227–8.

205. [Adams], 'Human Progress', 34; Allen, 'Are We Englishmen?', 249; Arnold, *On the Study of Celtic Literature*, 97; Nicholas, *Pedigree of the English People*, 532–3, 537; Pike, *English and their Origin*, 184–97; Smith, *Irish History and Irish Character*, 14. Cf. Kidd, *British Identities*, 199–200. An alternative was to attribute to the Normans the transformation of the 'cool-blooded', 'gluttonous', 'phlegmatic' Saxon: Taine, *History of English Literature*, vol. 1, 26–7, vol. 2, 314–15 – rather different from Stubbs' civilizational version of Norman beneficence; also Smith, *Irish History and Irish Character*, 56.

206. Eliot, *Impressions of Theophrastus Such*, 144–5 and see also 184, n. 6, where the editor of this edition suggests, plausibly enough, that the reference is to Green, though Eliot's version makes the Teutons sound much more Norse than Green's. The same theme appears in Smiles, *Autobiography*, 275–6. Brown, *Up-Helly-Aa*, 140–2, points out that Shetlanders at this time celebrated their own more 'authentic' Norse identity to contrast themselves with cold-blooded and respectable Scots.

207. 'Statistical Outline of the Anglo-Saxon Race', 164–5; Smiles, *Self-Help*, 20, 37.

208. [Adams], 'Human Progress', 26; Bain, *On the Study of Character*, 203; Kingsley, *Roman and the Teuton*, 6–7.

209. [Adams], 'Human Progress', 34; Freeman, 'National Prosperity and the Reformation', 286–7, 289–91. See also Burrow on Froude, *Liberal Descent*, 241–2.

210. Smith, *Irish History and Irish Character*, 56; cf. Stubbs, *Constitutional History*, vol. 1, 215–16. Buckle's view was that English energies were unleashed only by the decline of religion (as he saw it) from the seventeenth century. See also Lecky's discussion, very much inspired by Buckle, of the conditions fostering the 'industrial spirit' in *History of European Morals*, vol. 1, 146–9.

CHAPTER 4: GREAT BRITONS

1. For examples of conventional accounts of the English national character by or for Americans, see White, *England Without and Within* (1881), Collier, *England and the English* (1909); for a more social-scientific account by and for the French, see Boutmy, *The English People* (1901; English ed., 1904). On the liberal story becoming the national story, see also Burrow, *Liberal Descent*, 296; Smith, 'Englishness and the Liberal Inheritance'; and below, p. 127.

2. Harvie, *Lights of Liberalism*, esp. ch. 8; Kent, *Brains and Numbers*, esp. 142–3, 148–51; Pick, *Faces of Degeneration*, 194–6; Roach, 'Liberalism and the Victorian Intelligentsia'; and cf. Von Arx, *Progress and Pessimism*, which sees the pessimism already implicit in mid-Victorian liberalism.

3. Stedman Jones, *Outcast London*, traces this line of thinking back to the 1860s.

4. Buckle, *History of Civilization*, 358n., and see a similarly more positive evaluation of the French, converging with the English, in Hamerton, *French and English*, as early as 1886–87.

5. Maine, *Popular Government*, 97–8, 143–8. See also the works of Marcus Dorman, a kind of latter-day Bagehot: *Ignorance*, and especially *Mind of the Nation*. Also *The Times*'s criticism of Mandell Creighton's old Liberal pieties, 18 June 1896, 9.

6. Ernle, *Whippingham to Westminster*, 167–8.

7. Hobson, *Psychology of Jingoism*, esp. 6–10, 20; but note the contrasts between these reactions and the actual behaviour of the 'mafficking' crowds in Price, *An Imperial War*, ch. 4. See also, for reactions from the Left, Ward, *Red Flag and Union Jack*, 69–71.

8. Hobhouse, *Democracy and Reaction*, 69–71. See, further, Romani, *National Character and Public Spirit*, 258–60.

9. Whitman, 'The Metamorphosis of England', 205.

10. 'The Permanence of National Character', *Spectator*, 23 April 1887, 555. See also the similar 'Is England Growing Weaker?', *Spectator*, 12 March 1898, 369–70.

11. Smith to Professor J.K. Hosmer, 25 October 1890, in Haultain (ed.), *Goldwin Smith's Correspondence*, 228–9; also Smith, 'Schism in the Anglo-Saxon Race', 53–4. For similar views held by the historian J.R. Seeley and Mandell Creighton, see Wormell, *Seeley*, 171–2, and Seeley, 'Ethics and Religion', 506 (thanks to Duncan Bell for this last reference).

12. Petrie, *Janus in Modern Life*, 13–14.

13. Hueffer, *England and the English*, 239–40, but cf. 243, where he admits doubts. See also review of Boutmy's *The English People*, *Athenaeum*, 14 May 1904, 620–1.

14. Hueffer, *England and the English*, 251–2, 274–5, 300–2, 318, 331, 348–9. A more left-wing version was George Unwin's argument about the English national character and associationalism, for which see Stapleton, 'English Pluralism', 677–83, and, more surprisingly, Whitman in an earlier, optimistic mood, *Teutonic Studies*, 32.

15. For an example of the latter, see Field, *Towards a Programme*, 137–40, discussing George Steevens's February 1898 article 'The New Humanitarianism', and cf. 165, for Steevens's view that imperial responsibility maintained self-reliance.

16. Pearson, *National Life and Character*, esp. 99–102.

17. Tregenza, *Professor of Democracy*, 231–5; and see below, pp. 126–7, for further discussion of the book and its reception. For endorsements of Pearson's arguments on this particular point, see Harrison, 'The Evolution of Our Race: A Reply', 29, 31–4 (but rather celebrating English stagnation); Lyall, 'National Life and Character', 892–3; Ripley, *Races of Europe*, 584–6; and for a later, parallel argument, 'A Nation of Shopkeepers', *Saturday Review*, 10 May 1902, 591–2. There are also strains of this line of argument in *Essays in Liberalism* (1897).

18. Ritchie, *Darwinism and Politics*, 96–7.

19. But see, in addition to *National Life and Character*, Pearson's 'Answer to Some Critics', esp. 161–6, 169–70.
20. 'The Secret of British Success', *Spectator*, 1 October 1898, 433–4, responding to speeches at the Church Congress of that season. See subsequent correspondence in *Spectator*, 8 October 1898, 488–9; 15 October 1898, 522–3; 22 October 1898, 556–8; 29 October 1898, 598–9, and the *Spectator*'s final summation, 'The Relation between Religion and National Success', 29 October 1898, 590–1. See also below, pp. 116–22, as to whether this debate really betokened a substitution of 'race' for 'religion' in the *fin-de-siècle* understanding of 'national success'.
21. Review of Charles Elton, *Origins of English History*, in *Athenaeum*, 15 April 1882, 470.
22. Stephen, 'An Attempted Philosophy of History', 681, 695. See similar remarks from Buckle's 'heir', J.M. Robertson, in his introduction to the 1904 edition of Buckle's *Civilization*, esp. x–xiii, and Pollock, *Introduction to Science of Politics*, 83, 88–9.
23. *The Times*, 18 June 1896, 9.
24. Freeman, *Methods of Historical Study*, 8.
25. See the reviews of Green's posthumously published *Making of England* by Grant Allen, *Academy*, 18 February 1882, 111–12, and by an anonymous reviewer, *Athenaeum*, 25 March 1882, 374–5. Also Robertson, *Saxon and Celt*, 221–33.
26. See below, pp. 117–19 and 124–6.
27. Stephens, *Life and Letters of Freeman*, vol. 2, 369; Freeman, 'Latest Theories', 37 (1890), and 'Physical and Political Bases', 34 (1892). But for a balanced view of Freeman's confusions, see Babington, *Fallacies of Race Theories*, 6.
28. Round, quoted in Blaas, *Continuity and Anachronism*, 54–5.
29. Cunningham, quoted in Green, *Crisis of Conservatism*, 165, and see Blaas, *Continuity and Anachronism*, 47. On the historical economists, see Blaas, *Continuity and Anachronism*, ch. 5; Collini, Winch and Burrow, *That Noble Science*, 259–74; Kadish, *Oxford Economists*; Semmel, *Imperialism and Social Reform*, ch. 10.
30. On its influence, see John Gross's 'Introduction' to Seeley, *Expansion*, 1971 ed., esp. xi–xii; Grainger, *Patriotisms*, 190–1; MacKenzie, *Propaganda and Empire*, 179–80; Samuel, *Island Stories*, 81–2; Wormell, *Seeley*, 154.
31. Wormell, *Seeley*, 14, 16–19, 36–9, 75–80, 146–7, 169–72.
32. Seeley, *Expansion of England*, 80.
33. Ibid., 81, 84–5, 87.
34. Ibid., 37–46, 56–72. Colls, *Identity of England*, 133–4, seems to me to reverse Seeley's true position almost completely.
35. Morley, 'The Expansion of England', esp. 257–8; Smith, 'The Expansion of England', esp. 531, 533; Solly, 'The Expansion of England', 313–15, 319.
36. Seeley, *Expansion of England*, 15–16, 220–8.
37. See Wormell, *Seeley*, 169–70.
38. Lang, *Victorians and Stuart Heritage*, esp. chs. 3–4; also Blaas, *Continuity and Anachronism*, 140–52; Samuel, *Island Stories*, 285–8.
39. Weaver, *Hammonds*, esp. 101–8.
40. See early signs in *Essays in Liberalism* (1897), esp. Macdonell, 'Historic Basis of Liberalism'; Feske, *From Belloc to Churchill*, ch. 1; Grainger, *Patriotisms*, 104–23.
41. Ward, *Red Flag and Union Jack*, 21–6, 38–40, 70–1.
42. This seems to be the basis for Colls's interpretation of Seeley, *Identity of England*, 133–5, though he suggests it was in fact Seeley's own argument, which it was not.
43. See Bishop Creighton, *Church and the Nation*, esp. 170–1, but cf. 183–4; and Bishop Welldon's position in the *Spectator* debates in October–November 1898, above, n. 20.
44. Bryce, quoted in Loughlin, *Gladstone, Home Rule and the Ulster Question*, 188.
45. Fifoot, *Maitland*, 143, 149–50, 153. See also Blaas, *Continuity and Anachronism*, 244–5, 264–5; Stapleton, *Englishness*, 34–5, but cf. 74 and Stapleton, 'English Pluralism', 677–8.

46. Which is not to say that Lamarckianism disappeared altogether: see Jones, *Social Darwinism*, 96; Kuklick, *Savage Within*, 258–9. But neo-Lamarckians like William Ridgeway and William McDougall were not very influential in public debate after the 1890s.

47. Urry, 'Englishmen, Celts, and Iberians'. As a general European phenomenon, see Burrow, *Crisis of Reason*, 105–7. The 'Nordic'–'Alpine'–'Mediterranean' typology was popularized by the American anthropologist W.Z. Ripley, *Races of Europe*.

48. For the odd psychological speculation – mostly non-committal quotes from others – see Beddoe, *Races of Britain*, 10–11, 102, 152, 271–2, 275, 277, 288–9. Some readers of Beddoe claim he was low-key about racial psychology, others that he was bold: cf. Barkan, *Retreat of Scientific Racism*, 25–6; Curtis, *Anglo-Saxons and Celts*, 71–2; Jones, *Social Darwinism*, 106; Rich, 'Social Darwinism', 780–1; Young, *Colonial Desire*, 72–3.

49. 'The British Race-Types of To-Day: I.', *The Times*, 11 October 1887, 13. The argument went on – 25 October 1887, 4 – to urge as a consequence that modern anthropology offered no justification for Irish separatism. See further below, pp. 124–6, 133–5.

50. T.H. Huxley, 'British Race-Types of To-Day', *The Times*, 12 October 1887, 8.

51. Urry, 'Englishmen, Celts, and Iberians', 87–99.

52. Barkan, *Retreat of Scientific Racism*, 27–34; Stocking, *After Tylor*, 230–7; Thomson, '"Savage Civilisation"', 235–7. There was some interaction between this trend towards cultural anthropology and the new discipline of social psychology with its interest in instinct and the 'crowd' or 'mass', for which see Jones, *Social Darwinism*, 121–39; Leary, 'Fate and Influence of Ethology', 157–61; Soffer, *Ethics and Society*, chs. 10–11.

53. Cf. Keane, *Man Past and Present*, 529–38, and Keane, *Man Past and Present*, ed. Quiggin and Haddon, 525–9; and see a popularized version, *The World's Peoples*, with a new passage on the English at 379–81.

54. Keane's approach was similar to that of W.Z. Ripley and to a British follower of Ripley, N.C. Macnamara – see his *Origin and Character of the British People*. See also Stepan, *Idea of Race*, 83–110, on French and German as well as British followers of this school. Note the admission at 109, that this discussion covers 'only one aspect of race science', although on that basis she concludes that 'the British by the nineteenth century were not universalistic and cosmpolitan in outlook, but insular and narrow. Their commitment to the theory of racial types and racial inequality was, it appears, deeper than any commitment to a theory of biological change.'

55. Jones, *Social Darwinism*, 37–47, 55–8, 80–4, rather downplaying the 'sociological' outcome.

56. Helfand, 'Huxley's "Evolution and Ethics"'; Paradis and Williams (eds), *Evolution and Ethics*. Cf. also Jones, *Social Darwinism*, 61–2; Pick, *Faces of Degeneration*, 220–1; Stepan, *Idea of Race*, 78–82; and, for contemporary assessments of Huxley's influence here, Ritchie, *Darwinism and Politics*, 29–31; Robertson, *Saxon and Celt*, xiv–xv.

57. Ritchie, *Darwinism and Politics*, 60. Like Bagehot's *Physics and Politics*, whose title it echoes, this book is sometimes credited with more biology than it contains, precisely because of the title. It does, however, employ Darwinism as metaphor, for which see further below, p. 121.

58. Robertson, *Buckle and His Critics* (1895); Buckle, *History of Civilization*, ed. Robertson (1904).

59. Robertson, *Saxon and Celt*, x–xi, 30, 99–102. See also Buckle, *History of Civilization*, ed. Robertson, x–xii, and, a precursor of Robertson whose premature death in 1893 limited his influence, Babington, *Fallacies of Race Theories*, and the very ambiguous views of Wallace, 'Evolution and Character'.

60. See, for example, Collini, Winch and Burrow, *That Noble Science*, 236–46 on the Liberal James Bryce's position; Freeden, *New Liberalism*, 79–90, on the younger generation of Liberals; and below, pp. 125–6, on Unionists and the civilizational perspective. Rich,

'Social Darwinism', 782–3, and Blaas, *Continuity and Anachronism*, 68, comment on Robertson's influence.

61. Kidd, *Social Evolution*, 44–9, 56–8, 190–2, 249–50, 281–3, 317.

62. For example, Harvey, *Biology of British Politics*; Petrie, *Janus in Modern Life*; Wilkinson, *The Nation's Awakening*.

63. Pearson, 'On the Inheritance', 207; Pearson, *National Life from the Standpoint of Science*, vii, 21, 28–30, 30–2, 56–8.

64. Concerns about urbanization were more acute in Germany than in Britain or France: Lees, *Cities Perceived*, 311. Concerns about eugenics were more acute in France than in Germany or Britain: Nye, *Crime, Madness and Politics*, 330. Pick, *Faces of Degeneration*, 5, 237–40, concedes that the British took less political action against degeneration but does not believe that this is evidence of less pervasive concern.

65. Pick, *Faces of Degeneration*, 5–6, 180–1.

66. Disraeli, quoted in Kebbel (ed.), *Selected Speeches of Beaconsfield*, vol. 2, 490, 525, 528–9.

67. Ibid., vol. 2, 507, 534.

68. Which helps to explain the Tories' greater success at channelling national sentiment at this time. See the questions raised by Taylor, 'Patriotism, History and the Left', 974–7; and cf. Cunningham, 'Conservative Party and Patriotism', which raises similar questions but underestimates the strength of the traditional Tory appeal to institutions.

69. For which see Cunningham, 'Conservative Party and Patriotism'; Coetzee, *For Party or Country*; Pugh, *Tories and the People*; Thompson, 'Language of Imperialism'; and idem, *Imperial Britain*, esp. chs. 1–2.

70. Lecky, *Political Value of History*, 10–11. There are similar views in Maine, *Popular Government*, 27–8, 53–5, 172–5.

71. See above, ch. 3; also the excellent discussion in Peatling, *British Opinion and Irish Self-Government*, 18–20, 37–42.

72. Peatling, *British Opinion and Irish Self-Government*, 43–5. See also Loughlin, *Gladstone, Home Rule and the Ulster Question*, 175–6, though cf. also 179, reflecting on Gladstone's peculiarly Burkean arguments for Home Rule. Gladstone's peculiarities should not, however, be allowed to obscure the wider appeal that Home Rule had to many Liberals.

73. For Liberal rationales for Home Rule along these lines, see, for example, Freeman, 'Physical and Political Bases', 34–6; Kingsley, *Irish Nationalism*, esp. 5–8 (a work endorsed by Gladstone); Robertson, *Saxon and Celt*, 115–17, 281. For more organic rationales among the younger generation, see Peatling, *British Opinion and Irish Self-Government*, 56–9, and Phillimore, 'Liberalism in Outward Relations', 154. These latter views would resurface in sympathy for the Boers.

74. Though for two excellent inquiries into Unionist ideology, to which I am much indebted, see Loughlin, *Gladstone, Home Rule and the Ulster Question*, and Peatling, *British Opinion and Irish Self-Government*. See also Smith, 'Conservative Ideology and Representations of the Union' and Ward, 'Nationalism and National Identity in British Politics'.

75. Edwards, 'The Sentiment of Nationality', 502; Palmer, 'The Saxon Invasion', 192–3.

76. Smith, *Irish History and Irish Character*, 6; idem, 'Schism in the Anglo-Saxon Race', 51; also idem, 'Irish Question', 388. But see an even later, more ambiguous statement of the balance between race and civilization cited by Phillips, *The Controversialist*, 151.

77. Huxley, quoted in Desmond, *Huxley*, 731, n. 40.

78. Arnold-Forster, 'An English View of Irish Secession', 79–82. The 'historicist' arguments of some radicals that the Irish and Scottish Highlanders were in an earlier stage of civilization, which they thought required different economic policies, may have only reinforced the Unionist conviction that 'modern' political institutions alone would guarantee these peoples' further improvement. See Dewey, 'Celtic Agrarian

Legislation' and Hoppen, 'Nationalist Mobilisation', on historicism and Liberal land policy before 1886.

79. Arnold, *On Home Rule for Ireland*, 4–5.
80. See Dicey, *England's Case Against Home Rule*, 84–5, 96, 136–8, 282–3; Harris, 'Natural Laws and the Home Rule Problem', 98–104; Smith, 'Irish Question', 285–8. See also the discussions in Gilley, 'English Attitudes to the Irish', esp. 95–6; Peatling, *British Opinion and Irish Self-Government*, 41–5; and Thornton, *Imperial Idea and its Enemies*, 211–20, for some illuminating parallels with India and other extra-European colonies.
81. For example, [Croskerry], 'Irish Discontent', esp. 178–84; *Lights on Home Rule*, esp. 6, 13, 22.
82. For example, Arnold, *On Home Rule for Ireland*, 4–5; Blind, 'The Unmaking of England', 803; Dicey, *England's Case Against Home Rule*, 282–3; Lecky, *Democracy and Liberty*, 399–400; Smith to John Tyndall, 10 November 1885, in Haultain (ed.), *Goldwin Smith's Correspondence*, 180.
83. From a speech of 6 November 1911, Balfour, *Aspects of Home Rule*, 12–13. See also speech of 22 April 1893 in ibid., 170–1, 197–8; but cf. Balfour, *Nationality and Home Rule*, 10, 15–19, arguing for both nationality and civilization, reflecting some intervening effects of imperial federalism.
84. See further below, pp. 132–3; Smith, 'Conservative Ideology and Representations of the Union', 27–35; Thompson, *Imperial Britain*, 31–4. It is entirely consistent that the Unionist most likely to talk confidently about the 'national character' before then was Joseph Chamberlain, the most radical member of the crew: see, for example, Chamberlain, 'National Patriotism and the World', 64, 67–8, 76; Loughlin, *Ulster Unionism*, 29–31, on Chamberlain's willingness to apply the language of national character even to Ulster.
85. 'The Future of the Dark Peoples', *Spectator*, 28 January 1893, 121–3; Greenwood, 'The Limbo of Progress', esp. 397–400; Harrison, 'The Evolution of Our Race: A Reply', *Fortnightly Review*, n.s., 54 (1893), 29, 35–8; 'The Hopes of Humanity', *Church Quarterly Review* 36 (1893), 358, 361–2; Lyall, 'National Life and Character', esp. 895–6; 'Mr Pearson on the Decay of National Character', *Spectator*, 21 January 1893, 71–2; 'National Life and Character', *Quarterly Review* 177 (1893), esp. 118–30; [Seeley?], 'National Life and Character', esp. 274; [Walpole], 'The Forecast of Mr Pearson', esp. 292–303. In his reply to critics, Pearson granted that the church remained the greatest engine of character, though he felt that it was losing both function and credibility to the state: Pearson, 'An Answer to Some Critics', esp. 164–6.
86. See, further, Dunn, 'Is Our Race Degenerating?', 301–14. Dunn's answer was 'no'.
87. Lord Salisbury, quoted in Marsh, *Discipline of Popular Government*, 247.
88. Creighton, *English National Character*, 13–15; see further below, pp. 135–9.
89. Ibid., 31. Here Creighton was comparing the modern Englishman to an Elizabethan adventurer.
90. Dixon, *Poetry and National Character*, 8–10; Inge, *England*, 40–2.
91. *The Times*, 18 June 1896, 9.
92. Renan, 'What is a Nation?', 11, 19.
93. Wilkinson, *Nation's Awakening*, 276–7. See also Grainger, *Patriotisms*, 168, 188; Harvey, *Biology of British Politics*.
94. Searle, *Quest for National Efficiency*; Semmel, *Imperialism and Social Reform*. There were also groups within single parties thinking along the same lines: Fabians on the Left, tariff reformers on the Right. See further the Compatriots' Club, formed mostly by Tories who had been in the Coefficients: Green, *Ideologies of Conservatism*, 64–9. An alternative route to greater national cohesion lay through a 'Little England' strategy, as adopted by the Patriots' Club, for which see below, pp. 139–40.
95. Wells, *New Machiavelli*, and see, for example, Wells, *An Englishman Looks at the World*, 23–5, 41, 68–9, 226–8, 324–5.

96. Grainger, *Patriotisms*, 190.
97. Searle, *Eugenics and Politics*; Shipman, *Evolution of Racism*, 122–32, 140; Stepan, *Idea of Race*, 119–26. The need to continue to encourage diversity was urged even by other Social Darwinists: see Harvey, *Biology of British Politics*, 17, 28–32.
98. From Bateson's 1912 Herbert Spencer Lecture, 'Biological Fact and the Structure of Society', reprinted in Bateson (ed.), *William Bateson*, 342.
99. Pearson, *National Life from the Standpoint of Science*, 28; Searle, *Eugenics and Politics*, 79–80. See also the parallel Liberal protests against 'artificial' Unionist economic policies and their prioritization of 'intelligence, adaptability and diligence' in educational policy: Friedberg, *Weary Titan*, 76.
100. Stepan, *Idea of Race*, 121; Searle, *Eugenics and Politics*, chs. 7–8.
101. Feldman, 'Importance of Being English'. See further Cheyette, *Constructions of the 'Jew'*. Feldman emphasizes the local (London) significance of the Aliens Act and, as Cunningham also points out, it had limited political salience outside London: Cunningham, 'Conservative Party and Patriotism', 288.
102. Among Gladstonian Liberals, see Freeman, 'Physical and Political Bases'; among New Liberals, see Wallas, *Human Nature in Politics*, 280–2.
103. See the discussion in Rich, *Race and Empire*, esp. 54–5, 60–3 (Curtis quote at 62–3; Zimmern quote at 60–1). Note also the differences between the Liberal political philosopher Ernest Barker's more nationalist and Zimmern's more internationalist liberalism, as explicated by Stapleton, *Englishness*, 103–5; and, for a contemporary estimate of the difficulties, Beer, 'Lord Milner and British Imperialism', 301–8.
104. On which point, see Cunningham, 'Conservative Party and Patriotism', 297–9.
105. Grainger, *Patriotisms*, 76–7; Mallett, 'Kipling and the Invention of Englishness'.
106. Chancellor, *History for their Masters*, 28; MacKenzie, *Propaganda and Empire*, 174–88; Mandler, *History and National Life*, 65–6; Samuel, 'Continuous National History', 10–13. See also Liberal objections to the centralization of character building in schools in Readman, 'Liberal Party and Patriotism', 273–80.
107. Billig, *Banal Nationalism*.
108. Bosanquet, 'Teaching of Patriotism'; Field, *Towards a Programme*, esp. 98; Fulton, 'History and the National Life'; Grainger, *Patriotisms*, 27–40; Rose, *Intellectual Life*, 340, 351–2.
109. Heathorn, *For Home, Country and Race*. See also Field, *Towards a Programme*, 93–7, and Yeandle, 'Lessons in Englishness and Empire'.
110. Heathorn, *For Home, Country and Race*, 92–3.
111. Ibid., 36–7, 44–5, and cf. ix, 18, 112, where Heathorn assumes that these readers were a more or less accurate transcription of the authors' own world views. On imperial propaganda in the popular press, see Field, *Towards a Programme*, 155–6, 187–8, 190, contrasting popular and elite treatments.
112. Cf. Heathorn, *For Home, Country and Race*, 19–20, and Rose, *Intellectual Life*. The romantic racialism would certainly have embarrassed advanced opinion and, as Robertson pointed out, even instrumental nationalism useful to their cause made respectable Unionists squirm: Robertson, *Saxon and Celt*, 11. See also MacKenzie, *Propaganda and Empire*, 178–9, 183–4. Field, *Towards a Programme*, 229–40, takes a functionalist view of the significance of character building for social integration, while noting also the precariousness of the project.
113. See, for example, Hobhouse, *Democracy and Reaction*, 86–95, 101, 107, 114–16, intensified in the Introduction to 2nd ed. (1909), 250–4. See also the classic pre-war critique of Social Darwinism, Angell, *Great Illusion*, esp. 128–9, 140, 159–60, 226–39. A similar sequence of crisis followed by a return to 'the old consensus' has been detected in British evaluations of its relative position as a world power between 1895 and 1905 by Friedberg, *Weary Titan*, esp. 287.

114. Principally a Liberal theme before 1914: Bosanquet, 'Teaching of Patriotism', 3; Oldershaw, 'Fact of the Matter', 255; Robertson, *Saxon and Celt*, 115–17.

115. Pick, *Faces of Degeneration*, 185–6; Soloway, *Demography and Degeneration*, 45.

116. Pearson, *National Life from the Standpoint of Science*, vii.

117. On the older Liberals in this period, see Harvie, *Lights of Liberalism*, 237–8; Stapleton, *Political Intellectuals*, 38–9. On the New Liberals, see Clarke, *Liberals and Social Democrats*, ch. 5; Freeden, *New Liberalism*, 171–3, 176–81, 189–90, 194; Stapleton, *Political Intellectuals*, 39–46. See also, for example, Hobhouse, *Democracy and Reaction*, 159–164; idem, *Morals in Evolution*, 362–3; Hobson, 'Character and Society'; and the somewhat different position in Wallas, *Human Nature in Politics*, 274–82, 287–94.

118. Rosenthal, *Character Factory*. As José Harris points out, the idea that the Salvation Army might undertake compulsory character building on behalf of the state, which had been briefly mooted during and after the Boer War, appeared already by 1905 fairly ludicrous: Harris, *Unemployment and Politics*, 124–35.

119. Romani, *National Character and Public Spirit*, 308–28; but cf. Hobhouse, *Democracy and Reaction*, 159–60, for a Burkean twist on 'civism'.

120. Balfour, *Decadence*, 40, 43, 48–50, 56, 58–62. The credit Balfour gave to science was novel, particularly as he went out of his way to place it above political institutions and patriotism. For references to *Decadence* exaggerating its pessimism, see Pick, *Faces of Degeneration*, 214–15; Searle, *Eugenics and Politics*, 32.

121. 'National Decadence', *Spectator*, 1 February 1908, 178–9.

122. Francis Younghusband, 'Emerging Soul of England', 66–71, 82. See also Green, *Ideologies of Conservatism*, ch. 2.

123. For deliberate and pointed remarks on the need for Unionism to take seriously the national character, see Chamberlain, 'National Patriotism and the World', 68–9; Cramb, *Origins and Destiny*, 104–5; and see further Field, *Towards a Programme*, 90; Stapleton, *Political Intellectuals*, 51–3.

124. See above, pp. 125–6, and for specifically Unionist contexts, see Arnold-Forster, 'An English View of Irish Secession', 79; Balfour, *Nationality and Home Rule*, 14–15; Bonwick, *Our Nationalities*; [Croskerry], 'Irish Discontent', 157–8; Edwards, 'The Sentiment of Nationality', 502–3; Lecky, *Democracy and Liberty*, vol. 1, 396; Palmer, 'The Saxon Invasion', 192–3.

125. On the novelty of 'the British race', see Freeman, 'Latest Theories on the Origin of the English', 50. 'Celto-Teutonic' was a coinage of the socialist H.M. Hyndman in *Historical Basis of Socialism in England* (1883): Ward, *Red Flag and Union Jack*, 40. In addition to Freeman's criticism of Rosebery, see Cramb, *Origins and Destiny*, 10.

126. Chamberlain, 'National Patriotism and the World', 72.

127. On Anglo-Saxonism in the context of thinking about 'Greater Britain', see Bell, *Building Greater Britain*; and Searle, *A New England?*, 12, 24–9.

128. Rosebery, quoted in Anderson, *Race and Rapprochement*, esp. 97–8.

129. See the provocative discussion in Hitchens, *Blood, Class and Nostalgia*, ch. 3.

130. Anderson, *Race and Rapprochement*, 30–2, 41, 86–91; Barkan, *Retreat of Scientific Racism*, 23, but cf. 26.

131. Freeman, 'Latest Theories on the Origin of the English', 51.

132. See, for example, Thompson, *Imperial Britain*, 32–4, on tensions between Tories and Liberal Unionists over this issue.

133. See above, pp. 29–30, 68–70.

134. There is now a rich historiography on late Victorian and Edwardian hero-worship; see Castle, *Britannia's Children*; Chancellor, *History for their Masters*, 70–5; Dawson, *Soldier Heroes*; Driver, *Geography Militant*; Girouard, *Return to Camelot*, ch. 1; Jones, *Last Great Quest*; Tidrick, *Empire and the English Character* (not about 'national character' but rather character in heroic English individuals).

135. Girouard, *Return to Camelot*, esp. chs. 14–17.
136. For example, 'The English Want of Traditions', *Spectator*, 22 June 1889, 854–6; McDougall, *Group Mind*, 139.
137. Smith, 'Schism in the Anglo-Saxon Race', 19–20, and see above, nn. 10–12, for comments on the lack or loss of self-reliance. For reassertions of self-reliance, less common but not totally absent and mostly in more racial, Teutonist terms, see Dale, *National Life and Character*, 32; Keane, *The World's Peoples*, 379–81; Macnamara, *Origin and Character of the British People*, 223. Kidd, *Social Evolution*, 281–3, 302, has the Teutonic peoples combining individualism and altruism.
138. Seeley, *Expansion of England*, 307–8. See also above, p. 110, for F.M. Hueffer's views on the English balance between individualism and mass society.
139. Creighton, 'The Picturesque in History', 281–3 – a different spin on individualism than that conveyed in *English National Character*, 15.
140. For 'resolute' or 'resolve', see Creighton, *Church and the Nation*, 170–1 (a lecture of 1884); 'Is England Growing Weaker?', *Spectator*, 12 March 1898, 370; 'The Secret of British Success', *Spectator*, 1 October 1898, 433. On the martial virtues, see also 'The Relation between Religion and National Success', *Spectator*, 29 October 1898, 591. Energy is still a feature of domestic life, too, in anti-degenerationist arguments such as Balfour, *Decadence*, 54–7; Dunn, 'Is Our Race Degenerating?', 306; 'National Personality', 140–1.
141. Creighton, *English National Character*, 31–3; Harvey, *Biology of British Politics*, 28–30; Hueffer, *England and the English*, 351; Huntington, *Civilization and Climate*, 160; Kidd, *Social Evolution*, 55; 'The Secret of British Success', *Spectator*, 1 October 1898, 433; Seeley, *Expansion of England*, esp. 87. Liberals like John Swinnerton Phillimore, 'Liberalism in Outward Relations', 151, preferred colonizing to governing. See further the excellent discussion of empire as a sphere for the preservation or development of the English character in Field, *Towards a Programme*.
142. Froude, quoted in Girouard, *Return to Camelot*, 221.
143. Wallas, *Human Nature in Politics*, 280–1.
144. Coveney and Medlicott, *Lion's Tail*, 27–9.
145. Bagehot, *Collected Works*, vol. 4, 84. See also Escott, *England*, vol. 1, 239; Green, *Short History*, 89.
146. Brodrick, 'A Nation of Amateurs', 521; 'A Nation of Shopkeepers', *Saturday Review*, 10 May 1902, 591–2. See also Inge, 'The Future of the English Race', 229. For continuing defences of English materialism, see Creighton, *English National Character*, 32–3; Dorman, *Mind of the Nation*, 438–40; Kidd, *Social Evolution*, 56–7.
147. Hamilton, quoted in Surridge, *Managing the South African War*, 173, 158.
148. Milner, quoted in Pakenham, *Boer War*, 123. Also, against the effects of Jewish 'plutocracy' on the English character, [Crosland], *Egregious English*, 13–19; or in favour of Jewish cosmopolitanism, Escott, *Social Transformations*, ch. 5; Hueffer, *England and the English*, 255 and passim. Admittedly, Escott was paid to say such things by the Rothschilds – but he was hardly unique in saying them. (Information from the Rothschild Archive.)
149. See also the 'Little Englander' version of the Boer, discussed below, pp. 139–40.
150. Friedberg, *Weary Titan*, 32–3.
151. Creighton, *English National Character*, 19. See also Unwin, 'Note on the English Character'.
152. Bosanquet, 'The Teaching of Patriotism', 16–19; also idem, 'The English People', 76–7, 81.
153. Hughes, *English Character*, 300.
154. The phrase seems to have been put into currency in 1899 by the memoirs of the Irish novelist and Home Ruler Justin McCarthy, who remembered a comment of the radical MP John Bright during the American Civil War that the North would

'muddle through' (McCarthy, *Reminiscences*, vol. 1, 85). It was then picked up by (mostly) Liberal critics of the military response in South Africa in early 1900, though not yet applied to England or Britain generally.

155. The first such usages I have found applied to the whole nation are Bosanquet, 'The English People', 81, in January 1901 ('muddle along') and Pearson, *National Life and Character*, 11–15, in 1905 ('muddling through'). *OED* has nothing earlier than a Hilaire Belloc poem of 1910. The whole trajectory of this usage does not really bear out Donald Horne's suggestion that it 'grew up in the period when Britain had strength and confidence of such magnitude that it could afford mistakes, muddles and compromises': *God Is An Englishman*, 260.

156. Brodrick, 'A Nation of Amateurs', 521–2, 524, 534–5. See further Searle, *Quest for National Efficiency*, 76–8.

157. Rosebery, 'Business of the British Empire', 36, 38.

158. This applies to many if not most of the sources canvassed up to the early nineteenth century in Langford, *Englishness Identified*, though also still in the late nineteenth century such 'authorities' as Hippolyte Taine and Henry James.

159. Whitman, *Conventional Cant*, esp. 1–2, 6–8. Later examples are Crosland, *Unspeakable Scot*; idem, *Egregious English*; and Hughes, *English Character*. See also below, ch. 5.

160. Boyes, *Imagined Village*; Howkins, 'Discovery of Rural England'; Wiener, *English Culture*, esp. 44–71.

161. Collini, *Public Moralists*, 315–17, 345–50, but cf. 351, 358, where the literary and political modes are seen as overlapping and mutually reinforcing. Also Dodd, 'Englishness and the National Culture'; Doyle, 'Invention of English'. Cf. Mandler et al., 'Cultural Histories Old and New', 74–6.

162. For which see Mandler, 'Against "Englishness"', where I agree with Kumar, *Making of English National Identity*, 197–225.

163. Grainger, *Patriotisms*, 142–4; Weaver, *Hammonds*, 59–61, 238; Weaver, 'Pro-Boers'.

164. Grainger, *Patriotisms*, 157, comments of one New Liberal internationalist that 'Hobson's state is hardly recognizable as a "country"', but cf. 146–7 for Hammond's counter-argument that it was imperialism that was undermining nationality.

165. A selection of such views can be found in Oldershaw (ed.), *England*, originally papers of the Patriots' Club of (mostly Liberal) anti-imperial advocates of patriotism, including Chesterton and Masterman.

166. For example, Phillimore, 'Liberalism in Outward Relations'.

167. Bickley, 'The Cult of the Peasant', 3. See further Marsh, *Back to the Land*.

168. Girouard, *Sweetness and Light*, 15.

169. Taylor, quoted in Girouard, *Sweetness and Light*, 15. Note, however, the limits on a mid-Victorian idea of the English that excludes both Manchester and London.

170. Masterman, 'English City', esp. 61–6; idem, *Condition of England*, e.g. 82–3, 254–62; and the treatments in Grainger, *Patriotisms*, 154–5; Rich, 'A Question of Life and Death', 497; Soffer, *Ethics and Society*, 165–8, 172–4.

CHAPTER 5: LITTLE ENGLAND

1. Grainger, *Patriotisms*, 329; Stepan, '"Nature's Pruning Hook"'; and, for some comments to this effect in the midst of war, see, for example, Burns, *Morality of Nations*, vi–viii; Mitchell, *Evolution and the War*, ch. 1; Muir, *Nationalism and Internationalism*, 40–2; Robertson, *The Germans*, pt 1; idem, 'Idea of Race Psychology'.

2. For example, Barker, *Christianity and Nationality*, 29–30; Cecil, 'National Characteristics and the League'; A.D. Lindsay, Introduction to Dibelius, *England*, 8–9; Madariaga, *Englishmen, Frenchmen, Spaniards*, 228–30; Gilbert Murray, Preface to Kantorowicz, *Spirit of British Policy*, 14; and below, pp. 153, 178–84, on the debate

over national characteristics in foreign policy. See also Williamson, *Stanley Baldwin*, 146–7, on Baldwin's doubts about progress and civilization.

3. Dilks, 'Public Opinion and Foreign Policy', 61.

4. See, for instance, Ellis, 'Psychology of the German', 'Psychology of the Russian' and 'Psychology of the English'; Keene, 'A Polish People'; Sedlak, 'Life in a Moravian Village'. 'National characteristics' became a busy category for the first time in the *Subject Index to Periodicals* during the war, with many nationalities under the microscope – French, Germans, Irish, Italians, Spaniards, Montenegrins, Serbs, Poles, Rumanians, Russians, Turks, Japanese, Chinese, Americans, Mexicans – whereas after 1919 the English themselves featured primarily.

5. Newbigin, 'Origin and Maintenance of Diversity', 419.

6. See the discussions in Mazower, *Dark Continent*, ch. 2; Sluga, 'What is National Self-Determination?'; and idem, *Nation, Psychology, and International Politics*.

7. A good example, which prefigures many of the great inter-war clichés, is Galsworthy, 'Diagnosis of the Englishman', which appeared originally in the *Amsterdamer Revue*.

8. Maurois, *Silence of Colonel Bramble*, 9–11, but cf. Rice, 'Maurois' English Portraits'. A sequel, *The Discourses of Doctor O'Grady*, appeared in English in 1921. See also Maurois, *3 Letters on the English* (1938); cf. *Franco-British Studies* 14 (1992), Special Issue: 'French Attitudes to the British', 1, which claims, 'there is no trace of any work in French or English corresponding to this title' and no copy in the British Library, though there is at W.P. 1004/15. Another foreign commentary that was not warmly received was Wilhelm Dibelius' *England* (first published in German in 1922, but not translated into English until 1930), though it was often cited as evidence of German views on the English.

9. Fuller, 'English Spirit', 225.

10. On the revulsion against the French in British public opinion, see Bell, *France and Britain*, 159–61, 179–80; Cairns, 'A Nation of Shopkeepers'.

11. Forster, 'English Freedom', 791–2.

12. The quote continues, 'and share the ecstasy of Burke', concluding with one of Burke's paeans to the uniqueness of the British political dispensation. Neale, 'English Local Government', 202–3.

13. Rich, *Race and Empire*, 60–5.

14. For the debate over the 'Credo', see Mackinder, 'The English Tradition and the Empire', with ensuing discussion at the Royal Colonial Institute, *United Empire*, n.s., 16 (1925), 724–35.

15. See below, pp. 177, 180–1; this tended to be a charge laid by worried Continental liberals.

16. See suggestive remarks in Rich, 'Imperial Decline', which require some elaboration, below; and cf. Kennedy, *Realities Behind Diplomacy*, 247–8.

17. Kennedy, *Strategy and Diplomacy*, 38. See the excellent discussions in Loughlin, *Ulster Unionism*, esp. 99–103, and Peatling, *British Opinion and Irish Self-Government*, esp. 175–81, in different ways asserting the divergence of Ulster and English ideas of 'Britishness'; and, further, Boyce, *Englishmen and Irish Troubles*.

18. Loughlin, *Ulster Unionism*; McIntosh, *Force of Culture*. Thanks to Roy Foster for putting me onto this bibliographical trail.

19. Searle, *A New England?*, 8, makes the valuable point that, even before the partition of Ireland, England's predominance in the United Kingdom had been growing, from 56 per cent of the population in 1841 to over 75 per cent by 1911. But, of course, this was even more true after partition, so that by 1931 England accounted for over 80 per cent, as it has done ever since.

20. Macdonell, *England, Their England*. See also irritable exchanges in *Saturday Review*, 2–23 November 1929, 505, 541, 577, 607 (and continues into 1930); Ferrie, 'Interpreting England', 58–60; MacCulloch, 'English and Scots', 80–1.

21. Masefield, *Reynard*, esp. 18–19, 37–8, 46–7.
22. See the discussion in Hynes, *War Imagined*, 416–17.
23. I make these points at greater length in 'Against "Englishness"' and 'The Consciousness of Modernity?'
24. Notably Graham Wallas; see above, pp. 131–2, 140–1.
25. For changed estimates of the national character explicitly drawing on wartime experiences, see 'The British Spirit', 184–92; Fuller, 'English Spirit', 220–30; Holtby, 'The Egotistical English', 669; Nevinson, *Ourselves*, 34–6; and some elements in Bryant, *National Character*, e.g. 10, 17–18; Inge, *England*, e.g. 40–2, 64–5. See further, Williamson, *Stanley Baldwin*, 137, 144, 299, for the war's crucial role in shaping Stanley Baldwin's thinking. The impact of wartime experiences on the perceptions of specific traits is discussed in the next section.
26. [Begbie], *Conservative Mind*, 10–12. Stanley Baldwin was not above making similar remarks, though more often in private: see Williamson, *Stanley Baldwin*, 145, 148, 205.
27. Inge, *England*, esp. 86–7, 247.
28. Jarvis, 'Shaping of Conservative Electoral Hegemony', 136–7, 142; Nicholas, 'Construction of a National Identity', 132–41. In this the Conservatives were in advance of many so-called democrats on the Left, who tended to view the masses as 'the obedient automata of a system': Madge and Harrisson, *Mass-Observation*, 9.
29. Inge, *England*, 247, but cf. 64–5.
30. Baldwin, 'The Citizen and the General Strike', 12 June 1926, and 'Freedom', 19 June 1926, in *Our Inheritance*, 7–13, 212–26.
31. See, for example, 'The British Spirit', 184–92; Fuller, 'English Spirit', 222, 226–7; Seely, *For Ever England*, passim; Galsworthy, cited by Hynes, *War Imagined*, 416–17.
32. Demiashkevich, *National Mind*, 10–11; Ferrie, 'Interpreting England', 60; Hutton, '"Perfidious Albion"!', 431; Maurois, 'Englishman of To-Day', 13–15; Morgan, 'English Character', 789–90; Scarborough, *England Muddles Through*, 5.
33. Dalton, *Practical Socialism*, 4. See also Durbin, *What Have We To Defend?*, 39; Kantorowicz, *Spirit of British Policy*, 91; Kircher, *Powers and Pillars*, 252–3.
34. Fuller, 'English Spirit', 227.
35. Below, pp. 176–8.
36. Cammaerts, *Discoveries*, 7.
37. See below, p. 176.
38. Downs, 'As Others See Us', 84; von Stutterheim, *Those English!*, v; Marriott, 'England Through Foreign Spectacles', 343; Maurois, *3 Letters on the English*, 11.
39. Byron, quoted in Green, *Children of the Sun*, 294–5; cf. Carpenter, *Brideshead Generation*, 228.
40. Its course can be traced in the *Listener* from 4 October 1933 to 4 April 1934. Bryant, *National Character*, is the book version of only Bryant's own contributions – the full array was more various. Bryant's initial ideas rested heavily on Santayana, and the BBC was concerned that, left in Bryant's hands alone, 'the series might result too much in glorification of the national character': BBC Written Archives Centre, RCONT1, Arthur Bryant, Talks, File 1: 1933–1947, R.A. Rendall to Arthur Bryant, 16 June 1933, Bryant to Rendall, 15 August 1933. See also Nevinson, *Ourselves*, and cf. Nevinson's earlier *The English* (1929) and *Rough Islanders, or The Natives of England* (1930), in which he gets progressively more bufferish. The BBC ran at almost the same time a series on 'Vanishing England', about changes to the physical appearance of the country, for which see the *Listener*, 25 October to 6 December 1933. See also *The Times*' leader, 'The English Character', 26 September 1933, 15.
41. Of which the most substantial were Odette Keun, *I Discover the English* (1934); J.B. Priestley, *English Journey* (1934); Philip Gibbs, *England Speaks* (1935); Christen Hansen with H.W. Seaman, *The English Smile* (1935); D.F. Karaka, *Oh! You English* (1935); Kurt von Stutterheim, *Those English!* (1937); J.S. Collis, *An Irishman's England* (1937);

Norwood Young, *England Conquers the World* (1937); Wyndham Lewis, *The Mysterious Mr Bull* (1938); J.H. Wellard, *Understanding the English* (1938); Beverley Nichols, *News of England* (1938); W.J. Blyton, *We Are Observed* (1938); idem, *Arrows of Desire* (1938); Karl Heinz Abshagen, *King, Lords and Gentlemen* (1939). This then melts into wartime propaganda.

42. For different approaches to Baldwin's use of the 'national character', see McKibbin, 'Class and Conventional Wisdom'; Nicholas, 'Construction of a National Identity'; Schwarz, 'Language of Constitutionalism'; Williamson, *Stanley Baldwin*.

43. For Liberal expressions of pride in nationality, see, e.g., Burns, *Morality of Nations*, esp. 1–24, 61–3; Burns, *World of States*, 36–40; Muir, *Nationalism and Internationalism*, esp. 51–6, 83–6; Muir, *National Self-Government*, 7–8, 34–5; Oakesmith, *Race and Nationality*, 77, 82–6, 247–65; Barker, *Christianity and Nationality*, 21–23, 29–32. For Liberal doubts about nationality, Zimmern, *Nationality and Government*, 32–86; Jones, 'The Making of Nations', 70–5; Catlin, *Anglo-Saxon Tradition*, 9, 16–17, 19–20, 39–41, but cf. 252–4.

44. Priestley, *English Journey*, esp. 389–90; Orwell, 'The Lion and the Unicorn: Socialism and the English Genius', in *Collected Essays*, vol. 2, 74–134; Dalton, *Practical Socialism*, 3–7. But cf. Laski, 'Nationalism and the Future of Civilization', in *Danger of Being a Gentleman*, 189–225, very much echoing Liberal ambivalence.

45. In this Dalton was again rather more concerned with the character of the people than were those on the authoritarian Left, who might view the masses as 'the obedient automata of a system': see above, n. 28.

46. A.D. Lindsay, Introduction to Dibelius, *England*, 8–9; similar in Inge, *England*, 39–40.

47. Robertson, *Saxon and Celt*, 101–5, 291; idem, *The Germans*, 37–8; cf. Burns, *Morality of Nations*, 12–18, 21–24; idem, *World of States*, 37; Oakesmith, *Race and Nationality*, 82–6. See also the interesting development from Hertz, *Race and Civilization*, 56–9, to Robertson, 'The Illusion of Race', 32, to Hertz, 'National Spirit and National Peculiarity', about which more below, pp. 157, 160–1.

48. For example, Kircher, *Powers and Pillars*, 144–7, 252–3; Kantorowicz, *Spirit of British Policy*, 26–8; Renier, *The English: Are They Human?*, 174–5 and passim, and his contributions to Renier and Silex, 'Ourselves as Others See Us', pp. 442–3; Scarborough, *England Muddles Through*; Austin, 'Effects of Modern Industry on National Character', 408–10; Read (ed.), *English Vision*, x; Priestley, *English Journey*, 380, 385–6, 390; Nicolson, *National Character and National Policy*, 1–2, 9; and Orwell, 'The English People', in *Collected Essays*, vol. 3, 1–38, esp. 4–5, 22–3. Cf. the doubts of Burns in Wilson and Burns, 'The National Character: Tradition v. Change', 582–3. The outright repudiations of Fyfe, *Illusion of National Character*, were rare; Fyfe was a Communist.

49. Rich, 'Imperial Decline', 40; Stepan, '"Nature's Pruning Hook"'. For a riposte to Keith, see Mitchell, *Evolution and the War*. On Keith's influence, cf. Barkan, *Retreat of Scientific Racism*, 48–52; Jones, *Social Darwinism*, 130; Rich, *Race and Empire*, 116–17; which tend to assume that Keith's views on race carried more weight than they did. Keith's own retrospect did not share their optimism: *Autobiography*, 392–8, 554–5.

50. Bateson (ed.), *Bateson*, 356–87.

51. Keane, *Man Past and Present*, esp. 524–5; Haddon also made more categorical his own views on the disjuncture between race and culture: *Races of Man*, 3rd ed. (1929), esp. 2–4.

52. For exceptions, see Kenyon, 'Ideals and Characteristics of English Culture'; McDougall, *Group Mind*, esp. 221–31; and, predictably, Lewis, *Mysterious Mr Bull*, 28, 33–8, 43–8, 68; von Stutterheim, *Those English!*, 136–8.

53. McDougall, *Group Mind*, 121–3; Tuker, '"Teutons" Latinised and Unlatinised'; Bradley, *Racial Origins*; Inge, *England*, 11–27; Fallaize, 'Why Britain Needs a Race Survey', 302–4; Dixon, *Englishman*, 18–28; 'The Englishman' (leader), *Listener*, 4 October 1933, 488; Tilby, 'Regional Varieties of the English Genius', 682–4.

54. Dixon, *Englishman*, 28; Inge, *England*, 10–11.
55. Fleure, *Races of England and Wales*, 17–20, 83–6; 'Mental Characters and Physical Characters'; 'Regional Balance of Racial Evolution'; 'Races of Mankind'. See also Barkan, *Retreat of Scientific Racism*, 57–65.
56. Fleure, 'The Nordic Myth', 117–21.
57. Bryant and Fleure, ' Mingling of the Races', 579–82. Cf. a subsequent discussion of climate, with rather comical touches of mutual incomprehension: Bryant and Fleure, 'How Does Our Climate Affect Our Character?', 623–5, and a demurral later in the series from Thomas Jones, 'Welsh Character', 195–7. On the difficulties Fleure posed, see BBC Written Archives Centre, RCONT1, Arthur Bryant, Talks, File 1: 1933–1947, Mrs Adams to Arthur Bryant, 8 September 1933, Bryant to Adams, 30 September 1933.
58. Even in the *Spectator*: 'The Psychology of Nations', 5 November 1898, 652–3. See also Inge, *England*, 39–40.
59. Jones, *Social Darwinism*, 94–6, 125–39; Romani, *National Character and Public Spirit*, 252–5; Soffer, *Ethics and Society*, chs. 10–11; Thomson, ' "Savage Civilisation" ', 240–7; idem, 'Psychology and the "Consciousness of Modernity" ', 100–6.
60. MacIver, *Community*, 267.
61. Oakesmith, *Race and Nationality*, 1–2.
62. Ibid., 38–9, 247–65.
63. Hertz, *Race and Civilization*, esp. 1, 10–17.
64. Ibid., 56–63.
65. See references to Barker's work in, for example, Ginsberg, 'National Character and National Sentiments', 252; Hertz, 'National Spirit and National Peculiarity', 347.
66. Stocking, *After Tylor*, 146–51.
67. Kuklick, 'Tribal Exemplars', 69–71; Sluga, *Nations, Subjectivity, and International History*; Stocking, *After Tylor*, 230–7, 292; Thomson, ' "Savage Civilisation" '.
68. Breasted, 'The New Past', 2–3.
69. [Stocking], 'Essays on Culture and Personality'; Susman, ' "Personality" '.
70. See, for example, Hertz, *Race and Civilization*, ch. 13, and Massingham, *Heritage of Man*, 136–7, 147–57, for positions halfway between social evolution and relativism, and the approving comments on the social-evolutionary perspective in Ginsberg, *Essays in Sociology*, xii, and Geoffrey Gorer to Margaret Mead, 18 November 1938: Gorer MSS, University of Sussex Library, Brighton, Special Collections, Box 91.
71. Rudyard Kipling, 'The Strength of England', a speech to the Royal Society of St George on St George's Day 1920, *The Times*, 24 April 1920, 15–16.
72. Perry Anderson's 'Components of the National Culture' is the *locus classicus* of this indictment (reprinted with updatings in *English Questions*); echoed in, among others, Rich, *Race and Empire*, 92–3 and passim.
73. Stocking, *After Tylor*, passim; Barkan, *Retreat of Scientific Racism*, 119–27.
74. Thomson, ' "Savage Civilisation" ', 238–40.
75. See its influence in the anthropometric textbook that replaced Ripley, Coon, *Races of Europe*, ch. 10 (e.g., 398). Prehistoric archaeology has continued to rest on such foundations ever since, though today archaeologists are more likely to argue that cultural contact rather than migration is the principal means of diffusion.
76. Barkan, *Retreat of Scientific Racism*, 39–49; Kuklick, 'Tribal Exemplars', 66–9, emphasizing the former rather than the latter; Stocking, *After Tylor*, 208–30.
77. For example, Breasted, 'The New Past', 2–3, 8–9, 13–14.
78. For one clever stab at this, see Rivers, 'History and Ethnology'.
79. Royal Anthropological Institute, *Race and Culture*, quotes at 3–4, 5; Barkan, *Retreat of Scientific Racism*, 285–90. Kushner, *We Europeans?*, 39–48, gives an account of inter-war anthropology that, in my view, gives far too much weight to Fleure.

80. Huxley and Haddon, *We Europeans*. See also Barkan, *Retreat of Scientific Racism*, 261, 297–306; but cf. Kushner, *We Europeans?*, 48–55, criticizing Barkan's 'Whiggish' account and blurring the distinction between Huxley and Haddon and their more overtly racialist predecessors.

81. Raglan, 'Riddle of Race', 549–52, 583.

82. Huxley and Haddon, *We Europeans*, 7, 9, 11, 25, 89–93.

83. Ibid., 136.

84. Hertz, 'National Spirit and National Peculiarity'.

85. Ginsberg, 'National Character and National Sentiments'. See also Mace, 'National Stereotypes', 29–36. Elias, *Civilizing Process*, might be seen as a further contribution to this discussion.

86. Gorer, 'Notes on the Way', 753.

87. Orwell, *Collected Essays*, vol. 1, 251–2.

88. Angus Calder's Introduction to Harrisson and Madge, *Britain by Mass-Observation*, viii.

89. Madge and Harrisson, *Mass-Observation*, 11 (and note Introduction by Huxley); Madge and Harrisson (eds), *First Year's Work*, including press criticisms and Malinowski's addendum. See also Jeffrey, *Mass-Observation*, 4–6, 8, 11–20, and Stanton, 'In Defence of *Savage Civilisation*', 29, for Mass-Observation as the convergence of a number of contemporaneous currents.

90. For a sensible criticism along these lines, see Vaughan Jones, 'The English As Others See Them', esp. 113–14.

91. On the dance halls, see Silex, *John Bull at Home*, 56; on the boxrooms, Cammaerts, *Discoveries in England*, 87–9; on washing habits, Bradley, *Racial Origins of English Character*, 37; Macaulay, 'Past and Present', 792–3; but cf. '"The English Make Me Wild"', 957–8, saying more or less the opposite, and Silex, *John Bull at Home*, 289.

92. Bryant, 'The Englishman's Roots', 531–3; idem, *National Character*, 22–3, 25, 31–4, 48, 154–5. Julia Stapleton takes a more positive view of Bryant's 're-shaping [of] the idea of a common national character to broad Conservative advantage' in *Sir Arthur Bryant*, ch. 4 (quote at 72). It is hard to balance Bryant's private anxieties that the national character was in dissolution with his public cheerleading, aiming, sometimes with ill-disguised despair, to shore it up.

93. For the debate over Bryant's politics in the 1930s, see Stapleton, *Political Intellectuals and Public Identities*, 117–43, and eadem, *Sir Arthur Bryant*, chs. 7–8.

94. For (surprisingly rare) traditional evocations of John Bull, see Inge, *England*, 40–2; Wingfield-Stratford, *History of British Civilization*, 40; idem, *Foundations of British Patriotism*, 27 (but cf. idem, *New Patriotism*, 122, 128, 134). For his decline, see also Taylor, 'John Bull', 124–5, and Benson, *Strube*, 28–9 for the impact of the First World War in causing cartoonists to drop John Bull.

95. Galsworthy, 'Diagnosis of the Englishman', 839; Nevinson, *The English*, 4; idem, *Ourselves*, 6–7.

96. Hobson, 'In Praise of Muddling Through', 177; Lewis, *Mysterious Mr Bull*, 12, 73, 93; Nicholas, *Echo of War*, 229.

97. Williams, 'Florence and Lewis', 92–3; Heath, 'John Bull in English Literature', 155; Silex, *John Bull at Home*, 286–7; Fyfe, *Illusion of National Character*, 112–13; Mace, 'National Stereotypes', 31.

98. Cohen-Portheim, *England*, 24–8; Fyfe, *Illusion of National Character*, 112–13; Heath, 'John Bull in English Literature', 153–4; Lewis, *Mysterious Mr Bull*, 12, 93; Wellard, *Understanding the English*, 29–30. A vaguely Bull-ish character appeared in *Daily Mail* cartoons of the 1920s, but he took on highly variable social and political qualities to suit whatever editorial position was at hand; see further below, n. 102.

99. 'The British Spirit', 186–7.

100. Heath, 'John Bull in English Literature', 137; Cammaerts, *Discoveries in England*, 115–16; Nicolson, 'As Others See Us', 817; Lewis, *Mysterious Mr Bull*, 12; Harmsworth, 'The Essence of the English', 624; Wellard, *Understanding the English*, 29–30.

101. George Orwell, 'Charles Dickens', in *Collected Essays*, vol. 1, 454–504, esp. 473–4; Priestley, *English Journey*, 377–8 – only one encomium in what was a lifelong obsession.

102. Nicolson, 'As Others See Us', 817. But cf. Nicolson, *National Character and National Policy*, which offers timeless stereotypes. 'John Citizen' in the *Daily Mail* has occasionally been proposed as a similar inter-war archetype (for example, by Nicholas, 'From John Bull to John Citizen', 38, citing David Low). Drawn by 'Poy' (Percy Fearon), initially for the London *Evening News*, he was a precursor to the 'Little Man', small and quizzical, though with the sideburns, frock coat and (sometimes) posture of John Bull. But he did not appear in a national newspaper until 1934, and in fact the *Mail*'s more pointed political cartooning generally eschewed consensual national archetypes. The more influential Sidney Strube is not even included in the *DNB*; but see *Beaverbrook's England*, and Benson, *Strube*, esp. 29–36, 77–82 for the Little Man.

103. On the appropriation of the 'Cockney', see the marvellous essay by Stedman Jones, 'The "Cockney" and the Nation', 278–9, 300–15, although I think this underestimates the Cockney's contribution (especially in relation to the 'Tommy') in the inter-war period. The insurance clerk was a suggestion of Harold Nicolson's: 'When Allies Are Out of Touch: Ideas in France and England', *The Times*, 21 June 1939, 12; see similar in Wellard, *Understanding the English*, 44–7.

104. Castronovo, *English Gentleman*; Mason, *English Gentleman*. See also Collins, 'Fall of the English Gentleman', which begins with the gentleman's incorporation into the national character between the wars.

105. For example, Langford, *Englishness Identified*, 250, although note here the only source given is Princess Lieven – not someone who really believed in a cross-class national character.

106. See Collini, 'Literary Critic and Village Labourer'.

107. On the novelty of the gentleman as a type of the national character, see, for example, Ellis, 'The Psychology of the English', and sources in the following two notes.

108. Santayana, *Soliloquies*, 3, 31–2, 38. See also Dibelius, *England*, 120–1, 125–9, on the gentleman as 'a useful corrective to the nerve-destroying contemporary scramble for gold'. Bryant, *National Character*, uses this quote ('The Englishman is no missionary, no conqueror . . .') from Santayana as its opening epigraph.

109. Bryant and Fleure, 'How Does Our Climate Affect Our Character?', 625; similar in Inge, *England*, xii, 213–21; Williamson, *English Tradition*, 87–8, 91; Maurois, *3 Letters on the English*, 18. Dixon, *Englishman*, 115–19, has it both ways: money and morals.

110. Inge, 'The Future of the English Race', 229.

111. Kantorowicz, *Spirit of British Policy*, 25, 56–7; and similar in Morand, '"The Gentleman's Island"', 969–70, 1000; Scarborough, *England Muddles Through*, 1, 11, 15–16, 81–2, 98–105; Wellard, *Understanding the English*, 37–41; Hellstrom, 'Concerning the Englishman', 15–18.

112. Ubiquitous, but see Belloc, *Essay on the Nature of Contemporary England*, 24–30; Galsworthy, 'Diagnosis of the Englishman', 840–1; Hansen, *The English Smile*, 165–6; Mackenzie, *Arrows of Desire*, 101–3; Madariaga, *Englishmen, Frenchmen, Spaniards*, 123; Maurois, 'Englishman of To-Day', 6–7; Renier, *The English: Are They Human?*, chs. 13–14; von Stutterheim, *Those English!*, ch. 3.

113. Cammaerts, *Discoveries in England*, 124–33; Nevinson, *The English*, 28, 34–5, 39–42 (but cf. a somewhat different account in *Rough Islanders*, 55–9, 72–83); Renier, *The English: Are They Human?*, passim.

114. Weber, 'National Character and the Junkers', 392; Cammaerts, *Discoveries in England*, 130–9; Downs, 'As Others See Us', 91–2; von Stutterheim, *Those English!*, ch. 1. This skipping from the eighteenth to the twentieth century was easy to do for those who had not participated in the discourse of national character on class grounds in the intervening period.

115. Madariaga, *Englishmen, Frenchmen, Spaniards*, 123; Cohen-Portheim, *England*, 118–23; Grand'Combe, *England, This Way!*, 44; Keun, *I Discover the English*, 226; Collis, *An Irishman's England*, 133–7, 142–6.

116. Inge, *England*, 52–6; Rice, 'Andre Maurois' English Portraits', 94–5; Belloc, *Essay on the Nature of Contemporary England*, 30–2; Downs, 'As Others See Us', 91–2. These two positions – the gentleman as 'leading type' and the gentleman as 'model' or 'ideal type' – are not always easy to disentangle.

117. Renier, *The English: Are They Human?*, 161–212, 273–88; idem, *He Came to England*, 253–4. Wellard, *Understanding the English*, and Brogan, *English People*, follow Renier's analysis. There is something of this also in Orwell's *1984*, where the proles represent a common humanity the corruptions of power have squeezed out of the elite. Colls, *Identity of England*, 82, 310, almost inverts Renier's point here.

118. Macaulay, 'Past and Present', 792–3; for Gorer, see below, pp. 210–13; Gibbs, *England Speaks*, 3–4, 13, 456–7; Austin, 'Effects of Modern Industry on National Character', 408–10; Forster, 'Notes on the English Character', 30–1; Priestley, *English Journey*, 388–9 (but cf. his Introduction to Priestley (ed.), *Beauty of Britain*, 7).

119. Lewis, *Mysterious Mr Bull*, 20.

120. Langford, *Englishness Identified*, 285–90.

121. Ibid., 50–64.

122. I cannot find it anywhere in Froissart. See also Faber, *French and English*, 55–6. Jay, *Political Quotations*, and other reference works attribute it to Sully. But it was typical for partisans of 'national character' to throw it backwards as far as possible.

123. 'Has the English Character Changed?', *Spectator*, 26 May 1900, 733–4, and above, p. 109.

124. 'The British Spirit', 186–7. See also Inge, *England*, 40–2; Nevinson, *The English*, 58; Lewis, *Mysterious Mr Bull*, 149.

125. 'Some English Characteristics', *Saturday Review*, 29 July 1916, 103–4; Hynes, *War Imagined*, 416–17; Chesterton, *Short History*, 7; Seely, *For Ever England*, 247–51. Baldwin often said, 'we grumble, but we never worry': *On England*, 3; *Our Inheritance*, 104; 'Our National Character', 481–2; 'The Englishman in Politics', *The Times*, 21 April 1939, 8.

126. Mackenzie, *Arrows of Desire*, 95; Nevinson, *Ourselves*, 34–6, 41; Keun, *I Discover the English*, 127–8, 151; von Stutterheim, *Those English!*, 16–17. Or, as in Murray, 'English Character', 41, 43, one could fall back on the old standby, having it both ways: the English are both stolid and genial, because a people of 'mixture and surprise'. See also Scarborough, *England Muddles Through*, 102–5; 'Comedie Humaine' [leader], *The Times*, 26 February 1938, 13.

127. Bryant and Fleure, 'How Does Our Climate Affect Our Character?', 623–5.

128. [Clutton-Brock], 'The English Incuria', 445–6; Downs, 'As Others See Us', 91; '"The English Make Me Wild"', 957–8; Forster, 'Notes on the English Character', 34, 37; Saler, *Avant-Garde in Interwar England*, 148; and see Stansky, 'E.M. Forster', on the roots of these verdicts.

129. Quote in Cammaerts, *Discoveries in England*, 124–5. See also *England, by an Overseas Englishman*, 42–50; Cohen-Portheim, *England*, 49, but cf. 184–6; Grand'Combe, *England, This Way!*, 48. Dibelius, *England*, 21, 399–401, credits the aristocracy with lightheartedness.

130. Inge, *England*, 50–2; Bradley, *Racial Origins*, 116–17; Baldwin, *On England*, 5; Barker, *National Character*, 79–80; Nevinson, *Rough Islanders*, 204; Nicolson, 'As Others See Us', 818; idem, *National Character*, 7; Downs, 'As Others See Us', 86.

131. Spurling, 'The Secret of the English Character', 640.
132. Blyton, *We Are Observed*, 10, 12, 15–16; Galsworthy, 'Diagnosis of the Englishman', 942; Holtby, 'The Egotistical English', 669; Seely, *For Ever England*, 21. Dickens came in handy again here: for example, Baldwin, *On England*, 5; Collis, *An Irishman's England*, 204; Wellard, *Understanding the English*, 157.
133. Cammaerts, *Discoveries in England*, ch. 7; Spurling, 'The Secret of the English Character', 643; a hint of this also in Maurois, *Silence of Colonel Bramble*, e.g., 25. Orwell, 'The English People', in *Collected Essays*, vol. 3, 10–11, has them taking their pleasures 'furtively', but this is about puritanism and hypocrisy rather than melancholy.
134. Baldwin, *On England*, 4.
135. Massingham, *People and Things*, 50; Inge, *England*, 52–6, 286–7; Nevinson, *Ourselves*, 41; Priestley, *English Journey*, 388; Macaulay, 'Past and Present', 792–3; Nicolson, 'As Others See Us', 817–18; 'As Others See Us' (1937), 649; Nichols, *News of England*, 316; Chesterton, *Explaining the English*, 4; Blyton, *We Are Observed*, 15–16; Orwell, 'The English People', in *Collected Essays*, vol. 3, 2, 7–9.
136. Santayana, *Soliloquies*, 30–2, 38. See also Čapek, *Letters from England*, 174; Hansen, *The English Smile*, 206.
137. Dr O'Grady speaking of 'John Bull', in Maurois, *Silence of Colonel Bramble*, 54–5; cf. 'Sentiment and Phlegm' [leader], *The Times*, 2 May 1921, 9 – an attempt to reconcile these things.
138. Madariaga, *Englishmen, Frenchmen, Spaniards*, 215; Cohen-Portheim, *England*, 41; Renier, *The English: Are They Human?*, 30, 71–80, 161–72, 197–212; Grand'Combe, *England, This Way!*, 31–2; Downs, 'As Others See Us', 91–2; Keun, *I Discover the English*, 184–205, 210–16; Collis, *An Irishman's England*, 149–52. Cf. Nichols, *News from England*, 162–3, which sees repression as an American import (the 'hard-boiled' pose), and Maurois, *3 Letters on the English*, 17–18, which reverses Renier's equation and has the masses as the most repressed.
139. The exception that proves the rule being provided by Harold Nicolson, who referred explicitly to 'what might be called the feminine qualities of the English': 'When Allies Are Out of Touch: Ideas in France and England', *Times*, 21 June 1939, 12. The context, interestingly, was Nicolson's urging that the English consider their 'French' side (and vice versa).
140. Renier, *The English: Are They Human?*, 81–7, 276–8; idem, *He Came to England*, 118–19.
141. Bryant, 'The Housewife', 902–4 (but cf. Morand, '"The Gentleman's Island"', 1000); von Stutterheim, *Those English!*, ch. 2.
142. See contributions by women to symposia on national character, where they appear to be writing about almost a separate race: 'The National Character: A Working Woman Gives Her Views', 490–1; Strachey, 'The Women of England', 799–800; Hamilton, *The Englishwoman*.
143. Cf. Light, *Forever England*, and Winter, 'British National Identity'; also Rose, *Which People's War?*, esp. 153–8.
144. In addition to infantilization, this assignment of feminine traits to men could have fairly explicit homoerotic overtones, especially in Santayana, *Soliloquies*, 55–8. And see Rose, *Which People's War?*, esp. 153–4, on 'tempered masculinity' during the Second World War.
145. Galsworthy, 'Diagnosis of the Englishman', 842, 843, 845; 'The British Spirit', 189; Murray, 'English Character', 43.
146. Langford, *Englishness Identified*, 36–7.
147. The year 1926 is a pretty clear point of transition. In 1919, Oakesmith, *Race and Nationality*, 10, could still refer back to the pre-modern stereotype of laziness, confident that no one believed it any longer. After 1926, it returned with a vengeance – see the next note.

148. Galsworthy on the General Strike, quoted in Hynes, *War Imagined*, 416–17; 'The British Spirit', 189; Inge, *England*, 47, 85–6; Rice, 'Andre Maurois' English Portraits', 96; 'Defects of the English', *The Times*, 2 October 1929, 11; Cohen-Portheim, *England*, 49; Siegfried, *England's Crisis*, 22, 140–3; Renier and Silex, 'Ourselves as Others See Us', 443; Morand, '"The Gentleman's Island"', 970; Bryant, *National Character*, 11; Belloc, *Essay on the Nature of Contemporary England*, 13–14; Lewis, *Mysterious Mr Bull*, 109–10; 'When Allies are Out of Touch: Ideas in France and England', *The Times*, 21 June 1939, 12, quoting Harold Nicolson.

149. Nevinson, *The English*, 60; Langdon-Davies, 'English Amateurs and American Professionals', 232; 'As Others See Us' (1937), 649–50. By 1938, the iced water was on its way: Wellard, *Understanding the English*, 21–2.

150. See the discussion below, pp. 177 on the reaction to Siegfried's *England's Crisis*, and Baldwin, 'The Industrial Situation in England', in *Our Inheritance*, 103–16.

151. Maurois, *3 Letters on the English*, 39.

152. Wells, quoted in Blyton, *We Are Observed*, 15–16; Maurois, *Discourses of Doctor O'Grady*, 252–3; Fuller, 'English Spirit', 223; Inge, *England*, 278; Hobson, 'In Praise of Muddling Through', 180; 'A Picture of England' [leader], *The Times*, 10 March 1931, 15; Bryant, *National Character*, 10.

153. Nichols, *News of England*, 14.

154. For a few conventional assertions of English materialism, see Dibelius, *England*, 147; Madariaga, *Englishmen, Frenchmen, Spaniards*, 16; Nicolson, *National Character*, 7–8.

155. Tawney, *Acquisitive Society*, 1–3; and see Collini, *English Pasts*, 180, 192.

156. See above, pp. 166–7.

157. Against the 'nation of shopkeepers' were Inge, 'The Future of the English Race', 229; Bradley, *Racial Origins*, 91–2; Nevinson, *The English*, 71; Harmsworth, 'The Essence of the English', 624; Hansen, *The English Smile*, 194; 'As Others See Us' (1937), 649; Blyton, *We Are Observed*, 2; Fyfe, *Illusion of National Character*, 123. For it were Marvin, 'Britain's Place', 172–80; Forster, 'Notes on the English Character', 30; Wingfield-Stratford, *History of British Civilization*, 40. A mixed verdict is returned by Maurois, *Discourses of Doctor O'Grady*, 252–3; *England, by an Overseas Englishman*, 42–4; Kantorowicz, *Spirit of British Policy*, 62–3.

158. Maurois, *Silence of Colonel Bramble*, 32; Mackenzie, *Arrows of Desire*, 95–7; Cammaerts, *Discoveries in England*, 112; Siegfried, *England's Crisis*, 148–54; Silex, *John Bull at Home*, 193, 278–9; Renier, *The English: Are They Human?*, 161–72; Priestley, *English Journey*, 377–8; Wingfield-Stratford, *New Patriotism*, 122.

159. As with energy vs laziness, 'self-reliance' still figures into the early 1920s but, except for a few very traditional reassertions, it hardly appears thereafter: see, for example, Demiashkevich, *The National Mind*, 24; Dixon, *The Englishman*, 58–63. But for Baldwin's use, see Williamson, *Stanley Baldwin*, 184, 254.

160. As one might expect, 'self-respect' was already a prime English value in Emerson, *English Traits*, 87, and it is particularly associated with Americans (and possibly with the idea of 'personality') in the early twentieth century: Hobson, 'Character and Society', 65–6; McDougall, *Group Mind*, 124–5. It then plays a key role in Santayana, *Soliloquies*, e.g., 107 and Inge, *England*, e.g., 63–4, 283–5, after which it appears often: Austin, 'Effects of Modern Industry on National Character', 410; Bryant, 'The National Character', 485; Cammaerts, *Discoveries in England*, 123; Čapek, 'England from the Outside', 800–1; Cohen-Portheim, *England*, 46; Collis, *An Irishman's England*, 136–7; Scarborough, *England Muddles Through*, 82; Seely, *For Ever England*, 21, 60.

161. For 'self-mastery', 'self-control' and 'self-restraint', see Inge, *England*, 57–9, 63–4; Santayana, *Soliloquies*, 75; Madariaga, *Englishmen, Frenchmen, Spaniards*, 82–3; Cammaerts, *Discoveries in England*, 123; von Stutterheim, *Those English!*, 14–19.

162. Crediting (or blaming) the gentleman: Siegfried, *England's Crisis*, 151–2; Dixon, *The Englishman*, 77–86; Belloc, *Essay on the Nature of Contemporary England*, 30–1. Other

views: Hutton, '"Perfidious Albion"!', 431; in different ways both Sir Arnold Wilson and C. Delisle Burns in 'The National Character: Tradition v. Change', *Listener*, 4 April 1934, 582–3; Murray, 'English Character', 40.

163. For example, Galsworthy, 'Diagnosis of the Englishman', 841–2; Santayana, *Soliloquies*, 52–3; Madariaga, *Englishmen, Frenchmen, Spaniards*, 19–20; Cammaerts, *Discoveries in England*, 112; Downs, 'As Others See Us', 90; Baldwin, 'Our National Character', 482; Grand'Combe, *England, This Way!*, 68; Collis, *An Irishman's England*, 101; Marriott, 'England Through Foreign Spectacles', 349–50.

164. Madariaga, *Englishmen, Frenchmen, Spaniards*, 17–18; subsequently quoted by Barry (ed.), *This England*, xiii; Harmsworth, 'The Essence of the English', 624; and many others.

165. Morgan, 'The English Character', 789; the same triad appears in Hutton, '"Perfidious Albion"!', 431.

166. For example, Maurois, *Silence of Colonel Bramble*, 45; idem, *Discourses of Doctor O'Grady*, 256; Inge, *England*, 55; Fuller, 'English Spirit', 223; Siegfried, *England's Crisis*, 142–3; Macdonell, *England, Their England*; Hansen, *The English Smile*, 76–9; 'As Others See Us' (1937), 646–7; Collis, *An Irishman's England*, 166–72.

167. For example, 'The Immutable Briton' [leader], *The Times*, 23 June 1919, 15; Cohen-Portheim, *England*, 219; Dalton, *Practical Socialism*, 4–5; Read (ed.), *English Vision*, x; Orwell, 'The Lion and the Unicorn', in *Collected Essays*, vol. 2, 77–8; Brogan, *English People*, 88–91; Orwell, 'The English People', in *Collected Essays*, vol. 3.

168. For example, 'The British Spirit', 190–1; Kircher, *Powers and Pillars*, 245–7; Cammaerts, *Discoveries in England*, 135; Nevinson, *The English*, 60–3 (mostly cricket, but cf. idem, *Rough Islanders*, 157); Bryant, *The National Character*, 25; Young, *England Conquers the World*, 51; Wellard, *Understanding the English*, 176–8. 'Pont', *British Character*, 117, is an unusual example of rugby as an illustration of the 'love of games', but Pont's audience (in *Punch*) was very socially specific, and cf. 112 (cricket), 115 (golf) and 118 (hunting).

169. For 'good form', see Bradley, *Racial Origins*, 68–9; Collis, *An Irishman's England*, 143–6; Ellis, 'The Psychology of the English'; Forster, 'Notes on the English Character', 30; Hobson, 'In Praise of Muddling Through', 177; Laski, *Danger of Being a Gentleman*, 13–15; Santayana, *Soliloquies*, 36; Wellard, *Understanding the English*, 103–6. For 'fair play', very common as an older stereotype not necessarily connected to the 'gentleman', see, for example, Baldwin, 'Our National Character', 482; 'The British Spirit', 186–7; Čapek, 'England from the Outside', 800–1; Dalton, *Practical Socialism*, 4; *England, by an Overseas Englishman*, 33; Fox, *The English*, 100–1; Fuller, 'English Spirit', 222; Hutton, '"Perfidious Albion"!', 431; Inge, *England*, 55; Keun, *I Discover the English*, 128; Madariaga, *Englishmen, Frenchmen, Spaniards*, 4, 22–3; Murray, 'English Character', 42; Nevinson, *The English*, 29–32; idem, *Ourselves*, 41; Scarborough, *England Muddles Through*, 42–3; Tallents, *Projection of England*, 14–15; Young, *England Conquers the World*, 40. For 'rules of the game' or 'playing the game', see 'The British Spirit', 190–1; Burns, *Morality of Nations*, 18; Cohen-Portheim, *England*, 44–5; Downs, 'As Others See Us', 90; Galsworthy, 'Diagnosis of the Englishman', 840–1; Nevinson, *Ourselves*, 41. This latter shades into older stereotypes about 'ordered freedom' and abiding by the law, and was sometimes seen by foreign observers as a measure not of voluntarism and association but more or less the reverse, blind obedience: see Madariaga, *Englishmen, Frenchmen, Spaniards*, 32–3 but applying it to the French; Maurois, *Silence of Colonel Bramble*, 32; Renier, *He Came to England*, 332–3, citing Mill.

170. Spurling, 'The Secret of the English Character', 640. See also Galsworthy, 'Diagnosis of the Englishman', 842; Rudyard Kipling, 'The Strength of England', *The Times*, 24 April 1920, 15–16; Rice, 'Andre Maurois' English Portraits', 96. The more precise notion that the English finally rallied only when their backs were to the

wall is more specific to the moment of 1940, although Maurois, *3 Letters on the English*, 40, uses the phrase in December 1937.

171. Mackenzie, *Arrows of Desire*, 72–3, 76–8; Santayana, *Soliloquies*, 52–3; Cohen-Portheim, *England*, 129–30.

172. 'The British Spirit', 189; Forster, 'Notes on the English Character', 35; Barker, *National Character*, 79–80; Y.Y., 'The Modest Englishman', 692; Kantorowicz, *Spirit of British Policy*, 299; Scarborough, *England Muddles Through*, passim; Holtby, 'The Egotistical English'; Keun, *I Discover the English*, 176–9; Priestley, *English Journey*, 385–6; Hutton, '"Perfidious Albion"!', 430–1; Nicolson, 'As Others See Us', 818; Lin, 'China Speaks', 66–7; von Stutterheim, *Those English!*, 14; Demiashkevich, *The National Mind*, 129–31; W.R. Inge, letter to *Listener*, 4 February 1938, 183; Wingfield-Stratford, *Foundations of British Patriotism*, 28; Brogan, *English People*, 212; Baldwin, *God's Englishman*, 10–11.

173. Hobson, 'In Praise of Muddling Through'. This line about the flexible, improvisatory virtues of 'muddling through' would come out more strongly in some analyses after Dunkirk: for example, Landau, *Fool's Progress*, 90–5, though see also the more critical views of Priestley et al., discussed below, pp. 189–93.

174. For example, the many works of Jacques Bardoux, or books by Wilhelm Dibelius or Karl Wildhagen; Dibelius's *England*, published in German in 1922, was significantly only translated into English in 1930.

175. With the exception of Grand'Combe, none of these was strictly speaking a 'guide-book', meant for tourists; indeed, with the advent of the Depression at just this moment the tide was turning against tourism.

176. The reference is to Robert Burns's yearning 'to see ourselves as others see us' (from 'To a Louse'), as would have been understood by most contemporary readers.

177. Renier and Silex, 'Ourselves as Others See Us', 442.

178. *Listener*, 13 December 1933, 921.

179. Between December 1933 and March 1934, Morand, '"The Gentleman's Island"'; Haldane, 'Scot at Home and Abroad'; Jones, 'Welsh Character'; Healy, 'Irishman – Mystic and Realist'; Bonn, 'A Visitor Looks'; Frankfurter, 'Trans-Atlantic Misconceptions'; Čapek, 'Tribal Customs'.

180. For example, Downs, 'As Others See Us' (1933); Hutton, '"Perfidious Albion"!' (1934); 'Aspects of England' (1934); Nicolson, 'As Others See Us' (1935); Marriott, 'England Through Foreign Spectacles' (1937).

181. Of which the most substantial were Scarborough, *England Muddles Through* (American, 1932); Renier, *He Came To England* (Dutch, 1933); Keun, *I Discover the English* (French, 1934); Hansen, The *English Smile* (Danish, 1935); Karaka, *Oh! You English* (Indian, 1935); von Stutterheim, *Those English!* (German, 1937); Collis, *An Irishman's England* (Irish, 1937); Young, *England Conquers* (American, 1937); Wellard, *Understanding the English* (British, but for the American market, 1938); Abshagen, *King, Lords and Gentlemen* (German, 1939); Scarfoglio, *England and the Continent* (Italian, 1939).

182. Also a critic of long standing: see discussions of Siegfried's earlier criticisms in Hobson, 'In Praise of Muddling Through', 182–4; Williams, 'Florence and Lewis', 86; Maurois, 'Englishman of To-Day', 2–3.

183. Siegfried, *England's Crisis*, passim. It is hard not to notice the similarity between Siegfried's diagnosis and that of the post-war historian Correlli Barnett, especially in *The Collapse of British Power* (1972), although Barnett nowhere in that volume mentions Siegfried.

184. Siegfried, *England's Crisis*, esp. 148–51, 154, and chs. 7–9 passim. See criticism in 'A Picture of England' [leader], *The Times*, 10 March 1931, 15. But cf. Cammaerts, *Discoveries in England*, 184–5, sharing Siegfried's prescriptions and arguing also that in reality England was becoming more protectionist, agricultural and European.

185. Cammaerts, *Discoveries in England*, 147
186. Renier, *The English: Are They Human?*, esp. 287–8; Renier's contributions to Renier and Silex, 'Ourselves as Others See Us'; Scarborough, *England Muddles Through*, 96–7.
187. Silex leaned to both: *John Bull at Home*, 270–3, 293–6, and his contributions to Renier and Silex, 'Ourselves as Others See Us'. See also Cohen-Portheim, *England*, 218–19, 226; Morand, '"The Gentleman's Island"'; Hansen, *The English Smile*, 165–7, 247–8.
188. See 'Adaptability of the Empire: M. Siegfried's Tribute', *The Times*, 30 November 1932, 14, and especially the Introduction to the revised, 1933 edition of *England's Crisis*, x–xiii. Siegfried still felt that Britain's fundamental economic orientation had to change. See similar views in von Stutterheim, *Those English!*, 203, 206–7, 244–7.
189. Madariaga, *Englishmen, Frenchmen, Spaniards*, 135–6.
190. Downs, 'As Others See Us', 89–90; Madariaga, *Englishmen, Frenchmen, Spaniards*, 218–19; Collis, *An Irishman's England*, 101, 103–5.
191. Hutton, '"Perfidious Albion"!'; 'Through French Eyes: M. Maurois on the English', *The Times*, 28 June 1933, 13.
192. Kantorowicz, *Spirit of British Policy*, 134–5. See also Scarborough, *England Muddles Through*, 87–8; von Stutterheim, *Those English!*, 21.
193. Madariaga, *Englishmen, Frenchmen, Spaniards*, 218–19; Renier, *The English: Are They Human?*, 54–5; Collis, *An Irishman's England*, 102.
194. Banse, *Germany, Prepare for War!*, 248–50.
195. Ibid.,vii–ix (including Steed's letter to *The Times*, 26 October 1933), 250–4 (the passage quoted by Steed at 254, in a slightly different translation). Oddly, the episode does not appear in Strobl, *Germanic Isle*, and indeed somewhat contradicts Strobl's view that this Nazi diagnosis of the English only materialized in the late 1930s (98, 105).
196. Bell, *France and Britain*, 198–203. See also Cornick, 'Case Study of French Anglophobia'.
197. Kantorowicz, *Spirit of British Policy*, 14 (from the Introduction by Gilbert Murray), 20, 26. See also Hansen, *The English Smile*, 209–16.
198. Čapek, 'England from the Outside'. See also Madariaga's views in Catlin, *Anglo-Saxon Tradition*, 3–4, 16–17, 262–3.
199. Kantorowicz, *Spirit of British Policy*, ch. 3; 'As Others See Us' (1937), 649; von Stutterheim, *Those English!*, 1.
200. Collis, *An Irishman's England*, 124. But cf. Cohen-Portheim, *England*, 127–39, offering a more sceptical view.
201. Wellard, *Understanding the English*, 17–26.
202. Kantorowicz, *Spirit of British Policy*, ch. 4; Silex, *John Bull at Home*, 284–6; 'Through French Eyes: M. Maurois on the English', *The Times*, 28 June 1933, 13; von Stutterheim, *Those English!*, 13–14; Keun, *I Discover the English*, 152–60; Hellstrom, 'Concerning the Englishman', 18–21.
203. Kantorowicz, *Spirit of British Policy*, 159; Keun, *I Discover the English*, 176–81.
204. Nash, 'England Expects'. But Nash was no Anglophile, and the gist of his poem was to shore up the traditional prejudices.
205. 'Great Britain in Canada' [leader], *The Times*, 2 August 1927, 11; 'The English Character' [leader], *The Times*, 26 September 1933, 15.
206. Nicolson, 'As Others See Us'. See also Taylor, *Projection of Britain*, 222–4.
207. Bryant (ed.), *Complete Colonel Blimp*, 109–11.
208. Feske, *From Belloc to Churchill*, 188–9.
209. Benson, *Strube*, 35, 77.
210. Orwell, *Collected Essays*, vol. 1, 383, 444, 587, 592. Before the war, Orwell thought that the Left intellectuals' hostility to Blimp was skin-deep, but once war broke out he welcomed exactly the kind of solidarity that beforehand he had suspected.

211. Churchill as early as 1933, quoted in Weight, *Patriots*, 44 (and note author's endorsement of this view at 44–5); Brogan, *English People*, 219–22; Priestley, *Postscripts*, 10, 95; Rowse, *English Spirit*, vi–vii; Sayers, *Mysterious English*, 23–4; Stapleton, *Political Intellectuals*, 119–20; and, showing the persistence of this view, Grainger, *Patriotisms*, 331–3.

212. For anxieties, see Cohen-Portheim, *England*, 132–9; Lewis, *Mysterious Mr Bull*, 107–10; 'Dr Inge on a Softer Race', *The Times*, 7 June 1937, 16; and the critiques of the 'Little Man' described in Benson, *Strube*, 35, 77.

213. Cummings, *This England*, n.p. See also Morton, *I Saw Two Englands*; Rowse, *English Spirit*, vi–vii; Wingfield-Stratford, *New Patriotism*, 44–5; and a hint in Orwell, *Collected Essays*, vol. 1, 518. See further the reflective discussion of such retrospective hindsight in Weight, *Patriots*, 111–17.

214. This was pretty much the view of some writers on the national character – for example, G.J. Renier, who handed out copies of H.G. Wells's anti-national *Outline of History* to ordinary people he met on the road: Renier, *The English: Are They Human?*, 201–2, 273–88. See also Brogan, *English People*, 23–5.

215. For example, Laski, 'Nationalism and the Future of Civilization', in *Danger of Being a Gentleman*, 189–225; Williamson, *English Tradition*, 77–9, identifying Wells and Laski as among the chief culprits. Organized pacifism and its public voices tended to speak in the languages of Christianity and internationalism: Ceadel, *Pacifism in Britain*; Kyba, *Covenants Without the Sword*. But see also Kennedy, *Realities Behind Diplomacy*, 237–56, and Schmidt, 'Domestic Background', on the convergence between popular isolationism and a more explicitly 'English' elite political culture.

216. Crawford, 'History and the Plain Man'; Orwell, *Collected Essays*, vol. 2, 232–40; Wells, *Outline of History*, 601–2; idem, *New Teaching of History*, 8, 35; and see the discussion in Mandler, *History and National Life*, ch. 3. See further Zimmern's criticism of the counter-national effects of such writing in Stapleton, *Political Intellectuals and Public Identities*, 105.

217. Notably in Priestley's *The Good Companions* (novel 1929, film 1932), and especially in the film *Sing As We Go* (1934), for which see the perceptive analysis in Higson, *Waving the Flag*, 166–73, and conclusions at 275–7.

218. See, for example, 'The National Character: A Working Woman Gives Her Views', 490–1, a programme appended to Bryant's long-running series. Its protagonist gave an account of 'character' in everyday life almost wholly detached from 'Englishness'. See also Strachey, 'The Women of England', 799–800, near the end of a 1934 *Spectator* symposium, and Priestley, *Postscripts*, 76–80, towards the end of his first series of broadcasts.

219. I. Husain, *Bookman*, 1 March 1934, 488, responding to Hutton, '"Perfidious Albion"!'; Karaka, *Oh! You English*; Lin, 'China Speaks', 65–71. More positive contributions from 'A Japanese' and 'A Chinese', in 'As Others See Us', *Listener*, 7 April 1937, 646–7.

220. Laski, *Danger of Being a Gentleman*, 219–20, 224, despite a grim diagnosis of the nation, argues in favour of retaining nation states with appropriate safeguards in order to achieve desirable social and economic ends (including the fostering of citizenship as well as welfare).

221. Calder, *Myth of the Blitz*, while sensitive to such things, does not give directly a history of this usage (which he was himself partly responsible for popularizing).

222. Orwell, *Collected Essays*, vol. 2, 84–6, 98; Brogan, *English People*, 226–7; Rowse, *English Spirit*, 21. But cf. Durbin, *What Have We To Defend?*, 41 – a fairer diagnosis of social division and the structural limitations of democracy.

223. Calder, *People's War*.

224. Calder, *Myth of the Blitz*; Stedman Jones, 'Why is the Labour Party in a Mess?' in *Languages of Class*, 239–56; Wright, *On Living in an Old Country*, esp. 83–7. Richards,

Films and British National Identity, 4–26, and Weight, *Patriots*, 23–91, borrow from both interpretations.

225. Baxendale, '"You and I"'; Cook, *Fashioning the Nation*; Fielding et al., *'England Arise!'*; Kushner, *We Europeans?*, 233–5, somewhat at odds with the emphases of the rest of the book; Rose, *Which People's War?*

226. Quote in Nicholas, *Echo of War*, 229. See also Christie, *Arrows of Desire*, 35–6; Haggith, 'Citizenship, Nationhood and Empire'; and, for differences of opinion on the national character and how to tap into it, McLaine, *Ministry of Morale*, 20–2, 30–1.

227. *Listener* quote in Nicholas, *Echo of War*, 229, 233. See also Orwell, *Collected Essays*, vol. 2, 80, 133; Priestley, *Postscripts*, 7–8.

228. Nicholas, *Echo of War*, 233.

229. Ibid., 57–61, 240–8.

230. Priestley, *Postscripts*, 7, 21, 22, 34–5, 52, 71–2, 92–4.

231. Ibid., 22.

232. Ibid., 20, 22.

233. Ibid., 3, 10, 21, 34–5, 52. For a more bellicose version, see [Connor], *English At War*, esp. 9–13.

234. Orwell, *Collected Essays*, vol. 2, 75–9.

235. Ibid., 77, 88, 93, 133.

236. Ibid., 93–6, 98–9, 125–6, and pt. 3 passim.

237. See, for example, Durbin, *What Have We To Defend?*; Martin, 'Notes on the Anglo-Saxon Character', 218; and, for less militant versions, Brogan, *English People* (influenced by Renier); Crockett, *English Spirit*, esp. 58–62, 66–72; and see further Baxendale, '"You and I"', 314–21.

238. Michael Powell to Sir James Grigg, n.d. (draft), in Powell and Pressburger, *Life and Death of Colonel Blimp*, 28.

239. Laurence Olivier to Michael Powell, 28 May 1942, in Powell and Pressburger, *Life and Death of Colonel Blimp*, 21–3.

240. Ibid., 17, 33.

241. Despite Baxendale, '"You and I"', 313–14, even in this school it was not done to lay too much weight on mistrust of expertise or reliance upon 'muddling through': Baldwin, *The Englishman*, esp. 11–12, 20–5, 30–2, 34, but cf. 18–19; Menzies, 'The English Character', 284–9, 291–2, but cf. 290; Sayers, *The Mysterious English*, esp. 23–31; Inge, 'Nationalism and National Character', 140–1; Landau, *Fool's Progress*, passim, but cf. 90–5.

242. Cf. different interpretations in Richards, *Films and British National Identity*, 104–6; Higson, *Waving the Flag*, ch. 5; Samuel, *Theatres of Memory*, 219; Weight, *Patriots*, 323–5. It is also part of the historiographical revision to portray Orwell and Priestley as themselves nostalgic for a peaceful, cosy, submissive kind of Englishness: see Waters, 'J.B. Priestley'; Morgan and Evans, 'The Road to *Nineteen Eighty-Four*'; Baxendale, '"I Had Seen a Lot of Englands"'; Rose, *Which People's War?*, 79.

243. Against this, Marcus Collins asserts that the war saw 'a signal recuperation of the gentlemanly ideal', which there may have been among the gentlemanly class, though his own evidence rather argues against it as a national model: 'Fall of the English Gentleman', 99–100. Even supporters of the ideal agreed that it had taken a beating: Crockett, *English Spirit*, 61–72; Inge, 'Nationalism and National Character', 14.

244. Powell and Pressburger, *Life and Death of Colonel Blimp*, 54–60.

245. Feske, *From Belloc to Churchill*, ch. 5; Mackenzie, *Politics and Military Morale*, 99; Powell and Pressburger, *Life and Death of Colonel Blimp*, 42–53; Ward, *Britishness Since 1870*, 105.

246. Baxendale, '"You and I"', 307–10; Calder, *Myth of the Blitz*, esp. ch. 2; and Weight, *Patriots*, 27–48, give excellent accounts with differing emphases.

247. Rowse, *English Spirit*, 21.

248. Nicholls, 'German "National Character"'. See also Dower, *War Without Mercy*, 78–80, 140, which makes the point that the same distinction was not accorded the Japanese, for racial reasons.

249. Fielding et al., *'England Arise!'*, ch. 2, strongly emphasize the utilitarian elements in popular attitudes. See also Haggith, 'Citizenship, Nationhood and Empire'; McLaine, *Ministry of Morale*, 217, 240, 250–1, on the rise of 'common sense'.

250. Rose, *Which People's War?*, 153–8, 218–24, but cf. Weight, *Patriots*, 76–84.

251. Priestley, *Postscripts*, 3.

252. Mackenzie, *Politics and Military Morale*, chs. 6–7, and cf. Fielding et al., *'England Arise!'*, 27–30, for scepticism about the impact of such programmes.

253. *British Way and Purpose*, 198–9.

254. Weight, *Patriots*, is a partial exception: Weight sees the foundations of 'Britishness' wasting away after 1945, but assumes that alternative conceptions of nationality must have filled the vacuum.

CHAPTER 6: ENGLAND AFTER CHARACTER?

1. Barker's edited volume, *The Character of England*, appeared in 1947; see below, pp. 205–6, for discussion. Bryant and Priestley continued to write on the English national character into the 1970s. For references to the inter-war literature, see, for example, Smellie, *British Way of Life*, 22; [Elliot], 'The English', 438; Huizinga, *Confessions*, 64–5, 80–3; Pear, *English Social Differences*, 271–2; Pevsner, *Englishness of English Art*, 15.

2. Shipman, *Evolution of Racism*, 156–70.

3. Buchanan and Cantril, *How Nations See Each Other*, 50, though cf. 46–7 in which some of the negative consequences of stereotyping are explored.

4. Smellie, *British Way of Life*.

5. The American side of this enterprise is discussed in Herman, *Romance of American Psychology*, 32–43. I am grateful to John Carson for this and related references.

6. For an acute contemporary perception of the forces promoting interest in national character, omitting only the more ethnocentric impulses, see Farber, 'Problem of National Character', 307.

7. Gorer, *Americans*; Gorer and Rickman, *People of Great Russia*; and, for a transitional product, see the series on the national characters of the Americans, English, French, Germans, Japanese and Russians on the BBC Third Programme in autumn 1947, which brought together Gorer, Mead and Mead's mentor Ruth Benedict with other commentators. The idea for the series stemmed not from Mead and Gorer but from the BBC producer Peter Laslett (for which see BBC Written Archives Centre, Reading, RCONT1, Geoffrey Gorer, Talks, File 1, correspondence in 1946–47, and Dr Margaret Mead, Talks, File 1, Laslett to Mead, 10 July 1947). Most of the talks – not Gorer's, which had aroused objections from the contributors outside his circle – appeared in the *Listener*, August–September 1947.

8. La Barre, 'Columbia University Research'; Beeman, 'Margaret Mead', xvi–xxi; Mead to Gorer, 19 December 1950, and Mead, 'Attitude towards boundaries, neutral zones, etc.', 19 December 1950: typescript in University of Sussex Library, Brighton, Special Collections, Gorer MSS, Box 91. Mead also directed a separately funded project on Soviet culture, funded by the RAND Corporation, the American military-industrial think-tank.

9. For British social-scientific writings on the idea of the national character in this period, see Blackburn, *Framework of Human Behaviour*, ch. 6; Spinley, *The Deprived and the*

Privileged, esp. 4–16; and, of course, Gorer, *Exploring English Character*, discussed below pp. 210–13. A full international bibliography can be found in Duijker and Frijda, *National Character*, esp. 99–100.

10. Mead to Gorer, 19 December 1950: University of Sussex Library, Brighton, Special Collections, Gorer MSS, Box 91; Potter, *People of Plenty*, 47–8.

11. Bain, 'Ourselves as Others See Us' (1948); Hutton, 'As Europe Sees Us' (1950).

12. Mikes, *How to be an Alien?*, in *How to be a Brit*, 35, 54.

13. Maillaud, *English Way*, 18, 48–9, 51–3, 55; Orwell, *Collected Essays*, vol. 3, 2, 12–13; Stephan, 'Englishmen and Frenchmen', 511; Nicolson, 'Marginal Comment'; Commager, 'English Traits', 4–5; Bridie and McLaren, *Small Stir*, 71, 142–3, 145–7; Cowles, *No Cause for Alarm*, 11–12, 16–17; Nicolson, 'After the Festival', 733; Smellie, *British Way of Life*. This stereotype was still cherished by immigrants at the end of the 1950s, when few natives were any longer embracing it: see, for example, Chaudhuri, *Passage to England*, 115–17, 123–6, 129–30; many of the contributions to O'Keefe (ed.), *Alienation*, esp. 18–22, 70, 89, 138, 151–4, 172, 179; and, still later, Dean, 'Home Thoughts'.

14. Gorer, 'Notes on the British Character', 373.

15. Maillaud, *English Way*, 55; Stephan, 'Englishmen and Frenchmen', 511; Shahani, *Amazing English*, 24; Treves, *England*, 88; Nicolson, 'Marginal Comment'.

16. Ernest Barker, 'An Attempt at Perspective', in Barker (ed.), *Character of England*, 556; Treves, *England*, 85–6; Commager, 'English Traits', 10; Ervine, 'The English', 563; Gorer, *Exploring English Character*, 286–7.

17. McCarthy, 'Thoughts of an American', 1041.

18. As he was in, for example, Inge, 'An Old Man Looks at the World', 105.

19. Sitwell, *Laughter in the Next Room*, 326–7; for Hooper, see Waugh, *Brideshead Revisited*, esp. 14–15.

20. Betjeman, *First and Last Loves*, 1–2.

21. Waugh, quoted in Green, *Children of the Sun*, 394; and see the discussion of Betjeman in Stapleton, *Political Intellectuals*, 155–60.

22. Blackburn, *Framework of Human Behaviour*, 114; Stephan, 'Englishmen and Frenchmen', 511; Commager, 'English Traits', 10. See also Francis, 'Labour Party: Modernisation', esp. 156–8, on the quiet industry of the Englishman posited in social-democratic discourse.

23. Buchanan and Cantril, *How Nations See Each Other*, 46–7, 50–1.

24. Orwell, *Collected Essays*, vol. 3, 31, 37; Shahani, *Amazing English*, 24–5; Gorer, 'Notes on the British Character', 378–9.

25. Gorer, *Exploring English Character*, 286–7, 290. See also Lessing, *In Pursuit of the English*, 10–12. For an early social-scientific endorsement of this diagnosis, from an American, see Farber, 'English and Americans', esp. (1951) 244–6, (1953) 245–7, reporting on a study of insurance clerks in the two countries.

26. Maillaud, *English Way*, 24, 36.

27. Barker (ed.), *Character of England*, 185, 207–8.

28. Bain, 'Ourselves as Others See Us', 26.

29. The phrase 'middle way' had been applied to Britain by Harold Macmillan in the 1930s, where it referred to a balanced relationship between the individual and society rather than to British society as a whole: Macmillan, *Middle Way*, 24. It was also contemporaneously applied to Sweden by the American journalist Marquis Childs, who did refer to Sweden's middle way between capitalism and socialism, connected to national characteristics that sound very much like those also identified with the English (patience, perseverance, independence, self-respect, stoicism, justice, tradition): Childs, *Sweden*, esp. 163, 177. See also the discussion in Conekin, '*Autobiography of a Nation*', 57–8, on Britain and the middle way between the arts and sciences – a theme that would be taken up later by C.P. Snow, F.R. Leavis and the 'two cultures' debate.

30. Shils and Young, 'Meaning of the Coronation', 75; Maillaud, *English Way*, 23, 36, 40–1, 48–9, 68, 92, 116–19 (quote at 68). See further Richard Law, 'The Individual and the Community', in Barker (ed.), *Character of England*, 29–32; Fleure, *Some Aspects of British Civilization*, 30–1; Nicolson, 'After the Festival', 734; Laslett, 'On Being an Englishman', 491.

31. Treves, *England*, 59–60, 95–100; Shils and Young, 'Meaning of the Coronation', 76–7.

32. See below, p. 214.

33. Quote in Blackburn, *Framework of Human Behaviour*, 112–13. See also Ernest Barker, 'An Attempt at Perspective', in Barker (ed.), *Character of England*, 553–5, 563–8, 573–5; Nicolson, 'Marginal Comment'; Ervine, 'The English', 566.

34. Mead, 'The English', 475.

35. Cowles, *No Cause for Alarm*, esp. ix, 8–17. See also Matthews, *The Britain We Saw*, esp. 23, 29–31, 314; *As Others See Us*, 7–11; Middleton, *The British*, esp. 273, 281–4.

36. Maillaud, *English Way*, 266–7; Laslett, 'On Being an Englishman', 491–2; Hutton, 'As Europe Sees Us'; *As Others See Us*, 31.

37. Colls, *Identity of England*, 371–5; Stapleton, *Political Intellectuals*, 178.

38. Richard Law, 'The Individual and the Community', in Barker (ed.), *Character of England*, 32, 53; Cowles, *No Cause for Alarm*, 17.

39. Orwell, *Collected Essays*, vol. 3, 384–5; Stephan, 'Englishmen and Frenchmen', 511.

40. Bridie and McLaren, *A Small Stir*, 22; Nicolson, 'After the Festival'.

41. Riesman's schema makes Britain seem like a forerunner, the national character having shifted from the John Bull type ('inner-directed') to the 'Little Man' ('outer-directed') fifty years previously, as hinted, for example, by Klein, *Samples from English Cultures*, 544–8. However, Farber, 'English and Americans' (1951), 248, portrays the modern British type as more or less 'inner-directed' (self-reliant and, although tolerant and well behaved, much less interested than Americans in 'getting along with others'), suggesting how slippery these categories are.

42. Gorer, *Exploring English Character*, 290. There are affinities here with Renier's writing in the 1930s, except that Renier saw the problem as an upper-class one that was being alleviated by democratization.

43. [Walter Elliot], 'The English', *Times Literary Supplement*, 7 August 1948, 437; anonymous author identified by *TLS* Contributors' Index in *TLS* Centenary Archive Online (www.tls.psmedia.com).

44. Bridie and McLaren, *A Small Stir*, 13–14. 'James Bridie' was the pseudonym of O.H. Mavor. For further references to this debate, see Ervine, 'The English'; Pear, *English Social Differences*, 270–1, 282–5; also, on attitudes to the English (as distinct from the British), Laslett, 'On Being an Englishman', 490–1, and cf. Weight, *Patriots*, 115–17, 220.

45. Klein, *Feminine Character*, 1, 4–5.

46. Thomson, quoted in Stapleton, *Englishness*, 173–4. Stapleton quotes this and other reviews, 173–6, which work against her contention that Barker achieved success as a public figure during the 1940s; his star seems to me to have been clearly on the wane by then.

47. Buchanan and Cantril, *How Nations See Each Other*, 13–15, 71.

48. Orwell, *Collected Essays*, vol. 2, 75–6.

49. Betjeman, 'Coming Home', a talk on the BBC Home Service, 25 February 1943: in Betjeman, *Letters*, vol. 1, 323.

50. Eliot, *Notes towards the Definition of Culture*, 31, 37, 41.

51. Richards, *Films and British National Identity*, 129–43

52. Charters and Caldicott were played by Basil Radford and Naunton Wayne. The double act continued until Radford's death in 1952, though under other names, since 'Charters and Caldicott' was copyrighted by their originators, the screenwriters Frank

Launder and Sidney Gilliat. For a tribute to their influence, see French, 'Right Kind of Englishman?', 44–5.

53. Higson, *Waving the Flag*, 268–9.
54. MacInnes, 'The *Express* Families', in MacInnes, *England, Half English*, 31–45.
55. Morrison, quoted in Conekin, '*Autobiography of a Nation*', 17.
56. Laurie Lee, quoted in Conekin, '*Autobiography of a Nation*', 94.
57. Ibid., 17.
58. Ibid., ch. 6
59. Ibid., 91–4.
60. BBC Written Archives Centre, Caversham Park, Reading, R19/497, and R51/684, esp. D.F. Boyd to Controller of Talks, 18 September 1950, and [Roger Cary], 'Heritage of Britain', n.d. (*ca.* September 1950), with 'Additional Notes'.
61. Gorer, 'Notes on the British Character', 369, 378–9; Gorer, *Exploring English Character*, 1.
62. Gorer Papers, University of Sussex Library, Brighton, Special Collections, Box 91, Gorer to Mead, 17 February (1937).
63. Gorer Papers, University of Sussex Library, Brighton, Special Collections, Box 69, TS notes for a talk, n.t., n.d. (*ca.* 1950).
64. Geoffrey Gorer, 'Wanted: 1,600 English Men and Women to Help an Expert Find the Secret You', *People*, 31 December 1950; 'The Gorer Report: A Great Scientist Has Found out the Truth about the English', *People*, 5 August 1951. See also the correspondence in Gorer Papers, University of Sussex Library, Brighton, Special Collections, EEC1/F, detailing the rather painful negotiations between Gorer and the *People*, in which Gorer poses, somewhat disingenuously, as a scientist worried about his professional reputation and trying (not very hard) to keep his distance from the populist gutter.
65. Gorer, *Exploring English Character*, 13–17. Note, for example, his claim that there were no precedents for thinking of shyness as an English trait: ibid., 19–20.
66. Ibid., 303. For some later echoes, see Grabowski, 'Why are the English so Lonely?'; Allen, *British Tastes*, 30–1. Paxman, *The English*, 6, completely misunderstands Gorer in saying that he viewed the English national character as having been stable and unchanged for 150 years.
67. See, for example, the criticisms of Gorer's questionnaire by Rhoda Métraux, Mead's associate, in Margaret Mead Papers, Library of Congress, Washington DC, B6, Métraux to Gorer, 15 November 1950. The 10,000 completed questionnaires are safely lodged in the Gorer Papers at Sussex University, and would make a wonderful source for a historical study of Britain in the 1950s. Such a use might also reveal how far Gorer manipulated his data. One notes, for example, that the conclusions about 'shyness' bear very little relation even to the data presented in the text of *Exploring English Character* – see 280, 282 – and the chapter on the punishment of children skates blithely over a number of lacunae – see 169, 176, 197–8.
68. George Tansey, 'The Secret Life of John Bull', *Daily Dispatch*, 30 June 1955.
69. Cyril Connolly, 'The National Character', *Sunday Times*, 10 July 1955.
70. Elizabeth Bowen, 'English Lips Unsealed', *Tatler*, 3 August 1955; [H.F. Carlill], 'National Gallery', *Times Literary Supplement*, 12 August 1955; Eric Gillett, 'Our England', *National & English Review*, August 1955, 105–10; *Listener*, 21 July 1955; J.D. Scott, 'Not Passion's Slave', *Spectator*, 1 July 1955.
71. Bruce Bain, 'So This Is You', *Tribune*, 22 July 1955; 'The English – As We See Ourselves', *Nottingham Guardian-Journal*, 22 July 1955; 'The English Character', *Manchester Guardian*, 30 June 1955; 'English Under Scrutiny', *Glasgow Herald*, 16 August 1955; Lionel Hale, 'Would the Englishman be Better off Baiting Bears?', *News Chronicle*, 2 July 1955; Richard Mayne, 'New Stereotypes for Old', *Time and Tide*, 16 July 1955; George Mikes, 'Tyranny of Facts', *Observer*, 17 July 1955; *The Month*,

November 1955; Gilbert Thomas, 'The English Surveyed', *Birmingham Post*, 19 July 1955.

72. Richard Mayne, 'New Stereotypes for Old', *Time and Tide*, 16 July 1955; 'The Repressed English', *The Economist*, 13 August 1955; J.D. Scott, 'Not Passion's Slave', *Spectator*, 1 July 1955.

73. 'Books Reviewed', *Birmingham Mail*, 13 July 1955; George Mikes, 'Tyranny of Facts', *Observer*, 17 July 1955; V.S. Pritchett, 'John Citizen', *New Statesman*, 23 July 1955; 'The Repressed English', *The Economist*, 13 August 1955; *Sunderland Echo*, 21 July 1955.

74. Margaret Mead Papers, Library of Congress, Washington DC, B6, Mead to Gorer, 28 May 1952; Gorer to Mead, 9 June 1952.

75. Reginald Pound, 'Critic on the Hearth', *Listener*, 21 July 1955.

76. V.S. Pritchett, 'John Citizen', *New Statesman*, 23 July 1955.

77. Cf. Farber, 'English and Americans', with its broader array of criteria, able to probe 'direct good impulses and cognitions' and thus to locate English kindness, generosity, good humour, gentleness, and so on, esp. (1951) 245–6, 248.

78. Pevsner, *Englishness of English Art*, ch. 1. For discussions of the hostile reaction, see Banham, 'Revenge of the Picturesque', 268–71; Buruma, *Voltaire's Coconuts*, 260–2, 279–81. Pevsner suffered from the additional liability of being German (and, though this was less frequently pointed out, Jewish), but the equivalent rejection of Gorer's work shows that the hostility to Pevsner was due to more than simple nativism.

79. Ascherson, 'When was Britain?', inexplicably post-dates this phenomenon to the late 1960s.

80. Weight, *Patriots*, 307–10.

81. Orwell, *Collected Essays*, vol. 4, 322–4; Mead, 'The English', 475.

82. Laslett, 'On Being an Englishman', 491.

83. Webster, *Englishness and Empire*, chs. 2–3.

84. Shils and Young, 'The Meaning of the Coronation', 74. See also the sensitive commentary in Weight, *Patriots*, 113–14, 223–4, 228–9, 233–4, and Harvie, 'Moment of British Nationalism', 329–34.

85. Cf. Waters, '"Dark Strangers"', on 'Othering' in this period; Conekin, *'Autobiography of a Nation'*, 31–3, on ' belonging'; and Ward, 'End of Empire', on 'sameness'.

86. Hewstone, *Understanding Attitudes to the European Community*, xv, 20.

87. Bernstein, *Myth of Decline*, esp. chs. 5–6; Osmond, *Divided Kingdom*, 246–7; Tomlinson, 'Inventing "Decline"'.

88. A partial list would include BBC TV series, 'We The British', April 1956; 'This New England', a symposium in *Encounter*, June 1956; Maschler (ed.), *Declaration*, the classic 'Angry Young Man' outburst of 1957; O'Keefe (ed.), *Alienation*, views of England by immigrant writers (1960); Shanks, *Stagnant Society* (1961); Sampson, *Anatomy of Britain* (1962); 'Spectrum', another symosium in *Encounter*, January 1962; Carstairs, *This Island Now* (1963), the Reith Lectures for 1962; a ten-part series on 'The Pulse of England' in *The Times*, summer 1962; Koestler, *Suicide of a Nation?*, yet another symposium for *Encounter*, originally July 1963. Mayne, 'Any More for the Stereotype?', 7, comments on *Encounter*'s ususual interest in the problem of national identity.

89. As the *OED* comments, Fairlie's use of the term in *Spectator*, 23 September 1955, 380, is 'the *locus classicus* for this modern sense though occasional earlier uses are recorded'.

90. Sampson, *Anatomy of Britain*, 572.

91. Ibid., 638.

92. Crosland's interlocutor, sociologist Donald MacRae, was less explicit about pinning the blame on the ruling class: Crosland and MacRae, 'What is Wrong with Britain?'.

93. Cf. Collins, 'Fall of the English Gentleman', 91, 102–8, which sees the criticism, but assumes too readily that the gentleman then under attack had been the consensual

national icon of the past. Conversely, Ward, *Britishness*, 51, sees the ideal of the gentleman at a new peak in this period.

94. T.R. Fyvel's contribution to the 'This New England' symposium in *Encounter*, June 1956, 'Stones of Harlow', 15. See also Heppenstall, 'Divided We Stand'; Andrew Shonfield, 'The Plaintive Treble', in Koestler (ed.), *Suicide of a Nation?*, 72; and the burgeoning 'cultural Marxist' tradition which hypothesized a gentlemanly cultural hegemony, contested but still dominant, for which see Williams, *Culture and Society*; Anderson, *English Questions*; and a riposte, Thompson, 'Peculiarities of the English', esp. 266, noting the parallels between the Marxist and the journalistic analysis. For a superficially similar analysis, positing the cultural hegemony of a 'Southern' aristocratic 'metaphor' over a 'Northern' industrial one, see Horne, *God is an Englishman*, esp. 21–3, very influential on later critics of 'decline' such as Wiener, *English Culture*, 41–2. But in fact Horne saw the British crisis as primarily a 'crisis of the elites' and, like Renier, was more optimistic about the underlying healthiness of the British democracy: *God is an Englishman*, 7–8, 56–61.

95. Green, *Mirror for Anglo-Saxons*, 15–18, 34, 97–9, 112–15, 149, 167–73. Green's ideal was represented by Orwell, D.H. Lawrence and F.R. Leavis.

96. Huizinga, *Confessions of a European*, 80–90, 283–7.

97. Morris, 'Ancients and Britons', 686–7.

98. *Listener*, 12 July 1962, 69.

99. For example, Cooke, 'Face of England', and see further Mandler, 'How Modern Is It?'.

100. Koestler (ed.), *Suicide of a Nation?*, 13.

101. Sampson, *Anatomy of Britain*, 621–2, 626, 633–5; Wisdom, 'Social Pathology', 265.

102. John Osborne, 'They Call it Cricket', in Maschler (ed.), *Declaration*, 67–8; also appears as Osborne, 'And They Call it Cricket', in *Encounter*, October 1957, 23–30. See also Lindsay Anderson's fantasy of England as 'the nursery' in 'Get Out and Push' in Maschler (ed.), *Declaration*, 156.

103. Collins, 'Fall of the English Gentleman', 105; Green, *All Dressed Up*, 327–8; Weight, *Patriots*, 367–9.

104. For example, Gibbs, *How Now, England?*, 15–18, 23, 32–5, though still with a trace of the 'chirpy Cockney' stereotype at 31–2, to which Gibbs had contributed as a Great War correspondent; and modern elegies such as Raven, *English Gentleman*, 51–2, 70, 75, 95, 178–80, 183; King, '"The Gentleman"'; Raven, 'Merrie England'.

105. For example, Murray Sayle and some of the other contributors to O'Keefe (ed.), *Alienation*, esp. 123–4, 155–7; 'The Truth About Britain?', 453, 455.

106. Michael Shanks, 'The Comforts of Stagnation', in Koestler (ed.), *Suicide of a Nation?*, 63. A cognate view could be taken by Marxists: for example, Perry Anderson's famous dictum, 'a supine bourgeoisie produced a subordinate proletariat', *English Questions*, 35.

107. For some attempts at even-handedness, see Wayland Young's contribution to the 'This New England' symposium in *Encounter*, June 1956, 'Return to Wigan Pier', 11; Angus Wilson's to the 'Spectrum' symposium in *Encounter*, January 1962, 'Fourteen Points', 10–12; MacRae's contribution to Crosland and MacRae, 'What is Wrong with Britain?'; most of the contributors to Koestler (ed.), *Suicide of a Nation?*; Davenport, 'Split Society'; Gordon, 'Goodbye, England'; Wisdom, 'Social Pathology', 223.

108. Pryce-Jones, quoted in Knowler, *Trust an Englishman*, 222–3.

109. John Douglas Pringle, 'Re-winding the Clock', a contribution to the 'Spectrum' symposium in *Encounter*, January 1962, 9–10; similar reflections by Angus Wilson, J.G. Weightman and James Morris in ibid., 10–13, 17–18; Priestley, 'Fifty Years of the English', 566; Koestler, 'The Lion and the Ostrich', and Andrew Shonfield, 'The

Plaintive Treble', in Koestler (ed.), *Suicide of a Nation?*, 7–14, 71–3; Horne, *God is an Englishman*, 260, 268, 273–5.

110. Abrams, Gerard and Timms (eds), *Values and Social Change*, especially essays by Abrams, Halsey, Harding and Phillips.

111. Priestley, *The English*, 12–13, 240–6. This did not stop him from reinstating some of his older, more cherished stereotypes, including, significantly, tributes to the gentlemanly idea of Englishness that he would never have rendered in the 1930s: e.g., 30–3.

112. Holloway, 'Myth of England', 670. See also similar later in Irving, *True Brit*, 13–14; Asa Briggs, 'The English: Custom and Character', in Blake (ed.), *English World*, 248–50, 253–5.

113. BBC Written Archives Centre, Caversham Park, Reading, R51/930/1, Reith Lectures, J.A. Camacho, Head of Talks, to G.M. Carstairs, 15 February 1962.

114. Carstairs, *This Island Now*, 37, 53–4, 66, 83–102. 'The Changing British Character' was the subject of the final lecture. And see also Asa Briggs' commentary on the differences between Gorer, Carstairs and the view from 1980, 'The English: Custom and Character', in Blake (ed.), *English World*, 258.

115. For parallel changes in anthropology, social psychology and history, see [Stocking], 'Essays on Culture and Personality', 9; Spindler (ed.), *Making of Psychological Anthropology*, 7–9; Doob, *Patriotism and Nationalism*, 80–5; McGiffert, 'Selected Writings' (1963) and (1969); Tajfel, 'Formation of National Attitudes', 140, 149–52; Foot, 'Nature of Character'. Cf. the defensiveness of an embattled minority of believers: for example, Wallace, *Culture and Personality*, 123–9, 161; Peabody, *National Characteristics*, vii, 18–19. And for a retrospective critique, see Reicher and Hopkins, *Self and Nation*, 29–31, 34.

116. Duijker and Frijda, *National Character*, esp. 14–27, 31–6, represents the most careful and thorough analysis of the prevalent concepts. Published in 1960, it reflects growing scepticism about the idea of national character but a lingering desire to salvage something from it. The work of Walter Mischel in the 1960s, bringing together personality psychology and cognitive psychology, helped to complicate earlier, simpler ideas of 'personality'.

117. Klein, *Samples from English Cultures*, ix, 121–3, 544–9. Cf. the earlier, more confident generalizations of Spinley, *The Deprived and the Privileged*, based on similar observations in the early 1950s. See also Allen, *British Tastes*, for an attempt to break the British population down into seven regional personalities; this forms part of a broader trend towards segmentation in the marketing of consumer goods, for which see Cohen, *Consumers' Republic*, esp. 298–301.

118. Fiske et al., 'Cultural Matrix of Social Psychology', 919–20; Reicher et al., 'Lost Nation of Psychology', 55–6. See also Reicher and Hopkins, *Self and Nation*, 34, on the shift from psychological studies of national character to cultural studies of 'values'.

119. Riesman, *Lonely Crowd*, l, lxx.

120. Crosland and MacRae, 'What is Wrong with Britain?', 3.

121. Jacobson, 'The Secret of the English'.

122. Weight, *Patriots*, 322–6, vacillates between seeing privacy, domesticity and individualism as non-national fruits of affluence, or even retreats from 'national identity', and seeing these things as part of the 'national identity'; note particularly his revival of the 'nation of gardeners' stereotype for the 1960s, but cf. Pimlott, 'Nation of Gardeners?'.

123. French, 'The Right Kind of Englishman', 53–4. See also Richards, *Films and British National Identity*, 156–8.

124. As noted by Mayne, 'Any More for the Stereotype?', 4.

125. Windsor, 'Our Right Little, Loose Little Island', 34.

126. Frost and Jay, *To England With Love*, 10–18, including the classic formulation of having it both ways, that the English take their pleasures sadly; Johnson, *Offshore Islanders*, 393, 409, 413, where the English are both liberated by the loss of empire and basically unchanged by it; Knowler, *Trust an Englishman*, 7, 11–14, 24–6, where the English are both 'John Bull' and 'Jack Beaver'.

127. 'The Pulse of England', *The Times*, 28 July 1962, 6; MacRae, 'English Nationalism', 54; Cyril Connolly, 'This Gale-Swept Chip', in Koestler (ed.), *Suicide of a Nation?*, 193–4; Wybrow, *Britain Speaks Out*, 79; Bowle, *England*, 239–40; Muggeridge, 'I Love You England'; Radcliffe, 'Dissolving Society', 590–1; Simey, 'This England', 131–3. Some of these commentators thought these traits were new (post-1945, post-imperial), others were less specific. See also Webster, *Imagining Home*, 67, 69–72, 74–5, which otherwise says little about 'national' imagery. Enoch Powell also played into this rediscovery of the 'Little Man' but with much less specificity about his qualities: see Powell, *Freedom and Reality*, 253–7, and below, p. 227.

128. As late as the 1980s, Peabody, *National Characteristics*, 103–5, found a gulf between 'out-group' characterizations of the English as 'high on impulse-control and low on assertiveness' and English self-characterizations as generous, genial and trusting.

129. Henry Fairlie 'On the Comforts of Anger', in Koestler (ed.), *Suicide of a Nation?*, 25–6, disapproved of by Koestler as engendering complacency.

130. Kelvin, 'Here is What Sort of People?', 9. Gallup polls showed a slow but steady decline in belief in national 'greatness', at least as defined by world role, throughout the 1960s and 1970s: Rose, 'Proud to be British', 381.

131. 'The Pulse of England', *Times*, 28 July 1962, 6; Priestley, 'The Truth about the English'; Jenkins, *The British*, 4; Knowler, *Trust an Englishman*, 217–19.

132. Grigg, 'Mere English'; Roseman, 'As Others See Us'.

133. Marcus Cunliffe, 'The Comforts of the Sick-Bay', in Koestler (ed.), *Suicide of a Nation?*, 201.

134. Ibid., 200–3; Green, *Mirror for Anglo-Saxons*, 112–20; Mayne, 'Any More for the Stereotype?', 8; Grigson, 'On Being English'; Windsor, 'Our Right Little, Loose Little Island', 35; MacRae, 'Our Island Sleep'; Macrae, 'The People We Have Become', 7; Keats, 'Britain: A Sorry State'; and, retrospectively tracing the tendency to the 1960s, Appleyard, 'This is a Ghastly Place'.

135. See the discussion in Young, *This Blessed Plot*, esp. 162–3, 171.

136. On sport in particular, see Weight, *Patriots*, 457–62.

137. 'The Pulse of England', *The Times*, 28 July 1962, 6. For attempts to gauge the success of new national projects, see, for example, Kelvin, 'Here is What Sort of People?', 9; Kelvin, 'What Sort of People Now?', 488–9.

138. See the survey of attitudinal changes between 1959 and 1988 in *British Social Attitudes: Special International Report*, 122–33.

139. Examples from the 'satire boom' of the early 1960s are legion: see Carpenter, *That Was Satire*, e.g. 100, for the 'Beyond the Fringe' spoof on the National Anthem, but cf. Carpenter's point that the targets of the satire boom were just as often 'the old guard pathetically trying to modernize itself', 311; Webster, *Englishness and Empire*, 144–9, for Major Dennis Bloodnok of the Third Disgusting Fusiliers from the 'Goon Show' (from the 1950s) and other parodic evocations of imperial heroism; and, in an older idiom, Flanders and Swann's 'Song of Patriotic Prejudice' (1964), with its immortal refrain, 'The English, the English, the English are best/I wouldn't give tuppence for all of the rest'.

140. Tajfel, 'Nation and the Individual'; Doob, *Patriotism and Nationalism*, 24, 84–5; Tajfel, 'Formation of National Attitudes', 140–1, 153. Schlesinger, 'On National Identity', gives an interesting retrospective account. Although 'national identity' appears in print sporadically from the early nineteenth century (see above, p. 42), in loose analogy with individual 'identity', it only begins to come into use as a concept in its

own right around the early 1960s: for example, in Pringle, 'Re-winding the Clock', 9–10, from January 1962. Cf. Dennis, *Cards of Identity*, 100, a lone appearance in a 1955 novel obsessed with identity and in some respects with the nation, but not centrally with 'national identity'.

141. Radcliffe, 'Dissolving Society', 592; Hartley, *State of England*, 15, 18, 21–2; Simey, 'This England'; MacRae, 'Our Island Aleep'; O'Donovan, 'Who Do We Think We Are?'; Horne, *God is an Englishman*, 15. On the complicated feelings of intellectuals in this period, see also Collini, *English Pasts*, 17–18, 27–8, 36; Stapleton, *Political Intellectuals*, 166–8; Weight, *Patriots*, esp. 309–18, 348–54.

142. 'The Break-up of Britain' was the title of the Marxist critic Tom Nairn's book of 1977.

143. Priestley, 'Truth About the English'; Johnson, *Offshore Islanders*, 423–6; Macrae, 'The People We Have Become', 7; Salfeld, 'British Grizzle'.

144. See the excellent discussion in Weight, *Patriots*, 478–98, 510–12.

145. O'Donovan, 'Who Do We Think We Are?'; Johnson, 'Odd Man In', 727; Welch, 'Our Last Days as an Island'.

146. In an unfootnoted passage, Weight, *Patriots*, 555, says that polls 'consistently showed that around 75 per cent of Scots now thought themselves to be Scottish *rather than British*', but this exaggerates. As late as 1999, only 67 per cent of the Scots felt they were more Scottish than British, while only 32 per cent of the English and 36 per cent of the Welsh felt similarly about their own nationality: *British Social Attitudes* (2000), 157–8.

147. For a striking exception, by an educator, see Rae, 'Our Obsolete Attitudes'.

148. Priestley, *The English*, esp. 240–8; Rowse, 'When the English were Individuals'; Bryant, 'Heart of a Nation'. And see the writings of Honor Tracy in the *Daily Telegraph* in the 1970s and 1980s, decrying the break-up of the national character: for example, Tracy, 'An Englishman!'; idem, 'What *They* Think of Us'.

149. Powell, *Freedom and Reality*, 5–6, 186, 253–7; Heffer, *Like the Roman*, 334–6. Maude and Powell, *Biography of a Nation*, was essentially a historical account, much like J.R. Green's, but if anything making less reference to national character except in vague connection to institutional development, in both its 1955 and 1970 versions. See also Nairn, *Break-Up of Britain*, ch. 6, for a very good contemporary account of Powell's thought. We still know relatively little about Powell's grass-roots appeal. Cf. also Ward, 'End of Empire', for an earlier attempt by moderate Tories such as Harold Macmillan to 'repatriate' Englishness after the break-up of 'Greater Britain'.

150. Salfeld, 'British Grizzle'; Peyton, 'Time to Halt the Decline'. Nossiter, *Britain*, esp. 11, 17–38, gives a good contemporary account of Tory rhetoric along these lines.

151. Foot, 'Nature of Character'.

152. Briggs, 'The English: Custom and Character', in Blake (ed.), *English World*, 252–8; also Zeldin, 'Ourselves, As We See Us'; and Cohen (ed.), *Symbolising Boundaries*, celebrating the breakdown of 'big' into 'little' (that is, local community) identities.

153. Adamson, 'Nostalgia and a Lost Heritage'; Fairlie, 'Transatlantic Letter'; Barker, 'England's Mood'. This applied less to the Scottish Left, for whom Scottish nationalism could (just) be portrayed as a struggle of economic and political underdogs: see especially Nairn, *Break-Up of Britain*, ch. 3, in praise of Scottish 'neo-nationalism'.

154. Byatt, 'Who Are the English?'.

155. See, for example, Inglis, 'Patriotism and the Left'; Watt, 'What has Become of Our National Pride?'; Carter, 'So There'll Always Be an England' – like Byatt, with interesting notes of ambivalence.

156. Weight, *Patriots*, 322–57, makes the most sustained case.

157. Hewstone, *Understanding Attitudes to the European Community*, 21–5, 29–30, 33, 129, 146, 160–1, 191–5.

158. See material in reports of the European Values studies: Abrams, 'This Britain'; Abrams, Gerard and Timms (eds), *Values and Social Change*, 37, 148–51, 160–1, 174–5; Harding and Phillips, *Contrasting Values*, 94–5, 183–5. See also Rose, 'Proud to be British'; *British Social Attitudes* (1987), 63, 66. Surveys in the 1990s found again that the British had low levels of attachment to Europe but also low levels of attachment to their own country and average-to-high levels of abstract pride in nation: Ashford and Timms, *What Europe Thinks*, 16, 90–3; *British Social Attitudes* (1998), 4, 9, 15–16. For some press comment on the European Values Systems survey, see Berthoud, 'More Work, Please'; Gorton, 'Belief in Britain'; Halsey, 'Self-Conscious Traveller'.

159. Kumar, 'A Future in the Past?'; Nossiter, *Britain: A Future that Works*, esp. 197, 200–1; Allison, 'English Cultural Movement'; idem, *Condition of England*, esp. 8–41, 45–7; Wiener, *English Culture*, 160. But these voices, mostly from 1977–80, were conscious that they were in a small minority among intellectuals in denying a sense of national crisis.

160. On the impact of globalization, see Shenfield, 'Before Britain Went Pop'; Kearney, *British Isles*, 8–9; Landale, 'True Brits'; Seabrook, 'Tabula Rasa'; James, *Britain on the Couch*, x–xi, 26, 29; Wood, *In Search of England*, 91, 105; Driscoll, 'Goodbye, Stiff Upper Lip'; Norman, 'Why John Bull'; Hitchens, *Abolition of Britain*, xxv–xxxv. Cf. Billig, *Banal Nationalism*, 129–39, doubting the impact of globalization and pointing out, 143, the persistence of national identity in the highly 'globalized' United States. On the impact of immigration, Colls, *Identity of England*, 159–74; Stapleton, *Political Intellectuals*, 189–94; Warner, 'Home: Our Famous Island Race'; Wright and Gamble, 'End of Britain?'. Trevor Phillips has argued that globalization but not immigration is responsible for English national identity problems: Phillips and Worsthorne, 'England's on the Anvil', 17.

161. Aslet, *Anyone for England?*, 4, 20–5; Hitchens, *Abolition of Britain*, esp. 366–9; Landale, 'True Brits'.

162. In addition to Weight, *Patriots*, the most systematic argument of this kind, see journalistic versions in Dalrymple, 'Nasty, British and Short'; Ascherson, 'Chords of Identity'; idem, 'We Have Always Been a Grey Land'; Judt, 'Whose Common Culture?'.

163. Nairn, *Break-Up of Britain*, had a version of this argument before Colley, but his 1970s Marxist version emphasized the power of the British state rather than 'national identity'. Some shift from the former to the latter is already evident in 1988 in Osmond, *Divided Kingdom*, 21–6, 31–8, very much influenced by Nairn. By 2000, Nairn, *After Britain*, 23, 79, 88, 177, 242–7, betrays some confusion of his own about this shift.

164. Porter, 'England, Our England'. See also Appleyard, 'Yes, I Am an Englishman'; Warner, 'Home: Our Famous Island Race' (an edited version of the last of Marina Warner's 1993 Reith Lectures); Haseler, *English Tribe*, passim; Ascherson, 'Search for British Self-Knowledge'; Wood, *In Search of England*, 91; Leonard, *BritainTM*, 24–6, 28–9; Moore, 'Real Britannia'. For more academic uses of the same set of ideas, see, for example, Rich, 'Imperial Decline', 46–7; Marquand, 'How United is the Modern United Kingdom?', 286–8; Miller, *On Nationality*, 165–72, 177; Davies, *The Isles*, 1031–3, 1040–52; Colls, *Identity of England*, 5–6, 143, 338–9; Kumar, *Making of English National Identity*, 35–8.

165. For example, 'There is no native tradition of reflection on English national identity': Kumar, *Making of English National Identity*, x, 250, though cf. 9–17, 62, on the literature of national character – a very partial account of a literature that apparently does not count as 'reflection' (the more reflective – Mill, Buckle, Barker – hardly make an appearance). See similar in Ascherson, 'Chords of Identity': 'The English

have never bothered to define their national identity'; and Wood, *In Search of England*, 91.

166. Aslet, *Anyone for England?*, 5–6; Paxman, *The English*, ix, 1; Wallace, 'A Comfortable Illusion'.

167. Hennessy, 'What's Still Wrong with the Family'. Cf. Aslet's succession of statements, *Anyone for England*, 3–6; or Paxman, *The English*, ix, 1, 10, 13–15, where, despite knowing exactly 'who they were', they have only an 'elusive', oblique identity', muddled by imperial responsibilities and by a 'natural gloominess' that discourages introspection. Or, for a masterpiece of double-talk, see Nairn, *After Britain*, 314, n. 6: 'The unresolved dilemma of Englishness seems thus to be a contrast between [its] unique depth of field . . . and the final lack of focus inseparable from the extruded developmental mode of later British imperialism.' Some of this talk echoes the inter-war literature that wanted to make the English patriotic but not nationalistic, solidaristic but not self-conscious, as above, pp. 173–5, 178.

168. For a rare and commendable exception, see Buruma, *Voltaire's Coconuts*, esp. 17–18; also Cohen, 'Incredible Vagueness'; Clark, 'Not Fading Away Yet'. Ward, *Britishness*, 6–9, 172–3, takes an equable position that Britishness is in mild but not fatal decline, still 'in formation', and if no longer 'primary' at least 'important'. Fox, *Watching the English*, is not very interested in the political implications, but asserts the continuing salience of English 'national identity or character' simply as a set of distinctive behaviours.

169. Paxman, *The English*, 23.

170. Colls, *Identity of England*, 174, 378 and cf. 193. For similar sentiments, see Wallace, 'Foreign Policy and National Identity', 78.

171. For example, Appleyard, 'Yes, I Am an Englishman'; Fox, *Watching the English*, 21. For a recent academic use of this idea (often relying on the very simple ideas of Frederik Barth), see Kumar, *Making of English National Identity*, 62–3. Parekh, 'Defining British National Identity', 5–7, criticizes this view but sees national identity as just as inevitable, arising from internal as well as differentiating impulses.

172. Anderson, *Imagined Communities*, 7. See also Nairn, *After Britain*, 79–80, 246–7; Stapleton, *Political Intellectuals*, 196–7. Rée, 'Internationality', esp. 4, sees this as a non-natural process fostered by states and elites.

173. Paxman, *The English*, 23. See also Burgess, 'On Being British'; Colls, *Identity of England*, 193; Leonard, *Britain*TM, 37–8.

174. Colls, *Identity of England*, 381; Kumar, *Making of English National Identity*, 272–3; Leonard, *Britain*TM, 37–8; Miller, *On Nationality*, 25–6, 41, 175; Viroli, *For Love of Country*; Stapleton, *Political Intellectuals*, 196–7.

175. Billig, *Banal Nationalism*, 93–6, comments on this interestingly, but tends to see it as fixed and unchanging, thus also perhaps over-estimating the ubiquity of 'national identity'. See also Condor, '"Unimagined Community?"', 42; Wallace, 'A Comfortable Illusion'.

176. For a study of Thatcherite rhetoric at the time of the Falklands War, see Arblaster, *Iron Britannia*. For a partial study of public opinion, see Noakes, *War and the British*, ch. 5. For both, see Weight, *Patriots*, 612–27.

177. Powell, 'This New Unity'.

178. Critchley, 'Patriotism Waiting'. See also Booker, 'How Low Have We Sunk?'

179. For confessions of this sort, see Samuel, 'Patriotic Fantasy'; Akomfrah, 'Divide and Rule'; Hill, 'We Can Hear the War Drums'; Dawson, *Soldier Heroes*, 2–4. The inspiration of the Falklands lies behind much of the later work of Raphael Samuel, including the History Workshop project on patriotism that he edited, *Patriotism: The Making and Unmaking of British National Identity* (1989), and his two collections *Theatres of Memory* (1994) and *Island Stories* (1998). The same feelings animate an inspired film

of the period, *The Ploughman's Lunch* (1983), directed by Richard Eyre and scripted by Ian McEwan.

180. Most inflammatory were an interview with Nicholas Ridley in the *Spectator*, July 1990 – Lawson, 'Saying the Unsayable' – and leaked accounts of a seminar at Chequers about Anglo-German relations. On these and related concerns, see Mount, 'Hypernats and Country-Lovers'; Johnson, 'Why the Giant of Europe'; Powell, 'What the PM Learnt'; Garton Ash, 'What We Really Said'; Evans, 'Myth of the German Psyche'; Barber and Steen, 'What the Germans Think'; Robbins, *Present and Past*, 13–16.

181. For the growing association between hooliganism and nationalism, see Shenfield, 'Before Britain Went Pop'; Miller, 'English Death'; Buruma, 'His Finest Hour'; Landale, 'True Brits'; 'England, Whose England?' (1995); Condor, '"Unimagined Community?"'; Kumar, *Making of English National Identity*, 262–9.

182. Thatcher, quoted in *Woman's Own*, 23 September 1987: the relevant excerpts can be found on the Margaret Thatcher Foundation website, www.margaretthatcher.org/speeches/.

183. For comment to this effect, see Watt, 'What has Become of Our National Pride?'; Reid, *Dear Country*, 195–8, 204–5; Seabrook, 'Tabula Rasa'; Ascherson, 'We Have Always Been a Grey Land'; Marquand, 'How United is the Modern United Kingdom?', 290–1; Aslet, *Anyone for England?*, 26–8 and ch. 7; Hitchens, *Abolition of Britain*, 348–50; Weight, *Patriots*, 569–74.

184. Wiener, *English Culture*, 43.

185. Most of the concern about 'heritage' and the museumization of Britain before the early 1980s in fact came from the Right or thereabouts. For early examples, see Keats, 'Britain: A Sorry State'; Adamson, 'Nostalgia and a Lost Heritage'; Fairlie, 'Transatlantic Letter', 6–8; West, 'The English'; Barker, 'England's Mood'.

186. Wiener, *English Culture*, 162–4; Allison and Wiener, 'Is Britain's Decline a Myth?'.

187. Hewison, *Heritage Industry*, 47.

188. Ibid., 142. See also Leonard, *Britain^TM*, 71; Weight, *Patriots*, 630–1.

189. Wright, *On Living in an Old Country*, 70–1, 186; Hewison, *Heritage Industry*, subtitled 'Britain in a Climate of Decline'. See also Daniels, *Fields of Vision*, 224–36; Gervais, *Literary Englands*, 270–2. For later retractions from this position, see Samuel, *Theatres of Memory*, esp. 290–2; Dodd, *Battle over Britain*, 14, 26–33.

190. Speech to the Conservative Group for Europe, Mansion House, City of London, 22 April 1993; text cited slightly differently in different places, this version from Jay (ed.), *Oxford Dictionary of Political Quotations*, 248.

191. Appleyard, 'This is a Ghastly Place'; Porter, 'England, Our England'; Warner, 'Home: Our Famous Island Race'; Wood, *In Search of England*, 104; Urban, 'Which is the True Face of England?', on the intellectual reaction. But for some right-wing votes of approval, Aslet, *Anyone for England?*, 25–6; Worsthorne in Phillips and Worsthorne, 'England's on the Anvil', 17. Colls, *Identity of England*, 227–8, and Paxman, *The English*, 142–4, use this speech to demonstrate the potency of English images, although both also cite public reactions that show just as well how weak such images were. This speech was not Major's only such pronouncement: see, for example, the 1995 interview with a Madrid newspaper cited by Vansittart, *In Memory of England*, 151.

192. Leonard, *Britain^TM*, 48–62.

193. Leadbeater, 'Thoroughly Modern Britain'.

194. In this connection, note the reinterpretation of 'heritage' over the course of the 1990s as an expression of popular creativity and leisure rather than 'cultural conservatism' and elite domination: see, most substantially, Condor, '"Having History"'; Merriman, *Beyond the Glass Case*; and Samuel, *Theatres of Memory*.

195. For example, Brown, 'Outward Bound', the fourth annual Spectator/Allied Dunbar Lecture, *Spectator*, 8 November 1997.

196. Beckett, 'Myth of the Cool'.

197. Leonard, *BritainTM*, 13.

198. See Samuel, 'Patriotic Fantasy', 22, for a very early and prescient speculation about this phenomenon; also Dodd, *Battle over Britain*, 23–5.

199. It helped that *BritainTM* was launched days after Diana's death, so that discussion of 're-branding Britain' and the public reaction to the death tended to blur together: see Leonard, 'Britain Needs a New Brand Image'; Freedland, 'More Open and Tolerant'; Driscoll, 'Goodbye, Stiff Upper Lip'; Castle, 'Strong? Modern? Fair?'; Gerrard, 'We Are All Dianas Now'.

200. Thomas, *Diana's Mourning*, 8, 10–11, 13.

201. Driscoll, 'Goodbye, Stiff Upper Lip'.

202. Gerrard, 'We Are All Dianas Now'.

203. Orbach, quoted in Gerrard, 'We Are All Dianas Now'.

204. Johnson, quoted in Thomas, *Diana's Mourning*, 110–11.

205. Thomas, *Diana's Mourning*, 19, 22–3, 31, 89, 92, 100–2, 110–15. See also Hitchens, *Abolition of Britain*, xx, xxiv; Paxman, *The English*, 7–8.

206. Buruma, 'England, Whose England?'; Hill, 'The English Identity Crisis'.

207. Condor, '"Having History"', esp. 230–42; Mandler, *History and National Life*, ch. 5.

208. Bayley, 'Don't Phone the Identity Man Yet'; Castle, 'Strong? Modern? Fair?'; 'Compellingly Dull', *The Economist*, 27 November 1999, 36; Moore, 'Real Britannia'; Parekh, 'Defining British National Identity', 12–13; Schama, *History of Britain*, 555. The author of the report recognized this difficulty: Leonard, 'Britain Needs a New Brand Image'.

209. For typical assertions, see Paxman, *The English*, 20–1; Urban, 'Which is the True Face of England', summarizing a BBC2 *Leviathan* investigation; Weight, *Patriots*, 706–13, 721–6, but cf. 731 ('they are not sure what they want').

210. See reports of the 'Moreno scale' results in *British Social Attitudes* (2000), 157–60, 172, (2001), 236–7, 241. The 'Moreno scale' results from the Scottish Social Attitudes 2001 survey reported in Jeffery (comp.), 'Devolution', 15, yield slightly different figures without marking a further shift towards an exclusively 'English' identity; the principal change is a shift towards the middle of the scale, 'equally English and British'.

211. Weight, *Patriots*, 707–13. For a sample of thoughtful journalistic observations, Appleyard, 'Yes, I Am an Englishman' (1996); Bragg, 'I *Am* Looking for a New England' (1996); Moore, 'Real Britannia' (1998); Cox, 'At Last, the Silent People Speak' (2002); Clark, 'Not Fading Away Yet' (2002); Anthony, 'I'm English' (2004).

212. Ascherson, 'When was Britain?', 27; Condor, '"Unimagined Community?"', 52–5; 'England, Whose England?'; Heffer, *Nor Shall My Sword*, 35–6, 132–3; Kumar, *Making of English National Identity*, 262–9.

213. Condor, '"Unimagined Community?"', 59–61; Weight, 'Raise St George's Standard High'.

214. For example, Scruton, *England: An Elegy*; Vansittart, *In Memory of England*; Hitchens, *Abolition of Britain*; Aslet, *Anyone for England?*; Heffer, *Nor Shall My Sword*, only slightly less gloomy; and, for a left-wing version, Hoggart, *Townscape with Figures*, esp. 175–9, 200–1. Fox, *Watching the English*, is a notable exception in its strong assertions of the reality of an English national character.

215. Colls, *Identity of England*, 4–6, 377–81.

216. Paxman, *The English*, x. Miller, 'The English Death', goes further back and resurrects the 'Elizabethan' Englishman from before the Industrial Revolution.

217. Condor, '"Unimagined Community?"', 49–53. A decade earlier, Peabody, *National Characteristics*, 103–8, was already finding English respondents bucking against even the most apparently consensual national stereotypes.

218. Condor's research on 'trait terms', cited by Reicher and Hopkins, *Self and Nation*, 45–6, and see also Condor, 'Temporality and Collectivity'. When asked about the English national character specifically, still only 13.4 per cent of respondents cited trait terms.

219. Condor, 'Temporality and Collectivity'. See also Hopkins and Murdoch, 'Role of the "Other"', on the difficulty of fixing stereotypes based on contrasts to foreigners in conditions of globalization.

220. Fox, *Watching the English*, 192, 265, 400. This book, peppered with repeated assertions of national homogeneity (or, failing evidence of this, analogous 'patterns' linking highly disparate class behaviours), affects to use the language of contemporary social science but in practice takes up the thread of earlier national character studies such as those of Renier and Gorer.

221. Bryson, *Notes from a Small Island*, which is conspicuously lacking in observations on national character, though see 249 and lists at 281–2. The same applies to Bainbridge, *English Journey*; Raban, *Coasting*; but not to Theroux, *Kingdom By the Sea*, e.g. 2–3, 25, 131, 179, 211, 249, 259, 302, giving a slightly jaundiced version of the 'Little Man' – private, well behaved, kind, modest, domestic, but soured by bigness and (post-industrial) failed ambition.

222. Bryson, *Notes from a Small Island*, 281–2; Moore, 'Real Britannia'; Barnes, *England, England*; Davies, *The Isles*, 1055–6; Bernstein, *Myth of Decline*, 520.

223. Bracewell, 'Cultural Britannia'; also Appleyard, 'Creating the New Face of Britain'.

224. For a taste of the academic debate over whether 'shared values' can serve as a basis for 'national identity', see Henderson and McEwen, 'Do Shared Values Underpin National Identity?'

225. Elis-Thomas, 'Don't Lie Back'; Craig, 'Us and Them'; Deer, 'Disunited We Stand'; Dodd, 'A Mongrel Nation'; Bragg, 'I *Am* Looking for a New England'; Colls, *Identity of England*, 380–1; Kumar, *Making of English National Identity*, 272–3.

226. Townshend, 'On the National Health'; Crick, 'The English and the British', esp. 97–8; Wallace, 'A Comfortable Illusion'; Dodd, *Battle over Britain*, 34–44; Miller, *On Nationality*, 172, 175, 178–82; Ascherson, 'Search for British Self-Knowledge'; Partridge, 'Rebirth of a Nation?'; Wright and Gamble, 'The End of Britain?'; Buruma, *Voltaire's Coconuts*, 294; Rifkind, 'British Champion'; Parekh, 'Defining British National Identity', 8, 13. And note the new 'British' or 'four nations' history, just as popular if not more so than the inquests into English identity: Kearney, *British Isles*; Davies, *The Isles*; Schama, *History of Britain*.

227. Alibhai-Brown in Leslie and Alibhai-Brown, 'Proud to be British'; Alibhai-Brown, 'Bring England in From the Cold' (despite the title, about 'a multi-ethnic British identity'); Parekh, 'Defining British National Identity', 13. See also fears about an atavistic English nationalism in Ascherson, 'Search for British Self-Knowledge'; idem, 'When was Britain?'.

228. *British Social Attitudes* (2000), 167–9; *British Social Attitudes* (2001), 241.

229. Condor, '"Unimagined Community?"', 49–55. Further research showing the context sensitivity of 'national identity' talk in England is reported by Hopkins and Murdoch, 'Role of the "Other"'.

230. A conclusion that seems to be hinted at in Crick, 'The English and the British', 104.

231. *British Social Attitudes* (1998), 4–9, 15–16; already evident in *British Social Attitudes: Special International Report*, 125–6, 132–3.

232. The Synergy Brand Values Ltd survey, 'Insight 96', reported in Leonard, *Britain^{TM}*, 23–4.

233. Condor, '"Unimagined Community?"', 45–7.

234. But see Akomfrah, 'Divide and Rule', on the Channel 4 series 'The Divided Kingdom' (1988); Buruma, 'England, Whose England?'; Rée, 'Internationality', 11.

235. Condor, "'Unimagined Community?'", 58–9. Another alternative, voiced more in hope than in conviction, is that 'Europe' might be the home of such values: Ignatieff, 'Europe, My Europe'; Cohen, *Frontiers of Identity*, 215; Haseler, *English Tribe*; Ascherson, 'When was Britain?'.
236. As acknowledged even by Billig, *Banal Nationalism*, 89–92, 129–38; Condor, "'Having History'", 243–4, 248–50 (and see 251–2, pointing out that social scientists' own '(left-wing) progress narratives' have been used to stereotype the English as lagging behind in this respect).

Bibliography

This bibliography lists all printed works cited by short titles in the notes to the text. It omits some journalism (especially where anonymous) and archival sources, which are fully cited in the notes.

Abrams, Mark, 'This Britain: A Contented Nation', *New Society*, 21 February 1974, 439–40

Abrams, Mark, David Gerard and Noel Timms (eds), *Values and Social Change in Britain* (Basingstoke, 1985)

Abshagen, Karl Heinz, *King, Lords and Gentlemen: Influence and Power of the English Upper Classes* (London, 1939)

Acton, Lord, *Historical Essays and Studies*, ed. J.N. Figgis and R.V. Laurence (London, 1907)

—— 'Nationality' (1862), in *The History of Freedom and Other Essays* (London, 1907), 270–300

[Adams, W.B.], 'Human Progress', *Westminster Review* 52 (1849–50), 1–39

Adamson, David, 'Nostalgia and a Lost Heritage', *Daily Telegraph*, 27 December 1974, 8

Akomfrah, John, 'Divide and Rule', *New Statesman*, 21 November 1988, 37–8

Alibhai-Brown, Yasmin, 'Bring England in from the Cold', *New Statesman*, 11 July 1999, 24–6

Allen, D. Elliston, *British Tastes: An Enquiry into the Likes and Dislikes of the Regional Consumer* (London, 1968)

Allen, Grant, 'Are We Englishmen?' (1880), in *Images of Race*, ed. Michael D. Biddiss (Leicester, 1979), 237–56

Allison, Lincoln, 'The English Cultural Movement', *New Society*, 16 February 1978, 358–60

—— *The Condition of England: Essays and Impressions* (London, 1981)

Allison, Lincoln, and Martin Wiener, 'Is Britain's Decline a Myth?', *New Society*, 17 November 1983, 274–5

Anderson, Benedict, *Imagined Communities: Reflections on the Origin and Spread of Nationalism*, rev. ed. (London, 1991)

Anderson, Perry, *English Questions* (London, 1992)

Anderson, Stuart, *Race and Rapprochement: Anglo-Saxonism and Anglo-American Relations, 1895–1904* (London and Toronto, 1981)

Angell, Norman, *The Great Illusion* (London, 1910)

Anthony, Andrew, 'I'm English – but What does that Mean?', *Guardian*, 30 June 2004, supp., 5

Appleyard, Brian, 'This is a Ghastly Place', *Independent*, 21 July 1993, 23

—— 'Yes, I Am an Englishman', *Independent*, 27 June 1996, 17

—— 'Creating the New Face of Britain', *Sunday Times*, 13 June 1999

Arblaster, Anthony, *Iron Britannia* (London, 1982)

Arnold, Matthew, *On the Study of Celtic Literature* (London, 1867)

—— *On Home Rule for Ireland* (London, 1891)

Arnold, Thomas, *Introductory Lectures on Modern History* (Oxford, 1842)

—— 'On the Social Progress of States', in *The Miscellaneous Works of Thomas Arnold* (London, 1845), 81–111

Arnold-Forster, H.O., 'An English View of Irish Secession', *Political Science Quarterly* 4 (1889), 66–103

Ascherson, Neil, 'Chords of Identity in a Minor Key', *Observer*, 15 December 1985, 7

—— 'We Have Always Been a Grey Land, but Once We Believed in Something', *Independent*, 16 January 1994, 20

—— 'The Search for British Self-Knowledge Could End in the Usual Muddle', *Independent*, 2 April 1995, 26

—— 'When was Britain?', *Prospect*, May 1996, 25–9

Ashford, Sheena, and Noel Timms, *What Europe Thinks: A Study of West European Values* (Aldershot, 1992)

Aslet, Clive, *Anyone for England? A Search for British Identity* (London, 1997)

'As Others See Us', *Listener*, 7 April 1937, 646–50

As Others See Us: Six Studies in Press Relations. Britain, USA, Germany, India (Zurich, 1954)

'Aspects of England', *Spectator*, 23 November 1934, 787–802

Austin, Sir Herbert, 'Effects of Modern Industry on National Character', *Listener*, 7 March 1934, 408–10

Babington, William Dalton, *Fallacies of Race Theories as Applied to National Characteristics* (London, 1895)

Bagehot, Walter, *The Collected Works of Walter Bagehot*, ed. Norman St John-Stevas, 15 vols (London, 1965–86)

—— *Physics and Politics* (1872), in *The Collected Works of Walter Bagehot*, ed. Norman St John-Stevas, 15 vols (London, 1965–86), vol. 7

Bagehot, Walter, *The English Constitution* (1867), ed. Miles Taylor (Oxford, 2001)

Bain, Alexander, *On the Study of Character, including An Estimate of Phrenology* (London, 1861)

Bain, Sir Frederick, 'Ourselves as Others See Us', *Commonwealth and Empire Review*, January 1948, 23–6

Bainbridge, Beryl, *English Journey, or The Road to Milton Keynes* (Bath, 1986)

Baldwin, Leland Dewitt, *God's Englishman: The Evolution of the Anglo-Saxon Spirit* (London, 1943)

Baldwin, Stanley, *On England and Other Addresses* (London, 1926)

—— *Our Inheritance* (London, [1928])

—— 'Our National Character', *Listener*, 4 October 1933, 481–2

Baldwin, Stanley (Earl Baldwin of Bewdley), *The Englishman* (London, 1940)

Balfour, Arthur, *Decadence* (Cambridge, 1908)

—— *Aspects of Home Rule* (London, 1912)

—— *Nationality and Home Rule* (London, 1913)

Banham, Reyner, 'Revenge of the Picturesque: English Architectural Polemics, 1945–1965', in *Concerning Architecture*, ed. John Summerson (London, 1968), 265–73

Banse, Ewald, *Germany, Prepare for War!*, trans. Alan Harris (London, 1934)

Barber, Tony, and Edward Steen, 'What the Germans Think about the British', *Independent on Sunday*, 22 July 1990, 21

Barczewski, Stephanie L., *Myth and National Identity in Nineteenth-Century Britain: The Legends of King Arthur and Robin Hood* (Oxford, 2000)

Barkan, Elazar, *The Retreat of Scientific Racism* (Cambridge, 1992)

Barker, Ernest, *Christianity and Nationality* (Oxford, 1927)

—— *National Character and the Factors in its Formation* (London, 1927)

—— (ed.), *The Character of England* (Oxford, 1947)

Barker, Paul, 'England's Mood for Manana', *Spectator*, 7 June 1980, 12–13

Barnes, Julian, *England, England* (London, 1998)

Barry, Gerald (ed.), *This England: The Englishman in Print* (London, 1933)

Bateson, Beatrice (ed.), *William Bateson, F.R.S., Naturalist: His Essays and Addresses* (Cambridge, 1928)

Baxendale, John, '"You and I – All of Us Ordinary People": Renegotiating "Britishness" in Wartime', in *'Millions Like Us'? British Culture in the Second World War*, ed. Nick Hayes and Jeff Hill (Liverpool, 1999), 295–322

—— '"I Had Seen a Lot of Englands": J.B. Priestley, Englishness and the People', *History Workshop Journal* 51 (2001), 87–111

Bayley, Stephen, 'Don't Phone the Identity Man Yet', *New Statesman*, 12 September 1997, 16–17

Beaverbrook's England 1940–1965: An Exhibition of Cartoon Originals by Michael Cummings, David Low, Vicky and Sidney 'George' Strube (Canterbury: Centre for the Study of Cartoons and Caricature, University of Kent, 1981)

Beckett, Andy, 'The Myth of the Cool', *Guardian*, 5 May 1998, 2

Beddoe, John, *The Races of Britain: A Contribution to the Anthropology of Western Europe* (Bristol, 1885)

—— *Memories of Eighty Years* (Bristol, 1910)

Beeman, William O., 'Margaret Mead, Cultural Studies, and International Understanding', Introduction to Margaret Mead and Rhoda Métraux, *The Study of Culture at a Distance* (1953) (New York, 2000), xiv–xxxiv

Beer, G.L., 'Lord Milner and British Imperialism', *Political Science Quarterly* 30 (1915), 301–8

[Begbie, W.], *The Conservative Mind, by A Gentleman with a Duster* (London, 1924)

Bell, Duncan, *The Idea of Greater Britain: Empire and the Future of World Order, 1860–1900* (Princeton, forthcoming)

Bell, P.M.H., *France and Britain 1900–1940: Entente and Estrangement* (London, 1996)

Belloc, Hilaire, *An Essay on the Nature of Contemporary England* (London, 1937)

Benson, Timothy S., *Strube: The World's Most Popular Cartoonist* (Canterbury, 2004)

Berg, Maxine, *The Machinery Question and the Making of Political Economy, 1815–1848* (Cambridge, 1980)

Berger, Morroe (ed.), *Madame de Staël on Politics, Literature and National Character* (London, 1964)

Bernstein, George, *The Myth of Decline: The Rise of Britain since 1945* (London, 2004)

Berthoud, Roger, 'More Work, Please, We're British', *The Times*, 9 December 1981, 9

Betjeman, John, *First and Last Loves* (London, 1952)

—— *Letters*, vol. I, *1926–1951*, ed. Candida Lycett Green (London, 1994)

Bickley, Francis, 'The Cult of the Peasant', *Westminster Gazette*, 21 August 1913, 3

Biddiss, Michael D., 'Myths of the Blood: European Racist Ideology 1850–1945', *Patterns of Prejudice* 9:5 (September–October 1975), 11–18

Billig, Michael, *Banal Nationalism* (London, 1995)

Blaas, P.B.M., *Continuity and Anachronism: Parliamentary and Constitutional Development in Whig Historiography and in the Anti-Whig Reaction Between 1890 and 1930* (The Hague, 1978)

Blackburn, Julian, *The Framework of Human Behaviour* (London, 1947)

Blake, Robert (ed.), *The English World: History, Character and People* (London, 1982)

Blind, Karl, 'The Unmaking of England', *Fortnightly Review*, n.s., 46 (1889), 789–805

Blyton, W.J., *Arrows of Desire* (London, [1938])

—— *We Are Observed: A Mirror to English Character* (London, 1938)

Bock, Kenneth E., 'The Moral Philosophy of Sir Henry Sumner Maine', *Journal of the History of Ideas* 37 (1976), 147–54

Bolt, Christine, *Victorian Attitudes to Race* (London, 1971)

Bonn, Moritz, 'A Visitor Looks at his Hosts', *Listener*, 14 February 1934, 264–6

Bonwick, James, *Our Nationalities*, 4 vols (London, 1880–81)

Booker, Christopher, 'How Low Have We Sunk?', *Spectator*, 14 February 1987, 9–14

Bosanquet, Bernard, 'The English People: Notes on National Characteristics', *International Monthly* 3 (1901), 71–116
—— 'The Teaching of Patriotism' (1911), in *Social and International Ideals* (London, 1917), 1–19
Boutmy, Emile, *The English People: A Study of their Political Philosophy* (London, 1904)
Bowle, John, *England: A Portrait* (London, 1966)
Bowler, Peter J., *The Invention of Progress: The Victorians and the Past* (Oxford, 1989)
Boyce, D.G., *Englishmen and Irish Troubles: British Public Opinion and the Making of Irish Policy 1918–22* (London, 1972)
Boyes, Georgina, *The Imagined Village: Culture, Ideology and the English Folk Revival* (Manchester, 1993)
Bracewell, Michael, 'Cultural Britannia: Watch with Mothership', *Independent*, 21 July 1998, 8
Bradley, R.N., *Racial Origins of English Character* (1926) (Port Washington, N.Y., 1971)
Bragg, Billy, 'I *Am* Looking for a New England', *New Statesman*, 26 July 1996, 18–19
Breasted, J.H., 'The New Past', in *The New Past and Other Essays on the Development of Civilisation*, ed. E.H. Carter (Oxford, 1925), 1–16
Breuilly, John, *Nationalism and the State* (Manchester, 1985)
[Brewer, J.S.], 'Green's *History of the English People*', *Quarterly Review* 141 (1876), 285–323
Bridie, James [O.H. Mavor], and Moray McLaren, *A Small Stir: Letters on the English* (London, 1949)
Briggs, Asa, *The Age of Improvement* (London, 1959)
—— *Saxons, Normans and Victorians* (Hastings and Bexhill, 1966)
—— 'The English: Custom and Character', in *The English World: History, Character and People*, ed. Robert Blake (London, 1982), 248–58
'The British Spirit', *Quarterly Review* 247 (1926), 184–92
British Social Attitudes: The 1987 Report, ed. Roger Jowell et al. (Aldershot, 1987)
British Social Attitudes: The 15th Report, ed. Roger Jowell et al. (Aldershot, 1998)
British Social Attitudes: The 17th Report, ed. Roger Jowell et al. (Aldershot, 2000)
British Social Attitudes: The 18th Report, ed. Alison Park et al. (Aldershot, 2001)
British Social Attitudes: Special International Report, ed. Roger Jowell et al. (Aldershot, 1989)
The British Way and Purpose, consolidated edition (Directorate of Army Education, 1944)
Brockliss, Laurence, and David Eastwood (eds), *A Union of Multiple Identities: The British Isles, c.1750–c.1850* (Manchester, 1997)
Brodrick, George C., 'A Nation of Amateurs', *Nineteenth Century* 48 (1900), 521–35
Brogan, D.W., *The English People: Impressions and Observations* (London, 1943)
Brown, Callum G., *Up-Helly-Aa: Custom, Culture and Community in Shetland* (Manchester, 1998)
Brown, Gordon, 'Outward Bound', *Spectator*, 8 November 1997, 15–16
Brundage, Anthony, *The People's Historian: John Richard Green and the Writing of History in Victorian England* (Westport, Conn., 1984)
Bryant, Arthur, 'The Englishman's Roots in his Countryside', *Listener*, 11 October 1933, 531–3
—— 'The Housewife', *Listener*, 13 December 1933, 902–4
—— 'The National Character: England's Greatest Asset', *Listener*, 4 October 1933, 483–5
—— *The National Character* (London, 1934)
—— 'The Heart of a Nation', *Illustrated London News*, February 1981, 24
Bryant, Arthur, and H.J. Fleure, 'The Mingling of the Races: A Discussion', *Listener*, 18 October 1933, 579–82
—— 'How Does Our Climate Affect Our Character? A Discussion', *Listener*, 25 October 1933, 623–5
Bryant, Mark (ed.), *The Complete Colonel Blimp* (London, 1991)
Bryson, Bill, *Notes from a Small Island* (London, 1995)

Buchanan, William, and Hadley Cantril, *How Nations See Each Other: A Study in Public Opinion* (Urbana, Illinois, 1953)

Buckle, Henry Thomas, *History of Civilization in England* (1857–61), ed. John M. Robertson (London, 1904)

Bulwer, Edward Lytton, *England and the English* (Paris, 1833)

Burgess, Anthony, 'On Being British', *Sunday Times Magazine*, 1 March 1987, 23–5

Burke, Edmund, 'Essay towards an Abridgment of the English History', in *The Writings and Speeches of Edmund Burke*, vol. 1, *The Early Writings*, ed. T.O. McLaughlin and James T. Boulton (Oxford, 1997), 332–552

—— *Reflections on the Revolution in France* (1790), ed. Conor Cruise O'Brien (Harmondsworth, 1968)

—— *The Writings and Speeches of Edmund Burke*, vol. 7, *The Hastings Trial, 1789–1794*, ed. Peter Marshall (Oxford, 2000)

[Burke, Luke?], 'Types of Mankind', *Westminster Review* 65 (1856), 357–86

Burns, C. Delisle, *The Morality of Nations* (London, 1915)

—— *The World of States* (London, 1917)

Burrow, J.W., *Evolution and Society: A Study in Victorian Social Theory* (Cambridge, 1966)

—— *A Liberal Descent: Victorian Historians and the English Past* (Cambridge, 1981)

—— *Whigs and Liberals: Continuity and Change in English Political Thought* (Oxford, 1988)

—— *The Crisis of Reason: European Thought, 1848–1914* (New Haven and London, 2000)

Buruma, Ian, 'England, Whose England?', *Spectator*, 9 September 1989, 14–16

—— 'His Finest Hour', *Spectator*, 17 November 1990, 26–8

—— *Voltaire's Coconuts, or Anglomania in Europe* (London, 1999)

Byatt, A.S., 'Who Are the English?', *Listener*, 5 August 1976, 130–1

Byrne, Revd James, 'The Influence of National Character on English Literature', in *The Afternoon Lectures on English Literature* (London, 1863)

Cairns, John C., 'A Nation of Shopkeepers in Search of a Suitable France: 1919–40', *American Historical Review* 79 (1974), 710–43

Calder, Angus, *The People's War: Britain 1939–1945*, 2nd ed. (London, 1971)

—— *The Myth of the Blitz* (London, 1992)

Campbell, James, 'The United Kingdom of England: The Anglo-Saxon Achievement', in *Uniting the Kingdom? The Making of British History*, ed. Alexander Grant and Keith Stringer (London, 1995), 31–47

Cammaerts, Emile, *Discoveries in England* (London, 1930)

Čapek, Karel, *Letters from England*, trans. Paul Selver (London, [1925])

—— 'Tribal Customs of the English Native', *Listener*, 28 February 1934, 347–9

—— 'England from the Outside', *Spectator*, 23 November 1934, 800–1

Carlyle, Thomas, *Selected Writings*, ed. Alan Shelston (Harmondsworth, 1971)

Carpenter, Humphrey, *The Brideshead Generation: Evelyn Waugh and his Friends* (London, 1989)

—— *That Was Satire That Was* (London, 2000)

Carpenter, William B., *Principles of Mental Physiology* (London, 1874)

—— *Nature and Man: Essays Scientific and Philosophical* (London, 1888)

[Carpenter, William B.], 'Ethnology, or the Science of Races', *Edinburgh Review* 88 (1848), 429–87

Carstairs, G.M., *This Island Now: The BBC Reith Lectures 1962* (London, 1963)

Carter, Angela, 'So There'll Always Be an England', *New Society*, 7 October 1982, 17–19

Castle, Kathryn, *Britannia's Children: Reading Colonialism through Children's Books and Magazines* (Manchester, 1996)

Castle, Stephen, 'Strong? Modern? Fair?', *Independent on Sunday*, 7 December 1997, 5

Castronovo, David, *The English Gentleman: Images and Ideals in Literature and Society* (New York, 1987)

Catlin, George, *The Anglo-Saxon Tradition* (London, 1939)

Ceadel, Martin, *Pacifism in Britain, 1914–1945* (Oxford, 1980)

Cecil of Chelwood, Viscount, 'National Characteristics and the League of Nations', *Modern Languages* 7 (1925–26), 90–5

Chamberlain, Joseph, 'National Patriotism and the World', in *England's Mission by England's Statesmen*, ed. Arthur Mee (London, 1903), 63–79

Chancellor, Valerie E., *History for their Masters: Opinion in the English History Textbook, 1800–1914* (Bath, 1970)

Chaudhuri, Nirad C., *A Passage to England* (London, 1959)

Chenevix, Richard, *An Essay upon National Character*, 2 vols (London, 1832)

Chesterton, G.K., *A Short History of England* (London, 1917)

—— *Explaining the English* (London, [1939])

Cheyette, Brian, *Constructions of 'the Jew' in English Literature and Society: Racial Representations, 1875–1945* (Cambridge, 1993)

Childs, Marquis W., *Sweden: The Middle Way*, rev. ed. (New Haven, 1938)

Christiansen, Rupert, *The Visitors: Culture Shock in Nineteenth-Century Britain* (London, 2000)

Christie, Ian, *Arrows of Desire: The Films of Michael Powell and Emeric Pressburger*, new ed. (London, 1994)

Church, R.W., 'On Some Influences of Christianity upon National Character', in *The Gifts of Civilisation* (London, 1880), 209–344

Clark, Jonathan, 'Not Fading Away Yet', *Times Literary Supplement*, 7 June 2002, 3–4

Clarke, Peter, *Liberals and Social Democrats* (Cambridge, 1978)

Claus, Peter, 'Languages of Citizenship in the City of London 1848–1867', *London Journal* 24 (1999), 23–37

[Clutton-Brock, Arthur], 'The English Incuria', *Times Literary Supplement*, 21 September 1916, 445–6

Coetzee, Frans, *For Party or Country: Nationalism and the Dilemmas of Popular Conservatism in Edwardian England* (Oxford, 1990)

Cohen, Anthony P. (ed.), *Symbolising Boundaries: Identity and Diversity in British Cultures* (Manchester, 1986)

Cohen, Lizabeth, *A Consumers' Republic: The Politics of Mass Consumption in Postwar America* (New York, 2003)

Cohen, Robin, *Frontiers of Identity: The British and the Others* (London, 1994)

—— 'The Incredible Vagueness of Being British/English', *International Affairs* 76 (2000), 575–82

Cohen-Portheim, Paul, *England: The Unknown Isle*, trans. Alan Harris (London, 1930)

Coleridge, Samuel Taylor, *On the Constitution of Church and State* (1830), ed. John Colmer (London, 1976)

Colley, Linda, 'Whose Nation? Class and National Consciousness in Britain 1750–1830', *Past & Present* 113 (1986), 97–117

—— 'Britishness and Otherness: An Argument', *Journal of British Studies* 31 (1992), 309–29

—— *Britons: Forging the Nation 1707–1837* (New Haven and London, 1992)

Collier, Price, *England and the English from an American Point of View* (London, 1909)

Collini, Stefan, 'The Idea of "Character" in Victorian Political Thought', *Transactions of the Royal Historical Society*, 5th ser., 35 (1985), 29–50

—— *Public Moralists: Political Thought and Intellectual Life in Britain 1850–1930* (Oxford, 1991)

—— *English Pasts: Essays in History and Culture* (Oxford, 1999)

—— 'The Literary Critic and the Village Labourer: "Culture" in Twentieth-Century Britain', *Transactions of the Royal Historical Society*, 6th ser., 14 (2004), 93–116

Collini, Stefan, Donald Winch and John Burrow, *That Noble Science of Politics: A Study in Nineteenth-Century Intellectual History* (Cambridge, 1983)

Collins, Marcus, 'The Fall of the English Gentleman: The National Character in Decline, c. 1918–1970', *Historical Research* 75 (2002), 90–111

Collis, J.S., *An Irishman's England* (London, 1937)

Colls, Robert, *Identity of England* (Oxford, 2002)

Combe, George, *The Constitution of Man*, 8th ed. (Edinburgh, 1847)

Commager, Henry Steele, 'English Traits: One Hundred Years Later', *Nineteenth Century and After* 144 (1948), 1–10

Condor, Susan, '"Unimagined Community?" Some Social Psychological Issues Concerning English National Identity', in *Changing European Identities: Social Psychological Analyses of Social Change*, ed. Glynis M. Breakwell and Evanthia Lyons (Oxford, 1996), 41–68

—— '"Having History": A Social Psychological Exploration of Anglo-British Autostereotypes', in *Beyond Pug's Tour: National and Ethnic Stereotyping in Theory and Practice*, ed. C.C. Barfoot (Amsterdam, 1997), 213–53

—— 'Temporality and Collectivity: Diversity, History and the Rhetorical Construction of National Entitativity', *British Journal of Social Psychology*, forthcoming

Conekin, Becky E., *'The Autobiography of a Nation': The 1951 Festival of Britain* (Manchester, 2003)

Connell, Philip, *Romanticism, Economics and the Question of 'Culture'* (Oxford, 2001)

Connor, William [Cassandra, pseud.], *The English At War* (London, 1941)

Cook, Pam, *Fashioning the Nation: Costume and Identity in British Cinema* (London, 1996)

Cooke, Alistair, 'The Face of England: American Stereotypes', *Manchester Guardian*, 27 June 1959, 4

Coon, Carleton Stevens, *The Races of Europe* (New York, 1939)

Cooter, Roger, *The Cultural Meaning of Popular Science: Phrenology and the Organization of Consent in Nineteenth-Century Britain* (Cambridge, 1984)

Cornick, Martyn, 'Faut-il réduire l'Angleterre en esclavage? A Case Study of French Anglophobia, October 1935', *Franco-British Studies* 14 (1992), 3–19

Courtney, C.P., *Montesquieu and Burke* (Oxford, 1963)

Coveney, Dorothy K., and W.N. Medlicott (eds), *The Lion's Tail: An Anthology of Criticism and Abuse* (London, 1971)

Cowles, Virginia, *No Cause for Alarm: A Study of Trends in England To-day* (London, 1949)

Cowling, Mary, *The Artist as Anthropologist: The Representation of Type and Character in Victorian Art* (Cambridge, 1989)

Cox, David, 'At Last, the Silent People Speak', *New Statesman*, 22 April 2002, 14–15

Craig, Cairns, 'Us and Them', *New Statesman*, 16 March 1990, 24

Craik, George L., and Charles Macfarlane, *The Pictorial History of England*, 4 vols (London, 1837–41)

Cramb, J.A., *The Origins and Destiny of Imperial Britain* (London, 1915)

Crawford and Balcarres, Earl of, 'History and the Plain Man', *History* 23 (1938–39), 289–304

Creighton, Mandell, *The English National Character* (London, 1896)

—— *The Church and the Nation*, ed. Louise Creighton (London, 1901)

—— 'The Picturesque in History' (1897), in *Historical Lectures and Addresses*, ed. Louise Creighton (London, 1903), 261–84

Crick, Bernard, 'The English and the British' in *National Identities: The Constitution of the United Kingdom*, ed. Bernard Crick (Oxford, 1991), 90–104

Critchley, Julian, 'The Patriotism Waiting to be Voiced', *Daily Telegraph*, 6 July 1982, 12

Crockett, James, *The English Spirit* (London, 1941)

Crosby, Christina, *The Ends of History: Victorians and 'The Woman Question'* (New York, 1991)

[Croskerry, Thomas], 'Irish Discontent', *Edinburgh Review* 155 (1882), 155–85

Crosland, Anthony, and Donald MacRae, 'What is Wrong with Britain?', *Listener*, 5 July 1962, 3–5

Crosland, T.W.H., *The Unspeakable Scot* (London, 1902)

Crosland, T.W.H. [Angus McNeill, pseud.], *The Egregious English* (London, 1903)

Crossley, Ceri, *French Historians and Romanticism* (London, 1993)

Cummings, A.J., *This England: An Appreciation* (London, [1944])

Cunningham, Hugh, 'The Conservative Party and Patriotism', in *Englishness: Politics and Culture, 1880–1920*, ed. Robert Colls and Philip Dodd (London, 1986), 283–307

Curtin, Philip D., *The Image of Africa: British Ideas and Action, 1780–1850* (London, 1965)

Curtis, L.P., Jr., *Anglo-Saxons and Celts: A Study of Anti-Irish Prejudice in Victorian England* (Bridgeport, Conn., 1968)

Dale, Edmund, *National Life and Character in the Mirror of Early English Literature* (Cambridge, 1907)

Dalrymple, Theodore, 'Nasty, British and Short', *Spectator*, 21 September 1991, 9–10

Dalton, Hugh, *Practical Socialism for Britain* (London, 1935)

Daniels, Stephen, *Fields of Vision: Landscape Imagery and National Identity in England and the United States* (Cambridge, 1993)

Davenport, Nicholas, 'The Split Society: Stress and Depression', *Spectator*, November 1963, 593–6

Davies, Norman, *The Isles: A History* (Basingstoke, 1999)

Davies, R.R., 'The Peoples of Britain and Ireland 1100–1400: I. Identities', *Transactions of the Royal Historical Society*, 6th ser., 4 (1994), 1–20

—— 'The Peoples of Britain and Ireland 1100–1400: II. Names, Boundaries and Regional Solidarities', *Transactions of the Royal Historical Society*, 6th ser., 5 (1995), 1–20

Dawson, Graham, *Soldier Heroes: British Adventure, Empire and the Imagining of Masculinities* (London, 1994)

Dean, Michael, 'Home Thoughts from England', *Spectator*, 16 February 1978, 198–9

Deer, Brian, 'Disunited We Stand', *Sunday Times*, 5 February 1995

Defoe, Daniel, *The True-Born Englishman* (1700), in *The True-Born Englishman and Other Writings*, ed. P.N. Furbank and W.R. Owens (Harmondsworth, 1997)

Demiashkevich, Michael, *The National Mind: English, French, German* (New York, 1938)

Dennis, Nigel, *Cards of Identity* (1955) (London, 1999)

Desmond, Adrian, *The Politics of Evolution: Morphology, Medicine, and Reform in Radical London* (Chicago, 1989)

—— *Huxley: From Devil's Disciple to Evolution's High Priest* (Harmondsworth, 1998)

Devine, T.M., *The Scottish Nation, 1700–2000* (London, 1999)

Dewey, C.J., 'Celtic Agrarian Legislation and the Celtic Revival: Historicist Implications of Gladstone's Irish and Scottish Land Acts 1870–1886', *Past & Present* 64 (1974), 30–70

Dibelius, Wilhelm, *England* (London, 1930)

Dicey, A.V., *England's Case Against Home Rule* (1886), ed. E.J. Feuchtwanger (Richmond, 1973)

Dickens, Charles, 'Insularities' (*Household Words*, 19 January 1856), in *'Gone Astray' and Other Papers from Household Words 1851–59*, Dent Uniform Edition of Dickens' Journalism, vol. 3, ed. Michael Slater (London, 1998), 338–46

—— 'Why?' (*Household Words*, 1 March 1856), in *'Gone Astray' and Other Papers from Household Words 1851–59*, Dent Uniform Edition of Dickens' Journalism, vol. 3, ed. Michael Slater (London, 1998), 355–62

—— *Our Mutual Friend* (London, 1865)

Dilke, Sir Charles Wentworth, *Greater Britain: A Record of Travel in English-Speaking Countries* (1868), 8th ed. (London, 1885)

Dilks, David N., 'Public Opinion and Foreign Policy: Great Britain', in *Opinion Publique et Politique Exterieure*, vol. 2, *1915–1940* (Rome 1984), 57–79

Dinwiddy, John, 'Charles James Fox and the People', *History* 55 (1970), 342–59

—— 'England', in *Nationalism in the Age of the French Revolution*, ed. Otto Dann and John Dinwiddy (London, 1988), 53–70

Disraeli, Benjamin, *Vindication of the English Constitution in a Letter to a Noble and Learned Lord* (London, 1835)

—— *Whigs and Whiggism: Political Writings*, ed. William Hutcheon (London, 1913)

[Disraeli, Benjamin], *England and France; or a Cure for the Ministerial Gallomania* (London, 1832)

Ditchfield, G.M., 'Church, Parliament and National Identity', in *Parliaments, Nations and Identities in Britain and Ireland, 1660–1850*, ed. Julian Hoppit (2003), 64–82

Dixon, W. Macneile, *Poetry and National Character* (Cambridge, 1915)

—— *The Englishman* (London, 1931)

Dodd, Philip, 'Englishness and the National Culture', in *Englishness: Politics and Culture 1880–1920*, ed. Robert Colls and Philip Dodd (London, 1986), 1–28

—— *The Battle over Britain* (London, 1995)

—— 'A Mongrel Nation', *New Statesman*, 24 February 1995, 26–7

[Donne, W.B.], 'The Saxons in England', *Edinburgh Review* 89 (1849), 151–84

Doob, Leonard W., *Patriotism and Nationalism: Their Psychological Foundations* (New Haven, 1964)

Dorman, Marcus R.P., *Ignorance: A Study of the Causes and Effects of Popular Thought* (London, 1898)

—— *The Mind of the Nation: A Study of Political Thought in the Nineteenth Century* (London, 1900)

Dower, John W., *War Without Mercy: Race and Power in the Pacific War* (New York, 1986)

Downs, Brian W., 'As Others See Us', *Contemporary Review* 143 (1933), 85–93

Doyle, Brian, 'The Invention of English', in *Englishness: Politics and Culture 1880–1920*, ed. Robert Colls and Philip Dodd (London, 1986), 89–115

Driscoll, Margarette, 'Goodbye, Stiff Upper Lip', *Sunday Times*, 16 November 1997

Driver, Felix, *Geography Militant: Cultures of Exploration in the Age of Empire* (Oxford, 1999)

Duijker, H.C.J., and N.H. Frijda, *National Character and National Stereotypes: A Trend Report Prepared for the International Union of Scientific Psychology* (Amsterdam, 1960)

Dunn, Hugh Percy, 'Is Our Race Degenerating?', *Nineteenth Century* 36 (1894), 301–14

Durbin, E.F.M., *What Have We To Defend?* (London, 1942)

'An Easter Offering', *Anglo-Saxon* 1 (1849), pt II, 5–14

Eastwood, David, '"Amplifying the Province of the Legislature": The Flow of Information and the English State in the Early Nineteenth Century', *Historical Research* 62 (1989), 276–94

—— '"Recasting our Lot": Peel, the Nation, and the Politics of Interest', in *A Union of Multiple Identities: The British Isles, c.1750–c.1850*, ed. Laurence Brockliss and David Eastwood (Manchester, 1997), 29–43

Edwards, T. Robertson, 'The Sentiment of Nationality', *Westminster Review* 135 (1891), 501–11

Elias, Norbert, *The Civilizing Process* (1939), trans. Edmund Jephcott (Oxford, 1994)

Eliot, George, 'The Natural History of German Life' (1856), in *Essays of George Eliot*, ed. Thomas Pinney (London, 1963), 266–99

—— *Impressions of Theophrastus Such* (1879), ed. Nancy Henry (London, 1994)

Eliot, T.S., *Notes towards the Definition of Culture* (London, 1948)

Elis-Thomas, Dafydd, 'Don't Lie Back and Just Think of England', *Guardian*, 21 December 1987, 17

[Elliot, Walter], 'The English', *Times Literary Supplement*, 7 August 1948, 437–8

Elliott, Charles Boileau, *A Prize Essay on the Effects of Climate on National Character* (London, 1821)

Ellis, Havelock, 'The Psychology of the German', *New Statesman*, 20 March 1915, 587–9

—— 'The Psychology of the Russian', *New Statesman*, 22 May 1915, 154–6

—— 'The Psychology of the English', *Edinburgh Review* 223 (1916), 223–43

Emerson, R.W., *English Traits* (Boston, 1857)

'Emerson's English Traits', *London Quarterly Review* 7 (1856–57), 381–406

England, by an Overseas Englishman (London, 1922)

'"The English Make Me Wild" By An American', *Listener*, 3 November 1937, 957–8

'England, Whose England?', *New Statesman*, 24 February 1995

Ernle, Lord, *Whippingham to Westminster* (London, 1938)

Ervine, St John, 'The English Do Not Live by Luck', *Listener*, 14 October 1948, 563, 566

Escott, T.H.S., *England: Its People, Polity, and Pursuits*, 2 vols (London, [1879])
—— *Social Transformations of the Victorian Age* (London, 1897)
Essays in Liberalism By Six Oxford Men (London, 1897)
Essays on Reform (London, 1867)
Evans, Richard, 'Myth of the German Psyche', *Guardian*, 19 July 1990
Faber, Richard, *French and English* (London, 1975)
Fairlie, Henry, 'Transatlantic Letter to England', *Encounter*, January 1976, 6–21
Fallaize, E.N., 'Why Britain Needs a Race Survey', *Discovery* 10 (1929), 302–4
Farber, Maurice L., 'The Problem of National Character: A Methodological Analysis',
 Journal of Psychology 30 (1950), 307–16
—— 'English and Americans: A Study in National Character', *Journal of Psychology* 32
 (1951), 241–9
—— 'English and Americans: Values in the Socialization Process', *Journal of Psychology* 36
 (1953), 243–50
Feldman, David, 'The Importance of Being English: Jewish Immigration and the Decay of
 Liberal England', in *Metropolis-London: Histories and Representations since 1800*, ed. David
 Feldman and Gareth Stedman Jones (London, 1989), 56–84
—— *Englishmen and Jews: Social Relations and Political Culture* (New Haven and London, 1994)
Ferrie, W.S., 'Interpreting England', *Scots Magazine* 38 (1937–38), 58–60
Feske, Victor, *From Belloc to Churchill: Private Scholars, Public Culture and the Crisis of British
 Liberalism, 1900–1939* (Chapel Hill, N.C., 1996)
Field, H. John, *Towards a Programme of Imperial Life: The British Empire at the Turn of the Century*
 (Westport, Conn., 1982)
Fielding, Steven, Peter Thompson and Nick Tiratsoo, *'England Arise!' The Labour Party and
 Popular Politics in 1940s Britain* (Manchester, 1995)
Fifoot, C.H.S., *Frederic William Maitland: A Life* (Cambridge, Mass., 1971)
Fiske, A.P., S. Kitayama, H. Markus and D. Nisbett, 'The Cultural Matrix of Social
 Psychology', in *The Handbook of Social Psychology*, ed. D.T. Gilbert, S.T. Fiske and G.
 Lindzey, 4th ed. (Boston, 1998), vol. 2, 915–81
Fletcher, Anthony, 'The First Century of English Protestantism and the Growth of
 National Identity', in *Religion and National Identity*, ed. Stuart Mews, Studies in Church
 History 18 (Oxford, 1982), 309–17
Fleure, H.J., 'Mental Characters and Physical Characters in Race Study', *Discovery* 4
 (1923), 35–9
—— *The Races of England and Wales: A Survey of Recent Research* (London, 1923)
—— 'The Regional Balance of Racial Evolution', *Nature* 118 (1926), 380–3
—— 'The Races of Mankind', *Realist*, August 1929, 35–51
—— 'The Nordic Myth: A Critique of Current Racial Theories', *Eugenics Review* 22
 (1930–31), 117–21
—— *Some Aspects of British Civilization* (Oxford, 1948)
Flint, Kate, *The Woman Reader, 1837–1914* (Oxford, 1993)
Fontana, Biancamaria, *Rethinking the Politics of Commercial Society: The Edinburgh Review,
 1802–1832* (Cambridge, 1985)
Foot, M.R.D., 'The Nature of Character: At National Level', *Times Literary Supplement*, 27
 July 1973, 877
Foot, Sarah, 'The Making of *Angelcynn*: English Identity Before the Norman Conquest',
 Transactions of the Royal Historical Society, 6th ser., 6 (1996), 25–49
Forbes, Duncan, *The Liberal Anglican Idea of History* (Cambridge, 1952)
Forster, E.M., 'Notes on the English Character', *Atlantic Monthly*, January 1926, 30–7
—— 'English Freedom', *Spectator*, 23 November 1934, 791–2
Foster, R.F., 'Paddy and Mr Punch', in *Paddy and Mr Punch: Connections in Irish and English
 History* (London, 1993)
Fox, Frank, *The English, 1909–1922: A Gossip* (London, 1923)

Fox, Kate, *Watching the English: The Hidden Rules of English Behaviour* (London, 2004)

Francis, Martin, 'The Labour Party: Modernisation and the Politics of Restraint', in *Moments of Modernity: Reconstructing Britain 1945–1964*, ed. Becky Conekin, Frank Mort and Chris Waters (London, 1999), 152–70

Frankfurter, Felix, 'Trans-Atlantic Misconceptions', *Listener*, 21 February 1934, 299–301

Freeden, Michael, *The New Liberalism: An Ideology of Social Reform* (Oxford, 1978)

Freedland, Jonathan, 'More Open and Tolerant, Less Macho and Miserable: Welcome to New Britain', *Guardian*, 18 September 1997, supp., 2

Freeman, Edward A., 'The Continuity of English History', in *Historical Essays* (London, 1871), 40–52

—— *Comparative Politics* (London, 1873)

—— *The Methods of Historical Study* (London, 1886)

—— 'The Latest Theories on the Origin of the English', *Contemporary Review* 57 (1890), 36–51

—— 'Alter Orbis', in *Historical Essays*, 4th ser. (London, 1892), 219–48

—— 'National Prosperity and the Reformation', in *Historical Essays*, 4th ser. (London, 1892), 284–92

—— 'The Physical and Political Bases of National Unity', in *Britannic Confederation*, ed. Arthur Silva White (London, 1892), 33–56

—— 'Race and Language' (1877), in *Images of Race*, ed. Michael D. Biddiss (Leicester, 1979), 205–35

[Freeman, Edward A.], 'Dr. Vaughan's *Revolutions in English History*', *Edinburgh Review* 112 (1860), 136–60

'French Thought', *Saturday Review*, 14 February 1863, 196–7

French, Philip, 'The Right Kind of Englishman?', *Twentieth Century* 173 (1964–65), 44–55

Friedberg, A.L., *The Weary Titan: Britain and the Experience of Relative Decline, 1895–1905* (Princeton, 1988)

Frohnen, Bruce, 'An Empire of Peoples: Burke, Government and National Character', in *Edmund Burke: His Life and Legacy*, ed. Ian Crowe (Dublin, 1997), 128–42

Frost, David, and Antony Jay, *To England With Love* (London, 1967)

Froude, James Anthony, 'England's Forgotten Worthies', in *Short Studies on Great Subjects* (London, 1878–83), vol. 1, 443–501

—— 'The Science of History', in *Short Studies on Great Subjects* (London, 1878–83), vol. 1, 1–38

Fuller, J.F.C., 'The English Spirit', *National Review* 88 (1926–27), 220–30

Fulton, Ernest A., 'History and the National Life', *History* 3 (1914), 63–7

Fyfe, Hamilton, *The Illusion of National Character* (London, 1940)

Fyvel, Tosco, 'The Stones of Harlow', *Encounter*, June 1956, 11–17

Galsworthy, John, 'Diagnosis of the Englishman', *Fortnightly Review*, n.s., 97 (1915), 839–45

Galton, Francis, 'Hereditary Talent and Character' (1865), in *Images of Race*, ed. Michael D. Biddis (Leicester, 1979), 55–71

Gambles, Anna, *Protection and Politics: Conservative Economic Discourse, 1815–1852* (Woodbridge, 1999)

Garton Ash, Timothy, 'What We Really Said about Germany', *Independent*, 17 July 1990, 15

'Gentle-Women', *The Anglo-Saxon* 1 (1849), pt II, 195–200

Gerrard, Nicci, 'We Are All Dianas Now', *Observer*, 28 December 1997, 'Life', 10

Gervais, David, *Literary Englands: Versions of 'Englishness' in Modern Writing* (Cambridge, 1993)

Gibbs, Philip, *England Speaks* (London, 1935)

—— *How Now, England?* (London, 1958)

Gilley, Sheridan, 'English Atitudes to the Irish in England, 1789–1900', in *Immigrants and Minorities in British Society*, ed. Colin Holmes (London, 1978), 81–110

Gillingham, John, 'The Beginnings of English Imperialism', *Journal of Historical Sociology* 5 (1992), 392–409

—— 'Civilizing the English? The English Histories of William of Malmesbury and David Hume', *Historical Research* 74 (2001), 17–43

Ginsberg, Morris, *Essays in Sociology and Social Philosophy*, vol. 1, *On the Diversity of Morals* (London, 1956)

—— 'National Character and National Sentiments' (1935), in *Essays in Sociology and Social Philosophy*, vol. 1, *On the Diversity of Morals* (London, 1956), 243–56

Girouard, Mark, *Sweetness and Light: The 'Queen Anne' Movement 1860–1900* (Oxford, 1977)

—— *The Return to Camelot: Chivalry and the English Gentleman* (New Haven and London, 1981)

Godechot, Jacques, 'The New Concept of the Nation and its Diffusion in Europe', in *Nationalism in the Age of the French Revolution*, ed. Otto Dann and John Dinwiddy (London, 1988), 13–26

Goldman, Lawrence, 'The Origins of British "Social Science": Political Economy, Natural Science and Statistics', *Historical Journal* 26 (1983), 587–616

—— 'A Peculiarity of the English? The Social Science Association and the Absence of Sociology in Nineteenth-Century Britain', *Past & Present* 114 (1987), 133–71

—— *Science, Reform and Politics in Victorian Britain: The Social Science Association, 1857–1886* (Cambridge, 2002)

Gordon, Donald, 'Goodbye, England', *Spectator*, 5 July 1963, 9–11

Gorer, Geoffrey, 'Notes on the Way', *Time and Tide*, 23 May 1936, 752–4

—— *The Americans: A Study in National Character* (London, 1948)

—— 'Notes on the British Character', *Horizon*, December 1949, 369–79

—— *Exploring English Character* (London, 1955)

Gorer, Geoffrey, and John Rickman, *The People of Great Russia: A Psychological Study* (London, 1949)

Gorton, Ted, 'Belief in Britain', *Listener*, 17–24 December 1981, 741–2

Grabowski, Z.A., 'Why are the English so Lonely?', *Twentieth Century* 173 (1964–65), 97–101

Grainger, J.H., *Patriotisms: Britain 1900–1939* (London, 1986)

Grand'Combe, Felix de [F.F. Boillot], *England, This Way!*, trans. Beatrice de Holthoir (London, 1932)

Green, E.H.H., *The Crisis of Conservatism: The Politics, Economics and Ideology of the British Conservative Party, 1880–1914* (London, 1995)

—— *Ideologies of Conservatism: Conservative Political Ideas in the Twentieth Century* (Oxford, 2002)

Green, Jonathon, *All Dressed Up: The Sixties and the Counterculture* (London, 1998)

Green, J.R., *A Short History of the English People* (London, 1874)

—— *Historical Studies* (London, 1903)

Green, Martin, *A Mirror for Anglo-Saxons* (London, 1961)

—— *Children of the Sun: A Narrative of Decadence in England after 1918* (New York, 1976)

Greenfeld, Liah, *Nationalism: Five Roads to Modernity* (Cambridge, MA, 1992)

Greenwood, Frederick, 'The Limbo of Progress', *Macmillan's Magazine* 67 (1892–93), 391–400

Grigg, John, 'Mere English', *Guardian*, 23 April 1964, 22

Grigson, Geoffrey, 'On Being English', *Listener*, 16 October 1969, 517–18

Guizot, François, *The History of Civilization in Europe*, ed. Larry Siedentop (London, 1997)

Gunn, Simon, *The Public Culture of the Victorian Middle Class* (Manchester, 2000)

Haddon, A.C., *The Races of Man and their Distribution*, rev. ed. (Cambridge, 1929)

Haggith, Toby, 'Citizenship, Nationhood and Empire in British Official Film Propaganda, 1939–45', in *The Right to Belong: Citizenship and National Identity in Britain, 1930–1960*, ed. Richard Weight and Abigail Beach (London, 1998), 59–88

Haight, Gordon S. (ed.), *The George Eliot Letters*, 9 vols (London, 1954–78)

Haldane, Elizabeth, 'The Scot at Home and Abroad', *Listener*, 24 January 1934, 127–9, 161

Hall, Catherine, 'Missionary Stories: Gender and Ethnicity in England in the 1830s and 1840s', in *White, Male and Middle-Class: Explorations in Feminism and History* (Oxford, 1992), 205–54

—— ' "From Greenland's Icy Mountains . . . to Afric's Golden Sand": Ethnicity, Race and Nation in Mid-Nineteenth Century England', *Gender & History* 5 (1993), 212–30

—— 'The Nation Within and Without', in Catherine Hall, Keith McClelland and Jane Rendall, *Defining the Victorian Nation: Class, Race, Gender and the Reform Act of 1867* (Cambridge, 2000), 179–233

—— *Civilising Subjects: Metropole and Colony in the English Imagination, 1830–1867* (Oxford, 2002)

Hall, Catherine, Keith McClelland and Jane Rendall, *Defining the Victorian Nation: Class, Race, Gender and the Reform Act of 1867* (Cambridge, 2000)

Hall, Spencer T., 'Local and National Peculiarities', in *Biographical Sketches of Remarkable People* (London, 1873), 353–56

Halsey, A.H., 'The Self-Conscious Traveller Sets Out for London', *Listener*, 6 January 1983, 10–11

Hamerton, Philip Gilbert, *French and English: A Comparison* (London, 1889)

Hamilton, Cicely, *The Englishwoman* (London, 1940)

Hansen, Christen (with H.W. Seaman), *The English Smile* (London, 1935)

Harding, Stephen, and David Phillips, with Michael Fogarty, *Contrasting Values in Western Europe: Unity, Diversity and Change* (Basingstoke, 1986)

Harling, Philip, *The Waning of 'Old Corruption': The Politics of Economical Reform in Britain, 1779–1846* (Oxford, 1996)

Harling, Philip, and Peter Mandler, 'From "Fiscal-Military" State to Laissez-Faire State, 1760–1850', *Journal of British Studies* 32 (1993), 44–70

Harmsworth, Desmond, 'The Essence of the English', *North American Review* 229 (1930), 624–32

Harris, Frank, 'Natural Laws and the Home Rule Problem', *Fortnightly Review*, n.s., 40 (1886), 98–104

Harris, José, *Unemployment and Politics: A Study in English Social Policy 1886–1914* (Oxford, 1972)

Harrison, Frederic, 'The Evolution of Our Race: A Reply', *Fortnightly Review*, n.s., 54 (1893), 28–41

Harrison, Mark, *Climates and Constitutions: Health, Race, Environment and British Imperialism in India 1600–1850* (New Delhi, 1999)

Harrisson, Tom, and Charles Madge, *Britain by Mass-Observation* (1939) (London, 1986)

Hartley, Anthony, *A State of England* (London, 1963)

Harvey, Charles H., *The Biology of British Politics* (London, 1904)

Harvie, Christopher, *The Lights of Liberalism: University Liberals and the Challenge of Democracy, 1860–86* (London, 1976)

—— 'The Moment of British Nationalism, 1939–1970', *Political Quarterly* 71 (2000), 328–40

Haseler, Stephen, *The English Tribe: Identity, Nation and Europe* (Basingstoke, 1996)

Hastings, Adrian, *The Construction of Nationhood: Ethnicity, Religion and Nationalism* (Cambridge, 1997)

Haultain, Arnold (ed.), *A Selection from Goldwin Smith's Correspondence* (London, [1913?])

Healy, Maurice, 'The Irishman – Mystic and Realist', *Listener*, 7 February 1934, 229–31

Heath, A.G., 'John Bull in English Literature', *History* 4 (1915), 129–38, 152–5

Heathorn, Stephen, *For Home, Country, and Race: Constructing Gender, Class, and Englishness in the Elementary School, 1880–1914* (Toronto, 2000)

Heffer, Simon, *Like the Roman: The Life of Enoch Powell* (London, 1998)
—— *Nor Shall My Sword: The Reinvention of England* (London, 1999)
Helfand, M.S., 'T.H. Huxley's "Evolution and Ethics": The Politics of Evolution and the Evolution of Politics', *Victorian Studies* 20 (1977), 159–77
Helgerson, Richard, *Forms of Nationhood: The Elizabethan Writing of England* (Chicago, 1992)
Hellstrom, Gustaf, 'Concerning the Englishman', in *Sweden Speaks*, ed. Gustav Witting, trans. Edith M. Nielsen (London, 1942), 11–21
Henderson, Ailsa, and Nicola McEwen, 'Do Shared Values Underpin National Identity? Examining the Role of Values in National Identity in Canada and the United Kingdom', *National Identities* 7 (2005), 173–91
Hennessy, Peter, 'What's Still Wrong with the Family', *Independent*, 27 February 1990, 14
Heppenstall, Rayner, 'Divided We Stand: On "The English Tradition"', *Encounter*, September 1960, 42–5
Herder, J.G., *Outlines of a Philosophy of the History of Man*, trans. T. Churchill, 2nd ed. (London, 1803)
Herman, Ellen, *The Romance of American Psychology: Political Culture in the Age of Experts* (Berkeley, 1995)
Hertz, Friedrich, *Race and Civilization*, trans. A.S. Levetus and W. Entz (London, 1928)
—— 'National Spirit and National Peculiarity', *Sociological Review* 26 (1934), 346–72
Hewison, Robert, *The Heritage Industry: Britain in a Climate of Decline* (London, 1987)
Hewstone, Miles, *Understanding Attitudes to the European Community* (Cambridge, 1986)
Higson, Andrew, *Waving the Flag: Constructing a National Cinema in Britain* (Oxford, 1995)
Hill, Amelia, 'The English Identity Crisis: Who Do You Think You Are?', *Observer*, 13 June 2004, 16–17
Hill, Christopher, 'The Norman Yoke', in *Democracy and the Labour Movement: Essays in Honour of Dona Torr*, ed. J. Saville (London, 1954)
Hill, Dave, 'We Can Hear the War Drums Roll, but Who is Beating Them?', *Guardian*, 9 February 1991, supp., 4
Hilton, Boyd, *The Age of Atonement: The Influence of Evangelicalism on Social and Economic Thought 1785–1865* (Oxford, 1988)
Hitchens, Christopher, *Blood, Class and Nostalgia: Anglo-American Ironies* (New York, 1990)
Hitchens, Peter, *The Abolition of Britain*, rev. ed. (London, 2000)
Hobhouse, L.T., *Democracy and Reaction* (1904), ed. P.F. Clarke (Brighton, 1972)
—— *Morals in Evolution*, 3rd ed. (London, 1915)
Hobsbawm, E.J., *Nations and Nationalism since 1780* (Cambridge, 1990)
Hobson, J.A., *The Psychology of Jingoism* (London, 1901)
—— 'Character and Society', in *Character and Life: A Symposium*, ed. Percy L. Parker (London, 1912), 53–104
—— 'In Praise of Muddling Through: A Study of English Policy', *Harper's Magazine*, July 1926, 177–84
Hodgen, Margaret T., *Early Anthropology in the Sixteenth and Seventeenth Centuries* (Philadelphia, 1964)
Hodson, Frodsham, 'The Influence of Education and Government on National Character' (1792), in *The Oxford English Prize Essays*, vol. 1 (Oxford, 1836), 275–94
Hoggart, Richard, *Townscape with Figures: Farnham. Portrait of an English Town* (London, 1994)
Holloway, John, 'The Myth of England', *Listener*, 15 May 1969, 670–2
Holmstrom, John, and Laurence Lerner (eds), *George Eliot and Her Readers: A Selection of Contemporary Reviews* (London, 1966)
Holtby, Winifred, 'The Egotistical English', *Listener*, 1 November 1933, 669
Hoock, Holger, *The King's Artists: The Royal Academy of Arts and the Politics of British Culture, 1760–1840* (Oxford, 2003)
'The Hopes of Humanity', *Church Quarterly Review* 36 (1893), 349–62

Hopkins, N., and N. Murdoch, 'The Role of the "Other" in National Identity: Exploring the Context-Dependence of the National Ingroup Stereotype', *Journal of Community and Applied Social Psychology* 9 (1999), 321–38

Hoppen, K. Theodore, 'Nationalist Mobilisation and Governmental Attitudes: Geography, Politics and Nineteenth-Century Ireland', in *A Union of Multiple Identities: The British Isles, c.1750–c.1850*, ed. Laurence Brockliss and David Eastwood (Manchester, 1997), 162–78

—— *The Mid-Victorian Generation 1846–1886* (Oxford, 1998)

Horne, Donald, *God Is An Englishman* (Harmondsworth, 1969)

Horsman, Reginald, 'Origins of Racial Anglo-Saxonism in Great Britain before 1850', *Journal of the History of Ideas* 37 (1976), 387–410

—— *Race and Manifest Destiny: The Origins of American Racial Anglo-Saxonism* (Cambridge, Mass., 1981)

Hovelacque, Abel, *The Science of Language: Linguistics, Philology, Etymology*, trans. A.H. Keane (London, 1877)

Howitt, William, *The Rural and Domestic Life of Germany* (London, 1842)

—— *Homes and Haunts of the Most Eminent British Poets*, 2nd ed., 2 vols (London, 1847)

Howkins, Alun, 'The Discovery of Rural England', in *Englishness: Politics and Culture 1880–1920*, ed. Robert Colls and Philip Dodd (London, 1986), 62–88

Hudson, Derek, *Martin Tupper: His Rise and Fall* (London, 1949)

Hueffer, Ford Madox, *England and the English: An Interpretation* (New York, 1907)

Hughes, Spencer Leigh, *The English Character* (London and Edinburgh, 1912)

Huizinga, J.H., *Confessions of a European in England* (London, 1958)

Hume, A., 'Origin and Characteristics of the Population in the Counties of Down and Antrim', *Ulster Journal of Archaeology* 1 (1853), 9–26, 120–9, 246–54

—— *Origin and Characteristics of the People of the Counties of Down and Antrim* (Belfast, 1874)

Hume, David, 'Of National Characters' (1748), in *Political Essays*, ed. Knud Haakonssen (Cambridge, 1994), 78–92

Hunt, Tamara L., *Defining John Bull: Political Caricature and National Identity in Late Georgian England* (Aldershot, 2003)

Huntington, Ellsworth, *Civilization and Climate* (New Haven, 1915)

Hutton, Graham, '"Perfidious Albion"! Some Reasons for the Foreigner's Misunderstanding of our National Character', *Bookman* 85 (1933–34), 430–1

—— 'As Europe Sees Us', *Geographical Magazine* 23 (1950–51), 213–18

Hutton, William Holden (ed.), *Letters of William Stubbs* (London, 1904)

Huxley, Julian S., and A.C. Haddon, *We Europeans: A Survey of 'Racial' Problems* (London, 1935)

Huxley, Thomas Henry, *Evidence as to Man's Place in Nature* (London, 1863)

Huxley, Thomas Henry, 'The Forefathers and Forerunners of the English People' (1870), in *Images of Race*, ed. Michael D. Biddiss (Leicester, 1979), 157–69

Hyde, H. Montgomery (ed.), *A Victorian Historian: Private Letters of W.E.H. Lecky 1859–1878* (London, 1947)

Hynes, Samuel, *A War Imagined: The First World War and English Culture* (London, 1990)

Ignatieff, Michael, 'Europe, My Europe', *The Times*, 19 February 1987, 12

Inge, William Ralph, 'The Future of the English Race', *Edinburgh Review* 229 (1919), 209–31

—— *England* (London, 1926)

—— 'Nationalism and National Character', *Quarterly Review* 277 (1941), 125–43

—— 'An Old Man Looks at the World', *Hibbert Journal* 46 (1947–48), 103–6

Inglis, Fred, 'Patriotism and the Left', *New Statesman*, 12 August 1977, 198

Innes, Joanna, 'Legislating for Three Kingdoms: How the Westminster Parliament Legislated for England, Scotland and Ireland, 1707–1830', in *Parliaments, Nations and Identities in Britain and Ireland, 1660–1850*, ed. Julian Hoppit (2003), 15–47

Irving, Clive, *True Brit* (London, 1974)

Jacobson, Dan, 'The Secret of the English', *Times Literary Supplement*, 30 July 1971, 884

Jacyna, L.S., 'The Physiology of Mind, the Unity of Nature, and the Moral Order in Victorian Thought', *British Journal for the History of Science* 14 (1981), 109–32

James, Oliver, *Britain on the Couch: Why We're Unhappy Compared with 1950 Despite Being Richer* (London, 1997)

Jarvis, David, 'The Shaping of Conservative Electoral Hegemony, 1918–39', in *Party, State and Society: Electoral Behaviour in Britain since 1820*, ed. Jon Lawrence and Miles Taylor (Aldershot, 1997), 131–52

Jay, Antony (ed.), *The Oxford Dictionary of Political Quotations* (Oxford, 1996)

Jeffery, Charlie (comp.), 'Devolution: What Difference Has It Made?', Interim Findings from the ESRC Research Programme on Devolution and Constitutional Change (Edinburgh, [March 2004]), <http://www. devolution.ac.uk/Interim_Findings_04. pdf>

Jeffery, Tom, *Mass-Observation: A Short History*, Mass-Observation Archive Occasional Paper No. 10 (Brighton: University of Sussex Library, 1999)

Jenkins, Daniel, *The British: Their Identity and Their Religion* (London, 1975)

Johnson, Daniel, 'Why the Giant of Europe Must Expect Some Knocks', *The Times*, 14 July 1990

Johnson, Douglas, 'Odd Man In', *New Society*, 28 December 1972, 726–8

Johnson, Paul, *The Offshore Islanders* (London, 1972)

Jones, Greta, *Social Darwinism and English Thought: The Interaction between Biological and Social Theory* (Brighton, 1980)

Jones, H.S., *Victorian Political Thought* (Basingstoke, 2000)

—— 'The Idea of the National in Victorian Political Thought', *European Journal of Political Theory* 5 (2006), 12–21

Jones, Max, *The Last Great Quest: Captain Scott's Antarctic Sacrifice* (Oxford, 2003)

Jones, Thomas, 'The Making of Nations', *Welsh Outlook* 16 (1929), 70–5

—— 'Welsh Character', *Listener*, 31 January 1934, 195–7

Joyce, Patrick, *Visions of the People: Industrial England and the Question of Class, 1840–1914* (Cambridge, 1991)

—— *Democratic Subjects: The Self and the Social in Nineteenth-Century England* (Cambridge, 1994)

Judt, Tony, 'Whose Common Culture?', *Times Literary Supplement*, 14 September 1990, 967–8

Junius Junior, *National Character of the English and French People* (London, 1795)

Kadish, Alon, *The Oxford Economists in the Late Nineteenth Century* (Oxford, 1982)

Kantorowicz, Hermann, *The Spirit of British Policy and the Myth of the Encirclement of Germany*, trans. W.H. Johnston (London, 1931)

Karaka, D.F., *Oh! You English* (London, 1935)

Keane, A.H., *Man Past and Present* (Cambridge, 1899)

—— *The World's Peoples: A Popular Account of their Bodily and Mental Character, Beliefs, Traditions, Political and Social Institutions* (London, 1908)

—— *Man Past and Present*, ed. A.H. Quiggin and A.C. Haddon (Cambridge, 1920)

Kearney, Hugh, *The British Isles: A History of Four Nations* (Cambridge, 1989)

Keats, John, 'Britain: A Sorry State', *Daily Telegraph Magazine*, 28 January 1972, 7

Kebbel, T.E. (ed.), *Selected Speeches of the late Earl of Beaconsfield*, 2 vols (London, 1882)

Keene, Weyland, 'A Polish People', *Spectator*, 8 May 1915, 645–6

Keith, Sir Arthur, *An Autobiography* (London, 1950)

Kelvin, R.P., 'Here Is What Sort of People?', *New Society*, 9 May 1963, 8–14

—— 'What Sort of People Now?', *New Society*, 30 November 1972, 497–501

Kemble, John Mitchell, *The Saxons in England: A History of the English Commonwealth till the Period of the Norman Conquest*, 2 vols (London, 1849)

[Kemble, John Mitchell], 'English Historical Society', *British & Foreign Review* 7 (1838), 167–92

Kennedy, Paul, *The Realities Behind Diplomacy: Background Influences on British External Policy, 1865–1980* (London, 1981)

—— *Strategy and Diplomacy, 1870–1945: Eight Studies* (London, 1983)

Kent, Christopher, *Brains and Numbers: Elitism, Comtism, and Democracy in Mid-Victorian England* (Toronto, 1978)

Kenyon, Sir Frederic, 'Ideals and Characteristics of English Culture', *Cornhill Magazine*, n.s., 40 (1916), 326–44

Keun, Odette, *I Discover the English* (London, 1934)

Kidd, Benjamin, *Social Evolution* (London, 1898)

Kidd, Colin, *Subverting Scotland's Past: Scottish Whig Historians and the Creation of an Anglo-British Identity, 1689–c.1830* (Cambridge, 1993)

—— 'Teutonist Ethnology and Scottish Nationalist Inhibition, 1780–1880', *Scottish Historical Review* 74 (1995), 45–68

—— 'Sentiment, Race and Revival: Scottish Identities in the Aftermath of Enlightenment', in *A Union of Multiple Identities: The British Isles, c.1750–c.1850*, ed. Laurence Brockliss and David Eastwood (Manchester, 1997), 110–26

—— *British Identities Before Nationalism: Ethnicity and Nationhood in the Atlantic World, 1600–1800* (Cambridge, 1999)

—— 'Race, Empire, and the Limits of Nineteenth-Century Scottish Nationhood', *Historical Journal* 46 (2003), 873–92

King, Edmund, '"The Gentleman": The Evolution of an English Ideal', *Year Book of Education 1961*, ed. G.Z.F. Bereday and J.A. Lauwerys (London, 1961), 112–19

Kingsley, Charles, 'Froude's History of England', in *Miscellanies* (London, 1859), vol. 2, 25–76

—— *The Roman and the Teuton* (Cambridge and London, 1864)

—— 'The Ancien Regime' (1867), in *Historical Lectures and Essays* (London, 1880), 135–234

—— 'On English Literature' (1848), in *Literary and General Lectures and Essays* (London, 1890), 245–65

Kingsley, Fanny (ed.), *Charles Kingsley: His Letters and Memories of His Life*, 2 vols (London, 1877)

Kingsley, John, *Irish Nationalism: Its Origin, Growth, and Destiny* (London, [?1887])

Kircher, Rudolf, *Powers and Pillars: Intimate Portraits of British Personalities*, trans. Constance Vesey (London, 1928)

Klein, Josephine, *Samples from English Cultures* (London, 1965)

Klein, Viola, *The Feminine Character: History of an Ideology* (London, 1946)

Knight, Charles, *The Popular History of England*, 8 vols (London, 1856–62)

Knowler, John, *Trust an Englishman* (London, 1972)

Knox, Robert, *The Races of Men: A Fragment* (London, 1850)

—— *The Races of Men: A Philosophical Inquiry into the Influence of Race over the Destinies of Nations*, 2nd ed. (London, 1862)

Koestler, Arthur (ed.), *Suicide of a Nation? An Enquiry into the State of Britain* (1963) (London, 1994)

Kohn, Hans, 'The Genesis and Character of English Nationalism', *Journal of the History of Ideas* 1 (1940), 69–94

Kuklick, Henrika, 'Tribal Exemplars: Images of Political Authority', in *Functionalism Historicized: Essays on British Social Anthropology*, ed. George W. Stocking, Jr. (Madison, Wis., 1984), 59–82

—— *The Savage Within: The Social History of British Anthropology, 1885–1945* (Cambridge, 1992)

Kumar, Krishan, 'A Future in the Past?', *New Society*, 24 November 1977, 418–19

—— *The Making of English National Identity* (Cambridge, 2003)

Kushner, Tony, *We Europeans? Mass-Observation, 'Race' and British Identity in the Twentieth Century* (Aldershot, 2004)

Kyba, Patrick, *Covenants Without the Sword: Public Opinion and British Defense Policy 1931–1935* (Waterloo, Ontario, 1983)

La Barre, Weston, 'Columbia University Research in Contemporary Cultures', *Scientific Monthly* 67 (1948), 239–40

Laing, Samuel, *Notes of a Traveller, on the Social and Political State of France, Prussia, Switzerland, Italy, and other Parts of Europe* (London, 1842)

—— *Observations on the Social and Political State of the European People in 1848 and 1849* (London, 1850)

Landale, James, 'True Brits, and the Not-So-True', *Independent*, 20 May 1992, 16

Landau, Rom, *The Fool's Progress: Aspects of British Civilization in Action* (London, 1942)

Lang, Timothy, *The Victorians and the Stuart Heritage* (Cambridge, 1995)

Langdon-Davies, John, 'English Amateurs and American Professionals', *Harper's Magazine*, January 1933, 230–9

Langford, Paul, *Englishness Identified: Manners and Character 1650–1850* (Oxford, 2000)

Laski, Harold J., *The Danger of Being a Gentleman and Other Essays* (London, 1939)

Laslett, Peter, 'On Being an Englishman in 1950', *Cambridge Journal* 3 (1949–50), 486–96

Latham, R.G., *The Natural History of the Varieties of Man* (London, 1850)

—— *Man and His Migrations* (London, 1851)

—— *The Ethnology of the British Islands* (London, 1852)

—— *The Ethnology of Europe* (London, 1852)

Latham, R.G., 'Varieties of the Human Race', in *Orr's Circle of the Sciences: Organic Nature* (London, 1854), vol. 1, 305–76

—— *The Nationalities of Europe*, 2 vols (London, 1863)

Lawson, Dominic, 'Saying the Unsayable About the Germans', *Spectator*, 14 July 1990, 8–10

Leadbeater, Charles, 'Thoroughly Modern Britain', *New Statesman*, 10 October 1997, 22–3, 25

Leary, David E., 'The Fate and Influence of John Stuart Mill's Proposed Science of Ethology', *Journal of the History of Ideas* 43 (1982), 153–62

Lebow, Richard Ned, *White Britain and Black Ireland: The Influence of Stereotypes on Colonial Policy* (Philadelphia, 1976)

Lecky, W.E.H., *History of the Rise and Influence of the Spirit of Rationalism in Europe* (London, 1865)

—— *History of European Morals*, 2 vols (London, 1869)

—— *The Political Value of History* (Birmingham, 1892)

—— *Democracy and Liberty*, 2 vols (London, 1896)

Lees, Andrew, *Revolution and Reflection: Intellectual Change in Germany during the 1850s* (The Hague, 1974)

—— *Cities Perceived: Urban Society in European and American Thought, 1820–1940* (Manchester, 1985)

Leonard, Mark, *Britain^TM: Renewing Our Identity* (London, 1997)

—— 'Britain Needs a New Brand Image', *Independent*, 8 September 1997, 11

Leslie, Ann, and Yasmin Alibhai-Brown, 'Proud to be British', *New Statesman*, 26 June 1998, 14–15

Lessing, Doris, *In Pursuit of the English* (London, 1960)

Lewes, G.H., *The Study of Psychology: Its Object, Scope, and Method* (London, 1879)

[Lewes, G.H.], 'State of Historical Science in France', *British & Foreign Review* 16 (1843), 72–118

Lewis, Wyndham, *The Mysterious Mr Bull* (London, 1938)

Light, Alison, *Forever England: Femininity, Literature and Conservatism Between the Wars* (London, 1991)

Lights on Home Rule (London, [1893])

Lin, Yu-Tang, 'China Speaks – With a Smile: Wisdom and Humour about the English', *World Review*, December 1936, 65–71

Lorimer, Douglas A., *Colour, Class and the Victorians: English Attitudes to the Negro in the Mid-Nineteenth Century* (Leicester, 1978)

Lorimer, James, *Political Progress Not Necessarily Democratic: or Relative Equality the True Foundation of Liberty* (London and Edinburgh, 1857)

—— *Constitutionalism of the Future; or Parliament the Mirror of the Nation*, 2nd ed. (London, 1867)

Loughlin, James, *Gladstone, Home Rule and the Ulster Question 1882–93* (Dublin, 1986)

—— *Ulster Unionism and British National Identity since 1885* (London and New York, 1995)

Lyall, A.C., 'National Life and Character', *Nineteenth Century* 33 (1893), 892–6

Macaulay, Rose, 'Past and Present: Have We Improved?', *Spectator*, 23 November 1934, 792–3

MacCulloch, J.A., 'English and Scots: The Gulf Between', *Spectator*, 19 January 1934, 80–1

Macdonell, A.G., *England, Their England* (1933) (London, 1983)

Macdonell, P.J., 'The Historic Basis of Liberalism', in *Essays in Liberalism By Six Oxford Men* (London, 1897), 219–75

MacDougall, Hugh A., *Racial Myth in English History* (Montreal, 1982)

Mace, C.A., 'National Stereotypes – Their Nature and Function', *Sociological Review* 35 (1943), 29–36

MacInnes, Colin, *England, Half English* (London, 1961)

MacIver, R.M., *Community: A Sociological Study* (London, 1917)

Mackay, Jane, and Pat Thane, 'The Englishwoman', in *Englishness: Politics and Culture 1880–1920*, ed. Robert Colls and Philip Dodd (London, 1986), 191–229

MacKenzie, John M., *Propaganda and Empire: The Manipulation of British Public Opinion, 1880–1960* (Manchester, 1984)

Mackenzie, J.S., *Arrows of Desire: Essays on Our National Character and Outlook* (London, 1920)

Mackenzie, S.P., *Politics and Military Morale: Current-Affairs and Citizenship Education in the British Army, 1914–1950* (Oxford, 1992)

Mackinder, Sir Halford, 'The English Tradition and the Empire: Some Thoughts on Lord Milner's Credo and the Imperial Committees', *United Empire*, n.s., 16 (1925), 724–35

Macmillan, Harold, *The Middle Way: A Study of the Problem of Economic and Social Progress in a Free and Democratic Society* (London, 1938)

Macnamara, Nottidge Charles, *Origin and Character of the British People* (London, 1900)

MacRae, Donald G., 'English Nationalism', *Views*, Autumn–Winter 1963, 51–4

—— 'Our Island Sleep', *New Society*, 11 June 1970, 1009

Macrae, Norman, 'The People We Have Become', *The Economist*, 28 April 1973, 'Survey', 1–34

Madariaga, Salvador de, *Englishmen, Frenchmen, Spaniards* (1928), 2nd ed. (London, 1970)

Madge, Charles, and Tom Harrisson, *Mass-Observation* (London, 1937)

—— *First Year's Work 1937–38 by Mass-Observation* (London, 1938)

Maillaud, Pierre, *The English Way* (London, 1945)

Maine, Henry Sumner, *Ancient Law*, 3rd ed. (London, 1866)

—— *Popular Government* (London, 1885)

Mallett, Philip, 'Rudyard Kipling and the Invention of Englishness', in *Beyond Pug's Tour: National and Ethnic Stereotyping in Theory and Practice*, ed. C.C. Barfoot (Amsterdam, 1997), 255–66

Mandler, Peter, *Aristocratic Government in the Age of Reform: Whigs and Liberals, 1830–1852* (Oxford, 1990)

—— 'Against "Englishness": English Culture and the Limits to Rural Nostalgia, 1850–1940', *Transactions of the Royal Historical Society*, 6th ser., 7 (1997), 155–75

—— 'England, Which England?', *Contemporary British History* 13 (1999), 243–54

—— '"Race" and "Nation" in Mid-Victorian Thought', in *History, Religion and Culture: British Intellectual History 1750–1950*, ed. S. Collini, R. Whatmore and B. Young (Cambridge, 2000), 224–44
—— 'The Consciousness of Modernity? Liberalism and the English National Character, 1870–1940', in *Meanings of Modernity: Britain from the Late-Victorian Era to World War II*, ed. M. Daunton and B. Rieger (Oxford, 2001), 119–44
—— *History and National Life* (London, 2002)
—— 'How Modern Is It?', *Journal of British Studies* 42 (2003), 271–82
—— 'Gold out of Straw', *London Review of Books*, 19 February 2004
—— 'The Problem with Cultural History', *Cultural and Social History* 1 (2004), 5–28
—— 'What is "National Identity"? Definitions and Applications in Modern British Historiography', *Modern Intellectual History* 3 (2006), 271–97
Mandler, Peter, Alex Owen, Seth Koven and Susan Pedersen, 'Cultural Histories Old and New: Rereading the Work of Janet Oppenheim', *Victorian Studies* 41 (1997), 69–103
Marcus, Sharon, *Apartment Stories: City and Home in Nineteenth-Century Paris and London* (Berkeley, 1999)
Marquand, David, 'How United is the Modern United Kingdom?', in *Uniting the Kingdom? The Making of British History*, ed. Alexander Grant and Keith J. Stringer (London, 1995), 277–91
Marriott, Sir John, 'England Through Foreign Spectacles', *Fortnightly Review*, n.s., 142 (1937), 343–50
Marsh, Jan, *Back to the Land: The Pastoral Impulse in England, from 1880 to 1914* (London, 1982)
Marsh, Peter T., *The Discipline of Popular Government: Lord Salisbury's Domestic Statecraft 1881–1902* (Hassocks, 1978)
Martin, Kingsley, 'Notes on the Anglo-Saxon Character', *Political Quarterly* 11 (1940), 198–218
Marvin, F.S., 'Britain's Place in Western Civilization', in *The New Past and Other Essays on the Development of Civilisation*, ed. E.H. Carter (Oxford, 1925), 171–83
Maschler, Tom (ed.), *Declaration* (London, 1957)
Masefield, John, *Reynard the Fox, or The Ghost Heath Run* (London, [1919])
Mason, Philip, *The English Gentleman: The Rise and Fall of an Ideal* (London, 1982)
Massingham, H.J., *People and Things: An Attempt to Connect Art and Humanity* (London, 1919)
—— *The Heritage of Man* (London, 1929)
Masterman, C.F.G., 'The English City', in *England: A Nation*, ed. Lucian Oldershaw (London and Edinburgh, 1904), 44–94
—— *The Condition of England* (London, 1909)
Matthew, H.C.G., *Gladstone, 1809–1874* (Oxford, 1986)
Matthews, Herbert and Nancie, *The Britain We Saw: A Family Symposium* (London, 1950)
Maude, Angus, and Enoch Powell, *Biography of a Nation: A Short History of Britain* (1955), rev. ed. (London, 1970)
Maudsley, Henry, *The Physiology of Mind* (London, 1876)
Maurice, F.D., *Social Morality* (London and Cambridge, 1869)
Maurois, André, 'The Englishman of To-Day', *Cornhill Magazine*, n.s., 68 (1930), 1–16
—— *3 Letters on the English* (London, 1938)
—— *The Silence of Colonel Bramble and The Discourses of Doctor O'Grady* (1919–21) (London, 1965)
Mayne, Richard, 'Any More for the Stereotype?', *Encounter*, August 1966, 3–8
Mazower, Mark, *Dark Continent: Europe's Twentieth Century* (London, 1998)
[Mazzini, Giuseppe], 'The Works of Thomas Carlyle', *British and Foreign Review* 16 (1844), 262–93
McCarthy, Justin, *Reminiscences*, 2 vols (London, 1899)
McCarthy, Mary, 'Thoughts of an American in England', *Listener*, 17 June 1954, 1041–2
McDougall, William, *The Group Mind* (Cambridge, 1920)

McGiffert, Michael, 'Selected Writings on American National Character', *American Quarterly* 15 (1963), 271–88

—— 'Selected Writings on American National Character and Related Subjects to 1969', *American Quarterly* 21 (1969), 330–49

McIntosh, Gillian, *The Force of Culture: Unionist Identities in Twentieth-Century Ireland* (Cork, 1999)

McKibbin, Ross, 'Class and Conventional Wisdom: The Conservative Party and the "Public" in Inter-war Britain', in *The Ideologies of Class: Social Relations in Britain 1880–1950* (Oxford, 1994), 259–93

McLaine, Ian, *Ministry of Morale: Home Front Morale and the Ministry of Information in World War II* (London, 1979)

McLeod, Hugh, *Secularisation in Western Europe, 1848–1914* (Basingstoke, 2000)

Mead, Margaret, 'The English as a Foreigner Sees Them', *Listener*, 18 September 1947, 475–6

Meadows, Kenny, *Heads of the People: or, Portraits of the English. Drawn by Kenny Meadows. With Original Essays by Distinguished Writers*, 2 vols (London, [?1840])

Mehta, Uday Singh, *Liberalism and Empire: A Study in Nineteenth-Century British Liberal Thought* (Chicago, 1999)

Melman, Billie, 'Claiming the Nation's Past: The Invention of an Anglo-Saxon Tradition', *Journal of Contemporary History* 26 (1991), 575–95

Menzies, R.G., 'The English Character', *London Quarterly and Holborn Review* 166 (1941), 282–92

Merriman, Nick, *Beyond the Glass Case: The Past, the Heritage and the Public in Britain* (Leicester, 1991)

Metcalf, Thomas, *Ideologies of the Raj*, The New Cambridge History of India, vol. 3, pt 4 (Cambridge, 1994)

Middleton, Drew, *The British* (London, 1957)

Mikes, George, *How to be a Brit* (London, 1986)

Mill, John Stuart, *Collected Works of John Stuart Mill*, 33 vols (Toronto, 1981–91)

Millar, John, *An Historical View of the English Government, from the Settlement of the Saxons in Britain to the Revolution in 1688*, 3rd ed., 4 vols (London, 1803)

—— *The Origin of the Distinction of Ranks*, 4th ed. (Edinburgh, 1806)

Miller, Alistair, 'The English Death', *Spectator*, 10 March 1990, 18–19

Miller, David, *On Nationality* (Oxford, 1995)

[Milman, H.H.], 'Prescott's Conquest of Peru; Tschudi's Travels in Peru', *Quarterly Review* 81 (1847), 317–51

Mitchell, P. Chalmers, *Evolution and the War* (London, 1915)

Montesquieu, Charles Louis de Secondat, Baron de, *The Spirit of the Laws* (1748), ed. David Wallace Carrithers (Berkeley, 1977)

—— 'An Essay on Causes Affecting Minds and Characters' (1736–43), in *The Spirit of the Laws*, ed. David Wallace Carrithers (Berkeley, 1977)

Moore, Suzanne, 'Real Britannia: What Does it Mean to be British?', *Independent*, 20 July 1998, 1

Morand, Paul, '"The Gentleman's Island"', *Listener*, 27 December 1933, 969–70, 1000

Morgan, Charles, 'The English Character', *Spectator*, 23 November 1934, 789–90

Morgan, David, and Mary Evans, 'The Road to *Nineteen Eighty-Four*: Orwell and the Post-War Reconstruction of Citizenship', in *What Difference Did the War Make?*, ed. Brian Brivati and Harriet Jones (Leicester, 1993), 48–62

Morgan, Marjorie, *National Identities and Travel in Victorian Britain* (Basingstoke, 2001)

Morgan, Prys, 'Early Victorian Wales and its Crisis of Identity', in *A Union of Multiple Identities: The British Isles, c.1750–c.1850*, ed. Laurence Brockliss and David Eastwood (Manchester, 1997), 93–109

Morley, John, 'The Expansion of England', *Macmillan's Magazine* 49 (1883–84), 241–58

Morris, James, 'Patriotism', *Encounter*, January 1962, 17–18

—— 'Ancients and Britons', *Spectator*, 29 November 1963, 686–7

Morton, Graeme, *Unionist-Nationalism: Governing Urban Scotland, 1830–1860* (East Linton, 1999)

Morton, H.V., *I Saw Two Englands* (London, 1942)

Mount, Ferdinand, 'Hypernats and Country-Lovers', *Spectator*, 18 February 1989, 9–12

Muggeridge, Malcolm, 'I Love You England', *New Statesman*, 21 January 1966, 77

Muir, Ramsay, *Nationalism and Internationalism* (London, 1916)

—— *National Self-Government: Its Growth and Principles* (London, 1918)

Murray, Hugh, *Enquiries Historical and Moral Respecting the Character of Nations and the Progress of Society* (Edinburgh, 1808)

Murray, John, 'English Character', *Contemporary Review* 152 (1937), 39–47

Murray, Nicholas, *A Life of Matthew Arnold* (London, 1996)

Nairn, Tom, *The Break-Up of Britain* (London, 1977)

—— *After Britain: New Labour and the Return of Scotland* (London, 2000)

Nash, Ogden, 'England Expects', in *Collected Verse from 1929 On* (London, 1961), 193–4

'The National Character: A Working Woman Gives Her Views', *Listener*, 21 March 1934, 490–1

'National Personality', *Edinburgh Review* 194 (1901), 132–47

Neale, J.E., 'English Local Government: A Historical Retrospect' (1935), in *Essays in Elizabethan History* (London, 1958), 202–24

Nevinson, Henry W., *The English* (London, 1929)

—— *Rough Islanders, or The Natives of England* (London, 1930)

—— *Ourselves: An Essay on the National Character* (London, 1933)

Newbigin, Marion I., 'The Origin and Maintenance of Diversity in Man', *Geographical Review* 6 (1918), 411–20

Newman, Gerald, *The Rise of English Nationalism: A Cultural History, 1740–1830* (New York, 1987)

Nicholas, Sian, 'The Construction of a National Identity: Stanley Baldwin, "Englishness" and the Mass Media in Inter-War Britain', in *The Conservatives and British Society, 1880–1990*, ed. Martin Francis and Ina Zweiniger-Bargielowska (Cardiff, 1996), 127–46

—— *The Echo of War: Home Front Propaganda and the Wartime BBC, 1939–45* (Manchester, 1996)

—— 'From John Bull to John Citizen: Images of National Identity and Citizenship on the Wartime BBC', in *The Right to Belong: Citizenship and National Identity in Britain, 1930–1960*, ed. Richard Weight and Abigail Beach (London, 1998), 36–58

Nicholas, Thomas, *The Pedigree of the English People*, 2nd ed. (London, 1868)

Nicholls, Anthony J., 'The German "National Character" in British Perspective', in *Conditions of Surrender: Britons and Germans Witness the End of the War*, ed. Ulrike Jordan (London, 1997), 26–39

Nichols, Beverley, *News of England, or A Country Without a Hero* (London, 1938)

Nicolson, Harold, 'As Others See Us: How the English Appear to the Foreign Mind', *Listener*, 15 May 1935, 817–18

—— *National Character and National Policy* (Nottingham, 1938)

—— 'Marginal Comment', *Spectator*, 15 August 1947, 204

—— 'After the Festival: A Note for Posterity', *Listener*, 11 January 1951, 733–4

Noakes, Lucy, *War and the British: Gender, Memory and National Identity* (London, 1998)

Norman, Philip, 'Why John Bull has Exchanged his Stiff Upper Lip for a Stiff Upper Cut', *Sunday Times Magazine*, 31 October 1999, 60–6

Nossiter, Bernard D., *Britain: A Future That Works* (London, 1978)

Nye, Robert A., *Crime, Madness and Politics in Modern France: The Medical Concept of National Decline* (Princeton, 1984)

Oakesmith, John, *Race and Nationality: An Inquiry into the Origin and Growth of Patriotism* (London, 1919)

O'Donovan, Patrick, 'Who Do We Think We Are?', *Observer*, 20 October 1971, 8

Oergel, Maike, 'The Redeeming Teuton: Nineteenth-Century Notions of the "Germanic" in England and Germany', in *Imagining Nations*, ed. Geoffrey Cubitt (Manchester, 1998), 75–91

O'Keefe, Timothy (ed.), *Alienation* (London, 1960)

Oldershaw, Lucian, 'The Fact of the Matter', in *England: A Nation* (London and Edinburgh, 1904), 253–62

—— (ed.), *England: A Nation* (London and Edinburgh, 1904)

Orwell, George, *Collected Essays, Journalism and Letters*, ed. Sonia Orwell and Ian Angus, 4 vols (London, 1968)

Osborne, John, 'And They Call it Cricket', *Encounter*, October 1957, 23–30

Osmond, John, *The Divided Kingdom* (London, 1988)

Pakenham, Thomas, *The Boer War* (New York, 1979)

Palgrave, Sir Francis, *The Collected Historical Works of Sir Francis Palgrave*, ed. Sir Robert H.I. Palgrave, 10 vols (Cambridge, 1921)

Palmer, J. Foster, 'The Saxon Invasion and Its Influence on our Character as a Race', *Transactions of the Royal Historical Society*, n.s., 2 (1885), 173–96

Paradis, James, and George C. Williams (eds), *Evolution and Ethics: T.H. Huxley's Evolution and Ethics with New Essays on its Victorian and Sociobiological Context* (Princeton, 1989)

Parekh, Bhiku, 'Defining British National Identity', *Political Quarterly* 71 (2000), 4–14

Parker, Christopher, 'The Failure of Liberal Racialism: The Racial Ideas of E.A. Freeman', *Historical Journal* 24 (1981), 825–46

—— *The English Historical Tradition Since 1850* (Edinburgh, 1990)

Parry, J.P., *Democracy and Religion: Gladstone and the Liberal Party, 1867–1875* (Cambridge, 1986)

—— *The Rise and Fall of Liberal Government in Victorian Britain* (New Haven and London, 1993)

—— 'The Impact of Napoleon III on British Politics, 1851–1880', *Transactions of the Royal Historical Society*, 6th ser., 11 (2001), 147–75

Partridge, Simon, 'Rebirth of a Nation?', *New Statesman*, 27 October 1995, 18–19

[Pattison, Mark], 'History of Civilization in England', *Westminster Review* 68 (1857), 375–99

Paxman, Jeremy, *The English: A Portrait of a People* (London, 1998)

Peabody, Dean, *National Characteristics* (Cambridge, 1985)

Pear, T.H., *English Social Differences* (London, 1955)

Peardon, Thomas Preston, *The Transition in English Historical Writing 1760–1830* (New York, 1933)

Pearson, Charles H., 'On Some Historical Aspects of Family Life', in *Woman's Work and Woman's Culture*, ed. Josephine E. Butler (London, 1869), 152–85

—— *National Life and Character: A Forecast* (London, 1893)

—— 'An Answer to Some Critics', *Fortnightly Review*, n.s., 54 (1893), 149–70

Pearson, Karl, 'On the Inheritance of the Mental and Moral Characters in Man, and Its Comparison with the Inheritance of the Physical Characters', *Journal of the Anthropological Institute of Great Britain and Ireland* 33 (1903), 179–237

—— *National Life from the Standpoint of Science* (London, 1905)

Peatling, G.K., *British Opinion and Irish Self-Government 1865–1925* (Dublin, 2001)

Pecora, Vincent P., 'Arnoldian Ethnology', *Victorian Studies* 41 (1997–98), 355–79

Penny, Nicholas, '"Amor Publicus Posuit": Monuments for the People and of the People', *Burlington Magazine* 129 (1987), 793–800

'The People of England – Who Are They?', *Fraser's Magazine* 5 (1832), 98–106

Perkins, Mary Anne, *Nation and Word, 1770–1850: Religious and Metaphysical Language in European National Consciousness* (Aldershot, 1999)

Petrie, W.M. Flinders, *Janus in Modern Life* (London, 1907)

Pevsner, Nikolaus, *The Englishness of English Art* (London, 1956)

Peyton, John, 'Time to Halt the Decline', *Spectator*, 22 June 1974, 761

Phillimore, J.S., 'Liberalism in Outward Relations', in *Essays in Liberalism By Six Oxford Men* (London, 1897), 131–73

Phillips, Paul T., *The Controversialist: An Intellectual Life of Goldwin Smith* (Westport, Conn., 2002)

Phillips, Trevor, and Peregrine Worsthorne, 'England's on the Anvil', *Prospect*, March 1996, 16–19

Pick, Daniel, *Faces of Degeneration: A European Disorder, c.1848–c.1918* (Cambridge, 1989)

Pike, Luke Owen, *The English and Their Origin* (London, 1866)

Pimlott, J.A.R., 'A Nation of Gardeners?', *New Society*, 23 April 1964, 18–19

Pocock, J.G.A., *The Ancient Constitution and the Feudal Law*, 2nd ed. (Cambridge, 1987)

Pollock, Sir Frederick, *An Introduction to the History of the Science of Politics* (London, 1890)

[Pollock, W.F.], 'Civilization in England', *Quarterly Review* 104 (1858), 38–74

'Pont' [Graham Laidler], *The British Character* (London, 1938)

Poovey, Mary, *Making a Social Body: British Cultural Formation, 1830–1864* (Chicago, 1995)

Porter, Bernard, '"Bureau and Barrack": Early Victorian Attitudes Towards the Continent', *Victorian Studies* 27 (1983–84), 407–33

——— '"Monstrous Vandalism": Capitalism and Philistinism in the Work of Samuel Laing (1780–1868)', *Albion* 23 (1991), 253–68

——— 'Virtue and Vice in the North: The Scandinavian Writings of Samuel Laing', *Scandinavian Journal of History* 23 (1998), 153–72

Porter, Henry, 'England, Our England', *Guardian*, 28 July 1993, supp., 2

Porter, Theodore M., *The Rise of Statistical Thinking 1820–1900* (Princeton, 1986)

Potter, David, *People of Plenty: Economic Abundance and the American Character* (Chicago, 1954)

Powell, Charles, 'What the PM Learnt about the Germans', *Independent on Sunday*, 15 July 1990, 19

Powell, J. Enoch, *Freedom and Reality*, ed. John Wood (London, 1969)

——— 'This New Unity that our Leaders must not Betray', *The Times*, 14 May 1982, 10

Powell, Michael, and Emeric Pressburger, *The Life and Death of Colonel Blimp*, ed. Ian Christie (London, 1994)

Price, Richard, *An Imperial War and the British Working Class: Working-Class Attitudes and Reactions to the Boer War 1899–1902* (London, 1972)

Prichard, James Cowles, *Researches into the Physical History of Man* (1813), ed. George W. Stocking, Jr. (Chicago, 1973)

Priestley, J.B., *Postscripts* (London, 1940)

——— 'Fifty Years of the English', *New Statesman*, 19 April 1963, 560–6

——— 'The Truth about the English', *Sunday Times*, 20 September 1970, 12

——— *The English* (London, 1973)

——— *English Journey* (1934) (Harmondsworth, 1977)

——— (ed.), *The Beauty of Britain: A Pictorial Survey* (London, 1935)

Pringle, John Douglas, 'Re-winding the Clock', *Encounter*, January 1962, 9–10

Pugh, Martin, *The Tories and the People 1880–1935* (Oxford, 1985)

Raban, Jonathan, *Coasting* (London, 1986)

'The Races of Mankind', *Eclectic Review*, 6th ser., 1 (1857), 586–604

Radcliffe, Lord, 'The Dissolving Society', *Spectator*, 13 May 1966, 590–2

Rae, John, 'Our Obsolete Attitudes: Education and the National Malaise', *Encounter*, November 1977, 10–17

Raglan, Lord, 'The Riddle of Race', *Listener*, 3 October 1934, 549–52, 583

Raven, Simon, *The English Gentleman: An Essay in Attitudes* (London, 1961)

——— 'Merrie England', *Spectator*, 13 January 1967, 37–8

Read, Herbert (ed.), *The English Vision* (London, 1939)

Readman, Paul A., 'The Liberal Party and Patriotism in Early Twentieth Century Britain', *Twentieth Century British History* 12 (2001), 269–302

Rée, Jonathan, 'Internationality', *Radical Philosophy* 60 (1992), 3–11

Reicher, Steve, and Nick Hopkins, *Self and Nation: Categorization, Contestation and Mobilization* (London, 2001)

Reicher, Steve, Nick Hopkins and Susan Condor, 'The Lost Nation of Psychology', in *Beyond Pug's Tour: National and Ethnic Stereotyping in Theory and Literary Practice*, ed. C.C. Barfoot (Amsterdam, 1997), 53–84

Reid, Harry, *Dear Country: A Quest for England* (Edinburgh, 1992)

Renan, Ernest, 'What is a Nation?' (1882), trans. Martin Thom, in *Nation and Narration*, ed. Homi K. Bhabha (London, 1990), 8–22

Rendall, Jane, 'Tacitus Engendered: "Gothic Feminism" and British Histories, c.1750–1800', in *Imagining Nations*, ed. Geoffrey Cubitt (Manchester, 1998), 57–74

—— 'The Citizenship of Women and the Reform Act of 1867', in Catherine Hall, Keith McClelland and Jane Rendall, *Defining the Victorian Nation: Class, Race, Gender and the Reform Act of 1867* (Cambridge, 2000), 119–78

Renier, G.J., *The English: Are They Human?* (London, 1931)

—— *He Came To England: A Self Portrait* (London, 1933)

Renier, G.J., and Karl Silex, 'Ourselves as Others See Us: A Discussion', *Listener*, 16 September 1931, 442–3

Rice, Veronica, 'André Maurois' English Portraits', *Contemporary Review* 131 (1927), 93–100

Rich, Paul B., 'A Question of Life and Death to England: Patriotism and the British Intellectuals, c.1886–1945', *New Community* 15 (1988–89), 491–508

—— 'Imperial Decline and the Resurgence of English National Identity, 1918–1979', in *Traditions of Intolerance: Historical Perspectives on Fascism and Race Discourse in Britain*, ed. Tony Kushner and Kenneth Lunn (Manchester, 1989), 33–52

—— *Race and Empire in British Politics*, 2nd ed. (Cambridge, 1990)

—— 'Social Darwinism, Anthropology and English Perspectives of the Irish, 1867–1900', *History of European Ideas* 19 (1994), 777–85

Richards, Evelleen, 'The "Moral Anatomy" of Robert Knox: The Interplay between Biological and Social Thought in Victorian Scientific Naturalism', *Journal of the History of Biology* 22 (1989), 373–436

Richards, Jeffrey, *Films and British National Identity: From Dickens to Dad's Army* (Manchester, 1997)

Richardson, Benjamin Ward, 'Race and Life on English Soil', *Fraser's Magazine*, n.s., 26 (1882), 313–34

Riesman, David, with Nathan Glazer and Reuel Denny, *The Lonely Crowd: A Study of the Changing American Character* (1950) (New Haven, 2001)

Rifkind, Malcolm, 'British Champion', *Prospect*, January 2000, 26–9

Ripley, William Z., *The Races of Europe: A Sociological Study* (London, 1900)

Ritchie, David G., *Darwinism and Politics* (London, 1889)

Rivers, W.H.R., 'History and Ethnology', *History*, n.s., 5 (1920–21), 65–80

Roach, John, 'Liberalism and the Victorian Intelligentsia', *Cambridge Historical Journal* 13 (1957), 58–81

Robbins, Keith, *Nineteenth-Century Britain: Integration and Diversity* (Oxford, 1989)

—— *Great Britain: Identities, Institutions and the Idea of Britishness* (London, 1998)

—— *Present and Past: British Images of Germany in the First Half of the Twentieth Century* (Göttingen, 1999)

Robertson, John Mackinnon, *Buckle and His Critics: A Study in Sociology* (London, 1895)

—— *The Saxon and the Celt* (London, 1897)

—— *The Germans* (London, 1916)

—— 'The Idea of Race Psychology', *Polish Review* 2 (1918), 116–33

—— 'The Illusion of Race', *Contemporary Review* 134 (1928), 28–33

Rogers, Ben, *Beef and Liberty: Roast Beef, John Bull and the English Nation* (London, 2004)

Romani, Roberto, *National Character and Public Spirit in Britain and France, 1750–1914* (Cambridge, 2002)

Rose, Jonathan, *The Intellectual Life of the British Working Classes* (New Haven and London, 2001)

Rose, Richard, 'Proud to be British', *New Society*, 7 June 1984, 379–81

Rose, Sonya O., *Which People's War? National Identity and Citizenship in Wartime Britain 1939–1945* (Oxford, 2003)

Rosebery, Lord, 'The Business of the British Empire', in *England's Mission by England's Statesmen*, ed. Arthur Mee (London, 1903), 29–42

Roseman, Renee, 'As Others See Us', *Social Service Quarterly* 65 (1971–72), 82–4

Rosenthal, Michael, *The Character Factory: Baden-Powell and the Origins of the Boy Scout Movement* (London, 1986)

Rowse, A.L., *The English Spirit: Essays in History and Literature* (London, 1944)

—— 'When the English Were Individuals', *Daily Telegraph*, 5 May 1980, 12

Royal Anthropological Institute and the Institute of Sociology, *Race and Culture* (London, [1935])

Royle, Edward, *Radicals, Secularists and Republicans: Popular Freethought in Britain, 1866–1915* (Manchester, 1980)

Rylance, Rick, *Victorian Psychology and British Culture 1850–1880* (Oxford, 2000)

S.S., 'Love of Country in Town', *Eliza Cook's Journal* 1 (1849), 13–14

Sack, James J., *From Jacobite to Conservative: Reaction and Orthodoxy in Britain, c.1760–1832* (Cambridge, 1993)

St Aubyn, Giles, *A Victorian Eminence: The Life and Works of Henry Thomas Buckle* (London, 1958)

Saler, Michael, *The Avant-Garde in Interwar England: Medieval Modernism and the London Underground* (Oxford, 1999)

Salfeld, Frederick, 'The British Grizzle', *Daily Telegraph Magazine*, 9 November 1973, 7

Sampson, Anthony, *Anatomy of Britain* (London, 1962)

Samuel, Raphael, 'Patriotic Fantasy', *New Statesman*, 18 July 1986, 20–22

—— 'Continuous National History', in *Patriotism: The Making and Unmaking of British National Identity*, vol. 1, *History and Politics* (London, 1989), 9–17

—— *Theatres of Memory* (London, 1994)

—— *Island Stories: Unravelling Britain* (London, 1998)

Santayana, George, *Soliloquies on England* (London, 1922)

Savage, Mike, and Andrew Miles, *The Remaking of the British Working Class, 1850–1940* (London, 1994)

Sayce, Revd A.H., *Reminiscences* (London, 1923)

Sayers, Dorothy L., *The Mysterious English* (London, 1941)

Scarborough, Harold E., *England Muddles Through* (London, 1932)

Scarfoglio, Carlo, *England and the Continent* (London, 1939)

Schama, Simon, *A History of Britain: The Fate of Empire 1776–2000* (London, 2002)

Schlesinger, Philip, 'On National Identity: Some Conceptions and Misconceptions Criticized', *Social Science Information* 26 (1987), 219–64

Schmidt, Gustav, 'The Domestic Background to British Appeasement Policy', in *The Fascist Challenge and the Policy of Appeasement*, ed. Wolfgang J. Mommsen and Lothar Kettenacker (London, 1983), 101–24

Schwarz, Bill, 'The Language of Constitutionalism: Baldwinite Conservatism', in *Formations of Nation and People* (London, 1984), 1–18

Scruton, Roger, *England: An Elegy* (London, 2000)

Seabrook, Jeremy, 'Tabula Rasa', *New Statesman*, 4 June 1993, 16

Searle, G.R., *Eugenics and Politics in Britain 1900–1914* (Leyden, 1976)

—— The Quest for National Efficiency: A Study in British Politics and Political Thought, 1899–1914 (1971), reprint edition (London, 1990)

—— A New England? Peace and War 1886–1918 (Oxford, 2004)

Sedlak, Francis, 'Life in a Moravian Village', Spectator, 15 May 1915, 678–9

Seeley, J.R., 'Ethics and Religion: An Address Before the Ethical Society of Cambridge', Fortnightly Review 45 (1889), 501–14

—— The Expansion of England (London, 1883)

—— The Expansion of England (1883), ed. John Gross (Chicago, 1971)

[?Seeley, J.R.], 'National Life and Character', Athenaeum, 4 March 1893, 273–4

Seely, Maj.-Gen. J.E.B., For Ever England (London, 1932)

Semmel, Bernard, Imperialism and Social Reform: English Social-Imperial Thought 1895–1914 (London, 1960)

—— George Eliot and the Politics of National Inheritance (New York, 1994)

Shahani, Ranjee, The Amazing English (London, 1948)

Shanks, Michael, The Stagnant Society: A Warning (Harmondsworth, 1961)

Shannon, Richard, Gladstone, vol. 1, 1809–1965 (London, 1982)

Shenfield, Andrew, 'Before Britain Went Pop', Daily Telegraph, 27 April 1984, 16

Shils, Edward, and Michael Young, 'The Meaning of the Coronation', Sociological Review, n.s., 1:2 (December 1953), 63–81

Shipman, Pat, The Evolution of Racism: Human Differences and the Use and Abuse of Science (New York, 1994)

Siegfried, André, England's Crisis, trans. H.H. and Doris Hemming (London, 1931)

Silex, Karl, John Bull at Home, trans. Huntley Paterson (London, [1931])

Simey, Lord, 'This England', Studies 55 (1966), 131–8

Sitwell, Osbert, Laughter in the Next Room (London, 1949)

Slee, Peter R.H., Learning and a Liberal Education: The Study of Modern History in the Universities of Oxford, Cambridge and Manchester, 1800–1914 (Manchester, 1986)

Sluga, Glenda, 'What is National Self-Determination? Nationality and Psychology During the Apogee of Nationalism', Nations and Nationalism 11 (2005), 1–20

—— The Nation, Psychology, and International Politics, 1870–1919 (Basingstoke, 2006)

Smart, Paul, 'Mill and Nationalism: National Character, Social Progress and the Spirit of Achievement', History of European Ideas 15 (1992), 527–34

Smeed, J.W., The Theophrastan 'Character': The History of a Literary Genre (Oxford, 1985)

Smellie, K.B., The British Way of Life (London, 1955)

Smiles, Samuel, The Autobiography of Samuel Smiles, ed. Thomas Mackay (1905) (London, 1997)

—— Self-Help (1866), ed. Peter W. Sinnema (Oxford, 2002)

Smith, Anthony D., The Ethnic Origins of Nations (Oxford, 1986)

—— National Identity (Harmondsworth, 1991)

Smith, Dennis, 'Englishness and the Liberal Inheritance since 1886', in Englishness: Politics and Culture 1880–1920, ed. Robert Colls and Philip Dodd (London, 1986), 254–82

Smith, Goldwin, Irish History and Irish Character (Oxford and London, 1862)

—— 'The Greatness of England', Contemporary Review 34 (1878–79), 1–18

—— 'The Expansion of England', Contemporary Review 45 (1884), 524–40

—— 'The Schism in the Anglo-Saxon Race', in Canadian Leaves: History, Art, Science, Literature, Commerce, ed. G.M. Fairchild (New York, 1887), 19–57

Smith, Goldwin, 'The Irish Question', in Essays on Questions of the Day, 2nd ed. (New York, 1894), 285–330

Smith, Jeremy, 'Conservative Ideology and Representations of the Union with Ireland, 1885–1914', in The Conservatives and British Society, 1880–1990, ed. Martin Francis and Ina Zweiniger-Bargielowska (Cardiff, 1996), 18–38

Smith, Paul, Disraeli: A Brief Life (Cambridge, 1996)

—— (ed.), *Lord Salisbury on Politics: A Selection from His Articles in the Quarterly Review, 1860–1883* (Cambridge, 1972)

Smith, R.J., *The Gothic Bequest: Medieval Institutions in British Thought, 1688–1863* (Cambridge, 1987)

—— 'European Nationality, Race and Commonwealth in the Writings of Sir Francis Palgrave, 1788–1861', in *Medieval Europeans: Studies in Ethnic Identity and National Perspectives in Medieval Europe*, ed. Alfred P. Smyth (Basingstoke, 1998)

Smith, Woodruff D., *Politics and the Sciences of Culture in Germany, 1840–1920* (New York, 1991)

Soffer, Reba N., *Ethics and Society in England: The Revolution in the Social Sciences, 1870–1914* (Berkeley, 1978)

Solly, Henry, 'The Expansion of England', *Modern Review* 5 (1884), 309–33

Soloway, Richard A., *Demography and Degeneration: Eugenics and the Declining Birthrate in Twentieth-Century Britain* (Chapel Hill, N.C., 1990)

Spencer, Herbert, 'The Comparative Psychology of Man' (1876), in *Essays: Scientific, Political, and Speculative* (London, 1891), vol. 1, 351–70

[Spencer, Herbert], 'Progress: Its Law and Causes', *Westminster Review* 67 (1857), 445–85

Spindler, George D. (ed.), *The Making of Psychological Anthropology* (Berkeley, 1978)

Spinley, B.M., *The Deprived and the Privileged: Personality Development in English Society* (London, 1953)

Spurling, Cuthbert, 'The Secret of the English Character', *Contemporary Review* 110 (1916), 639–45

Stafford, William, 'Religion and the Doctrine of Nationalism in England at the Time of the French Revolution and Napoleonic Wars', in *Religion and National Identity*, ed. Stuart Mews, Studies in Church History 18 (Oxford, 1982), 381–95

Stansky, Peter, 'E.M. Forster: Connecting the Prose and the Passion in 1910', in *After the Victorians: Private Conscience and Public Duty in Modern Britain*, ed. Susan Pedersen and Peter Mandler (London, 1994), 127–46

Stanton, Gareth, 'In Defence of *Savage Civilisation*: Tom Harrisson, Cultural Studies and Anthropology', in *Anthropology and Cultural Studies*, ed. Stephen Nugent and Cris Shore (London, 1997), 11–32

Stapleton, Julia, 'English Pluralism as Cultural Definition: The Social and Political Thought of George Unwin', *Journal of the History of Ideas* 52 (1991), 665–84

—— *Englishness and the Study of Politics* (Cambridge, 1994)

—— 'James Fitzjames Stephen: Liberalism, Patriotism, and English Liberty', *Victorian Studies* 41 (1997–98), 243–63

—— 'Political Thought and National Identity in Britain, 1850–1950', in *History, Religion and Culture: British Intellectual History 1750–1950*, ed. S. Collini, R. Whatmore and B. Young (Cambridge, 2000), 245–69

—— *Political Intellectuals and Public Identities in Britain since 1850* (Manchester, 2001)

—— *Sir Arthur Bryant and National History in Twentieth-Century Britain* (Lanham, Md., 2005)

'A Statistical Outline of the Present Condition and Progress of the Anglo-Saxon Race', *Anglo-Saxon* 1 (1849), pt II, 161–72

Stedman Jones, Gareth, *Outcast London: A Study in the Relationship between Classes in Victorian Society* (London, 1971)

—— *Languages of Class: Studies in English Working Class History, 1832–1982* (Cambridge, 1983)

—— 'The "Cockney" and the Nation, 1780–1988', in *Metropolis-London: Histories and Representations since 1800*, ed. David Feldman and Gareth Stedman Jones (London, 1989), 272–324

Steedman, Carolyn, 'Inside, Outside, Other: Accounts of National Identity in the Nineteenth Century', *History of the Human Sciences* 8:4 (1995), 59–76

Steele, E.D., 'J.S. Mill and the Irish Question: The Principles of Political Economy, 1848–65', *Historical Journal* 13 (1970), 216–36

—— 'J.S. Mill and the Irish Question: Reform and Integrity of the Empire, 1865–70', *Historical Journal* 13 (1970), 419–50

Stepan, Nancy, *The Idea of Race in Science: Great Britain 1800–1960* (London, 1982)

—— '"Nature's Pruning Hook": War, Race and Evolution, 1914–18', in *The Political Culture of Modern Britain*, ed. J.M.W. Bean (London, 1987), 129–48

Stephan, E.M., 'Englishmen and Frenchmen – Some Contrasts', *Listener*, 25 September 1947, 510–11

[Stephen, J.F.], 'Buckle's *History of Civilization in England*', *Edinburgh Review* 107 (1858), 465–512

—— 'National Character', *Cornhill Magazine* 4 (1861), 584–98

Stephen, Leslie, 'An Attempted Philosophy of History', *Fortnightly Review*, n.s., 27 (1880), 672–95

—— (ed.), *Letters of John Richard Green* (London, 1901)

Stephens, W.R.W., *The Life and Letters of Edward A. Freeman*, 2 vols (London, 1895)

Stocking, George W., Jr., 'From Chronology to Ethnology: James Cowles Prichard and British Anthropology 1800–1850', in J.C. Prichard, *Researches into the Physical History of Man* (1813), ed. George W. Stocking, Jr. (Chicago, 1973), ix–cx

—— *Victorian Anthropology* (New York, 1987)

—— *After Tylor: British Social Anthropology, 1888–1951* (London, 1996)

[Stocking, George W., Jr.], 'Essays on Culture and Personality', Introduction to *Malinowski, Rivers, Benedict and Others: Essays on Culture and Personality*, ed. George W. Stocking, Jr. (Madison, Wis., 1986), 3–12

Strachey, Ray, 'The Women of England', *Spectator*, 23 November 1934, 799–800

Strobl, Gerwin, *The Germanic Isle: Nazi Perceptions of Britain* (Cambridge, 2000)

Stubbs, William, *The Constitutional History of England in its Origin and Development*, 3 vols (Oxford, 1874–78)

—— 'The Comparative Constitutional History of Mediaeval Europe' in *Lectures on Early English History*, ed. Arthur Hassall (London, 1906), 194–204

—— 'The Elements of Nationality Among European Nations', in *Lectures on Early English History*, ed. Arthur Hassall (London, 1906), 205–25

Stutterheim, Kurt von, *Those English!*, trans. L. Marie Sieveking (London, 1937)

Sumner, John Bird, *A Treatise on the Records of Creation and on the Moral Attributes of the Creator*, 2 vols (London, 1816)

Surridge, Keith Terrance, *Managing the South African War, 1899–1902: Politicians v. Generals* (Woodbridge, 1998)

Susman, Warren I., '"Personality" and the Making of Twentieth-Century Culture', in *Culture as History: The Transformation of American Society in the Twentieth Century* (New York, 1984), 271–85

Sweet, Rosemary, *Antiquaries: The Discovery of the Past in Eighteenth-Century Britain* (London, 2004)

Tacitus, *Agricola and Germany*, ed. Anthony R. Birley (Oxford, 1999)

Taine, H.A., *History of English Literature*, 2 vols (Edinburgh, 1871)

—— *Notes on England*, ed. Edward Hyams (London, 1957)

Tajfel, Henri, 'The Nation and the Individual', *Listener*, 12 May 1960, 846–7

—— 'The Formation of National Attitudes: A Social-Psychological Perspective', in *Interdisciplinary Relationships in the Social Sciences*, ed. M. Sherif and C.W. Sherif (Chicago, 1969), 137–76

Tallents, Sir Stephen, *The Projection of England* (London, 1932)

Tawney, R.H., *The Acquisitive Society* (New York, 1920)

Taylor, Helen (ed.), *Miscellaneous and Posthumous Works of Henry Thomas Buckle*, 3 vols (London, 1872)

Taylor, Miles, 'Patriotism, History and the Left in Twentieth-Century Britain', *Historical Journal* 33 (1990), 971–87

—— 'John Bull and the Iconography of Public Opinion in England c.1712–1929', *Past & Present* 134 (1992), 93–128

—— *The Decline of British Radicalism* (Oxford, 1995)

Taylor, Philip M., *The Projection of Britain: British Overseas Publicity and Propaganda 1919–1939* (Cambridge, 1981)

Thackeray, W.M., 'Miss Tickletoby's Lectures on English History', in *Contributions to 'Punch'* (London, 1886), 3–78

Theroux, Paul, *The Kingdom by the Sea* (London, 1983)

Thomas, James, *Diana's Mourning: A People's History* (Cardiff, 2002)

Thomas, William, *The Quarrel of Macaulay and Croker: Politics and History in the Age of Reform* (Oxford, 2000)

Thompson, Andrew, 'The Language of Imperialism and the Meanings of Empire: Imperial Discourse in British Politics, 1895–1914', *Journal of British Studies* 36 (1997), 147–77

—— *Imperial Britain: The Empire in British Politics c.1880–1932* (Harlow, 2000)

Thompson, E.P., 'The Peculiarities of the English' (1965), in *The Poverty of Theory and Other Essays* (New York, 1978), 245–301

Thomson, Mathew, '"Savage Civilisation": Race, Culture and Mind in Britain, 1898–1939', in *Race, Science and Medicine, 1700–1960*, ed. Waltraud Ernst and Bernard Harris (London, 1999), 235–58

—— 'Psychology and the "Consciousness of Modernity" in Early Twentieth-Century Britain', in *Meanings of Modernity: Britain from the Late-Victorian Era to World War II*, ed. M. Daunton and B. Rieger (Oxford, 2001), 97–115

Thornton, A.P., *The Imperial Idea and Its Enemies*, 2nd ed. (Basingstoke, 1985)

Tidrick, Kathryn, *Empire and the English Character* (London, 1990)

Tilby, A. Wyatt, 'Regional Varieties of the English Genius', *Nineteenth Century and After* 115 (1934), 679–90

Tomlinson, Jim, 'Inventing "Decline": The Falling Behind of the British Economy in the Postwar Years', *Economic History Review*, 2nd ser., 49 (1996), 731–57

Topinard, Paul, *Anthropology*, trans. Robert T.H. Bartley (London, 1878)

Toulmin Smith, J., *Local Self-Government and Centralization. . .including Comprehensive Outlines of the English Constitution* (London, 1852)

Townshend, Charles, 'On the National Health', *Times Literary Supplement*, 28 November 1986, 1335–6

Tracy, Honor, 'An Englishman! Admit It!', *Daily Telegraph*, 1 May 1976, 12

—— 'What *They* Think of Us', *Daily Telegraph*, 11 February 1984, 12

Tregenza, John, *Professor of Democracy: The Life of Charles Henry Pearson, 1830–1894* (Melbourne, 1968)

Treves, Paulo, *England, The Mysterious Island* (London, 1948)

'The Truth About Britain?', *Listener*, 23 September 1965, 453, 455

Tuker, M.A.R., '"Teutons" Latinised and Unlatinised', *Nineteenth Century* 89 (1921), 881–99

[Twiss, Travers], 'Austria and Germany', *Quarterly Review* 84 (1848–49), 185–222

—— 'The Germanic Confederation and the Austrian Empire', *Quarterly Review* 84 (1848–49), 425–61

Unwin, George, 'A Note on the English Character', *International Journal of Ethics* 18 (1907–08), 459–65

Urban, Mark, 'Which is the True Face of England?', *Guardian*, 5 May 1999, 12

Urry, James, 'Englishmen, Celts, and Iberians: The Ethnographic Survey of the United Kingdom, 1892–1899', in *Functionalism Historicized: Essays on British Social Anthropology*, ed. George W. Stocking, Jr. (Madison, Wis., 1984), 83–105

Vansittart, Peter, *In Memory of England: A Novelist's View of History* (London, 1998)

Varouxakis, Georgios, 'The Public Moralist versus Ethnocentrism: John Stuart Mill's French Enterprise', *European Review of History* 3 (1996), 27–38

—— 'John Stuart Mill on Race', *Utilitas* 10 (1998), 17–32

—— *Mill on Nationality* (London, 2002)

—— *Victorian Political Thought on France and the French* (Basingstoke, 2002)

Vaughan, Henry Halford, *Two General Lectures on Modern History* (Oxford, 1849)

Vaughan, Robert, *Revolutions in English History*, 3 vols (London, 1859–63)

Vaughan Jones, Geraint, 'The English As Others See Them', *Congregational Quarterly* 23 (1945), 107–21

Viroli, Maurizio, *For Love of Country: An Essay on Patriotism and Nationalism* (Oxford, 1995)

Von Arx, Jeffrey Paul, *Progress and Pessimism: Religion, Politics, and History in Late Nineteenth-Century Britain* (Cambridge, MA, 1985)

Wahrman, Dror, *Imagining the Middle Class: The Political Representation of Class in Britain, c.1780–1840* (Cambridge, 1995)

Waitz, Theodor, *Introduction to Anthropology*, ed. J. Frederick Collingwood (London, 1863)

Wallace, Alfred Russel, 'Evolution and Character', in *Character and Life: A Symposium*, ed. Percy L. Parker (London, 1912), 3–50

Wallace, Anthony F.C., *Culture and Personality*, 2nd ed. (New York, 1970)

Wallace, William, 'A Comfortable Illusion', *Guardian*, 21 June 1991, 23

—— 'Foreign Policy and National Identity in the United Kingdom', *International Affairs* 67 (1991), 65–80

Wallas, Graham, *Human Nature in Politics* (London, 1908)

[Walpole, Spencer], 'The Forecast of Mr Pearson', *Edinburgh Review* 178 (1893), 277–304

Ward, Paul, *Red Flag and Union Jack: Englishness, Patriotism and the British Left, 1881–1924* (Woodbridge, 1998)

—— *Britishness Since 1870* (London, 2004)

—— 'Nationalism and National Identity in British Politics, c.1880s to 1914', in *History, Nationhood and the Question of Britain*, ed. Helen Brocklehurst and Robert Phillips (Basingstoke, 2004), 213–23

Ward, Stuart, 'The End of Empire and the Fate of Britishness', in *History, Nationhood and the Question of Britain*, ed. Helen Brocklehurst and Robert Phillips (Basingstoke, 2004), 242–58

Warner, Marina, 'Home: Our Famous Island Race', *Independent*, 3 March 1994, 18

Wasson, E.A., 'The Great Whigs and Parliamentary Reform, 1809–30', *Journal of British Studies* 24 (1985), 434–64

Waters, Chris, 'J.B. Priestley: Englishness and the Politics of Nostalgia', in *After the Victorians: Private Conscience and Public Duty in Modern Britain*, ed. Susan Pedersen and Peter Mandler (London, 1994), 209–26

—— '"Dark Strangers In Our Midst": Discourses of Race and Nation in Britain, 1947–1963', *Journal of British Studies* 36 (1997), 207–38

Watt, David, 'What Has Become of Our National Pride?', *Times*, 10 July 1981, 12

[?Watts, Alaric], 'Characters of the English, Scots and Irish', *Blackwood's Edinburgh Magazine* 26 (1829), 818–24

Waugh, Evelyn, *Brideshead Revisited* (1945) (Harmondsworth, 1992)

Weaver, Stewart A., *The Hammonds: A Marriage in History* (Stanford, Ca., 1997)

—— 'The Pro-Boers: War, Empire, and the Uses of Nostalgia in Turn-of-the-Century England', in *Singular Continuities: Tradition, Nostalgia and Society in Modern Britain*, ed. George K. Behlmer and F.M. Leventhal (Stanford, Ca., 2000), 43–57

Weber, Max, 'National Character and the Junkers' (1917), in *From Max Weber: Essays in Sociology*, ed. H.H. Gerth and C. Wright Mills (London, 1947), 386–95

Webster, Wendy, *Imagining Home: Gender, 'Race' and National Identity, 1945–64* (London, 1998)

—— *Englishness and Empire 1939–1965* (Oxford, 2005)

Weight, Richard, 'Raise St George's Standard High', *New Statesman*, 8 January 1999, 25–7

—— *Patriots: National Identity in Britain 1940–2000* (London, 2002)

Weightman, J.G., 'The Non-Compulsive Society', *Encounter*, January 1962, 12–13

Welch, Cheryl B., *Liberty and Utility: The French Ideologues and the Transformation of Liberalism* (New York, 1984)

Welch, Colin, 'Our Last Days as an Island', *Daily Telegraph*, 30 December 1972, 18

Wellard, James Howard, *Understanding the English* (London, [1938])

Wells, H.G., *The New Machiavelli* (London, 1911)

—— *An Englishman Looks at the World* (London, 1914)

—— *The Outline of History* (London, 1920)

—— *The New Teaching of History* (London, 1921)

West, Richard, 'The English, Still a Race Apart', *Daily Telegraph*, 30 August 1976, 6

White, Donald A., 'Changing Views of the *Adventus Saxonum* in Nineteenth and Twentieth-Century English Scholarship', *Journal of the History of Ideas* 32 (1971), 585–94

White, Richard Grant, *England Without and Within* (London, 1881)

Whitman, James, 'From Philology to Anthropology in Mid-Nineteenth-Century Germany', in *Functionalism Historicized: Essays on British Social Anthropology*, ed. George W. Stocking, Jr. (Madison, Wis., 1984), 214–29

Whitman, Sidney, *Conventional Cant: Its Results and Remedy* (London, 1887)

—— *Teutonic Studies* (London, 1895)

—— 'The Metamorphosis of England', *Fortnightly Review*, n.s., 82 (1907), 203–14

'Who Are the Anglo-Saxons?', *Anglo-Saxon* 1 (1849), pt III, 5–16

Wiener, Martin J., *English Culture and the Decline of the Industrial Spirit, 1850–1980* (Cambridge, 1981)

—— 'Homicide and "Englishness": Criminal Justice and National Identity in Victorian England', *National Identities* 6 (2004), 203–13

Wiley, Raymond A. (ed.), *John Mitchell Kemble and Jakob Grimm, A Correspondence 1832–1852* (Leiden, 1971)

Wilkinson, Spenser, *The Nation's Awakening* (Westminster, 1896)

Williams, Orlo, 'Florence and Lewis: or, the English Mind and the European', *Cornhill Magazine*, n.s., 68 (1930), 83–93

Williams, Raymond, *Culture and Society, 1780–1950* (London, 1958)

Williamson, Philip, *Stanley Baldwin: Conservative Leadership and National Values* (Cambridge, 1999)

Williamson, S.C., *The English Tradition in the World* (London, [1939])

Wilson, Angus, 'Fourteen Points', *Encounter*, January 1962, 10–12

Wilson, Kathleen, *The Island Race: Englishness, Empire and Gender in the Eighteenth Century* (London, 2003)

Wilson, Sir Arnold T., and C. Delisle Burns, 'The National Character: Tradition v. Change. Part of a Discussion', *Listener*, 4 April 1934, 582–3

Windsor, Philip, 'Our Right Little, Loose Little Island', *Observer Magazine*, 28 December 1969, 34–5

Wingfield-Stratford, Esme, *The History of British Civilization* (London, 1928)

—— *The Foundations of British Patriotism* (London, 1939)

—— *The New Patriotism and the Old* (London, [1943])

Winter, Alison, *Mesmerized: Powers of Mind in Victorian Britain* (Chicago, 1998)

Winter, J.M., 'British National Identity and the First World War', in *The Boundaries of the State in Modern Britain*, ed. S.J.D. Green and R.C. Whiting (Cambridge, 1996), 261–77

Wisdom, J.O., 'The Social Pathology of Great Britain', *Listener*, 18 August 1966, 223–5

Wood, Michael, *In Search of England: Journeys into the English Past* (London, 1999)

Wormald, Patrick, '*Engla Lond*: The Making of an Allegiance', *Journal of Historical Sociology* 7 (1994), 1–24

Wormell, Deborah, *Sir John Seeley and the Uses of History* (Cambridge, 1980)

Wright, Patrick, *On Living in an Old Country* (London, 1985)

Wright, Tony, and Andrew Gamble, 'The End of Britain?', *Political Quarterly* 71 (2000), 1–3

Wybrow, Robert J., *Britain Speaks Out, 1937–87* (London, 1989)

Y.Y., 'The Modest Englishman', *New Statesman*, 19 March 1927, 692–3

Yeandle, Peter, 'Lessons in Englishness and Empire, c.1880–1914: Further Thoughts on the English/British Conundrum', in *History, Nationhood and the Question of Britain*, ed. Helen Brocklehurst and Robert Phillips (Basingstoke, 2004), 274–86

Young, Hugo, *This Blessed Plot: Britain and Europe from Churchill to Blair* (Macmillan, 1998)

Young, Norwood, *England Conquers the World* (London, 1937)

Young, Robert J.C., *Colonial Desire: Hybridity in Theory, Culture and Race* (London, 1995)

Young, Wayland, 'Return to Wigan Pier', *Encounter*, June 1956, 5–11

Younghusband, Francis, 'The Emerging Soul of England', *National Review* 55 (1910), 66–82

Zeldin, Theodore, 'Ourselves, As We See Us', *Times Literary Supplement*, 31 December 1982, 1435–6

Zimmern, Alfred E., *Nationality and Government* (London, 1918

ABBREVIATED TITLES

OED	*Oxford English Dictionary*
Old *DNB*	*Dictionary of National Biography*
New *DNB*	*Oxford Dictionary of National Biography*, online edn (www.oxforddnb.com)
Wellesley	*Wellesley Index to Victorian Periodicals, 1824–1900*, ed. Walter E. Houghton, 5 vols (Toronto, 1966–89)

Index

Vikings 13, 14, 104, 114, 266
Voltaire 18

Wales 4, 9, 11, 16, 154, 177, 194
 and nationalism 97–8, 148, 226, 229,
 238
 see also national character, Welsh
Wallace, William 134
Wallas, Graham 136
Walpole, Horace 36
Waugh, Evelyn 200–202
Wayne, Naunton 291
 see also Charters and Caldicott
Weight, Richard 213
Weismann, August 117
Wellington, 1st Duke of 29, 30, 99

Wells, Herbert George 128, 185, 287
Westmacott, Richard 30
'whig interpretation of history' 36–8,
 46–7, 88, 185, 242
Whitman, Sidney 109, 138
Wiener, Martin 233–4
Wilkinson, Spenser 128
women 6, 46, 55–6, 103, 140, 141, 171,
 186, 194, 206, 212, 222, 237, 252,
 265
Woolf, Virginia 185
Wright, Patrick 234
Wyclif, John 10

Zimmern, Alfred 130, 147, 197, 271